icono

seits der Bilderkriege

clash

Beyond the Image War

BEYOND

THE IMAGE WARS IN SCIENCE, RELIGION, AND ART

icono

Yeshiva University Museum

clash

edited by Bruno Latour and Peter Weibel

ZKM
Center for Art and Media | Karlsruhe

The **MIT** Press
Cambridge, Massachusetts
London, England

THE EXHIBITION

Curators
Peter Weibel, Bruno Latour, Peter Galison, Dario Gamboni,
Joseph Leo Koerner, Adam Lowe, and Hans-Ulrich Obrist

Scientific advisory committee
Hans Belting, Boris Groys, Denis Laborde, Marie-José Mondzain,
and Heather Stoddard

Project Management and Curatorial Assistance
Gregor Jansen and Sabine Himmelsbach

Assistance
Andrea Buddensieg, Anke Hoffmann, Katrin Kaschadt, Ika Szope, Barbara
Filser, Christina Schüler, Valérie Pihét, Vincent Boureau, Tania Gorucheva,
Anna-Karina Birkenstock / Trainees: Jaana Schmidt, and Nadine Vogt

Exhibition Architecture
Manfred Wolff-Plottegg / Assistance: Arne Böhm

Registrar
Gina Linder

Conservation
Silvia Krauß, Cornelia Weik, and Tilman Daiber

Technical Manager
Martin Häberle

Construction Management
Ronald Haas and Christiane Ostertag

Construction Team
Werner Hutzenlaub, Gisbert Laaber, Mirco Frass, Marco Sonntag,
Gregor Gaissmaier, Claudius Böhm, Volker Becker, Martin Boukhalfa,
Silke Fehsenfeld, Lego Nainggolan, Oliver Klingel, Thomas Linder,
Manfred Stürmlinger, Dortje Drechsel, Peter Gather, Ines Gottwald,
Peter Dinckelacker, Martina Haitz, Gabriel Vormstein, Pedrag Zaric,
Jürgen Galli, Jan Birkholz, Gregor Stehle, Matthias Bitzer, Axel Reusch,
Karen Markert, Christine Müller, Sebastian Reiter, Frederick Busch,
Joachim Hirling, Amin Mehanna, Tinka Stock, Werner Wenzel,
Steffen Wolf, Elke Cordell, Anna Reiss, Manfed Hauffen, Torsten Ziegler

Facility Management
Martin Braun, Peter Futterer, Hartmut Kampe, Peter Kiefer, Peter Kuhn,
Michael Mack, Christof Menold, Kurt Pfund, Karl Stumm, Klaus Wirth

IT Support
Joachim Schütze and Uwe Faber

Educational Programm
Bernhard Serexhe

Public Affairs
Carmela Thiele, Sabine Peters, and Petra Meyer

Website
Silke Altvater, Heike Borowski, Anna Elkins, Maryam Foroozanfar, Arne Gräßer,
Inge Hinterwaldner, Petra Kaiser, Christoph Pingel, and Andreas Schöller

Special thanks to
All the lenders, museums, galleries, artists without such an outstanding
project never could be realized. We would like to express our deepest
gratitude to: the SMPK, Berlin / British Museum, London / Albertina, Wien /
Neue Galerie am Landesmuseum Joanneum, Graz / Pascal Cordereix, BNP /
Jean-Luc Estournel, Paris.
For their precious support we say thanks to the people around and in the
ZKM, Ecke Bonk, Axel Heil, Ingrid Truxa, Ingrid Walther, Ilse Schott,
Kuno Schmitt, Margit Rosen, Boris Kirchner, Ulrike Havemann, Elke
Karras, Ilona Bucke-Mock, Hartmut Bruckner, Hans Gass, Markus
Kritzokat, Marianne Bruder, Petra Zimmermann, Petra Koger, Viola Gaiser,
Monika Leyenberger, Manuel Weber, Ike Palmer, Michael Minschke, Tilo
Reeb, Rupert Vogel (Bartsch & Partner), Tanja Schiatti, Ole Fuhlrott,
Claudia Gehrig.

Our heartfelt thanks for the realisation of the science cell by Peter Galison
to Karl-Heinz Kampert, Günter Quast, Harald Schieler, Forschungszentrum
Karlsruhe / Samuel J. Patterson, University of Göttingen / Ulf Hashagen,
Deutsches Museum München / Gerd Fischer, University of Düsseldorf /
Hans Drevermann, CERN, Genève / Thomas Hebekker, RWTH Aachen /
Wolfgang Rhode, University of Wuppertal / Hans-J. Grabosch, DESY Zeuthen.
For the re-construction of the installation "Eletric Labyrinth" by
Arata Isozaki we would like to thank Arata Isozaki & Associates /
Jin Hidaka, Slowmedia, Tokyo / Firma Ortlepp & Hudarin, Schutterwald /
Christopher Gutmann, Pollux Company, Ottenhöfen /
Centrallabor, Karlsruhe / Axel Kaeshammer.

Partner of ZKM Partner der Staatsoper Stuttgart und des Zentrums für Kunst und Medientechnologie Karlsruhe (ZKM).

Landesbank Baden-Württemberg

Main Sponsor Global Future Technologies

Sponsors
For the installation "Electric Labyrinth" by Arata Isozaki we would like
to thank for generous support and coprodution The Japan Foundation,
Tokyo / Ida Gianelli, Castello di Rivoli, Torino and Francesco Todoli,
Musee de Seralves, Porto.

For the financial support of the short-guide we would like to thank the
AFAA – Bureau des Arts Plastiques / French Embassy

For the works of Felix Gmelin Moderna Museet, Stockholm

Forschungszentrum Karlsruhe

Videor Technical, Rödermark

THE BOOK

A publication by the ZKM | Center for Art and Media, Karlsruhe
on the occasion of the exhibition

iconoclash
Beyond the Image Wars in Science, Religion, and Art
ZKM | Karlsruhe
4 May – 4 August 2002

Editors
Bruno Latour and Peter Weibel

ZKM | Karlsruhe Publication Program
Dörte Zbikowski, editor
Ulrike Havemann, assistant editor

Assistance
Jens Lutz and Miriam Stürner

Special thanks to
Andrea Buddensieg, Andreas Kühner, Adolf Mathias,
Margit Rosen, Pamela Schmidt, Christina Schüler, Dominika Szope,
and Thomas Zandegiacomo Del Bel

Translators
Charlotte Bigg, Richard Carpenter, Sarah Clift, Jennifer Dawes,
Jeremy Gaines, June Klinger, Liz Libbrecht, Matthew Partridge,
and Lisa Rosenblatt

Copy editors
Charlotte Eckler and Lisa Rosenblatt

Lithography
Karl Specht – Moderne Reprotechnik, Karlsruhe

Design
[thinc]2 communications, Cologne
Michael Throm: design concepts,
Marion Haimel, Matthias Rincon: design, layout

This book was printed and bound in Karlsruhe, Germany,
by Engelhardt & Bauer.

ISBN 0-262-62172-X

The editors wish to carry their warmest thanks to Dörte Zbikowski and her team for the incredible amount of work they put under extreme pressure in the making and design of this volume.
They also wish to carry their warmest thanks to Gregor Jansen and Sabine Himmelsbach and their team for the thoughtful planning, organization and realization of the exhibition, Martin Häberle and his team for the technical realization of the exhibition architecture and the general set up of the show. They all put an incredible amout of work into this extraordinary project which had to be realized in an extreme short period of time.

CONTENTS

CONTENTS

CAN THE GODS COHABITATE?

BUT THERE IS NO IMAGE ANYMORE ANYWAY!

CAN WE GO BEYOND THE IMAGE WARS?

HAS CRITIQUE ENDED?

WHAT HAS HAPPENED TO MODERN ART?

APPENDIX

What is iconoclash?

WHAT IS ICONOCLASH? OR IS THERE A WORLD BEYOND THE IMAGE WARS?

Bruno Latour

Prologue: A Typical Iconoclash

This image comes from a video. What does it mean? Hooligans dressed in red, with helmets and axes are smashing the reinforced window that is protecting a precious work of art. They are madly hitting the glass that splinters in every direction while loud screams of horror at their action are heard from the crowd beneath them that, no matter how furious it is, remains unable to stop the looting. Another sad case of vandalism captured by a camera of video-surveillance? No. Brave Italian firemen a few years ago risking their lives in the cathedral of Turin to save the precious Shroud from a devastating fire that triggers the screams of horror from the impotent crowd that has assembled behind them. In their red uniforms, with their protective helmets, they try to smash with axes the heavily reinforced glass case that has been built around the venerable linen to protect it – not from vandalism – but from the mad passion of worshippers and pilgrims who would have stopped at nothing to tear it to pieces and obtain priceless relics. The case is so well protected against worshippers that it cannot be brought to safety away from the raging fire without this *apparently* violent act of glass breaking. Icono*clasm* is when we know what is happening in the act of breaking and what the motivations for what appears as a clear project of destruction are; icono*clash*, on the other hand, is when one does not know, one hesitates, one is troubled by an action for which there is no way to know, without further inquiry, whether it is destructive or constructive. This exhibition is about icono*clash*, not icono*clasm*.

Why Do Images Trigger So Much Passion?

"Freud is perfectly right in insisting on the fact that we are dealing in Egypt with the first counter-religion in the history of humanity. It is here that, for the first time, the *distinction* has been made [by Akhenaton] that has triggered the hate of those excluded by it. It is since this distinction that hatred exists in the world and the only way to go beyond it is to go back to its origins."[1] No quote could better summarize what I see as the goal of *Iconoclash*. (I should warn the reader from the start that none of the curators completely agree on the goals of this exhibit! As an editor, I just have the privilege of having my say first.) What we propose here in this show and in this catalog is an archeology of hatred and fanaticism.[2]

Why? Because we are digging for the origin of an absolute – not a relative – distinction between truth and falsity, between a pure world, absolutely emptied of human-made intermediaries and a disgusting world composed of impure but fascinating human-made mediators. "If only, some say, we could do *without* any images. How so much better, purer, faster our access to God, to Nature, to Truth, to Science could be." To which other voices (or sometimes the same) answer: "Alas (or fortunately), we cannot do *without* images, intermediaries, mediators of all shapes and forms, because this is the only way to access God, Nature, Truth and Science." It is this quandary that we want to document, to fathom and, maybe, to overcome. In the strong summary that Marie-José Mondzain proposed of the Byzantine quarrel over images, "La vérité est image mais il n'y a pas d'image de la vérité." (Truth is image, but there is no image of truth.)[3]

What has happened that has made images (and by image we mean any sign, work of art, inscription, or picture that acts as a mediation to access something else) the focus of so much passion? To the point that destroying them, erasing them, defacing them, has been taken as the ultimate touchstone to prove the validity of one's faith, of one's science, of one's critical acumen, of one's artistic creativity? To the point where being an iconoclast seems the highest virtue, the highest piety, in intellectual circles?

Furthermore, why is it that all those destroyers of images, those "theoclasts," those iconoclasts, those "ideoclasts" have also generated such a fabulous population of new

1 3 2

_ Retranslated from the French. Jan Assmann, *Moïse l'égyptien. Un essai d'histoire de la mémoire*, Aubier, Paris, 2001, p. 283: "Freud a parfaitement raison d'insister sur le fait que nous avons affaire en Egypte à la première contre-religion monothéiste qu'ait connu l'histoire de l'humanité. C'est ici que s'est opérée pour la première fois la *distinction* qui a attiré sur elle la haine des exclus. *C'est depuis lors que la haine existe dans le monde*, et le seul moyen de le dépasser est de revenir à ses origines," since the English version is very different: "Freud concentrates all the counter-religious force of Biblical monotheism in Akhenaton's revolution from above. This was the origin of it all. Freud stresses (quite correctly) the fact that he is dealing with the absolutely first monotheistic, counter-religious, and exclusivistically intolerant movement of this sort in human history. The similarity of this interpretation to Manetho's is evident. It is this hatred brought about by Akhenaton's revolution that informs the Judeophobic texts of antiquity." (*Moses the Egyptian. The Memory of Egypt in Western Monotheism*, Harvard University Press, Cambridge, 1997, p. 167).

_ On the genealogy of fanatics and other *Schwärmer*, see the fascinating account of Dominique Colas, *Le glaive et le fléau: généalogie du fanatisme et de la société civile*, Paris, 1992. Olivier Christin, *Une révolution symbolique*, Minuit, Paris, 1991.

_ See her chapter in this catalog and Marie-José Mondzain, *Image, icône, économie. Les sources byzantines de l'imaginaire contemporain*, Le Seuil, Paris, 1996.

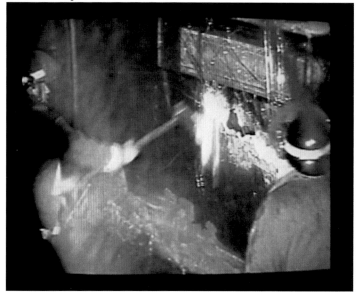

Firemen breaking the shroud of Turin to save it / film still

images, fresh icons, rejuvenated mediators: greater flows of media, more powerful *ideas*, stronger *idols*? As if defacing some object would inevitably generate new faces, as if defacement and "refacement" were necessarily coeval (see Belting, Powers).[4] The tiny Buddha head that Pema Konchok offered for our meditation, even after having been smashed by the Red Guards during the Cultural Revolution, managed to take up a new sarcastic, cringing and painful face … (see Konchok).

And what has happened to explain that after every icono-*crisis* infinite care is taken to reassemble the smashed statues, to save the fragments, to protect the debris? As if it was always necessary to apologize for the destruction of so much beauty, so much horror; as if one was suddenly uncertain about the role and cause of destruction that, before, seemed so urgent, so indispensable; as if the destroyer had suddenly realized that something *else* had been destroyed by mistake, something for which atonement was now overdue. Are not museums the temples in which sacrifices are made to apologize

for so much destruction, as if we wanted suddenly to stop destroying and were beginning the indefinite cult of conserving, protecting, repairing?

This is what our exhibition attempts to do: this capharnaum of heterogeneous objects that we have assembled – broken, repaired, patched up, re-described – offers the visitors a meditation on the following questions:

Why have images attracted so much hatred?

Why do they always return again, no matter how strongly one wants to get rid of them?

Why have the iconoclasts' hammers always seemed to strike *sideways*, destroying something *else* that seems, after the fact, to matter immensely?

How is it possible to go *beyond* this cycle of fascination, repulsion, destruction, atonement, that is generated by the forbidden-image worship?

An Exhibition About Iconoclasm

Contrary to many similar undertakings, this is not an iconoclastic exhibition: it is *about* iconoclasm.[5] It attempts to *suspend* the urge to destroy images, requires us to pause for a moment; to leave the hammer to rest. It prays for an angel to come and arrest our sacrificial arm holding the sacrificial knife ready to cut the sacrificial lamb's throat. It is an attempt to turn around, to envelop, to embed the worship of image destruction; to give it a home, a site, a museum space, a place for meditation and surprise. Instead of iconoclasm being the meta-language reigning as a master over all other languages, it is the worship of icononoclasm itself which, in turn, is interrogated and evaluated. From a *resource*, iconoclasm, is being turned into a *topic*. In the words proposed by Miguel Tamen's beautiful title: we want visitors and readers to become "friends of interpretable objects" (see Tamen).[6]

In a way, this exhibition tries to document, to expose, to do the anthropology of a certain gesture, a certain move-

4

5 6

_ Several centuries after Farel, the Neuchâtel iconoclast, had burned books and smashed statues of the Catholic church, he himself was honored by a statue in front of the now emptied church. See picture and text by Léchot in this catalog. The most striking cases of speedy replacement of one idol by an icon (or depending on the point of view of one idol by another one) are described in Serge Gruzinski, *La colonisation de l'imaginaire. Sociétés indigènes et occidentalisation dans le mexique espagnol XVIe XVIIIe*, Gallimard, Paris, 1988. When during the Spanish conquest of Mexico priests ask other priests to tend the statues of the Virgin Mary in the very places where the "idols" lay smashed to the ground.

_ Miguel Tamen, *Friends of Interpretable Objects*, Harvard University Press, Cambridge, 2001.

_ See, for instance, the Berne and Strasbourg exhibit in 2001: Cécile Dupeux, Peter Jezler, et al., (eds), *Iconoclasme. Vie et mort de l'image médiévale*, Somogy editions d'art, Paris, 2001. The Bern exhibit was entirely built in the honor of the courageous icon breakers who had freed the city from the power of images to lead to the superior symbolism of the cross … all the way to a diorama where wax figures were melting useless calices and reliquaries to mold useful Swiss gold coins! But in a nice iconoclash the last room showed the permanent remnants of the broken statues which had been transmogrified from hideous idols into art work piously conserved! No indication was given the visitors of any possible icono*clash* … The same iconoclastic *piety* can be seen in the Louvre's recent exhibit by Régis Michel called *La peinture comme crime*, Réunions des musées nationaux, Paris, 2002.

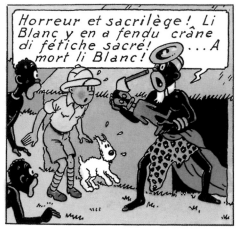

Tintin in Congo.
Broken Fetiche / Hergé /
Tintin au Congo /
image from the comic /
© Hergé/Moulinsart.
Brussels. 2002

ment of the *hand*. What does it mean to say of some mediation, of some inscription, that it is *human-made*?

As is well known from art historians and theologians, many sacred icons that have been celebrated and worshipped are called *acheiropoiete*; that is, *not* made by any human hand (see Koerner, Mondzain). Faces of Christ, portraits of the Virgin, Veronica's veil; there are many instances of these icons that have fallen from heaven without any intermediary. To show that a humble human painter has made them would be to weaken their force, to sully their origin, to desecrate them. Thus, to *add the hand* to the pictures is tantamount to spoiling them, criticizing them. The same is true of religion in general. If you say it is man-made you nullify the transcendence of the divinities, you empty the claims of a salvation from above.

More generally, the critical mind is one that shows the *hands* of humans at work everywhere so as to slaughter the sanctity of religion, the belief in fetishes, the worship of transcendent, heaven-sent icons, the strength of ideologies. The more the human hand can be seen as having worked on an image, the weaker is the image's claim to offer truth (see Tintin's prototypical example). Since antiquity, critics have never tired of denouncing the devious plots of humans who try to make others believe in non-existing fetishes. The trick to uncover the trick is always to show the lowly origin of the work, the manipulator, the counterfeiter, the fraud behind the scenes who is caught red-handed.

The same is true of science. There, too, objectivity is supposed to be *acheiropoiete*, not made by human hand. If you show the hand at work in the human fabric of science, you are accused of sullying the sanctity of objectivity, of ruining its transcendence, of forbidding any claim to truth, of putting to the torch the only source of enlightenment we may have (see Lévy-Leblond). We treat as iconoclasts those who speak of the humans at work – scientists in their laboratories – behind or beneath the images that generate scientific objectivity. I have also been held by this paradoxical iconoclash: the new *reverence* for the images of science is taken to be their *destruction*. The only way to defend science against the accusation of fabrication, to avoid the label of "socially constructed," is apparently to insist that no human hand has ever touched the image it has produced (see Daston).[7] So, in the two cases of religion and science, when the hand is shown at work, it is always a hand with a hammer or with a torch: always a critical, a destructive hand.

But what if hands were actually indispensable to reaching truth, to producing objectivity, to fabricating divinities? What would happen if, when saying that some image is human-made, you were *increasing* instead of decreasing its claim to truth? That would be the closure of the critical mood, the end of anti-fetishism. We could say, contrary to the critical urge, that the more human-work is shown, the *better* is their grasp of reality, of sanctity, of worship. That the more images, mediations, intermediaries, icons are multiplied and overtly fabricated, explicitly and publicly constructed, the more respect we have for their capacities to welcome, to gather, to recollect truth and sanctity ("religere" is one of the several etymologies for the word religion). As Mick Taussig has so beautifully shown, the more you reveal the *tricks* necessary to invite the gods to the ceremony during the initiation, the

7

_ Lorraine Daston and Peter Galison, The Image of Objectivity,
in *Representation*, 40, 2001, pp. 81-128; Galison chapter in
Caroline A. Jones and Peter Galison (eds), *Picturing Science,
Producing Art*, Routledge, New York, 1998.

Mandarom being destroyed / 6 September 2001 / Castellane, France /
policemen destroy the effigy of the Mandarom secte guru because of its unlicensed construction / © AFP, Patrick Vallasseris/STF

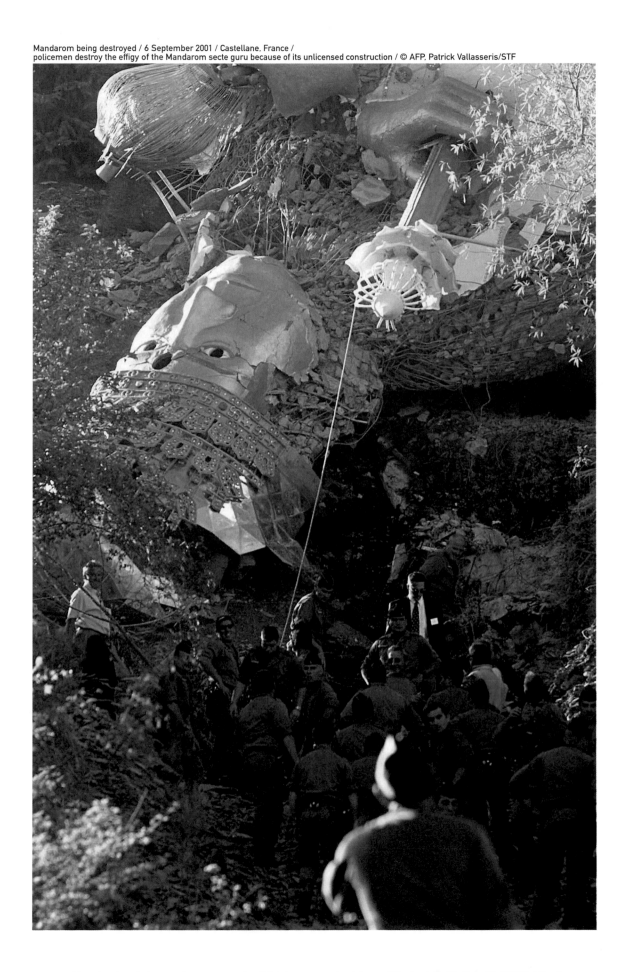

stronger is the certainty that the divinities are present.[8] Far from despoiling access to transcendent beings, revelation of human toil, of the tricks, reinforce the quality of this access (see Sarro, de Aquino).

Thus, we can define an icono*clash* as what happens when there is *uncertainty* about the exact role of the hand at work in the production of a mediator. Is it a hand with a hammer ready to expose, to denounce, to debunk, to show up, to disappoint, to disenchant, to dispel one's illusions, to let the air out? Or is it, on the contrary, a cautious and careful hand, palm turned as if to catch, to elicit, to educe, to welcome, to generate, to entertain, to maintain, to collect truth and sanctity?

But then of course, the second commandment can no longer be obeyed: "You shall not make for yourself an idol in the form of anything in heaven above or on earth beneath or in the waters below." No need to try to fudge the intention and tension of this exhibition as we have imagined it for the last four years: it is about the second commandment. Are we sure we have understood it correctly? Have we not made a long and terrifying mistake about its meaning? How can we reconcile this request for a totally aniconic society, religion, and science with the fabulous proliferation of images that characterizes our media-filled cultures?

If images are so dangerous, why do we have so many of them? If they are innocent, why do they trigger so many and such enduring passions? Such is the enigma, the hesitation, the visual puzzle, the icono*clash* that we wish to deploy under the eyes of the visitor and reader.

Religion, Science and Art: Three Different Patterns of Image-Making

The experiment we have devised consists in bringing together three sources of icono*clashes*: religion, science, and contemporary art. We want to situate the many works, sites, events, and examples presented in this catalog and exhibition amidst the tension created by this triangular set-up.

Although *Iconoclash* assembles lots of religious material, it is not a theological pilgrimage; although it offers many scientific inscriptions, it is not a science museum for pedagogical wonders; although it assembles numerous works of art, it is *not* an art show. It is only because each of us, visitors, curators, and readers, harbors such a different pattern of belief, rage, enthusiasm, admiration, diffidence, fascination, suspicion, and spite for *each of the three* types of images that we bring them to bear on one another. What interests us, is the even more complex pattern created by their *interference*.

Icons and Idols

But why bring so many religious icons into this show? Have they not been emptied by aesthetic judgment, absorbed by art history, made routine by conventional piety, to the point of being dead forever? On the contrary, it is enough to remember the reactions to the destruction of the Bamiyan Buddhas by the Taliban in Afghanistan, to realize that religious images are still the ones that attract the fiercest passions (see Centlivres, Frodon, Clement).[9] From Akhenaton's "theoclast" onwards, destroying monasteries, churches, and mosques and burning fetishes and idols in huge bonfires, is still a daily occupation for huge masses of the world exactly as in the time of what Assman calls the "mosaic distinction" (see Pietz, Corbey, Taylor). "Break down their altars, smash their sacred stones and burn their sacred poles" (Exodus, 34, 13): the instruction to burn the idols is as present, as burning, as impetuous, as subterraneous as the ever threatening lava flows along the Etna. Even in the hilarious case of the destruction this summer of the "Mandarom" – a hideous, gigantic statue erected by a sect in the South of France – the destruction of which, the believers have compared to the demise of the Afghan Buddhas.

8

9

_ Michael Taussig, *Defacement. Public Secrecy and the Labor of the Negative,* Stanford University Press, Stanford, 1999.

_ Pierre Centlivres, *Les Boudhas d'Afghanistan,* Favre, Lausanne, 2001.

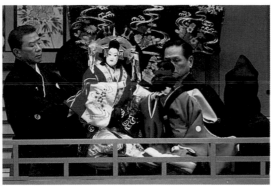

Scene from the Bunraku puppet theater / Miyagino (left) & Shinobu (right) from Go Taiheiki Shiraishi Banashi-Shin Yosiwara Ageya no Dan Puppeteers Yoshida Minesuke-Miyagino (left) and Kiritake Monju-Shinobu (right) / National Bunraku Theater, Osaka / 1997 / © the puppeteers

And of course, idol smashing is in no way limited to religious minds. Which critic does not believe that her ultimate duty, her most burning commitment, is to destroy the totem poles, expose ideologies, disabuse the idolaters? As many people have remarked, 99 percent of those who were scandalized by the Taliban gesture of vandalism descended from ancestors who had smashed to pieces the most precious icons of some other people – or, indeed, they had themselves participated in some deed of deconstruction (see Nathan, Koch).

What has been most violent? The religious urge to destroy idols to bring humanity to the right cult of the true God or the anti-religious urge to destroy the sacred icons and bring humanity to its true senses? An icono*clash* indeed, since, if they are nothing, no one knows whether those idols can be smashed without any consequences ("They are mere stones," said Mollah Omar[10] in the same fashion as the Byzantine and later Lutheran iconoclasts) or whether they have to be destroyed because they are so *powerful*, so ominous ("If they are so vacuous why do you take up on them?" "Your idol is my icon.") (See Koerner, Christin).

Scientific Inscriptions

But why, then, scientific images? Surely, these offer cold, unmediated, objective representations of the world and thus cannot trigger the same passion and frenzy as the religious pictures. Contrary to the religious ones, they simply describe the world in a way that can be proven true or false. Precisely because they are cool, they are fresh, they can be verified, they are largely undisputed, they are the objects of a rare and almost universal agreement. So the pattern of confidence, belief, rejection, and spite is entirely different for them than the one generated by idols/icons. This is why there are so many of them here and, as we will see, why they offer different sorts of icono*clashes*.

To begin with, for most people, they are not even images, but the world itself. There is nothing to say about them except learning their message. To call them image, inscription, representation, to have them exposed in an exhibition side by side with religious icons, is already an iconoclastic gesture. "If those are *mere* representations of galaxies, atoms, light, genes, then one could say indignantly, they are not real, they have been *fabricated*." And yet, as will be made visible here (see Galison, Macho, Huber, Rheinberger), it slowly becomes clearer that without huge and costly instruments, large groups of scientists, vast amounts of money, long training, nothing would be visible in those images. It is *because* of so many mediations that they are able to be so objectively true.

Here is another icono*clash*, exactly opposite to the one raised by the worship of religious image-destruction: the more instruments, the more mediation, the *better* the grasp of reality (see Schaffer). If there is a domain where the second commandment cannot be applied, it is the one ruled by those who shape objects, maps, and diagrams "in the form of anything in heaven above or on earth beneath or in the waters below." So the pattern of interference may allow us to rejuvenate our understanding of image making: the more human-made images are generated, the more objectivity will be collected. In science, there is no such a thing as "mere representation."

10

_ "Ou ces statues sont liées à des croyances idolâtres, a commenté le Mollah, ou il ne s'agit que de simples cailloux; dans le premier cas, l'islam commande de les détruire, dans le second, qu'importe qu'on les brise," Centlivres, Paris, 2001, p. 141.

Judith Baudinet / Project Holy Shroud / 2002 /
multimedia installation / 236.2 x 315'' / Judith Baudinet

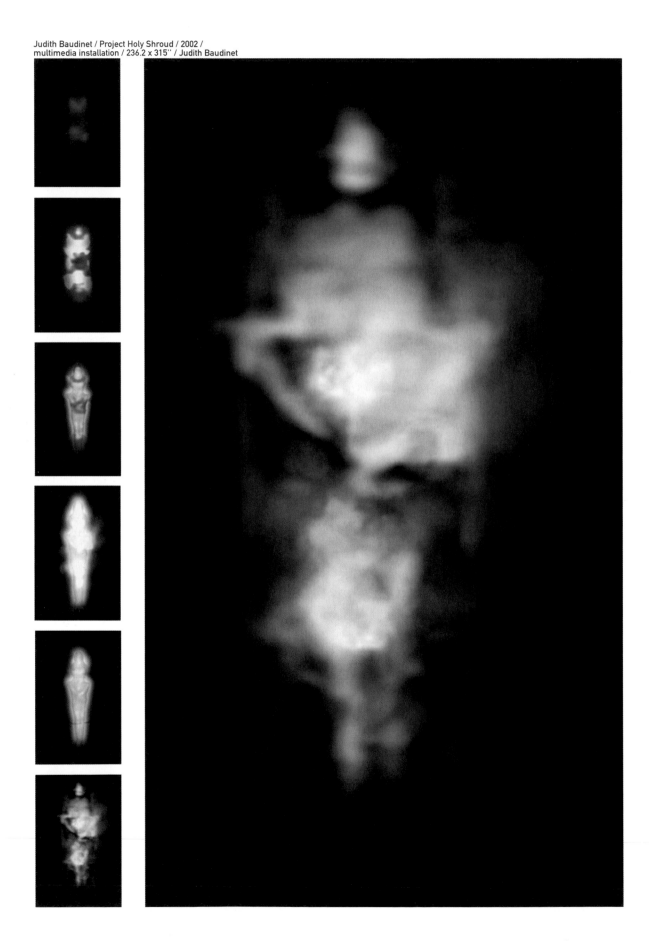

Contemporary Art

Then why link religious and scientific mediations to contemporary art? Because here at least there is no question that paintings, installations, happenings, events, and museums are *human*-made. The hand at work is visible everywhere. No *acheiropoiete* icon is expected from this maelstrom of movements, artists, promoters, buyers and sellers, critics and dissidents. On the contrary, the most extreme claims have been made in favor of an individual, human-based creativity. No access to truth or to the divinities. Down with transcendence! (see Belting, Groys, Weibel).

Nowhere else but in contemporary art has a better laboratory been set up for trying out and testing the resistance of every item comprising the cult of image, of picture, of beauty, of media, of genius. Nowhere else have so many paradoxical effects been carried out on the public to complicate their reactions to images (see Gamboni, Heinich). Nowhere else have so many set-ups been invented to slow down, modify, perturb, lose the naive gaze and the "scopic regime" of the *amateur d'art* (see Yaneva, Lowe). Everything has been slowly experimented against and smashed to pieces, from mimetic representation, through image making, canvas, color, artwork, all the way to the artist herself, her signature, the role of museums, of the patrons, of critics – not to forget the Philistines, ridiculed to death.

Everyone and every detail of what art is and what an icon is, an idol, a sight, a gaze, has been thrown into the pot to be cooked and burnt up in the past century of what used to be called modernist art.[11] A Last Judgment has been passed: *all our ways to produce representation* of any sort have been found wanting. Generations of iconoclasts smashing each other's faces and works. A fabulous large-scale experiment in nihilism (see Sloterdijk, Weibel). A maniacal joy in self-destruction. A hilarious sacrilege. A sort of deleterious aniconic inferno.

And yet, of course, as one might expect, here is another icono*clash*: so much defacement and so much "re-facement" (see Obrist, Tresch, Lowe). Out of this obsessive experiment to avoid the power of traditional image making, a fabulous source of *new* images, *new* media, *new* works of art has been found; *new* set-ups to multiply the possibilities of vision. The more art has become a synonym for the destruction of art, the more art has been produced, evaluated, talked about, bought and sold, and, yes, worshipped. New images have been produced so powerful that they have become impossible to buy, to touch, to burn, to repair, even to transport, thus generating even more icono*clashes* ... (see Gamboni). A sort of "creative destruction" that Schumpeter had not anticipated.

A Reshuffling of Confidence and Diffidence Towards Image

So we have assembled three different patterns of image rejection and image construction, of image confidence and image diffidence. Our bet is that interference between the three should move us beyond the image wars, beyond the *"Bildersturm."*

We have not brought religious images into an avant-garde institution of contemporary art to have them again subjected to irony or destruction, nor to again present them to be worshipped. We have brought them here to resonate with the scientific images and show in which ways they are powerful and what sort of *invisibility* both types of images have been able to produce (see Koerner, Mondzain).

Scientific images have not been brought here to instruct or enlighten the public in some pedagogical way, but to show how they are generated and how they connect to one another, to which sort of iconoclasm they have been subjected (see Galison, Schaffer), what peculiar type of invisible world they generate.

11

_ See for instance the magnificent Tim J. Clark, *Farewell to an Idea: Episodes from a History of Modernism*, Yale University Press, New Haven, 1999.

As to contemporary art pieces, they are not being shown here to compose an art show, but to draw the conclusions of this huge laboratory experiment on the limits and virtues of representation that has been going on in so many media and through so many bold innovative enterprises (see Weibel).

In effect, we are trying to build, for recent iconoclastic art, a sort of *idol-chamber*, similar to the ones made by Protestant desecrators when they tore the images away from cult, turning them into objects of horror and derision, *before* they became the first kernels of the art museum and aesthetic appreciation (see Koener). A little twist to be sure, and more than a little ironic, but much welcome.

The routine patterns of respect, wonder, diffidence, worship, and confidence, which usually distinguish religious, scientific, and artistic mediations, should be more than slightly redistributed throughout this show.

Which Object to Select?

As should be clear by now, *Iconoclash* is neither an art show nor a philosophical argument, but a cabinet of curiosities assembled by "friends of interpretable objects" to fathom the source of fanaticism, hatred, and nihilism generated by the image issue in Western tradition. A small project, if any! But since the curators of this show are not totally mad, we have not tried to cover the whole question of image worship and destruction from Akhenaton to *911*. Ours is not an encyclopedic undertaking. On the contrary, we have very selectively chosen only those sites, objects, and situations where there is an ambiguity, a hesitation, an icono*clash* on how to interpret image-making and image-breaking.

Each of the curators has a different selection principle which they present below, so I will state mine as clearly as I can: I am interested in representing the state of mind of those who have broken fetishes – or what I prefer to call "fac-tishes"[12] – and who have entered into what Assmann names "counter-religion."

An Impossible Double Bind

How can they stand living with the broken pieces of what, until they came along, had been the only way to produce, to collect, to welcome the divinities? How startled they should be when they look at their hands which are no longer able to complete the tasks they had succeeded in doing for eons: namely, to be busy at work and nonetheless to generate objects which are not of their own making? Now they have to choose between two contradictory demands: is this made by your own hands, in which case it is worthless; or is this objective, true, transcendent, in which case you cannot possibly have made it? Either God is doing everything and humans are doing nothing, or the humans are doing all the work and God is nothing. Too much or too little when the fetishes are gone.

Yet, of course, fetishes have to be made. Human hands cannot stop toiling, producing images, pictures, inscriptions of all sorts, to still generate, welcome, and collect objectivity, beauty, and divinities, exactly as in the – now forbidden – repressed, obliterated old days. How could one not become a fanatic since gods, truths, and sanctity have to be made and there is no longer any *legitimate* way of making them? My question throughout this exhibit is: how can you live with this double bind without becoming mad? Have we become mad? Is there a cure to this folly?

Let us contemplate for a moment the tension created by this double bind, which may explain a lot of the archeology of fanaticism. The idol smasher, the mediator breaker is left with only two polar opposites: either he (I guess it is fair to put it in the masculine) is in full command of his hands, but then what he has produced is "simply" the "mere" consequence of his own force and weakness projected into matter

12

_ Bruno Latour, *Petite réflexion sur le culte moderne des dieux Faitiches*, Les Empêcheurs de penser en rond, Paris, 1996; How to be Iconophilic in Art, Science and Religion?, in C. Jones / P. Galison, op. cit., pp. 418-440; *Pandora's Hope. Essays on the reality of science studies*, Harvard University Press, Cambridge, 1999.

since he is unable to produce more output than his input; in which case, there is no other way for him but to alternate between *hubris* and despair depending on whether he emphasizes his infinite creative power or his absurdly limited forces.

Or else he is in the hands of a transcendent, unmade divinity who has created him out of nothing and produces truth and sanctity in the acheiropoietic way. And in the same way that he, the human fabricator, alternates between *hubris* and despair, He, the Creator, will alternate wildly between omnipotence and non-existence, depending on whether or not His presence can be shown and His efficacy proven. What used to be synonymous: "I make," and "I am not in command of what I make" has become a radical contradiction: "Either you make or you are made."[13]

This brutal alternation between being in command as a powerful (powerless) human creator or being in the hand of an omnipotent (powerless) Creator is already bad enough, but worse, what really knots the double bind and forces the strait-jacketed human into extreme frenzy, is that there is no way to stop the proliferation of mediators, inscriptions, objects, icons, idols, image, picture, and signs, in spite of their interdiction. No matter how adamant one is about breaking fetishes and forbidding oneself image-worship, temples will be built, sacrifices will be made, instruments will be deployed, scriptures will be carefully written down, manuscripts will be copied, incense will be burned, and thousands of gestures will have to be invented for recollecting truth, objectivity, and sanctity (see Tresch on the striking case of Francis Bacon, Halbertal on the sad case of the Jerusalem temple).

The second commandment is all the more terrifying since there is no way to obey it. The only thing you can do to pretend you observe it is to *deny* the work of your own hands, to *repress* the action ever present in the making, fabrication, construction, and production of images, to *erase* the writing at the same time you are writing it, to *slap* your hands at the same time they are manufacturing. And with no hand, what will you do? With no image, to what truth will you have access? With no instrument, what science will instruct you?

Can we measure the misery endured by those who have to produce images and are forbidden to confess they are making them? Worse, either they will have to say that the demiurge is doing all the work, writing the sacred scriptures *directly*, inventing the rituals, ordering the law, assembling the crowds, or else, if the work of the faithful is revealed, we will be forced to denounce those texts as "mere" fabrications, those rituals as make-believe, their making as nothing but making up, their constructions as a sham, their objectivity as socially constructed, their laws as simply human, too human.[14]

So the idol-smasher is doubly mad: not only has he deprived himself of the secret to produce transcendent objects, but he continues producing them even though this production has become absolutely forbidden, with no way to be registered. Not only does he hesitate between infinite power and infinite weakness, infinite creative freedom and infinite dependence in the hand of his Creator, but he also constantly alternates between the denial of the mediators and their necessary presence. Enough to render one mad. Enough at least to produce more than one icono*clash*.

Freud, in his strange nightmare about Moses, has offered to explain a similar madness – the invention of "counter-religion" – a most bizarre legend, that of the murder of the selfish, overpowering father by the primitive horde of his jealous sons.[15] But the tradition offers another, more revealing legend, where it is not the father that is killed, but the father's *livelihood* that is smashed to pieces by his over enterprising son.[16]

Abraham, at the age of six, is said to have destroyed the idol-shop of his father, Terah, with which he had been temporarily entrusted (see insert). What a good icono*clash*! To this day no one understands the ambiguous response of the

13

_ See a striking case in La Fontaine's fable *Le statuaire et la statue de Jupiter*, Livre neuvième, fable VI, see Gamboni for another interpretation.

16 15

_ See Jean-François Clément, L'image dans le monde arabe: interdits et possibilités in *L'image dans le monde arabe*, G. Beaugé, J.-F. Clément (eds), Editions du CNRS, Paris, 1995, pp. 11-42. For a careful inquiry into the "jealousy" of God the Creator towards the artist and the constant possibility of atheism in the maniac rejection of idols, see the catalog.

14

_ Sigmund Freud, *L'homme Moise et la religion monothéiste. Trois essais*, Gallimard, Paris, 1996.

_ The difference between the two types of murders, might explain some of the strange visual features of Freud's cabinet. See Marinelli, and more largely what Andreas Mayer calls "psychic objects."

Maurizio Cattelan / La Nona Ora / 1999 / polyester resin, natural hair, accessories, stone, carpeted floor / dimension variable / courtesy Galerie Emmanuel Perrotin, Paris / © photo: Galerie Emmanuel Perrotin, Paris

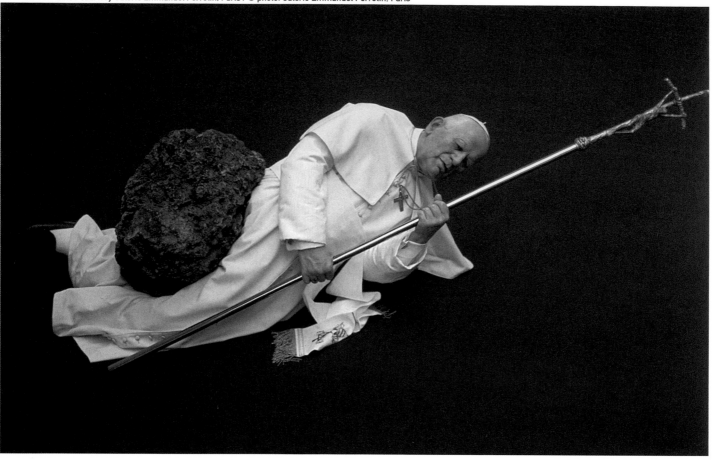

father to the son's question: Why does your ear not listen to what your mouth says? Is the son shaming his father for his idol worship, or is it, on the contrary, the father who is shaming his son for not understanding what idols can do (see Nathan)?" If you start to break the idols, my son, with what mediations will you welcome, collect, access, assemble, and gather your divinities? Are you sure you understand the dictates of your God? What sort of folly are you going to enter if you begin to believe, that I, your father, *naively* believe in those idols I have made with my own hands, cooked in my

own oven, sculpted with my own tools? Do you really believe I ignore their origin? Do you really believe that this lowly origin *weakens* their claims to reality? Is your critical mind *so very naive?*"

This legendary dispute can be seen everywhere in more abstract terms, whenever a productive mediation is smashed to pieces and replaced by the question: "Is this made or is this real? You have to choose!"[17] What has rendered constructivism impossible in the Western tradition? Tradition which, on the other hand, has constructed and deconstructed so

17

_ Nowhere is it clearer than in science studies, my original field, where it organizes every position between realism and constructivism, see Ian Hacking, *The Social Construction of What?*, Harvard University Press, Cambridge, 1999.

since he is unable to produce more output than his input; in which case, there is no other way for him but to alternate between *hubris* and despair depending on whether he emphasizes his infinite creative power or his absurdly limited forces.

Or else he is in the hands of a transcendent, unmade divinity who has created him out of nothing and produces truth and sanctity in the acheiropoietic way. And in the same way that he, the human fabricator, alternates between *hubris* and despair, He, the Creator, will alternate wildly between omnipotence and non-existence, depending on whether or not His presence can be shown and His efficacy proven. What used to be synonymous: "I make," and "I am not in command of what I make" has become a radical contradiction: "Either you make or you are made."[13]

This brutal alternation between being in command as a powerful (powerless) human creator or being in the hand of an omnipotent (powerless) Creator is already bad enough, but worse, what really knots the double bind and forces the strait-jacketed human into extreme frenzy, is that there is no way to stop the proliferation of mediators, inscriptions, objects, icons, idols, image, picture, and signs, in spite of their interdiction. No matter how adamant one is about breaking fetishes and forbidding oneself image-worship, temples will be built, sacrifices will be made, instruments will be deployed, scriptures will be carefully written down, manuscripts will be copied, incense will be burned, and thousands of gestures will have to be invented for recollecting truth, objectivity, and sanctity (see Tresch on the striking case of Francis Bacon, Halbertal on the sad case of the Jerusalem temple).

The second commandment is all the more terrifying since there is no way to obey it. The only thing you can do to pretend you observe it is to *deny* the work of your own hands, to *repress* the action ever present in the making, fabrication, construction, and production of images, to *erase* the writing at the same time you are writing it, to *slap* your hands at the same time they are manufacturing. And with no hand, what will you do? With no image, to what truth will you have access? With no instrument, what science will instruct you?

Can we measure the misery endured by those who have to produce images and are forbidden to confess they are making them? Worse, either they will have to say that the demiurge is doing all the work, writing the sacred scriptures *directly*, inventing the rituals, ordering the law, assembling the crowds, or else, if the work of the faithful is revealed, we will be forced to denounce those texts as "mere" fabrications, those rituals as make-believe, their making as nothing but making up, their constructions as a sham, their objectivity as socially constructed, their laws as simply human, too human.[14]

So the idol-smasher is doubly mad: not only has he deprived himself of the secret to produce transcendent objects, but he continues producing them even though this production has become absolutely forbidden, with no way to be registered. Not only does he hesitate between infinite power and infinite weakness, infinite creative freedom and infinite dependence in the hand of his Creator, but he also constantly alternates between the denial of the mediators and their necessary presence. Enough to render one mad. Enough at least to produce more than one icono*clash*.

Freud, in his strange nightmare about Moses, has offered to explain a similar madness – the invention of "counter-religion" – a most bizarre legend, that of the murder of the selfish, overpowering father by the primitive horde of his jealous sons.[15] But the tradition offers another, more revealing legend, where it is not the father that is killed, but the father's *livelihood* that is smashed to pieces by his over enterprising son.[16]

Abraham, at the age of six, is said to have destroyed the idol-shop of his father, Terah, with which he had been temporarily entrusted (see insert). What a good icono*clash*! To this day no one understands the ambiguous response of the

13

16 15 14

_ See a striking case in La Fontaine's fable *Le statuaire et la statue de Jupiter*, Livre neuvième, fable VI, see Gamboni for another interpretation.

_ See Jean-François Clément, L'image dans le monde arabe: interdits et possibilités in *L'image dans le monde arabe*, G. Beaugé, J.-F. Clément (eds), Editions du CNRS, Paris, 1995, pp. 11-42. For a careful inquiry into the "jealousy" of God the Creator towards the artist and the constant possibility of atheism in the maniac rejection of idols, see the catalog.

_ Sigmund Freud, *L'homme Moïse et la religion monothéiste. Trois essais*, Gallimard, Paris, 1996.

_ The difference between the two types of murders, might explain some of the strange visual features of Freud's cabinet. See Marinelli, and more largely what Andreas Mayer calls "psychic objects."

Maurizio Cattelan / La Nona Ora / 1999 / polyester resin, natural hair, accessories, stone, carpeted floor /
dimension variable / courtesy Galerie Emmanuel Perrotin, Paris / © photo: Galerie Emmanuel Perrotin, Paris

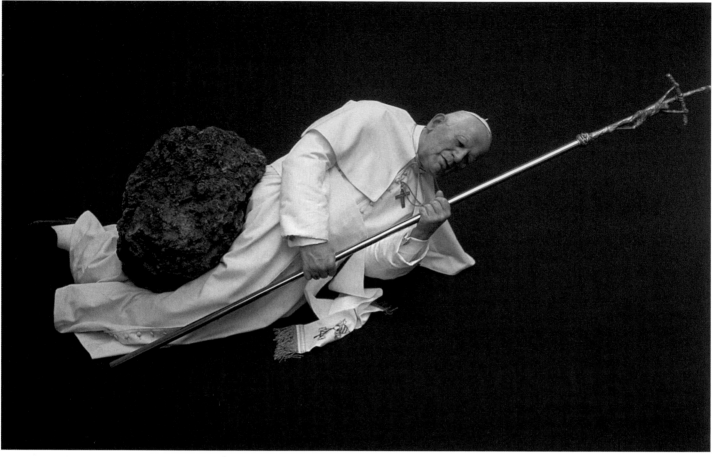

father to the son's question: Why does your ear not listen to what your mouth says? Is the son shaming his father for his idol worship, or is it, on the contrary, the father who is shaming his son for not understanding what idols can do (see Nathan)?" If you start to break the idols, my son, with what mediations will you welcome, collect, access, assemble, and gather your divinities? Are you sure you understand the dictates of your God? What sort of folly are you going to enter if you begin to believe, that I, your father, *naively* believe in those idols I have made with my own hands, cooked in my own oven, sculpted with my own tools? Do you really believe I ignore their origin? Do you really believe that this lowly origin *weakens* their claims to reality? Is your critical mind *so very naive?*"

This legendary dispute can be seen everywhere in more abstract terms, whenever a productive mediation is smashed to pieces and replaced by the question: "Is this made or is this real? You have to choose!"[17] What has rendered constructivism impossible in the Western tradition? Tradition which, on the other hand, has constructed and deconstructed so

17

_ Nowhere is it clearer than in science studies, my original field,
where it organizes every position between realism and
constructivism, see Ian Hacking, *The Social Construction of
What?*, Harvard University Press, Cambridge, 1999.

much, but without being able to confess how it managed to do it. If westerners had really believed they had to choose between construction and reality (if they had been consistently modern), they would never have had religion, art, science, and politics. Mediations are necessary everywhere. If you forbid them, you may become mad, fanatic, but there is no way to obey the command and choose between the two-polar opposites: either it is made or it is real. That is a structural impossibility, an impasse, a double bind, a frenzy. It is as impossible as to request a Bunraku player to have to choose, from now on, between showing his puppet or showing himself on the stage (see picture).[18]

To Increase the Cost of Criticism

So, for my part, I have selected items that reveal this double bind and the fanaticism it triggers (for the prototypical example at the origin of this show see insert "Abraham and the Idol Shop of His Father Terah").[19] It is as if the critical mind could not overcome the original breaking of "factishes" and realize how much it had lost in forcing the fabricator into this impossible choice between human construction and access to truth and objectivity. Suspicion has rendered us dumb. It is as if the hammer of the critique had rebounded and struck senseless the critic's head!

This is why this exhibit is also a *revision of the critical spirit*, a pause in the critique, a meditation on the urge for debunking, for the too quick attribution of the naive belief in others (see Koch).[20] The devotees are not dumb (see Schaffer). It is not that critique is no longer needed, but rather that it has, of late, become too *cheap*.

One could say, with more than a little dose of irony, that there has been a sort of *miniaturization* of critical efforts: what in the past centuries required the formidable effort of a Marx, a Nietzsche, a Benjamin, has become accessible for nothing, much like the supercomputers of the 1950s, which used to fill large halls and expend a vast amount of electricity and heat, and are now accessible for a dime and no bigger than a fingernail. You can now have your Baudrillard's or your Bourdieu's disillusion for a song, your Derridian deconstruction for a nickel. Conspiracy theory costs nothing to produce, disbelief is easy, debunking is what is learned in 101 classes in critical theory. As the recent advertisement of a Hollywood film proclaimed, "Everyone is suspect … everyone is for sale … and nothing is true!"

We wish (I wish) to make critique more difficult, to increase its cost, by adding another layer to it, another icono*clash*: what if the critique had been uncritical enough to the point of making invisible the necessity of mediation? What is the Western underbelly, modernism's hidden spring that makes its machinery tick? Again, what if we had misunderstood the second commandment? What if Moses had been forced to tone it down for the narrow bandwidth of his people?

A Rough Classification of the Iconoclastic Gestures

Now that we have some idea of how the material for the show and the catalog has been selected, it might be useful for the reader as well as for the visitor to benefit from a classification of the icono*clashes* presented here. It is of course impossible to propose a standardized, agreed-upon typology for such a complex and elusive phenomenon.

It would even seem to run counter to the spirit of the show. As I have claimed, somewhat boldly: are we not after a *re-description* of iconophilia and iconoclasm in order to produce even *more uncertainty* about which kind of image worship/image smashing one is faced with? How could we neatly pull them apart? And yet it might be useful to briefly present the *five types* of iconoclastic gestures reviewed in this show, for no better reason than to gauge the extent of the ambiguity triggered by the visual puzzles we have been looking for.

18 20 19

_ Anantha Murthy, *Bharathipura*, Macmillan, Madras, India, 1996.

_ To be compared with the illustration of La Fontaine fable, see p. 33 in this catalog.

_ Peter Sloterdijk, *Critique of Cynical Reason*, University of Minnesota Press and catalog, Minneapolis, 1987.

The principle behind this admittedly rough classification is to look at

the inner goals of the icon smashers,

the roles they give to the destroyed images,

the effects this destruction has on those who cherished those images,

how this reaction is interpreted by the iconoclasts,

and, finally, the effects of destruction on the destroyer's own feelings.

This list is rudimentary but sturdy enough, I think, to guide one through the many examples assembled here.

The »A« People Are Against All Images

The first type – I give them letters to avoid loaded terminology – is made up of those who want to free the believers – those they *deem* to be believers – of their false attachments to idols of all sorts and shapes. Idols, the fragments of which are now lying on the ground, were nothing but obstacles in the path to higher virtues. They had to be destroyed. They triggered too much indignation and hatred in the hearts of the courageous image breakers. Living with them was unbearable.[21]

What distinguishes the As from all other types of iconoclasts is that they believe it is not only necessary but also possible to *entirely* dispose of intermediaries and to access truth, objectivity, and sanctity. Without those obstacles, they think one will at last have smoother, faster, more direct access to the real thing, which is the only object worthy of respect and worship. Images do not even provide preparation, a reflection, an inkling of the original: they *forbid* any access to the original. Between images and symbols you have to choose or be damned.

Type A is thus the pure form of "classical" iconoclasm, recognizable in the formalist's rejection of imagination, drawing, and models (see Galison) as well as in the many Byzantine, Lutheran, revolutionary movements of idol smashers, and the horrifying "excesses" of the Cultural Revolution (see Konchok). Purification is their goal. The world, for A people, would be a much better place, much cleaner, much more enlightened, if only one could get rid of all mediations and if one could jump directly into contact with the original, the ideas, the true God.

One of the problems with the As is that they have to believe that the others – the poor guys whose cherished icons have been accused of being impious idols – believe naively in them. Such an assumption entails that, when the Philistines react with screams of horror to pillage and plunder, this does not stop the As. On the contrary, it proves how right they were (see Schaffer). The intensity of the horror of the idolaters is the best proof that those poor naive believers had invested too much in those stones that are essentially nothing. Armed with the notion of naive belief, the freedom-fighters constantly misconstrue the indignation of those they scandalize for an abject attachment to things they should destroy even more radically.

But the deepest problem of the As, is that no one knows if they are not Bs!

The »B« People Are Against Freeze-Frame, Not Against Images

The Bs too are idol smashers. They also wreak havoc on images, break down customs and habits, scandalize the worshippers, and trigger the horrified screams of "Blasphemer!, Infidel!, Sacrilege!, Profanity!" But the huge difference between the As and the Bs – the distinction that runs through this whole exhibit – is that the latter do not believe it possible nor necessary to get rid of images. What they fight is *freeze-framing*, that is, extracting an image out of the flow, and becoming fascinated by it, as if it were sufficient, as if all movement had stopped.

What they are after is not a world free of images, purified of all the obstacles, rid of all mediators, but on the contrary, a world *filled* with active images, moving mediators.

21

_ As recalled into Centlivres (see catalog) Mollah Omar made a sacrifice of 100 cows, a very costly hecatomb by Afghan standards, as atonement for having *failed* to destroy the Buddhas for so long: 100 cows to ask remission for this horrible sin of eleven centuries without wrecking them.

They do not want the image production to stop forever – as the As will have it – they want it to *resume* as fast and as fresh as possible.

For them, iconophilia does not mean the exclusive and obsessive attention to image, because they can stand *fixed* images no more than the As. Iconophilia means moving from one image *to the next*. They know "truth is image but there is no image of truth." For them, the only way to access truth, objectivity, and sanctity is to move fast from one image to another, not to dream the impossible dream of jumping to a non-existing original. Contrary to Plato's resemblance chain, they don't even try to move from the copy to the prototype. They are, as the old iconophilic Byzantine used to say, "economic" (see Mondzain), the word meaning at the time a long and carefully managed flow of images in religion, politics, and art – and not the sense it now has: the world of goods.

Whereas the As believe that those who hold to images are iconophilic and the courageous minds who break away from the fascination with images are iconoclastic, the Bs define iconophilic as those who *do not* cling to one image in particular but are able to move from one to the other. For them iconoclasts are either those who absurdly want to get rid of all images or those who remain in the fascinated contemplation of one isolated image, freeze-framed.

Prototypical examples of Bs could be: Jesus chasing the merchants out of the Temple, Bach shocking the dull music out of the Leipzig congregation's ears,[22] Malevich painting the black square to access the cosmic forces that had remained hidden in classical representative painting,[23] the Tibetan sage extinguishing the butt of a cigarette on a Buddha's head to show its illusory character.[24] The damage done to icons is, to them, always a charitable injunction to *redirect* their attention towards other, newer, fresher, more sacred images: not to do without image.

But of course many icono*clashes* come from the fact that no worshipper can be sure when his or her preferred icon/idols will be smashed to the ground, or whether an A or a B does the ominous deed. Are we requested, they wonder, to go without any mediation at all and try out direct connections with God and objectivity? Are we invited to simply change the vehicle we have used so far for worship? Are we spurred into a renewed sense of adoration and asked to resume our work of image-building anew? Think of the long hesitation of those waiting at the foot of Mount Sinai for Moses to return: what have we been asked to do? It is so easy to be mistaken and to begin molding the Golden Calf (see Pinchard).

Are neither the As nor the Bs sure of how to read the reactions of those whose icon/idols are being burned? Are they furious at being without their cherished idols, much like toddlers suddenly deprived of their transitional object? Are they ashamed of being falsely accused of naively believing in non-existing things? Are they horrified at being so forcefully requested to renew their adhesion to their cherished tradition that they had let fall into disrepute and mere custom? Neither the As nor the Bs can decide, from the screeching noise made by their opponents, what sort of prophets they are *themselves*: are they prophets who claim to get rid of all images, or the ones who, "economically," want to let the cascade of images move again to resume the work of salvation?

But this is not the end of our hesitation, of our ambiguity, of our icono*clash*. As and Bs could, after all, be simply Cs in disguise.

The »C« People Are Not Against Images, Except Those of Their Opponents

The Cs are also after debunking, disenchantment, idol-breaking. They too leave in their trail plunder, wreckage, horrified screams, scandals, abomination, desecration, shame, and profanation of all sorts. But contrary to the As and to the Bs, they have nothing against images in general: they are only

24 22 23

_ Denis Laborde, Vous avez-tous entendu son blasphème? Qu'en pensez-vous? Dire la Passion selon St Matthieu selon Bach, in *Ethnologie française*, 22, 1992, pp. 320-333.

_ Heather Stoddard, *Le Mendiant de l'Amdo*, Société d'ethnographie, Paris, 1985.

Boris Groys, *Staline, oeuvre d'art totale*, Editions Jacqueline Chambon, Paris, 1990.

against the image to which their opponents *cling* most forcefully.

This is the well-known mechanism of provocation by which, in order to destroy someone as fast and as efficiently as possible, it is enough to attack what is most cherished, what has become the repository of all the symbolic treasures of one people (see Lindhardt, Sloterdijk). Flag-burning, painting-slashing, hostage-taking are typical examples. Tell me what you hold to be most dear, and I will wreck it so as to kill you faster. It is the mini-max strategy so characteristic of terrorist threats: the maximum damage for the minimum investment. Box cutters and plane tickets against the United States of America.

The search for the suitable object to attract destruction and hatred is *reciprocal*: "Before you wanted to attack my flag, I did not know I cherished it so much, but now I do" (see Taussig). So the provocateurs and those they provoke are playing cat and mouse, the first looking for what triggers indignation faster, the others looking eagerly for what will trigger their indignation most fiercely.[25] During this search, all recognize the image in question as a mere *token*; it counts for nothing but an occasion that allows the scandal to unfold (see Koch). If it were not for the conflict, everyone in the two camps would be perfectly happy to confess that it is not the object that is disputed; it is just a stake for something entirely different.[26] So for the Cs, the image *itself* is not in question at all, they have nothing against it (as the As do) or for it (as in the case of the Bs). The image is simply worthless – worthless but attacked, thus defended, thus attacked …

What is so terrible for idol smashers is that there is no way to decide for good whether they are As, Bs, or Cs. Maybe they have entirely misunderstood their calling; maybe they are misconstruing the screams of horror of those they call Philistines who witness their idols smashed to the ground. They see themselves as prophets but maybe they are mere "agents provocateurs." They see themselves as freeing the poor wretched souls from their imprisonment by monstrous things, but what if they were, on the contrary, scandal-mongers looking for ways to shame their opponents most efficiently?

What would happen to me if, in criticizing the critics, I myself was simply trying to create another scandal? What if *Iconoclash*, in its pretension to re-describe iconoclasm, was nothing but another boring iconoclastic gesture, another provocation, the mere repetition of the endless gesture of the intelligentsia's most cherished treasures? We don't know for sure.

Ah, but that is why it is called *Iconoclash*.

The »D« People Are Breaking Images Unwittingly

There is another kind of icon smasher present in this exhibit, a most devious case, those who could be called the "innocent vandals." As is well known, vandalism is a term of spite invented to describe those who destroy not so much out of a hatred of images but out of ignorance, a lust for profit and sheer passion and lunacy.[27]

Of course, the label can be used to describe the action of the As, the Bs, and the Cs as well. They *all* can be accused of vandalism by those who don't know if they are innocent believers furious at being accused of naiveté, Philistines awakened from their dogmatic sleep by prophetic calls, or scandal-lovers delighted at being the butt of criticism and thus able to demonstrate the strength and self-righteousness of their indignation.

But the innocent vandals are different from the normal, "bad" vandals: they had absolutely no idea that they were destroying anything. On the contrary, they were cherishing images and protecting them from destruction, and yet they are accused later of having profaned and destroyed them![28] They are, so to speak, iconoclasts in *retrospect*. The typical example is that of the restaurateurs who are accused by some

26 25 27 28

_ Political correctness is part of this attitude: scouting everywhere for good occasions to be scandalized.

_ Censorship may be one aspect of the Ds: tearing down or hiding images for the sake of protecting other images and choosing the wrong target. Filmmakers are busy deleting images of the World Trade Center from their film so as not to shock the viewers. In *International Herald Tribune*, 25 October 2001.

_ For the mechanism of scandal mongering in contemporary art, see Heinich, Gamboni, in this catalog and his book, *The Destruction of Art. Iconoclasm and Vandalism since the French Revolution*, Reaktion Books, London, 1996. For social and political "affaires" see Luc Boltanski, *L'amour et la justice comme compétences*, A.-M. Métailié, Paris, 1990. The typical mechanism for seeing objects as tokens has been proposed by René Girard, *Things Hidden Since the Foundation of the World*, Stanford University Press, Stanford, 1987.

_ Louis Réau, *Histoire du vandalisme. Les monuments détruits de l'art français*, Edition augmentée par Michel Fleury et Guy-Michel Leproux, Bouquins, Paris, 1994; André Chastel, *The Sac of Rome – 1527*, Princeton University Press, Princeton, 1983.

M. Kreuzberger / Les Idoles au Champ de Mars. L'Exposition universelle / éd Dentu, Paris, 1867 / © photo: Agence photographique de la Réunion des Musées Nationaux

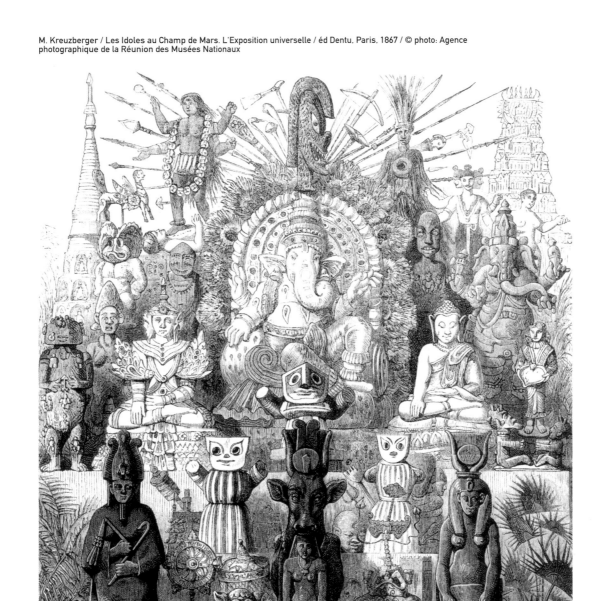

LES IDOLES AU CHAMP DE MARS. — Dessin de M. Kreuzberger.

of "killing with kindness" (see Lowe). The field of architecture is especially filled with those "innocents" who, when they build, have to destroy, when their buildings are accused of being nothing but vandalism (see Obrist, Geimer). Their heart is filled with the love of images – so they are different from all the other cases – and yet they trigger the very same curses of "profanation," "sacrilege," and "desecration" as all the others.

Life is so difficult: by restoring works of art, beautifying cities, rebuilding archeological sites, they have destroyed them, their opponents say, to the point that they appear as the worst iconoclasts, or at least the most perverse ones. But other examples can be found like those museum curators who keep the beautiful New Guinean "mallagans" although they have become worthless since, in the eyes of their makers, they should be destroyed after three days (see Derlon, Sarro) or those African objects which have been carefully made to rot on the ground and which are carefully saved by art dealers and thus rendered powerless – in the eyes of their makers (see Strother).[29] The apprentice sorcerer is not a really wicked sorcerer, but one who *becomes* wicked out of his or her own innocence, ignorance, and carelessness.

And here again, the As as well as the Bs and the Cs can be accused of being Ds, that is, of aiming at the wrong target, of forgetting to take into account the side effects, the far reaching consequences of their acts of destruction. "You believe you freed people from idolatry, but you have simply deprived them of the means to worship;" "You believe you are a prophet renewing the cult of images with fresher images, you are nothing but a scandal-monger thirsty for blood;" and similar accusations are frequently leveled in revolutionary circles, accusing one another of being constantly on the wrong foot, of being *horresco referens*, reactionary. What if we had killed the wrong people, smashed down the wrong idols? Worse, what if we had sacrificed idols for the cult of an even bloodier, bigger, and more monstrous Baal?

29

The »E« People Are Simply the People: They Mock Iconolasts and Iconophiles

To be complete, one should add the Es who doubt the idol breakers as much as the icon worshippers. They are diffident to any sharp distinctions between the two poles; they exercise their devastating irony against all mediators; not that they want to get rid of them, but because they are so conscious of their fragility. They love to show irreverence and disrespect, they crave jeers and mockery, they claim an absolute right to blasphemy in a fierce, Rabelaisian way (see Pinchard), they show the necessity of insolence, the importance of what the Romans called "pasquinades," which is so important for a healthy sense of civil liberty, the indispensable dose of what Peter Sloterdijk has called kynicism (by opposition to the typically iconoclastic cynicism).

There is a right not to believe and the even more important right not to be accused of believing *naively* in something. There may be no such a thing as a believer. Except the rare icon smasher who believes in belief – and, strangely enough, believes himself or herself to be the only *unbeliever*. This healthy, wide ranging, popular, indestructible agnosticism may be the source of much confusion because, here again, the reactions they trigger are indistinguishable from those created by the As', Bs', Cs', and Ds' acts of destruction-regeneration. It is so easy to be shocked. Everyone has a quantity of "shockability" that can certainly be applied to different causes, but not in any case emptied or even diminished.

Take the now famous icon of Pope John-Paul II struck to the ground by a meteorite (see Maurizio Cattelan, *La Nona Ora*). Does it demonstrate a healthy irreverence for authority? Is it a typical case of a cheap provocation aimed at *blasé* Londoners who expect to be mildly shocked when they go to an art show but don't really give a damn for the killing of such a boring image as that of the Pope? Is it, on the

_ Other cases could be found of retrospective destruction in technology: asbestos used to be the "magic material" before its producers were accused of killing thousands of people with it; DDT used to be the magic pesticide before being accused of the same crimes. See Ulrich Beck, *Ecological Politics in an Age of Risk*, Polity Press, Cambridge, 1995, for an account of this retrospective accusation around the notion of "after-effect."

Pietà / fifteenth century / Musée Anne de Beaujeu, Moulins, Collection Tudot

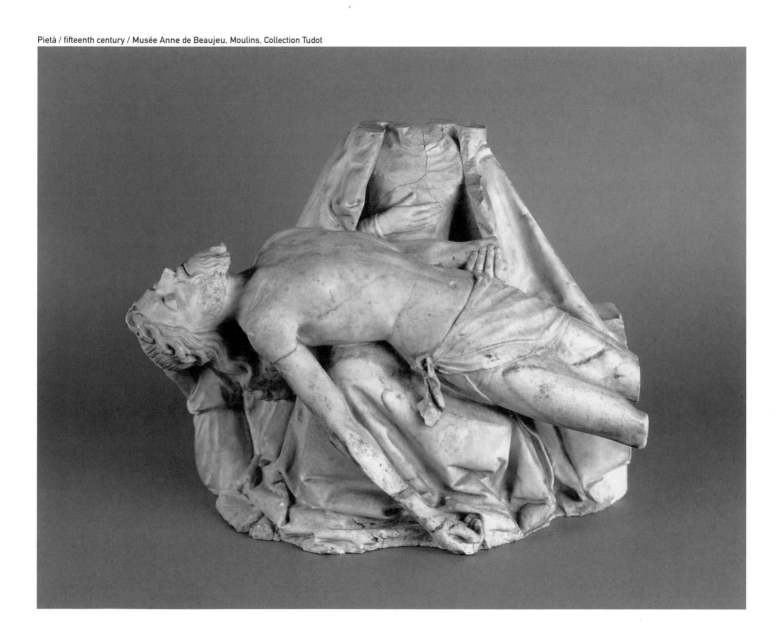

contrary, a scandalous attempt to wreck the belief of Polish museum visitors when the piece is shown in Warsaw? Or is it, as Christian Boltanski claims, a deeply respectful image showing that, in Catholicism, the Pope is requested to suffer the same breaking, the same ultimate destruction as Christ himself?[30] How is it possible to test this range of interpretations?[31]

Hence the *sound-scape* of this exhibit.

A Welcome Cacophony

Our show aims at *hearing* those cries of despair, horror, indignation, and stupefaction simultaneously, all at once, without having to choose too fast, without having to join our usual camps and brandish some hammer to complete some act of deconstruction. Hence the *cacophony*, which is the audible equivalent of the icono*clashes* and which occupies so much of the space of the exhibit (see Laborde).

Through sound as well as image, we want to restore this sense of ambiguity: who is screaming against destruction and why? Are these the lamentations of the eternal Philistines shocked to be forced out of their boring and narrow circle of habits? Hear, hear! Are these the wailings of humble worshippers deprived of their only source of virtue and attachment, the sacred relics, the precious fetishes, the fragile factishes that used to keep them alive and which are now broken by some blind and arrogant reformer?[32] Hear, hear! The weeping sound made by the As realizing that they will never attain the gentle violence of the prophetic Bs, and that they have simply emptied the world and made it even more terrifying. Hear again, behind the cacophonic laments, the sardonic laugh of the blasphemous Es, so healthy, so happy to deploy their juvenile charivari. And behind it all, what is it, this other sound? Hear, hear! the prophetic trumpet waking us out of our deadly attachment to resuscitate a new sense of the beauty, truth, and sanctity of images. But who makes this horrible raucous noise?

Hear, hear! what a racket, the blaring sound of the provocateurs, looking for new prey.

Yes, a pandemonium: our daily world.

Beyond the Image Wars: Cascades of Images

How can we be sure that our show is not another iconoclastic show? That we are not asking the visitor and the reader to descend one more spiral in the inferno of debunking and criticism? That we are not adding another layer of irony, piling disbelief upon disbelief, continuing the task of disenchantment with even more disenchantment? Again, among the curators, no one agrees and anyway, agreement is not our goal since we are after icono*clashes*, not certainty. And yet our exhibition claims to be able to go *beyond* the image wars. Always a bold claim this little preposition: beyond. How can we be faithful to it?

By presenting images, objects, statues, signs, and documents in a way that demonstrates the connections they have with other images, objects, statues, signs, and documents. In other words, we are trying to claim that we belong to the people of the Bs against the As, the Cs, the Ds, and even the Es. Yes, we claim to be of prophetic stock! Images do count; they are not mere tokens, and not because they are prototypes of something away, above, beneath; they count because they allow one to move to *another* image, exactly as frail and modest as the former one – but *different*.[33]

Thus, the crucial distinction we wish to draw in this show is not between a world of images and a world of no-images – as the image warriors would have us believe – but between the *interrupted* flow of pictures and a *cascade* of them. By directing the attention of visitors to those cascades, we don't expect peace – the history of the image is too loaded for that – but we are gently nudging the public to look for other properties of the image, properties that religious wars have completely hidden in the dust blown up by their many fires and furies.

31 30 32 33

_ Christian Boltanski, personal communication.

_ Tobie Nathan, *L'influence qui guérit*, Editions Odile Jacob, Paris, 1994.

_ In his nice visual summary of images and their prototype, Jean Wirth, Faut-il adorer les images? La théorie du culte des images jusqu'au concile de Trente, in C. Dupeux, P. Jezler, J. Wirth, op.cit., pp. 28-37, manifests once more the perfect contradiction of the argument since in order to show the difference between respect for the image (dulie) and adoration of the model (latrie), he is *forced*, by necessity, to *draw* two images – one for the prototype and another one for the original.

_ I proposed a test to Cattelan: to replace the Pope, whom everyone (but perhaps not the Poles) expects to see smashed to the ground, by someone whose destruction would trigger the intellectuals' indignation: for instance to show Salman Rushdie shot to death by an Islamist bullet ... Too horrifying, too scandalous, I was told (Obrist, personal communication). Ah ah! so the Pope can be struck but not someone *really* worthy of respect in the eyes of the critically minded! But when I proposed what appeared to be a true sacrilege and not a cheap one, what was I after? Another provocation directed at faithful critics instead of faithful Popists? Who can tell? I can't even be sure I understand the reactions of those who recoiled in horror at my suggestion.

The Opacity of Religious Icons

Take for instance this small and humble Pietà coming from the Museum of Moulins in France. Protestant or later revolutionary fanatics (or maybe vandals), have decapitated the Virgin's head and broken the limbs of the dead Christ – although the scriptures say that none of your bones will be broken. A tiny, intact angel, invisible in the picture, holds in sorrow the falling head of the Savior. An iconoclastic gesture, to be sure. But wait! What is a dead Christ if not another broken icon, the perfect image of God, desecrated, crucified, pierced, and ready to be entombed? So the iconoclastic gesture has struck an image that had *already* been broken (see Koerner). What does it mean to crucify a crucified icon?

Are we not confronted here with a good icono*clash*? The idol smasher has been redundant since he (for rather obscure reasons, I keep maintaining the masculine for that sort of deed) has smashed a pre-broken icon. But there is a difference between the two gestures: the first one was a deep and old meditation on the weakness of all icons, the second has only added a sort of simple-minded will to get rid of all idols, as if there were idols, and idol worshippers! The image warriors always make the same mistake: they naively believe in naive belief. Has not the idol-breaker only demonstrated his naiveté in imagining that the first was an idol-worshipper whereas he or she must have been a pretty good icon-breaker. In this tradition, image is always that of a breaching to render the object unfit for normal consumption (see Mondzain, Stoddard).[34]

As Louis Marin has argued in a beautiful book, the same is true of Christian religious paintings that do not try to show anything but, on the contrary, to obscure the vision.[35] Thousands of little inventions force the viewer, the worshipper, into *not* seeing what is presented in front of him or her. Not, as the defenders of icons often say, by redirecting the attention away from the image to the prototype. There is no prototype

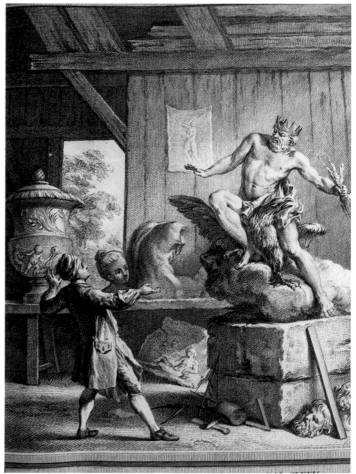

J.B. Oudry / engraving / for Jean de la Fontaine, Fables Choisies, Charles Antoine Jombert, Paris, 1756, vol. 3, fable CLXXV, p. 117

34 35

_ See Joseph Koerner's beautiful chapter on Bosh in Jones, Galison, op. cit. The notion of "dissimiles" in Georges Didi-Huberman, *Fra Angelico. Disssemblance et figuration*, Flammarion, Paris, 1990.

_ Louis Marin, *Opacité de la peinture. Essais sur la représentation*, Usher, Paris, 1989.

to be looked at – this would be Platonism run mad – but only the redirecting of attention to *another* image.

The Emmaus pilgrims see nothing in their fellow traveler as painted by Caravaggio, but the *breaking* of the bread reveals what they should have seen, what the viewer can only see by the very dim light the painter has added to the bread. But it is nothing but a painting. *Redirecting* attention is always the job those pictures try to do, thus forcing the faithful to move from one image to the next. "He is not here. See the place where they laid him" (Mark 16:6).

How wrong headed were the image wars: there is not one of those pictures that is not already broken in the middle. Every icon repeats: *Noli me tangere*, and they are accused by their enemies of attracting too much attention! Are we really going to spend another century naively re-destroying and deconstructing images that are so intelligently and subtly destroyed *already*?

Isolated, a Scientific Image Has No Referent

The cascade of images is even more striking when one looks at the series assembled under the label of science.[36] An isolated scientific image is meaningless, it proves nothing, says nothing, shows nothing, has no referent. Why? Because a scientific image, even more than a Christian religious one, is a *set of instructions to reach another one* down the line.[37] A table of figures will lead to a grid that will lead to a photograph that will lead to a diagram that will lead to a paragraph that will lead to a statement. The whole series has meaning, but none of its elements has any sense.

In the beautiful examples shown by Galison on astronomy, you cannot stop at any place in the series if you want to "grasp" the phenomenon they picture. But if you go up or down the whole series, then objectivity, visibility, veridicality will ensue. The same is true of the molecular biology example offered by Rheinberger: in radio labeling,

there is nothing to see at any stage, and yet, there is no other way to see genes. Invisibility in science is even more striking than in religion – and hence nothing is more absurd than the opposition between the visible world of science and the "invisible" world of religion (see Huber, Macho). They both cannot be grasped except by images broken in such a way that they lead to yet another one.

If you wanted to abandon the image and turn your eyes instead to the prototype *that* they are supposed to figure out, you would see less, infinitely less.[38] You would be blind for good. Ask a physicist to turn her eyes away from the inscriptions produced by her detectors, and she won't detect a thing: she will begin to have an inkling only if she assembles even more inscriptions, even more instrumental results, even more equations.[39] Only down *inside* the closed walls of her ivory tower does she gain some access to the world "out there."

This paradox of scientific images is again entirely lost by the image warriors who would violently ask us to *choose* between the visible and the invisible, the image and the prototype, the real world out there and the made-up, artificial world in there. They cannot understand that the more artifactual the inscription, the better its ability to connect, to ally with others, to generate even better objectivity.

Thus, to request the idol-breakers to smash the many mediators of science in order to reach the real world out there, better and faster, would be a call for barbarism, not for enlightenment. Do we really have to spend another century alternating violently between constructivism and realism, between artificiality and authenticity? Science deserves better than naive worship and naive contempt. Its regime of invisibility is as uplifting as that of religion and art. The subtlety of its traces requires a new form of care and attention. It requires – why abstain from the word? – yes, spirituality.

36 37

39 38

_ This is why it took so long for the scientific gaze to *accommodate* their sight to those strange new scientific images, as is magnificently shown in Lorraine Daston, Katharine Park, *Wonders and the Order of Nature*, Zone Books, Cambridge, 1999.

_ For a description of this cascading effect see Bruno Latour, *Pandora's Hope. Essays on the reality of science studies*, Harvard Univ. Press, Cambridge, 2000, chapter 2.

_ Peter Galison, *Image and Logic. A Material Culture of Microphysics*, The University of Chicago Press, Chicago, 1997.

_ The word "cascade" to describe this succession has first been used by Trevor Pinch, Observer la nature ou observer les instruments, in *Culture technique*, 14, 1985, pp. 88-107. Mike Lynch and Steve Woolgar (eds), *Representation in Scientific Practice*, MIT Press, Cambridge, 1990; and Jones and Galison, op. cit.

Khalil Joreige and Joanna Hadjithomas / The circle of confusion – The wonder of Beirut / 1995 / installation, photos, mirror /
© Khalil Joreige and Joanna Hadjithomas, Paris

Art is not To Be Redeemed

Connecting images to images, playing with series of them, repeating them, reproducing them, distorting them slightly, has been common practice in art even before the infamous "age of mechanical reproduction." "Intertextuality" is one of the ways in which the cascading of images is discernible in the artistic domain – the thick entangled connection that each image has with all the others that have been produced, the complex relation of kidnapping, allusion, destruction, distance, quotation, parody, and struggle (see Jones, Belting, Weibel). Even the simplest connection is so important for a definition of an *avant-garde* that, once a type of image has been devised, it is no longer possible for others to produce it in the same fashion.

But there is a more direct relation: in many ways, through the question of mimetic representation, Western arts have been obsessed by the shadows cast by scientific and religious pictures: how to escape from the obligation of once again presenting the credos of the faithful? How to escape from the tyranny of "simply objective," "purely representative," quasi-scientific illustrations? Freeing one's gaze from this dual obligation accounts for a great deal of the inventions of what is called modern art. And of course "reactionary" critics never tire of asking for a "return" to "real presence" to "accurate representation" to "mimesis" and the worship of beauty as if it were possible to turn back the clock.[40]

So here is another paradox, another icono*clash*: what is it that contemporary art has so forcefully tried to escape? To what target was so much iconoclasm directed, so much asceticism, so much violent and sometimes frenetic energy? To religious icons and their obsession for real presence? But they have never been about presenting something other than absence. To scientific imagery? But no isolated scientific image has any mimetic power; there is nothing *less* representational, no *less* figurative, than the pictures produced by science, which are nonetheless said to give us the best grasp of the visible world.[41]

Here, again, we have another case of image wars directing our attention to a completely false target. Many artists have tried to avoid the heavy load of presence and mimesis by avoiding religion and science, which have striven even more intensely to shun presence, transparency, and mimesis! A comedy of errors.

How long are we going to judge an image, installation, and object by those other images, installations, and objects it aims at fighting, replacing, destroying, ridiculing, bracketing, parodying? Is it so essential to art that a long retinue of slaves and victims accompanies every piece? Is the distortion of an already existing image really the only game in town?

Fortunately, there exist many other forms of art types of installations, devices of all sorts that do not in any way rely on this negative connection between image and distortion. Not that they rely on mimesis, which would restrict the gaze to the most boring type of visual custom, but because what they like most is the transformation of images; the chain of modifications that completely modify the scopic regimes of the classic frozen image extracted from the flow (see Lowe, Yaneva, Jaffrennou).

This difference between iconoclast distortion, which always relies on the power of what is destroyed, and a productive cascade of re-representation might explain why, in this exhibition, Peter Weibel's definition of art, for instance, does not intersect at all with that of someone like Adam Lowe: another icono*clash* and, hopefully, a visually very fecund one.

After 911

As Christin, Colas, Gamboni, Assmann and many others have shown, there has always been a direct connection between the status of image and politics. Destroying images has always

40

41

_ James Elkins, *Why are our Pictures Puzzles*, Routledge, London, 1999. It could even be argued that it is from looking at paintings (probably Dutch painting) that philosophers of science have taken their ideas of the visible world and their model/copy epistemology. See the classic: Svetlana Alpers, *The Art of Describing*, University of Chicago Press, Chicago, 1983.

_ George Steiner, *Real Presences*, University of Chicago Press, Chicago, 1991; Jean Clair, *Considérations sur l'état des beaux arts. Critique de la modernité*, Gallimard, Paris, 1983. For a file about the debate around contemporary arts see P. Barrer, *(Tout) l'art contemporain est-il nul? Le débat sur l'art contemporain en France avec ceux qui l'ont lancé. Bilan et perspective*, Favre, Lausanne, 2000.

been a carefully planned, elitist, and governed action. Nothing less popular, spontaneous, and undirected than idol-wrecking. Although the word representation appears even more vividly in the public sphere than in science, religion, and art, we have not treated iconoclasm in politics as a separate domain.

There is a simple reason for that: in order to rejuvenate the definition of political mediators, it is essential to first go *beyond* the image wars. Politics is everywhere in the show but intentionally spread out. Iconoclasm has become much too cheap when applied to the political sphere. Nowhere more than in politics can the absurd but strident request: "Is it manipulated or is real?" be heard. It is as if, again, the work of the hands, the careful manipulation, the human made mediation had to be put in one column, and truth, exactitude, mimesis, faithful representation into another. As if everything that was added to the credit in one column had to be deducted from the other. Strange accounting! – that would make politics as well as religion, science, and art, utterly impossible. Another case of an impossible application of the second commandment.

But image destruction worship, the cult of iconoclasm as the ultimate intellectual virtue, the critical mind, the taste for nihilism – all of that may have changed abruptly due to the terrifying event, strangely coded by the figure 911 – the emergency telephone number in the United States. Yes, since 11 September 2001 a *state of emergency* has been proclaimed on how we deal with images of all sorts, in religion, politics, science, art, and criticism – and a frantic search for the roots of fanaticism has begun.

Nihilism – understood here as the denial of mediators, the forgetting of the hand at work in the waking of transcendent objects, the modernist cut between what one does and what one thinks one is doing – could appear as a virtue, a robust quality, a formidable source of innovation and strength, as long as we could apply it to the others *for real* and to us only *symbolically*. But now, for the first time, it is the US, it is *us*, the westerners, the courageous idol-breakers, the freedom-fighters who are threatened by annihilation and fanaticism.

In the same way as Hollywood script writers are suddenly finding unbearable the special effects of the horror-movies they had concocted because their realities are too vivid and were only bearable when they could *not* happen, we might find the constant talk of destruction, debunking, critique, exposure, denunciation, not so funny after all, not so productive, not so *protective*.

We knew (I knew!) we had never been modern, but now we are even less so: fragile, frail, threatened; that is, back to normal, back to the anxious and careful stage in which the "others" used to live before being "liberated" from their "absurd beliefs" by our courageous and ambitious modernization. Suddenly, we seem to cling with a new intensity to our idols, to our fetishes, to our "factishes," to the extraordinarily fragile ways in which our hand can produce objects over which we have no command. We look at our institutions, our public spheres, our scientific objectivity, even our religious ways, everything we loved to hate before, with a somewhat renewed sympathy. Less cynicism, suddenly, less irony. A worshipping of images, a craving for carefully crafted mediators, what the Byzantine called "economy," what used to simply be called civilization.

No exhibition, no catalog can do much. I know that well, but redirecting attention to the weakness and fragility of the mediators that allow us to pray, to know, to vote, to enjoy living together, this is what we have tried in *Iconoclash*. Now, readers and visitors, it is up to you to *see* for yourselves what you want to protect and what you want to destroy.

Ah, by the way, how should Moses have written the second commandment had he not misinterpreted it? It is a bit early to know, we need to first hear and see your reactions, but my bet is that a safer reading would be: "Thou shall not freeze-frame any graven image!"

ABRAHAM AND THE IDOL SHOP
OF HIS FATHER TERAH

Rabbi Hiya the son of Rabbi Ada said that Terah [Abraham's father] was an idol worshipper. One day Terah had to leave the store [in which he sold idols]. He left Abraham to manage the store in his absence. A man came and wanted to buy an idol. Abraham asked him »How old are you?« And he responded »Fifty or sixty years old.« Abraham then said, »Pitiful is the man who is sixty and worships idols that are only a day old.« So the man left in embarrassment. Once, came a woman with an offering of fine flour. She said to him [Abraham]: »Here, take it and bring it before [the idols].« Abraham stood up, took a stick, broke all the idols, and put the stick back in the hands of the biggest idol among them. When his father returned he asked »Who did this to them?« Abraham answered, »I will not deny you the truth. A woman came with an offering of fine flour and asked me to bring it before them. So I brought it before them, and each said, ›I shall eat first.‹ Then the biggest one stood among them, he took a stick in his hand and broke them all.« So Terah said to him, »Why do you mock me? Do these [idols] know anything [to speak and move]?« And Abraham replied, »Won't your ears hear what your mouth speaks?« ||

MIDRASH RABBAH, NOAH, PORTION 38, SECTION 13

Translated by Shai Lavi

Why do images trigger so much furor?

BUDDHISM AS A FOCUS OF ICONOCLASH IN ASIA

Pema Konchok

THE JUDEO-CHRISTIAN AND ISLAMIC CIVILIZATIONS of the Middle East, and the modern western world have by no means the prerogative of the polymorphic phenomenon that we call "iconoclash." Asia has an ancient history of violent confrontation in thought, religion, and art, involving the idea, the word, and the image and the economy which both sustains and feeds off them. Indeed the last two thousand years have seen several violent periods when the proliferation of imagery – closely linked to religious ideology and economy – has been followed by large scale destruction of physical objects at the hands of those who claim to have cleaner, fresher, newer, purer, better, more economic, more relevant systems to replace those which they seek to destroy.

In the twentieth century three terrible iconoclastic campaigns have been waged in Asia against "useless relics of the past" or "mere stones." The proponents of each had a world vision disseminated over wide territories. All three took the Mahayana Buddhist communities of Central Asia, their temples and their imagery, as one of the major targets of attack. It is this phenomenon – in particular events that took place in Tibet between 1966 and 1978 during the Great Proletarian Cultural Revolution, that is the object of inquiry, with the perspective of trying to understand the "iconoclash," the gesture of rupture within a society expressed forcefully though the breaking and replacing of images.

The first two campaigns in Soviet Russia and Maoist China sought to uproot the past and eradicate religion in order to establish a more humanistic doctrine for all of humanity. They did succeed in covering at least half of the planet for much of the twentieth century. As part of that vast movement, the Bolsheviks launched anti-Buddhist attacks in Mongolia, Siberia, Buriatia, and Tuva, following the 1917 Revolution.[1] In Buriatia alone, six hundred monasteries were razed to the ground, their contents seized, the monks massacred or forced to marry and/or become soldiers.[2] The wealth of the temples, especially tens of thousands of gilt bronze Buddhas were stacked onto train wagons, and carted off to be melted down for arms and coinage, while the less valuable objects that remained were stored in "Museums of Atheism and Religion" and go-downs throughout the Soviet Union until Perestroika was declared in the early 1990s.[3] Half a century after the Bolshevik Revolution, during the Cultural Revolution, Mao's Red Guards carried out the same violence in Inner Mongolia and Tibet. We shall come back to this later.

The third and latest twentieth century campaign is still fresh in the public eye. Faced with a hostile world, but with the media at their command, the fundamentalist Muslim Taliban decided it was their sacred duty to eliminate all vestiges of human representation – largely from the Buddhist tradition and kept in the museum of Kabul, in 1998 – followed by destroying the already "de-faced" giant Buddhas of Bāmiyān in March 2001.[4]

Each of these movements aimed at a radical purification of the "mental, verbal, and physical" plane,[5] in order to (re-)establish the parameters of society on what its ideologues saw as a sound ethical basis. These violent episodes are but the latest in a series of crises in Asian history. Each one ultimately (mis-)took the religion and imagery of the other as "superstition" and "idolatry," in accordance with their own understanding of what the tangible image and the spoken word stood for. It was reported in the world news, for example, that the Taliban considered the two Buddhas of Bāmiyān to represent a couple, although the smaller blue one had no particular feminine distinguishing marks. First they destroyed with comparative ease the wife (38 meters), then they attacked the red husband (55 meters), but he was "very difficult."[6] Other warriors referred to the giant pair as "Iskandar," recalling ancient tribal memories of the invasion of Alexander the Great, c. 330 B.C.E. and the domination of the region by the Greeks until 130 B.C.E.! In the first case it is tempting to catch a distant echo of the "father-mother" imagery of Tantrayana, both Hindu and Buddhist, which

2 1 6 4 3 5

_ See the excellent narrative on the Bolshevik Revolution in Siberia, Ferdynand Ossendowski, *Les Bêtes, les Hommes et les Dieux*, first edition, Plon, Paris, 1924.

_ The "defacing" of the giant Buddhas must have taken place during another iconoclastic campaign perhaps many centuries before the first photos were taken in the early twentieth century.

_ *The Guardian*, 27 March 2001, pp. 12-13; *Herald Tribune*, 27 March 2001, front page.

_ André Terentyev, an independent scholar and editor of *Buddhism of Russia*, in St. Petersburg, has a made a collection of black and white photos of the monasteries and temples before destruction.

_ In 1991, Mongolian delegations started to come from Siberia and Buryatia to the Russian-kept museums in Moscow, St. Petersburg and Ulan Ude, to claim their images and ritual treasures. These, contrary to the "cultural relics" in China during the Cultural Revolution, were meticulously registered in the museum ledgers. Thus they could be taken back to the Mongolian temples that were being newly reconstructed.

_ The trinary structure of "body, speech and mind," based on the Indo-Buddhist analysis of the human entity, will be used in this essay, cf. Robert J. Litton, *Revolutionary Immortality*, Penguin Books, Harmondsworth, 1970, chapter 6: The Immortalisation of Words, pp. 63-95, for the divinisation of Mao's speech and mind, to which we can clearly add his body, through the sun deity idealized portrait images projected by the Chinese Communist Party (CCP) during the "Great Leap Forward" and on through the Cultural Revolution.

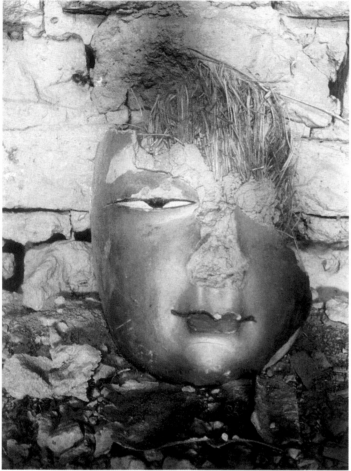

Broken Statue / from: Masterpieces throughout the Ages. A Selected Collection of Ngari Ancient Frescoes of Tibet, China, 2001, p. 54

flourished for several centuries in the empire of Greater Kashmir, whose territory bordered on and included for a lengthy period the region of Bāmiyān. In the second case, perhaps the tall Buddha images with their golden faces and hands are being assimilated with memories of unwelcome invaders from the West? Whatever the case may be, the symbolic and ethical connections with the teachings of Buddha Shakyamuni may be in the background somewhere, but the links are tenuous indeed!

For the Bolshevik Russians and the Chinese Red Guards, the multitude of shining Buddha images found in the temples all over the Mongolian and Tibetan territories, were proof of the rapacious, blind ignorance of their hereditary barbarian neighbors and foes. The Buddhist clergy and the proud nobility who supported them in those wild nomad lands, were nothing but the cruel exploiters of the devout and unsuspecting "masses."

In destroying the "idols" of the past – each according to his own interpretation – the aim was to replace them immediately with newly valid, living human heroes and leaders. But these, paradoxically, and almost as quickly, became or were rather deliberately projected, as beloved, larger-than-life superhuman "icons" themselves. Until not long ago, in the early to mid-1990s, giant figures and heads of Lenin and Mao stood in every town center from Moscow to Beijing, from Chengdu to Ulan Ude, while their faces beamed radiantly from large colored posters in the naïve wholesome style of "social realism." They are now being sold as curios in the antique markets of that same vast Eurasian continent, from the Workers Market in St. Petersburg, to the Lhasa Barkor, and the Lamaist Temples in Jehol, north of the Great Wall of China.

In the case of the anti-representational Taliban leaders, who were fully displayed on Muslim television, heard on radio *Al Jazira*, shown on CNN, and in the world press – these latest (false?) prophets have been turned into icons-cum-idols projected before our very eyes, as Bin Laden and the hidden "faceless" Mollah Omar.

The blowing up of the Buddhas of Bāmiyān by the Taliban is but the most recent of attacks on the "Religion of Idols," as emperor Wuzong of the Tang dynasty described Buddhism in the mid-ninth century. In order to understand this phenomena in Asia, it is "enlightening" to take a look at a few historical examples, before returning to the massive replacement of imagery and ideology that took place during the Great Cultural Revolution.

»Outer« Iconoclash: Anti-Buddhist Persecutions

Buddhism is one of the most widespread religions in Asia. Its anti-caste, anti-class, non-racist view of the human condition led to an easy crossing of frontiers, to the rapid growth of economic power within the monastic communities, and to the rise of learned monks to positions of influence in the courts of the kings and emperors.

Two thousand years ago, when Indian monks began travelling with merchant caravans along the silk routes, and eastwards across the ocean, they carried small golden images with them. They brought new teachings, learned the languages of the people they met, developed the art of translation, founded hermitages, built monasteries and temples in the desert oases and city-states on their way. They traveled far and wide establishing communities throughout East and Southeast Asia. Over the centuries, their monasteries became wealthy and filled with golden Buddha images and rich adornments of all kinds. Then, as *metek*, they found themselves at the center of powerful econo-ethno-ideo-clashes with the local religious groups and ruling elites. Perhaps the most widespread and violent period of confrontation and persecution was from the early eighth through to the end of the twelfth century, when Buddhism was effectively eradicated from the land of its origin.

It has already been observed that the early period of this anti-Buddhist campaign coincides with the iconoclastic purges of Byzantium. In Central Asia, where East meets West, the early eighth century saw the "clashing" together of three expanding military empires, the Caliphate of Baghdad – carrying its own new and fervent Islamic iconoclasm – the Pugyel empire of "Great Tibet," and Tang China. Although Empress Ireni's iconoclastic campaigns came to an end in 787 C.E.;[7] it is worthy of note that by the early ninth century, Buddhism was coming under attack from Muslim armies in Afghanistan, and Confucianists in China. This was followed by two major persecutions in Tibet and China, bringing about the end of the "Golden Age" of Buddhism in Asia.[8] Though apparently not connected, and even – if we are to believe a twelfth century historian of Tibet – antagonistic, the persecutions in Tibet and China were both aimed ideologically at the icon-cum-idol of the historical Buddha Shakyamuni and economically at the ever increasing influence of the monks. The persecutions were preceded in both empires by a slow build-up of anti-Buddhist sentiment which led to full-blown destruction of the "foreigness" of Sangha in 842 C.E. in Tibet, and in 846 C.E. in China.

The Melting Down of an Idol of Gold in the Form of a Man, Belonging to »a King from among the Kings of Tibet« in Mecca in the Ninth Century

A detailed narrative from the early ninth century, reflecting events taking place in Kabul, was recorded by the medieval Arab historian Azraqi. It evokes the easterly spread of iconoclastic Islam in the very context we are discussing, and reflects a certain fascination with the "golden idol," on the part of both Azraqi himself and the Muslims of Mecca.

The military empire of Great Tibet was at the height of expansion, spreading across the heart of Asia, between Baghdad and Changan, and extending far into Afghanistan. The Tibetans had been in conflict and alliance with the Arabs since 715 C.E., and were particularly affected by movements on their western front. The struggle for control of Afghanistan came to a head in 809-810 C.E. when:

> "The armies of al-Fadl, viceroy of al Ma'mun, who had just concluded a treaty of peace with his eastern neighbors, launched a jihad against four states, the kingdom of Kabul Shah, the kingdom of Utrarbandah (northeast India), the realm of the yagbhu of the Qarlugs (Central Asian Turks), and the empire of the Great Khan of Tibet, that had been at war with al-

7

_ John J. Norwich, *Byzantium. The Early Centuries*, Penguin Books, London, 1996, 3 vols., see vol. 1, chapter 17: The First Iconoclasts 711-775; vol. 2, chapter 2: The Return of Iconoclasm; chapter 4: Images Restored.

8

_ See Tarthang Tulku, *Ancient Tibet*, Research materials from The Yeshe De Project, Dharma Publishing, Berkeley, CA, 1986, pp. 312-313.

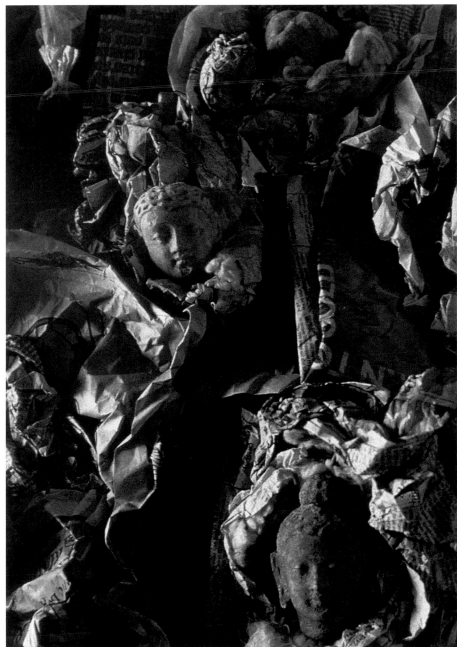

Heads of Buddhas / Museum of Kabul / from: Bérénice Geoffrey-Schneiter, Gandhare. La mémoire de l'Afghanistan. Éditions Assoline, Paris, 2001, p. 62 / © photo: Pascal Maistre, Agence Gamma, Paris

Ma'mun before 809-810 C.E. The first to capitulate was the king of Kabul, who submitted and became a Muslim sometime between 812 and 815 C.E. As a token of his submission and conversion, he sent al-Ma'mun a golden statue on a silver throne. Sa'id b.Yahja of Balkh described it to Azraqi: 'A king from among the kings of Tibet became a Muslim. He had an idol of gold that he worshipped, which was in the shape of a man. On the head of the idol was a crown of gold bedecked with chains of jewelry and rubies and green corundum and chrysolite. It was on a square throne, raised above the ground on legs, and the throne was of silver. On the throne was a cushion of brocade; on the fringe of the cushion were tassels of gold and silver hanging down, and the tassels were as ... draperies on the face of the throne.'"

Al-Ma'mun sent it to Mecca as a trophy to be stored in the treasury of the Ka'ba. In Mecca it was first displayed in the Square of Umar b. al-Khat-tab for three days, with a silver tablet on which was written: "In the name of God, the Merciful, the Compassionate. This is the throne of so-and-so, son of so-and-so, king of Tibet. He became a Muslim and sent this throne as a gift to the Ka'ba; so praise God who guided him to Islam." Beckwith notes that the statue and throne were melted down to make coins in 817-818 C.E., but the crown and tablet were kept in the Ka'ba until the time of Azraqi, who copied the inscriptions on them. Al Ma'mun's next move was further to the east. Al-Fabl b. Sahl led a campaign "to Kashmir and to the realm of Tibet." He triumphed in Wakhan and in the country of Balur, and sent the captured Tibetan commander and "Tibetan cavalrymen" back to Baghdad.[9]

Just four years later in China, in 814 C.E., the "relics" of the Buddha Shakyamuni came under attack. Han Yu, an eminent literary figure of the Tang dynasty, took it upon himself to weaken the influence of the Sangha, in order to restore Confucianism to its position of preeminence in the minds of the people. The occasion he chose was the emperor's annual welcoming into the palace of a relic bone of the Buddha kept in the Famen Temple, in a suburb of the capital.[10] It was a popular annual festival that attracted huge throngs of people. The memorial read:

"Now the Buddha was of Barbarian origin. His language differed from Chinese speech; his clothes were of a different cut; his mouth did not pronounce the prescribed words of the Former Kings, his body was not clad in the garments prescribed by the Former Kings. He did not recognize the relationship between prince and subject, nor the sentiments of father and son. Let us suppose that he was living today, and that he had come to the court at the capital as an emissary of his country. How much less, now that he has long been dead, is it fitting that his decayed and rotten bones, his ill-omened and filthy remains, should be allowed to enter in the forbidden precincts of the Palace? Confucius said: 'Respect ghosts and demons but keep away from them.'"[11]

Such anti-Buddhist feeling led to a large-scale persecution in the mid-ninth century, when Emperor Wuzong wrote his own edict. He was at the time desperately seeking the secrets of immortality, and was under the influence of the Taoist priests who urged him to repress their rivals. The justification for this move as set forth in the edict is largely Confucian and practical, rather than ideological in nature. The advantages of confiscating Buddhist wealth and secularizing monks and nuns so that they might serve the state as cultivators liable to land and labor taxes had been pointed out long before. The Edict of the eighth month 845 A.D. proclaimed:

"We have heard that up through the Three Dynasties the Buddha was never spoken of. It was only from the

9

11 10

_ Kenneth Chen, *Buddhism in China*, Princeton University Press, Princeton, 1964, p. 225.

_ Tang dynasty golden reliquary containers of the "real body of the Buddha," dated 871 C.E., were excavated in 1987, in Famensi on the outskirts of Xian, and displayed in the exhibition *Gloire des empereurs de la Chine* (exhib. cat. Petit Palais, Paris, Findakly, Paris, 2000, p. 326).

_ Christopher I. Beckwith, *The Tibetan Empire in Central Asia*, Princeton University Press, Princeton, 1993, pp. 158-162.

Han and Wei on that the 'Religion of Idols' gradually came into prominence. In this latter age it has transmitted its strange ways, instilling infection with every opportunity, spreading like a luxuriant vine, until it has poisoned the customs of our nation; gradually before anyone was aware, it beguiled and confounded men's minds so that the multitude have been increasingly led astray ... It wears out the strength of the people with constructions of earth and wood, pilfers their wealth for ornaments of gold and precious objects, causes men to abandon their lords and parents for the company of teachers, and severs man from wife with its monastic decrees. In destroying law and injuring mankind indeed nothing surpasses this doctrine!"

Whereas the public temples and private chapels have reached boundless numbers, all with soaring towers and elegant ornamentation sufficient to outshine the imperial palace itself the exhaustion of goods and manpower, and the corruption of morals that beset the Jin, Song, Qi, and Liang dynasties were all caused by just this situation. Over 4,600 temples of the empire have been demolished; 26,500 monks and nuns have been returned to lay life and enrolled as subjects to the Twice-a-Year Tax; over 40,000 privately established temples have been destroyed, releasing thirty to forty million qing of fertile, top-grade land, and 150,000 male and female servants who will become subject to the Twice-a-Year Tax. Monks and nuns have been placed under the jurisdiction of the Director of Aliens to make it perfectly clear that this is a foreign religion. Finally, we have ordered over 2,000 men of the Nestorian and Mazdean religions to return to lay life and cease from polluting the customs of China.[12]

Awareness of the fragility of the made image is reflected in a twelfth century Tibetan narrative, written just when Buddhism was being dealt a final blow in India by invading Muslim armies, causing numbers of yogins, and scholars from the great universities of northern India to flee up into the Himalayas for safety. It describes the first emperor Songten Gampo (c. 612-649 C.E.), musing on the creation of the first Buddhist statue for Tibet:

"The great king thought, 'I must have a statue of my tutelary deity made in order to promote the welfare of sentient beings here in this barbarous Land of Snows, but of what material shall it be? If it is made of earth and stone, these materials are too inferior. If it is made of wood it will split. If it is made of jewels, gold and silver, I fear that in this 'Degenerate Age' it may be destroyed by ill-intentioned people of little merit, and they will be polluted (by their act). Since it will be part of the treasury of the Sangha, I will have it made of copper and brass."[13]

The cataclysmic econo-ideo-icono-clashes – and the immense destruction of and replacement of imagery that occured during the Bolshevik Revolution in Russia (1917), and during the Cultural Revolution in China (1966-1978), were based initially on Marxist and thus on Western thought. But they may be observed from a broader perspective through such examples taken from Asian history.

The »Great Proletarian Cultural Revolution« Mao Zedong Thought: »A Spiritual Atom Bomb of Infinite Power«, »A Compass and Spiritual Food«

The Great Cultural Revolution in China produced what must have been one of the most radical and concentrated iconoclastic decades in the history of mankind. Finding its source in the early period of communism in China, and in Mao's ideology as expressed from 1919 onwards,[14] it was ideoclash, econoclash, iconoclash, and ethnoclash all at once. In the quarter century since it came to an end, it has not yet

12 13 14

_ Nyang.ral (1124-1192), *History of the Dharma*, extract translated from the Tibetan, *Chos.'byung me.tog snying.po sbrang.rtsi'i bcud*, Lhasa, 1988, pp. 175-176.

_ Litton, op. cit., pp. 68-69.

_ William Theodore de Bary, *Sources of Chinese Tradition*, Columbia University Press, New York, 1964, vol. 1, pp. 379-382; see also Paul Demiéville, L'iconoclasme anti-bouddhique en Chine, in *Mélanges d'histoire des religions*, Presses universitaires de France, Paris, 1974, pp. 17-25.

been fully digested by eighter the people or by the ruling classes. Writers and artists who represent it in words or images still often go into self-imposed exile. Yet it is an important, violent, radical moment in the history of the twentieth century.

In terms of the image, taken here in its broadest sense – as polysemic mental, verbal, and visual projections – the entire population went through an intense process of "re-education." Rejection of the "Four Olds," continuous re-thinking and re-orientation of objectives and party lines, were all accompanied by an intense process of ideological substitution imposed from above.

In 1963, during the Great Leap Forward and the purge of the Party hierarchy, just three years before launching the Cultural Revolution, Mao wrote the following poem, described as: "an extraordinary mixture of revolutionary and traditional imagery which epitomizes the whole of Mao's thought and action." It too stands as a prophecy of the violent upheaval that would shake the whole of China.

"On our tiny globe, A few flies smash into the walls,
They buzz, some loudly complaining, others weeping.
The ants climb the flowering locust, boasting of their great country,
But for ants to shake a tree is easier said than done.
Just now the west wind drops leaves on Ch'angan,
Whistling arrows fly through the air.
How many urgent tasks have arisen one after the other?
Heaven and earth revolve. Time presses. Ten thousand years is too long.
We must seize the day.
The four seas rise high, the clouds and the waters rage,
The five continents tremble, wind and thunder are unleashed.
We must sweep away all the harmful insects
Until not a single enemy remains."[15]

15

_ Litton, op. cit., pp. 87-88.

The self confident heroes of the "masses" of the world, and the joyful material abundance that mark the imagery of this period stood sharp contrast to the desperate economic situation inside China. Then on 8 August 1966, Mao announced that a "16-point Decision" concerning the "Great Proletarian Cultural Revolution" which was to "touch people to their very soul, as a new, broader and deeper stage in China's socialist revolution" was about to begin. The sophisticated quadri-millenial tradition of the Middle Kingdom was cast away as representing the "old ideas, old culture, old customs, and old habits" of the exploiting classes. The "Four Olds" were forbidden, ousted, and uprooted. Art and imagery were torn up, smashed, burnt, buried, melted down. Discerning members among the idol smashers made sure that the finer examples were put aside for later sale on the international market.

The "Four Olds" were to be replaced by the "Four News," in order to change the mental habits of the entire population of China, and as was clearly suggested, of all humanity. The Great Cultural Revolution was a vast and profound ideological transformation that would spread right across the world.

The »Newest and Most Beautiful Pictures«

During the "Great Leap Forward" in 1958, Mao had written that the "broad masses" of the people are like a clean, white, innocent, unwritten page. They are the motivating force of history:

"Apart from their other characteristics, China's 600 million people have two remarkable peculiarities: they are, first of all, poor, and secondly, blank. That may seem like a bad thing. But it is really a good thing. Poor people want change, want to do things, want revolution. A clean sheet of paper has no blotches, and so the newest and most beautiful words can be written on it, the newest and most beautiful pictures can be painted on it."[16]

16

_ Litton, op. cit., pp. 93-94.

In 1966, inspired by Mao's discourse on Art and Literature in Yenan, in May 1937, discussions were held in Shanghai, under the general guidance of Jiang Qing, pushing for a socialist purification of art. "Members of this group would all have approved of Mao's sarcastic observation that, because of its fascination with past glories, the Ministry of Culture in Beijing should be renamed the 'Ministry of Emperors, Kings, Generals, and Ministers', 'the Ministry of Talents and Beauties', or 'the Ministry of Foreign Mummies'."

In autumn 1966, the movement began: "The Red Guards have opened fierce fire on the old thinking, old culture, old customs, and old habits of the exploiting classes. They have swept away all ancestral tablets, 'idols', 'superstitious objects', old books and old wall cloths. In their place, portraits and quotations of Chairman Mao have been hung up everywhere."[17]

In Tibet, it was reported: "Lhasa's revolutionary masses have swept off the 'Four Olds' and removed the dirt at home. At a most conspicuous place in the house, they hang a portrait of Chairman Mao, and paste posters of quotations from Chairman Mao."[18]

Millions of adolescent, "innocent vandals,"[19] were let loose across the land, smashing the idols of the old society, uprooting "poisonous weeds." Impromptu accusation sessions and destruction in private homes marked the initial stages. The "idol smashers" were quite unaware of the beauty, the age, and even the monetary value of what they saw and broke, for with the crescendo of violence they began to carry out indiscriminate looting.[20] With the backing of "Mao Zedong Thought," the destruction was on a massive scale, perhaps such as has never been seen in the history of humanity. It spread like wildfire all over the countryside destroying millenia of art, architecture, and the people who attempted to resist the insistant demands of teenagers who had all power to smash all in sight that did not please them. The campaign reached a highpoint when organized "self-criticism" meetings were held in public, with parades, violent denunciation and disgrace of the "class enemies." The "underdogs" of China were encouraged to speak out against their former masters, in a cathartic process that was designed to cleanse "old thinking" and "old habits" and produce a new clean self image. Those who were considered beyond reform were to be eliminated, along with the "Four Olds." Public beatings led to the deaths of unknown numbers, while the intellectuals who had never worked with their hands – which were carefully inspected – were sent off into the countryside for re-education, or for up to twenty years in the *laogai* camps. The "reactionary" ruling classes were brushed aside like "harmful insects." The campaign had been announced much earlier on.

"It is up to us to organize the people. As for the reactionaries in China, it is up to us to organize the people to overthrow them. Everything reactionary is the same: if you don't hit it, it won't fall. This is also like sweeping the floor. As a rule, where the broom does not reach, the dust will not vanish of itself."[21]

As campaign followed campaign, slogan followed slogan, and new party line followed new party line, the definition of the "reactionary" or "class enemy" changed, pulling more and more people into target range, including many of Mao's old comrades.

The Revolution was to be continuous, each new wave putting in question the previous one. In contrast to the childlike innocence, or valiant heroism of the participants, the whole process was interfaced with a necessary, menacing violence, well integrated from Mao's earlier guerilla period:

"A revolution is not like a dinner party, or writing an essay, or painting a picture, or doing embroidery. It cannot be so refined, so leisurely and gentle, so temperate, kind, courteous, restrained, and magnanimous. A revolution is an insurrection, an act of violence by which one class overthrows another."[22]

18 20 19 17 22 21

_ Selected Works, vol. 4, p. 301, Carry Revolution
Through to the End, 30 December 1948.

_ See Adam Lowe, on "innocent vandals."

_ Tibet 1950-1967, Union Research Institute, Hong Kong, 1968, p. 611; Thomas W. Robinson (ed.), The Cultural Revolution in China, University of California Press, Berkeley, 1971, pp. 106-107.

_ Richard Baum, The Cultural Revolution in the Countryside, p. 378, from news announcement on Radio Haikow, Hainan Island, 31 August 1966. See also Jonathan Spence, The Search for Modern China, Norton, New York and London, 1999, pp. 571-578.

_ Selected Works of Mao Zedong, vol. 4, p. 19, The Situation and Our Policy after the Victory in the War of Resistance Against Japan, 13 August 1945.

_ Nien Cheng, Life and Death in Shanghai, Harper & Collins, New York, 1986, chapter 5: The Red Guards, pp. 63-79; Jung Chang, Wild Swans. Three Daughters of China, Harper & Collins, New York, 1991, pp. 376-393, chapter 16: Soar to Heaven and Pierce the Earth. Mao's Red Guards (June – August 1966); p. 429: Where there is a will to condemn, there is evidence, December 1966-1967; p. 464: Brain-death of a nation.

Li Gong Visits Tibetan Nomads / A Portrait of Chairman Mao adorns their Tent / 1964 / from: Jean-Yves Bajon, Les années Mao. Une histoire de la Chine en affiches (1949-1979), Les éditions du pacifique, Paris, 2001

李 貢

李貢,甘肃省兰州人,生于1932年。家庭为城市贫民,童年生活极为困苦。1946年入兰州高级工业职业学校;1952年投考兰州卫生学校。结业后,于1955年春分配到甘南藏族自治州玛曲县卫生院作医疗工作,成绩根出色。藏民曹加因大伤,久治不愈,李贡想给曹加作人工植皮手术,但牧区的医疗设备有限,为了抢救曹加,密切党和藏胞的关系,他亲手剥自己腿上的皮为曹加医伤,深受当地牧民的赞扬。1959年元月,他参加中国共产党,为候备党员。同年11月出席甘肃省先进工作者代表大会会后又出席全国群英大会。1959年12月29日,随全省慰问野外工作人员代表团去刘家峡水库工地慰问时,不幸失足落水牺牲,时年二十七岁。1960年1月5日,中国共产党甘肃省委追认李贡为正式党员。

青年英雄挂图(十三) 文国璋 程乐森 画

The »Little Red Book«

"Mao Zedong's Thought" was enshrined in the *Little Red Book*. This abstracted, simplified version of the four volumes of his collected writings was for the use of the illiterate masses of China, to learn by heart and to use under all circumstances. "Mao Zedong Thought" became the sole tool of education, the uniquely valid philosophical, political, and literary reference for 800 million people over one whole decade. In contrast to the proletarian revolution of the Soviet Union, this was to be an agrarian peasant revolution, based on the specific pre-industrial conditions pertaining in China. Maoism was based on Marxist-Leninism, but came to emphasize more directly the experience that Mao and his comrades gathered during their years of fighting as guerillas against the Guomindang, and especially during the Long March. Mao's bitter memories of the crossing of the Maoergai marshlands in eastern Tibet influenced to a considerable degree the particularly harsh treatment that was inflicted on Tibet.[23]

In the background lay China's humiliation at the hands of the imperial powers in the early twentieth century. The Middle Kingdom had lost its self image as the center of the civilized world. The alternative to the rapacity of the West, and the corruption of the Guomindang Republican Party, was the Soviet model. The faltering industrial revolution that had begun in the 1950s with the aid of the Soviet "big brother," was re-launched all over the countryside, where each and every village learnt to produce transistor radios and iron ore smelting factories. With the "Great Leap Forward" (1957-1961), the deeply entrenched self denial[24] of the "broad masses" was, according to the official imagery, overcome. The Chinese people had learned to "walk on their own two feet." However, faced with catastrophic economic crises inside the country in 1960 and 1961, and with growing isolation on the international front, Mao rose like the "Sun in the East" to lead the Chinese people along the path to modernization through

23 24

_ Luxun was promoted as a national hero during the Cultural Revolution. His short novel, *The True Story of Ah Q*, published in 1921, was considered to be the epitome of a description of the way of life of poor day workers in China before the revolution.

_ Edgar Snow, *Red Star over China*, London, 1968 (revised edition), pp. 202-205. See also J. Fresnais, *La Protection du patrimoine en République Populaire de Chine (1949-1999)*, Éditions du C.T.H.S., Paris, 2001, p. 101, Tibet was hit particularly "badly ..."

a moral struggle, a genuine attempt to create a new kind of ethical human being. In the early days, the "broad masses" had been set the task of mastering nature. United, they could overcome all difficulties. They could build defenses to halt the terrible annual flooding of the Yellow River, "China's Sorrow." They could build bridges[25] and dams and reclaim the land, plant new crops, develop new strains that would provide bumper harvests. They could overcome all natural enemies.

Archeology played a significant part in this process. As monumental engineering works were undertaken to improve the life of the people, unexpected pre-historic[26] and archeological treasures were discovered beneath the soil. Dozens of tomb sites of the ancient Chinese "feudal lords" were revealed, and thus the people could go back to the roots of their own ancient history. The feudal lords were set up as examples of the exploiting classes, but they also demonstrated to the world that China was indeed the center of civilization. Scenes of mass archeological excavation matched similar images of mass industrial and engineering constructions. Although Mao said: "Power comes out of the barrel of a gun," it was clear that China's great power was the muscles of its millions. Later on, towards the end of the Cultural Revolution, the Han, united with the multi-ethnic "minorities" of China, were shown reaping the benefits of their hard labor, enjoying the new materialistic society.

Since the "broad masses" of China were illiterate, the use of images and daily memorization of quotations from the *Little Red Book* became tools that affected everyone's everyday life. The language of the quotations took on an oral quality, "as if the dictatorship of the masses was embodied in Mao's own word." Large poster images were a powerful means, comprehensible by all, in the projection of policy and campaign. "One look is worth a thousand tellings," as the Chinese proverb says. The campaign to crush the "Four Olds," and to promote "Mao Zedong Thought" produced new styles

in painting and sculpture, following the Soviet model of socialist realism, or adapting traditional "folk" styles and techniques. Mao had long been projected as a massive, kindly father figure, a friendly human substitute to replace the inaccessible, mysterious, invisible emperor of China. Then, in symbiosis with the father image, the god-like omnipotence of the Great Helmsman began to emerge. The corpus of his "word" was "elevated to an all-consuming prophecy: it nurtures men, predicts their future, and changes the world to accomplish its own prediction; it sets in motion spiritual forces against which nothing can stand."[27] The national anthem of the People's Republic of China (PRC) centered around Mao's role as the one savior of the Chinese people. Ideological imagery matched the words.

> "The East is red. The Sun has risen. China has given birth to Mao Zedong.
>
> He plots and plans for the happiness of the people. He is the great saving star of China."

The Cultural Revolution came to be centered entirely on the glorified person of the Chairman. On 16 December 1966, just three months after it began, Lin Piao declared triumphantly, in the labored language of the Communist Party, where every word was weighed for political correctness:

> "In our great motherland, a new era is emerging in which the workers, peasants, and soldiers are grasping Marxism-Leninism, Mao Zedong's thought. Once Mao Zedong's thought is grasped by the broad masses, it becomes an inexhaustible source of strength and a spiritual atom bomb of infinite power. The large-scale publication of *Quotations* from Chairman Mao Zedong is a vital measure for enabling the broad masses to grasp Mao Zedong's thought and for promoting the revolutionization of our people's thinking. It is our hope that all comrades will learn earnestly and diligently, to bring about a new nation-wide high

25 26 27

_ Jean-Yves Bajon, *Les années Mao. Une histoire de la Chine en affiches* (1949-1979), Les éditions du pacifique, Paris, 2001, p. 43, "The first bridge built over the Yangze," without external aid, Wuhan, 1960.

_ Litton, op. cit., p. 73.

_ Beijing Man was discovered at this time, see *China Reconstructs*, 5 May 1966.

in the creative study and application of Mao Zedong's works and, under the great red banner of Mao Zedong's thought, strive to build our country into a great socialist state with modern agriculture, modern industry, modern science and culture, and modern national defense!"[28]

The world looked on in admiration as the "East is Red" propaganda was churned out month after month, year after year, in all the languages of the laboring masses of the world. Each issue of *China Constructs* showed pictures of progressive events taking place in the heart of the People's Republic. These were increasingly removed from space and time. Specific geographic locations were not mentioned. A guess at the region could be made from the landscape in the photo images, or from the dresses of the "national minorities" who danced and sang to their hearts' content in the wonderful new motherland, or learned from their "big Han" brothers and sisters. China was a wholesome paradise on earth. A new mythology was in the making.

Counter Images

A number of detailed narratives of life in China during this period have been published. The authors – who managed to survive – tend to come from the former elite, thus sharp counter-images and descriptions of intense agony abound. Like the BBC film on Mao's life,[29] their writings provide graphic and harsh images of the events that followed in rapid succession throughout the decade, as compared to the idealized, paradise-like representations proclaimed and pasted up by the Chinese Communist Party (CCP). Over and above the immeasurable loss that occured with respect to "old idols" and "things of culture,"[30] it is the human dimension of suffering that prevails most forcefully in these accounts.[31]

In Paris in the last couple of years, in contrast to the river of pain written by those who went through the real thing as victims, the light and airy, heroic propaganda imagery of the Cultural Revolution has found a new flowering that is fetching high prices. In October 1999, a (false) announcement of the creation of a new magazine, *Immédiatement*, by Philipe Sollers, was made by pasting newly made (tiny) *"da" zibao* posters on the walls of the chic quarter of the sixth arrondissement, representing the philosopher as a "Paper Tiger!"[32] A couple of years later, just before Christmas 2001, a fashionable exhibition of posters, and the launching of a large and well produced "coffee table book," *Les années Mao*, was opened just near where the *"da" zibao* had appeared. The chosen imagery of the exhibition was "all sweetness and light," the swinging, blasé intellegensia of Paris its target.[33]

Tibet and the Cultural Revolution: Divine Substitution

In 1956, a high-ranking ecclesiastical delegation from Tibet, headed by the young Dalai and Panchen Lamas, was invited on a six month tour of China to see the revolutionary work that was being done under the guidance of the Communist Party. It was their very first exposure to the world of the twentieth century. When they met Mao in Beijing, he told them bluntly: "Religion is the opium of the people." In spite of this, the party was truly impressed with the charisma of the "Great Helmsman," by the huge modernizing activity and material progress they saw. They attended the first National People's Deputies Assembly where they made speeches, while radio broadcasts are attributed to other members of their party. Among the published speeches, one very long one held to have been made by the Junior Tutor of the Dalai Lama, Trijang Rinpoche, praises in rich detail the "blessed meritorious activities" of Mao Zedong in working for the good of the family of peoples in the "Ancestral Kingdom," dedicating his life for the good of all living beings, in a way that was rarely

31 28 30 29 33 32

_ BBC film on Mao's life...

_ Lin Piao, 16 December 1966, in
Quotations from Chairman Mao Tse-tung,
Beijing, 1967.

_ *"Da" zibao* means "giant written poster," used first as part of the
verbal and visual projection of party policy, and then by dissident
Chinese intellectuals to denounce the corruption of the communist
regime. The posters of *Immédiatement* were tiny.

_ Cf. note 20 for bibliography.

_ Bajon, op. cit. The author makes a close and well informed analysis of the "Mao years," based on
contemporary propaganda posters. Several of the posters are reproduced here and in the exhibition.

_ The PRC's translation into English, "cultural relics"
is much more pejorative than the Chinese, wenwu,
which means simply "things or objects of culture."

to be seen in actual practice, thus promoting Mao to the rank of bodhisattva. Such sentiment, no doubt sincere at the time, was quite widespread before the Cultural Revolution. Yet, in the thick forest of propaganda and counter-propaganda it is not easy to know who was actually responsible for the texts.[34]

One decade later, in 1966, without the slightest time-lag – so well was the PLA orchestrated in Tibet – the destruction of the "Four Olds" went into full and immediate swing. Once again Mao's most celebrated slogan: "Power comes out of the barrel of a gun," was well applied to incite the people to attack their own Buddhas, and to blow up the huge

monastery walls. Combined with the practical, revolutionary, incantantory "Mao Zedong Thought," qualified by Lin Biao in December 1966, as a "Spiritual Atom Bomb of Infinite Power" the body, speech, and mind activities of the Chairman were designed to eradicate all manifestations of superstition and religiosity among the people.

According to the imagery projected by the Tibetan community in exile, "6,000 monasteries" and their contents were destroyed. Yet inside Tibet the campaign was much more radical. Down with Buddha, the Dalai Lama, the monastic rulers and the feudal landlords, down with the implacable traditional vertical hierarchy, down with the

Portrait of Mao as the Sun, with the Broad Masses holding up the Little Red Book / 1990 / from: Jean-Yves Bajon. Les années Mao. Une histoire de la Chine en affiches (1949-1979). Les éditions du pacifique. Paris. 2001. p. 92

34

_ See the Tibetan publication *Ta.laí bla.ma dang/Pan.chen Ertini lhan.rgyas kyis skabs dang.po'i rgyal yongs mi.dmangs 'thus.mi tshogs.chen thengs dang.po'i gros. Tshogs thog.tu gnang.ba'i gsung.bgros*, Nationalities Publishing House, Beijing, 1955, pp. 18-43.

Leifeng and a Tibetan Child in the Snow / © photo: Eric Daviron, Paris, Archive ZKM | Center for Art and Media, Karlsruhe

Border Guards / Chinese PLA showing Tibetans where to point the Gun / © photo: Eric Daviron, Paris, Archive ZKM | Center for Art and Media, Karlsruhe

excruciating humility of the poor ignorant people – "When serfs stood up" – was one of the slogans of the day.[35] Down with the law of karma that relegates every one to his position in society, down with the estates of the nobles and monasteries that held their peasants and nomads in a tight clutch. Down with ancient culture in any shape or form. *The People's Daily*, published in Lhasa on 12 August 1966, announced: "The liberated serfs were excited beyond words when they received the booklets of *Quotations from Chairman Mao*. They said, Chairman Mao's books are a talisman with which to move heaven and earth."[36]

Thus instead of the vast hierarchical array of Buddhist deities in temples and private chapels, portrait posters of Mao, Marx, Engels, Lenin, and Stalin were aligned horizontally in the new committee rooms. They were being proposed as equal, democratic heroes in the Marxist pantheon. Together with the red flag, they remained on display in every village headman's house, in every remote high mountain valley of the Land of Snows, until the late 1980s.

As the Cultural Revolution advanced, even these fathers of the Communist Party were eclipsed by the shining rays of the new "Great Saving Star," Chairman Mao, the one and only "Helmsman," the "Red Sun in the East." The Red Guards were charged with the destruction of all material culture. As they split into two main warring factions, they destroyed in surprisingly orderly fashion, thousands of monasteries, temples, stupas, hermitages, manor houses, palaces, and forts with their huge, thousand year old libraries, millions of books and wood cut blocks, uncountable numbers of statues and paintings, ritual implements and textiles. Tibet was indeed the "Western Treasure House,"[37] for in the high altitude and dry climate nothing rotted, and the "treasure" had been gathering over the last thirteen centuries. Nothing in the human landscape of architecture was to be left, except the humble village dwellings of the "broad masses" of newly liberated "serfs." The operation was done in stages. First the most precious im-

ages, books, and ritual objects were removed: then the ancient furnishings and tapestries; then the precious wooden beams, doors, and windows. Finally the "worthless," or unmovable left-overs (often superb stucco images going back many hundreds of years) were smashed and the walls blown to pieces.[38]

Young heros showing the way with brush and pen. sticking up »da« zibao: »Philippe Sollers is a Paper Tiger« / Stuck up on the walls in the rue de Sèvres. Paris / October 1999

36 37 35 38

_ *Tibet 1950-1967*, op. cit., p. 603.

_ In Chinese, Tibet is Xizang, meaning the "Western Treasure House," with traditionally, the Kunlun mountains, bordering the northern periphery of the Tibetan plateau, as paradise of the "Queen of the West." See Document 28: Treasure House of the Fatherland – The Tibetan Plateau, April 20, 1956, in *Tibet 1950-1967*, Hong Kong, 1968, pp. 126-131; Catriona Bass, *Inside the Treasure House*, Victor Gollancz, London, 1990, on education in the new Tibet.

_ During the late 1950s and early 1960s, a team of Chinese art historians and archeologists spent quite some time exploring the monasteries, temples, and palaces in Tibet. They gathered significant data and published a series of seven articles in *Wenwu* in 1960 (6, 8, 10) and 1961 (4, 5, 6, 7). Later on, in the 1980s, a much more detailed series of books on sites in the Tibet Autonomous Region was published based partly on their research, edited by Sonam Wangdu, then head of Cultural Relics Department in the Norbulingka, Lhasa. Thus, it is said that referring to these notes taken before 1966, the Red Guards knew exactly what should be removed from each important place.

_ The author of *When Serfs Stood Up in Tibet* (Beijing, 1960), Anna-Louise Strong, was one of the foreign friends of China who took an active part in promoting the Maoist vision of Tibetan feudal society. See *Tibet 1950-1967*, op. cit., pp. 602-619, and pp. 633-699, for contemporary documents commenting or announcing the different campaigns in Tibet, such as "Four Olds are also swept off in Homes," and "Attacking Local Overlords."

From 1966 onwards through till the early 1980s, the destruction was so radical that an estimated 90-95 percent of all material culture disappeared or was carried away. Many Tibetans joined in what had become on the surface a vast movement of mass hysteria, and yet, paradoxically, was well organized. There was little choice, it was positive (in terms of social and political advancement), exciting; and dangerous not to take part.

In China, for at least half a century, the imperialist strangle hold, civil war, revolution, the Communist Party, luxurious modernity, new art, and literature had been on the horizon, if not directly in the sitting room, for a vast number of people. For Tibet, barely aware of the vast eruptions that were shaking the world in the twentieth century, the Great Cultural Revolution came on very quickly indeed. Following 1951, when the PLA had, for the first time, painfully climbed up 4,000 meters onto the high Tibetan plateau, they arrived from four directions at once, in four columns of bedraggled, starving soldiers. It was promised then that nothing in that ancient society would change.[39] Little did change, until 1959 when the Dalai Lama fled to India. Then the tone hardened. The reforms had to go much faster, and the task was immense. The order was to replace superstition with science; the Buddha and his teachings by Mao Zedong and his "thought." The new imagery showing Mao as the sun shining on the "broad masses" in their earthly paradise, and the praise given by Trijang Rinpoche according him the status of bodhisattva, paved the way for Mao to become a universal sovereign and savior of all living beings.[40] Although not stated so explicitly, such thoughts may well have echoed in the sub-conscience of the devout Tibetan Buddhists. Mao was the "sun rising in the East," but he was also the Buddha of Boundless Light, Amitabha with his paradise in the West, where everyone is born not of the human sexual act, but on a lotus blossom. Effectively, and paradoxically, during that period of extraordinary freedom, for teenagers,

sexuality was taboo. The human figure in the well-padded Maoist suit was a-sexual, couples were separated, sometimes for years, over huge distances, sacrificed on the altar of the CCP. Families were divided, children denounced their parents, service to the community was the supreme virtuous activity. Indeed,. the People's Liberation Army (PLA) were to be the new Sangha in the eyes of the people. Images published in the magazines *China Reconstructs* and *Illustrated National Minorities* showed viril, wholesome PLA soldiers having their shirts washed and darned by the winsome, splendid natural beauties of Tibet.[41] It was not the lazy, good-for-nothing, avaricious Buddhist monks who were working for the common good but these young, shining Chinese "angels."[42]

In sharp contrast, the old society was depicted with an extreme, dark violence. Tibet, before the advent of Maoist-Leninism, was hell on earth.[43] The act of destruction of all facets of tradition was an act of "killing with kindness." The people in their ignorance did not know better. They needed a new moral guide to lead them to a bright new future.

One small example among hundreds that pervaded every aspect of life demonstrates the widespread and far-reaching implications of "new ideas, new culture, new customs, and new habits." The need to watch every word and deed, the infinite weight that an innocent slip of the tongue, a minute deviation from the correct image might imply. One of the most popular traditional Tibetan oaths was the trisyllabic "Konchoksum!" meaning, I swear by the "Three Jewels" (the Buddha, his teachings, and his community of followers, the Sangha). This is rather polite and at the same time a little pious, a bit like saying in English: "Oh my God!" During the Cultural Revolution any invocation with a religious tinge was counted as belonging to the "old idols." Thus a new, politically correct trisyllabic exclamation came into usage, and was on everyone's lips right through till the mid-1980s: "Mao Zhuxi!"; I swear by "Chairman Mao"!

39 40

_ Bajon, op. cit.

42 43 41

_ Jampel Gyatso, *bKal.bzang Me.tog*, op.cit., the first modern Tibetan novel, in which the PLA arriving in Eastern Tibet, are literally described as saving "golden angels."

_ A museum of horrors of the old society was built at the foot of the Potala, and remained there till the mid-1980s. A large part was made up of clay sculptures, in the style of social realism, depicting all the crimes against humanity believed to have been perpertrated by the old "feudal regime," see *China Reconstructs*, February 1968, p. 18: "Art that Serves the Proletariat," scenes from the "old society" shown in lifesize clay sculptures, made according to an oral communication, by young artists from the Orphanage in Lhasa.

_ *Minzu huabao*, 1974, 6, "Tseten Dolma sewing the clothes of the PLA," (no page number given); see also Jampel Gyatso, *bKal.bzang Me.tog*, (Flowers for the Good Age), Beijing, 1982, opp. p. 160, a Tibetan girl gazing lovingly at a PLA soldier.

_ See Melvyn Goldstein, *A History of Modern Tibet. 1913-1951*, University of California Press, Berkeley, 1989, pp. 737-772: "The 17 point Agreement"; Tsering Shakya, *The Dragon in the Land of Snows*, Pimlico, London, 1999, pp. 52-91; and chapter 12, where he shows that the Cultural Revolution began in Tibet as early as February 1966.

Marx, Engels, Lenin, and Stalin
/ © photo: Eric Daviron, Paris,
Archive ZKM | Center for Art
and Media, Karlsruhe

The extent to which the *Little Red Book* took over every zone of existence, becoming a substitute for the "poisonous weeds", is described in a recent biographical essay by the Tibetan writer in exile, Pema Bhum. In *Tibetan Memoirs of the Great Cultural Revolution, The Crooked Necked Pleiades*, he describes with light humor his childhood as a Red Guard, the innocent pleasure and pride he took in learning all the slogans by heart, the grave importance of carrying the little sack with the book inside, the fear of the crime of being found without it.[44] All forms of literature were forbidden, not to speak of religious chanting or reading of texts, the telling of stories, reciting the Gesar epic, and love songs. In the words of the Amdo bard in Dondrup Gyal's short story:

44

"Oh my friend! These are words between you and me. I don't know if I'm right or wrong, but these last years the policies seem to have been changing quite a bit. Earlier on they said that there was freedom of religious belief. But recently, we are forbidden to recite Buddhist prayers, we are forbidden to turn our mani wheels, we are forbidden even to carry a rosary. The whole land is full of forbidden things. It's strange because I am getting on for sixty, and not only have I never lit a butter lamp in my life, I haven't even recited a single Mani. Admittedly I could never muster much faith in the 'Three Precious Ones', but I don't want to give them up altogether! In fact, this question of freedom of

_ Pema Bhum, *Dran.tho sMin.drug ske 'khyog* (Six Stars with a Crooked Neck), for an extract in English translated by Lauran R. Hartley (to be published), see Mao's Cuckoo, in *Index on Censorship*, 1, 2001, pp. 176-181.

Narthang Monastery and Library / founded 1153 / © photo: Pema Konchok

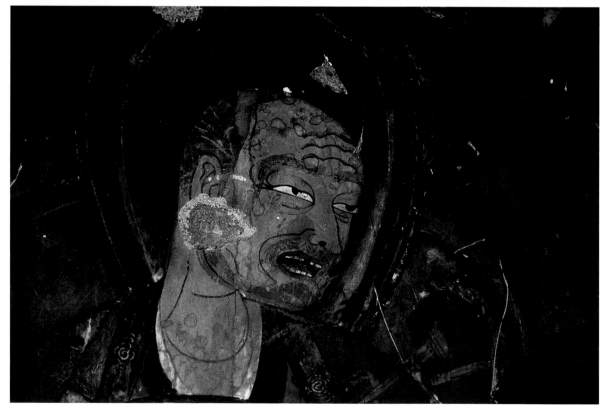

PEMA KONCHOK

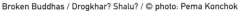

Broken Buddhas / Drogkhar? Shalu? / © photo: Pema Konchok

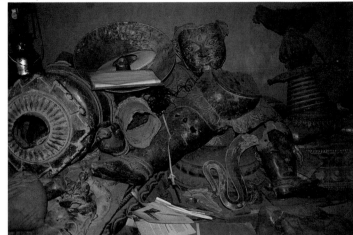

religious belief barely touches me at all. If it's allowed that's fine. If it's not allowed then I'll give it up, but it's hard to fathom what they are up to!" Then he let out a little laugh. "The astonishing thing is that they are saying now that we are not allowed to sing! We are not even allowed to recite the Gesar Epic! If we can't sing we can't sing, since anyway we can still sing when no-one's listening. But still it's hard to fathom!" At this point his voice rose as if to emphasize something terribly important. "But to say that we aren't allowed to recite the Gesar Epic is nothing other than violence done against the natural order of things ... From when I was a youth with white teeth to me now as an old man with white hair, I have never heard anyone say anything so absurd as to forbid the reciting of Gesar!"[45]

New, politically correct words were put to old melodies, to be sung when in earshot of anyone who might be listening!

> The mountain has three peaks. High above the first peak, shines the sun.
> But it's not the sun! It is Chairman Mao! Chairman Mao shines like the sun!

The mountain has three peaks. High above the middle peak, shines the moon.
But it's not the moon! It is Chairman Mao! Chairman Mao shines like the moon!
The mountain has three peaks. High above the last peak, shine the stars.
But they are not the stars! They are the broad masses! The broad masses shine like the stars![46]

»Kill« the Image

Disposing of the material heritage of Buddhist Tibet was polyvalent in intent and function. It was absolutely necessary to get rid of the massive, overbearing presence of the Buddhist deities, the thousands of Buddhas, lamas, and yidam father-mother images, in order to substitute the new pantheon of the CCP. Furthermore, the best examples of that "old" imagery had monetary value, as the 1960s survey had proved. The fabled wealth amassed over centuries in the monasteries, palaces, and fortresses of Tibet was indeed there. So the finest pieces were taken out and saved, and later sold via Hong Kong on the international market. Well known networks have

45

46

_ Bhum, op.cit.

_ Don.grub.rgyal, 'Bol.rtsom zhog.pa'i skya.rengs (Writing on my pillow at dawn), New China Publishing House, Xining, 1981; sGrung.pa (The Bard), pp. 40-41. This short story, which ends with the death of the bard in mid Cultural Revolution, is the first of the very few Tibetan literary narratives of that period published in China. The author, considered to be the first and finest of post-Cultural Revolution Tibetan writers, has since become a cult figure. See Heather Stoddard, Don.grub.rgyal (1953-1985). Suicide of a Modern Tibetan Writer and Scholar, in Tibetan Studies, vol. 2, Oslo, 1994, pp. 825-836.

supplied museums and private collections all over the world since the early 1980s. They have enriched a certain number of people in China, and in the West. The Densathil gilt copper imagery is a prime example.

Another vital aspect was the symbolic act of "killing" the graven image. Many half destroyed statues have been seen and photographed in temples all over Tibet over the last two decades. Often the heart was torn open, limbs torn off, the face smashed, the eyes scratched out – this last especially in the case of paintings. The image was certainly blind, deaf, and dumb, but the people were superstitious. They needed to show that the only issue in question was base matter. Numerous examples reveal, however, a complex of associations, not simply a will to destroy "old idols," old false mediators of the imaginary, inexistent divine nature. Large images often contained precious substances, smaller, older images and texts in the centers of the head, throat, and heart. Thus the tearing out of a heart, not only revealed the will to "annihilate" what the Red Guards thought that the ignorant Tibetans considered to be a "living" image, but rather the vulgar (anti-Confucian, anti-Buddhist) desire for profit.

Three Case Histories:
1. Brikuti's Padmapani

One case seems to exemplify mindful rage on the part of the "executioner," in the only too present context of the rewriting of history. Otherwise it is difficult to understand the "assassi-nation" of a fine standing Padmapani *Lotus in Hand* image, the size of a young child, a beautiful, slender, half-naked youthful prince, believed to have been brought to Tibet by the Nepalese princess in the seventh century. During the Cultural Revolution, the statue was machine-gunned in a frenzy that might be interpreted as: "kill the Nepalese queen." Did the statue represent, in the minds of the Red Guards, the Nepalese princess Brikhuti, who preceded the Chinese princess Wen-cheng, as the first foreign spouse of Songtsen Gampo, almost ten years before princess Wencheng? It was procured by art dealers in the mid 1990s and brought to Europe still full of diagonal rows of bullet holes. The dark brown bronze image was restored to perfection and sold to a private collector.

2. The Silver Lord From Kochar

Another case is one of the three famous, solid silver statues from the tenth century temple of Kochar in western Tibet. The gullible Tibetans could not destroy the biggest one; it was nearly life size. Swords and axes would make no mark until the Red Guards ordered that the Tibetans defecate and urinate on the fallen image. Only then, did the protecting "life force" – instilled during the consecration ritual – leave the statue and allow it to be sliced up as base matter (or rather as valuable solid silver) and carted away. The Red Guards did not themselves believe, of course, but they had the pious Tibetans desecrate the Buddha image in order to destroy their blind superstitious faith, and in order no doubt, to sell the silver to use the money for more practical, immediate purposes.

3. A Twelfth Century Manuscript of the Sutra of the »Perfection of Wisdom«

A third story amongst thousands of attempts to save what was going to be destroyed, is that of the stash of precious early manuscripts and paintings hidden away in a cave, perched high out of reach, somewhere in eastern Tibet. Having lain there forgotten for twenty-five years, they were covered in bird droppings, for the cave was also the home of a flock of pigeons. They came onto the international market in the 1990s and have been distributed around the planet in public and private collections. A large number of illuminated pages from a fine twelfth century manuscript of the *Sutra of the Perfection of Wisdom* were extracted from the debris.

Broken Buddhas / Pema Konchok / © photo: Eric Daviron, Paris, Archive ZKM | Center for Art and Media, Karlsruhe

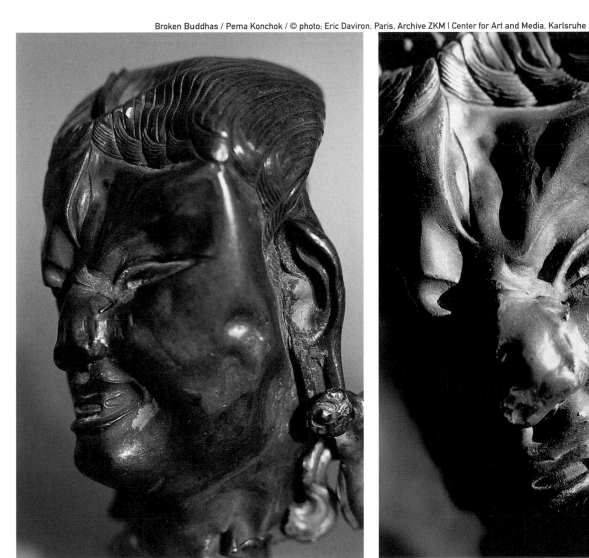
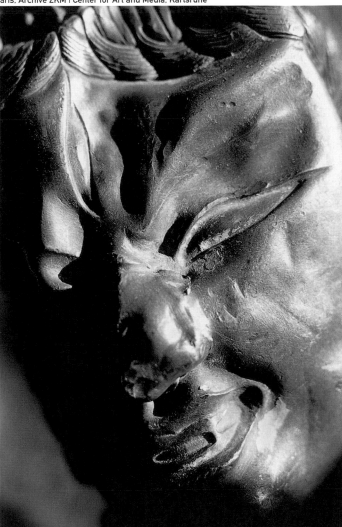

GOD DOESN'T LIVE THERE ANYMORE

Moshe Halbertal

THE ISRAELI-PALESTINIAN CONFLICT is not a border dispute. It is a homeowners' quarrel over the same piece of land, and it can only be resolved through compromise. After years of effort, the thick rind of the Jewish-Arab conflict has been peeled away. Paradoxically, however, and contrary to all internal and political logic, just as the end of the conflict was in sight, the battle has become tougher than ever, broadening into a war of religion, a struggle between Jews and Muslims. By focusing on the Temple Mount, a small, symbolic rock, the national dispute between Israelis and Palestinians has become a religious confrontation that threatens to convulse the entire region. Water, land, and the resettlement of refugees may be difficult issues, but these are things which lend themselves to division and compromise. Elevating the struggle to the symbolic plane and handing it over to religious leaders is to turn it into an apocalyptic showdown between religions which cannot be resolved. Land and water can be divided. But can a symbol?

In the ensuing religious debate, both parties have voiced a similar but baseless claim that sanctity and sovereignty are directly related. "If a place is sacred to us, then it belongs to us," is the mantra repeated by rabbis, qadis, statesmen, politicians, and ignoramuses. The Chief Rabbinate, for example, swiftly declared that giving up the sovereignty of the Temple Mount is a blow to all that Israel holds sacred, as if there is some axiomatic connection between sacredness and control.

Actually, it works the other way around: holiness exists in a time, place, or person that is not subject to rule. Sacred time, in the halakhic sense, is time where human's controlling, creative activity is brought to a halt. The sacredness of time in Jewish law is represented first and foremost by the prohibition of labor, which on the Sabbath, involves setting aside all controlling, creative pursuits. "Labor" is not only strenuous effort. A Sabbath observer can push a heavy wardrobe from one side of the room to the other without desecrating the Sabbath, but even the slightest change to the world around him or her would be a violation of the holy day. The profane, by contrast, is a controlled and subjugated domain. On weekdays, a person creates and seeks to control; on the Sabbath, the person relates to nature as a gift. It is accepted as is, without change.

This approach to sacredness, in which sovereignty and holiness are a contradiction in terms, is shared by all manifestations of sanctity in Jewish law, great or small. In the shmitta year farmers are commanded to let their fields lie fallow. According to Jewish law, the "fruits of the seventh year are sacred," and man is forbidden to "manipulate" the fruit. The fruit may be eaten, but not processed. It cannot be used by the pharmaceutical industry, for instance.

The sacred is a domain which is not directly approachable or controllable. A holy site cannot be used as a tool by human beings. One is forbidden, for instance, to cut through a synagogue in order to reach one's destination more quickly. "A man must not enter the Temple Mount with his walking stick, his shoes, and his pouch, with the dust clinging to his feet, or use it as a short-cut," the Mishna tells us. The essence of sanctity, in all its halakhic variations, is separation, retreat. The object is to limit control and sovereignty.

Most experts in Jewish law say that the Temple Mount itself is sacred and hence off-limits to Jews today. How can one claim ownership of a place where it is forbidden to set foot? Since the days of the Second Temple, from the Maccabis to the zealots, fierce historical battles have been waged over control of the Temple Mount compound. But these battles were related to the Jewish fight against idolatry, against imperialist Greek and Roman efforts to "erect statues in the Sanctuary."

The Muslims, as everyone knows, are not idolaters. They adhere strictly to the prohibition against pictures and graven images. Islam upholds the absolute uniqueness of God, wrote Maimonides. Yet the ferocious struggle to fly this or that national flag atop the Temple Mount is a clear case of "erecting statues in the Sanctuary" and turning a holy site into a domain of

manipulation and strife. Muslims and Jews who worship the same god have transformed the site of the Temple into an altar to Moloch, the god of human sacrifice. People who call themselves servants of God, who have monopolized religion on both sides, are prepared to sacrifice an entire generation of young people to gain control of a holy place. To these, it is said: "He who is enthroned in heaven laughs; the Lord mocks at them" (Psalms 2:4).

Bloodshed in a sacred place is nothing new. Sanctity has a way of attracting forces of corruption and impurity. In the Tosefta, appended to the Talmudic tractate of Yoma, we are told of an incident that took place toward the end of the Second Temple period: In the midst of a competition to determine who would perform a certain Temple rite, one of the priests stabs a fellow priest to death.

"Once there were two priests who were about to score a tie while racing up the ramp. One of them pushed the other so that he lost by four cubits. [The loser] seized a knife and plunged it into [his opponent's] heart. Rabbi Zadok stood on the steps to the hall and said: 'If someone slain is found lying in the open, the identity of the slayer not being known, your elders and officials shall go out and measure the distances from the corpse to the nearby towns' [Deut. 21:1-3]. Let us measure and see which the heifer should be brought for: the sanctuary or the courtyard? And then they all wept.

Jerusalem Temple / built by Herodes / reconstruction: model / Hotel Holyland. Jerusalem / © photo: Günter Zbikowski. 1980

Along came the father of the young man and said: 'Brothers, I am your atonement. My son is still convulsing. The knife is not defiled.' This teaches us that the impurity of a knife was a graver matter to the Israelites than bloodshed. It is also said: 'Moreover, Manasseh put so many innocent persons to death that he filled Jerusalem [with blood] from end to end' [II Kings 21:16]. Hence we learn that when blood is spilled, the Shechina disappears and the Temple is defiled."

At the temple, as a contest is being held for the right to carry out a ritual, a hot-headed priest stabs his competitor. Rabbi Zadok, who happens to be present, turns to the people and painfully refers them to the atonement laws in Deuteronomy which require the breaking of a heifer's neck. The bible describes a case in which a murdered man is found outside the city. The elders of the city closest to where the corpse is found, responsible for the safety of wayfarers traveling on the city outskirts, are told to bring a heifer and atone for their sin with the words: "Our hands did not shed this blood, nor did our eyes see it done." But because this incident happened inside the Temple, Rabbi Zadok asks whether responsibility for bringing the heifer falls on the sanctuary or the courtyard, both of which are close to the murder site. The people burst into tears when they realize what a grave matter this is. Atonement is possible as long as the Temple's sanctity is preserved. But how can there be atonement when the Temple itself has been defiled?

The matter does not end with Rabbi Zadok's shocking remarks. As the rabbi and the people are grieving over the murder, the father of the dead priest hurries over and exclaims with relief: "My son is still convulsing. The knife is not defiled." The knife used as the murder weapon is a holy implement used in Temple rites, and as we all know, contact with the dead is a source of impurity. Unlike Rabbi Zadok, the priest's father is not concerned about the defilement of the Temple, or even his son's life. What interests him is whether or not the knife has become impure. If his son is not yet dead, the knife can be saved.

To the narrator, the conduct of the murdered priest's father is not unusual. With his swift and critical response, he encapsulates the whole cultural situation on the eve of the Temple's destruction: "This teaches us that the impurity of a knife was a graver matter to the Israelites than bloodshed." This caustic remark on the prevailing mood during the late Second Temple period offers a profound insight into what might have led to the destruction of the Temple and the breakdown of Jewish society.

In recent months, when blood has flowed freely on the Temple Mount and both sides have shown a willingness to sacrifice the young people of Israel and Palestine on the altar of Moloch, Jewish and Muslim spiritual leaders should harken to the words of the Tosefta. To those who claim ownership over the Temple Mount and dream of spending their lives in the House of God, let it be known that the Shechina, the holy spirit, has abandoned that blood-soaked place. God doesn't live there anymore.

To end the Israeli-Palestinian conflict, a number of tough but legitimate questions must be asked. Are the Palestinians serious in their desire for peace? What are Israel's defense needs and how do they fit in with a respectable sovereign territory for the Palestinians? Is a Jewish democratic state possible with the demographic outlook what it is today? And then we have the Jewish connection to the Temple Mount, which is related to the sensitive issue of the Palestinians recognizing the national and historical rights of the Jewish people and guaranteeing access to the Jewish holy places. The debate over these issues is important and legitimate, but those who insist on dragging in the matter of sovereignty over the holy places are only violating that which is holy. |

THE SIN OF SAUL

William Pietz

HERE IS A BRASS PYTHON HEAD from Berlin's Staatliche Museum. It has a familiar tale to tell. The holes drilled toward the back tell us it was once part of something larger. But now it is an object unto itself, an artistic artifact, ethnology. For us today, as an ethnographic object, it has been critiqued to a second death: Devalued once when it was ripped from its living culture, it has now been stripped bare even of its minor museological dignity as the truth-bearing fragment of some vanishing culture saved from the wreckage of history and progress. Perhaps the only power left to it is to summon a moment of useless compassion. But compassion for whom or for what? Although I am still puzzling over the notion of iconoclash, I will suggest an answer to this question.

This python image is an emblem of modern civilization's triumph over fetishism. A real triumph, for the object was seized by British forces when, in 1897, they sacked Benin City, considered at the time the greatest stronghold of "fetishism" in West Africa. The assault was an act of retribution for the killing of a British consul, but it was considered an act of absolute righteousness because the king of Benin practiced human sacrifice. What violence is not justified to put an end to the most evil practice of false religion? Moreover, fetishism was regarded as the most false among the false religions of the world because it was thought to be the worship of mere earthly objects and forces without any conception of God or the divine as a transcendent absolute – and without the latter how can there be any salvation?

There was little public doubt about the righteousness of the destruction of Benin City because there was scientific proof of the horrific customs of this culture. British soldiers carried with them the new Kodak camera with which they documented headless sacrificed corpses and, even more horrifying to Christians, trees bearing crucified bodies.

At some point, as fighting gave way to looting, the python head was ripped off the outside of the palace, where it had been attached to a serpentine brass body so long it wrapped protectively around the entire royal edifice. Because the python can move both on the ground below and in the trees above, it is a mediator between heaven and earth, just as the royal human sacrifices were messengers sent to the divine power beyond this world. They were, indeed, the opposite of the condemned criminals and witches who had been nailed to the execution trees outside the royal compound. To crucify is to transform a living being into an accursed object suspended between heaven and earth so that it cannot touch and pollute either realm. At least until the transvaluation of Christianity, the crucified was the perfect opposite of a mediator between the living and the gods. It was the serpent able to climb from the ground up a tree into the air, or the mudfish that appeared on the shore from the depths when the fertile rains came down, that were logical images of our power to communicate with the invisible other world of gods and ancestors.

There is one snap shot in which the python head can be seen. It seems to have been placed in a position of honor atop a table or altar in the center of what had been the king's council chamber. But this kingship, which had lasted continuously as many centuries as the English throne, was now overthrown and the room had been turned into a make-shift treasure house filled with stacks of ivory tusks and any other object that caught a British eye as valuable loot. The python head had fallen into a new regime of value, the international law of the prize. The leader of the victorious force, Admiral Rawson, got first pick and chose an ivory and copper statue of the royal leopard, which he presented to Queen Victoria. Other loot was distributed according to rules of military hierarchy and on-site auction. A few weeks later the loot began to be offered for sale in London where much of it, including the python head, was acquired for the famous Berlin collection of fetishes and other exotic examples of "primitive art."

Head of a Python / Benin, Nigeria / eighteenth century / brass / height 16.5˝ /
Staatliche Museen zu Berlin – Preußischer Kulturbesitz, Museum für Völkerkunde

Were there second thoughts, doubts, regrets about this most famous destruction of the regime of Fetish? The most memorable may have been that of the moving force behind the whole affair, the head of Britain's Oil Rivers Protectorate, Sir Ralph Moor, who uttered the triumphalist proclamation at Benin, "There is only one king in this country and that is the white man." Twelve years later, in retirement at his home in London, Moor committed suicide by swallowing some potassium cyanide that he had purchased to exterminate a nest of wasps in his garden. Some speculate that this was a final act of despair, not for the destruction at Benin, but for the career it failed to win him. His life has been likened to that of Joseph Conrad's Mr. Kurtz: his successes provided what the state desired, but his methods could not be sanctioned. The ransacking of Benin City brought him nothing but the end of his career, a bitter retirement and, it seems, a depth of despair he could not tolerate.[1]

It is this that I would add to the conversation about iconoclash: beneath the purity of any act of iconoclasm one can always discover a maze of all too human motives – desires for a successful career, social acceptance, wealth, a land where one's people can live; simply to survive. Absent the absolute, the holy, the desires that drive us seem monstrously disproportionate to the atrocities we are willing to commit to fulfill them. What can save us from the pettiness that lies behind our crimes against humanity? The absolute will of God, of course. And that is why acts of iconoclasm fail if any fragment escapes the destruction. Why? Because the purity of motive – absolute obedience to the absolutely holy – is polluted by the intrusion of merely human motives. Call it the sin of the souvenir. It is the sin of Saul that proved him an unworthy king: having destroyed the Amelkites as God commanded, he listened to the voice of the people instead of the voice of God, allowing them to keep as prizes the best sheep and goats, things valuable to mere mundane life (Samuel 1:15). In this, Saul disobeyed God's simple Kurtzean command, "Exterminate them all, every Amelkite and all their property." An imperfect iconoclast is a bad ruler, for surely it is the task of the sovereign, whether by ancient divine right or modern reasons of state, to justify the slaughters we desire for our own reasons and thereby to save us from the despair that might otherwise haunt our acts of inhumanity. Iconoclasm is at once the crime and its absolution, but only if nothing remains. But something always remains. Hence, I suppose, iconoclash.

1

_ The story of Sir Ralph Moor is told in Robert Home, *City of Blood Revisited: A new look at the Benin expedition of 1897*, Rex Collings, London, 1982.

THE IDOL KING?

Olivier Christin

EVERYTHING IS SURPRISING IN THE NUMEROUS MUTILATIONS of images of kings of France during the sixteenth century religious wars. These figurative representations were, strictly speaking, neither religious images nor objects of a cult associated with Catholic liturgy. There probably were some exceptions, like those of Saint Louis used extensively by the monarchy in its legitimization strategies. Owing to his prestige and role in the struggle against heresy, Saint Louis' images could serve as an affordance in the iconoclastic controversy. In 1562 in Le Mans, for example, a man broke the arm of a statue of Saint Louis and laughed at the fact of having amputated "the king of the sergeants."[1] But most cases of destruction of images of rulers were more complex and cannot be related to common forms of destruction of religious images during wars. They therefore prompt us to consider the specific significance of this political iconoclasm rooted in both the theory of resistance and the theology of the icon.

In Cléry, Orléans, Tours, or Saint-Jean-d'Angély, statues, paintings, reliefs bearing the effigy of kings, and royal tombs were all damaged or destroyed during the wars. Although the royal authorities remained cautious, Catholic controversialists and chroniclers wanted to reap the political benefits of this destruction by denouncing it as sacrilege and crimes of lese majesty. Their main weapon was a rather weak argument concerning civil honor based on the idea of a prototype: honor bestowed on the king's portrait is reflected on the king himself, as is injury. Nicole Grenier, for example, stated in *Doctrine catholique de l'invocation et vénérations des saints* in 1562 that "injury and dishonor shown to an image fall on the person it represents. There is no king nor prince who would not claim to be seriously harmed if his representation were insulted." To disprove the accusation of sacrilege, protestant opuscules endowed iconoclasm with a providential nature, which paradoxically likened it to a miracle: it was God who had overturned the images that contravened his explicit commandments. God carries on doing miracles through images, but to destroy them. Several Protestant authors nevertheless thought it necessary to put forward further justification for iconoclasm, less contradictory this time, even when it defied the magistrates' control, contrary to the wishes of Calvin and Theodore de Bèze. In 1562, for example, a *Remonstrance au Roy sur le fait des idoles abattues* justified the action by asserting: "we have broken stones, but they killed men." A text from 1563 deplored the death of the "living images" of Christ that the faithful Protestants were. In both cases, the justification for iconoclasm is clearly grounded in a theory of legitimate resistance to persecution and the tyrants supporting it;[2] the young King had little choice between either imitating Asa (Kings 1:15) or Ezekias (Kings 2:18) – who had the courage to destroy idols – or becoming a new Herod.[3] The concomitance in the early 1560s between episodes in which the destruction of images of kings was presented as symbolic executions, and the first expressions of tyrannical positions is therefore by no means the fruit of fate;[4] iconoclasm was also becoming a discourse on politics.

Yet, this type of explanation remains insufficient if we fail to question the particular ontology of images at play in these conflicts, and to dilute the specificity of royal portraits in the very general issue of the cult of images. The destruction of images of kings relates to contemporary transformations in modes of representation of monarchical power and to attempts to symbolically ennoble it along the lines of a model explicitly derived from eucharistic theology.

Although in this particular field there was probably nothing new in the religious symbolism of the king's arms (azure, fleur-de-lis) and in his way of entering towns riding under a canopy, for example, the sixteenth century introduced or accelerated a series of decisive changes: use of the title "Majesty" to refer to the king, to the surprise of many contemporaries and especially of de Bèze; the exaltation of mysticism of the royal blood to eliminate possible problems of inheritance and exclude the idea

| 1 | 2 | 4 | 3 |

_ Olivier Christin, *Une révolution symbolique: l'iconoclasme huguenot et la reconstruction catholique*, Éditions de Minuit, Paris, 1991.

_ Cf. "l'Oraison au Sénat de Paris pour la cause des Crestiens," cited by El Kenz, *Les Bûchers du roi: la culture protestante des martyrs*, Seyssel, Champ-Vallon, 1997, pp. 180-181: "The king our prince and all his people are subject to the commandments of the sovereign King, and himself commits the crime of lese-majesty if he determines anything against the will of his King and ours, and is thereby guilty of murder if he persists with a misdeed that he should condemn."

_ Among numerous examples, see: Exhortation chrestienne au Roy de France Charles neufiesme, in *Mémoires de Condé*, London, 1743-1745, vol. II, p. 222.

_ Comparable texts in the Netherlands after the explosion of the iconoclastic issue in 1566, cf. Martin Van Gelderen, *The Political Thought of the Dutch Revolt 1555-1590*, Cambridge, 1992.

Richard Verstegan, Le théâtre des cruautés des hérétiques de notre temps, texte établi,
présenté et annoté par Frank Lestringant, Editions Chandeigne, Paris, 1995, p. 103

Horribles cruautés des huguenots en France

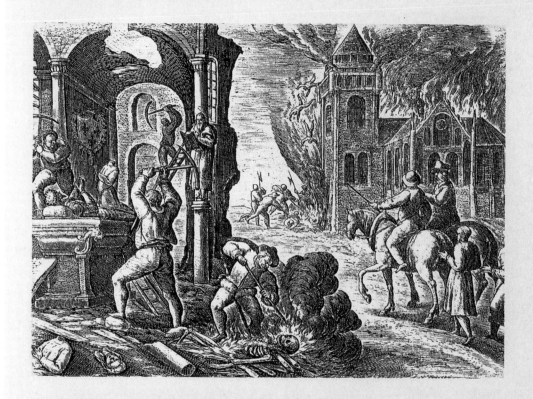

La rage des malins ne laisse être en repos
Les os sacrés des saints aux sépulcres enclos,
Ô rebelles mutins, en méprisant les lois!
Leurs corps ensevelis par plusieurs ans passés
Brûlés tu as en cendre, et puis en l'air jetés,
N'ayant aucun respect aux seigneurs ni aux rois.

103

of subjects' consent to the monarchy; and the recurrent likening of the king to a pelican in a series of public ceremonies, for instance in Lyons in 1559 and even in 1595. The pelican refers to a religious interpretation of a sacrificial monarchy, which is reminiscent of and imitates Christ's sacrifice on the cross for the salvation of man. In a long iconographic tradition based on Psalms 101:7, the pelican is the symbol of love, of Christ, and of redemption because it was thought that these birds fed their offspring with pure blood by digging into their own chests with their beaks. That explains why pelicans are found in decorations of tabernacles and in certain emblems.[5]

In these conditions, contemporary evolution of the theoretical and symbolic foundations of monarchical authority could but raise the problem of the exact status of figurative representations of the sovereign and consequently prompt certain historical actors to question the real presence of the king in his portraits. Drawing on John of Damascus, Nicole Grenier affirmed that if the image of the king is the king, then the image of Jesus Christ is Jesus Christ, and the image of a saint is a saint. He thus established a parallel between the punishment reserved for whoever injured the image of the king and, worse still, awaiting whomever treated the image of the king of kings with irreverence. In similar terms, the Catholic controversialist Gentien Hervet, in his *Ruses et finesses du diable pour tascher abolir le saint sacrement de l'autel* published the same year, openly linked the eucharistic debate, iconoclasm, and political disloyalty by questioning the strange contradiction of Protestant ministers who knelt and bowed down before the king at Poissy in 1561 while expressly prohibiting the adoration of Jesus Christ.[6] Several specific iconoclastic episodes should probably be understood in this particular theoretical context. As a pamphleteer reporting the mutilation of royal tombs at Notre-Dame de Cléry commented with horror, iconoclasts "treated the image of King Louis XI as if they were holding him alive between the hands of an executioner who cut off his arms, legs, and finally his head."[7] By multiplying relations between the symbolism of power and the eucharistic cult and by thus raising the question of the real presence of the king in his countless images, concrete transformations of political practice and the representation of the monarch created the conditions that were to make political iconoclasm a decisive issue at the beginning of the wars of religion, for they seemed to link obedience to the king to adhesion to Catholicism. It is probably the cruelest paradox of Catholic defense of religious images that, through constant comparisons with the image of the king, it ended up making thinkable, the mutilations of royal portraits and tombs. |

Translated from French by Liz Libbrecht

5

6 7

_ *Lexikon der christlichen Ikonographie*, Herder, Freiburg, 1994, vol. 3; and
A. Saunders, *The Seventeenth Century French Emblem*, Droz, Geneva, 2000, pp. 92, 278.

_ Cited by C. Elwood, *The Body Broken. The Calvinist Doctrine of the Eucharist and the Symbolization of Power in 16-th Century France*, Oxford University Press, Oxford, 1999.

_ Claude de Sainctes, *Discours sur le saccagement des églises catholiques par les hérétiques anciens et nouveaux calvinistes*, 1562.

IMAGE-BREAKING ON THE CHRISTIAN FRONTIER

Raymond Corbey

ACCORDING TO THE PHOTOGRAPH'S CAPTION this burning of traditional ritual woodcarvings "was done by the population at the occasion of their passing over to Christianity," suggesting native agency. But the event took place in the context of Protestant missionary activity, and the photo was published in a book by a missionary entitled *Of struggle and victory on Alor*. It is probable therefore that this case of image breaking was facilitated, triggered, suggested, or even ordered by missionaries.

Roman Catholic and Protestant missionaries in the Dutch colonies and others collected as well as destroyed indigenous objects associated with ancestors and spirits. Often they saved the finest specimens from piles before the rest was destroyed and sent home for sale, missionary exhibitions, the training of missionary personnel, or museums of ethnography. Sometimes image-breaking was clearly initiated by the missionaries, sometimes predominantly or even exclusively by natives. In the latter case, image-breaking could occur in the context of interactions with dwellers of the north Atlantic, but also without foreign influence in the context of native traditions disposing of ritual objects once these had served their function. Ritual objects have their own life cycles, of which destruction or desecration can be an essential part. In that case, the objects are disabled by setting fire to them, letting them rot away in the forest, exposure to termites, and so on (see Strother).

An example of image-breaking with obvious native agency in a contact situation are Melanesian cargo cults from the colonial period, turning around the expected arrival of material wealth and salvation from heaven or overseas, through spirits, ancestors, or foreigners. There is much controversy over the interpretation of such cults, but two points are clear: that they often involved the ritual destruction of traditional goods, tied to the striving for new, modern ones, and that they clearly were the initiative of natives.

Often the various forms of iconoclastic agency were intertwined. Given the scarceness, succinctness, and colored character of sources it is mostly difficult if not impossible to sort out who exactly was doing what, with what motives, to whom, and for whom. Research during the last decade has increasingly stressed native agency – local agendas, initiatives, and creativity – in colonial contexts. The earlier tendency to see locals as passive recipients of western influences is criticized as continuing colonial perceptions of local peoples. This angle proves fruitful with respect to iconoclastic practices, not as a preconceived diagnosis, of course, but as a heuristic point of view.

A look at an analogous, better documented case in the same region at about the same time may be helpful. It concerns the solemn burial of indigenous ancestral figures, personal amulets, and other items associated with ancestors and spirits on 17 July 1927, on one of the smallest Batu Islands, off the west coast of Sumatra. This took place in the context of a Lutheran baptism of some fifty villagers, and was described in a letter home to the Netherlands by the missionary's wife. She describes how all those who wanted to be baptized had to hand in their ritual objects, which were piled up next to a hole dug near the church. During a service they were buried, while an appropriate song "made clear that just as these figures were being buried, so now must all that is heathen in our hearts die and also be buried. The spirit of Christ must now lead us."[1]

This suggests a major role for the missionary, but the letter also describes how after the burial over one hundred people, apparently on their own initiative, solemnly slaughtered, divided, and ate a pig while the missionary and his family stood aside. Despite their austere practices, several missionaries of the (Dutch) Luther's Genootschap collected ethnographics on the Batu Islands, and one of them studied, and published repeatedly on traditional shaman chants.

A particularly cunning iconoclastic strategy was desecrating secret paraphernalia by showing them to the uninitiated. More common was burning, dismantling, cutting up, burying, throwing into the sea or over a cliff, or hiding in caves. Whipping

1

_ A. Steinhart, *1889-1989: Honderd jaar kerk op de Batu-Eilanden*, Stichting Lutherse Uitgeverij en Boekhandel, Woerden, 1989, pp. 27-28.

Burning of naga woodcarvings representing the mythical serpent island Alor, the Dutch East Indies / 1920s /
from: A.A. van Dalen, Van strijd en overwinning op Alor, H.J. Spruyt's Uitgevers, Amsterdam, 1928, frontispiece

and mutilating figures occurred, too. Confiscation and collecting could serve as an alternative way of getting rid of indigenous sacred objects. Exclusion from the sacraments and the religious services was a common sanction against baptized individuals who had indulged in traditional ceremonies or consulted shamans. Indigenous psychological devastation is mentioned regularly as an effect of missionary iconoclasm.

Two analytical concepts seem relevant to such events. Mircea Eliade has coined the concept of "cosmicization" for missionaries' activities. According to him, such religious places as Rome and Jerusalem are seen as navels of the world, directly tied to the divine, and ordering, sacralizing what is around them. The Greek word for nature or reality, "kosmos," has connotations of order and beauty. The periphery of the known, here Christian, world is perceived as heathen, barbaric, chaotic, demonic. It has to be incorporated by ritual activities of ordering the chaotic, civilizing and domesticating the wilderness, christianizing it.[2] This happens by building churches, planting flags, drawing maps and boundaries, erecting heraldic signs, and giving names. It is those sorts of activities to which the concept of cosmicizing refers, and this would seem to be a neat description of what missionaries do when they baptize, or, indeed, burn indigenous things. However, Eliade would seem to underestimate the agency of those to be converted.

Secondly, Victor Turner's theory of "rites of passage" may shed light on what happens. This concept refers to culturally prescribed actions, which accompany changes in social or life cycle states. Usually they show up in three principal phases, each of which can be more or less elaborate: rites of separation of the old status (for example, of being "heathen"), a period of being "liminal" (literally: on the threshold), and reaggregation or incorporation into a new condition.[3]

The focus in the foregoing, on missionary and native image-breaking, should not distract from the fact that there were still other backgrounds to such phenomena, processes of acculturation and globalization which started in connection with trade contacts even before colonization. In Indonesia there was also pressure towards modernization by authorities. Conversion to Islam of *suku suku yang belum beragama* – groups which do not yet have a religion – was high on the agenda of the strongly Islam-minded Indonesian *Departemen Agama* (Department of Religion) over the last few decades, and school teachers and local officials were instructed accordingly.

2

_ Mircea Eliade, *The Sacred and the Profane: the Nature of Religion*, translated from French by Willard R. Trask, Harcourt, Brace, New York, 1959, Chapter 1.

3

_ Richard Schechner, Ritual and performance, in Tim Ingold (ed.), *Companion Encyclopedia of Anthropology: Humanity, Culture and Social Life*, London and New York, 1994, pp. 613-647.

GILDED SILENCE: THE KING OF KOSALA'S SIXTEEN DREAMS

Adam Lowe

THE BURMESE HAVE, ARGUABLY, ALWAYS LIVED under harsh rulers. Throughout their history, the Buddhist attitude of acceptance of one's *karma* (conditioned rebirth) in the face of *dukkha* (suffering), found an unfortunate match in being trod upon by despotic kings and cruel local sheriffs, the *myo-sa* (town-eaters). And yet – or rather because of it – Burmese Buddhists have traditionally looked more to religious faith than to secular politics for deliverance, often giving their prayers visible form in votive paintings that draw upon some relevant moral text. The most popular source, the classic *Jataka* tales of the Theravada tradition, relate some 500 of the Buddha's past lives – all of which are believed to be literally true. Not surprising, since of the three main schools of Buddhism – Theravada (Southeast Asia and Sri Lanka), Mahayana (East Asia), and Vajrayana (Tibet and Mongolia) – Burmese Theravada claims to adhere most adamantly to the letter of the original "orthodox" Buddhist canon. The temple, in the absence of the "public square" of Western town planning, functions as a place where people can meet, so that an image hung there becomes a highly visible symbol of community standing and shared values. Donors are usually wealthier merchants and officials, often persons with chronic ills seeking otherworldly intervention or spiritual relief, though occasionally broader worldly concerns are addressed indirectly via parable depiction. Townsfolk are generally quite literate in "reading" the teachings represented in temple paintings; most Burmese can even coax a meaning from the choice of the specific text for illustration. Thus, the marked rise in popularity of temple paintings based on *The Sixteen Dreams of the King of Kosala* from the *Mahasupina Jataka* to cult status throughout Burma in the nationalist 1920s and again in the mid-1970s, invites interpretation.

Burma, a union of very diverse ethnic states and cultures – likened by some to a "Yugoslavia in Southeast Asia" – has experienced almost continuous civil unrest since its independence from Britain in 1948. Indeed, this potentially explosive situation was the very rationale for the military takeover in 1962, now forty years ago. Ostensibly socialist at the outset, the military regime also looked to Buddhism as a binding influence – only 60 percent of the multi-ethnic population is Burman, but some 90 percent are Buddhist – and even incorporated trappings of Buddhist ideology into a rather uniquely muddled vision of a "Burmese Way to Socialism" (lauded at face-value in American economist Schumacher's best-selling *Small is Beautiful).* Meanwhile, living standards in Burma declined under increasingly bureaucratic controls; the isolationist military reduced this former "Rice Basket of Asia" to dire poverty and open dissent became impossible. All media were nationalized and a Board of Scrutiny straitjacketed personal expression. Fine art remained negligible – despite the existence of two state art schools – though it should be stressed that "art" as a distinct cultural practice unto itself is a very Western notion. Before Western expansionism imposed an altogether foreign brand of "modernity," Asian cultures generally had no blanket concept of "art," no theoretical category or term inclusive of practices as diverse as sculpture, dance, music, and poetry; the Burmese word /anupinya/ (literally "delicate talent") was only coined around the turn of the twentieth century. Certainly art never assumed the socio-critical role it has in the West, and more importantly, Burmese society has always stressed oblique, sidelighted, non-confrontational criticism. Sign painters, who commonly ply their trade near temple precincts, generally work in ordinary enamel housepaints on tin sheets, scraping down old paintings when new tin is unavailable. Prices run from around 10,000 kyats per panel – approximately US $15 – and vary according to the size, detail, and degree of finish required, as well as the renown of the painter. Painting styles are by now heavily influenced by Western conventions of perspective and modeled rendering, but still retain some of the flat cartoonish qualities of traditional murals and *parabaik* folding book figuration. Painters will sometimes also paint in a likeness of their patrons, invariably bearing the donors' names followed by the words

Dream of the King of Kosala: Calf suckling a cow. A parable of adults humbled by their children
Tin Maung Oo / 1995 / housepaint on zinc / 40 x 60" / two out of sixteen panels / Adam Lowe

၆ အဖိုးတသိန်းတန်ရွှေခွက်ငယ်ကျင်ယ်စွန်ပါ လေ့ဟုမြေဆွေးအားပေးသည်ဟု
မြင်မက်ပုံ

ဆုတ်ယုတ်သောကာလဝယ်အမျိုးမမွန်သော်လည်းအဖိုးတန်သီးရတနာကိုလိုင်းယူပါ
ရန်ဒူးတုပ်ခါ ဆက်သရလိမ့်မည်ဟုဟောပြောသောပုံ

၇ နွားမကြီးတို့သည် မွေးဖွါးစ နွားကလေးတို့၏နို့ကို စို့ကြသည်ဟု မြင်မက်ပုံ

၈ရွာ၏ဝတရားပျက်ပြားသော ကာလ၌ သား သွီး ငယ်တို့ထံမိဘများရှိ ကျိုးခိုက်နေရခြင်း

kaung-hmu (good deed) to indicate the accruing of spiritual merit that may be shared by all who call praise upon it. The donation of paintings, instead of the more typical "good deed" of gilding Buddha images or the *chedi* temple spire, is furthermore said to carry educational value in spreading the teachings to children and the illiterate. The paintings shown here illustrate Gautama's recounting of sixteen extraordinary dreams that troubled the ruler of Kosala, a fifth century B.C.E. lower Himalayan kingdom (now the Indian state of Uttar Pradesh) in whose capital, Sravasti, the Buddha spent much of the last twenty-five years of his life. Each dream was interpreted as a prophesy of an age to come when lack of faith and bad government would corrode the fabric of society. The dreams decry the inversion of natural laws or freak phenomena in a "world turned upside down," but here both the dreams and their sometimes quite obscure interpretations are transposed to a modern-day Burmese setting. The inclusion of such pictorial details as modern architecture and household furnishings is surely significant. Likewise of note, uniformed malefactors in khaki seem to be British military, but are left ambiguous enough to stand for military in general, perhaps suggesting that the Burmese military have assumed an "imperialist" role within their own country.

Sixteen 48 x 24 inch panels, each comprising two frames – dream image on the left, prophetic interpretation on the right – make for surreal juxtapositions, though with equal measures of charm and earthy humor. The paintings shown here were painted at the request of the author in 1995 by Tin Maung Oo, a Mandalay artist who supports his efforts in "fine art" by doing temple paintings.

The compositions are very closely based on a particularly famous set of the *Sixteen Dreams* now hanging in Kyauktawgyi Temple, commissioned by an elderly Mandalay merchant couple in 1968. These original images were in turn based on illustrations in a popular religious pamphlet entitled *Great Kosala's Sixteen Dreams* by U Lin,[1] which remains well-known but unavailable; whether or not such popular Kosala commentaries actually imply criticism of the present regime, they have been kept "out of print" for almost twenty years now.

1

_ U Lin, *Great Kosala's Sixteen Dreams*,
Zabu Meitswe Press, Yangon, 1936; reprinted 1976.

LIFE, DEATH, AND ETERNITY OF THE BUDDHAS IN AFGHANISTAN

Pierre Centlivres

WHEN SHEIKH YOUSSOF AL-QARDHAOUI, an authority on lawfulness and unlawfulness, warned that "by considering themselves more knowledgeable and more pious than the Companions of the Prophet and the 'well-guided caliphs' [the first four caliphs, according to the Sunnites], who all respected historical relics, the Taliban were demonstrating impious pride,"[1] Mullah Omar, their leader, answered: "How could we justify [at the time of the last judgement] having left these impurities on Afghan soil?"[2]

The presence in Afghanistan of statues of Buddha was thus deemed a befoulment. The fact that they were there long before the arrival of the Taliban did nothing, however, to make the task of getting rid of them less urgent. Objections by UNESCO emissaries who tried in early March 2001 to persuade their Afghan interlocutors that the statues "are not religious objects" were to no avail; the ambassadors of culture had no chance of success. "If they were objects of the cult of an Afghan minority, we would have to respect their belief and its objects, but we do not have a single Buddhist in Afghanistan," said the Mullah, "so why preserve false [sic!] idols? And if they have no religious character, why get so upset; it's just a question of breaking stones."

The notion of world heritage corresponds with a belief, as Jean-Michel Frodon pointed out.[3] The Mullah was right to affirm that "some people believe in these statues." In his eyes, the notion of cultural heritage, excluding any religious reference, is suspect. Is aesthetic delectation not idolatry, or at least something that can distract men and women from the struggle in the way of God? Any cult of the art object that implies "a non-religious relationship with the invisible" is reprehensible.

Buddhist sculptures, major impurities in general – but especially in the case of the two Bāmiyān giants – therefore call for eradication. The consequence is a twofold sacrifice: the purifying sacrifice of the statues, ordered by decree on 26 February 2001, and the expiatory sacrifice which was to erase their very long presence in a Muslim country and the 1999 decree in which the Taliban granted the Bāmiyān Buddhas their protection.

On 15 March 2001, Mullah Omar ordered the sacrifice of one hundred cows throughout the country, including twelve in the former presidential palace. In compliance with religious dictates, the meat was to be given to the poor. As for the fragments of the Buddhas at the foot of the Bāmiyān cliff, some of which are still identifiable, the Mullah prohibited their intended sale to Pakistan on the grounds that it would make the sacrifice unlawful. Art dealers in Peshawar have affirmed, however, that the prohibition has not been observed.

The Bāmiyān statues, protected works in 1999, intolerably defiled in 2001, became enemies for the Taliban. A kind of jihad was launched against them: "our soldiers are working hard; they are using all available arms against the Buddhas," said the Taliban spokesman. Rocket and tank shells were brought in to help, and the destruction was completed with dynamite. "It took us twenty days, it was trying work," he insisted.

In reality, the victory is won only if there are witnesses. Journalists, who on 22 March witnessed the emptiness of the Kabul museum, were flown to Bāmiyān on 26 March to see with their own eyes the gaping openness of the niches deep into the cliff. Prior to that, 19 March, the Taliban had agreed for this one occasion to overlook their aversion to television by inviting cameramen from al-Jazira (Qatar) to witness the final phase of the sacrificial explosion.

The last act in an iconoclastic enterprise started, we are told, with the establishment of Islam in Afghanistan. For many European travellers and archaeologists, Moslems are destroyers of statues par excellence. Aurangzeb (1618-1707), the last of the great Moguls, is said to have tested the effectiveness of his canons against the two colossuses whose faces reportedly disappeared first. To finish off the giants it took the considerable pyrotechnic means implemented by the Taliban.

<div align="right">

3 1 2

</div>

_ Pierre Lafrance, Témoignage. Comment les bouddhas de Bamyan n'ont pas été sauvés, in *Critique internationale*, 12 July 2001, pp. 18-19. See also: Pierre Centlivres, *Les Bouddhas d'Afghanistan*, Favre, Lausanne, 2001; Tarzi Zemaryalai, *L'architecture et le décor rupestre des grottes de Bâmiyân*, 2 volumes, Bibliothèque du Centre de Recherche sur l'Asie centrale et la Haute Asie, Paris, 1977.

_ *Le Monde*, 12 March 2001.

_ Lafrance, op. cit., p. 19.

a

b

Big Buddahs / axonimetric views, and sections of the head / Bāmiyān /
from: Tarzi Zemaryalaï, L'architecture et le décor rupestre des grottes de Bāmiyān, 2 vols,
Bibliothèque du Centre de Recherche sur l'Asie centrale et la Haute Asie, Paris, 1977, fig. 5

coupe de la niche et galerie
suivant AB

coupe de la galerie
et ouverture de la voûte

The Buddha of 55 meters / Bāmiyān / facade and section /
from: Tarzi Zemaryalaï, L'architecture et le décor rupestre des grottes de Bāmiyān, 2 vols,
Bibliothèque du Centre de Recherche sur l'Asie centrale et la Haute Asie, Paris, 1977

But now an Afghan archaeologist, Zemaryalaï Tarzi, has put forward an astounding and convincing hypothesis: the Buddhas never had a face but a smooth surface over which gilded wooden masks were placed during ceremonies in Buddhist times. The Bāmiyān Buddhas were thus born disfigured, and the Taliban are simply finishing off an absence.

Henceforth, the two niches are immense sarcophaguses inhabited by the Buddhas' shadow, a void that must disturb Mullah Omar. "The Buddha is not in his statues," say Buddhists. And what if this void represented the very aim of Buddhism "which ironically finds the ultimate truth in nothingness," as a Bangkok newspaper suggested.[4]

Since then, giant Buddhas have been proliferating: a fourteen meter long sleeping Buddha rediscovered in Tadzhikistan and exhibited in August 2001 in Douchanbe; other colossuses, known and neglected for a long time, were restored in China; yet another, even bigger than the others, built in gold in Thailand. The biggest of the Bāmiyān Buddhas, or rather, the reproduction of an English nineteenth century engraving, is exhibited on the façade of the Pompidou Centre in Paris. Lastly, there is talk of a threefold Swiss project. The first, virtual and visible in three dimensions on the Internet, will be computer designed. The second, it is said, will resuscitate the great Buddha somewhere in Switzerland, but in a tenth of its original size and in two copies: one in its pre-26 February state and the other in its assumed original form. Finally, an identical reconstruction of the two giants, in concrete, is to be undertaken in the niches of the august cliff in Bāmiyān.[5] This proliferation suggests a new occurrence of the Great Miracle, the magical multiplication of Buddha, found in Tantrism. It is also a new form of iconoclasm, one which claims, through reconstruction/reconstitution, to efface a destructive act. The injunction of the ninth century Zen master is still relevant today: "If you meet the Buddha, kill the Buddha!"

Translated from French by Liz Libbrecht

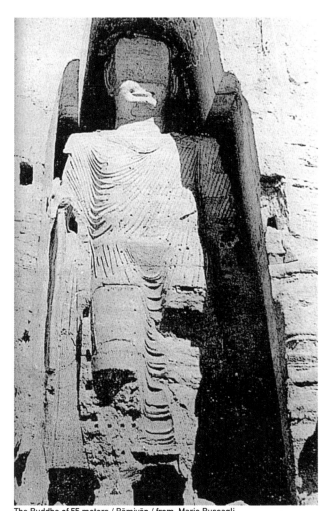

The Buddha of 55 meters / Bāmiyān / from: Mario Bussagli, L'art du Gandhâra, Librairie général française, Paris, 1996

4 5

_ *Sunday Nation*, 4 March 2001.

_ *Neue Zürcher Zeitung*, 17 October 2001.

THE FETUS AND THE IMAGE WAR

Luc Boltanski

IN 1965, THE PHOTOGRAPH OF AN EIGHTEEN-WEEK-OLD FETUS enclosed in the amniotic sac inside the womb was published on the cover of *Life* magazine. Taken by Swedish photographer Lennart Nilsson, this photograph is a milestone, and not only in the sense that it was the product of a technological innovation. It also marks access to the order of representation for a being who, up until then, had evaded this order. As such, the photo prefigures the progressive entry, some years later, of the fetus into a social order, which had ignored it[1] up until then, acting as if it didn't exist.

How is it then that the fetus made its entry into society? By virtue of a series of technical, political, and symbolic operations which imparted a weight and a presence to this practically absent being that it had never known up until then, and through which it was endowed with new qualities.

The work of qualification of the fetus – that conferred presence on it – was, above all, the result of innovations which made it accessible to the senses. With the development of medical imagery and particularly of ultrasound, one can see the fetus in the womb, follow its evolution, know its sex well before its birth and, in certain cases, repair anomalies that it might be carrying. One can also hear the beating of the heart (and record it). As well, the development of cognitive psychology gives it capacities for communication, capacities, which until then had not been recognized as such. The parents are encouraged to touch it through the abdominal wall, in a way to familiarize themselves with it and, particularly in the case of the father, to allow him to get to know it. The fetus has become "a someone."

However, it is not only in becoming accessible to the senses that the fetus has entered into society in the course of the last thirty years. Its recently acquired social presence is also the result of its being placed at the center of two social conflicts of primary importance, the first revolving around the conditions of its destruction; the second around the conditions of its fabrication. In the course of these conflicts, it acquired a new weight with regard to practices, to techniques, to discourse, and perhaps above all, to juridical decisions. In these conflicts – which continue up to our time – the question of the representation of the fetus has occupied a central place.

The first conflict was provoked by the decriminalization and then the legalization of abortion in principle western countries. The opponents to such measures made extensive use of the photography of the fetus in order to support the position according to which, to abort is to kill an unborn infant. They either used photos – those of Nilsson or others – in order to celebrate the fetus insofar as it represents human life in gestation, in the womb, or they used photos of dead fetuses after abortion, often brandished at anti-abortion demonstrations, in order to dramatize their protest. Since from very early on, the dispute centered on the question of knowing whether the fetus was a "person" or not, the morphological similarity between the fetus and the infant that would have come into the world if the fetus had survived was used to prove that the fetus was indeed a person. Relying on the politics of human rights, they also made the demand that the life of this contested person be the object of protection on the part of the State.

To counter these arguments and to reduce the emotional effects that such photos could provoke, university academics with affiliation to pro-choice movements (sociologists, philosophers, jurists, historians of science, members of women's studies departments, etc.) undertook to decode the rhetoric of the opponents of abortion and to deconstruct the images that the latter utilized. This endeavor led them to attempt to divest the fetus of the presence and the status that it had recently acquired. Academics who engaged in this undertaking made frequent use of conceptual instruments borrowed either from the practice of deconstruction in the literary or philosophical arena, or from the new sociology of sciences. They took as

1

_ Editor's note: The fetus is referred to as "it" solely for linguistic reasons.
It could also be termed as "it/he/she."

their primary target the realism that the users of these photos claimed as their authority and, in so doing, adopted a constructivist position. They sought to demonstrate that, far from being "real," these images were artifacts and as a consequence were the instruments of an ideological propaganda, either because they decontextualized the fetus in isolating it from the womb (that is to say from the mother, whose presence was excluded from the images), or because these photos were the object of a technological coding (using electronic microscopes and techniques of digital imagery). What is more, it was argued that using artificial techniques in order to show that which is normally hidden, in fact amounted to producing an artifact.

Thus, the deconstruction of the images of the fetus triggered a deconstruction of the fetus itself. In using elements connected to the history of women and to the history of the sciences, these researchers thus insisted on the "historical character" of the fetus. Far from constituting a "natural being," eternal in its naturalness, or a "creature of God," as affirmed, among the opponents of abortion, who claimed religion as their authority, the fetus was, according to these pro-choice advocates, "in fact" only "a product of history."

A Catholic protester participates in a 10,000-strong march against the legalization of abortion / Mexico City, 24 September 2000 / © photo: Ramon Cavallo-STR, AFP

The »March for life« protest was organized by Catholic groups to demand the repeal of a law passed by the Federal District's legislative assembly that legalized abortions in cases of rape and where the mother's or fetus' life is in danger.

A pro-abortion demonstator (R) holds
a placard reading »Our bodies belongs
to us« as she confronts a pro-life
demonstrator holding a placard reading
»Abortion kills children« during an
anti-abortion rally / 24 April 1993, Paris /
© photo: Pascal Pavanti-STF, AFP

Pro and anti-abortion protesters march
in front of the US Supreme Court Building
in Washington DC / 25 April 2000 /
© photo: Georges Bridges-STR, AFP

After an eight-year absence, justices are
hearing arguments in the Sternberg V. Carhart
case and trying to decide whether individual
states may ban a surgical procedure known as
»partial birth abortions.«

The fetus was at the center of a second conflict, tied to the appearance of new reproductive technologies (Medically Assisted Procreation). This conflict was carried out relatively independently of the preceding one, engaging other arguments and other actors. This latter conflict focused specifically on the fate of "frozen embryos." Since the success of the MAP technique was uncertain, it is well known that doctors in numerous countries (of which France is one, but not Germany) decided to multiply the fabrication of embryos and to freeze them, allowing for possible re-implantation in the case of failure. A very important stock of human embryos (many hundreds of thousands) was thus constituted and questions were raised concerning their status, concerning their future and eventually, concerning their usage (to destroy them, to sell them, to use them for industry, to use them for research, etc.). The debates over questions raised by the accumulation of "embryos frozen without parental plan" (this is their official name in France), which initially took place within "ethics committees," resulted in the introduction of the fetus into law: a law of the embryo is in the process of being introduced, which aims at assuring them certain protections from acts from which human beings benefit (for example, the protection against the possibility of being used as objects of sale in the normal sense of the term), without, however, conferring on them the first of the protections inscribed in human rights, namely, the right to life.

In this latter dispute, the product of conception was considered specifically in terms of its membership in the human species insofar as its fate concerned the "dignity of the human being" in its generality, and less often in terms of its status as a singular being, morphologically similar to the infant, as was most often the case in disputes over the question of abortion. Seized at this precarious moment in their evolution, weakly singularized, never having been carried by a woman, the frozen embryos and, in general, the subject of debates regarding biotechnology, represent the human species in its conceptual dimension, not human beings in their sensible dimension. In this case, the question of the usage of the visual is kept in the background of the controversy. For the moment, they are only represented by words.

In the course of this tumultuous history, the fetus has fully entered society, but in a fragmented and confused form. Leaving for a moment the constructivism of the scholars, it is necessary to turn to the constructivism of the everyday, according to which ordinary women and men now live in a world where the fetus is fully present but under labels that are diverse and contradictory. On the one hand, when the decision is made to "keep" the fetus, it is a familiar being, one offered to the senses, a lot closer to the child than it was fifty years ago; on the other hand, when the decision is made to abort it, *it* is a non-existent being ("a mass of cells"); finally, as the subject of bio-ethical debates – summaries of which everyone can read in their daily newspapers – the fetus is also a transcendental being with neither flesh nor singularity.

The development of a moral grammar founded on the recognition of a radical distinction between these different beings would not have been possible without the intense theoretical work of separation, of the construction of frontiers, and of categorization which we have witnessed over the last thirty years, and which is in the process of remodeling anthropology. In this work of re-categorization, the war of images has played a very important role. The fact remains, that at this time, it is impossible to say whether these categories will succeed in institutionalizing themselves to the point where one will no longer make the connection between the desired fetus (already introduced into the company of humans), the aborted fetus (nothing at all), and the technological fetus (a legal being without the right to life), or whether they will continue to experience a painful and conflicting relationship. At any rate, this relationship is surely one that can play itself out elsewhere than in books or on the street: it can also play itself out in the unconscious. |

Translated from French by Sarah Clift

OLD GLORY

Michael Taussig

LIKE THE BIBLE. sales of the American flag shot up after 11 September 2001. People in the US reflected more on the value of life, meaning largely their own, and on family. Many abruptly changed their travel plans, deciding to stay home, as the airline and other industries took advantage of the soaring patriotism to extract billions from the Bush government while no provision was made for the employees they fired. In the days after the attack, people in the fashion business suddenly declared their business was spiritually worthless. Instead, Old Glory had become fashion. The name is not without significance. Old Glory suggests the flag is venerable in the same way as a person. It is more than a symbol. It is animate and becomes more so in times of war; a state of iconic hypertrophy.

Upstate New York, where people are mostly poor (and white) and supply a lot of soldiers (and prison guards), the flag is everywhere. One old pick-up I see has a crude wooden frame as big as the truck itself nailed to the back as support for two giant flags that stream behind it. But most people are content to buy the little flags, twenty centimeters by ten that can be fixed to the back windows with plastic clips. Large flags are hung on the fronts of homes. Flag-making companies have run out of flags.

Like flowers in spring, American flags burst forth everywhere. But apart from this, nobody seems to have much of a handle on how to ritualize the event. Grieving is complicated for some people, Republican Party domestic political agendas become ascendant while the Democratic opposition says virtually nothing, smothered by the flag.

In Manhattan, during the week of the attack, I see people clapping for the police, the firemen, and the construction workers along the West Side highway, down at Christopher Street, and outside St. Vincent's hospital. They have American flags and crudely lettered cardboard signs saying "We Love You," and "The Bravest." There is a feeling of carnival in the air and the cars honk back. Foucault is famous for his idea of bio-power, that the modern state is dedicated not to punishment or violence but to life, that it practices a sort of manipulative altruism. Don't think of the hangman. Think of the fireman. An older wisdom than Foucault's has long maintained that war is the health of the state. A professor of history on National Public Radio says he is encouraged that this will put an end to criticism of the police in NYC. Dawn of a new era. The commonest site of the flag is the gas-guzzling SUV (suburban utility vehicle) truck, or van, and the commonest site on these vehicles to attach the flag is on the radio aerial down which the news travels. By New Year 2002 those flags look wind-torn and scraggly, no longer artificial but something organic, like moss or dried blood as if flag and automobile had fused into one transcendent unit.

The President urges us to pray. He is absorbing the enormous power of the dead whose spirits are otherwise uncontainable. He says this is the first war of the twenty-first century. Fighting terrorism will be the focus of his administration. "We will lead the world to victory," he says.

A strange sense of "imagined community" is being forged before our eyes and inside our psyches. What do you do if you don't feel part of it or feel repulsed by it? Susan Stanberg talks on National Public Radio of "the weapon of patriotism," in "disrepute the past decades," now bursting forth and you can hear the choking in her voice. She loves "these simple things" such as a flag and a song. The things "we" learned in grade school. I love her voice, the same way people love the flag. It is ineffable. It suggests so much, but can't be pinned down. We don't often hear her these days but in the early 1980s she *was* National Public Radio. There was no other.

By New Year's Day 2002 there are fewer flags, it seems to me, and they tend to be concentrated on large aggressive vehicles like SUVs vastly exceeding the speed limit or on beaten up cars desperately trying to look legal. Is this a sign of things to come in the War Against Terrorism?

Of all icons there can be few as powerful as a nation's flag, especially Old Glory, loved and reviled the world over. How many times have we seen photographs of people burning that flag in some exploited third world country blaming the US for its woes! However in the US, when the liberals held a slender majority in the Supreme Court in 1989, it was found that it was not a crime to burn the flag as a protest at the 1984 Republican Party National Convention in Dallas, thereby overruling the Texas court of criminal appeals which held that this amounted to "desecration of a venerated object."

Five out of nine of the justices declared that to deface the flag was to exercise freedom of symbolic speech enshrined in the Constitution. The flag is but a symbol of something far more important which includes the right to burn it as part of the exercise of free speech. Indeed, what could be more expressive of that right? But for Chief Justice Rhenquist, the flag cannot be so easily detached from what it signifies. For him, defacing the flag is a criminal act. For some people, this served merely to heighten the paradox; that which symbolized the Constitution, namely the flag, was not itself protected by the Constitution. In response, President George H.W. Bush, tried unsuccessfully to get another amendment to the Constitution to protect the flag.

Even before 11 September, the US was a flag-prone society. Rarely could you pass a gas station or a used car lot without seeing Old Glory. This was patently not desecration. What could be more patriotic than a gas station or a car? Which just goes to show that the dependence on oil is not lost on the automobile industry. Yet even my Cannondale bicycle made in Pennsylvania has an American flag painted on it just below the saddle. The restaurant in the town I go to two hours upstate has had an enormous flag draped over its ancient stone walls most of the year, for the past decade. But in the food coop, managed by peaceniks, in that same upstate town, there is no flag. "After 11 September we wanted to put up a dove as a sign of peace," one member told me, "but we were too scared of physical retaliation. So we put up nothing."

Like them I have no flag either and I wonder whether having nothing marks you even more than having something? Can nothing be an icon too?

© Michael Taussig

© Michael Taussig

Gregor Jansen

PAINTER EUGEN SCHÖNEBECK IS A LEGEND in German post-war art. His scant oeuvre was produced between the building of the Berlin Wall and the student protests, while his wrestling with the figure and his break with abstraction ended in the heroic, revolutionary portrait. Schönebeck is today considered to be one of the important representatives of "new figuration." Born in 1936, Schönebeck grew up in Dresden and began studying wall painting in East Berlin. Then, after one term, he moved in 1955 to the West where he painted in an abstract vein following the academic style. His friendship with Georg Kern (later Baselitz) led three months after the building of the Wall to an exhibition and manifesto, the legendary first "Pandämonium" succeeded in spring 1962 by the actual Pandämonium. The two students described their call for honest painting and cited poets such as Artaud or Lautreamont and painters such as Dossi, Wrubel, and Dado. The rebellious nature of the agitprop texts reflected the political dimension of art, which, as soon as it disappeared in one, emerged clearly in another. Schönebeck's paintings from this period, for instance *The Hanged Man*, already depict the isolated figure, a topic that went largely unnoticed at the time. In 1963 he developed maltreated figures reminiscent of animals, which, squashed as they are into the square-shaped canvas, suggest a senseless existence. He began to work on a series of crucifixes, in which a sense of accusation is discernible from a disembodied portrait recalling van Gogh, to an anonymous incarnation in front of Berlin's Kreuzberg district. Through *The True Human* (dated 1965), Schönebeck expressly confronted the observer with the figure, and via his study of Fernand Lèger and Jean Hèlion he arrived at a mechanically dismembered body.

His critique of the prevailing conditions in the interplay of political forces in Berlin is unique, since he combined the doctrine of artistic breaking away in the East with the liberty of painting in the West. In the division of the canvas into segments he was elaborating the wall painting he had executed as a student in East Berlin. And yet, as was already the case in *The True Human*, he placed cross-like barriers in front of the subjects' faces in the head-and-shoulders portraits. The barriers restrict the figure, and create a distance to the subject. The portraits *Lenin, Mayakovsky,* and *Mao Zedong*, but also the *Red Army Soldier* (all produced in 1965), are a combination of the standardized model of a propagandistic message with the artistic reproduction struggling for identity. Those portraits executed in the final year of his accessible works, namely of the Mexican painter Siqueiros, the Russian author Pastemak, and Jewtuschenko round out his gallery of heroic persons. The revolutionary leaders, painters, and literary men, symbols of a new society, were depicted in abstract blobs of pigment, which knit to form a portrait on closer inspection. It would have been possible to transfer them to walls or banners, but this remained a utopian idea. Although the link to his days as a student in East Berlin is evident – the propaganda machinery had produced pictures of this nature since Stalin's time – the personally formulated portraits as wafting banners of the coming students' revolution were not related to any political system, and like Schönebeck were located in the no-man's land of protest. Painting had come to the end of the road – and rigorous as he was, Schönebeck ended his own creative work in 1967! Students and the revolution were opposed to paintings, favoring photos of Che Guevara, whom Schönebeck could not paint, as he did not consider the latter to be an intellectual. Or photos of Mao, whose "red bible" was to thrill the masses.

Even Trotsky, whom he painted in 1966, believed the artistic avant-garde was reconcilable with Lenin's concept of revolution, as all three – including the artist – believed in the aggressive theory of the elite. Yet it was not the protesting students that proved Schönebeck's paintings doomed to failure, seeing his banners as provocation only, and believing in the success of the theories alone – after all, the starting point for Schönebeck's manifestos had been the same. Provocation came in the form of an image, yet the student rebellion opposed such images. The new scepter of power lay in the hands of the culture industry;

Eugen Schönebeck / Mao Tse Tung / 1965 / oil on canvas / 86.6 x 73" /
Collection Frieder Burda / © VG Bild-Kunst, Bonn 2002

as such, when he talked of "leftist fascism" Jürgen Habermas bewildered the students on a superficial level only; on a deeper level, he referred to their own lack of political identity. The end of utopia marked the start of post-modernism. Schönebeck must have already come to this sad conclusion when he fell silent, and no longer made his painting available to the public in the spirit of a new society. Ingmar Bergmann's *Silence* fell victim to a similar level of censure, and both degenerated into an idyl which is provided new fodder by the paintings. And although the revolt in art promised death once again: "L'art est mort, ne consommez pas son cadavre," (art is dead, do not consume its corpse), precisely the time after 1967 represented a kind of new start, but one in which the 31-year old Schönebeck did not wish to take part.

What had begun was the phase of the affluent society, of lifestyle marketing, in the final analysis the fusion of counterculture and culture industry, first for economic reasons, later for purely commercial ones. Schönebeck must have surmised how "tasteful" and bloodless the coming time would be, prompting him to paint the Mao in front of a cross. Mao, the poet who "let a thousand roses bloom" and at whose media temples we – the children of Marx and Coca-Cola as Goddard describes us – see our children drool. But even at that time, and certainly later in the case of Warhol's *Mao* (1974), media response and political effect were confused. At any rate in a divided Germany, what Eugen Schönebeck presented was (above all in its reception) paradoxically iconoclastic and iconophilic, and moved him to finish painting in 1967. And somehow the revolution never came about.

Translated from German by Jeremy Gaines

LE STATUAIRE ET LA STATUE DE JUPITER

Un bloc de marbre était si beau
Qu'un statuaire en fit l'emplette.
»Qu'en fera, dit-il, mon ciseau?
Sera-t-il dieu, table ou cuvette?

Il sera dieu: même si je veux
Qu'il ait en sa main un tonnerre.
Tremblez, humains! faites des voeux:
Voilà le maître de la terre.«

L'artisan exprima si bien
Le caractère de l'idole,
Qu'on trouva qu'il ne manquait rien
A Jupiter que la parole.

Même l'on dit que l'ouvrier
Eut à peine achevé l'image,
Qu'on le vit frémir le premier,
Et redouter son propre ouvrage.

A la faiblesse du sculpteur
Le poète autrefois n'en dut guère,
Des dieux dont il fut l'inventeur
Craignant la haine et la colère.

Il était enfant en ceci;
Les enfants n'ont l'âme occupée
Que du continuel souci
Qu'on ne fâche point leur poupée.

Le coeur suit aisément l'esprit:
De cette source est descendue
L'erreur païenne, qui se vit
Chez tant de peuples répandue.

Ils embrassaient violemment
Les intérêts de leur chimère:
Pygmalion devint amant
De la Vénus dont il fut père.

Chacun tourne en réalités,
Autant qu'il peut, ses propres songes:
L'homme est de glace aux vérités;
Il est de feu pour les mensonges. ||

JEAN DE LAFONTAINE

Why are images so ambiguous?

IMAGE TO DESTROY, INDESTRUCTIBLE IMAGE

Dario Gamboni

I ONCE TRIED TO EXPRESS THE MUTUAL DEPENDENCE of iconoclasm and iconophily by saying that in the domain of cultural heritage, elimination is the other side of preservation, and that the history of iconoclasm accompanies that of art like a shadow, bearing witness to its substance and weight.[1] This exhibition shows that the two are not only inseparable but also sometimes indistinguishable. Attempts to get rid of a specific image or of images at large almost invariably lead to a proliferation of new images. The gesture of aggression itself, in retrospect or seen from a different perspective, can reveal itself to be a gesture of reverence – and vice versa.

This ambiguity was wittingly exploited in 1895 by an anonymous Argentinean caricaturist.[2] A painting exhibited at the Salón del Ateneo in Buenos Aires illustrated the miraculous origin of the sanctuary of Nuestra Señora de Luján: gauchos and peasants are shown praying before the statue of the Virgin which, while being transported, has manifested its will to remain and be worshiped on this spot. In the cartoon, a few of them, labeled "atheists," are threatening the statue with their clubs and a raised fist. One could argue that the cartoonist has merely taken advantage of the relative ambiguity of the

figures' gestures and attitudes to mock a superstitious legend or its choice as subject matter for a genre picture claiming the status of historical painting. But the irony goes deeper. The statue of the story is an active object that imposes its will upon the humans who are carrying it. The naturalist idiom of the painting, however, fails to convey this potency, and thus enables the caricature to revert to a rationalist distribution of agency: the humans are about to smash a piece of inanimate matter.

Jasper Johns brilliantly incorporated a comparable ambivalence within a single work of art in his 1961 *Painting Bitten by a Man*. The painting shows the imprint of a human mouth and teeth. It appears therefore to have been attacked and, in relation to other works by the artist depicting art critics as predators, one can interpret this attack as a metaphor of the spectator's gaze. The picture is here an innocent and impotent victim, unable to defend itself against the consumption to which it is destined. However, since the work is not in a vandalized state and the title is original, a suspicion must arise: whose teeth are these? Most probably the painter's, who at the very least anticipated the spectator's predatory gaze and

Augusto Ballerini / Miraculous Origin of Our Lady of Luján in the year 1630 / 1895 / oil on canvas / 25.8 x 40" / Museo Nacional de Bellas Artes, Buenos Aires

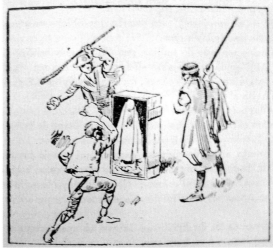

Anonymous / The Atheists / caricature after Ballerini's »Miraculous Origin of Our Lady of Luján« / published in Buenos Aires, 30, 27 October 1895

2 1

_ I thank Laura Malosetti Costa for having brought these images to my attention.

_ Dario Gamboni, *The Destruction of Art: Iconoclasm and Vandalism since the French Revolution*, Reaktion Books/Yale University Press, New Haven and London, 1997, p. 336. I allow myself to refer the reader to this book for bibliographic references and further details about many of the cases and problems discussed in this essay. The following notes will be essentially restricted to the sources of quotations.

of its plot is most revealing. The scene in which Rowan Atkinson destroys James McNeill Whistler's *Arrangement in Grey and Black: Portrait of the Painter's Mother* (1871, Musée d' Orsay, Paris) belongs to the tradition of slapstick comedy, in which objects refuse to obey humans and hold them up to ridicule. Bean, merely interested in the picture's frame, removes dust from it, then sneezes, and irreparably ruins the painting by trying to undo each step of the escalation. His consummate awkwardness is matched by an exhilarating skill in the scene where he doctors a reproduction to substitute it for the original. The painting is exhibited in such a way and to such an audience that no one notices that it is a replacement, and Bean's unintentional assault shows no less respect than the unashamed political and commercial exploitation of "Whistler's Mother" by its new Californian owners. The original, on which Bean has drawn a new, grotesque head, eventually finds its way into his private home.

Ambiguity and ambivalence, however, are not identity, and the recurrence of several traits in phenomena separated by time and place does not mean that there exists a timeless grammar of iconoclasm and iconophily. What follows is clearly predicated upon the gradual emergence in the West, from the Renaissance and especially the eighteenth century onwards, of a specific domain of art, distinct and independent from religion, politics, and science. Major iconoclastic episodes like those of the Reformation, the French Revolution, and the Third Reich, contributed to the exclusion from the

made it a condition of the painting's completion. Only through this mark does the relatively undifferentiated surface come alive, animated by the capacity to have triggered someone to bite into it *à pleine pâte*.

A third and last example brings us into the realm of popular culture and the museum industry. No one seems to have taken Mel Smith's 1997 long-feature film *Bean* seriously, but the choice and treatment of iconoclasm as the key element

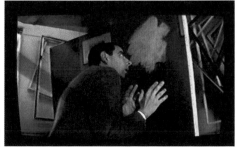
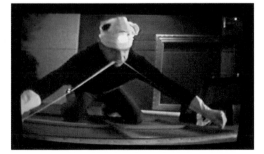

Bean / director: Mel Smith / 1997 / color / 90 min /
film stills / title role: Rowan Atkinson / © PolyGram

realm of art of images fulfilling extrinsic functions, prone to be attacked because of these functions, while damaging or destroying a work of art as such was deemed uncivilized. The Argentinean caricature showed that painting could not claim to manifest the sacred or to edify its public any more, and the iconoclast Bean could only be a clown. On the other hand, the ideology of progress saw the *tabula rasa* as a prerequisite for the construction of a new purified world. In art, the criticism

Chludov Psalter / mid-nineteenth century / cod. 129. fol. 67 / comparison of the effacement of an image of Christ with the Crucifixion / State Historical Museum, Chludar Collection, Moscow

of tradition and conventions led to the metaphorical "iconoclasm" of the avant-garde, which became a tradition in its own right while prompting an anti-modernist "vandalism" acting in the name of art. Who has bitten John's painting, the artist in revolt against his inherited medium, or the spectator outraged by one more monochrome? Finally, the growing importance of the uniqueness of the work of art as a material object, the visibility of its value and the measures taken to protect it have increased the tension between the desire to appropriate it and the interest of its preservation – a tension that Bean can again illustrate.

The following essay examines the ambivalence of iconoclasm and iconophily in this chronological frame and in relation to specific parts of the present exhibition, focusing on representations of iconoclasm, the fate of political monuments (especially those from Communist regimes after 1989) and the relationship between avant-garde „iconoclasm" and "vandalism." I will then discuss the typology proposed by Bruno Latour and turn to the issue of representation in nineteenth and twentieth century art in connection with religion and science.

Representations of Iconoclasm

Images of iconoclasm are always reflections upon it. They propose an interpretation of iconoclastic actions, attribute motives to their perpetrators, and more or less explicitly pass judgment on them. Since the authors of such representations tend to be professionally involved in the production of images or works of art, one is not surprised to find out that they often take sides against iconoclasm. But this is not always the case: the authors may have been converted to iconoclasm, or they may belong to a different party or category than the craftspeople or artists under attack. In any case, their visual statements arise from a situation of crisis and contribute to a controversy.

Erhard Schön / Klagrede der verfolgten Götzen und Tempelbilder
[Complaint of the Persecuted Idols and Temple Images] / c. 1530 / woodcut / 5 x 14" / Germanisches Nationalmuseum, Nuremberg

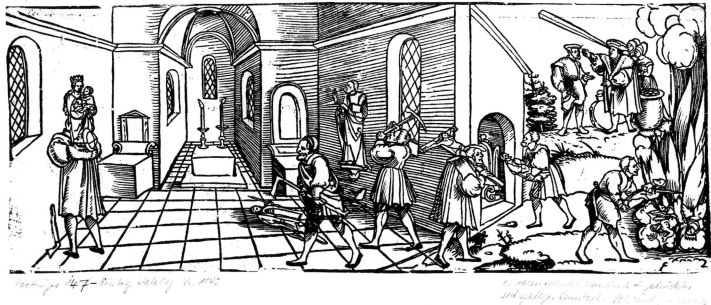

At the end of the eighth to mid-ninth century Byzantine "Quarrel of the Images," the illuminator of the Chludov Psalter compared the effacement of a painted image of Christ by means of a sponge with the Crucifixion itself. The iconoclasts, whose arguments we know only through those of their victorious opponents, did not mean to attack Christ through his images. But they objected to the cult use of images, as well as to the wealth and power that the Church derived from them, and they criticized the equation of image and prototype that this illumination precisely suggests.[3] During the Reformation, in which it is the iconoclasts who won, a pamphlet defended the images in an opposite way, by showing them as innocent and powerless productions of man. In the pamphlet's text, the images complain that they are being attacked by the same people who had turned them into idols in the first place. The engraving, by Erhard Schön, compares the destruction of church paintings and statues with the Biblical parable (represented in the upper right corner) in which a man objects to

3

the straw in his neighbor's eye but is unaware of the beam in his own. Schön adopts Luther's stance, according to which the images are neither good nor bad in themselves but depend on the use to which they are put and the words employed to interpret them. It is a position described by Werner Hofmann

E. Le Sueur / Vandalist. Destroyer of the Productions of the Arts / c. 1806 / gouache / 14 x 21" / Musée Carnavalet, Paris / © Musées de la ville de Paris by SPADEM

_ Jean Wirth, Soll man Bilder anbeten? Theorien zum Bilderkult bis zum Konzil von Trient, in *Bildersturm: Wahnsinn oder Gottes Wille?*, Cécile Dupeux, Peter Jezler and Jean Wirth (eds), exhib. cat. Bernisches Historisches Museum, Bern, Musée de l'Œuvre Notre-Dame, Strasbourg, NZZ Buch-Verlag, Zurich, 2000, pp. 28-37.

H. Baron / The Breaker of Images / etched on steel by L. Massard / 6 x 4" /
in Augustin Challamel and Wilhelm Ténint, »Les Français sous la Révolution«, Paris, 1843 /
private collection

Francisco de Goya / No sabe lo que hace [He doesn't
Know What He's Doing] / c. 1814–17 / brush, gray and
black wash / 10.6 x 7" / Staatliche Museen zu Berlin –
Preußischer Kulturbesitz, Kupferstichkabinett /
© photo: Jörg P. Anders

as liberating art and founding the modern aesthetics of the beholder[4] – and one can indeed compare the beam projecting from the rich man's eye with the mouth carved into Jasper Johns's painting.

During the French Revolution, coats of arms, statues, paintings, monuments, and buildings came under attack as symbols and instruments of the patrons who had commissioned them and whom they directly or indirectly represented: the king, the nobility, and the Church. They were first assaulted as surrogate targets, then in order to visualize the fall of the Ancien Régime, after which the remaining ones tended to be perceived as an "offense" to "republican eyes." Their defenders had to reinterpret them as historical monuments and works of art, essential to the identity of the nation and of mankind. They created the notion of cultural heritage and coined the terms "vandal" and "vandalism" to exclude those who continued to attack such objects from the civilized community and to banish their actions from the domain of enlightened, rational behavior. Le Sueur's *vandaliste*, desultorily leaning against the statue he has broken, looks relatively meek but is labeled a "destroyer of the productions of the Arts." In Lafontaine's drawing, the heroic gesture of Alexandre Lenoir – creator of the Musée des Monuments Français – in an attempt to protect the royal tombs of Saint-Denis is contrasted with the confused fury of the *sans-culottes*, who are ready to turn their hammers against him. This image remained attached to the Revolution and in an engraving published under the July monarchy, the gross appearance of a "breaker of images" and the feminine, politically inoffensive character of the sculpture he is about to deface present revolutionary "vandalism" as a sort of rape, a revolt of the lowly against beauty rather than tyranny. The art historian Louis Réau would extend this view to the interpretation of any damage done to art, defining vandalism as "Caliban's revenge," writing: "Inferior beings, conscious of their inferiority, instinctively hate all that exceeds them."[5]

A more profound view is expressed in a drawing by Goya. The man holding a pickaxe and pointing to the bust he has just smashed is balanced precariously on a ladder with his eyes shut. The inscription makes the meaning of this pose clear: "He doesn't know what he's doing." The drawing alludes perhaps to the anti-parliamentary violence that took place in Madrid on Ferdinando VII's return from France in 1814, and Goya may imply that those who participated in these events were acting blindly and didn't understand they were hurting themselves. But his use of iconoclasm as a

P.-J. Lafontaine / Alexandre Lenoir Opposing the Destruction of the Royal Tombs in the Church of St Denis / 1793 / drawing / 9 x 8" / Musée Carnavalet, Paris / © Musées de la ville de Paris by SPADEM

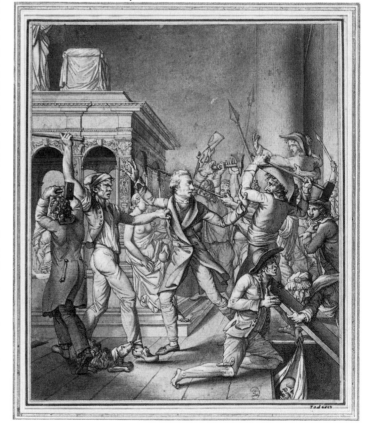

4

_ Werner Hofmann, Die Geburt der Moderne aus dem Geist der Religion, in *Luther und die Folgen für die Kunst*, W. Hofmann (ed.), exhib. cat. Hamburger Kunsthalle, Prestel, Munich, 1983, pp. 46-51.

5

_ Louis Réau, *Histoire du vandalisme. Les monuments détruits de l'art français*, Robert Laffont, Paris, 1994 (first edition 1959), p. 14 ("Les êtres inférieurs, et qui ont conscience de leur infériorité, haissent instinctivement tout ce qui les dépasse.")

Sergio von Helder beating a statue of Nossa Senhora Aparecida on television (Recording). 12 October 1995

political metaphor is telling, and in its visual complexity and effectiveness, the drawing goes beyond the occasion of its creation and raises some of the central questions of our exhibition: does the iconoclast's weapon rebound and make him fall on the ground like his victim? Shouldn't he open his eyes and suspend the gesture of destruction?

A consensus was progressively built in the West around the condemnation of "vandalism" that Réau expressed in his brutally revealing way. It is typical of its logic that the same term was used to refer to attacks against works of art and to apparently unmotivated damage caused to any kind of public or private property: as a poster glued in the Berlin buses argued in 1992: "One can be of different opinions about art and taste, not about vandalism." However, as far as art and cultural heritage are concerned, a certain amount of unease and dissent never totally disappeared, fed by spectacular increases in financial value and physical protection. The attribution of resources to their preservation could be resented as an expression of materialism and passé-ism, privileging objects over human life, tradition over living experience. This is a point that a cartoonist made during World War I, describing as an "ante-bellum tragedy" the condemnation of a young boy for breathing on the glass of a show-case containing Egyptian mummies in the British Museum; released after a life of hard labor, he blows his last breath on the same show-case

and is found dead by an indignant guard. It can be argued that among the many factors involved in the Taliban's destruction of the Bamiyan Buddhas in 2001 was the importance of the statues as part of the "world heritage" for the international community, which had refused to politically recognize the Taliban. In addition to the iconoclastic argument that the statues were "mere stones," they did not fail to contrast the outrage provoked by the destruction with an alleged lack of international concern about the plight of the Afghan population.[6]

The Fate of Political Monuments

The argument that the Taliban put forward, nevertheless, was a fundamentalist interpretation of Islam. Religious motives do play a role in some recent iconoclastic episodes, like the bizarre assault on the patron saint of Brazil, Nossa Senhora Aparecida, performed on television in 1995 by a minister of the Universal Church of the Reign of God, a controversial Protestant sect, or the more sinister destruction by Hindu militants of the Babri Mosque in 1992, after which a week of rioting followed in which over a thousand people died in India. But more than ever, these motives are combined with political and economic ones, especially given the importance of "ethnic" identity issues in recent conflicts. In more secularized societies, the importance of religious iconoclasm has declined together with that of religious art, and aesthetic considerations have also come to the fore in this domain.

The growing autonomy of art weakened the position of genres such as church art, which remained dependent on commission, function, audience, and was submitted to the control of ecclesiastical authority.[7] In the course of the twentieth century, the modernization of taste and liturgy led to the elimination of nineteenth century realizations, considered guilty of historicism, academicism, and industrialization. On the other hand, attempts at reconciling the Church with artistic modernity and with the expression of contemporary tragedies,

6 7

Henry Mayo Bateman / The Boy who Breathed on the Glass in the British Museum / 1916 / drawing from Punch / reprinted in Bateman, A Book of Drawings, New York, 1921

THE BOY WHO BREATHED ON THE GLASS IN THE BRITISH MUSEUM
AN ANTE-BELLUM TRAGEDY

_ See the contributions by Pierre Centlivres and Jean-Michel Frodon in the present catalog, as well as Dario Gamboni, World Heritage: Shield or Target?, in *Conservation: The Getty Conservation Institute Newsletter*, 16, 2, 2001, pp. 5-11.

_ Olivier Christin and Dario Gamboni (eds), *Crises de l'image religieuse / Krisen religiöser Kunst*, Editions de la Maison des Sciences de l'Homme, Paris, 2000.

On ne se moque pas de Dieu [One Doesn't Mock God!] /
pamphlet / issued in Angers / 1951 / reproduced in L'Art Sacré, 9-10 May-June 1952
left: Germaine Richier / Christ de l'Autel [The Christ of Assy] / crucifix for the main altar of
the church of Assy / 1950 / bronze / height 73"

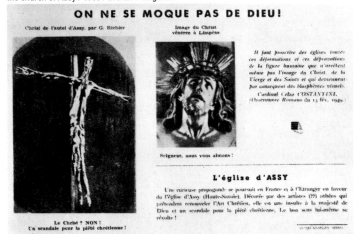

for example by relating the sacrifice of Christ to the sufferings caused by World War II, were attacked as sacrilegious and iconoclastic by those who equated the traditional forms of religious art with faith itself. These controversies were sometimes defined as a new "Quarrel of Images," although they had more to do with the form of images than with the principle of their use. But the difficulty of reaching a consensus on representations did lead to the adoption of aniconic solutions

Johann Martin Will / The Demolition of the Bastille, 14 July 1789, Paris /
1789 / engraving / 14 x18.6" / Heeresgeschichtliches Museum, Vienna /
© photo: Heeresgeschichtliches Museum, Vienna

such as abstract art and an often destructive "purification" of churches supported by the Second Vatican Council.

The French Revolution shows very well how the elimination of material symbols tends to be accompanied by a proliferation of new ones. The demolition of the Bastille was advertised as the destruction of a "symbol of despotism" all over Europe. The private entrepreneur in charge of it even produced profane relics representing the fortress, allegedly out of bits of the walls, to commemorate its fall. The troubled times that followed did not allow the more ambitious plans for the erection of symbols of the Revolution to be realized. As in the case of church art, the artistic status of political commissions decreased, while attacks against monuments tended to lose all political legitimacy, particularly when they came "from below." On 16 May 1871, the Colonne Vendôme was pulled down by the Paris Commune as a "symbol of tyranny and militarism," possibly also as a substitute for military victories in its struggle with the Versailles government. The column had been made from the bronze of German cannons, erected by Napoleon I on the site previously occupied by a royal statue, and refurnished with an effigy of the Emperor by his nephew Napoleon III. Photographs by Bruno Braquehais convey a sense of the collective emotions at stake. Courbet, who had pleaded earlier for the "screwing off" of the column, was condemned by the government of the Third Republic to pay for its reconstruction. Caricaturists tended to relate the episode with the painter's public persona and his work, for instance by borrowing an iconoclast's hammer from his 1849 *The Stone Breakers*. But Courbet himself argued that the monument was of low aesthetic value and although he was repeatedly hailed as an anti-traditionalist "iconoclast" in art, no one proposed to see in a positive light the responsibility he may have had in this literal destruction.

This evolution led Martin Warnke to conclude in 1973, in his introduction to a collection of essays on the history of iconoclasm, that it was a thing of the past and could only

Demolition of the Christoffel Tower in Berne, spring 1865 / albumin paper photography / 9 x 6.6" / Burgerbibliothek Berne / © photo: Burgerbibliothek Berne

Demolition of the Christoffel Tower in Berne / albumin paper photography / Bernisches Historisches Museum, Berne / © photo: Stefan Rebsamen, Bernisches Historisches Museum, Berne

Christoffel Tower in Berne / c. 1860-1865 / photography, black-and-white / Bernisches Historisches Museum, Berne / © photo: Stefan Rebsamen, Bernisches Historisches Museum, Berne

Fichot / Berne seen from the Goliath Tower / c. 1860 / lithography / 20 x 26" / Bernisches Historisches Museum, Berne / © photo: Stefan Rebsamen, Bernisches Historisches Museum, Berne

Feet of the Christoffel figure / 1498 / fragment of the figure once placed at the Christoffel Tower, Berne / 13 x 22 x 27" (right foot), 14 x 20 x 30" (left foot) / Bernisches Historisches Museum, Berne / © photo: Stefan Rebsamen, Bernisches Historisches Museum, Berne

survive in the Third World.[8] But this view was challenged when, with the crumbling of the Communist regimes in Central and Eastern Europe, the monuments erected under their rule came under attack. The coincidence of the fall of the Berlin Wall with the 200th anniversary of the French Revolution made a comparison inevitable. Like the Bastille, the Wall was destroyed (almost) entirely, although in a less organized fashion, and it was turned more systematically into relics and souvenirs. Images of the removal or destruction of monuments proved the most dramatic and efficient visual-

ization of the political transformations of which they were a part, and it has been argued that in some cases at least, their appeal for the mass media was one of the reasons why they took place.

To a large extent, this late twentieth century iconoclastic wave derived from the role that the personality cult and visual propaganda had played in the Soviet Union and its zone of influence. Far from the relative autonomy – and, according to some critics, irrelevance – that it enjoyed in the West, the art of "Socialist Realism" had been subjected to strict controls

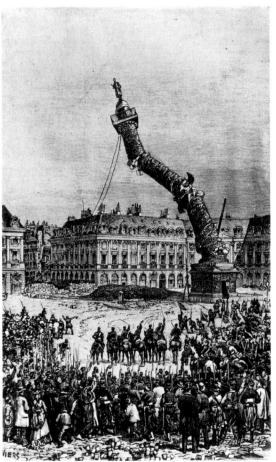

D. Vierge / The Fall of the Vendôme Column, Paris 16 May 1871 / wood engraving by F. Méaulle / 8 x 5" / published in Victor Hugo, L' année terrible, Paris, 1874

8

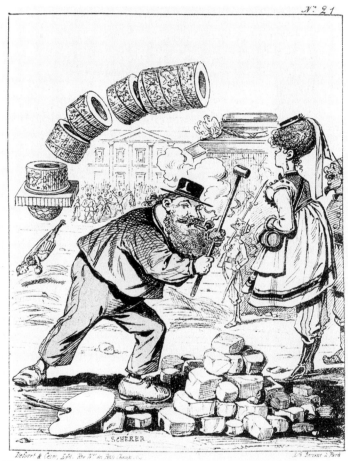

Léonce Schérer / cartoon / from Souvenirs de la Commune, 4 August 1871 / reprinted in Charles Léger, Courbet selon les caricatures et les images, Paris, 1920, p. 101

_ Martin Warnke, Bilderstürme, in *Bildersturm: Die Zerstörung des Kunstwerks*, M. Warnke (ed.), Syndikat, Frankfurt/M., 1977, pp. 7-13.

Demolition of a portion of the Berlin wall after 9 November 1989 /
© photo: Pavel Sima, courtesy Skowronski & Szelinski Verlag, Berlin

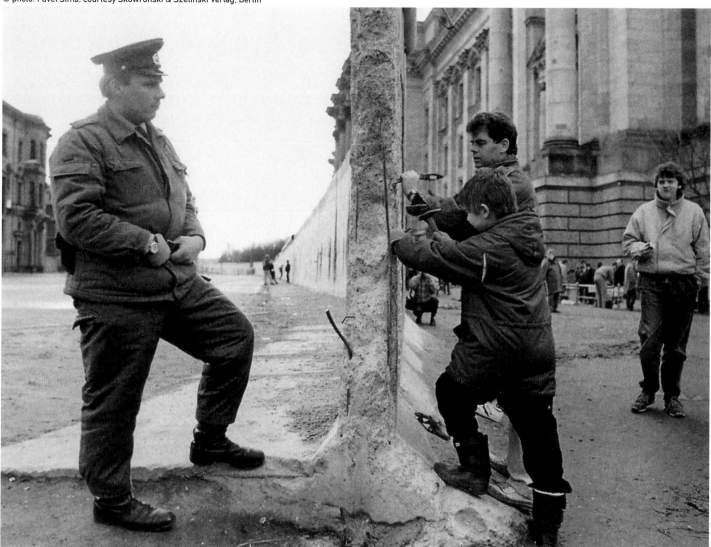

Fragments of the Berlin Wall sold as souvenirs at the
Mauermuseum Haus am Checkpoint Charlie, Berlin / 1992 /
© photo: Dario Gamboni

as a means of mass communication and it was a crucial part of the political fabric. The French cartoonist Serguei took advantage of this when he compared Mikhail Gorbachev's admission that the Soviet federation was a myth with a self-defeating act of iconoclasm in which the cracks inflicted upon the "superstructure" extend into the "infrastructure." A few weeks later, the First Secretary of the Communist Party had to sign a decree "on stopping the defacing of monuments that are linked to the state and its symbols."

Some removals or destructions of monuments happened more or less spontaneously, as had been the case in 1956 in Budapest when the Revolution began with the pulling down of the statue of Stalin. Some received the half-hearted support of transitional authorities, and others were entirely planned and executed "from above" like the laborious removal of the most important Communist statue in Berlin – Nicolai Tomsky's 1970 monument to Lenin. The controversies surrounding its fate and the wealth of images it generated are good examples of the dynamics of iconoclasm. Opponents to the removal protested against the "violence" and argued that it amounted to a "cleansing action against dissenters" and an "elimination

The End of Communism – And Now? / Die Zeit, 29 December 1989

„Ende des Kommunismus — und was nun?"

of history." After it was over, Lenin Square – renamed United Nations Square – became a sort of mourning place for the lost monument, its memory kept alive by stencil silhouettes and inscriptions denouncing the "iconoclasts" sprayed on the empty pedestal. Small posters were glued to the poles that used to carry flags, carrying pictures of the statue, which, in their turn, became targets of attack.

Serguei / cartoon / published in Le Monde, 21 September 1990

Preparations for the removal from its pedestal of Sándor Mikus's 1950-51 Stalin Monument, Budapest / 23 October 1956 / © photo: Horus Archívum, Budapest

While curators of monuments warned that the removal of the Lenin monument would provoke a visual collapse of the square for which it had been designed, no one defended it as a work of art. The elimination of Socialist Realism from public view was often justified with the argument that it had been a "non-art" exerting a "daily deformation of taste."[9] Given the development of the idea of the autonomy of art since the French Revolution, the reinterpretation of Communist monuments (and paintings) in terms of artistic and even historical heritage proved more difficult than it had been for those of the Ancien Régime. Musealization has been relatively slow and limited. "Statue parks" have been created in several cities, in order to remove monuments from their usual, often central locations, and to allow their preservation and a possible relocation. Revealingly, they sometimes display statues in a lying position or in a damaged state, as if to commemorate their fall and make clear that they are meant to document an

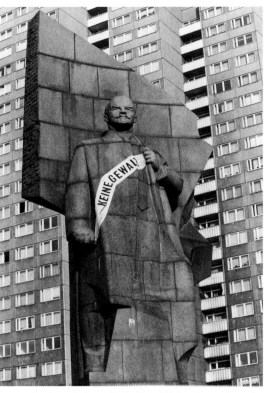

Nicolai Tomsky / Lenin monument / 1970 / with inscription protesting against its imminent removal / Leninplatz, Berlin-Friedrichshain, 1991 / © photo: Landes-bildstelle Berlin

Platz der Vereinten Nationen, Berlin [United Nations Square, formerly the Leninplatz] / July 1992 / with two sprayed stencil silhouettes of Tomsky's Lenin monument and of the Television Tower / © photo: Dario Gamboni

Platz der Vereinten Nationen, Berlin [United Nations Square, formerly the Leninplatz] / July 1992 / with the edge of the plinth of Tomsky's Lenin monument carrying the inscription »Against Iconoclasts« / © photo: Dario Gamboni

9

_ Paul Stoop, Die lästigen Zeugnisse. Kontroverse Debatte um die Denkmäler im Osten Berlins, in *Der Tagesspiegel*, 27 October 1990.

Platz der Vereinten Nationen, Berlin [United Nations Square, formerly the Leninplatz] / July 1992 / with a poster carrying a damaged picture of Tomsky's Lenin monument pasted on a pole / © photo: Dario Gamboni

under the title *Die Endlichkeit der Freiheit* with a temporary projection transforming Tomsky's Lenin into a Polish shopper equipped with a cart filled with cheap electronic products. Caricatures offered another possibility of appropriating monuments without actually touching them. A favorite target was Vera Mukhina's sculpture *The Worker and the Collective-Farm Woman*, realized to crown the Soviet Pavilion in the Paris World Exhibition of 1937 transformed for example in 1992 into an updated and disillusioned image of the state of the country. In 1993, the Russian expatriate artists Komar and Melamid presented an exhibition in New York and Moscow entitled *Monumental Propaganda* which intended to oppose the elimination of monuments as the latest instance of the "recurrent obliteration of Russian history." Among the entries was another transformation of Mukhina's statue by the American cartoonist Art Spiegelman, which, by a slight displacement, turned the heroic progress of the figures into an imminent fall. Komar and Melamid's own proposal consisted of "lifting a statue by hydraulic cranes, as if to remove it, but then leave it hanging in the air, ambiguously arresting the moment of dismantlement and extending it into eternal retribution."[10]

This project, which has been realized for the present exhibition, embodies its wish to suspend the iconoclastic gesture. Lifted from its pedestal, the hanging statue is shown to have lost its power over the spectators, but it is preserved and, by remaining present, can be remembered and submitted to scrutiny, instead of being replaced by a new "idol." This corresponds to Komar and Melamid's analysis of the link between iconoclasm and iconolatry in Russian politics: "This is classic old Moscow technique, either worship or destroy. Bolsheviks topple czar monuments, Stalin erases old Bolsheviks, Krushchev tears down Stalin, Brezhnev tears down Krushchev, and now this."[11] The suspended statue suggests a way out of this cyclical repetition by the very ambiguity of its situation: it can refer to the moment of its erection as well as to that of its removal, while preventing the completion of either.

era and not to be revered. Separated from their original context and function, the statues become available, ready to be turned into spectacular pictures by foreign photographers or mockingly imitated by local teenagers.

Less direct forms of "neutralization" and appropriation have also been attempted. Inscriptions or objects were added to modify the message of monuments, to comment on them or put them between sorts of visual quotation marks. In 1990, the Polish-born Canadian artist Krzysztof Wodiczko contributed to an exhibition of contemporary art organized in Berlin

11

10

_ Komar et Melamid, What Is to Be Done with Monumental Propaganda?, in *Artforum*, 30, May 1992, pp. 102-103.

_ Vitaly Komar quoted in Lawrence Wechsler, Slight Modifications, in *The New Yorker*, 12 July 1993, pp. 59-65.

Open Air Museum of Socialist Realism, Moscow / 1996 / © photo: Michel Melot, Paris

Interviewed in the film *Disgraced Monuments* realized in 1993 by Mark Lewis and Laura Mulvey, the Russian art critic Viktor Misiano similarly stated that at the end of the failed coup, on 22 August 1991, the crowd gathered in Moscow on Dzerzhinsky Square in front of the KGB headquarters would have been content with playful, provisional abuses of the monument to the founder of the Bolshevik secret police, and that the removal of the statue authorized by the mayor Gavril Popov had signified the end of the "performance" and the start of the "mechanism of history." The interpretation of Russian history as a mechanical succession of phases of worship and destruction was brilliantly presented in the pavilion of the Russian Federation at the Venice Biennale in 1995 by means of a film using archive material shown in a loop. The video starts with the inauguration by the clergy of the monument to

Szobórpark [Statue Park], Budapest / 17 April 1995 / © photo: Dario Gamboni

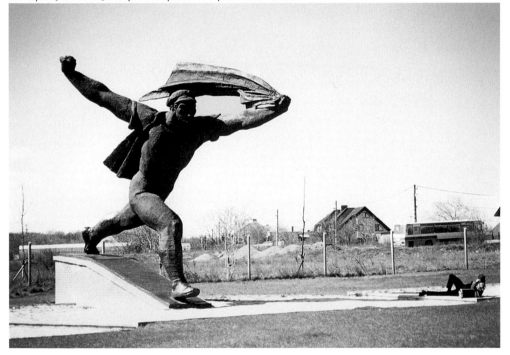

Szobórpark [Statue Park], Budapest / 17 April 1995 / with a young visitor imitating the figures of the monument to the International Brigades by Makrisz Agamemnon (1968) / © photo: Dario Gamboni

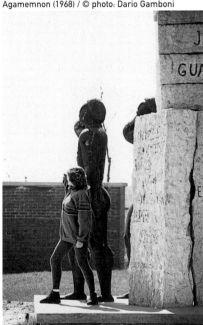

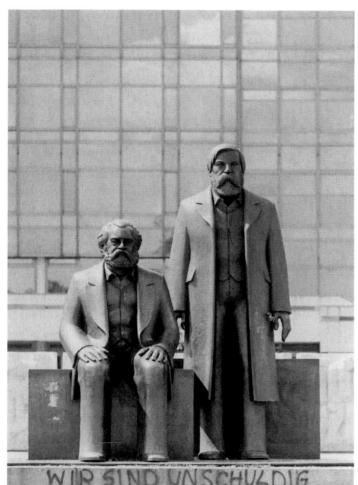

»We Are Innocent« / inscription on the central pedestal of Ludwig
Engelhardt's 1977-86 statue of Marx and Engels / Marx-Engels-Forum,
Berlin / 12 May 1991 / © photo: Landesbildstelle Berlin

Vera Mukhina / The Worker and the Collective-Farm Woman / 1937 /
chrome-nickel steel / Moscow / from Vladimir Kemerar, The USSR Academy of Arts,
Leningrad, 1982 / © photo: Louise-Marie Fitsch

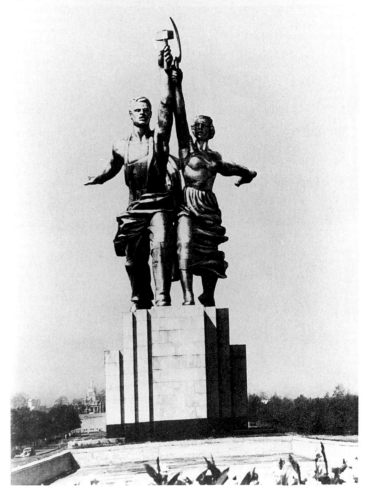

A. Chabanov / cartoon / in Izvestia, 1992

Art Spiegelman / One Step Forward, Two Steps Back (After) / 1992 / photocopy, color / 11 x 8.5"

Vitaly Komar and Alexander Melamid / Project for the modification of a monument from the Communist era / 1999 / computer-assisted drawing / 11 x 8.5" / private collection

Alexander III in front of the church of Christ-the-Saviour in Moscow, proceeds with the toppling of the statue in 1923, the blowing up of the church in 1931, projects for the gigantic Palace of the Soviets crowned by a statue meant to replace the church, the Moskva swimming-pool built instead, then its closure, and ends up with the inauguration by priests and politicians in 1994 of the substructure for the replica of the church (since completed), at which point the film starts again and makes us wonder who is the next czar.

Progress, Avant-gardism and »Iconoclasm«

David's rebellious pupils seem to have been the first artists to define iconoclasm as a condition for the renewal of art and to call for the burning down of museums at the very beginning of the nineteenth century, when museums were still a new institution. In 1851, the philosopher Proudhon suggested "for our own most rapid regeneration" to throw to the flames not only museums but "cathedrals, palaces, salons, boudoirs, with all their furniture, ancient and modern," and to forbid artists to practice their art for fifty years: "Once the past was forgotten, we would do something."[12]

This was in his *Philosophie du progrès*, and the link between the *tabula rasa* ideal and the notion of progress is obvious. It is particularly clear in architecture and city planning, where modernization has been (and remains) extremely destructive. Technical and utilitarian reasons are generally given as justifications but there are also aesthetic

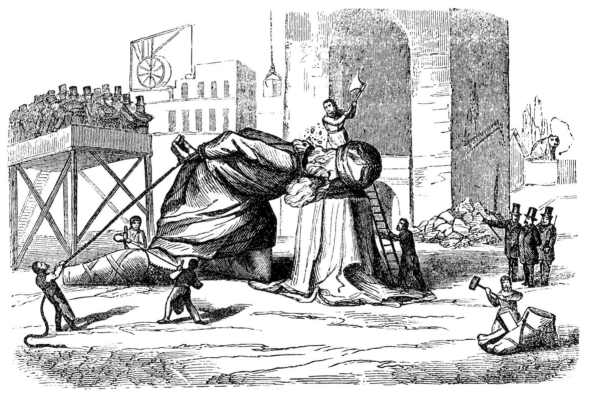

Anonymous / »Als wie der größte Mann Berns auf Befehl der kleinen Götter des Materialismus geopfert und enthauptet wird« [How the Biggest Man of Berne is Being Sacrificed and Beheaded on Order of the Little Gods of Materialism] / woodcut / published in Die Schweiz, 3 March 1865 / 4 x 6" / Bernisches Historisches Museum, Berne

12

_ Pierre Joseph Proudhon, *Philosophie du progrès* (1851), quoted in T. J. Clark, *Image of the People: Courbet and the 1848 Revolution*, Thames & Hudson, London, 1973, p. 20.

arguments and, more implicitly, the targets may symbolize the past that has to be obliterated. In some cases, the parallel with iconoclasm cannot be missed. In Berne, for instance, the construction of the railway station in 1865 required the demolition of the Christoffelturm (Tower of St. Christopher), a part of the medieval fortification; station and tower represented respectively the "needs of progress" and the identity of the ancient town. A long fight between their supporters concentrated on the large wooden figure of St. Christopher (1498), which had survived the iconoclasm of the Reformation as a kind of gatekeeper. It did not survive progress, and a cartoonist interpreted its elimination as the beheading of "the biggest man of Berne ... on the order of the little gods of materialism." The statue was indeed cut into pieces and distributed as firewood to the poor, just as in the Reformation, while defenders of Christopher made relics out of a few remaining fragments.

The connection between the ideal of progress and destructive renovation was expressed in a sort of visual pun on the 1913 monument to a mayor of Lyon who had reconstructed a central quarter of the city, considered to be insalubrious: the personification of Progress holds above building tools a torch that one expects to symbolize enlightenment, as in Bartholdi's statue of Liberty, but that, in effect, is about to set fire to the medieval houses visible on the right. The advertisement poster for an American demolition company recently attested to the enduring faith in this identity of progress and the wiped slate: "Breaking into the Future!" Its optimism can seem outdated in the wake of the 11 September 2001 terrorist attack on the World Trade Center in New York, but it may well survive it. Even in the case of the destruction of the Twin Towers, a connection with the metaphorical iconoclasm of the artistic avant-garde became apparent when the German composer Karlheinz Stockhausen publicly expressed envy at the degree of focus and dedication shown by the terrorists and called the attack "the greatest work of art that is possible in the whole cosmos." Two months later, the French conductor and composer Pierre Boulez was briefly detained by the Swiss police because he had apparently declared in the 1960s that opera houses should be blown up.[13]

Courbet and his followers were called "iconoclasts of art," whose dismissal of traditional notions of beauty was compared to the hammer of a stonebreaker chipping a statue of Venus "into a curbstone."[14] At the same time, the ruins left by the Communards were admired by some visitors as the

Thumb of the wooden statue of St. Christopher mounted as a drinking cup / 1867 / painted wood and silver / height 13" / Gesellschaft zu Schmieden. Berne

14 13

_ Anthony Tommasini, Explaining Stockhausen, in *International Herald Tribune*, 2 October 2001, p. 20; Anonymous, Musical Terrorism? Swiss Detain Boulez, in *International Herald Tribune*, 6 December 2001.

_ Quoted in Champfleury, Courbet en 1860, here after Klaus Herding, *Courbet: To Venture Independence*, Yale University Press, New Haven and London, 1991, p. 6.

Monument to Antoine Gailleton / Lyon / 1913 / bas-relief of Progress by Maspoli / montagny stone / 40.5 x 144" / state before restoration / © photo: Dario Gamboni

works of unconscious artists, and Joris-Karl Huysmans concluded from them that "fire is the essential artist of our time and that the architecture of the [nineteenth century], so pitiful when it is raw, becomes imposing, almost splendid, when it is baked."[15] Metaphorical iconoclasm became a distinctive element of the artistic program of the "avant-garde" – another reference to the idea of progress – around the time of World War I. The Futurists proposed to free Italy from its "cancer of professors, archaeologists, tourist guides, and antiquaries" by demolishing museums and libraries,[16] the Russian Constructivists, Productivists, and Suprematists tried to contribute to the construction of a new world promised by the Soviet Revolution, and the Dadaists radicalized the rejection of past art into an overall condemnation of art as such, seen as part of the values and civilization that the War revealed to be false and destructive.

Poster advertising a demolition company in Chicago / August 1997 / © photo: Dario Gamboni

15

_ Joris-K. Huysmans, Fantaisie sur le Musée des arts décoratifs et sur l'architecture cuite, in *Revue indépendante*, n.s., 1, November 1886, reprinted in Joris-K. Huysmans, *Certains* (1889), Union Générale d'Editions, Paris, 1975, pp. 397-399.

16

_ Filippo Tommaso Marinetti, Manifeste technique de la littérature futuriste, in *Le Figaro*, 20 February 1909, republished in Giovanni Lista, *Futurisme. Manifestes, proclamations, documents*, L'Age d'Homme, Lausanne, 1973, pp. 85-89.

Daniel Spoerri / Utiliser un Rembrandt comme planche à repassser (Marcel Duchamp) [Use a Rembrandt as an Ironing Board (Marcel Duchamp)] / 1964 / assemblage / 34 x 29 x 16" / Tel Aviv Museum of Art, Tel Aviv / © photo: Bacci Attilio, courtesy Galleria Schwarz, Milan

Marcel Duchamp / La boîte-en-valise (1936/41) [Box in a suitcase] / 1966 / box, coated with red linen, contents 80 parts / 16.3 x 15 x 4" / Neue Galerie am Landesmuseum Joanneum, Graz / photo: Koinegg, Neue Galerie am Landesmuseum Joanneum, Graz

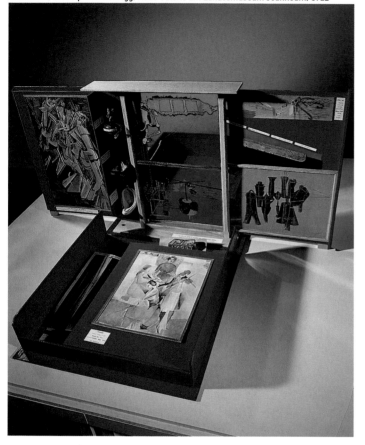

The artist whose work is often considered to embody this nihilistic impulse in the most influential way is Marcel Duchamp, especially in his Readymades. His most explicit statement about the Readymades as anti-art is a note written between 1911 and 1915: "RECIPROCAL READYMADE / Use a Rembrandt as an ironing board."[17] Its impact was demonstrated by homages rendered in the 1960s and 1970s in the form of playful realizations. Daniel Spoerri replaced the "Rembrandt" with a reproduction of Mona Lisa in reference to Duchamp's 1919 *L.H.O.O.Q.*; Carel Blotkamp – without knowledge of Spoerri's work – used a doll's house ironing board and a reproduction of the *Portrait of Elisabeth Bar*, then believed to be by Rembrandt but attributed since to Ferdinand Bol.

If, according to Duchamp's own definition, a ready made is an "Everyday commodity promoted to the dignity of work of art by the mere choice of the artist," a reciprocal ready made is a work of art demoted to the status of everyday commodity.[18] Duchamp later asserted that this idea had resulted from the desire "to expose the basic antinomy between art and ready mades."[19] But the matter is more complicated with ready mades, as shown by the most famous (or infamous) of them, the tilted urinal that Duchamp attempted to have included under a pseudonym and the title

Marcel Duchamp / La boîte verte [The Green Box] / 1934 / box coated with green velvet, contents 93 parts / 13 x 11 x 1" / Neue Galerie am Landesmuseum Joanneum, Graz / © photo: Koinegg, Neue Galerie am Landesmuseum Joanneum, Graz

18 19 17

_ Marcel Duchamp, *La Mariée mise à nu par ses célibataires, même* (1934), quoted after Marcel Duchamp, *Duchamp du signe. Ecrits*, Flammarion, Paris, 1975, p. 49 ("READYMADE RÉCIPROQUE / Se servir d'un Rembrandt comme planche à repasser").

_ Marcel Duchamp, Apropos of "Readymades," in *The Essential Writings of Marcel Duchamp*, Michel Sanouillet and Elmer Peterson (eds), Thames & Hudson, London, 1975, p. 142.

_ *Dictionnaire abrégé du surréalisme*, Galerie Beaux-Arts, Paris, 1938 ("Objet usuel promu à la dignité d'objet d'art par le simple choix de l'artiste").

Robert Rauschenberg / Erased de Kooning Drawing / 1953 / traces of ink and crayon on paper /
gold-leaf frame / 19 x 14.2" / San Francisco Museum of Modern Art, San Francisco /
© photo: Leo Castelli Gallery, New York

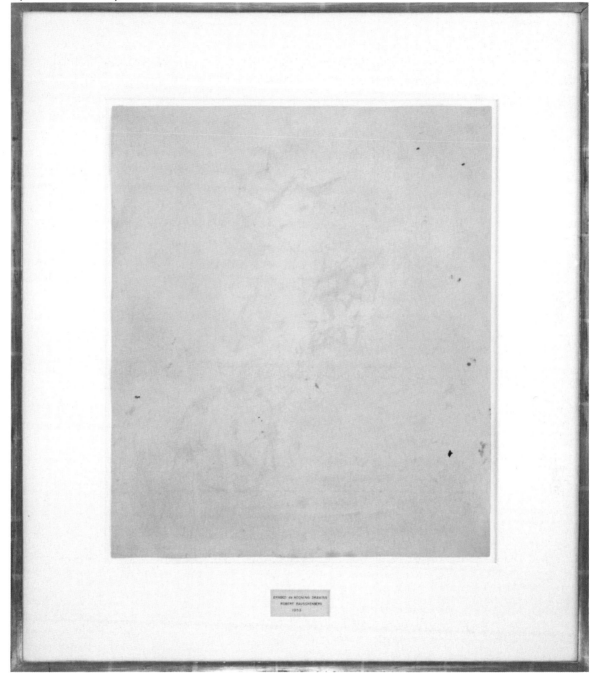

Fountain in the 1917 Exhibition of the American Society of Independent Artists in New York. This move was a test of the organizers' fidelity to their principle of unlimited inclusion, and to some extent a provocation, but it was also much more than that. In my hypothesis, one of the reasons for the title *Fountain* is a pun on the name of the seventeenth century French poet La Fontaine and a reference to his fable *Le statuaire et la statue de Jupiter* in which a sculptor, after wondering whether he will turn a beautiful piece of marble into "a god, a table, or a basin," opts for the god and ends up trembling in front of his own creation. Like Abraham attempting to shame his father Terah for selling idols, La Fontaine shames his sculptor for believing in the work of his own hands, an attitude that he compares with playing with dolls and man's passion for dreams and lies: "L'homme est de glace aux vérités, / Il est de feu pour les mensonges."[20]

One could argue that Duchamp similarly shames artists for being craftsmen and believers, and shows that art is only a matter of faith, magic, or consensus. At least this is the way in which the ready made has been interpreted by sociologists and philosophers of art. Pierre Bourdieu, for instance, defined it as a "ritual desecration," which "cannot unveil the truth on art without taking it away by turning this unveiling into an artistic manifestation."[21] But this is not the way in which Duchamp's closest friends saw *Fountain* in 1917. Rather than a "piece of marble" mocking the possibility of becoming "dieu, table ou cuvette," they saw it as a urinal mentally freed to become whatever the beholder wanted, especially a "buddha" or a "virgin," with which it was revealed to have formal analogies.[22]

Another characteristic of the ready made that modified the relationship between modern art and iconoclasm is the way in which it questions the importance of the artist's physical intervention and of the artwork's uniqueness. This change was demonstrated and thematized by Man Ray when a 1923 assemblage he had entitled *Object to be Destroyed* was

George Maciunas / Diagram of Historical Development of Fluxus and Other 4 Dimensional, Aural, Optic, Olfactory, Epithelial and Tactile Art Forms / 1973

22 21 20

_ *Fables mises en vers par Jean de La Fontaine*, Verdun Louis Saulnier (ed.), Armand Colin, Paris, 1960, vol. 2, pp. 135-136 (Deuxième recueil de Fables, 1678, IX, VI; Un bloc de marbre était si beau / Qu'un statuaire en fit l'emplette / Qu'en fera, dit-il, mon ciseau? / Sera-t-il dieu, table ou cuvette?). On Abraham and Terah, see Bruno Latour's introduction to the present catalog.

_ William A. Camfield, *Marcel Duchamp: Fountain*, The Menil Collection, Houston Fine Art Press, Houston, 1989.

_ Pierre Bourdieu, La production de la croyance. Contribution à une économie des biens symboliques, in *Actes de la recherche en sciences sociales*, 13, February 1977, pp. 4-43 (p. 8: "L'art ne peut livrer la vérité sur l'art sans la dérober en faisant de ce dévoilement une manifestation artistique").

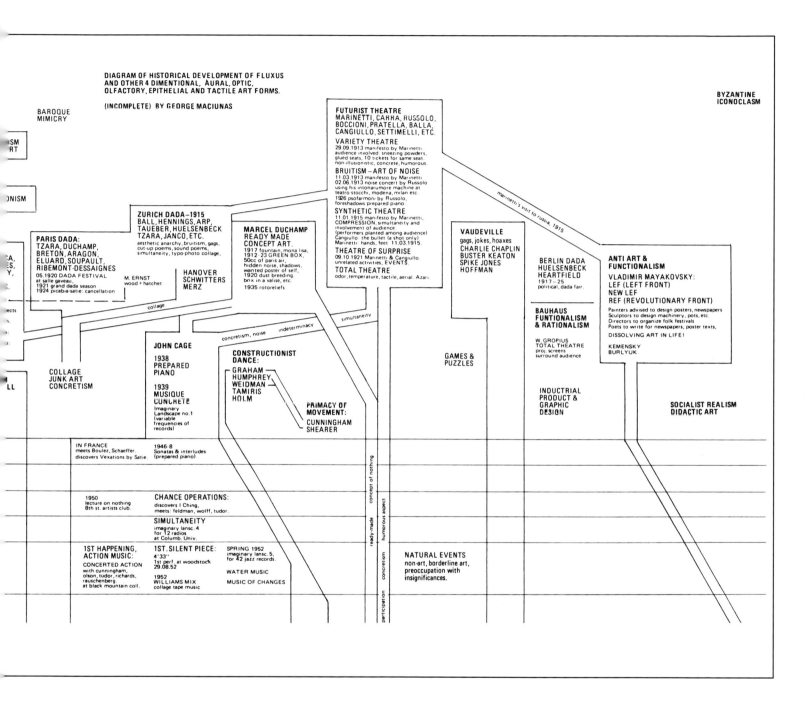

DIAGRAM OF HISTORICAL DEVELOPMENT OF FLUXUS
AND OTHER 4 DIMENTIONAL, AURAL, OPTIC,
OLFACTORY, EPITHELIAL AND TACTILE ART FORMS.

(INCOMPLETE) BY GEORGE MACIUNAS

BYZANTINE
ICONOCLASM

BAROQUE
MIMICRY

FUTURIST THEATRE
MARINETTI, CARRA, RUSSOLO,
BOCCIONI, PRATELLA, BALLA,
CANGIULLO, SETTIMELLI, ETC.

VARIETY THEATRE
29.09.1913 manifesto by Marinetti
audience involved: sneezing powders,
glued seats, 10 tickets for same seat.
non-illusionistic, concrete, humorous.

BRUITISM—ART OF NOISE
11.03.1913 manifesto by Marinetti
02.06.1913 noise concert by Russolo
using his intonarumore machine at
teatro stocchi, modena, milan etc.
1926 psofarmoni by Russolo,
foreshadows prepared piano.

SYNTHETIC THEATRE
11.01.1915 manifesto by Marinetti,
COMPRESSION, simultaneity and
involvement of audience.
(performers planted among audience)
Cangiullo: the bullet (a shot only)
Marinetti: hands, feet 11.03.1915.

THEATRE OF SURPRISE
09.10.1921 Marinetti & Cangiullo
unrelated activities, EVENTS.

TOTAL THEATRE
odor, temperature, tactile, aerial. Azari.

ZURICH DADA—1915
BALL, HENNINGS, ARP,
TAUEBER, HUELSENBECK
TZARA, JANCO, ETC.
aesthetic anarchy, bruitism, gags,
cut-up poems, sound poems,
simultaneity, typo-photo collage,

MARCEL DUCHAMP
READY MADE
CONCEPT ART.
1917 fountain, mona lisa,
1912-23 GREEN BOX,
50cc of paris air,
hidden noise, shadows,
wanted poster of self,
1920 dust breeding,
box in a valise, etc.
1935 rotoreliefs

PARIS DADA:
TZARA, DUCHAMP,
BRETON, ARAGON,
ELUARD, SOUPAULT,
RIBEMONT-DESSAIGNES
05.1920 DADA FESTIVAL
at salle gaveau,
1921 grand dada season
1924 picabia-satie: cancellation

M. ERNST
wood + hatchet

HANOVER
SCHWITTERS
MERZ

collage

VAUDEVILLE
gags, jokes, hoaxes
CHARLIE CHAPLIN
BUSTER KEATON
SPIKE JONES
HOFFMAN

marinetti's visit to russia, 1915

BERLIN DADA
HUELSENBECK
HEARTFIELD
1917—25
political, dada fair.

**BAUHAUS
FUNTIONALISM
& RATIONALISM**

W. GROPIUS
TOTAL THEATRE
proj. screens
surround audience

**ANTI ART &
FUNCTIONALISM**

VLADIMIR MAYAKOVSKY:
LEF (LEFT FRONT)
NEW LEF
REF (REVOLUTIONARY FRONT)

Painters advised to design posters, newspapers
Sculptors to design machinery, pots, etc.
Directors to organize folk festivals
Poets to write for newspapers, poster texts,

DISSOLVING ART IN LIFE!

KEMENSKY
BURLYUK

concretism, noise indeterminacy simultaneity

JOHN CAGE

1938
PREPARED
PIANO

1939
MUSIQUE
CONCRETE
Imaginary
Landscape no.1
(variable
frequencies of
records)

**CONSTRUCTIONIST
DANCE:**
GRAHAM
HUMPHREY
WEIDMAN
TAMIRIS
HOLM

PRIMACY OF
MOVEMENT:
CUNNINGHAM
SHEARER

GAMES &
PUZZLES

INDUCTRIAL
PRODUCT &
GRAPHIC
DESIGN

SOCIALIST REALISM
DIDACTIC ART

COLLAGE
JUNK ART
CONCRETISM

			concept of nothing			
IN FRANCE meets Boulez, Schaeffer. discovers Vexations by Satie.	1946-8 Sonatas & interludes (prepared piano)					
1950 lecture on nothing 8th st. artists club.	**CHANCE OPERATIONS:** discovers I Ching, meets: feldman, wolff, tudor.		ready-made	humorous aspect		
	SIMULTANEITY imaginary lansc. 4 for 12 radios at Columb. Univ.					
1ST HAPPENING, ACTION MUSIC: CONCERTED ACTION with cunningham, olson, tudor, richards, rauschenberg. at black mountain coll.	**1ST. SILENT PIECE:** 4'33'' 1st perf. at woodstock 29.08.52 1952 WILLIAMS MIX collage tape music	SPRING 1952 imaginary lansc. 5, for 42 jazz records. WATER MUSIC MUSIC OF CHANGES	concretism	participation	**NATURAL EVENTS** non-art, borderline art, preoccupation with insignificances.	

stolen and probably destroyed by students of the Ecole des Beaux-Arts who protested in 1957 against Dada and Surrealism. The destruction mentioned in the title was meant to remain a fiction or be performed publicly by the artist. Confronted with this unauthorized enactment and having obtained his insurance claim, Man Ray emphasized the fact that an (aided) ready made cannot be eliminated by calling the replica that he realized *Indestructible Object.*

The radical 1960s and 1970s were the golden age for (neo-) avant-garde iconoclasm. In 1973, George Maciunas placed "Byzantine iconoclasm" at the top of his retrospective

Man Ray / Object to Be Destroyed / 1923 / drawing reproduced in Dictionnaire abrégé du surréalisme. Paris, 1938

M. R.

genealogical chart of Fluxus and related movements. Twenty years earlier, Robert Rauschenberg had gone beyond Duchamp's use of a reproduction of Mona Lisa in *L.H.O.O.Q.* by asking Willem de Kooning to give him a real drawing to be erased. This gesture was directed against an artist whom he admired and who belonged to the generation of Abstract Expressionists. Rauschenberg explained later: "I was trying to make art and so therefore I had to erase art." He had not wanted to erase one of his own drawings because the erased work would have gone "back to nothing."[23] Many other artists explored the possibilities of self-destroying works, and some of them were brought together in 1966 by the Destruction in Art Symposium (DIAS) organized in London by the German-born Gustav Metzger, who had written a manifesto entitled *Auto-Destructive Art* in 1959 and intended to "isolate the element of destruction in new art forms, and to discover any links with destruction in society."[24] This development pushed the assault on uniqueness and materiality further by challenging the artwork's claim to endure and to be preserved. It was also part of the move from product to process and from object to "happening" or "performance," famously exemplified by Jean Tinguely's *Homage to New York*, his first auto-destructive "machine-happening" executed (in both senses of the term) on 17 March 1960 in the garden of the Museum of Modern Art. In the same year, Tinguely also realized a *Machine for Breaking Sculptures* (since then destroyed). The equation of new art with the elimination of the past also had an impact on the teaching of art and the preservation of collections, as shown by the fate of a collection of original plaster models of the Grand Prix de Rome, banished in a cellar of the Ecole des Beaux-Arts in Paris since 1968.

Vandalism and the Destruction of Art as Art

Artistic assaults against artistic traditions did not go without a price. From the late nineteenth century onwards, works of

24 23

_ Barbara Rose, *An Interview with Robert Rauschenberg*, Vintage Books, New York, 1987, p. 51; *Interview*, 6, 5, 1976, quoted in Felix Gmelin, *Art Vandals*, exhib. cat. Riksutställningar, Stockholm, 1996, p. 27.

_ Gustav Metzger, *Auto-Destructive Art* (1959), quoted in John A. Walker, Message from the Margin. John A. Walker tracks down Gustav Metzger, in *Art Monthly*, 190, October 1995, pp. 14-17.

modern art came to be attacked as "degenerate" by those who identified representations of nature with nature itself, and the Nazis turned this condemnation into a cleansing operation that was part of their political program. They persecuted artists and burnt works or sold them outside Germany after declassifying them from museums. In 1937, they organized a pair of contrasting exhibitions in Munich. One of them, comparable to a "statue park," was devoted to "degenerate art" and meant to prove its infamous and perverse character. Revealingly, it made use of the "iconoclastic" display methods forged by the Dadaists and turned them against their authors. The other was devoted to the "new and true German art" (Hitler's words) and presented artists affiliated with the regime. Willi Baumeister, whose works were vilified in the *Entartete Kunst* exhibition, bought postcards of paintings by Adolf Ziegler, the organizer of the Große Deutsche Kunst-ausstellung, and painted them over, turning, for instance, the

"healthy" representation of the *Goddess of the Arts* into a grotesque male bust.

After the war, the Nazi persecution of "degenerate art" added to the condemnation of iconoclasm and ever since it has remained a favorite argument against the criticism of modern and contemporary art. But there has been criticism, as well as physical attacks, related in various ways to the avant-garde "iconoclasm." This is particularly

Opening of the Erste Internationale Dada-Messe [First International Dada Fair] / Burchard Gallery / Berlin, 30 July 1920 / © photo: Bildarchiv Preußischer Kulturbesitz, Berlin / from left to right: [standing] Raoul Hausmann, Otto Burchard, Baader, Wieland and Margarete Herzfelde, George Grosz, John Heartfield, [sitting] Hanna Höch, Otto Schmalhausen

The Dada wall in the »Entartete Kunst« [Degenerate Art] exhibition / Munich, 1937 / © photo: Stadtarchiv München, Munich

Willi Baumeister / Simultan-Bild: »Mann mit Spitzbart II« [Simultaneous Image: »Man With Pointed Beard«] / c .1941 / pencil, gouache and watercolor / on postcard of Adolf Ziegler's painting »Göttin der Künste« / 6 x 4" / Archive Baumeister, Stuttgart / © VG Bild-Kunst, Bonn 2002 / © photo: Reinhard Truckenmüller, Archive Baumeister, Stuttgart

Willi Baumeister / Mann mit Spitzbart [Man With Pointed Beard] / c .1941 / pencil, and colored pencil, writing / on postcard / 6 x 4" / Archive Baumeister, Stuttgart / © VG Bild-Kunst, Bonn 2002 / © photo: Reinhard Truckenmüller, Archive Baumeister, Stuttgart

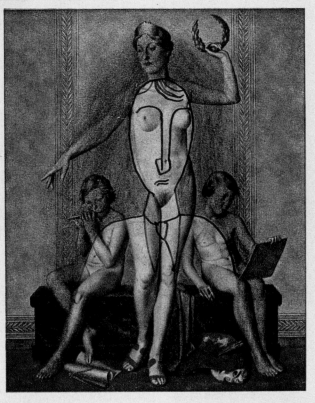

obvious in public space, where modern art came in contact with what has sometimes been termed "involuntary visitors" or the "non-public." An almost emblematic case is that of a work called *Action Sculpture*, which was meant to turn the "aggression of the public" into an alleged participation in artistic creation. The four hammers attached with ropes to its base, rather than being used as proposed to fold the exterior sheet-iron envelope onto the interior steel core, were probably stolen and employed against other sculptures that had not required any physical intervention. Here again, the iconoclast's hammer had not struck where it was expected.

Action Sculpture was part of the 8th Swiss Sculpture Exhibition taking place in 1980 in Bienne, a small industrial town, where almost half of the works on show were anonymously damaged or destroyed. Interviews of passers-by and letters in the press show that the introduction of art "in the street" was not perceived as the intended democratization of art and enrichment of daily life, but as a sort of invasion. The targets were not selected at random but tended to be made of materials not traditionally associated with art or to show no easily recognizable sign of an artistic competence in the manual or technical sense. The "vandal" could only be found in one case: it was the owner of a gardening business, and he claimed that he had mistaken the work for rubbish, lying on the ground he had to prepare, and had it thrown away accordingly. The work in question was called *Video Blind Piece* and by Gérald Minkoff, an artist who had elected "Miss Understanding" as his Muse: the paradoxes it involves seemed to unfold themselves in its fate. *Video Blind Piece* consisted of fourteen exhausted television tubes buried in the ground with the screens facing up, disposed in a pattern similar to the one of the fourteen dots forming the word *video* ("I see" in Latin) in Braille. A blind person could not touch them and a seeing person could not read them; only the catalog of the exhibition provided the necessary explanation. When his

"misunderstanding" was discovered, the gardener offered to help redo the work and even published an advertisement in the local newspaper to find the TV tubes "to restore a sculpture of the sculpture exhibition not recognized as such and for this reason removed to the refuse-dump." But rather than repentance and respect, the artist saw in this proposal a continuation by other means of the iconoclastic gesture, implying that the lost work could be repeated at will. In

Plaster models by winners of the Grand Prix de Rome between 1815 and 1900 / in store in a cellar of the Ecole des beaux-arts, Paris / 1994 / © photo: Marianne Haas, Paris

Roland Lüchinger / Aktionsplastik [Action Sculpture] / 1979 / steel / height 98" / in its damaged state / at the 8th Swiss Sculpture Exhibition in Bienne, 1980 / © photo: Jeanne Chevalier, La Fuentecilla

Anton Egloff / Profil eines Fluges [Profile of a Flight] / 1976–1977 / bronze / with artist's drawing on tracing paper suggesting how his work was damaged

Gérald Minkoff / sketch of his 1980 Video Blind Piece / 1978 / reproduced in the catalog of the 8th Swiss Sculpture Exhibition in Bienne, 1980

Advertisement for the reconstruction of Minkoff's Video Blind Piece / Bieler Tagblatt, 25 June 1980

Dringend gesucht

14 alte Fernsehbildröhren

(einheitliches Format 59×29) zur Wiederherstellung einer nicht als solche erkannten und deshalb irrtümlicherweise in die Schuttdeponie abtransportierten Skulptur der Plastikausstellung.

Sich bitte melden bei

Oscar Fischer, Gärtnermeister
Tulpenweg 4 Biel

The two notes left close to Newman's Who's Afraid of Red, Yellow and Blue IV by Josef Kleer on 13 April 1982 in the Nationalgalerie, Berlin

»Any Apprentice Could Have Painted This« / with photo and papers of Josef Kleer, perpetrator of the 13 April 1982 attack on Newman's Who's Afraid of Red, Yellow and Blue IV / as well as readers' letters / Berliner Zeitung, 22 April 1982

the new version of *Video Blind Piece*, realized twenty-two years later for *Iconoclash*, Minkoff has opened the eyes of his TV screens and connected them to cameras watching the various parts of the exhibition, proposing a reflection on the fate of his work, the fragility of display, and the development of surveillance.

Museums have indeed been increasingly forced to protect the works they display from intentional damage. Here too, modern art has been a special target, but the thresholds associated with cultural institutions have tended to add particular psychological or psychopathological factors to the profile of "art vandals." The properties of the targeted works also play a role. Several late paintings by Barnet Newman, in which he proposed a modern version of the experience of the "sublime," seem for instance to have elicited fear and aggression in some spectators, as well as incomprehension of the type of artistic competence they require and the reasons for their financial value and the reverence they receive in the art world. At the Stedelijk Museum in Amsterdam, the same man slashed with a knife Newman's *Who's Afraid of Red, Yellow and Blue III*

Barnett Newman / Who's Afraid of Red, Yellow and Blue III / 1967-1968 / acrylic on canvas / 96 x 214" / attack of 21 March 1986 / © photo: Stedelijk Museum, Amsterdam

(1967-68) in 1986 and his *Cathedra* (1951) in 1997. In the first case, he declared that his act was an "ode to Carel Willink," a Dutch exponent of "Magic Realism" whose anti-modernist book *Painting in a Critical Phase* (1950) he quoted before the court; the restoration of the painting ended in a bitter dispute between the museum and the hired conservator, who was accused of having completed the destruction.[25]

Arman (Armand Fernandez) / Conscious Vandalism / 1975 / happening at the John Gibson Gallery, New York / © photo: courtesy Archives of Armand P. Arman, New York

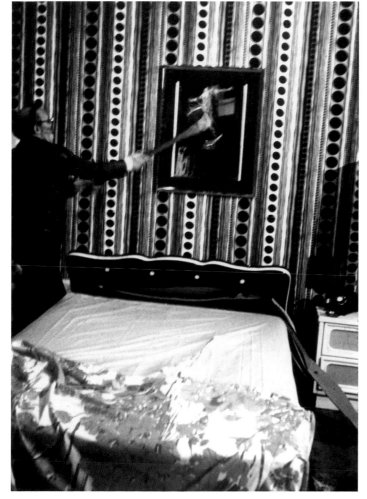

Hans Haacke / Brocken R.M... / 1986 / enamel plaque, gilded snow shovel with broken handle / courtesy Galerie Hubert Winter, Vienna / © photo: Galerie Hubert Winter, Vienna

In the Berlin Nationalgalerie, a student of veterinary medicine named Josef Kleer attacked Newman's *Who's Afraid of Red, Yellow and Blue IV* (1969-70) in 1982 with one of the plastic bars meant to keep the visitors at a respectful distance from the painting. He placed on and around the damaged work several documents, which enabled the police to identify him, and explained that he had been afraid of the painting, that it was a perversion of the German flag and that its purchase with public funds was irresponsible.[26] The acquisition of the work had been prepared by an aggressive fundraising campaign, and Kleer later declared that the other visitors' attitude towards Newman's work had reminded him

25

26

_ Vernieler doek wil museum blijven bezoeken, in *NRC Handelsblad*, 3 April 1986; Jan Eilander, De Newman killer, in *Haagse Post*, 5 April 1986; Vernieler van schilderij ziet daad als kunstkritiek, in *Reformatorisch Dagblad*, 26 June 1986; Man vernielde schilderij 'om de discussie', in *Het Parool*, 18 September 1986; (anp), Verbod voor vernieler schilderij, in *Het Parool*, 2 October 1986; Renée Steenbergen, Kritiek face-lift doek Newman, in *NRC Handelsblad*, 16 August 1991; Christian Chartier, L'honneur perdu d'un restaurateur, in *Le Monde*, 31 January 1992; *Barnett Newman: Cathedra*, exhib. cat. Stedelijk Museum, Amsterdam (*SMA Cahiers* 24), 2001.

_ Peter Moritz Pickshaus, *Kunstzerstörer. Fallstudien: Tatmotive und Psychogramme*, Rowohlt, Reinbek, 1988, pp. 65-123.

Par une belle journée, dans une lumière très claire de montagne on va décapiter un homme. Il lève les yeux vers le ciel. C'est l'effort même vers la disparition. Je ne peux pas en dire plus ♦ Je trouvais ce tableau pompeux. C'était un Gleyre, une œuvre locale, mais on n'en a jamais fait un tabac. La preuve, il était à l'écart, mal éclairé. Sa chance, c'est d'avoir brûlé. Il faut qu'une chose s'absente pour nous faire courir. Comme James Dean qui s'est tué en voiture, ça nous a évité de le voir gras et alcoolique ♦ C'était un tableau extrêmement calme. On ne croise pas un regard. Chacun est à sa place et tient son rôle. Toute la scène se passe sur l'échafaud. On voit le major Davel, vêtu d'une chemise blanche, d'un gilet beige et de bottes brunes, haranguant la foule venue assister à son exécution. Il apparaît résigné et courageux, c'est un mystique. Il est encadré par le bourreau, son aide, les pasteurs. Il est surveillé par deux soldats. Il me semble que j'aperçois des peupliers et quelqu'un qui grimpe dans l'un des arbres. Les couleurs c'était surtout du brun ♦ C'était un tableau léché, dessiné, un tableau de commande réalisé en 1846. La scène est figée. Les acteurs d'un fait historique sont posés là, les uns à côté des autres. Je comparerais leurs regards à ceux d'individus qui ont été fortuitement entassés dans un ascenseur. Ils sont bien obligés de regarder mais ils essaient de dire : « N'ayez crainte, je ne vous vois pas. » Davel a un côté Jeanne d'Arc. Il rentre dans l'Histoire. Deux ecclésiastiques en noir lui donnent les derniers sacrements. Le bourreau serre sous son manteau rouge l'épée du supplice. Son assistant tient une corde entre les mains. Au bas de l'échafaud on a une foule étonnante de gens hébétés venus ici au spectacle pour assister à l'exécution de leur héros par des officiants eux-mêmes Vaudois. Un père soulève son gamin pour qu'il puisse voir. Cette cérémonie masochiste est mise en scène magnifiquement, sans pudeur. Pendant dix ans je l'ai vu quasiment chaque jour. J'avais avec lui un lien de familiarité ♦ C'est un tableau d'apparence parfaitement académique, d'une facture pré-photographique, en clairs-obscurs et en glacis. A l'inverse de la scène édifiante du devant, le fond est la partie la plus moderne du tableau. C'est un paysage traité d'une manière très luministe ♦ C'était un grand format, plus de deux mètres sur deux, avec un énorme cadre doré. Le major est sur un truc surélevé, avec la main en l'air. Il implore le ciel. Et puis il y a deux prêtres ou des juges, enfin des gars en robe noire et le bourreau avec la hache, en rouge si mes souvenirs sont bons. Il a été détruit par un visiteur en 1980. Tout a brûlé sauf un soldat qui se cache les yeux comme s'il ne voulait pas voir ce qui se passe ♦ C'était un tableau assez pompier qui ne me touchait pas particulièrement. Je me souviens qu'il était dans le corridor, près du bassin aux poissons rouges. Il me semble qu'il était très coloré. Davel a une belle moustache, il porte une veste rouge et un chapeau noir. L'horizon est très bas, le ciel immense. Est-ce qu'il y a un cheval ? Je n'en suis pas certain. Il y a un morceau qui reste, c'est le fameux soldat qui est en bas, à droite. Il pleure ♦ On m'a montré ce tableau parce que c'est une page d'histoire vaudoise. Le major Davel nous aurait sauvés par sa mort de la présence des Bernois mais pour moi il évoquait surtout les livres d'école ♦ Davel monte sur l'échafaud, il lève le bras. Le bourreau détourne la tête. Les pasteurs expriment leur tristesse au premier plan. Un soldat se cache la face pour pleurer. Entre les jambes du major on voit la foule. En fait de paysage, il me semble que l'on voit surtout le ciel, quelques arbres dans le fond et la rive du lac. C'était une peinture assez quelconque, elle ne cassait pas des briques ♦ C'était le tableau le plus lourd du musée. Je participais au déplacement de l'œuvre chaque fois qu'on désirait l'exposer, alors la première chose qui me vient à l'esprit quand je pense à ce tableau c'est son poids. Au niveau des émotions il m'aurait plutôt fait sourire ♦ Je passais devant lui à neuf heures, à midi et le soir. Je l'aimais bien parce que je distinguais les Dents du Midi exactement comme je les vois depuis chez moi. C'était bien fait. C'est moi qui ai ramassé ses cendres par terre. Je voulais faire un joli petit cercueil et les mettre dedans. C'est tout ce qui restait à part ce soldat qui pleure... A croire que ses larmes ont arrêté le feu.

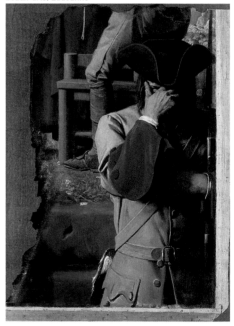

Charles Gleyre / The execution of Major Davel / 1850 / oil on canvas / 41 x 40" / Musée cantonal des beaux-arts, Lausanne / © photo: J.-C. Ducret, Musée cantonal des beaux-arts, Lausanne

Sophie Calle / Le Major Davel / 1994 / installation / detail / cibachrome in gilded frame / 59 x 53" / Musée cantonal des beaux-arts, Lausanne / © photo: J.-C. Ducret, Musée cantonal des beaux-arts, Lausanne

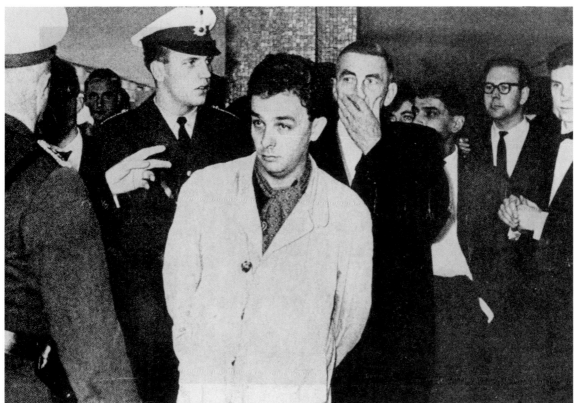

Arnulf Rainer at his arrestment in the Wolfsburger Kunstverein / November 1961 / from: Peter Weibel (ed.), Wien. Bildkompendium Wiener Aktionismus und Film, Kohlkunstverlag, Frankfurt, 1970, p. 5

At the prize giving and opening of the exhibition »Junge Stadt sieht junge Kunst« Arnulf Rainer painted over one of the VW-award winning paintings. He was sentenced in 1962.

of the dance around the Golden Calf. His personal history shows that he was experiencing a sort of identity crisis, but public comments on the damage, especially readers' letters published by a Berlin tabloid under the heading "Any apprentice could have painted this" show that his action corresponded to widespread opinions and attitudes. Kleer himself, however, did not criticize Newman's work by reference to older or more traditional art. In fact, he chose the documents he left around the painting in relation to its colors, included two slips of paper speaking of an "action artist" and of a "work of art of the commune" where he was living, and defined his intervention as an artistic "happening" and a way of "completing" the painting.

Even if one cannot take this claim seriously, it must be admitted that the line between a metaphorical artistic "iconoclasm" and a literal anti-artistic (or, rather, anti-modernist) "vandalism" has become increasingly blurred. The "historical" avant-gardists tended to deface or appropriate reproductions of artworks – like the Mona Lisa or Ziegler's *Goddess of the Arts,* both of which would of course have been difficult to reach – or objects recognized to have little aesthetic (and financial) value. After World War II, Asger Jorn "improved" paintings found in Paris flea markets. Like Duchamp he added a moustache and a goatee to the portrait of a girl with a skipping-rope, as well as caricatures and the emphatic (or ironic?) inscription "The avant-garde will not give in" in the

Felix Gmelin / The Overpainting / 1996 / from The Art Vandal Series / after Arnulf Rainer (1973) and Arnulf Rainer? (1994) / oil on canvas / 43 x 36" / © VG Bild-Kunst, Bonn 2002 / © photo: Karl-Olov Bergström

Felix Gmelin / Kill Lies All / 1996 / from The Art Vandal Series / after Pablo Picasso (1937) and Tony Shafrazi (1974) / oil on canvas / 77 x 116" / © VG Bild-Kunst, Bonn 2002 / © photo: Karl-Olov Bergström

The title of Arman's 1975 happening *Conscious Vandalism* emphasizes its distance as well as its inspiration from the allegedly "unconscious" vandalism of those who might have inhabited the "lower middle class interior" that the artist destroyed with a club and an axe in a New York Gallery. When Hans Haacke criticized the historical transformation of Duchamp's "iconoclastic" gestures into "relics" or commodities by breaking his 1915 *In Advance of the Broken Arm* and by replacing the first part of the inscription of *Eau & gaz à tous les étages* (Water & Gas on Every Floor) with "Art and Money", he resorted to replicas. Rauschenberg had erased an original drawing, but he had asked for it from de Kooning for that purpose, thus obtaining the author's permission – if not his approval. None of this applies when, the year following Picasso's death in 1973, the Iranian-born Tony Shafrazi sprayed the enigmatic phrase "KILL LIES ALL" on *Guernica* in the Museum of Modern Art in New York. He shouted that he was an artist when arrested and later explained he had wanted "to bring the art absolutely up to date, to retrieve it from art history and give it life," admitting to having done something like "reacting against the father almost" but claiming that Picasso would not have been "able

background. Jorn encouraged his colleagues of the COBRA movement to do the same and proposed "to improve old canvases, collections and entire museums," to "paint over the pictures to preserve their actuality and to help them from falling into oblivion."[27] Overpainting became the essential *modus operandi for* Arnulf Rainer, culminating (from our point of view) in the insurpassably ambiguous discovery in 1994 that twenty-five of his paintings and photographs had been overpainted in his studio at the Vienna Academy of Fine Arts – by right-wingers trying to defame contemporary art according to the local press – by himself to help stimulate a stagnant market according to the police.[28]

27

28

_ Troels Andersson, *Asger Jorn, en biografi*, Copenhagen, 1994, quoted in Gmelin, op. cit., p. 25.

_ Djawid C. Borower, Übermalter Übermaler. Wiener Schlammschlacht: Der Fall Arnulf Rainer, in *Frankfurter Allgemeine Zeitung*, 17 February 1995.

to question" his gesture. The attack, hailed by the "Guerilla Art Action Group," was condemned by other artists, among whom Louise Bourgeois, Hans Haacke, and Yvonne Rainer, who declared that Shafrazi had "attempted to suppress the artistic freedom of Picasso by infringing on the artist's inviolate right to make a statement without censorship, alerting, annexing, or parasitic 'joining'."[29]

Such infringing multiplied in the 1990s and the evolution has reasons to cause concern not only among museum curators.[30] In the Carré d'Art in Nîmes in 1993, the French Pierre Pinoncelli hit a 1964 version of Duchamp's *Fountain* with a hammer after allegedly peeing into it. He explained his "iconoclastic gesture" as a way of giving life again to what had become "a public monument" and claimed that Duchamp "would have understood" it.[31] The following year, Mark Bridger poured black dye into Damien Hirst's *Away from the Flock* at London's Serpentine Gallery, thus making the sheep suspended in a formaldehyde solution invisible, and covered the title of the work with a label reading "Mark Bridger, *Black Sheep*, May 1, 1994." In November 1996, a Toronto art student vomited a blue substance on Mondrian's *Composition in White, Black and Red* (1936) at the Museum of Modern Art

Felix Gmelin / Erased Green Dollar Sign / 2001 / from The Art Vandal Series / after Kasimir Malevich and Alexander Brener (1997) / oil on panel, white gold leaf frame / 31.5 x 26" / © VG Bild-Kunst, Bonn 2002 / © photo: Svante Larsson

Felix Gmelin / The Avant-garde Will Never Change Its Spots / from The Art Vandal Series / 1996 / after an unknown artist and Asger Jorn (1962) / oil on polyester / 29 x 24" / © VG Bild-Kunst, Bonn 2002 / © photo: Karl-Olov Bergström

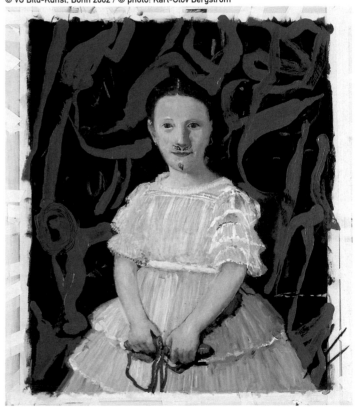

30 29 31

_ Michael T. Kaufman, Guernica Survives a Spray-Paint Attack by Vandal, in *New York Times*, 1 March 1974, p. 60; On the Arrest of Jean Toche, in *Artforum*, 8, November 1974, quoted in John Henry Merryman and Albert Elsen, *Law, Ethics, and the Visual Arts*, University of Pennsylvania Press, Philadelphia, 1987, p. 322.

_ See Jeffrey Kastner, Art Attack, in *Artnews*, October 1997, pp. 154-156; and Gmelin, op. cit.

_ Gilles Lorillard, Un mois de prison avec sursis pour le "bourreau de l'urinoir," in *Le Midi Libre*, 28 August 1993; Nathalie Heinich, C'est la faute à Duchamp! D'urinoir en pissotière, 1917-1993, in *Giallu*, 2, 1994, pp. 7-24; Pierre Pinoncelli, J'irai pisser sur vos tombes, in *Bonjour Monsieur Pinoncelli*, Cahiers de création, Saint-Etienne, 1994, pp. 11-14.

Max Dean / As Yet Untitled / 1992-1995 / mixed media / installation views / © photo: Isaac Applebaum

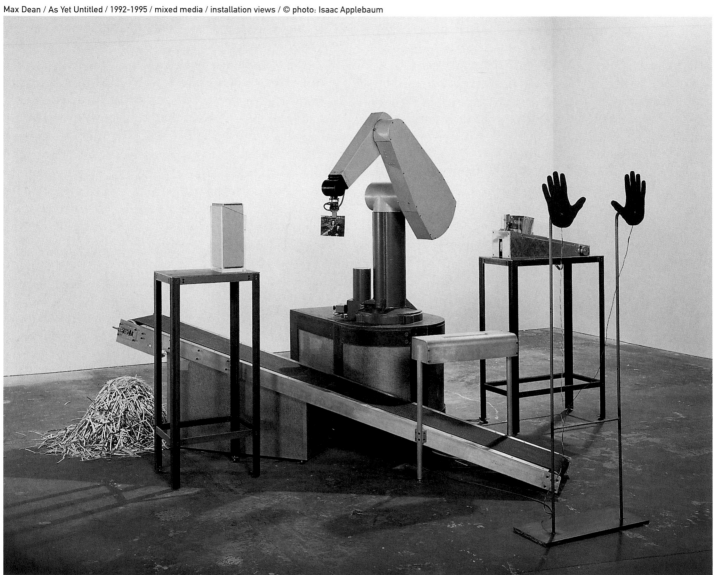

in New York, explaining that this action was the second in a planned three-part performance piece targeting with the primary colors "oppressively trite and painfully banal art." And in January 1997, the Russian performance artist Alexander Brener sprayed a green dollar sign on Malevich's *Suprematism* (1920-27) in the Stedelijk Museum in Amsterdam, defining his gesture as "a political and cultural action against corruption and elitism in culture."

The artistic status of the authors of these gestures is at best disputed, but they have put their "actions" and "performances" more squarely in the context of contemporary art theory and practice than their predecessors. Bridger declared for instance that "in terms of conceptual art, the sheep had already made its statement," and Brener found a passionate defender within the art world in the person of Giancarlo Ponti, editor and publisher of *Flash Art*, who wrote that his arrest was "an offense to the artist's freedom of expression."[32] But one can also notice a growing number of artists who deal with attacks against art in a reflexive way and who, to quote Bruno Latour's suggestion, turn iconoclasm into a topic rather than a resource.

In 1994, for an exhibition entitled *Absence* at the Musée Cantonal des Beaux-Arts in Lausanne, Sophie Calle devoted an installation to a large painting by Charles Gleyre that had been destroyed intentionally by fire in 1980. The lost painting, which represented the execution of a local hero by his own compatriots, is evoked by a photograph of its vandalized state and by a framed surface on which the artist has inscribed memories and comments about the work gathered from among the museum staff. One of its members considers that the painting has gained from burning; another one, who had gathered its ashes and says he wanted to put them in a coffin, suggests that the only remaining part, reproduced in the lower right corner, may have been saved by the tears of the depicted soldier, who conceals his sadness at the hero's imminent death. Calle's work is a monument to the post-humous mental life of a work of art, including the mourning process strangely visualized by its fate.

The Swedish painter Felix Gmelin, born in 1962, took a more systematic and exacting approach in his series entitled *Art Vandals*. Presented as a touring exhibition and on a website since 1996, it is currently being updated and augmented beyond the twelve works originally included, which each referred to a documented case of attack against a work of modern or contemporary art. Gmelin's paintings (and one object) propose a reconstruction of the damaged state of the works in question, which have normally been restored since, and generally include visible modifications that can amount to an explicit comment on the works and their fate. According to Jörgen Gassilewsky's introduction to the catalog of the 1996 exhibition, Gmelin "explores different vantage points, but does not endorse any one of them."[33] Indeed, *Art Vandals* avoids clearly taking sides on an issue that generally attracts passions or silence. On the one hand, Gmelin shows himself critical of Jorn, whose slogan "The avant-garde will not give in" is replaced by ambiguous arabesques and mocked by the title *The Avant-Garde Will Never Change Its Spots*. His generic embodiment of Rainer's overpainted overpaintings also strongly suggests that the Austrian artist was his own "vandal" and condenses visually Jasper Johns with Barnett Newman. But in his comment on Shafrazi's attack on *Guernica*, Gmelin suggests that Picasso might have approved of it, quoting his declaration that "a picture is a sum of destructions," and writes that by turning the painting "into a masterpiece, the museum helps to make the picture historic, thereby rendering it invisible in the present."[34] By following his titles with a mention of the type "After Pablo Picasso (1937) and Tony Shafrazi (1974)," he appears to endorse the claims of "collaboration" made by several of the "art vandals," and the title *Erased Green Dollar Sign* chosen for the work "after Malevich and Brener," while relating it to Rauschenberg's treatment of the de Kooning drawing, also

32

33 34

_ Jörgen Gassilewski, Advantage Point,
in Felix Gmelin, op. cit., p. 5.

_ Quoted in Kastner, op. cit.

_ Op. cit., p. 17. The statement comes from Pablo Picasso, Conversations avec Christian Zervos, in *Cahiers d'art*, 1935, pp. 173-178 ("Auparavant les tableaux s'acheminaient vers leur fin par progression. chaque jour apportait quelque chose de nouveau. Un tableau était une somme d'additions. Chez moi, un tableau est une somme de destructions.")

Henry Mayo Bateman / Brother Brushes II / detail / from: A Book of Drawings, New York, 1921

suggests that the restoration of the Malevich painting amounted to the destruction of a work of art. The very recreation of the damaged state of works of art implies a valuation of this traumatic and fleeting moment in their "social life," and Gassilewsky considers that Gmelin's *mise en abyme* "honors institutions that exhibit the work of artists who honor artists who destroy the works of other artists."

This recreation can also be compared to Komar and Melamid's eternization of the moment when a monument has been lifted from its pedestal but not yet removed – or put back. But a closer expression with contemporary means of the call for a suspension of the iconoclastic gesture has been realized by the Canadian artist Max Dean with his installation *As Yet Untitled*, in which a robot takes a small picture from a reserve, presents it to the spectator, then puts it into a machine to destroy documents, before taking the next picture. If the viewer presses two hand-shaped metal poles with his or her hands while a picture is being presented, this picture is saved and put back into the cycle. One is thus made aware of an ongoing, automatic process of image destruction and of one's own involvement and responsibility in this process. Taking the opposite path from that blindly suggested by *Action Sculpture*, *As Yet Untitled* forces us, like Goya's *No sabe lo que hace*, to open our eyes and our hands.

Motives and Typologies

Dean's work takes advantage of new modes of producing and eliminating images. In the age of technical reproducibility and electronic images, creating and destroying, defacing and refacing go even more hand in hand.[35] A few years ago, I fell victim to the crafty machination of vandals who had modified a photo-booth in such a way that each user would automatically receive a sprayed representation of his or her face.

The degradation and destruction of images and works of art is a very heterogeneous phenomenon and there have been many typologies proposed to analyze it, from Montalembert's

Joseph Beuys' former assistant Johannes Stüttgen holding the remains of Beuys' 1982 Fettecke [Fat Corner] in the Kunstakademie Düsseldorf / with another showing its original location in the background / 9 October 1986 / © VG Bild-Kunst, Bonn 2002 / © photo: Bernhard Neubauer, Düsseldorf

35

_ See the contribution by Richard Powers
in the present catalog.

Ronald Searle / The Philistines: 4 / 1968 / ink / 9.6 x 8"

is always polemical. Nonetheless, the typology proposed by Bruno Latour, which relies mainly on the "inner goals" of iconoclasts, may help to clarify on a more theoretical level the issues involved by the phenomena that we have been examining.

The elimination of political monuments seems to be clearly ascribable to Latour's "Cs," who are against the images of their opponents and attack them as a way to reach and wound their adversaries. It must be added that the images or monuments themselves may have been produced and erected for a similar purpose, so that creation and destruction are literally part of the same process in its various phases and changing circumstances. However, it would be generally simplifying to assume that the images here are mere instruments and play no role in their fate. As the *topos* of the image that "hurts the eye" expresses, they can be felt to exert a violence to which the iconoclastic violence responds, and their specific material, formal, iconographic properties can all be actively involved in this.

The same can be said of anti-modernist "art vandals," who, for reasons of practical convenience (such as easy access), may select a target that stands for their generic foe, but who generally react also to the specific appearance and effect of a given work. We have seen that statues erected by fallen regimes have also been "estranged," modified, or completed as a way of appropriating them and helping bridge their original function and the status of historical monument. Such approaches come closer to Latour's "Bs," who are against "freeze-framing," although the reversible modifications they introduce may be paradoxically intended to allow the original objects to endure rather than be permanently eliminated.

"Innocent" vandals (Latour's "Ds") seem a suspicious category, always on the brink of revealing themselves to be something else, or at least of being attributed malicious intentions. Images and works of art have often been a "collateral

distinction between a "destructive" and a "restorative vandalism" to Warnke's opposition between an "iconoclasm from above and from below," including various sets of categories based on background, context, objectives, and mode of execution.[36] Louis Réau distinguished between "avowable motives" and "unavowed motives," but his "psychology of vandals" amounted to a catalog of sins justifying the "excommunication" deserved in his eyes by "any attack against a work of beauty."[37] The use of motives and intentions as a basis for classification and interpretation is difficult because – in addition to the problems they pose for the understanding of any human behavior – their identification is complicated in the case of iconoclastic actions by the condemnation or at least the ambivalence that these actions elicit, in a context that

36 37

_ Charles de Montalembert, Du vandalisme en France. Lettre à M. Victor Hugo, in *Revue des Deux Mondes*, n.s., 1, 1833, pp. 477-524; Warnke, op. cit.; pour d'autres typologies, voir Dario Gamboni, *The Destruction of Art*, op. cit., pp. 13-24.

_ Réau, op. cit., p. 13.

damage" of military operations, but their destruction has been increasingly used to denounce the barbary of assailants, and recent "ethnic" conflicts have seen a rise of damages caused to purposely wound or weaken the cultural identity of adversaries. As far as preservation is concerned, John Ruskin already wrote in 1849 that the "restoration" of a building means the most total destruction which it can suffer because it is "accompanied with false descriptions of the things destroyed."[38] In the case of modern and contemporary art, the traditional mission of conservators and curators often comes into conflict with the built-in obsolescence of "iconoclastic" works, and only recently has one begun to look for ways to reconcile the artistic programs of self-degradation with the public's interest in the preservation of cultural heritage.

The most intriguing group of "innocent vandals" is comprised of those who explain that they have damaged or destroyed a work of art by mistake, because they had not understood it to be a work of art. The phenomenon is recent

Auguste Rodin / Assemblage: Torso of the Woman Centaur and Minotaur / c. 1910 / plaster / 13 x 13 x 8" / Musée Rodin, Meudon / © Musée Rodin, Paris/ © photo: Adam Rzepka

Joseph Hoffmann / Palais Stoclet, Brussels / 1905 / Hall of Pillars / © photo: Bildarchiv Foto Marburg

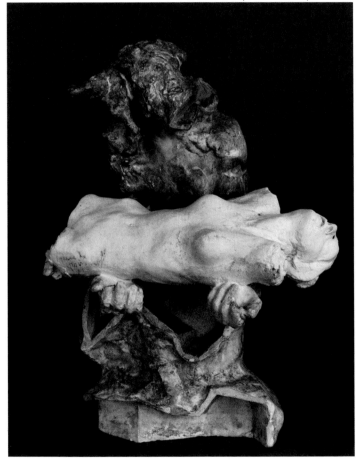

38

_ The Works of John Ruskin, London, 1903, 8, p. 242, quoted in Nikolaus Pevsner, Scrape and Anti-Scrape, in The Future of the Past: Attitudes Towards Conservation, Janet Fawcett (ed.), Thames & Hudson, London, 1976, pp. 33-53, 154-155.

Willi Baumeister / Mann mit Hut [Man with Hat] / 1955 / gouache, ballpoint pen / 6 x 4" / Archive Baumeister, Stuttgart / © VG Bild-Kunst, Bonn 2002 / © photo: Archive Baumeister, Stuttgart

but there are already countless such stories, and it must be admitted that the evolution of art theory and practice in the twentieth century, especially the invention of the Readymade and its legacy, have created the conditions for such "mistakes" to happen, as we have seen with the disappearance of *Video Blind Piece*. However, these narratives often have a stereotyped character and are "too beautiful to be true." When sufficient information is available, the "mistake" tends to become less plausible as an explanation and to appear as an argument that enforces the attack while exonerating the assailant. Not surprisingly, Joseph Beuys was the victim of such "mistakes" on several occasions. After his death, his assistant Johannes Stüttgen discovered in a waste-paper basket a *Fettecke* (fat corner) made of butter that Beuys had installed five meters high in a corner of his studio at the Düsseldorf Kunstakademie. The school claimed that the janitor and his workers had "not recognized Beuys' work as an art object" when cleaning the room, but Stüttgen brought the case before trial and won.

The director of the school received a letter congratulating the janitor for having "done consciously or unconsciously, the only right thing to do with this Beuysian trash, namely to put it where it belongs, on the rubbish heap."[39] This comment makes explicit what the gardener's advertisement probably insinuated, as well as the meaning of many instances of "iconoclasm by mistake": by treating as waste what is presented to them as art, the "innocent vandals" reject this claim, express their contempt of the object, and lay on it the blame for its own destruction. A parallel can be found in Natalie Zemon Davis' interpretation of sixteenth century religious acts of violence, to which she finds "the character either of rites of purification or of a paradoxical desecration, intended to cut down on uncleanliness by placing profane things, like chrism, back in the profane world where they belonged" in order to redraw "the line between the sacred and the profane."[40] The element of joke also relates "iconoclasm by mistake" to the tradition of carnival, understood as a way to restore rather than overthrow a given order. Josef Kleer, who defined his action against Newman's painting as "a small contribution to cleanliness," also found the "order of values somehow downright topsy-turvy," and the author of *The Boy who Breathed on the Glass in the British Museum* used the same metaphor to describe the conversion of a painter to Futurism or Vorticism. With the means at their disposal, the "innocent vandals" attempt to put art and the world back on their feet.

39 40

_ Natalie Zemon Davis, The Rites of Violence: Religious Riot in Sixteenth Century France, in *Past and Present*, 59, May 1973, pp. 51-91 (pp. 5, 83).

_ Letter of 21 October 1986 from Manfred Huppertz to Professor Irmin Kamp, reproduced in Johannes Am Ende (ed.), *Joseph Beuys und die Fettecke: Eine Dokumentation zur Zerstörung der Fettecke in der Kunstakademie Düsseldorf*, Edition Staeck, Heidelberg, 1987, p. 13 ("Er hat, bewußt oder unbewußt, das einzig richtige getan, das man mit diesem Beuys'schen Mist machen muß, ihn nämlich dahin zu befördern, wo er hingehört, auf den Müllhaufen!")

Battista Angolo del Moro (attributed) / A Vision of the Holy Family Near Verona / 1581 / oil on canvas / 35 x 43.25" / Allen Memorial Art Museum, Kress Study Collection, Oberlin College, Ohio / © photo: Allen Memorial Art Museum, Ohio

Indestructible Images

Latour's "As," who are against all images, are expectedly rare in the domain of art, and, rather, represent a sort of limit. One misses a category situated somewhere between "As" and "Cs" for those who do not reject the principle of using images but certain images, favored or defended by others. This is for

Markus Raetz / Aus der Serie »Im Bereich des Möglichen« [From the Series »In the Realm of the Possible«] / 1976 / diluted ink / 7 x 9.5" / Aargauer Kunsthaus, Aarau

instance the case in the movement of modernization of church art, where a rejection of all images tended to appear only when other attempts had failed. One can locate to some extent "As" in the anti-art tendency of Dada and – provided one understands "image" in the restricted sense of mimetic representation – in the anti-figurative tendencies of modernism.

The more or less explicit references to the idea of a "murder of the father" we have encountered make clear that avant-garde "iconoclasm" can be linked to the desire and necessity to outstrip one's predecessors (in Rauschenberg's case the dominant generation). In 1968, Ronald Searle suggested that the iconoclasm of the "Philistine" springs from (real rather than merely feared) impotence. The logic of the art market and of art criticism (and history) supports this in-built aggression, which can also respond to real attempts at immobilizing tradition and to the growing cult of heritage. Not only have most artistic assaults against art been the source of new forms of creation, but the rejection of the artwork's claim to endure has provided experiments in other modes of preservation – for instance of process rather than product – that only begin to be acknowledged and explored.

Many "iconoclasts" have been consistent with this logic in including the destruction of their own work in their calls for renewal. Marinetti, when proposing to free Italy from the burden of its past by demolishing its museums and libraries, also predicted that ten years later, younger creators rising to attack him and his fellow Futurists would find them burning their own books and would have to kill them, "for art can only be violence, cruelty and injustice."[41] The art dealer Ambroise Vollard recalled what Degas told him when he regretted that the artist had turned back into a ball of wax the almost finished sculpture of a dancer: "You think mostly of what it was worth, Vollard, but had you given me a hat full of diamonds, I would not have been as happy as I was to demolish this for the pleasure of starting again."[42] Rodin made a working method out of this constructive destruction,

41 42

_ Filippo Tommaso Marinetti, Manifeste technique de la littérature futuriste, in Le Figaro, 20 February 1909, quoted after Giovanni Lista, Futurisme. Manifestes, proclamations, documents, L'Age d'Homme, Lausanne, 1973, pp. 85-89.

_ Vollard, Degas 1834-1917, Paris, 1924, p. 113 ("Vous pensez surtout, Vollard, à ce que ça valait, mais m'auriez-vous donné un chapeau plein de diamants que je n'aurais pas eu un bonheur égal à celui que j'ai pris à démolir ça pour le plaisir de recommencer.")

Raoul Ubac / Natural Objects and Landscape / photographies / reproduced in Dictionnaire abrégé du surréalisme, Paris, 1938, p. 32

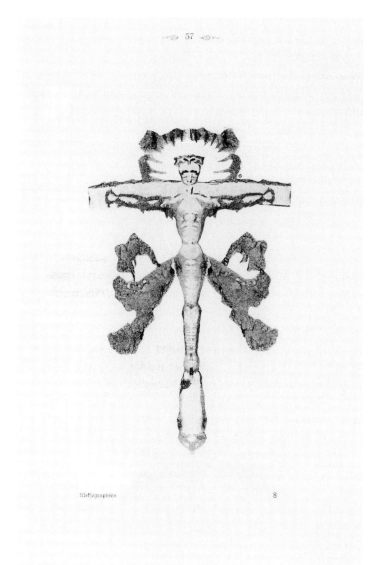

»Menschenhand hat nicht dies Bild gemacht ...« [This picture was not made by human hand ...] / Christ on the cross, interpreted blot by Justinus Kerner / before 1857 / from his book Kleksographien, Deutsche Verlags-Anstalt, Stuttgart, 1890

Minette Varí / Mirage / 1999 / video animation / 40 seconds / looped indefinitely / 100 seconds / videostill

constantly recycling fragments and casts of his own previous works. Baumeister not only overpainted postcards of paintings by his nemesis Ziegler, but also of his own works.

Those who damage or "complete" works in order to bring them back from the status of historical monument to that of "iconoclastic" breakthrough, like Tony Shafrazi, claim to belong to the "Bs," who are against "freeze-framing" and not against images or art. We have seen that Jorn suggested to "paint over the pictures to preserve their actuality and to help them from falling into oblivion." But they fall victims to a form of materialism or realism by thinking that a work must be modified physically in order to survive or be resurrected, and they seem blind to the fact that they appropriate what they claim to be liberating, in a way that is bound to impose their view on others, maybe forever. Felix Gmelin, who does not confront his "art vandals" with this criticism, is led by the institutional theory to believe that "by turning Picasso's *Guernica* into a masterpiece, the museum helps to make the picture historic, thereby rendering it invisible in the present." "The museum" is only one actor of the collective process by which a work becomes "a masterpiece," a process that can make it more difficult, but never impossible, to see it "in the present."

In the case of works like Duchamp's *Fountain*, the iconoclastic "resurrection" also simplifies the matter by trying not only to erase the historical process of entering the canon but by reducing its initial ambiguity to the "iconoclastic," anti-art component. In fact, the great "iconoclasts" of modernism tend to oscillate between "As" and "Bs." We have seen it in the case of Duchamp, and there is no need to emphasize the extraordinary artistic fecundity of the Readymade. Something analogous can be said of Malevich, whose *Black Square on White Ground*, presented in 1915 at the *0.1* exhibition in St. Petersburg, was meant to "reduce everything to zero" before starting again and can be seen as the negation of all images or, in the artist's own terms, as "the embryo of all possibilities."[43] The fight against "freeze-framing" became ever more urgent in the 1930s when the totalitarian regimes endeavored to re-instrumentalize art and make it serve a univocal, controllable communication. Baumeister's overpainting of Ziegler's Nazi allegory is a perfect example of this fight: it makes a freezed and freezing image move again, and it reveals its implicit ingredients, the male spectator and sexuality.

Authoritarian tendencies, however, were not absent from the field of modern art itself. They are particularly apparent in the aniconism of rationalist architecture and of geometric abstraction, as the language of a Le Corbusier or a Mondrian sometimes betray, and they can also be found at the opposite end of the controversy between abstraction and figuration, in the manipulation of the viewer by Dalí and his followers.[44] The modernist identification of the work of art with its formal and material traits enforced these tendencies and allowed Leo Steinberg to criticize formalism in 1968 for its "interdictory stance – the attitude that tells an artist what he ought not to do, and the spectator what he ought not to see."[45] Those who considered non-objectivity as the sole end of art tended to accuse the defenders of "representation" of fostering and falling prey to an "illusion," as if painting had not always played on the tension between image and surface and reminded the spectator, like a remarkable late sixteenth century painting, that an image leads to another image.

This "interdictory stance" forced some modes of representation to lead a life in disguise, like "figuration" in abstract art or ornament in modern architecture, which tended to employ mostly or exclusively the suggestive power of the materials themselves. Unexpectedly, the use of marble facing returns to the late Antique taste for colored marble and its use in Byzantine architecture, where it paralleled the veneration of acheiropioetic images (i.e. not made by human hands) and contributed to the iconography as well as to the decoration of churches.[46] This is not so surprising after all because the dedication of modern and contemporary art to metamorphosis and to what Latour calls "cascades of images" is closely

43 45 46 44

_ Kazimir Malevich, Du cubisme au suprématisme en art, au nouveau réalisme de la peinture en tant que création absolue (1915), in Kazimir Malevich, *De Cézanne au suprématisme. Tous les traités parus de 1915 à 1922*, trans. Jean-Claude and Valentine Marcadé, L'Age d'Homme, Lausanne, 1974, pp. 37-43; Charlotte Douglas, Evolution and the Biological Metaphor in Modern Russian Art, in *Art Journal*, 44, 2, Summer 1984, pp. 153-161

_ Leo Steinberg, Other Criteria, in *Artforum*, March 1972, reprinted in Leo Steinberg, *Other Criteria: Confrontations with Twentieth Century Art*, Oxford University Press, New York, 1972, pp. 55-91 (p. 64).

_ John Onians, Abstraction and Imagination in Late Antiquity, in *Art History*, 3, 1, March 1980, pp. 1-24; James Trilling, The Image not Made by Hands and the Byzantine Way of Seeing, in *The Holy Face and the Paradox of Representation*, Herbert L. Kessler and Gerhard Wolf (eds), Nuova Alfa Editoriale, Bologna, 1998, pp. 109-127; J. Trilling, *The Language of Ornament*, Thames & Hudson, London, 2001.

_ For more details on this and what follows, see Dario Gamboni, *Potential Images: Ambiguity and Indeterminacy in Modern Art*, Reaktion Books, London, 2002.

linked to a fascination for accidental images and for techniques that allow the artist to be an "operator," a mediator, or a "medium" rather than an author. Interestingly, this fascination tends to bring together the domains and resources of science, religion, and art around the genesis of images. One can think of the German physician and poet Justinus Kerner, a follower of Mesmer and early explorer of parapsychology, who made blots that he saw as creatures who had used his inkpot to enter into our world; of the Swedish playwright and painter August Strindberg, who in 1893-1894 claimed to produce true images of the stars by exposing to the night sky photographic plates immersed in developing fluid; of the Surrealists' interest in "fetishes," divination and the representational capacities of "natural objects"; and of post-modernist pseudo-mimetic images like Markus Raetz's series of ink drawings entitled *In the Realm of the Possible.*

Such images involve the spectator in their making and establish a problematic relationship with their author and with their referent. Mallarmé, who referred to the ideal author as an "operator," adopted a position that seems paradoxical in being simultaneously iconoclastic and iconophilic, when he wrote that the agent of literary pleasure is a *beyond* that may not exist and defined as "impious" the temptation to "disassemble the mechanics of literature in order to show its chief cog – or nothing."[47] Pierre Bourdieu has described this attitude as "decisory fetishism," a desperate attempt at preserving the "play" (Mallarmé's word) of literature without sharing the "illusion" or "belief" on which it is based.[48] But Mallarmé admits that this *beyond* is a "lure" only to the extent that "we are prisoners of an absolute formula according to which only what exists exists." I think that the apparent inconsistency Mallarmé describes is an attempt to save literature from iconoclasm while confronting the latter, and a positive definition of "fiction" as literature's proper realm. One finds a contemporary and parallel attitude toward the visual arts in Odilon Redon's definition of the "sense of mystery," which consists of "a continuous ambiguity, in double and triple aspects, hints of aspects (images within images), forms that are about to be or will take their being from the onlooker's state of mind."[49] The physical and mental flow of images that Redon evoked in relation to drawings, prints, and paintings can now use the capacity for metamorphosis of virtual imagery. In a recent video animation by the South African artist Minette Varí, a coat of arms suggesting formality and stability transforms itself into moving nude bodies until it completely loses shape and then regains a heraldic structure. In the process, the initial Latin motto "The heat of history is in our breath" becomes "The fever of memory is in our veins"[50]: the dissolution of the initial image has allowed the transmission of memory. |

47

50 49 48

_ Clive Kellner, Minette Varí 1968, in *La Biennale di Venezia,
49. Esposizione Internazionale d'Arte,* exhib. cat., Electa, Milano, 2001, vol. 1, p. 236.

_ Pierre Bourdieu, *Les règles de l'art. Genèse et structure du champ
littéraire,* Seuil, Paris, 1992, p. 382 ("fétichisme décisoire").

_ Odilon Redon, *A soi-même. Journal (1867-1915). Notes sur la vie, l'art et les artistes,* José Corti, Paris, 1961, p. 100.
(1902: "Le sens du mystère, c'est d'être tout le temps dans l'équivoque, dans les double, triple aspects, des soupçons
d'aspect (images dans images), formes qui vont être, ou qui le seront selon l'état d'esprit du regardeur.")

_ Stéphane Mallarmé, La musique et les lettres (1894), in Stéphane Mallarmé, *Œuvres complètes,* Henri Mondor and
Georges Jean-Aubry (eds), Gallimard, Paris, 1945, p. 647 ("Nous savons, captifs d'une formule absolue que, certes, n'est
que ce qui est. Incontinent écarter cependant, sous un prétexte, le leurre, accuserait notre inconséquence, niant le plaisir
que nous voulons prendre: car cet au-delà en est l'agent, et le moteur dirais-je si je ne répugnais à opérer, en public, le
démontage impie de la fiction et conséquemment du mécanisme littéraire, pour étaler la pièce principale ou rien.")

NATURE PAINTS

Lorraine Daston

EVEN IF ICONOCLASTS SUCCEEDED IN DESTROYING all representations made by human beings, the world would still be full of images: *natura pingit* – nature paints. There would be the portraits of bearded men and stalking cats discerned in marble, the delicately boned and fronded imprints of fish and ferns left in sandstone, the polyhedra arranged with a geometer's precision as a cluster of quartz crystals, the bluish-brownish landscapes of mountains, seas, and cities in Florentine jaspar. From Pliny through the Enlightenment, the works of naturalists catalog nature's mineral images: the agate of King Pyrrhus depicting Apollo and the nine muses described by Pliny,[1] stones bearing the forms of Saint John the Baptist and all the letters of the Latin alphabet reported by the Jesuit savant Athanasius Kircher in his *Mundus subterraneus* (1665), whole categories of stones resembling parts of the human body and various plants and animals listed in *L'Histoire naturelle éclaircie* (1742): breast-stones *(matites)*, dog-stones *(cynites)*, pheasant-stones *(perdicites)*, laurel-stones *(daphnites)*. Nature was an indefatigable image-maker, sometimes imitating her own works in other media (plants and animals depicted in stone), but sometimes also the work of human hands, as in the case of this "Pierre de Florence," which seems to show a city of jutting "towers, belfries, obelisks, buildings of every kind, but half-ruined, and surrounded by debris," as the French mineralogist Eugène-Melchior-Louis Patrin described this particular piece in his *Histoire naturelle des minéraux*.[2]

These "Florentine stones" were so named because they were plentiful in Tuscany, and the scenes that emerged when their surfaces were polished resembled in form and color the local landscapes where they were found: sunburnt hillsides the color of ochre, bare of vegetation; turreted towns like San Gimigniano – nature painting from nature, as it were. Because they blurred the boundary between the fundamental categories of art and nature, Florentine stones were as much marvels as monsters that straddled the line between animals and humans, and both were coveted by proprietors of Renaissance *Wunderkammern*. Florentine stones also ornamented the cabinets custom-built to house and display such wonders. The Augsburg entrepreneur Philip Hainhofer, who oversaw the construction of several fabulous *Kunstschränke* (including the one presented in 1632 to King Gustavus Adolphus of Sweden and now on display at the University of Uppsala), kept up a lively trade with Florentine merchants for such stones "with landscapes and buildings that grow by themselves." Just as the artists who painted the trompe l'oeil still-lifes also favored by *Wunderkammer* collectors strove for a perfect mimesis of nature, so nature repaid the compliment to art in the landscapes of Florentine stones. Art and nature might even collaborate on one and the same image. The Museo dell' Opificio delle Pietre Dure in Florence contains many examples from the Medici collection in which the human artist has followed nature's cue, adding a ship in full sail to the waves formed by nature, or an Andromeda and Perseus to a wild grotto already etched in stone.

How and why did nature paint? The thirteenth century natural philosopher Albertus Magnus thought it unsurprising that nature's works should resemble and often surpass in craftmanship those of art: art and nature after all formed objects by the same processes. Hence Albertus identified a Hellenistic cameo (probably the Ptolemy cameo, now owned by the Kunsthistorisches Museum in Vienna) as a work of nature, hardened by astral influences out of vapors, just as heavenly bodies could sometimes impress the face of a human onto the soft matter of a pig or calf embryo.[3] Other naturalists, like the sixteenth century physician and mathematician Girolamo Cardano, pointed to the "gorgonizing" power of certain springs: Cardano argued that the celebrated Pyrrhus agate had originally been a painting by a human artist accidentally left in a cave, which gradually petrified the image. Still others invoked nature's "plastic virtues": nature was brimming over with forms in the forms of seeds, which occasionally were deposited in the wrong matter, producing for example animal or vegetable forms in minerals.

1

_ Pliny, *Historia naturalis*, XXXVII. 3.

2 3

_ Albertus Magnus, *De lapidus*, II.iii.ix.

_ Eugène-Melchior-Louis Patrin,
Histoire naturelle des minéraux,
Crapelet, Paris, An IX.

Writing in 1676 to the Royal Society of London about trochites he had found in Somersetshire, John Beaumont was willing to accept that some might indeed be the fossilized remains of plants or animals, but insisted that this explanation could hardly account for all figured stones: let skeptics concerning nature's plastic virtues "view the figurations in *Snow*, let them view those delicate landskips ... carrying the resemblances of whole groves of Trees, Mountains and Vallies, & c." Nature's images – including what we would now call fossils, crystals, snowflakes, agates, dendrites, as well as Florentine stones – formed a unified category until well into the eighteenth century, and therefore demanded a uniform explanation.

The notions of imagination and play, have, since antiquity, clung to the category of nature's images, but their subject has migrated in remarkable ways. Following Pliny, Renaissance naturalists described Florentine stones and other images painted by nature as sports of nature, *lusus naturae*. Here nature strayed from her wonted paths, and decoupled form and function as well as form and matter from their familiar pairings. In contrast to the leaf of a plant or the eye of an animal, a mineral landscape had been engineered to no conceivable purpose except to delight – hence the notion of nature at play. The imagination in question was nature's own, fertile in forms and surprises. Nature's imagination might inspire that of the artist: Leonardo da Vinci recommended staring at suggestive natural forms like clouds until an idea emerged from nature's rough sketches. This was surely the process by which Filippo Napoletano and other artists elaborated the Florentine stones in the Medici collection. But in the course of the eighteenth century, the locus of imagination and play slowly migrated from nature to the human beholder. In his *Protogaia* (1749), Leibniz ridiculed Kircher's inventory of fantastic forms in stone, claiming that the more one looked, the less one saw; by the late eighteenth century, learned mineralogists insisted that the landscapes detected in Florentine stones were entirely due to the projections of the human imagination. By the late nineteenth century, some naturalists went so far as to deny the existence of the stony landscapes altogether; only humans could make images. Thus nature's images succumbed to the peculiar opposition of anthropocentrism and anthropomorphism that was so characteristic of post-seventeenth century metaphysics: because human beings monopolize thought and agency in the universe, any resemblance in nature to human artifice must be rejected as subjective projection – anthropocentrism combats anthropomorphism. Nature no longer paints; if she plays, it is a blind game of chance, not an artful crafting of forms. |

FROM NEW IRELAND TO A MUSEUM: OPPOSING VIEWS OF THE MALANGGAN

Brigitte Derlon

MANUFACTURED OBJECTS, IRRESPECTIVE OF WHAT THEY ARE or where they come from, can easily defy their initial destiny, be diverted from their original function or meaning, and become something other than they were intended to be. Which one of us has never used an empty glass bottle for a rolling pin or a toothbrush to spray paint on a sheet of paper? Who, as a child, never transformed an object with a suitable shape into a gun or magic wand? While all objects are subjected to and all individuals practice this type of diversion, museums are their institutional settings par excellence.

The case of objects from distant civilisations is particularly interesting. By entering Western museums they not only penetrate another space marked by its own rules; they also enter into another culture, ours, which has its own systems of representation and therefore intellectually re-appropriates these objects by giving them new meaning.

Based on a particular example with which I am thoroughly familiar, the *malanggan* sculptures from the Melanesian island of New Ireland I question the nature of the diversion of these objects by museums and, more generally, our Western cultures. This questioning leads me to consider the differences and similarities of the relationship to an object in these two very distant cultures, both geographically and ideologically.

If a Melanesian from New Ireland were to visit the Vieille Charité Museum, he would be astounded to see *malanggan* sculptures on display. What would probably puzzle him most would be to see, first, that we have carefully conserved sculptures which his people normally discarded or burned only a few hours after they had been carved. Second, he would be amazed that we have also exhibited the *malanggan*, as in New Ireland, but for longer than three days, in a place other than a burial site, without excluding women from the show and therefore in total contradiction to rules on New Ireland.

In their home country, the *malanggan* were produced, exhibited, and destroyed on the burial ground, out of sight of women, as part of the ceremonies concluding all the funeral rites of one or more individuals. Their life span never exceeded three days, the maximum period for which they were displayed in a small open hut or against a fence – the equivalent, in a sense, of a museum plinth or showcase. And that is where we Westerners are, in turn, perplexed. What is the meaning of the exhibition of objects in a culture that traditionally has no knowledge of museums and that is part of those peoples, formerly described as primitive, who are often said to have no idea of aesthetic contemplation? Moreover, why do Melanesians spend many months making very elaborate sculptures in a lasting material (wood), to destroy them so quickly afterwards by burning or deliberately leaving them to deteriorate under the combined effects of the weather, worms, and insects? Why make to destroy?

I start by considering the meaning of the exhibition of objects both in New Ireland and in our own Western societies.

Note that some analogies do exist between the inauguration of an exhibition such at that of Papuan Art, and the revelation of the *malanggan* sculptures as formerly practised in New Ireland.

In Western societies, an inauguration is the ceremony in which the objects carefully selected by the organizers of the exhibition, generally from different private and public collections, are revealed to the public for the first time. The material presence of the objects always produces a shock among the visitors, even those who have already seen some of the exhibits in museums or in photographs and have memorized some form of image.

In New Ireland most of the men who eagerly went to see the *malanggan* sculptures on display had already seen similar pieces in previous ceremonies. Yet, as in our case, the actual presence of the object was far more impressive than the memory. Furthermore, the secrecy shrouding the sculpting of the *malanggan* was intended to enhance the effect of surprise produced by their subsequent exhibition.

While we can sometimes talk of a form of dramatization of museum inaugurations, especially when they include speeches by one or more official persons, this dramatization bears no comparison with that accompanying the ritual unveiling of exhibited *malanggan* on their island of origin. Everything was then made to convince the public that the *malanggan*, too impressive to be mere artifacts, were embodied supernatural entities to be looked at with great respect.

In museums visitors are also expected to be respectful, to stand at a certain distance from the objects, not to touch them and, if they wish to share their impressions with someone, to do so softly. Not only does visitors' expected behavior have something religious about it but, like Melanesian beholders, they are also confronted with a transcendence related to the impression of beauty. As many specialists have pointed out, art has become our religion and museums our temples in which visitors, faced with the sacredness of the art, communicate. Aesthetic contemplation is akin to prayer. In short, each culture has its transcendence.

Yet, for Melanesians, the *malanggan* that we exhibit in our museums are ugly things; ugly because old. For them, our museums are full of junk, used objects without the slightest value, objects that westerners collected at precisely a time when the Melanesians were about to burn or discard them.

In our view, by contrast, the older a piece and the more faded and worn it is by time, the greater its aesthetic qualities and market value will be. For lovers of so-called primitive art, the most beautiful pieces are always the oldest ones, those produced in the pre or early colonial era. There is total irreducibility between Western culture which is so fond of old *malanggan* and Melanesian island cultures in which only new *malanggan* have guaranteed beauty and effectiveness.

More than the object itself, destined for a fleeting existence, what interested the Melanesians was precisely its creation and destruction, two highly significant ritual acts. The slow and secret production of the *malanggan*, accompanied by multiple ritual steps punctuating the progressive shaping of the object, was likened to a gestation or birth. Their destruction by fire or decomposition of the wood related, by contrast, to the treatment of human corpses that were burned or left to rot in the open or underground. By destroying them the men forced themselves to have to make new sculptures for subsequent ceremonies. The ritual death of the *malanggan* was, in a sense, a sign that other sculptures would be born in the future.

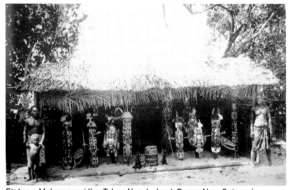

Statues, Malanggan / Iles Tabar, New Ireland, Papua New Guinea / photograph, black-and-white / Staatliche Museen zu Berlin – Preußischer Kulturbesitz, Ethnographisches Museum

Two Statues, Malanggan / Iles Tabar, New Ireland, Papua New Guinea / collected by captain Farrell in 1887 / wood, fiber, seashell, (organic) pigments / hight 28.8" / Australia Museum, Sydney

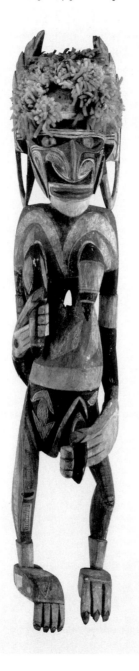
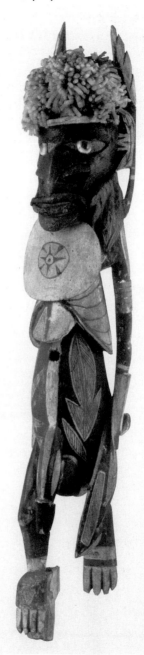

While the destruction or abandoning of *malanggan* sculptures at the end of funeral rites explains why so many of them were able to be collected by Europeans in Melanesia and are now part of public and private collections throughout the world, one must understand that, for Melanesians, their destruction was an important element in the cycle of regeneration, that is, in the idea that death and rot are at the origin of all life. Thus, considering as some do that by saving objects from destruction we have saved the "soul" of a culture is totally meaningless.

We should not, however, deduce from the ephemeral nature of the sculptures that the Melanesians had no desire for permanence in the *malanggan*. For us, a *malanggan* is a sculpture, a concrete reality. For them, a *malanggan* was above all an abstract image, a permanent mental representation that was episodically materialized in the tangible form of sculptures. The notion of ownership related not to the temporary sculptures but to their abstract image, their model, considered to be permanent. It was not the physical objects themselves but the rights to have them made that circulated among individuals and clans and could be traded.

We can well imagine how astounded the Melanesians would be if they discovered the exorbitant market value we give to *malanggan* – that is, to perishable, old and ugly goods, in short, their trash. For them, the only thing that has a market value is the image of each type of *malanggan* and the right to materialize that image, in other words, the right to have new sculptures carved. Conserving *malanggan* as we do, without trying to reproduce them, to make new ones, would probably seem to them the height of sterility.

Another paradox would undoubtedly strike a Melanesian visiting our countries. Why have westerners collected and conserved in their museums effigies of supernatural beings which the missionaries considered to be pagan idols or false gods, the production of which they strove to eradicate?

By way of conclusion, on the basis of the comparison of our conception of the *malanggan* and that of the New Ireland islanders, I think that in many ways our culture is as strange to them as theirs is to us. At a time when the introduction of primitive art into the Louvre and the creation in Paris of a future museum of arts and civilizations are endorsing the recognition of the plastic forms of expression of these cultures, placed on a par with the best Western art, it seems useful to remember two things. First, although Melanesians are profoundly sensitive to the beauty of their sculptures, their aesthetic conceptions which liken beautiful to new are antinomic to ours. Second, our concern for preservation, reflected in the very existence of museums as institutions, is for them synonymous with death; not a good death that is transformed into life, but definitive death not followed by regeneration, and therefore the opposite of permanence. For them, our museums are full of corpses against the decomposition of which curators and restorers pathetically struggle, unaware that they are the real mechanisms of the reproduction of life. The only points that we really have in common, the Melanesians from New Ireland and ourselves, are sacred nature, the transcendence and the elitism of art, the force and impact of the raw presence of the object revealed, and the aesthetic emotion it arouses, even if these phenomena convey very different meanings in our respective cultures, as I hope I have shown here. |

Translated from French by Liz Libbrecht

SEARCHING FOR SOMETHING. ON PHOTOGRAPHIC REVELATIONS

Peter Geimer

SINCE 1578, THE CATHEDRAL OF TURIN has housed a cloth that shows a weak, brownish silhouette of a male body. It is said to be the Holy Shroud, the linen that wrapped the corpse of Christ after the crucifixion (Mark 15:46). In 1898 Secondo Pia, a lawyer and photographer, was instructed to take the first photographs of the shroud. On 28 May he exposed two 20 x 23.5" glass plates, which he developed the same night. The photographs were said to have revealed something new and unexpected: on the negative there appeared a positive image. It showed the front and the back of a male body, bright on a dark background, apparently three-dimensional as though lit from above. The brownish traces – hardly decipherable on the shroud itself – became a light and readable image. Pia concluded that the traces on the linen must have been a negative: that is why the negative of this negative became a positive image.

The long history of the shroud suddenly appeared as a prelude. In retrospect it became the history of a code, unlocked only in the age of photographic reproduction. On 2 June, the shroud was shut away again. In the absence of the shroud the photographic double took on its own life, provoking a scientific debate about the authenticity of the shroud – hidden in its silver case.

In 1902 the French biologist Paul Vignon published a monograph on the shroud: *Le linceul du Christ. Etude scientifique.*[1] Vignon attached great importance to his thesis that no human hand was at work in the production of the image on the shroud. As an artifact, the linen would have been just one of the thousands of representations of Christ that art history had put into circulation. In Vignon's view none of these images resembled its historical model. Art history had yielded typifying pictures of Christ but no corporal inscription of his identity.

Vignon's experiments attempted to reproduce the effects that had caused the inscription on the linen in his laboratory to verify their natural origin. He denied any possibility of fraud by *printing* the image. Vignon asked an assistant to color his own face and print it on linen. Corresponding to his reproductions of the shroud, he reproduced his results both in negative and positive versions (fig. 1). Unlike Vignon's face printing, the image on the shroud is said to be a projection that cannot alter the proportions of the model. The greater the distance between object and screen, argues Vignon, the weaker the image. Thus, it must have been a chemical action at a distance *(action à distance)* that had yielded the traces on the shroud – traces beyond contact: "*Quelque chose* a émané du corps et a agi sur le drap." It is this blank, this *quelque chose*, that Vignon tried to identify in his experiments.

Finally the blank was filled with help from a French physicist. In 1900 Réné Colson published an article that mentioned the mysterious action at a distance already in its title: *Revue des actions à distance capable d'influencer les couches photographiques.*[2] The text concerned a series of experiments in which Colson tested the sensitivity of the photographic plate. Like Vignon, Colson searched for *something*. His final aim was to explain the miraculous origin of disturbing artifacts (veils, fogs, and spots) that appeared on the photographic print. "Il y a donc émission de quelque chose ..." Among other substances to produce these accidents, Colson tried zinc. He discovered that a roughened piece of zinc affects the photograpic plate – even at a distance. Vignon later used this research on photochemical artifacts to explain the image on the shroud: Colson and Vignon constructed models, treated them with zinc-powder and let them react against a photographic plate. According to Vignon, the results were relief-pictures, similar to the ones on the shroud. But the last gap – the chemical origin of the traces – had to be closed as well. With reference to Hebrew burial-rites, Vignon discovered the sensitizing capacity of aloe. The active substance was ammonia-carbonate, released by the sweat of Christ. Finally Vignon dared a neologism: "Nous savons enfin quel nom qu'il faudrait donner aux empreintes [...]: ce sont là des impressions vaporographiques."

1 2

_ Paul Vignon, *Le linceul du Christ. Etude scientifique*, Masson, Paris, 1902.

_ Réné Colson, Revue des actions à distance capable d'influencer les couches photographiques, in *Comptes rendues de l'Académie des Sciences*, X, 1896.

Printing of Paul Vignon's face on linen / from: Paul Vignon, Le lincuel du Christ.
Etude scientifique, Masson, Paris, 1902, plate VII

Head of Christ / emanation of zinc on a photographic plate / from: Paul Vignon, Le lincuel du Christ. Etude scientifique, Masson, Paris, 1902, plate VIII

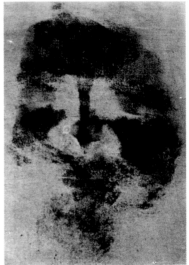

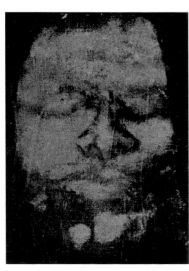
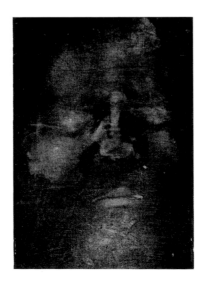
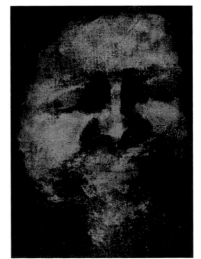

In Vignon's view, photography was a medium of truth: a technique that allowed one to explore the invisible without being visible itself. In A. L. Donnadieu's study *Le Saint Suaire de Turin devant la science* (1903),[3] the forgotten materiality of photographs again attracted attention. What Vignon had treated as a photographic revelation of hidden truth now seemed to be the effect of photographic failure. Donnadieu, professor at the Faculté Catholique des Sciences in Lyon, did not deny the scientific usefulness of photography at all. However, in the case of Pia's photographs of the shroud, Donnadieu reduced their optical information to the artificial effects of technology itself: the appearance of a positive image on a photographic negative could be explained simply by the different photochemical activities of every single part of the spectrum. In order to demonstrate this phenomenon, Donnadieu presented a drawing and its photographic reproduction. A blue drawing on a yellow ground forms a positive image. But due to the varying photogenic activities of blue and yellow, a photographic negative of these drawings reveals a positive image as well.

It seems as though the differences between Vignon's and Donnadieu's approaches could not be greater. Vignon's true image of Christ turned into a photochemical accident. The medium was the message. However, it is worth noting that Vignon and Donnadieu both shared the same heuristic principles. Like Vignon, Donnadieu contrasted the capacity of photographs with the failure of human eyes. With regard to Pia's technical mistakes, Donnadieu argues: "Si l'œil humain s'y est trompé, la plaque photographique, elle, ne s'y est pas trompée ..." Thus, Donnadieu did not accuse photography but Pia's and Vignon's deficient use of it. The medium is innocent. Indeed, the photographs were false; but they were *truly* false, they were genuine artifacts, exact recordings of existing phenomena. They stick to reality where our eyes must fail. It was exactly this incorruptibility of the photographic plate that Donnadieu's own photographs should demonstrate.

Our story ends with a peculiar perspective. Beyond Vignon's and Donnadieu's incompatible interpretations of Pia's photography, a strange agreement on the reliability of media is at work. Vignon und Donnadieu both agreed on the optical surplus that Pia's photographs revealed – in both cases the photographic plate is said 1. to reveal *more* (and/or *something else*) than the original linen itself and 2. to have registered what no human eye could decipher – a hidden portrait of Christ / the effects of unnoticed photographic failure. Donnadieu, who attempted to unmask Vignon's dependence on photography, shared this dependence himself. He even showed how, under certain circumstances, the photographic plate could survive the scientific demonstration of its own deficiency – since this demonstration was carried out by photographic plates. |

3

_ A.-L. Donnadieu, *Le Saint-Suaire de Turin devant la science*, Charles Mendel, Paris, 1903.

GALILEO'S FINGER

Jean-Marc Lévy-Leblond

THE PICTURES OF NATURE THAT SCIENCE GIVES US purport to show reality as it is. But this is equally true for the pictures that science gives of its own nature; hence the various instruments and apparatuses exposed in the museums of science and technology, which are supposed to represent and demonstrate the objectivity and neutrality of science's views of the world. Contrary to the paintings and sculptures exhibited in art museums, scientific artifacts are supposed to be appreciated, not for their aesthetic value, but for the cleverness of their conception and operation. Their cultural value, as well as their social settings, is rarely emphasized.

Nevertheless, as visitors sensitive to the decorative style of objects will immediately note, the materials and decorations of any scientific instrument, expressing the contemporary craftsmanship, bear strong witness to its geographical, historical, and social context. Convincing examples are offered by the comparison between the elaborate and ornate optical instruments belonging to royal collections of scientific patrons such as King George II of England, and the much more sober instruments to be found in the Boerhaave Museum at Leiden, clearly reflecting the Protestant and bourgeois ethics of the seventeenth century Netherlands. A more exotic example, but no less impressive, is furnished by the seventeenth century astronomical instruments still to be found at the old Beijing observatory; while being built under the incentive of the Jesuit scholars, they display the whole repertory of traditional Chinese decorations, with heavenly dragons used both symbolically and technically as elements of construction.

But the cultural mark of the times and places of science can be found as well in pieces of the scientific heritage which might easily be neglected, as they are secondary from the point of view of the production of knowledge as such. Let us go to the Museo di Storia della Scienza in Florence and visit the Galileo room. Of course, we will first see the telescopes, inclined planes, thermoscopes, and lodestones which exemplify the scientific work of the founder of modern physics. But two more objects, without any scientific use whatsoever, demand our attention, objects that look much more like those that can be found in the nearby churches than their technical neighbors in the same showcases. Indeed, the first item of the Galilean collection is an elaborate frame of ivory on ebony (16 x 12"), gracefully carved and decorated with floral ornaments and scientific instruments. The role of this contraption is mysterious enough, until one realizes, that, right in its center, lies a small round glass (in 1.2"diameter), split in two parts. It is the lens of the telescope used by Galileo to make his epochal discoveries of January 1610 (the mountains on the moon, the satellites of Jupiter, the stars in the Milky Way, etc.). In fact, this telescope was offered by Galileo to Ferdinand II de Medici when, a few months later, he was enrolled as First Mathematician of the Grand Duke of Tuscany. Accidentally broken, the lens was carefully rescued and framed in 1677 to be part of the prestigious Medici collection. What is this, if not a host in a monstrance?

Nearby is a small marble column surmounted by a glass globe (6" in diameter, 17.5" in height). Within the globe stands, a parched and crumpled finger – no less than the middle finger of Galileo's right hand. At the base, an engraved Latin inscription reads, "This is the finger with which the illustrious hand covered the heavens and indicated their immense space, etc." The story of this rather macabre display goes back to 12 March 1737, when Galileo's remains, which had been relegated to a small closet of the church of Santa Croce for almost a century, were finally transferred to the majestic mausoleum built on the incentive of his pupil Vincenzo Viviani and facing, in the nave of the church, the funerary monument of Michelangelo. The finger was piously detached by the scholar Antonio Gori, and one may well wonder why he did not remove the index finger certainly the one with which Galileo used to point out at the sky. With the books of Galileo still put on the index, the irony would have

been tempting, but perhaps risky. Finally, the finger, naturally pointing upward, was mounted in its elaborate casket, quite similar to those holding various bits and pieces of so many saints in neighboring churches. What indeed, if not a holy reliquary, is this stand?

These objects unwittingly show how the figure of Galileo was seen within a context dominated by the art forms and mental representations of the Catholic culture. Even for those who, in the eighteenth century, raised Galileo's character to the status of a hero of (scientific) reason against (religious) obscurantism, the patterns of worship set up by the Church were inescapable. And it would amount to a complete misunderstanding if one were to interpret these icons as archaic elements, leftovers from an ending era. Galileo's reliquary and monstrance are simultaneously religious and scientific objects. Galileo's ideas had to fight against the Church's dogma, but this was a fight *within* the cultural and social context of the times.

Let us leave the Museo di Storia della Scienza for the nearby church of Santa Croce, to have a look at the mausoleum of Galileo – not a particularly inspiring, rather pompous and conventional work of art. If our gaze now errs around the sepulcher, we see, on the wall against which it is set up, the remains of a fresco from the Quattrocento, dedicated to Santa Magdalena. Most of the painting has been masked by the cenotaph. However on the left, near the side of the monument, a charming feminine figure subsists; with her long and blonde hair. It is Magdalene herself who still kneels and prays, while adoring – no longer the Son of God, but – the Father of Science.

There is a well-known saying, attributed to traditional Chinese wisdom: "When the finger points at the Moon, the idiot looks at the finger." Doesn't the exhibit of Galileo's finger, and his other relics, tend to prove that, when it comes to science, we are all idiots?

Objective lens of Galileo / 161 x 118" (frame) / Museo di Storia della Scienza, Florence / © photo: Franca Principe

Middle finger of Galileo's right hand / Museo di Storia della Scienza, Florence / © photo: Franca Principe Detached from Galileo's body by Anton Francesco Gori on 12 March 1737 when Galileo's remains were transferred from a small closet next to the chapel of Santa Cosmas and Damian to the main body of the Church of Santa Croce where a mausoleum had been built by Vincenzo Viviani.

ALL WINDOWS WERE OPEN, BUT NOTHING HAPPENED. NOTHING? WELL ... EXCEPT A LOT!

Dominique Linhardt

WHEN THE EXPLOSION OCCURRED that Friday, 2 June 1972, in Stuttgart, somewhere between the main railway station and Königstrasse, it was precisely two minutes past ten. Terrified, a shopkeeper ran out into the street, her arms full of stockings, then changed her mind. Her expression switching from terror to embarrassment, she returned to her shop and awkwardly explained to her disconcerted customers: "I'd forgotten ..." At the same instant a member of the local police who, with good reason, had not forgotten, dubiously shook his head, muttering: "an explosion ... today ... precisely today ..." What happened? In the early 1970s Stuttgart was busy building an underground railway, and the violent explosion was part of the work on the tunnel by a civil engineering company.

However, the policeman's muffled grumbling and the shopkeeper's brief panic are explained by something else. A few days earlier, a letter signed by the Red Army Fraction (RAF) had been sent to some members of the press. The few lines were addressed to the "citizens of Stuttgart." "Fate" was said to have chosen the industrious capital of Baden-Wuerttemberg: on 2 June, exactly five years after the young demonstrator Benno Ohnsorg was killed by the police, between 1 and 2 p.m., three car bombs with the equivalent of thirty tons of TNT would explode in the streets of Stuttgart. The RAF pointed out that its aim was not to kill anyone but to make the masses, blinded by The System, aware of the "war of destruction conducted by American imperialism" in Vietnam. The call was clear: "Evacuate the streets and go into your houses ... open your windows and hide in your cellars, just for one hour; the people of Hanoi and many other towns spend many more hours than that under shelter and die anyway. [...] nobody will have to say that the town of Stuttgart was not warned in time! Everyone must do what is necessary to ensure that there is no black Friday in Stuttgart!" That was why the shopkeeper had been so scared; she had forgotten the construction of the metro, but not the RAF threat.[1]

What happened? An explosion due to underground construction work, on the one hand; an anonymous letter, on the other. Nothing but a piece of paper, the importance of which could easily be relativized since its authenticity was by no means guaranteed. From 30 May, the day after the threat, the federal criminal police publicly announced its doubts as to the identity of the real authors of the letter. A second letter had, in the meantime, been received by the *Frankfurter Rundschau* and the *Deutsche Presseagentur*, signed by none other than ... the RAF. Denying any involvement by the organization in the threats on Stuttgart, the letter advised the government not to mask the real nature of RAF actions which, it specified, were targeted exclusively at "enemies of the proletariat, enemies of the Vietnamese people, imperialists." In other words, the RAF would never attack ordinary people, innocent people, the oppressed in short, The People. There would be no blind attacks on the masses ... However, the authenticity of this second letter did not either – alas! – seem guaranteed.[2]

What actually happened on 2 June 1972 in Stuttgart? Nothing. No bomb exploded. At 2 p.m. everything was still intact and the inhabitants of Stuttgart were able to freely express their relief before carrying on with their lives.

Yet something did happen in Stuttgart in early June of that year. As soon as he was informed of the threats, the prime minister of Baden-Wuerttemberg, Mr. Filbinger, called a security meeting of the cabinet ministers and senior officials concerned, to decide on preventive measures. An emergency committee was thus formed: 1,800 police officers, including 300 in plain clothes, were dispatched to cover the town and 600 members of the riot squad were stationed about 40 km away, on the alert; over 20,000 vehicles were checked and searched in a few days; many people had the unpleasant experience of being suspected for some reason or other either by the police or simply by individuals on the look-out (had Chancellor Brandt himself not solemnly called on the entire population to cooperate with the police?); police files were searched with a fine-tooth comb

1

2

_ It is important to note that the Stuttgart episode took place after a series of six attacks by the RAF within one month. This wave of attacks was known as the "May offensive."

_ In a subsequent document, considered to be authentic, the RAF took up the argument in this letter point by point (RAF, Die Aktion des Schwarzen September in München. Zur Strategie des antiimperialistischen Kampfes, in *Dokumente zur Zeitgeschichte: Bundesrepublik Deutschland (BRD)/Rote Armee Fraktion (RAF)*, GNN-Verlag, Cologne, 1987).

to identify those who met certain criteria, who had the "profile" of an "anarchist" or at least of a potential supporter and who might then be carefully watched by the police. The daily press unleashed its fury, as it had done so often in previous years. Anyone who was not devoted to the glorification of the "German miracle," anyone who dared to express criticism of the established order, all those who had long hair, students, the youth – what is our youth coming to? – were branded as participants in this plot hatched by murderous and treacherous anarchists in the same society that had always given them the best. On D-day the town was but a shadow of its usual self: shops closed, streets deserted (apart from a few school children looking for adventure), uniforms as far as the eye could see. Despite their attractive shade of green, their omnipresence naturally brought to mind a not-so-distant past when uniforms were still black or brown. All windows were open, as if to conjure a spell that no one doubted, nor entirely believed.

Building, Königstraße, Stuttgart / 2 June 1972 / photography / Frankfurter Rundschau, 3 June 1972 / © dpa

However much the authorities congratulated themselves for thwarting the plot, and Horst Herold, head of the BKA, repeatedly stated that the police had dealt with the threat without flouting the rule of law, the episode left its marks. Something was broken. Not windows, but the civil link, the bond between citizens and between them and government institutions. Mutual mistrust probably reached its climax when the church bells solemnly announced the time that the ghost was supposed to appear: people stared at one another, stopped in their tracks, stayed where they were as if abandoned while the police bustled about like robots. The price that was paid can be found in no police report recounting the events of that day. The "maximum security" based on general mistrust – mistrust demanded of everyone by the highest political authorities and systematically practiced by the security agencies – came at a very high cost. The "solidarity of democrats in their vigilance and sangfroid," as the head of the Baden-Wuerttemberg SPD put it, resulted in the fact that democrats treated one another in a less-than-democratic manner, and the democratic state turned into a police state.

What happened? A letter composed, as could be expected – one cannot escape the *lois du genre* – of letters cut out of newspapers and bearing the acronym of a clandestine armed organization, was sent to a few newspaper editors. Nothing? No! An act of formidable effectiveness, the real bomb! The RAF wanted to show that the Federal Republic of Germany (FRG) was an oppressive police state, an apparatus for alienating and dominating the masses, designed to facilitate the full deployment of imperialism by the few with all the power who were controlling it, and that the so-called democracy was a myth, a veil covering the reality of a totalitarian state that had to be "unmasked"[3] and "shown for what it was." This was how the state started resembling what the RAF wanted it to be, in order to fight it.

A few months later it was easy for the RAF to accuse the state: it *just had to point a finger* at Stuttgart. The FRG, a democratic state? "Hundreds of homes searched," "thousands of kilometers of roads checked," "millions of calls in the media" for people to inform. Bomb scares? A total fabrication through which "the pigs and the media" produced "the chaos" subsequently used to legitimize the "re-establishment of order and security." One *just has to look*! It is a new "fascism" that is gradually revealing its hostility to the oppressed masses.

The minimalism of the action – a simple letter, the real authors of which have still not been identified – is inversely proportional to its yield: "the anti-imperialist war uses the arms of the system to fight the system." The action of the urban guerrilla made use of provocation: it prodded where it hurt and the reaction of those it provoked took care of the rest. During the 1970s the state thus increasingly came under caustic attacks from circles that were far wider than those of revolutionary agitators. Its arbitrariness and injustice were highlighted, as were the undermining of public freedoms and of the principles of the rule of law. At the end of the decade a Russell human rights court symbolically condemned the FRG, following an increasing number of unfavorable reports by Amnesty International.

What happened? A series of next-to-nothings which smashed to pieces the icon of the good German democracy. On the ruins of the icon, the FRG was forced to reinvent its democracy. |

3

_ All the following citations are from RAF, op. cit.

TENDER BLASPHEMY
THREE STATES OF THE IMAGE, THREE STATES OF LOVE, IN THE RENAISSANCE

Bruno Pinchard

WE ARE IN THE LAND OF LOVE and two lovers are subjected to trials, the style of which is found even in Mozart's *Magic Flute*. But the engravings illustrating the 1499 Aldine edition of *The Dream of Poliphilo* are more than symbols of an initiatory quest; they summarize the new breakthrough of Eros' paganism in the face of a heritage of over a thousand years of Christian love. Engraving love thus in 1499, in an anonymous book, anonymously, was a way of rivalling a divine love that had long been identified exclusively with that of a man-god and with his sacrifice. If *The Dream of Poliphilo* – or, in Latin, *Hypneroto-machia Poliphili*, that is, Polia's lover's war with Eros in dream – was indeed the strife of love in a dream, that strife was to be above all rivalry between Eros and Agape, and the irresistible return in the heart of the Christian era of gestures and signs suited more to Plato's spirit than to the mediator of the Gospels. Designing these illustrations, imposing their ternary rhythm in the extract that we have chosen, repeating their parallel, parodic signification, as blasphemous as it is staggering, is stronger than entering into the uncertainty of romantic values between desire and the divine; it means unveiling the secret iconoclasm of the image in the age which celebrates its triumph.

The Renaissance attests to credible thinking about love because in it desire is never immediate. Love is less naked than we think in this Renaissance of which the dreamed paganism is always preceded by real Christianity. That is why its figurations are never icons but also contain a curse that no one escapes. For all these reasons we divide our comments on these three illustrations of Polia and Poliphilo's love into three stations, like the inexorable Way of the Cross.

First Station

A man is lying on the floor of a rigidly structured room, dead. A bare-headed woman is crying over him. She is kneeling, her arms outstretched, as if she were burying the one who was Love. Three columns of unadorned rectangular crates border the space on the right. At the back, on the left, is a door through which the woman entered, unless it is the opening through which the lover's soul flew away, or the winged love, fleeing after its infamy.

The man is lying on the cold stone floor, his feet parallel, one hand on his genitals, the other on his heart. The woman is lamenting the death of the lover or the son, but the man is not buried like the dead, he is lain down outstretched like a thing in the middle of this room. No excavation, no sepulcher, no promise of entry into the ground announces a glorious exit through another end of the earth. The dead body can be divided up in such a way that each of its forms can be analysed according to an exact law. Everything, including the dead man's clothes with their folds impeccably arranged close to the body, participates in the general geometry prevailing throughout the scene.

The woman loved the breath and thoughts of this man, for she is kneeling near the upper part of the corpse. The dead man's head is treated strangely, lying not on a cushion or a folded garment, but on a stone, the edges of which are a concentration of all the volumes of the room. Just as Jacob, in his sleep, saw the angels climbing up and down a ladder only after laying his head on a stone that he was to bless upon awakening, so too the man journeys in death by laying his head on a perfect stone that participates both in the laws of the ground and in the erection of any edifice. If there is mystery in death, it is measured like the stone on which this head is lying. Christ never found a stone on this earth on which to lay his head …

Second Station

The geometry remains, but what intimacy of the cloth! This image is the most touching confession of happiness. Yet make no mistake, the lovers are not only clasped in an embrace; there is still *pietà* in this love. The woman is a Virgin in all her glory on her throne and the lover she holds against her, warms, wakes up, is her son reborn not from Easter Saturday but from the abundance of her affection.

The story tells us that the woman kissed her stone lover so much that he came back to life, and it is the moment of this awakening that the painting depicts. The gentleness of the features and gestures, the abundant folds of the clothes, no longer those of the shroud but of the nuptial bed, do nothing to erase the rectilinear division of the ground into implacable rectangles. The embrace here is surely not against the prevailing order; it is granted by a great architect. No kiss is better placed at the center of a picture; love has its place among the powers governing the world.

But what is the internal rhythm of this cosmic order in which reconciliation is so personal and intimate? Just as there are two lovers, one living and the other dead, a woman and a man, the former seated and the latter half-lying on her lap, there are, at the end of the room, two twin alters whose complex architecture is above all a symmetrical work. Death was accompanied by three columns; the love now being accomplished is twofold. No generation of the father and of the son, no deification of the mother by the son, no "daughter of her son" could reintroduce a hierarchy of descent or begetting between the two protagonists. One has to understand that the two lovers here are in a situation of perfect reciprocity which prefers happy intimacy to the urgency of salvation.

The two alters are therefore the same. The difference between the man and the woman has no effect on the form of the table or of the alcove where people pray and sacrifice to their own genius. Yet the woman, in her central embrace, has clasped the man so much that she has drawn him towards her alter, or at least towards one of the alters. But this asymmetry is that of fervor; it does not stray from the general symmetrical order reinforced by the movement of the lover's foot touching the step of the other alter. Although, like the paving, the architecture of these alters topped by an empty marble table and a Venusian shell (Venus was born from the froth of the sea) remains perfectly icy, the enveloping gesture of the woman, the abandoned embrace of the man, concentrate an affection that withstands all tests and has enough intimacy of the cloth to bury its secret. Who could break the lines of such an idol?

Third Station

You will be chased from the Paradise of this image! You have to go, to abandon the emerging promises of order. But where are the vengeful angels? One sees only women beating the guilty couple under the instigation of some matron (the "Pontiff," says the text). The paving has disappeared and this time there are five columns supporting four equal arches. The law is neither uneven (death) nor even (love); it is the paradoxical composition of their difference. Over this forced harmony blows a sinister wind.

The door is open, the only alternative is to flee. This kiss was one too many, the history of the world does not end with intimacy and confession. "That day, we read no further," confesses Francesca. But this time it is not the lord of Rimini's sword that puts an end to the idyll, but the sticks of the harpies at the orders of the Masters of the temple.

Polia mourning the dead Poliphilo / woodcut / from: Francesco Colonna, Hypnerotomachia Poliphili. The Strife of Love in a Dream, Aldus Manutius, Venice, 1499, p. 421

Polia embracing Poliphilo / woodcut / from: Francesco Colonna, Hypnerotomachia Poliphili. The Strife of Love in a Dream, Aldus Manutius, Venice, 1499, p. 422

Diana's Nymphs chase Polia and Poliphilo from the Temple of Venus / woodcut / from: Francesco Colonna, Hypnerotomachia Poliphili. The Strife of Love in a Dream, Aldus Manutius, Venice, 1499, p. 422

The text insists that the chastisement of the fleeing lovers is the chastisement of those who united carnally in the temple of a divinity. The attention of the ministers of religion seems to have been drawn by the echoing moans of the woman and the sighs of the lover under the empty arches: the terrible echo of these thundering structures where love can neither hide nor keep silent!

It was inevitable for the woman's initial compassion to become an extreme desire at the time of the awakening, just as it was predictable that the temple guards would appear and expel the lovers who had forgotten the laws of the world. All lines here tend towards simplification and continue the story of love since Héloïse and Abelard. After their wrongful union, any kiss or embrace is an awakening of the dead, but any awakening of the dead is a stain in the temple whose sanctity allows only the chastity of the dead. There is no love that is not forbidden, but the prohibition is also an appropriate site for the propagation of attractions, the vehemence of which is suggested by the wild look of the woman: it stands out like the trace, the scratches of the love on the vacant space of the open space.

What do we learn from this series of engravings passed down to us through an anonymous book of which Dürer himself kept a copy in his library? We learn that Renaissance perspectives should be admired not only for their power of conquering space. They shelter dramas of death and resurrection, where bare-headed women run through noisy corridors. This architecture is never placed on an empty space that it fills only by means of the force of an arbitrary conception. Here walls are built and columns erected only against two laws: the law of the ancient lamentation of Christ, and the law of new romantic codification. Between these opposing thrusts, the lovers, pursued for their original sin but happy to give a center to the world that is not only a vanishing point, run from room to room, leaving the imprint of their breath on the pure marble. |

Translated from French by Liz Libbrecht

SAINTS ALIVE / THE ICONOGRAPHY OF SAINT GEORGE

Jerry Brotton

SAINT GEORGE IS THE ULTIMATE SYMBOL of the clash between icon and iconoclasm. Worshipped as an early Christian martyr, George was one of the first great iconoclasts. The earliest historical accounts of George present him destroying pagan icons, not slaying dragons and rescuing princesses. The story of George's life emerges from Coptic and Ethiopian texts first written in the fourth century, in which George is born in Cappadocia in central Turkey around AD 270. As a Christian officer in the Roman army, he is asked to make a sacrifice to the Roman gods by a pagan ruler (usually called Dacian). George refuses, and in most versions of the story he destroys the idolatrous icons in the temples of Apollo, Heracles, and Bacchus. As a feared icon of Christian militancy, George was then dismembered. Medieval tableaux delighted in depicting his gruesome torments, which included flaying, burning, crushing, amputation, poisoning, and, finally, decapitation. His pagan adversary dies shortly after George's martyrdom, which leads to a series of converts to Christianity.

This archetypal story of the trial and martyrdom of a militant believer was however not limited to Christianity. In Islam, George is also Al Khidr (or Khizr), "The Verdant One," a key figure in Sufism, and another religious warrior, who some sources claim, was a general in the army of Alexander the Great. Like Saint George, it was believed that Al Khidr was resurrected after his death at the hands of a pagan king. The shared genealogy of George and Khidr can be seen in the Christians and Muslims who still revere George's tomb in the Palestinian town of Lod (ancient Lydda) southeast of Tel-Aviv.

While Islam rarely reproduced visual images of Al Khidr, the image of St. George was aggressively circulated among Christian communities throughout the Crusades, where the story of his slaying the dragon and rescuing the princess became common currency, and was subsequently celebrated most famously in Jacob of Voragine's *Golden Legend* (c. 1260). The scattering of George's body and story throughout the East and West led to a cascade of images in which he was celebrated as the Redcross Knight, whose triumphant image compensated for Christianity's ultimate defeat in the Holy Land. George was officially adopted as the patron saint of soldiers after stories began to circulate that he appeared before the Christian army before their triumphant victory at the Battle of Antioch in 1098.

George's reputation as both an iconoclast and a slayer of Moors is vividly captured in the German artist Marzal de Sas' Valencia altarpiece (c. 1400). This shows George violently spearing a Moorish soldier through the face. Here is the militant Christian, George, slaying the symbolic dragon of Islam, and demanding the forced conversion of the pagan town ravaged by the dragon before agreeing to rescue the Princess. Subsequent images of George by Donatello, Pisanello, and Raphael reinforced his symbolic status as a militant Christian holding the line against Islamic expansionism. Carpaccio's paintings of St. George, commissioned for the Scuola di San Giorgio degli Schiavoni and completed in 1504-1507, were designed to celebrate the valiant struggle of the Knights of St. John against the Turks in Dalmatia. The Knights were ultimately defeated, but in Carpaccio's paintings of George slaying the dragon and baptising the "pagans," the iconic image turns military defeat into a miraculous, fantasized victory.

George is the patron saint of many places including Georgia, Portugal, and Catalonia, but he is most readily identifiable with England. George was transplanted from the East into England in the aftermath of the Crusades, when in 1348 Edward III adopted George as patron saint of England and his chivalric Order of the Garter. But George's iconic status as a slayer of icons and pagans ultimately led to his downfall. The Protestant Reformation of the sixteenth century had little time for the worship of saints and their relics like St. George. In 1550 the young King Edward VI ridiculed the cult of St. George at the Order of the Garter ceremony held at Windsor. The following year he redrafted the statutes of the Order, as well as its regalia,

excising all images of and references to St. George, and finally banning the celebration of St. George's Day in 1552. The Protestant radical John Foxe also castigated the worship of saints like George, claiming in his *Acts and Monuments* (1570), "He that bringeth St. George or St. Denis as patrons to the field to fight against the Turk, leaveth Christ, no doubt, at home."

This political embargo on the veneration of George's religious image gave the saint a new lease of life, as Catholic counter-attacks deployed his image as a figure crushing all forms of belief that rejected Catholicism. Titian portrayed the Holy Roman Emperor Charles V as a crusading St. George figure in his portrait of *Charles V at the Battle of Mühlberg* (1548), symbolically crushing both Protestant and Muslim heresy beneath his horse's hooves. However, George's tradition as a good iconoclast also allowed some Protestant thinkers and artists to use him as a figure trampling upon what they saw as the idolatry of Catholic worship.

This intensely political struggle over possession of George's image ultimately drained the saint of much of his religious significance. In *The Most Famous History of the Seven Champions of Christendom* (1597), Richard Johnson re-appropriated George as an Englishman, claiming he was born in Coventry, while Shakespeare sealed the saint's Englishness with his jingoistic "Cry 'God for Harry! England and St. George!'" in *Henry V* (1599). George's iconic power stemmed from his ability to encapsulate a range of military, religious, and political conflicts between Eastern and Western cultures. Reduced to a national logo, George is today the preserve of racist nationalists and iconoclastic English football hooligans, who would be shocked to hear that St. George was actually a Turk.

Marzal de Sas / Retable of St. George (The Valencia altarpiece) / detail: St. George in Battle /
c. 1400 / tempera on wood / 264 x 191" (full retable) / Victoria and Albert Museum, London

THEOPHILIA

Miguel Tamen

IN THE NINTH CENTURY, SEVERAL BYZANTINE BISHOPS wrote a long letter to a fictional friend of God, naturally named Theophilos. The letter, known as *Ad Theophilum*, contains one of the many extant defenses of images in the context of the intricate iconoclastic crises.[1] Among other things it tells the story of an icon of St. Andrew, one of whose eyes had been removed by a momentarily possessed priest, only to be replaced, by divine justice, with an eye taken from the orb of that very same priest. The miracle requires no further explanation and if you are a Theophilos you require none.

Ten centuries later, Maxime Du Camp gave an epistolary form to his account of Egypt (made famous by the conspicuous absence of his travel-companion Gustave Flaubert as well as by 150 accompanying calotypes) by way of another long letter to yet another Theophilos, this time the eponymous nonfictional poet Gautier. The letter was published subsequently as the book *Le Nil: Égypte et Nubie*.[2] The image on the opposite page is one of such calotypes, perhaps the best-known: Ramses II's head, in the western colossus of the Temple of Re, in Abu Simbel. In the letter, the head is uncontroversially described as "buried ... almost up to its chin."[3] As to the temple as a whole, Du Camp remarks in his letter, "nothing in our part of the world [rien dans nos pays] can give an idea of the work that went into this gigantic piece."[4]

Apparently, however, Du Camp was wrong – both his letter and the calotype undertake precisely the task of giving an idea of an otherwise incomprehensible, gigantic, piece. Or perhaps, one can metaphysically surmise, his own Theophilos was more demanding in his requirements for belief. How are these met? Unsurprisingly, in different ways. In the case of the letter, one has similes: Theophilos is required to "picture [him]self the Notre-Dame in Paris carved out of a single piece of rock,"[5] and the statues are said to be sixty-one feet tall.[6] The calotype, however is not a letter: it is an image, and images are notoriously unfit for unambiguous exemplification. How, given the epistemic anxieties of his own Theophilos, was then Du Camp to solve this particular problem?

His solution was a simple, tried and true one: by asking one of his assistants (by the name of Louis Sassetti) to pose sitting on top of the colossus, therefore redescribing the size of something hitherto unknown as a function of the size of something roughly known. The "gigantic piece" is therefore measured up in Sassettis, so to speak (which after all shouldn't surprise us in a world where measuring scales are often named after proper names: amperes, joules, watts). Let us then agree that, at least in this image, Sassetti is the measure of all things, the yardstick for the portrayed head in the image. But let us also bear in mind that the reverse could not be true, since the category of the "roughly known" could not possibly apply to it – the world of Theophilos #2, which for short one could call our world, is simply not one in which Sassettis are measured up in ramses-heads. That this is *our* world means that (given some rough assumptions about the identity of the species) Sassetti-like yardsticks are used to measure up un-Sassetti-like things. Whose foot is a foot, anyway?

Conversely, in the world of Theophilos #2, the description of Du Camp's calotype as "the measuring of Sassetti" would at most elicit embarrassed smiles. Wittgenstein once remarked, apropos yardsticks, that "it is *impossible* to set one scale simultaneously at two graduation marks."[7] Applying a scale "already implies ... that in every case only *one* state of affairs can be obtained."[8] One could also say that it is impossible to set one graduation mark simultaneously at two scales, given that such marks are already marks in *one* scale. Behind the meter hides not so much a dignified fraction of the quadrant of the Earth's circumference as a distance formerly measured up in feet – and I don't mean Ramses-like feet.

Still, one often believes that one can choose one's world, one's *theory* about images (whatever this means), indeed one's theory about *anything*, as one can choose between certain alternative yardsticks. One pictures oneself as susceptible of going

5 8 1 3 2 7 6 4

_ Published by Louis Duchesne, L'Iconographie byzantine dans un document grec du IXe siècle, in *Roma e l'Oriente. Rivista criptoferratense per l'unione delle chiese*, 1912-1913, vol. 5, pp. 222-239, pp. 273-285, pp. 349-358.

_ Du Camp, op. cit., p. 138.

_ Du Camp, op. cit., p. 138.

_ Du Camp, op. cit., p. 139.

_ Wittgenstein, op. cit., p. 317.

_ Du Camp, op. cit., p. 139.

_ Maxime Du Camp, *Le Nil. Égypte et Nubie*, Hachette, Paris, 1877.

_ Ludwig Wittgenstein, *Philosophical Remarks (Philosophische Bemerkungen)*, R. Rhees (ed.), transl. R. Hargreaves & R. White, Blackwell, Oxford, 1975, p. 112.

Westernmost Colossus of the Temple of Re, Abu Simbel / 1850 / Maxime Du Camp (French, 1822–1894) / Salted paper print from paper negative / 9 x 6.5" / Gilman Paper Company Collection, New York

Farenheit, and then going Celsius, and then back again. This notion of free-will is perhaps unnecessarily robust. Once the notion of "roughly familiar" has changed, there is no going back. No amount of eye-squinting will ever turn that picture into a picture *about* the size of Louis Sassetti or, for that matter, will turn Theophilos #2 back into Theophilos #1, complete with his many beliefs about the optical workings of divine justice.

What is to be done? Sainte-Beuve, a contemporary of Du Camp, remarked that, when one is dealing with the Ancients, one can never quite have "sufficient means of observation."[9] "True Ancients" come down to us as "half-broken statues ... that one can only admire sideways *[admirer ... à travers]*." "A wide river," he gloomily adds, "and in most cases an unbridgeable one, separates us from the great men of antiquity. Let us salute them from our side." This melancholy gesturing towards something dead and gone, whether by Sainte-Beuve or by many of us Theophilians of persuasion #2, should only be taken for what it essentially is: a prestigious aphrodisiac for no particular purpose. Admiring something *sideways* appears to affect the whole ritual of admiration. No amount of affection for the hieratic features of Ramses II will ever be perceived to require anything from anyone anymore. The story of the Greek priest is now merely quaint or, worst of all, thought to be delightful. Their images have become windows open unto something else, and are no longer part of anything else.

A few pages after the description of the colossii, Maxime Du Camp, accompanied by his crew, enters the halls of the temple in Ibsambul. "While I was taking notes," he writes, "an argument arose between my two assistants about the function of these immense chambers. 'It was a coffeehouse,' one said; 'It was a bazaar,' said the other. This archeological dispute became so violent that I had to put an end to it by having them both shut up."[10] Du Camp, of course, believed he knew what those chambers truly were. He took pictures of them, and most of these pictures contain Sassetti-like yardsticks of one kind or another. How is it then that his advice to the crew still manages to retain a good measure of commonsense and could perhaps also be usefully directed at himself? |

9 10

_ Du Camp, op. cit., p. 144.

_ Charles Augustin Sainte-Beuve, Chateaubriand jugé par un ami intime en 1803 [1862],
in *Pour la critique,* A. Prassoloff and J.-L-Diaz (eds), Gallimard, Paris, 1992, p. 147
(all further quotes from this page).

Many years ago lived an emperor, who thought so much of new clothes that he spent all his money in order to obtain them; his only ambition was to be always well dressed. He did not care for his soldiers, and the theatre did not amuse him; the only thing, in fact, he thought anything of was to drive out and show a new suit of clothes. He had a coat for every hour of the day; and as one would say of a king »He is in his cabinet« so one could say of him, »The emperor is in his dressing-room.« || The great city where he resided was very gay; every day many strangers from all parts of the globe arrived. One day two swindlers came to this city; they made people believe that they were weavers, and declared they could manufacture the finest cloth to be imagined. Their colours and patterns, they said, were not only exceptionally beautiful, but the clothes made of their material possessed the wonderful quality of being invisible to any man who was unfit for his office or unpardonably stupid. || »That must be wonderful cloth,« thought the emperor. »If I were to be dressed in a suit made of this cloth I should be able to find out which men in my empire were unfit for their places, and I could distinguish the clever from the stupid. I must have this cloth woven for me without delay.« And he gave a large sum of money to the swindlers, in advance, that they should set to work without any loss of time. They set up two looms, and pretended to be very hard at work, but they did nothing whatever on the looms. They asked for the finest silk and the most precious gold-cloth; all they got they did away with, and worked at the empty looms till late at night. || »I should very much like to know how they are getting on with the cloth,« thought the emperor. But he felt rather uneasy when he remembered that he who was not fit for his office could not see it. Personally, he was of opinion that he had nothing to fear, yet he thought it advisable to send somebody else first to see how matters stood. Everybody in the town knew what a remarkable quality the stuff possessed, and all were anxious to see how bad or stupid their neighbours were. || »I shall send my honest old minister to the weavers,« thought the emperor. »He can judge best how the stuff looks, for he is intelligent, and nobody understands his office better than he.« || The good old minister went into the room where the swindlers sat before the empty looms. »Heaven preserve us!« he thought, and opened his eyes wide, »I cannot see anything at all,« but he did not say so. Both swindlers requested him to come near, and asked him if he did not admire the exquisite pattern and the beautiful colours, pointing to the empty looms. The poor old minister tried his very best, but he could see nothing, for there was nothing to be seen. »Oh dear,« he thought, »can I be so stupid? I should never have thought so, and nobody must know it! Is it possible that I am not fit for my office? No, no, I cannot say that I was unable to see the cloth.« || »Now, have you got nothing to say?,« said one of the swindlers, while he pretended to be busily weaving. || »Oh, it is very pretty, exceedingly beautiful,« replied the old minister looking through his glasses. »What a beautiful pattern, what brilliant colours! I shall tell the emperor that I like the cloth very much.« || »We are pleased to hear that,« said the two weavers, and described to him the colours and explained the curious pattern. The old minister listened attentively, that he might relate to the emperor what they said; and so he did. || Now the swindlers asked for more money, silk and gold-cloth, which they required for weaving. They kept everything for themselves, and not a thread came near the loom, but they continued, as hitherto, to work at the empty looms. Soon afterwards the emperor sent another honest courtier to the weavers to see how they were getting on, and if the cloth was nearly finished. Like the old minister, he looked and looked but could see nothing, as there was nothing to be seen. || »Is it not a beautiful piece of cloth?,« asked the two swindlers, showing and explaining the magnificent pattern, which, however, did not exist. »I am not stupid,« said the man. »It is therefore my good appointment for which I am not fit. It is very strange, but I must not let anyone know it,« and he praised the cloth,

which he did not see, and expressed his joy at the beautiful colors and the fine pattern. »It is very excellent,« he said to the emperor. || Everybody in the whole town talked about the precious cloth. At last the emperor wished to see it himself, while it was still on the loom. With a number of courtiers, including the two who had already been there, he went to the two clever swindlers, who now worked as hard as they could, but without using any thread. || »Is it not magnificent?« said the two old statesmen who had been there before.»Your Majesty must admire the colours and the pattern.« And then they pointed to the empty looms, for they imagined the others could see the cloth. || »What is this?« thought the emperor, »I do not see anything at all. That is terrible! Am I stupid? Am I unfit to be emperor? That would indeed be the most dreadful thing that could happen to me.« || »Really,« he said, turning to the weavers, »your cloth has our most gracious approval;« and nodding contentedly he looked at the empty loom, for he did not like to say that he saw nothing. All his attendants, who were with him, looked and looked, and although they could not see anything more than the others, they said, like the emperor, »It is very beautiful.« And all advised him to wear the new magnificent clothes at a great procession which was soon to take place. »It is magnificent, beautiful, excellent,« one heard them say; everybody seemed to be delighted, and the emperor appointed the two swindlers Imperial Court weavers. || The whole night previous to the day on which the procession was to take place, the swindlers pretended to work, and burned more than sixteen candles. People should see that they were busy to finish the emperor's new suit. They pretended to take the cloth from the loom, and worked about in the air with big scissors, and sewed with needles without thread, and said at last: »The emperor's new suit is ready now.« || The emperor and all his barons then came to the hall; the swindlers held their arms up as if they held something in their hands and said: »These are the trousers! This is the coat!« and »Here is the cloak!« and so on. »They are all as light as a cobweb, and one must feel as if one had nothing at all upon the body; but that is just the beauty of them.« || »Indeed!« said all the courtiers; but they could not see anything, for there was nothing to be seen. || »Does it please your Majesty now to graciously undress,« said the swindlers, »that we may assist your Majesty in putting on the new suit before the large looking-glass?« || The emperor undressed, and the swindlers pretended to put the new suit upon him, one piece after another; and the emperor looked at himself in the glass from every side. || »How well they look! How well they fit!« said all. »What a beautiful pattern! What fine colors! That is a magnificent suit of clothes!« || The master of the ceremonies announced that the bearers of the canopy, which was to be carried in the procession, were ready. || »I am ready,« said the emperor. »Does not my suit fit me marvellously?« Then he turned once more to the looking-glass, that people should think he admired his garments. || The chamberlains, who were to carry the train, stretched their hands to the ground as if they lifted up a train, and pretended to hold something in their hands; they did not like people to know that they could not see anything. || The emperor marched in the procession under the beautiful canopy, and all who saw him in the street and out of the windows exclaimed: »Indeed, the emperor's new suit is incomparable! What a long train he has! How well it fits him!« Nobody wished to let others know he saw nothing, for then he would have been unfit for his office or too stupid. Never emperor's clothes were more admired. || »But he has nothing on at all,« said a little child at last. »Good heavens! listen to the voice of an innocent child,« said the father, and one whispered to the other what the child had said. »But he has nothing on at all,« cried at last the whole people. That made a deep impression uponathe emperor, for it seemed to him that they were right; but he thought to himself, »Now I must bear up to the end.« And the chamberlains walked with still greater dignity, as if they carried the train which did not exist. ||

HANS-CHRISTIAN ANDERSEN (1837)

Why do gods object to images?

THE ICON AS ICONOCLASH

Joseph Koerner

»There is no stronger evidence that we have been successful in our effort ... than when the patient reacts to it with the words 'I didn't think that,' or 'I didn't (ever) think that.'« SIGMUND FREUD, NEGATION (1925)

Two Aspects, Two Objects

Especially when they seek to publish their endeavors, image breakers become image makers. Marcus Gheerhaerts the Elder, a Calvinist iconophobe with an immense imagination, gave defacement an unforgettable face.

Produced in the immediate wake of Protestant iconoclasm in the Low Countries in 1566, when a good proportion of Netherlandish church art was smashed and burned within weeks, his large anamorphic etching is the sixteenth century's most dialectical icon of iconoclash. Surviving today in only one impression, and brought to the present exhibition quasi as its monstrous mascot, it presents to the eye two distinct images, the one forming and the other deforming.

Viewed from up close, at reading distance, it displays iconoclash. On a strange, bulbous hill, along its terraces and in its hollows, swarming figures engage in religious practices of the type that Protestant reformers branded as idolatry. The seven sacraments of the Roman Church, along with such Catholic usages as pilgrimage, bell-ringing, the sale of indulgences, and image veneration itself, are each described with an ethnographer's precision. It is only the stray detail (e.g., a bird shitting on a monk from atop an icon-bearing pole), plus the overall chaos of the whole, that condemns and enters them into a gallery of folly and deception. Iconophilia is at once censored and preserved, like the Soviet Union's museums of atheism. In the early sixteenth century, in the Church of St. Mary in Zwickau, offensive images were taken to a storeroom named the *Götzenkammer* (the idol-chamber). There they languished as baleful documents of superstition until around 1850, when they were earmarked for the city's new historical museum.[1] In order to vilify, it is also necessary to exhibit. At the base of his print, in the undulating flatlands from which

the hill of idolatry rises, Gheerhaerts repudiates what he displays. Image breakers – tall, bearded men in long furlined coats – break, bury, and burn church ornament as if it were garbage.

Viewed from afar, from the distance not from where one reads a page but from where one beholds a picture, the print displays an altogether different aspect: the grotesque icon of a tonsured monk. The bonfire of vanities in the landscape's lower right, suggestive of a topology of hell, also rises from the monster's heart. In their archimbaldesque interplay, the etching's dual aspects of place (landscape of iconoclash) and of person (icon of monk) at once perform and undo defacement. Instances of idolatry are fitted into appropriate zones of the face that they (the little structured scenes themselves) reciprocally shape and reinforce. The Eucharist is elevated in the monster's mouth, where the wheaten disk will be received, and confession is heard in his ear. And right between his cavernous eyes – which are filled, and thus blinded, by the (to Protestant eyes) unbiblical sacraments of marriage and orders – stands a venerated crucifix: Christ on the cross as the veritable icon of icons.

The grotesque face, in turn, gets modified by these scenes. The figures crawl on and into it, like insects picking a cadaver clean. Note how the birds that dot the sky read like flies buzzing above carrion. The iconophiles infiltrate the face's orifices so that it (he, the monk) becomes like the idols it adores, those monsters of whom the Psalmist warns, "They have mouths but they speak not: eyes have they, but they see not: they have ears, but they hear not."[2] Gheerhaerts' image argues that, even before the hammer strikes, idolatry, having mistaken objects for humans, made humans into objects. Iconophilia is its own defacement, creating through its own energy the etching's festive furor-fare. Iconoclasts, for their part, do not deface the face but merely bare its prior deface-

[1] Sergiusz Michalski, Das Phänomen Bildersturm, in *Bilder und Bildersturm im Spätmittelalter und in der frühen Neuzeit*, Robert Scribner (ed.), Harrassowitz, Wiesbaden, 1990, p. 110, citing Ernst Fabian, Der erste Versuch, in Zwickau ein Museum zu errichten, in *Mitteilungen des Altertumsvereins für Zwickau und Umgebung*, 11, 1914, pp. 1-13.

[2] Psalm 115: 4-8; Psalm 135: 15-18; Margaret Aston, *The King's Bedpost: Reformation and Iconography in a Tutor Group Portrait*, Cambridge University Press, Cambridge, 1993, p. 170.

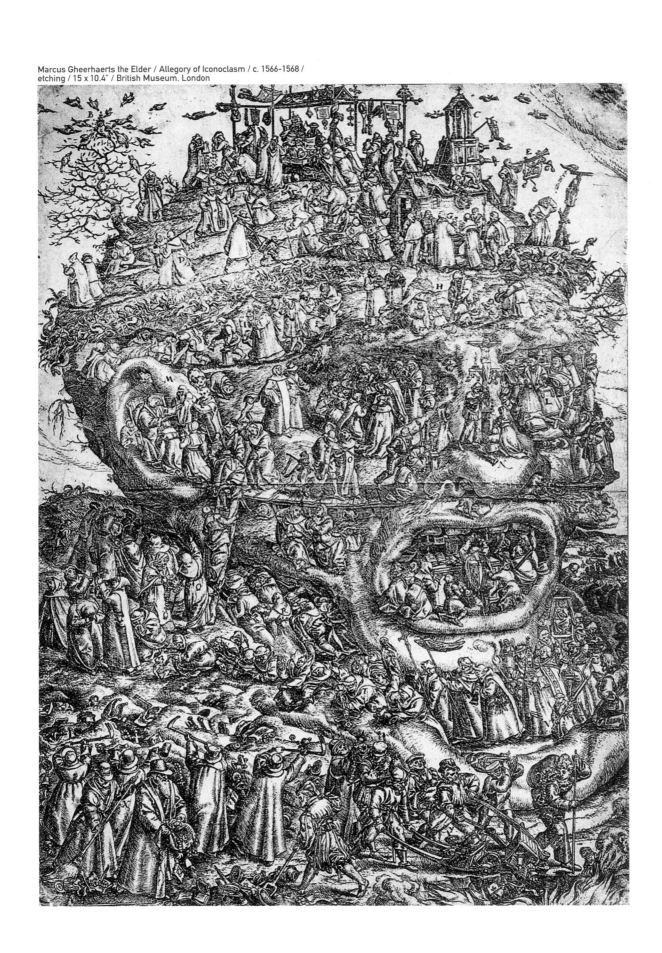

Marcus Gheerhaerts the Elder / Allegory of Iconoclasm / c. 1566-1568 /
etching / 15 x 10.4" / British Museum, London

»We want no more cross …« / c. 1526 / woodcut /
in A Truly Horrific History of the Peasant Rebellion

»The crucified idol we raze out of childish scorn« / c. 1526 / woodcut /
in A Truly Horrific History of the Peasant Rebellion

ment. Clearing things away to reveal the underlying monster, they disenchant a world that, even after their toil, will be haunted still. What if this etching were not an object in the exhibition but the exhibition itself? Iconoclash: a rhizomorphous passage among an architecture of cells, in which having images and having done with images collide to form a new image where iconoclash, personified, is glimpsed again. We would wish, of course, that the idol chambers on the hill were less prejudicially appointed, that is, that the use of images were not *always* staged as an emblem of abuse. Then what believers do with pictures might seem, for once, less naive and penetrable: an activity fully as complex (and as "knowing") as what the critical eye performs in its search for an imageless beyond. Then, too, we would be able at least to hesitate before censoring and mourning what the scenography of museological display will have modified: authentic religion, beautiful art, scientific science. More crucially, we would wish the face that iconoclash globally shaped to be a visage not of the iconoclast's imaginary *fanaticus* (from Latin *fanum* =

temple), villain of so many anti-superstition campaigns, but of the hatred and fanaticism of the clash itself. But we certainly would relish the supreme and paradoxical *visuality* of Gheerhaerts's image. For both aspects – furor-fare and anamorphic face, iconoclash and icon – are deeply engaging images of the two mutually incompatible absolutes that this exhibition seeks to put on view: if only we could do without representation / we cannot do without representation.[3]

We could not turn the galleries of the ZKM into a life-size equivalent of this amusement park monster.[4] The print must therefore hang as but one offering within a cell exploring the clash of face with defacement, of image with non-image, of God's necessary representation and non-representation, within the domain of religion. There, the artist-iconophobe Gheerhaerts performs an iconoclasm through the icon itself. Beyond the story of Protestant image breaking unfolding in the landscape, beyond even the blow symbolically struck at an idolatrous clergy by way of the face, the etching systematically disfigures whichever figure it yields. Whatever we see

4 3

_ See Bruno Latour's essay in this catalog.

_ Bruno Latour suggested such an architecture during an early meeting of the curatorial group.

ends up belonging to some other thing, some other viewpoint, thus undoing both object and beholder. In shifting between the perspectives of landscape and face, the etching also repeats – as in an apotropaic ritual – the error it imputes to its target, the idols, which confuse *things* and *persons*. Yet what were those quasi-objects, the *Götzen*, that Gheerhaerts breaks and collects? Or to put this more generally, which is to say, to situate this one offering within a history of Western monotheism, as an interminable, agonistic succession of non-image by non-image all within the ineluctable medium of images: what and how does the divine image show?

Long before the hammer strikes them, religious images are already self-defacing. Claiming their truth by dialectically repeating and repudiating the deception from which they alone escape, they are, each of them, engines of the iconoclash that periodically destroys and renews them. In Christian culture of the late Middle Ages – the assault on which continues to model the modern critique – the image that people principally venerated was such a picture. It was an icon of God's hiddenness from icons like itself.

The Image Breakers Are Image Makers[5]

Protestant iconoclasts took a special relish in breaking crucifixes.

Certainly, they smashed other church pictures with zeal. They vented great fury on effigies of the Virgin and the saints. Held to be invested with miraculous powers, and venerated in special cults, these exemplified for iconophobes both the idolatrous belief in pictures and an erroneous faith in intercessors: both as images and as personage, that is, the Virgin and saints were an affront to the one unrepresentable God. The cult of the so-called Beautiful Maria of Regensburg stands advertised (documented?) by a large woodcut by Michael Ostendorfer. Ecstatic pilgrims crowd into a temporary wooden church containing an icon that, in 1519, was believed

Michael Ostendorfer / Die Wallfahrt zur Schönen Maria von Regensburg [The Pilgrimage to the Beautiful Virgin of Regensburg] / c. 1519 / woodcut / two sheets sticked together. image and text. inscription by Albrecht Dürer / 15 x 26" / Kunstsammlungen der Veste Coburg. Kupferstichkabinett

5

_ This formula modifies the famous dictum of the historian Hermann Heimpel, (Die Bilderstifter waren die Bilderstürmer, in *Der Mensch in seiner Gegenwart,* second edition, Vandenhoeck & Ruprecht, Göttingen, 1957, pp. 377-404.) That is, the same class of people who fervently venerated pictures became, in the course of the Reformation, the very ones who fervently smashed them.

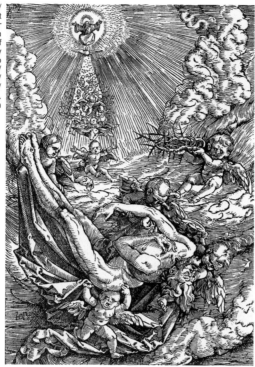

Hans Baldung Grien / Christi Himmelfahrt (Christuskörper, der zum Himmel getragen wird) [The Ascension of Christ (Christ's Body Being Carried to Heaven)] / 1517 / woodcut, hand colored / Albertina, Vienna / © photo: Albertina, Vienna

Albrecht Dürer / Schweißtuch Christi von einem Engel ausgebreitet [The Veil of Christ Being Spread by Angels] / 1516 / etching / 7.4 x 5.3" / Albertina, Vienna / © photo: Albertina, Vienna

to have healed a man injured while demolishing the synagogue of the city's violently evicted Jews. Note the ruined building in the right background, remnants of a Jewish house of worship. The impression displayed in the present exhibition bears an indignant inscription by its original collector, the artist Albrecht Dürer, who laments the disgrace to God that such idolatry represents.[6]

In the public performances of church cleansing, however, it was the removal, degradation, and destruction of crucifixes that held pride of place. Perhaps this was because the crucifix seemed to instance idolatry in its most primary form, as the worship of the image instead of God. Yet never is the ambivalence of iconoclasm more evident than when it strikes the image of Christ on the cross.

A few examples from a host of documented instances: in Stadelhofen near Zurich in 1523, a certain Klaus Hottinger, having obtained a wooden wayside crucifix from its owner, broke it into pieces, which he gave to the poor as firewood, in a typical gesture of critical economy.[7]

First exiled, then tried for blasphemy in the Catholic city of Lucerne, Hottinger refused to honor a crucifix brought before him. He confessed that "the passion of Christ must be received in true faith in the heart," and declared the picture itself to be a mockery: as with the prophet Jeremiah, inward religion repudiates external pictures. In 1523, iconoclasts had numerous rationales: images contradicted the Old Testament law, were a wasteful expenditure, exiled Christians from God's word, distracted the eye, symbolized the power of a corrupt Church, contradicted apostolic poverty, perpetrated fraud, etc. But in the sixteenth century, the most global objection was Hottinger's: as spirit to flesh, as inner to outer, religion had to be purified from things of this world, and to achieve this, certain things that were not thus purified had to be eradicated according to the formula made famous by Zwingli: out of sight is out of mind; to rid the heart of idols one must first banish them from the heart; *ab Aug, ab Herz*. Burned at the stake,

6 7

_ *Albrecht Dürer. Schriftlicher Nachlaß*, Hans Rupprich (ed.), Deutscher Verlag für Kunstwissenschaft, Berlin, 1956-1969.

_ Heinrich Bullinger, *Reformationschronik*, manuscript c. 1605, Copy of Heinrich Thomann, Zentralbibliothek Zürich, MS B 316; see Peter Jezler, Tempelreinigung oder Barbarei? Eine Geschichte vom Bild des Bilderstürmers, in *Bilderstreit. Kulturwandel in Zwinglis Reformation*, Hans-Dietrich Altendorf and Peter Jezler (eds), Theologischer Verlag, Zurich, 1984, pp. 78-79.

Klaus Hottinger Topples a Wayside Crucifix in Stadelhofen / illustration / pen and ink and watercolor /
in Heinrich Bullinger, Chronical of the Reformation / manuscript copy c. 1605 / Zentralbibliothek Zürich, MS B 316, fol. 99r

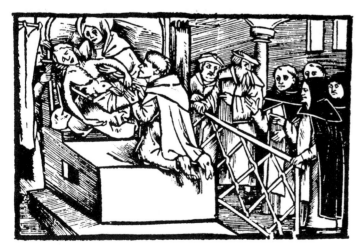

Urs Graf / Fraudulent Image-Miracle in Bern / 1507 / woodcut / in Thomas Murner,
On the Four Heretical Preachers of the Observant Order at Bern, Strasbourg, 1509

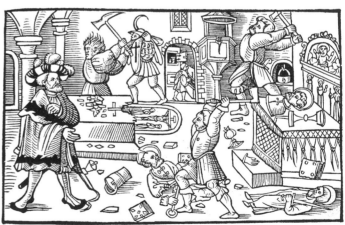

»Here speaks a pious Christian and admonishes the scandalous people that they
abstain from their evil mischief« / c. 1526 / woodcut / in A Truly Horrific History of the
Peasant Rebellion

and immortalized in Heinrich Bullinger's *Chronicle of the Reformation*, Hottinger became the first Protestant martyr. On one manuscript copy of the *Chronicle*, an early seventeenth century illustrator depicts Hottinger toppling an empty cross rather than a crucifix, perhaps because he (the watercolorist) was unwilling to paint a Christ statue. Hottinger, meanwhile, wields a shovel that extends, formally, into the lance which, according to legend, was wielded by the Roman centurion and delivered Christ's mortal wound.[8] This is a typically ambivalent motif, on the one hand depicting the idea that Hottinger, in being martyred, suffered a Passion, while on the other hand linking him with the Passion's original perpetrators. Another example: in Basel in 1529, a crucifix was pulled from the Münster's rood screen and dragged to the market, where a crowd mocked it with the words, "If you are God, then save yourself, but if you're a man, then bleed."[9] Addressed to the effigy by people who deny that pictures can hear or speak, this taunt recalls the standard plea, repeated in prayers and votiv inscriptions attached to images, "Help me!" At the same time, it also echoes the words Christ's tormentors spoke at the crucifixion: "If thou be the Son of God, come down from the cross" (Matt. 27:40); "If thou be Christ, save thyself and us" (Luke 23:37), etc. Complexly allusive, the iconoclast's taunt seems oddly well rehearsed, more like a chronicler's embellishment than an image breaker's spontaneous cry. Yet it plays throughout Protestant iconoclasm like a steady refrain.[10] It adds insult to another ubiquitous injury: the public demonstration that the image is a fabricated thing, an object made of wood or stone. "Look," the image breakers like to cry, showing a broken effigy to a gathered crowd, "Can't you see? It's nothing but wood!" The eye, believed to have been formerly dazzled into seeing the thing as a person, is forced to look again and see a thing. Exposed *as* a thing, the idol is revealed to be ... nothing: "We know that an idol is nothing at all in the world and that there is no God but one" (1 Cor. 8:4). "Look," cried a weaver in Tournai, grabbing the Host

from a priest, "Deceived people, do you believe this is the King, Jesus Christ, the true God and Savior? Look!" Then he crumbled the Host and ran. "Look," exclaimed an iconoclast in Albiac holding up relics, "Look, they are only animal bones!"[11] Already in 1507, rumors circulated of a fraudulent image miracle in Bern, in which a pietà that appeared to weep was exposed as a deceptive artifice involving piped in varnish. The Swiss artist Urs Graf's woodcut illustration diagrams the trick, yet one wonders how sharp the distinction was between such automata and veristic pictures and theater of the time, and whether in all cases viewers easily maintained a suspension of disbelief in order to feel piously sacred presence.

Unlike these disenchanting cries and demonstrations, however, the phrase "save yourself" enrolls the crucifix in new fiction, one in which it, as object, is ritually crucified. A Catholic broadsheet from 1621 vilifying Calvinist iconoclasm in Veltin (in present-day Lombardy) records the gesture.[12] At the right, a sculpted crucifix has been hung upside down, presumably after being whipped by the scourge balanced on the hook. Woodcuts from a Catholic pamphlet from one century earlier depict similar degradations and blames them on "Martin Luther's teaching."[13]

In the rites of violence they improvised[14], iconoclasts seemed to relish their role as scoundrels. During carnival celebrations in Hildesheim in 1543, members of the tailors' guild hauled a much-venerated Christ statue from the church of St. Andreas into their drinking hall, where they ordered it to drink. Playing off its non-response, they began to taunt the effigy with words like those spoken by Christ's tormentors in Passion plays of the time: "Now how's he supposed to drink? Can't you see? He's been whipped, his blood is squirting out of him and he's holy and impotent, so he just can't do it."[15] Then, after a pause that made muteness audible, the statue was "forced" to drink, and a cup was rudely tossed in its face. More rude still was the gesture of a burgher in Ulm in 1534, who shat into the mouth of a Christ-effigy pulled from Our Lady's Gate.

8 9 10 11 13 14 15 12

_ Cécile Dupeux, Peter Jezler and J. Wirth (eds), *Bildersturm. Wahnsinn oder Gottes Wille*, exhib. cat. Historisches Museum, Bern, 2000, cat. 151.

_ *Basler Chroniken*, 1, 1874, p. 447, cited Dieter Koepplin, Komet her zu mir alle. Das tröstliche Bild des Gekreuzigten nach dem Verständnis Luthers, in *Martin Luther und die Reformation in Deutschland*, Kurt Löcher (ed.), Gütersloh, 1983, p. 155.

_ Natalie Zemon Davis, *Society and Culture in Early Modern France*, Stanford University Press, Stanford, 1975, p. 157.

_ See Norbert Schnitzler, *Ikonoklasmus-Bildersturm*, Fink, Munich, 1996, p. 17, p. 214; Michalski, op. cit., pp. 97ff.

_ *Luther und die Folgen für die Kunst*, Werner Hoffmann (ed.), exhib. cat. Hamburger Kunsthalle, Prestel, Munich, 1983, cat. 26.

_ The term is Natalie Zemon Davies' (The Rites of Violence: Religious Riot in Sixteenth Century France, in *Past and Present*, 59, 1973, pp. 51-91).

_ Eyn Warhafftig erschröcklich Histori von der Bewrischen vffrur ..., in Dupeux, et.al., *Bildersturm*, op. cit., cat. 147.

_ Schnitzler, op. cit., pp. 214-15.

Anonymous / »Kurtzer vnnd warhaffter Bericht des KelchenKriegs« [Short and True Report on the Thirty Years' War] /
Iconoclasm in Calvinist Veltlin / 1621 / engraving / 13.7 x 11.5″ / Kunstsammlungen der Veste Coburg, Kupferstichkabinett

Kurtzer vnnd warhaffter Bericht deß KelchenKriegß/ so von de

Ertzketzern Caluin: Püntner: Zwinglischen/ Zürchern vnd Grauern/ in Veldtlin von

dem 15. Augusti Anno 1620. biß dato her volbracht worden.

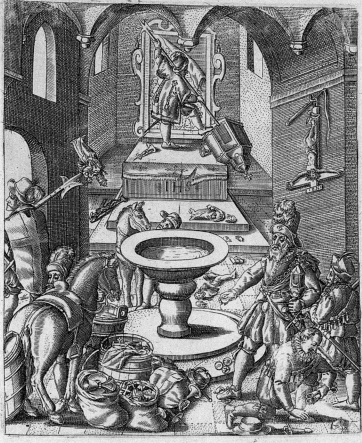

Getruckt im Jahr / 1621.

Israel van Meckenem / Gregormesse [St Gregory's Mass] /
etching / 17.9 x 11.6" / Albertina, Vienna / © photo: Albertina, Vienna

Hans Weiditz / Pietà / woodcut / 11.6 x 8.6" /
Albertina, Vienna / © photo: Albertina, Vienna

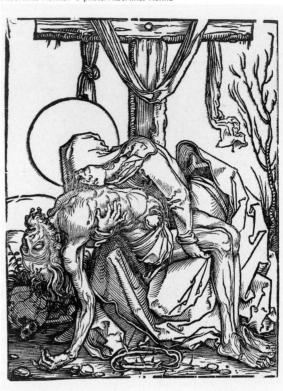

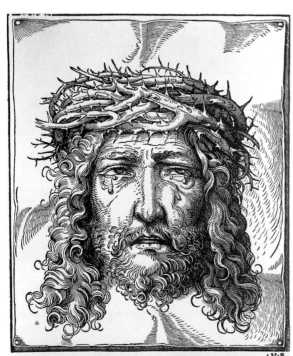

Hans Burgkmair / Schweißtuch der Hl. Veronika [The Veil of St. Veronica]
/ 1510 / woodcut / 8.6 x 6.5" / Albertina, Vienna / © photo: Albertina, Vienna

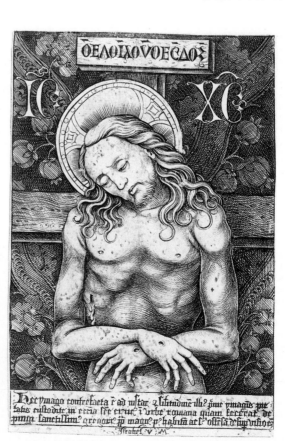

Israel van Meckenem / Schmerzensmann [Man of Sorrow] / etching /
6.8 x 4.5" / Albertina, Vienna / © photo: Albertina, Vienna

Monogrammer H / Christus als Grundstein [Christ as Cornerstone] / 1524 /
woodcut / 22 x 14" / Germanisches Nationalmuseum, Nuremberg

From a protest lodged against the tailors by the Bishop of Hildesheim we know that the "misused" Christ was a statue "which, for the remembrance of the bitter suffering he endured, showed [Christ] scourged, bloodily crowned, and with the cross on his shoulder."[16] In other words, it was the sort of statue – grimly detailed, sometimes life-sized, sometimes with movable limbs – that might be used in staging Passion plays, and that became a special target of iconoclastic fury.

Perhaps the tailors were good at playing the bully because bullying is what men in drinking halls generally do best. Perhaps, though, they knew their roles because they had

Crucifixion with Movable Arms / c. 1515 / wood / Diözesanmuseum. Klagenfurt

acted them already in church, in paraliturgical dramas, where the evil characters often got the best lines. In Dresden, for example, in a scene worthy of Monty Python, a layman playing the Bad Thief got laughs for improvising on Christ's "I thirst!" (John 19:28) by calling for beer from the cross.[17] Now everyone in the culture in question was taught that Christ's biblical henchmen, his villainous judges, torturers, and executioners, were Jewish. And rumors routinely circulated of contemporary Jews who, itching to crucify Christ again, spied on, or infiltrated, performances of Passion plays. It was for this reason that many German towns locked Jews in their houses, barricading town gates during times of sacred theater.

In Regensburg, a converted Jew named Kalman was drowned in 1470 for (among other things) watching, disguised as a Christian, the municipal Good Friday procession.[18] On the eve of the Reformation, Jews were usually blamed for image desecration, as in a case much publicized by Emperor Maximilian, of a Marian statue mutilated in Camberon in 1322.[19]

How, then, did Hildesheim's tailors understand the likeness between their iconoclastic acts and the crimes pinned upon the Jews. If such rites aimed to punish Christ's false image, if they fit a pattern of associating papal religion with renewing Christ's torment, why did they model retribution so overtly on the scandal of all scandals, Christ's murder by his own people? And might the effigy's inertness, configured as inaction by means of the mocking command "save yourself," have resembled Christ's stoic endurance? What a risky demonstration, behaving like villains and allowing the effigy to act like Christ! "By mocking and jeering his effigy," observed a Lutheran preacher in 1596 denouncing contemporary iconoclasm in Anhalt, "you tear open the holy wounds of Christ the Lord again and crucify him anew."[20]

But then again, in Christian thinking, every semblance hides a dissemblance and every dissemblence, a

16

_ Schnitzler, op. cit., p. 214.

18 20 19 17

_ Johannes Pauli, *Schimpf und Ernst*, Johannes Bolte (ed.), H. Stubenrauch, Berlin, 1924, cited Scribner, *Bilder...*, op. cit., p. 215.

_ Pamphilus Gengenbach, *Daz ist ein erschrockenliche history von fünff schnöden juden, wie sie das bild Marie verspottet durchstochen haben*, Basel, 1517; see Schnitzler, op. cit., p. 123. On rare cases of the sanctioned destruction of Christian images by Jews, see Michele Luzzati, Jews, the Local Church, the 'Prince' and the People, in *Microhistory and the Lost Peoples of Europe*, Edward Muir and Guido Ruggiero (eds), trans. Eren Branch, Johns Hopkins University Press, Baltimore, 1991, pp. 101-118.

_ Abraham Taurer, *Hochnotwendigster Bericht. Wider den newen Bilderstürmerischen Carlstadtischen Geist im Fürstenthumb Anhald*, Jaubisch, Magdeburg, 1597, p. Niiii.

_ Raphael Straus, *Urkunden und Aktenstücke zur Geschichte der Juden in Regensburg 1453-1738*, Münster, 1960, pp. 29ff; see Po-Chia Hsia, *The Myth of Ritual Murder: Jews and Magic in Reformation Germany*, Yale University Press, New Haven, 1988, pp. 66-68.

Albrecht Dürer / Engelsmesse [Angel's Mass] / c. 1500 / pen, ink, and watercolor over metalpoint /
24 x 19" / Musée des beaux arts, Rennes

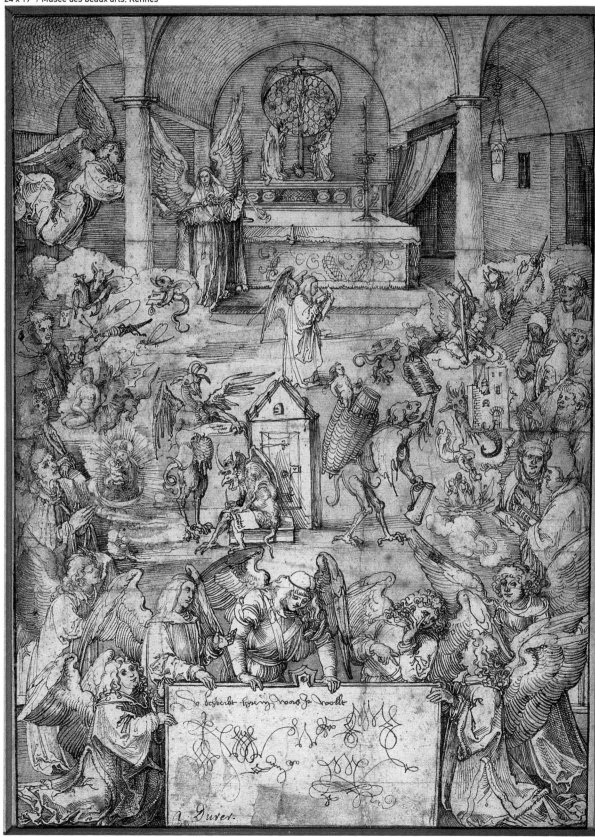

semblance. Sacred theater delighted its audience with a routine in which the actor playing Christ, as if suddenly fed up with being beaten and mocked, pretends to step out of character and strike back at the other actors with the words such as "If that's the way you're going to play the Passion, then next time let the devil be your God."[21] Comic interludes like these encouraged more serious suspicions. Might the actor playing Christ in fact be the devil? Might the play-acting tormentors be Jews disguised as Christians representing Jews? Representations of Christ, whether pictorial, dramatic, or ritual, were self-consciously deceptive, partly to reflect the deceitfulness of the world, partly to accord with the vagaries of subjective response. A drawing by Albrecht Dürer included in the exhibition introduces the crucifix into a plot about sinful sight.[22]

Clergy and lay folk gather round an angelic celebration of the Mass. And in accord with that ritual arrangement, Dürer aligns his own depiction with the central altar, as well. In the intermediary space, however, within a band of clouds separating the altar – with its backing ensemble of reliquary and carved crucifixion, from its depicted supplicants – the artist has sketched little figures representing what the individual people think[23] and see – or better, what temptation induces them to desire and imagine. These thought-bubbles show people visualizing wine, women, food, dice, cards, and game boards, which are served up by little demons, while others appear contemplating visions of the Virgin, or of their own salvation, or indeed of the crucifix itself (upper right of the group, between a game board and a roast chicken), in a curious doubling of the altar cross. Around the sheet's center, and therefore aligned with the altar, an angel (above) and a devil (below) draft testimonies that, filed away in the gabled box, will damn or save.[24]

Dürer's drawing is itself not easy to decipher. Unconventional in subject matter, and lacking any clarifying labels, it invites us to engage visually in the good and evil visions it

Anonymous / St. Bridget Triptych / c. 1490 / woodcut, handcolored / 10.5 x 15" / British Museum, London

22 23 24 21

_ The attribution of this drawing to Dürer has been disputed. For a summary of opinions, see Walter Strauss, *The Complete Drawings of Albrecht Dürer*, Abaris Books, New York, 1974, 4, p. 524. The inscription is certainly Dürer's, as is the overall plan.

_ Moriz Thausig, *Dürer. Geschichte seines Lebens und seiner Kunst*, second edition, Seemann, Leipzig, 1884, 2, p. 235.

_ Johannes Pauli, *Schimpf und Ernst*, Hermann Österley (ed.), Litterarischer Verein, Stuttgart, 1866, p. 416; cited and discussed in Valentine Groebner's extraordinary essay, "Abbild" und "Marter." Das Bild des Gekreuzigten und die städtische Strafgewalt, in *Kulturelle Reformation. Sinnformationen im Umbruch 1400-1600*, Bernhard Jussen and Craig Koslofsky (eds), Göttingen, 1999, p. 227.

_ On this motif, see Jean Michel Massing, Sicut erat in diebus Antonii: The Devils Under the Bridge in the Tribulations of St. Antony by Hieronymus Bosch in Lisbon, in *Sight and Insight: Essays on Art and Culture in Honor of E. H. Gombrich at 85*, J. Onians (ed.), Phaidon Press, London, 1994, pp. 108-127.

St. Francis / dorsal of a choir stall / 1445-1447 /
iconoclastic intervention 1537 / Church of Saint-Gervais, Geneva

artist himself, has beat us to the task, filling the space not quite with writing but with skillful calligraphic lines. It is tempting to take these inimitable arabesques as enacting at the level of *fabrication* the free play of response staged above. Laying bare the image's liminal condition between fact and fiction, however, the lovely, errant lines – this German painter's signature artistic medium – aestheticize, and thereby to a degree also neutralize, representation's dangerous errancy. While there are good and bad responses to the sculpted crucifixion represented in the picture, the picture itself can be labeled as you want.

The premier image-maker of northern European culture at 1500, Dürer recognized that pictures are, at best, mediators, affecting without determining what their viewers see in them. Or as Bruno Latour puts it, "Images do count, they are not mere tokens, but not because they are the prototype of something away, above, beneath: they count because they allow one to move to *another* image, exactly as frail and modest as the former one – but *different*."[25] In the sketch, the worshiper who thinks of Christ while beholding the mass does so, it seems, with another image in mind: not the carved crucifixion see raised above the mensa itself but something more like a memory tag: a crucifix held by a mediating angel. During the 1510s, just prior to the outbreak of Protestant iconoclasm, Dürer argued explicitly that, contrary to what "many crude people who hate art say,"[26] images do not corrupt their viewers. Only their improper use does this, just as weapons don't kill but murderers using weapons do. "Non est disputatio de substantia, sed usu et abusu rerum," wrote Luther in a similar vein.[27] This has always been the standard argument for moderation on the question of images: the supreme irrationality is not to venerate images but to imagine that it is the images themselves that cause their own abuse. Already in 1522, opponents of iconoclasm sharpened this critique by blaming idolatry on the image breakers, whose fury seemed to prove their own belief (one not shared by the pious users of images) in an intrinsic power of images.

imagines. At the sheet's base, as if to provide space for an explanatory gloss, Dürer has drawn a blank tablet and headed it: "Here write whatever you want." Someone, probably the

27 26 25

_ See Bruno Latour's essay in this catalog.

_ Martin Luther, *Werke. Kritische Gesammtausgabe,* Böhlau, Weimar, 1883-1980, 28, p. 554; Luther's position here agrees with that of Hugo of St. Victor: *Idolum nihil est (Patrologia Latina,* 175, col. 527).

_ Dürer, op. cit., 2, p. 107.

And it was also true that iconoclasts utilized images in their war against the idol, making and remaking visuality in their own terms. As in Gheerhaerts' print, defacement itself leaves a face behind. When iconoclasts cleansed their churches (e.g., in Münster, Bern, Zurich, and Geneva), they left the ruined idols standing as emblems of defeat. A dorsal from the dismantled choir stalls of a Franciscan church in Geneva displays iconoclastic anti-carving as a theological skill. The elements gouged away in 1535-36 (the patron-saint's face, hands, halo, and insignia, as well as the face and hands of the Christ seraph) play off the carving from circa 1445 that leaves, in this case, uncannily, the scar of the stigmata.[28]

Scores of extant sacred sculptures evidence a similar destructive routine.[29] The deleted features – the eyes, mouth, and hands, as organs of sight, speech, and action – had been places of the image's purported power. Erased, they display the object's impotence, as blind, mute, and anonymous stone. Yet in the targets of their aim, iconoclasts also treated that stone as if it were a criminal to be punished. As Martin Warnke wrote in his seminal study of this material, such blows reference the deformations with which offenders at the time were disciplined.[30] Convicted criminals were variously scarred, burned, blinded, castrated, and dismembered, then left alive to advertise that, on them, justice had been served. But in similarly punishing and preserving idols, did the iconoclasts not invest them with a personhood they abhored? How material was materiality shown to be when, as sometimes occurred, a saint's effigy was decapitated by the town executioner?[31] And what about the many legends of miraculous iconoclasm? The iconophobic Martin Bucer wrote of statues in Basel breaking at the touch of a wand; the Calvinist martyrologist Jean Crespin reported of great stone idols being more easily removed by women and children than by workmen; and the traveller Richard Clough describes Antwerp's iconoclasm as if it were a supernatural event: "It was the marveylest piece of work that ever was sene done in so short a tyme; and so

Master of Frankfurt / Flight into Egypt / c. 1505 / oil on panel / Staatsgalerie Stuttgart

terybell in the doing, that yt wolde make a man afrayd to thinke uppon it – being more like a dreme than such a piece of work."[32] There were old precedents for the image's instantaneous collapse. Legend had it that when Christ was carried by Joseph and Mary into Egypt, the idols toppled as he passed; pictures of this episode are some of medieval art's liveliest fantasies of what pagan idols looked like: misshapen to begin with and therefore destined for the fall they now endure.

Already at the moment of their earliest circulation, Erasmus labeled Protestant tales of wondrous church cleansing as "superstitions," and accused them of the naive conviction they pretended to vanquish. Thus arose the "critique of the critique" that is still omnipresent today.

What is gained by calling the image breaker an idolator? If idolatry is indeed but an accusation made by

30 29 31 28 32

_ Dupeux, op. cit., p. 343.

_ Martin Warnke, Durchbrochene Geschichte? Die Bilderstürme der Wiedertäufer in Münster 1534-1535, in *Bildersturm. Die Zerstörung des Kunstwerks*, Martin Warnke (ed.), Syndikat, Frankfurt/M., 1977, pp. 159-167.

_ Dupeux, op. cit., cat. 168.

_ Michalski, op. cit., pp. 120ff.

_ John William Burgon, *The Life and Times of Sir Thomas Gresham*, Wilson, London, 1839, p. 145; discussed in Christine Göttler, Ikonoklasmus als Kirchenreinigung, in *Georges-Bloch-Jahrbuch des Kunstgeschichtlichen Seminars der Universität Zürich*, 4, 1997.

Lucas Cranach the Younger / The Old and New Testament / book / 10.5 x 13" / British Museum, London

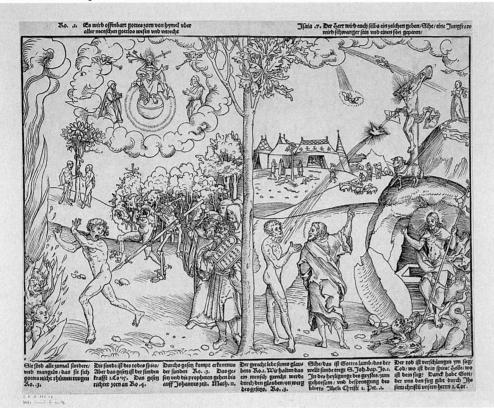

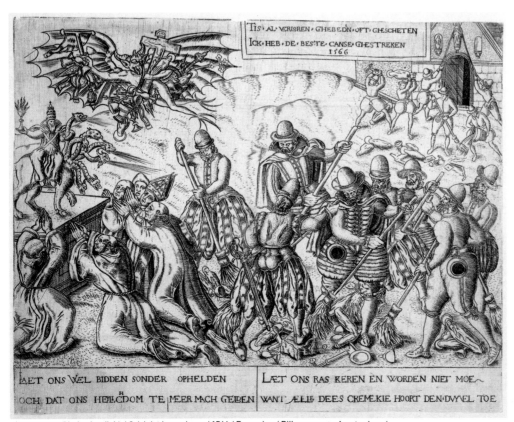

Anonymous (Netherlandish) / Calvinist Iconoclasm / 1566 / Engraving / Rijksmuseum Amsterdam /
© photo: Rijksmuseum Amsterdam

Raphael Sadeler / Die vier letzten Dinge [The Four Last Things] / series of four engravings / 66.5 x 43.3", 66 x 45", 66 x 45", 65 x 43.3" /
Staatliche Graphische Sammlung München, Munich / © photo: Engelbert Seehuber, Staatliche Graphische Sammlung München

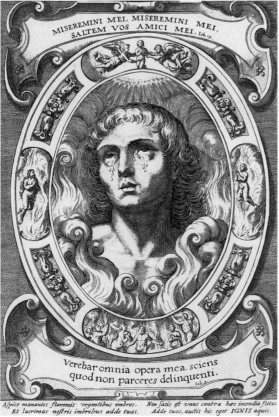

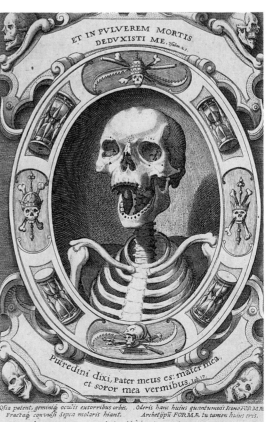

iconoclasts to caricature certain uses of pictures, if (as this exhibition contends) it is less a belief than a fiction of naive belief, what function is served by accusing the accusers of their accusation? For some observers, turning the tables is a way of insisting that, although they deny it, everyone – the iconoclast, the iconophile, even the historian of art – is a naive believer, hard-wired to exhibit certain "natural" symptoms of re-

sponse.[33] And as in Freud's treatment of an interlocutor's "no," the more the patient protests that he or she "didn't think that," or "didn't (ever) think that," the more certain the para-critical verdict: "What, we ask, would you consider the most unlikely imaginable thing in that situation? What do you think was furthest from your mind at the time? If the patient falls into the trap and says what he thinks is most incredible, he almost always makes the right admission."[34] For those who

Hans Baldung Grien / Martin Luther / 1521 / woodcut

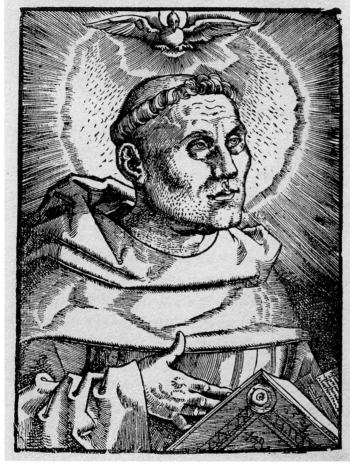

Hans Baldung Grien / Martin Luther / 1521 / woodcut defaced with pen and ink / date of defacement unknown / Universitätsbibliothek Marburg

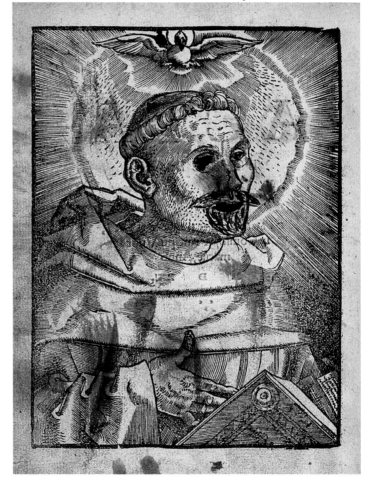

33

34

_ The strongest proponent of this view is David Freedberg, *The Power of Images*, University of Chicago Press, Chicago, 1989.

_ Sigmund Freud, *Negation*, *Standard Edition of the Complete Psychological Works*, Alan Strachey (ed.), London, 1953-1974, 19, p. 233.

are closer to iconoclasm's frontlines, table-turning is a sly, polemical trick, as when Luther blames Wittenberg's chief iconoclast, Andreas Bodenstein von Karlstadt, of idolatry. It is not that the iconoclast really is an idolator. However, calling him one while smiling knowingly at his denial inflames his self-incriminating zeal.

Yet when a reformer holds up the broken idol and cries, "Behold, it's only wood," wood is what he thinks he holds. If, in seeking to make that knowledge vivid, he further breaks, burns, or degrades the wood, it is still wood in his mind. Granted, from outside, his antics seem possessed by a fury that exceeds the fact. But this is because he believes the wood had been everything to someone else. He assaults the deception he believes attached to the wood, the fiction of a spirit inhabiting the fact. That the iconoclast believes in idolatry does not make him an idolator, though. He is simply another believer, another person with "a strong commitment to representation," in this case, that of naive belief itself. To phrase this in terms borrowed from Dan Sperber, believers in belief do not confuse representations with persons (the idolator's imputed error). Rather, they confuse representations with facts.[35] Imagining that iconophiles know the wood falsely (as God, not wood), they hit the wood but instead strike *representation* – of a deity, of an institution, of a social body. No wonder the critical gesture rebounds.

Representation from the start, the wood becomes, in its "specious" (as the iconophile Hieronymous Emser put it) exposure, representation once again.[36]

We can observe this succession of image by image in the polemical art of the period, as Protestants and Catholics did battle by disfiguring each other's representations. By 1519, before the war against idols had even begun, images of Luther began circulating in printed form.[37] Hans Baldung Grien depicted the reformer nimbused like a saint, and with the Holy Spirit overhead, affirming his divine election as interpretor of the Bible he holds.

Scandalized by this woodcut, Catholics accused its purchasers of idolatrously "kissing it and carrying it." At the Diet of Worms, the Papal authorities banned it, burning and mutilating extant impressions. One surviving example displays such a defacement, including, in addition to the mocking mustache, marks on the eyes that cancel Luther's heavenward gaze.[38]

Hans Brosamer / Martinus Luther Siebenkopf [Seven-Headed Martin Luther] / woodcut / title illustration / in Johannes Cochlaeus, Sieben Köpffe Martini Luthers, Valentin Schumann, Leipzig, 1529 / Germanisches Nationalmuseum, Nuremberg

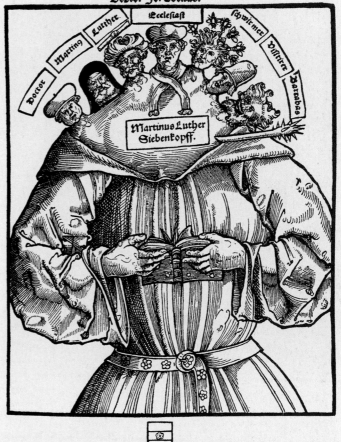

36 37 35 38

_ Dan Sperber, *On Anthropological Knowledge,* Cambridge University Press, Cambridge, 1985, pp. 54-60.

_ Hieronymus Emser, Das man der heyligen bilder in der kirchen nit abthon, noch unehren soll, in *A Reformation Debate: Karlstadt, Emser, and Eck on Sacred Images,* Bryan D. Mangrum and Giuseppe Scavizzi, (trans. and ed.), Dovehouse Ed., Ottawa, 1991, p. 62.

_ Robert Scribner, *For the Sake of Simple Folk: Popular Propaganda for the German Reformation,* second ed., Claredon Press, Oxford, 1994, pp. 14-36; Martin Warnke, *Cranachs Luther: Entwürfe für ein Image,* Fischer, Frankfurt/M., 1984.

_ The impression is in University Library in Marburg; see Warnke, op. cit., pp. 66-68.

Within a few years, Catholics consolidated their critical gestures in a printed image of infamy. *The Seven-Headed Martin Luther* accompanied Johannes Cochlaeus' refutation of the Protestant altar sacrament. Probably designed by Hans Brosamer, the 1529 woodcut shows the Reformer as the apocalyptic dragon or Antichrist described in *Revelations 13*. The seven heads – here as doctor, saint, infidel, priest, fanatic,

church supervisor, and Barabbas – visualize Luther's deception and the falsehood of his creed, the sola scriptura. Though Luther reads from one book (as in Baldung's woodcut), his opinions will be as various as his heads. Within a year, Protestants responded with the woodcut *The Seven-Headed Papal Beast*.

This effigy of an effigy of an effigy assaults church pictures on several levels. Giving the Antichrist the heads of the

Seven-Headed Papal Beast / 1530 / woodcut /
Staatliche Museen zu Berlin – Preußischer Kulturbesitz, Kupferstichkabinett

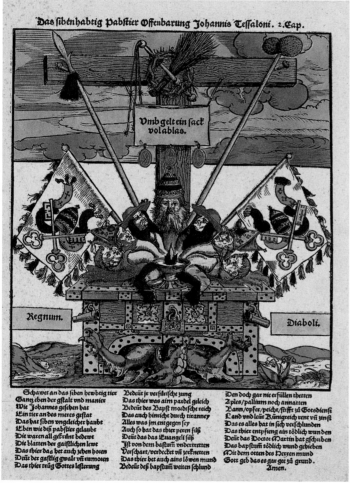

Anonymous / Gregormesse [Mass of St. Gregory] / woodcut /
in Johann Bäumler, Chronik von 1476 (Augsburg), 1476 / Justus-Liebig-Universität, Gießen

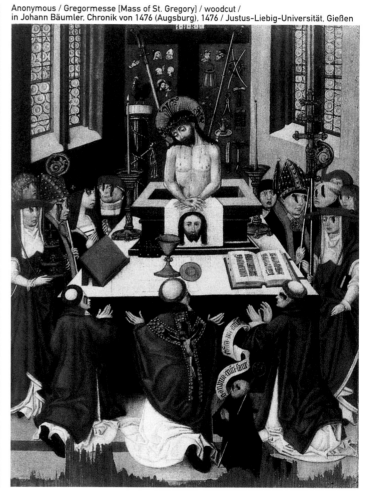

Pope and his officers, it mocks Catholic mockery of Luther portraits. The monster placed on an altar of mammon also specifies what the likes of Cochlaeus do to the sacrament they feign to defend. As an accompanying text explains, the papacy "places itself in the temple of God and thereby declares itself to be God." Behaving like an idol, demanding material tribute in return for salvific reward ("for money a sack of indulgences"), the Church stands condemned by its own representations. Altar and altarpiece, turned into cash box and apocalyptic beast, become the "kingdom of the devil." And these are framed by the deformation of another instrument of Catholic piety, the devotional woodcut.

The late Robert Scribner observed that the *Seven-Headed Papal Beast* parodies popular images of the Mass of Saint Gregory. One such print published in 1476 promises in its inscription some 430 years of indulgence to "he who honors this figure with a Pater Noster."[39]

The Protestant satire so resembles this, its target, that a casual viewer would be led to think that it is itself an indulgenced print. Only close inspection reveals the defacements. Instead of the resurrected Christ, there is the Antichrist; instead of the INRI inscription, an indulgence letter; instead of the wine chalice, a demonic flame, etc. These deformations might signal the work of some iconoclast were it not for signs of an inside job. Papal flags fly at both sides; and on a seal of the indulgence letter stands the Medici coat-of-arms of Pope Clement VII. Contrasted with the humble *arma Christi* (the cross, lance, sponge, crown of thorns, etc.), the papacy's symbols profane their setting with worldly pomp. Not some iconoclast but the Church itself has desecrated this altar.

The woodcut strikes a blow both against the things it depicts and against the framing depiction it parodically appropriates. Images of the Mass of St. Gregory celebrated clerical agency. They portrayed the miracle, attributed by legend to Pope Gregory the Great, in which Christ appeared visibly at the altar sacrament. The priest's power to transubstantiate

the wheaten disk of the Host into Christ's flesh was thus, for this once, made sensibly evident (since ordinarily, the flesh was hidden under the "species" of the bread). Various versions of the legend link this capacity to represent Christ sacramentally to the cult of images. To commemorate the miracle, Gregory was said to have made a portrait icon of Christ as he appeared

Anonymous (Master Seewald?) / Mass of St. Gregory / 1491 / tempera on wood / 40 x 30" / date of defacements unknown / Stadtmuseum Münster

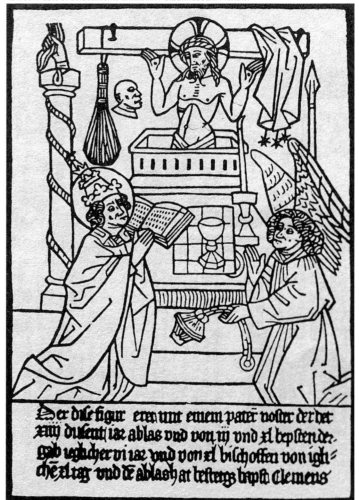

39

_ Johann Bämler, *Chronik*, Augsburg, 1476, fol. 140v; Scribner, *For the Sake of...*, op. cit., pp. 102-104.

Peter Flötner / Die Neue Passion Christus [The New Passion of Christ] /
c. 1535 / woodcut / 5 x 18.7" / Germanisches Nationalmuseum, Nuremberg

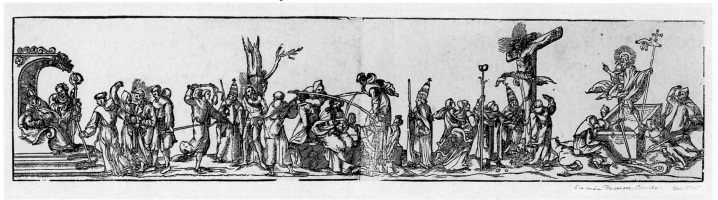

in the vision: a ruined cadaver risen from the grave and backed by the tools of the Passion. This portrait, identified with an actual icon displayed in the church of Santa Croce in Gerusaleme in Rome, and enormously indulgenced (up to 32,755 years of pardon), modeled all late medieval images of Christ as the Man of Sorrows. And because of their narrative link to the altar rite, and due also to Gregory's role as main apologist for Church art, such pictures became meta-emblems of Christian images generally. More than any other iconography, they diagram divine presence at the altar, making explicit what both liturgy and sacred images themselves do implicitly.

It is difficult to fathom the grounds of the assault of the Gregory panel, dated 1491 and signed by the artist ("Seewald"). The attacker scratched out every eye of the surrounding clerics and donor, but left untouched the sacred icons they are shown to behold. Whatever the reason for this restraint, the panel occasioned at some point in its reception a limited symbolic violence against priests and their supporters; note that two layfolk in the background are spared. To venerate the 1491 panel, like a prayer to the Augsburg woodcut, meant committing to the Church's institutional, sacramental, and pictorial representation of Christ, hence the generous indulgence.

Imitating such pictures in medium, layout, composition, and motif, *The Seven-Headed Papal Beast* disfigures its model from within. Christ, whom the target picture makes multiply present, has vanished. The altar's specific debasements explain his absence. The money chest accuses the Church of transforming sacrament into a business by its sale of private masses and its receipt of pious donations. The Papal Beast, in turn, pictures what the sacrament, thus corrupted, represents: not Christ but the Church itself. The woodcut makes these charges by using elements from its Catholic prototype. For example, it shifts the triple-crowned pope from the margin to the center, indicating that priestly mediation, idealized in Gregory's Mass, stops with the mediator, who celebrates himself. By placing the Papal Beast on the altar in the manner of an idol, the woodcut extends its critique to the cult of images. At one level, the heads of the pope and his officers evoke late-medieval polyptych altarpieces, which featured mediators (the Virgin and saints) more prominently than Christ.

Also, the Beast's pomp, contrasting with the aesthetics of the Man of Sorrows, repeats the old complaint about church art as contrary to Christ's humility. At another level, the putative indulgence letter hanging from the cross recalls that the Protestant print's pictorial model – the Catholic indulgenced woodcut – belongs to the same corrupt regime. What one worships in it is Antichrist.

Lucas Cranach the Elder / Christ Entering Jerusalem / The Pope Waging War / woodcuts / 3.7 x 4.7 ¨ /
in Passional Christi und Antichristi, texts by Melancthon and Johan Schwerdtfeger, Wittenberg, 1521 / British Museum, London

Paſſional Chriſti und
Sanfftmütig der Herr kam geritten —

Sich an, dein König kompt dir demüthig, uf einem jungen Eſel, Matthäi 21. (V. 5.). Alſo iſt Chriſtus kommen reitend uf in frembden Eſel, arm und ſanftmütig, und reit, nicht zu regieren, ſondern uns allen zu einem ſeligen Tode. Johannis 12. (V. 41.)

Antichriſti.
Der Papſt in Hoffart und ſtolzen Sytten.

Die Geiſtlichen ſeind alle Königè, und das bezeugt[1] die Platten ufim Kopfe, duo. 12. q. 1. Der Papſt mag gleich, wie der Kaiſer reiten, und der Kaiſer iſt ſein Trabant, uf daß biſchofflicher Würden Gehalt nicht gemindert werde. c. Constantinus 10. c. 6. Dis. Der Papſt iſt allen Volkern und Reichen vorgeſetzt. Exvag. sup. gentes, Johannis 22.

1 bezeugen.

Paſſional Chriſti vnd
1904 · 2 · 6 · 41(1)
Chriſus.
Alß Jheſus iſt eyn weyten wegk gangen / iſt er müd worden: Johan. 4. Der mir will nach folgen / der nem ſeyn Creutz vff ſich vnd folge mir. Matthei 16. Er hat yn ſeyn Creutze ſelbſt getragen vnd iſt zu der ſtell die Caluarie genant wirdt/gangen. 19.

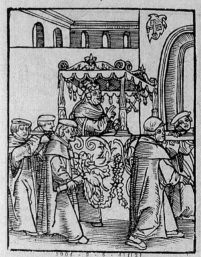

Antichriſti.
1904 · 2 · 6 · 41(2)
Antichriſtus.
Das capittel Si quis ſuadente vñ der gleychen zeygt gnug an wie gerne der Bapſt das Creutz der wyderwertigkeyt duldet/ſo er alle die iheuen/die hande an die pfaffen an legt vormaladeyet vñ dem teuffel gibt Vnd alſo ouch erregt der Bapſt das Creutz das ynnen getrauffe Chriſten vff yren achſſeln tragen muſſen. B iij

Iconoclasm in Zurich / 1587 / pen, ink, and watercolor / in Chronical of Johann Jakob Wick / Zentralbibliothek Zürich

It is tempting to seek a message behind each deformation, as if the idol's fragments catalogued every reason for its ruin. Yet like the broken statues and scraped paintings that iconoclasts preserved, pictures such as the *Seven-Headed Papal Beast* speak chiefly in negations. To every statement appropriated from the model they append a mocking "not!" Antithesis is the controlling device of polemic prints in this period.

Sharpening doctrinal controversy into an Armageddon of absolutes, it stamps antithesis opponent's "yes'" with indelible "no's." To say "no" is at once to communicate rejection and to reject communication. "No" exits social interaction in the double negative "I will not do what you want if you do not do what I want."[40] Reformation historians often ask whether visual propaganda persuaded, or whether it only preached to the converted.[41] We might rephrase this by asking if the polemicist's "no" is a communicative event at all. On the one hand, it states its refusal to belong together with the Other: "alter" is false, is the Devil, is Antichrist. On the other hand, negation cannot stand on its own, but depends on the societal communication to which it negatively refers. Instead of sending messages, "no" is communication's background noise, the broken idol's dumb stock and stone. Yet noise is also negation's resource, and fills each "no" with alien communiqués.

41 40

_ Niklas Luhmann, *Social Systems*, Stanford University Press, Stanford, 1995, pp. 371-391.

_ Scribner, *For the Sake of...*, op. cit., p. 248.

The Image Makers Are Image Breakers

From where did the destroyers of crucifixes derive their representations? Historians have long observed the resemblance between iconoclastic riot and carnival. Often breaking out during the revelry prior to Lent, iconoclasm modeled its actions both on church rites (as when Wittenburgers, in 1522, stripped the altars on Green Thursday, the customary day of ritual church cleansing) and on parodies of church rites that already formed part of the liturgical year. Such travesties flourished on *Fastnacht*, on the food-and-drink-filled eve of

»Alexamene Worships His God!« / anti-Christian graffiti /
early third century / poster / Palatine, Rome / Archive Alinari

the fast, after which the eating of meat, along with a host of carnal pleasures, would be forbidden ("carnival" means *carne vale*, "farewell to flesh"). Under the motto world-upside-down, carnival engendered a jumble of transgressive antitypes: parodic Masses sung by children, Passion plays with Christ impersonated by a fool or devil, crude mimicry of local notables, etc. Sometimes sanctioned, sometimes curtailed, and often slipping uncomfortably into general unrule, these serio-comical interludes violated the order to which they, as part of the calender, also belonged. For Mikhail Bakhtin, who largely shaped current attention to this material, one essential feature of carnival was that, like the literary forms derived from it, it spoke in multiple voices. Expressing itself "dialogically," it mimicked official speech only to reveal that that speech was mimicry, too. "Discourse lives," wrote Bakhtin, "on the border between its own context and another, alien context."[42] In staging their acts of destruction, and in retrospectively describing them, iconoclasts utilized the places, gestures, and timing of carnival transgression. An illustration of an iconoclastic episode in Zurich in 1587 shows young men tossing sacred effigies into a fountain.

Such public shaming is scripted by carnival pranks, which mix cruelty and comedy. Note how the illustrator carries forward this mockery by showing at the fountain's center a statue of St. Veit boiling in his caldron; the nude martyr seems comically content in his new bath. The Basel chronicler and iconophobe Fridolin Riff termed the bonfires of images set in his town "carnival fires" not just because, occurring on 10 February 1529, they blazed on the Wednesday before Lent. Riff termed them thus also because, like the bonfires that concluded Carnival, their flames were meant symbolically to purify the flesh of its attachments – to meat, to drink, to beautiful things.[43] But these transgressions, in turn, were appropriated from rituals that were themselves carnivalesque to begin with, rites of a religion whose God was a man arrested, mocked, tortured, and crucified.

43 42

_ Mikhail Bakhtin, *The Dialogic Imagination*, Michael Holquist (ed.), University of Texas Press, Austin, 1981, p. 284.

_ Lee Palmer Wandel, *Voracious Idols and Violent Hands*, Cambridge University Press, Cambridge, 1995, pp. 174-182.

Sheet of Four Veronicas / before 1462 / Cistercian psalter, illuminated / 4.3 x 3.2" / Het Kongelige Bibliothek, Copenhagen, MS Thott 117, 8, fol. iv

Claude Mellan / Das Schweißtuch der Heiligen Veronika [The Veil of St. Veronica] / etching / Hamburger Kunsthalle / © photo: Elke Walford, Hamburg

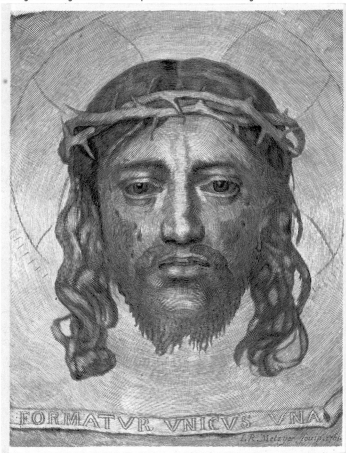

At the center of the great machinery of Christian images stood the paradox of the cross: what to the rest of the world was the ultimate punishment – crucifixion as the most painful, public, and humiliating of deaths reserved for criminals, traitors, and slaves, as the "most crude and horrendous torture" (Cicero), the unspeakable "sign of shame" (Hebrews 12:2)[44] – was for Christians the emblem of their God. There survives some evidence of how this paradox was received by non-Christians. On the walls of the Palatine in Rome, in the former barracks, someone scratched a crude caricature of a donkey-headed man crucified on the cross; below, a mocking inscription probably targets some Christians in the graffitist's midst: "Alexamene worships his god."[45]

Augustine, seeking to reconcile the low literary style of the gospel texts (especially the Vulgate) to their divine content, argued that humble expression not only spoke to all men, but fitted Christ's incarnation as man.[46] The humility of Christ's birth and life among the poor, and more so, his cruel death, formed a *sermo humilis* that ought to be preached in a humble way. The Bible's aesthetics are of the ugly not the beautiful.

[44]

[46] [45]

_ Erich Auerbach, Sermo humilis, in *Literary Language and Its Public in Late Latin Antiquity and in the Middle Ages*, Auerbach, Erich (ed.), Princeton University Press, New York, 1965, pp. 25-81; Hans Robert Jauss, Die klassische und die christliche Rechtfertigung des hässlichen in mittelalterlicher Literatur, in *Die nicht mehr schönen Künste. Grenzphänomene des Ästhetischen*, Hans Robert Jauss (ed.), Fink, Munich, 1968, pp. 143-168.

_ Hengel, op. cit., p. 52.

_ Martin Hengel, *Crucifixion: In the Ancient World and the Folly of the Message of the Cross*, SCM Press, London, 1977, pp. 7-10; Mitchell B. Merback, *The Thief, the Cross and the Wheel: Pain and the Spectacle of Punishment in Medieval and Renaissance Europe*, Reaktion Books, London, 1999, pp. 201-204.

Anonymous / Herz Jesu [The Holy Heart] / c. 1460 / woodcut, handcolored, with tear / 3 x 2.4" / Albertina, Vienna / © photo: Albertina, Vienna

Anonymous (German) / Christi Wunden [Wounds of Christ] / c. 1450 / woodcut, hand colored / 22.6 x 17" / Staatliche Museen zu Berlin – Preußischer Kulturbesitz, Kupferstichkabinett

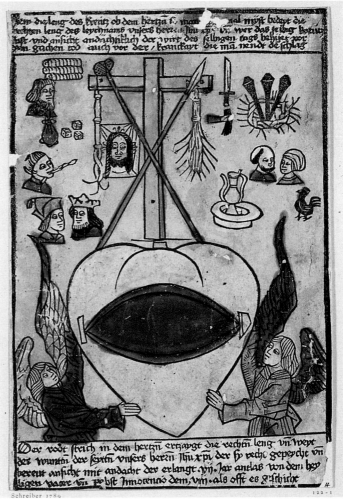

And its ontology of the image is based as much in dissimilarity as in resemblence: likeness *and* difference of man, of Satan, of Christ, to God. Created in God's image ("resemblance in humility"), but tempted by Satan to be God's equal ("resemblance in equivalence"), man fell into sin ("resemblance in conflict"), was expelled into a world of dissimilarity (the world as "regio dissimilitudinis"), there to remain until one man, Christ (true "resemblance in equivalence"), through his crucifixion (which makes him dissimilar again), regains our blissful seat.[47] The aesthetics of the ugly, whether Christian or modern, are a provisional, deceptive stage in a larger movement at the end of which truth, beauty, and power stand revealed.

In striking the crucifix, iconoclasts at once negate and repeat the likenesses cultivated in their target. Their blows are negations of a negation, "no's" cancelled by an ultimate "no." Religious imagery has iconoclasm built into it. Charged with illustrating how God's only son suffered the most miserable of human deaths, church pictures were made both to save and to reject phenomenal appearances. God became visible and circumscribable in his incarnation as Christ: true picture of his

47

_ Georges Didi-Huberman, *Vor einem Bild*, Hanser, Munich, 2000, pp. 218ff; see also Robert Javelet, *Image et ressemblance au XIIe siècle de saint Anselm à Alain de Lille*, Université de Strasbourg, Paris, 1967; A. E. Taylor, Regio dissimilitudinis, in *Archives d'histoire doctrinale et littéraire du Moyen Ages*, 9, 1934, pp. 305ff. See, too, Didi-Huberman, *Fra Angelico. Dissemblance et figuration*, Flammarion, Paris, 1990.

father, Christ could therefore be pictured, indeed produced pictures of himself miraculously, like his Virgin birth, without human manufacture *(acheiropoetos)*, as in the likeness deposited on St. Veronica's cloth. Betrayed, humiliated, tortured, and crucified, however, Christ was also concealed in his visibility, God's perfect likeness transformed into the ugliest of things: "with no beauty in him nor comeliness ... the man of sorrows" (Isaiah 53).

In the late Middle Ages, painted, sculpted, and printed images of Christ on the sudarium reflected this duality. Depicting – often in the very same format[48] – Christ's face untouched

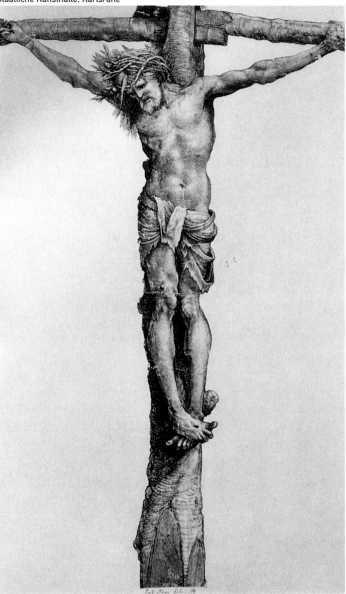

Mathias Grünewald / Crucifixion / c. 1520-25 / black chalk, and black, gray and white pencil / Staatliche Kunsthalle, Karlsruhe

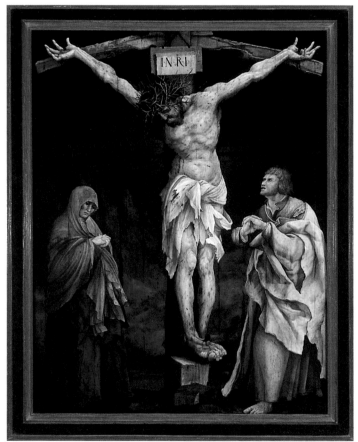

Mathias Grünewald / Crucifixion / c. 1520-25 / oil on panel / Staatliche Kunsthalle, Karlsruhe

48

_ James Marrow made this important observation some twenty years ago.

Anonymous / Christ in the Wine Press / woodcut, handcolored / 4.8 x 3" / The British Museum, London / © photo: The British Museum, London

by the Passion (because outside of death and time) or else abjectly distorted by it, these hybrid index-icons merge beauty with ugliness, concealment with ostentation. On the one hand, everything about these holy faces shouts visibility: the shining halo, the *en face* view without viewpoint, the visage on cloth that in no way adheres to that cloth's heavy folds, etc. On the other hand, typically, those faces are difficult to see, and not only because they have often been effaced by use (e.g., in osculories, where kissing rather than beholding is the key receptive practice). The gilded frames, mirroring silver surrounds, and chrystal capsules that encase the face, which is itself often dark and featureless, eclipse the image in a blaze of reflective light.[49]

In his brief account of the sudarium in the *Golden Legend*, Jacobus de Voragine stresses how being affected by the Holy Face is contingent on the viewer: "Can this image be bought for gold or silver," inquires a friend of Pontius Pilate,

to which Veronica responds, "No, only true piety can make it effective." Along these lines, the thirteenth century mystic, Gertrude of Helfta, in her meditations, glimpsed in the sudarium both darkness and light, concealment and clarity; for her, as Jeffrey Hamburger put it, "the Veronica cannot simply be characterized as either blank or stained, billian or sullied; it is, paradoxically, both at once, just as Christ is both human and divine."[50]

At the eve of Protestant iconoclasm, people reveled in grisly depictions of Christ's abject body, in which every bit of necrotic flesh stood artfully portrayed. Ubiquitous paintings and woodcuts of Christ's wounds and of the "arms" of his Passion, wounded images, even, of those wounds, in which the image of the cut is printed, painted over in red, and then physically slashed, give collections of fifteenth century prints the character of a chamber of horrors.

49

50

_ Hamburger, op. cit., p. 359.

_ Didi-Huberman, *Vor einem Bild*, op. cit., pp. 198-206; Jeffrey Hamburger, *The Visual and the Visionary: Art and Female Spirituality in Late Medieval Germany*, New York, 1958, pp. 317-382.

Michael Wolgemut / Sketchbook / pen, ink, and watercolor / 7.8 x 5.5" /
Staatliche Museen zu Berlin – Preußischer Kulturbesitz, Kupferstichkabinett / © photos: Jörg P. Anders

Christus am Ölberg [Christ at the Mount of Olives]

Gefangennahme Christi [Capture of Christ]

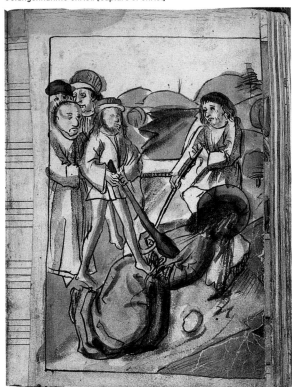

Christus vor Pilatus [Christ ahead of Pilatus]

Geißelung Christi [Flagellation of Christ]

Geißelung Christi [Flagellation of Christ]

Christus im Gefängnis [Christ in Prison]

Der gefangene Christus [Captured Christ]

Verspottung Christi [Mocking of Christ]

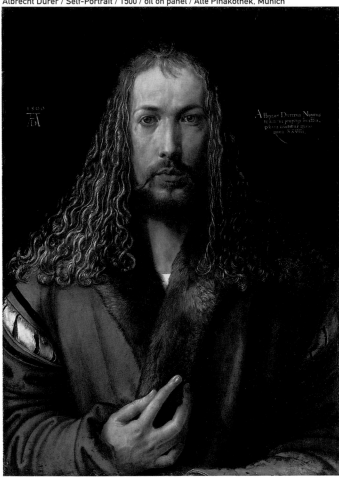

Albrecht Dürer / Self-Portrait / 1500 / oil on panel / Alte Pinakothek, Munich

Karlsruhe's most famous artistic possession is such a thing: the large Crucifixion from Tauberbischofsheim by the painter who now goes by the disputed name Mathias Grünewald.[51]

Everything that Christ became – hands and feet wrenched and dislocated by the nails; loin-cloth hyperbolically shredded; skin darkened by filth, gangrene, and congealed blood and bristling with thorns, each causing a specific infection; rib-cage collapsed in the suffocation that, were it not for the centurion's lance, would have killed Christ that much more painfully – becomes hyperbolically visible within the deprived visibility of a nighttime setting. For Christians of Grünewald's time, this spectacle would have aided their piety. The practice of religion consisted primarily in meditating on Christ's death by imaginative recollecting (on the basis of stories, pictures, or improvised fancy) its minute particulars. Yet the end of this exercise of achieving a mental picture of the ruination of a body was finally the recognition that what we end up seeing – in our minds, in our hearts, in the painting before us – is also everything Christ is *not*. The incarnation of Christ as man conceals his divinity. Though created in God's image and likeness, Christ, though humble birth and humiliating death on the cross, makes God's invisibility *also* visible. And images of that image, second-order icons of the true icon of God, repeat the paradox not only by dwelling on the frailty of Christ's body but turning that flesh into a repertoire of signs, those paratactic "arms" which allow their viewers to remember the item (the nails, sponge, wound, etc.) yet know that it, the sign, is not that item. As Peter Galison reminds us, the mathematician David Hilbert, imagining a purely abstract geometry, quipped that if the indicators "point," "line," and "plane" were replaced by, say, "chair," "table," and "mug," the propositions of geometry would be just as true.[52] The medieval maker of devotional images excelled in fashioning signs announcing their status as mere signs.[53]

Long before Luther's doctrine of the hidden God, the Gothic Christ was already an erasure: what Heidegger, in another connection (but linked, in my view, to the religious tradition) termed the "sign of crossing through" *(Zeichen der Durchkreuzung)*.[54] This crossing had been applied by his human tormentors, racialized as the Jews, who, unable to see it, concealed Christ's majesty wholly under the form of supreme abjection. Visited on a crucifix, iconoclasm merely repeated the antagonism between appearance and truth that the image itself already displayed.

51

54

53

52

_ Robert Suckale, Arma Christi. Überlegungen zur Zeichenhaftigkeit mittelalterlicher Andachtsbilder, in *Städel Jahrbuch*, 6, 1977, pp. 177-208.

_ Martin Heidegger, *The Question of Being*, trans. William Kluback and Jean Wilde, bilingual edition, Vision Press, New York, 1959, pp. 80-83.

_ See Peter Galison's essay in this catalog.

_ On Crucifixion in the Karlsruhe Kunsthalle, in Jan Lauts, *Grünewald. Kreuztragung und Kreuzigung,* Staatliche Kunsthalle, Karlsruhe, 1968. My initial idea for Iconoclash had been to organize it around this masterpiece.

Self-negating from the start, and "realistic" only as massive deceptions (for their real Real was Christ's invisible beauty), such spirit-bound descents into flesh played tricks on those who negated them, short-circuiting their critical gestures or writing them into contrary plots. How exactly to separate the iconoclast's hammer blow from the defacement evident in a sketchbook from the shop of the late fifteenth century Nuremberg master Michael Wolgemut (Albrecht Dürer's teacher) and included in the present exhibition.[55]

The sketchbook is a puzzling object both in form and in function. Formally, it gathers drawing by at least four different hands: Wolgemut's, two of his assistants', and that of another later artist who, inspired by drawing sheets, adds new ones and corrects some of the old. Functionally, it probably began as a draft for the pictorial program of Fridolin's *Schatzbehälter* but ended up as a devotional book in its own right. Of its 105 sheets, thirty-five are full-page drawings of Christ's Passion; in these, violence begets violence. First there are the blows of the tormentors who, in page after blood-filled page of the sketchbook, are shown variously to whip, club, kick, and cut Christ; to undress, blindfold, and mock him; to suffocate him with their spittle and then to drag him away and start all over again; and finally, again in several repeating scenes, to nail him to the cross and crucify him.

Then there are the painters' gestures, those hectic brush-strokes of color that, painting over outline drawings of cruelty, themselves turn cruel, rendering gore in wild, red scribbles, while managing their sadism in crucial spots – evocative of bedrock reality – as where Christ's blood, after flowing from his multitude of wounds, meets the ground and pools neatly about his feet. Almost none of this blood finds a place in the woodcuts of the *Schatzbehälter*, not even in its hand-painted copies; it seems to belong to a logic of production and reception particular to these sketched and painted sheets. On one unforgettable page, Christ's face is wholly concealed by dirt, blood, and spit, the last layer (spit)

55

_ Richard Bellm, *Wolgemuts Skizzenbuch im Berliner Kupferstichkabinett. Ein Beitrag zur Erforschung des graphischen Werkes von Michael Wolgemut und Wilhelm Pleydenwurff. Studien zur deutschen Kunstgeschichte,* 322, Heitz, Baden-Baden and Strasbourg, 1959.

Rembrandt / A Scholar in his Studio (Faust) / 1652 / etching / 8.4 x 6.6" / The British Museum, London / © photo: The British Museum, London

Rembrandt / Three Crosses / 1653 / etching / 12 x 20" / The British Museum, London / © photo: The British Museum, London

Bartolomé Bermejo / c. 1480 / Christ Shows His Crucified Image to the Patriarchs / Institut Amatller d'Art Hispànic. Barcelona

being painted in opaque, white "body color" over black and red watercolor.

Here, it might seem, is the antithesis of the miraculously non-manufactured "true image" of God: the Holy Face thoroughly defaced by the sinful hands of men. Yet in the legend, it is also of sweat and blood that the image was made, hence its index status as stain. Of the face upon the sudarium one fifteenth century female mystic wrote: "His face was stained a brownish yellow color from the great duress in which he found himself there." In the Sketchbook, this face concealed in abject, corporeal excretions, both of Christ and of his tormentors, is recollected by the skillful hand of Dürer's teacher, or of a fellow member of Wolgemut's shop. Remember here that it would be Dürer who, in his self-portrait of 1500, would equate himself and his mimetic powers with Christ and the *acheiropoetos*, respectively. At the eve of the Reformation, display of the image's madeness was not a sign of infamy – the iconoclast's perspective – but the very index of its value.[56]

The culminating violence of the Sketchbook is of a different kind. At some point after the intervention of the fourth painter, who was himself inspired by the extant sheets to paint more violent scenes, an owner – or user – of the book attacked eighteen Passion images with a sharp object. These thrusts are inflicted on the painted image itself, in which some viewer, offended by what the tormentors do, has jabbed or scraped away their faces. These are responses to the image rather than against it, violence turned against the violent. Yet they nonetheless produce wounds not unlike those on Geneva's choir stalls attacked in 1537.

The *Schatzbehälter* itself provides the program for such a response. Fridolin's text insists that loving Christ means also hating passionately his enemies, the Jews: even if they did not directly scourge his body, the Jews "pled, screamed, begged, and threatened and forced the heathen judge against his will to give him the death sentence ... and so it is appropriate that the flagellation of Christ, as well as the crucifixion, is attri-

56

_ Joseph Leo Koerner, *The Moment of Self-Portraiture in German Renaissance Art*, University of Chicago Press, Chicago, 1993. Here I argue that this self-portrait, in addition to recuperating prelapsarian man through the perfection of art, also signals the abjection inherent in the image: the artist becomes the example of fallenness.

Lucas Cranach the Elder and shop / Luther Preaching the Crucified Christ / Last Supper Altarpiece / detail: Predella / completed 1547 / Stadtkirche, Lutherstadt Wittenberg

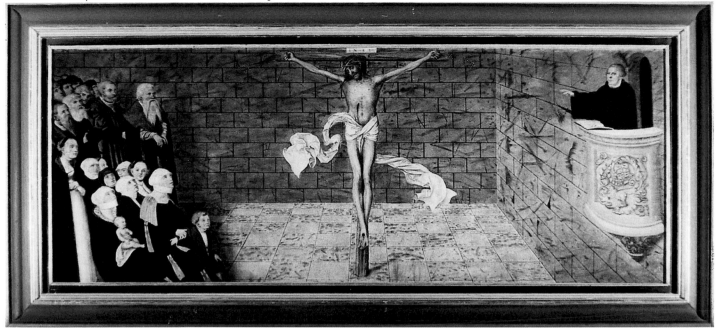

buted to the wrathful and merciless Jews, by which one should understand that the same people whom the Lord freed from their scourgers by scourging them, they scourged the Lord."[57] "Our Lord," wrote the pious laywoman around 1420 of her visions of Christ, "showed her on his face how he was treated and how he appeared when he was in the cruel hands of the Jews who had imprisoned him. And his face was stained a brownish color from the great duress in which he found himself." Religion becomes a negation in infinite regress: the chosen people scourged, their redeemer scourged by them, they scourged by his people, the Christians, who, from time to time, in order to renew their faith, will scourge his effigy.

A panel painted around 1470 by the Spanish master, Bartolemé Bermejo, discerns the ruined Christ even at the very limits of visualization.[58]

The resurrected Christ, having passed through limbo, enters heaven itself and points to his own image on the cross.

Lucas Cranach the Elder and shop / Last Supper Altarpiece / completed 1547 / Stadtkirche, Lutherstadt Wittenberg

58 57

_ El Renascimiento Mediterraneo, Mauro Natale (ed.), exhib. cat. Museo Thyssen Bornemiza, Madrid, 2000, cat. 82 with bibliography.

_ Schatzbehälter, z3, Nuremberg, 1493; I am indebted here to the forthcoming Harvard Ph.D. dissertation on the Schatzbehälter by Cindy Hall.

Pieter Saenredam / Interior of St. Bravo in Haarlem, Southern Transept /
black crayon, brown ink, gouache / Albertina, Vienna

Pieter Saenredam /
Interior of St. Bavo
in Haarlem / 1637 /
oil on panel /
Louvre, Paris

Yet even here Christ himself insists, with his pointing finger, that we still behold what the Old Testament patriarchs do for the first time: the crucifix. It is only by way of Christ's blood (here streaming into the Tree of Knowledge, which trespass the blood redeems) that heaven is reached. The icon of Christ, even one representing the unrepresentable, displays invisibility still. For despite what iconoclasts imagine, believers are not fools. No one in the picture or before it beholds the naked Christ's outstretched finger and prays to it.

Infinite Regression

"The holes in the hands and feet of the dead Christ," wrote Michel Serres of Michelangelo's *Dead Christ*, "the gaping wound in his flank, the traces of spears or hammered nails: are they any different from the hammer wounds inflicted onto the surface of the marble Mother by a dangerous lunatic that Whitsunday in 1972, or from the sculptor's blow to Moses as he threw the hammer and chisel at him, begging him to speak?

Standing in an interior of multicolored marble blocks, Christ triumphant wears a transparent robe that shows him naked underneath. This frontal nudity, realizing the eschatological dream of seeing God in himself – *deus nudus* – "face to face," plays off against the naked, aged bodies of Adam and Eve, recalling that it was Christ's flesh that arose from the dead, and that he will raise us as flesh, too. These are the furthest shoals of the Christian image, a scene set beyond the "covering cherubs" of Old Testament aniconicity, here represented in reflective gold. Visualizing Christ's absolute form, the painter allows the "naked person to see the naked God" (Luther).[59]

59

_ Luther, op. cit., 40, 2, p. 330.

Anonymous (Niederrhein) / Die Vision des Heiligen Bernhard [St. Bernard Embracing the Crucifix] /
c. 1340 / pen, ink, and watercolor / Schnütgen Museum, Cologne / © photo: Rheinisches Bildarchiv, Cologne

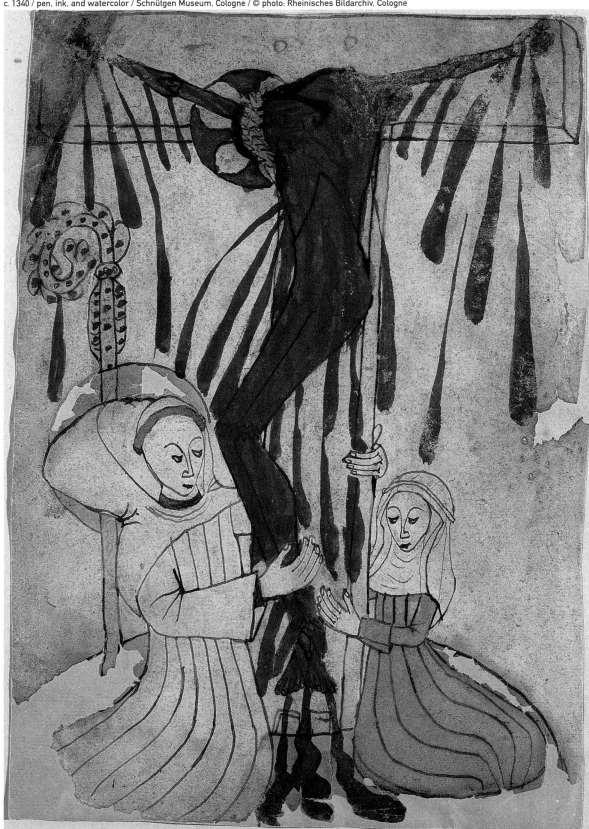

Lucas Cranach the Elder / Crucifixion with Longinus / 1538 / oil on panel / 33.5 x 22" / Museo de Bellas Artes, Sevilla

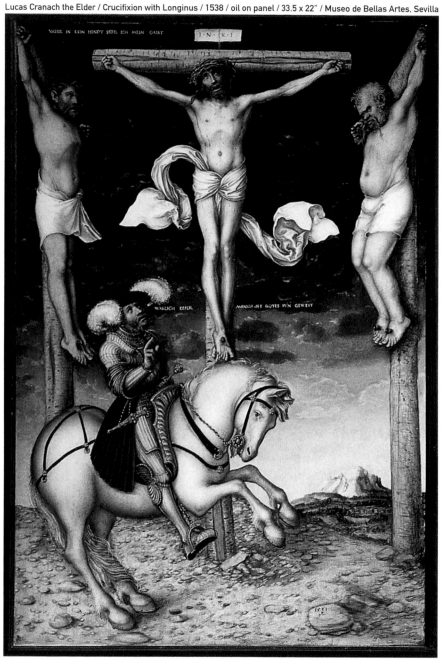

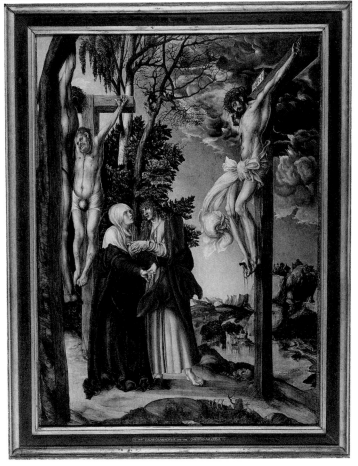

Lucas Cranach the Elder / Christus am Kreuz [Crucifixion] / 1503 / oil on panel / 54.5 x 39" / Alte Pinakothek, Munich / © photo: Archiv J. Hinrichs. Peissenberg – Artothek Weilheim

Or from the blows that carved it?"[60] There are differences, of course. Doing requires time and skill that undoing does not. Image breakers, wrote Dürer on the eve of Protestant iconclasm, destroy "what required great effort and time to be invented, and what is given by God alone."[61] In the German Pietàs of the fourteenth and fifteenth centuries that inspired Michelangelo, sculptors lavished extra care precisely on carving Christ's wounds. In their hands, the layered flesh and bone glimpsed beneath cut-open skin, and blood flowing and congealing round the wound and over the body's surface, becomes an ambivalent spectacle at once ugly and beautiful, and engineered to augment the projective imagination of viewers themselves steeped in metaphorical ways of seeing the wound as relic, as jewel, as blossom, etc.

Yet there will be times when wounding such wounds will be harder to do than carving them. For modernists in 1900, for example, *un*-making ornament was harder to do, and caused more social pain, than making ornament. Adolf Loos' 1910 construction of a plain facade or "house without eyebrows" at the entrance to the sprawling imperial palace of Habsburg Austria, which forced the outraged Prince Franz Ferdinand to thereafter use another entrance, was certainly a more difficult and perilous undertaking than applying, in pressed cement, the usual Viennese pseudo-Renaissance decor.

In the 1520s, striking church pictures was a tough undertaking for people who, perhaps just weeks before, had been praying to them. Wittenberg's iconoclast preacher Karlstadt acknowledged this when, in his tract against images, he asks Christians to overcome their terror at striking "some devil's block of wood," and recollects the enchanted world-view that goes with this fear of magical retribution: "Although, on the one hand, I have Scripture and know that images have no power and also no life, no blood, no spirit, yet, on the other hand, fear holds me and makes me stand in awe of the image of a devil, a shadow, the noice of a small falling leaf."[62] Unattended by such fears, image breaking is no longer quite iconoclastic, turning into a routine that is as difficult to undo as were once the images themselves. Most of the time, people live in iconoclasm's aftermath, totemically preserving and neutralizing its gestures and settlements. We can observe iconoclasm's normative obsolescence in Lutheran icons of the crucified Christ.

On 6 March 1522, Martin Luther returned to Wittenberg from his ten-month captivity in the Wartburg Castle and

60

_ Michel Serres, *Statues: Le second livre des fondations*, Editions F. Bourin, Paris, 1987, p. 195; I am grateful to Bruno Latour for this reference.

61

_ Rupprich, op. cit., p. 113.

62

_ Mangrum / Scavizzi, op. cit., p. 36.

Altarpiece with Texts of Ten Commandments
and Institution of the Lord's Supper / 1537 / wood /
Heilig Geist Kirche, Dinkelsbühl

Last Supper / c. 1537 / oil on panel / 49,2 x 46,5" / Heilig Geist Kirche, Dinkelsbühl

immediately set about tempering a city that had grown radical in his absence. In his famous *Invocavit* sermon of 9 March, he sought largely to undo the new church constitution that the Wittenberg Council had recently approved. There, among other things, it had been decreed that "images and altarpieces shall be removed from the churches."[63] In his sermon, Luther countered that the destruction of religious pictures, whilst theologically admissible, unnecessarily aroused "indignation" in the weaker brethren. (Equivalent to the Greek *skandalon*, indignation – German *Ärgernis* – named both for what images were to iconoclasts and what image breaking was to iconophiles: both were mutually scandalized.)[64] More crucially, iconoclasm was done in "tumult and violence" and had to be avoided, for it threatened the communal order.[65] By March 1522, however, iconoclasm had already destroyed much of Wittenberg's church art,[66] and what Luther now said about images was meant to justify the proper future making and use of pictures. This justification grew stronger in Luther's writings, and by 1525, in a tract titled *Against the Heavenly Prophets*, he attacked iconoclasm by confessing the ineluctable iconocity of his word-based faith:

> "I know for certain that God desires that one should hear and read his work, and especially the passion of Christ. But if I am to hear and think, then it is impossible for me not to make images of this within my heart, for whether I want to or not, when I hear the word Christ, there delineates itself in my heart the picture of a man who hangs on the cross, just as my face naturally delineates itself on the water, when I look into it. If it is not a sin, but a good thing, that I have Christ's image in my heart, why then should it be sinful to have it before my eyes?"[67]

This minimal image dominates the predella of the altarpiece of the Wittenberg City Church, where it appears to support the whole ensemble of images above.

Executed by the shop of Lucas Cranach, the Wittenberg Altarpiece was commissioned by the City Council, perhaps as an epitaph to Luther who, deceased in 1546, appears twice: once as the preacher in the predella, and again as the recipient of the chalice in the Last Supper scene.[68] Tradition has it that the retable was dedicated on 24 April 1547, the day of the Battle of Mühlberg, when the army of Emperor Charles V defeated the Lutheran forces under John Frederick of Saxony. Within this context, the panels appear like an open confession, made against the invading Catholic enemy, in which the evangelical faith is proclaimed to be a proper *church*, hence the unusual depiction of the three sacraments as accepted by Luther: on the left, baptism, with Melanchthon officiating; on the right, confession; and at the center, an apostolic communion in both kinds. These representations of church service, raised behind the altar in defiance of annihilation, also occupy a space within the city church that, in January 1522, partly through the instigation of Karlstadt, had been cleared by iconoclastic riots. Yet the predella, which literally forms the base of this new and radically contingent Lutheran altarpiece, recalls the scenario imagined in the Reformer's anti-iconoclastic tract. God's passion read and heard becomes unified in the scene of preaching, where Luther *reads* aloud from the Bible and his flock *listens* to his words. These words are not pictured, and Luther's mouth is shut, but the *content* of the words delineates itself at the center, in the picture of a man who hangs on the cross. Thus the preacher and his congregation are physically shown to *see*.

Yet Cranach also indicates that this crucifix, beheld by us frontally, and in a vacuous interior, is actually meant to stand in our hearts, as an *inner* picture. He constructs the void itself through the geometry of a corner of architectural space, of church (in Luther's sense) as functional *Predigtraum*. In this, it prefigures Pieter Saenredam's whitewashed church interiors, which metabolize the aesthetic dimension of Catholic space and practice into the art of painting itself.

66

_ A summary, with bibliography, of the events and controversies is offered by Sergiusz Michalski, in *The Reformation in the Visual Arts*, Routledge, London, 1993, pp. 9-28.

67 63 64 65

_ Luther, op. cit., 10, 3, p. 29.

_ Ulrich Bubenheimer, Scandalum et ius divinum. Theologische und rechtstheologische Probleme der ersten reformatiorischen Innovationen in Wittenberg 1521/1522, in *Zeitschrift der Savigny-Stiftung für Rechtsgeschichte*, Böhlau Verlag, Vienna, 1973, pp. 262-342.

_ Sehling, *Die Evangelischen Kirchenordnungen des XVI. Jahrhunderts*, Leipzig, 1902, p. 697.

_ Luther, op. cit., 18, p. 83.

68

_ Oskar Thulin, *Cranach-Altäre der Reformation*, Evangelische Verlags-Anstalt, Berlin, 1955, pp. 5-32; Joseph Leo Koerner, The Image in Quotations: Cranach's Portraits of Luther Preaching, in *Shop Talk: Studies in Honor of Seymour Slive*, Cynthia P. Schneider, et al. (eds), Harvard University Art Museums, Cambridge, 1995, pp. 143-146; and idem, *The Reformation of the Image*, London, forthcoming.

Heinrich Göding the Elder / Last Supper Altarpiece / 1568 / oil on panel / Marienkirche, Mühlberg

Preacher and congregation, reading and listening, are pushed to the sides, as if to constitute a framework. Luther preaches from a stone pulpit introjected into the void, its portal giving way to a blackness that only heightens the scene's hermetic closure; and to the left, the congregation is arranged to close off this void like a second side wall. The void itself pictures the heart's interior as an empty space, as a church after the idols have been stripped, bare except for the regular grid of tiles and stones relieved only by random cracks and by those smudgy brush-stokes that render variegation in the pictured stone, but that, disobeying the grid, adhere to the panel's surface, like marbling paint on wood.

Interiority's ineluctable content – the referent of the Bible's word – appears closed off from its enclosure. Unlike the gore of the late Gothic crucifix. Christ's streaming blood stops just short of the clean-swept floor; his cross stands at the exact center of the picture panel but slightly off-center on the perspectively rendered tile floor; and his huge loin-cloth billows wildly, but in the dead air of a windowless interior. Cranach intensifies this irreality by opposing our frontal perspective on Christ with the profile view, within the picture's internal logic that the preacher and congregation have of what they see. Because of this disparity between inner and outer viewpoints, we find it difficult to place ourselves *in* the scene, which further banishes us to the surface. And Cranach emphasizes precisely the opacity *of* surfaces by his eerie treatment of the architectural setting, which recedes perspectively, but into a windowless, imageless wall. I would also note that Luther, in describing how Christ's image projects itself ineluctably in our heart, used the word "entwerfen," which refers to the

Heinrich Göding the Elder / Communion / Last Supper Altarpiece / detail: Predella / 1568 / oil on panel / Marienkirche, Mühlberg

Hans Weigel / Last Supper and Communion in Both Kinds / c. 1560 / woodcut /
in Johannes Brenz, Eine tröstliche Vermahung zu dem Empfang des Heiligen Sakraments nach Nürnbergischer Ordnung, Nuremberg

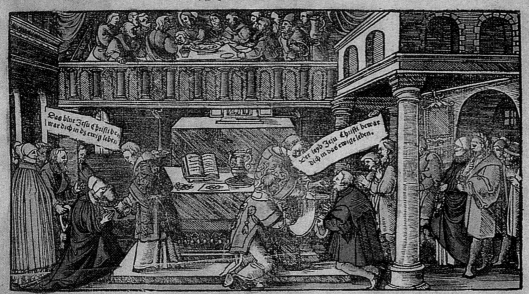

painter's practice of outlining figures in ink or chalk before beginning to paint. Cranach's Christ, with its lack of surface detail and emphasis on contour, matches nicely the schematic character of the Reformer's imagined internal image.

In the Wittenberg altarpiece, the crucifix's citational character is given in the structure of the whole scene. Christ on the cross, meant to exist at once before our eyes (note its reifying shadow) and in our hearts, stands here as if the materialized content of a speech act, or more precisely, of a *recitation* of scripture. What Luther reads, and what his audience hears, appears delineated as this curiously cipher-like picture, this at once concrete and abstract crucifix. The whole scene pictures the force and directness of reference specific to preaching. With his left hand Luther indicates a text of the Bible, while with his right, he points to Christ. The word, materialized as inscription on the open book, passes from index finger to index finger by way of Luther's heart, then meets its mark in the Crucifixion, upon which converge, from the left, all the eyes that see what has been spoken and heard. Thus pointing and seeing, saying and hearing, resolve in one and the same thing. This thing, this minimal image, models the ineluctable presence of *mediators* even within a religion of inner faith. Words refer to images, which refer to words. An altarpiece erected in Dinkelsbühl in 1537, and included in the exhibition, consists (now) only of texts – the Ten Commandments flanking the institution of the Last Supper. These are placed on a panel shaped like a predella.

It would seem that the word strips the altar bare. Yet even here, words contain images: a little blossom punctuates the text, separating the blessing of the bread from the words about the wine. And the ensemble is more visible than legible (especially given literacy rates in 1537): the word has itself become the icon of a word-based faith. Furthermore, as this exhibition will propose, it is possible that the retable is more iconoclastic now than in its original state, when it may have supported a painting of the Last Supper, in accordance with later Lutheran altarpieces and with the Reformer's own preference, stated in 1530, for altars with just that biblical scene pictured behind them and accompanied by words illuminating it.[69]

Cranach was the perfect artist of this compromise. Briefly, in his youth, he was Germany's greatest painter of the crucified Christ, producing images unmatched for their ability to make viewers feel themselves present at the scene of Christ's death.

In the years after 1520, when through his large Wittenberg shop, he shaped a distinctly Lutheran art, his painting lost this power. But it also gained a consciousness of mediation that could only come from one who was once a master of immediacy. Cranach, that is, learned to deaden his pictures by inscribing their surfaces with biblical quotations that collapse pictorial space, or by announcing in the gesture of his figures, or through his own painterly style, that what we see is only a visual quotation, an image of an image rather than the thing itself. We can observe this in a Cranach included in the exhibition. The *Crucifixion with the Converted Centurion* on loan from Seville exemplifies this mortification of painting through text, gesture, and style.[70]

Longinus appears at the moment of his conversion, when he points to the crucified body and says, against the evidence of what he sees, and in the words now inscribed before him in German: "Warlich diser Mensch ist Gotes Son gewest" (Truly this man was God's son). At the top of the panel, meanwhile, over the INRI where Cranach's Crucifixions usually end, Christ's last words, directed upwards with his gaze, synchronize Longinus's confession with another moment: "Father, into your hands I commend my spirit" (Luke 23:46). The one text states (to whosoever reads it) who it is who dies, and, in stating this, it announces what Christians believe. The other (whispered by the son to his father, and only overheard by us) draws us into that death and shows what, because of it, dying will become: with and through Christ, *our*

69 70

_ In 1995, the present deacon of the Hospital Church, Herbert Reber, discovered an uninventoried Last Supper panel in the upper gallery and, on the basis of its probable date (before 1550) and size, has speculated that it is the text-retable's missing pictorial *corpus*. I am grateful to Reber for generously sharing his discovery and research.

_ On Cranach's several Longinus panels, see John Oliver Hand, *German Paintings of the Fifteenth through the Seventeenth Centuries*, National Gallery of Art Washington, 1993, cat. no. 1961.9.69, pp. 44-48.

spirit too shall be commended to heaven. In Luke, Christ speaks these words after his dialogue with the Good Thief, who requests and receives redemption. Faith (the thief's, Longinus', the viewers') and salvation thus converge on Christ at the threshold of death.

Our visual experience of this convergence is, however, anything but immediate. Whereas in earlier depictions, Longinus makes his gesture in the bustle of the real world – Christ's cross death (to borrow Leopold Ranke's phrase) "as it actually was" – here he gestures alone on Calvary, which itself stands isolated from the world as a weird swelling of rocky ground set off from the blankness of the sky. And elements that elsewhere place the action in place and time here increase the scene's abstraction. Longinus' horse rears up, wild and mobile, against the flat and static background as if it had galloped into the wrong movie set. Its left eye placed along the picture's median, in unnaturally exact alignment with the cross, Christ's body, and the words *diser mensch* (this man) and *ich mein* (I my), it gazes straight out of the picture at us, as to interpellate our response to Christ in *all* his visual and verbal appellations. No one thus hailed feels this is how it actually was on Calvary, though. At best, one feels monitored for one's attention to a difficult lesson. Here, as in the Wittenberg predella, Christ dies in the dead air of a school room, despite the flapping loin cloth.

Although the freeze-framed horse and loin cloth convey its temporal status as historical event, Cranach's crucifixion takes place more in words than in a world, as one element in the syntax of a sentence. The cross interrupts the inscription, pushing "this" and "man" apart. This unusual interaction between writing and its support, seemingly courteous to painting, benefits writing more. It allows us to "read" the cross as if it were a word in a grammatical sequence. Here is Wittgenstein's dictum reversed, "A sentence is a picture." This painting is a sentence, one that claims to state, from the universe of the sayable, what most crucially is the case.

In its home-baked way, Cranach's *Longinus* grapples with the paradox of an absolute message transmitted by hyper-incommensurate means. Everything struggles to attach the deictic "my" and "this" (those pointers whose failure introduced Hegel's phenomenology) to their object. Christ's body literally spans the space between them, between the gospel's first-person "I my" and third-person "this man," epigrammatically inscribed on or about the painted cross. And to this painted conjunction of word and object, Cranach adds Longinus's finger pointed upward at Christ. Here gesture returns words to that primordial movement of hand to thing which St. Augustine, in his *Confessions*, describes as the very origins of language: "this" *names* what the pointing finger *shows*. In Cranach, moreover, Christ hardly needs denotation, since he veritably *is* the painting. His frontality, spot-lighting, and isolation make him a pure silhouette, as if the minutest obscuring of the hidden god through foreshortening, shadow, or overlap were taboo. Cranach's Christ is a visual deixis at once transmitted and received. Indeed the audience (an implied second-person "you") will have seen "this man" before noticing Longinus's gesture. Longinus himself sees first and speaks second. Christ confronts the Roman outsider as an abject visual spectacle – the public eradication of state criminal – that he penetrates: "And when the centurion, who was standing right in front of him [in Luther's German, *gegenüber*], saw the way He breathed His last, he said "Truly this man was the Son of God" (Mark 15:39). Cranach shifts Longinus to the side of the cross only to place the viewer in a position "right in front." Unlike the "cryptic" *(kryptos)* of the Greek gospels that names the cross's secret in terms illegibility, the Latin *absconditus* (as in "videre in abscondito") means "that which retreats from the visible," thus entrusting secrecy to sight.[71] Both the existence of Lutheran church pictures, as visible things for a hearing-religion, and their inertness, their signature reluctance to visualize any invisible beyond, thus follow from the nature of their task.

71

_ Jacques Derrida, *The Gift of Death*, trans. David Wills, University of Chicago Press, Chicago, 1996, pp. 88-89.

Anonymous / Flagellation / woodcut / 6 x 5.1" / British Museum, London

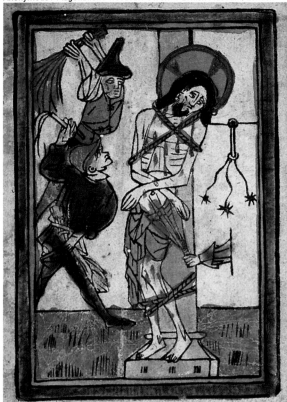

Anonymous / Christ Ecce Homo / 7.6 x 5.3" / British Museum, London

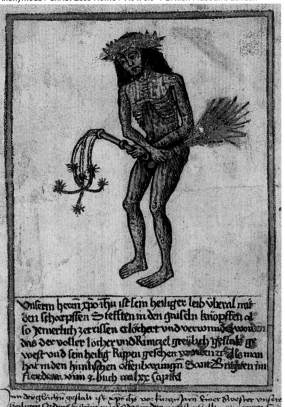

Anonymous / Vision of St. Bernard of Clairvaux / woodcut, handcolored / 11.2 x 8" / Albertina, Vienna / © photo: Albertina, Vienna

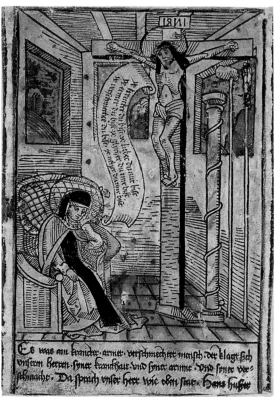

Anonymous / Vision of a Sick Woman / woodcut / 7 x 5" / British Museum, London

In the Longinus legend, beholding Christ *as* Christ was radicalized as a conversion from blindness into sight: the centurion saw nothing until he saw Christ. Cranach preserved this prior deprivation in the setting of his panel: besides the crucifix and those who behold or ignore it, there is nothing but night and death. But then, blindness was implied by all his crucifixions, since it was the historical circumstance of Christ's death, in which no one but Longinus identified who "this man" was – except in the double irony of mocking labels like the crown of thorns and the INRI superscription. And how could they have, beholding Rome's ultimate penalty for slaves. In arguing, contra the spiritualizing iconoclasts, that hearing God's word is obligatory, Luther points out that those who actually witnessed Christ stood infinitely less a chance of grasping him than we who, though remote in time and place, have the gospel to rely on. The empirical facts of condemning Christ to death and blankly watching him die revealed his identity (the Son of God) to be imperceptible *in* those facts and thus available only through testimony that must be heard and counterfactually heeded. The reference of Cranach's crucifixes – condensed in Longinus's equation "this *is* God's son" – must remain invisible. They are icons, quite specifically, of the *deus absconditus* that stood at the heart of Luther's theology. Even if we gaze at the gaze of one who believes, what Cranach paints is another blankness neither more nor less penetrable than were the original facts themselves. Christian art, as an art which has Christ as its only center, must be crude.

In Cranach, Longinus's sentence ends in darkness. Whereas English bibles render the centurion's words with the preterit "was," Luther used the compound "ist ... gewest" to indicate that Christ died just now. Inscribing it on his panels, Cranach makes the sentence keep pace with death. He encloses the crucifix and its label ("diser mensch") between "Warlich" and "ist," so that, at that point in the sentence, those words seem to properly describe his painting of a still-living Christ. But he lets the death-knell "gewest" ring out as if afterwards, and in the empty space before the damned Thief. Viewing and reading thus begin in the present and end in the past. Long before the curtain closes, however, Cranach already absented his image of Christ. He extracted it from the world where the enunciation occurred, placing it inside a sentence, a word about the sentence, and a scene of Longinus' statement of both of these. And he so standardized his painting of the cross that no viewer would judge Longinus' statement on what they see. Materially and syntactically embedded in the gospel quote, and itself resembling other painted crucifixes more than a "visibly living Christ," Cranach's crucifix itself stands inside implicit quotation marks. It is a "sign of a sign" (Frege) that can be understood and believed without being directly experienced. The drastically formulaic character of the painting *as painting* thus suits a religion where the real truth, by definition, lies not in faithfulness to a world but in faith in words.

At its furthest limits, at the point where it most explicitly denies its own access to a beyond, the iconoclastic icon postulates the world. In Mühlberg in 1568, the city erected a *Last Supper* altarpiece by the painter Heinrich Göding.

Dresden's major painter during the last decades of the sixteenth century, Göding had trained under the elder Cranach, and collaborated with Lucas the Younger. As in the Wittenberg Altarpiece, Göding centers the Mühlberg retable on the biblical event of the Last Supper, staging it in a lavish Renaissance interior. Contemporary persons, though, appear only in the predella, where the local pastors, Johann Liebe and Paul Taucher, administer the sacraments in both kinds to their Mühlberg flock. The formula is a familiar one in Lutheran art: a liturgical Last Supper attached to its biblical precedent above.

In Mühlberg, what is paired in the altarpiece's panels is meant also to duplicate what would occur in the church before it, as the everyday routines of a reformed German mass. To make this redundancy complete, Göding portrays behind the pictured altar in the predella a *painted* predella, in which

his own predella repeats itself; and in this predella one glimpses the same predella again, and so forth, in infinite regression.

This *mis-en-abyme* of the altar sacrament takes place at the painted scene's perspectival vanishing point, which occurs unusually at the center of the predella's upper edge, indeed at the very spot where liturgy meets its historical antecedent.

I am tempted to take this eccentric detail as an emblem of the disenchantment of the world. Christ may be shown thus to be, according to Luther's view, "ubiquitous" in the eucharist, as simultaneously everywhere and in the bread and wine.[72] Göding gives this ubiquity a temporal dimension. The communion scene occurs out-of-doors (note the birch trees and the weeds between the paving stones), in the everywhere of Lutheran service: where word and sacrament, there church,

as the reformer often put it. More specifically, this setting is a churchyard, a Lutheran *Friedhof*. Carved epitaphs are visible in the background; formally, they are like those in Mühlberg, in the church were Göding's altarpiece once stood. The dead are shown to live in Christ just as the congregation of 1568 lives on in its portrayal. Yet the predella also displaces Christ from the world to the point, literally, where the picture "vanishes" infinite. At the point where the image *represents itself* it also disappears. The impulse to pass beyond representation – or to do without representation – entraps us in a world that is *only* representation: religion as nothing but what people customarily do. "Do you not feel the breath of empty space?" asks Nietzsche's madman as he raises his lantern to the sun.[73]

Lorenz Strauch / Saal der reformierten Gemeinde Stein bei Nürnberg [Hall of the Reformation Church in Stein near Nuremberg] / etching / 10.2 x 13.5" / Germanisches Nationalmuseum, Nuremberg

72

_ Hans Grass, *Die Abendmahlslehre bei Luther und Calvin*, Bertelsmann, Gütersloh, 1954, pp. 57-86.

73

_ Friedrich Nietzsche, *The Gay Science*, trans. Walter Kaufmann, Vintage Books, New York, 1974, p. 184; cited Michael Taussig, *Defacement*, Stanford University Press, Stanford, 1999, p. 1.

»IDOLS FALL AND THE GOSPEL ARISES!«
THE FAREL MEMORIAL IN NEUCHÂTEL: HISTORY OF A PARADOX

Pierre-Olivier Léchot

ON 4 MAY 1876, WITH MUCH POMP and ceremony, the Swiss town of Neuchâtel inaugurated a monument to the glory of its Protestant Reformer. From the bottom of the hill, an imposing procession of ecclesiastical authorities and representatives of various religious communities set off in the direction of the Esplanade de la Collégiale where the half-patriotic, half-religious ceremony was to be held. Despite the bad weather, large numbers of curious onlookers followed the procession to witness an event that some would soon qualify as historical. The pealing bells were relayed by the singing of Luther's hymn ("It's a rampart that our God …") by an elated crowd accompanied by a booming brass band. Soon the prayers and psalms were followed by speeches reported by chroniclers a few days later to highlight the public's piety and its enthusiasm as regards the proclamation of the Gospel. The Reformer being celebrated was William Farel (1489-1565), the same man who, 350 years earlier, had initiated the destruction of statues and images at the Collegiate Church of Notre Dame, transforming it into the "Neuchâtel Protestant Church." Erecting a statue in memory of a champion of iconoclasm is certainly surprising. Was it a paradox? A denominational loss of control? An excess of religious identity?

Farel, Iconoclastic Fighter Canonized

In his day, William Farel, that "fighter of God" (Gottfried Hammann), a veritable "Alpine chasseur" (Lucien Febvre), was one of the most ardent "opponents of idolatry" and one of the first spokespersons of the Reform movement in the French-speaking world. From the early 1520s, this native of Gap became known for his acts in favor of the Reformation, in Meaux (where he still belonged to the group of "reformists" gathered around Bishop Briçonnet), Montbéliard, Neuchâtel and, later, Geneva (where he was the first Reformer, even before Calvin), Metz and the Piedmont valleys.

In Farel's career, Neuchâtel was certainly an important victory in so far as it was the first French-speaking town to switch to Protestantism, under his influence. On 23 October 1530, "idolatry" was removed from the collegiate church, statues and relics thrown into the river bordering the hill, and the Reformation officially proclaimed on 4 November, after only six months of unrest.

Now, it was precisely this event in the preacher's life that the statue inaugurated in May 1876 commemorated, as a contemporary chronicler noted in his description: "Idols fall and the Gospel arises, … the Reformer has broken images which lie at his feet [in fact a statue of Saint Peter], he confidently steps over the debris and energetically lifts the Gospel into the air, loudly proclaiming its holiness."[1]

Dedicating a monument to a destroyer of images and, what is more, one which represents him precisely in that position: did believers at the time not see any paradox? To answer this question it seems wise to turn to the creator of the work.

The Sculptor Charles Inguel and Institutional Art

Charles Iguel (1827-1897), a travelling sculptor from Wuerttemberg, was the perfect example of a sought-after official artist. Established in Paris after leaving his home country, he was a student of Rude before rapidly becoming the champion of commissioned works of all kinds. Iguel's sculpture, with its fairly simple but highly-rated academic realism, covered all styles, from busts of contemporary personalities to monuments dedicated to Joan of Arc or statues of

1

_ Unsigned, Le monument de Guillaume Farel,
in *Le véritable messager boiteux de Neuchâtel*,
1877, p. 48.

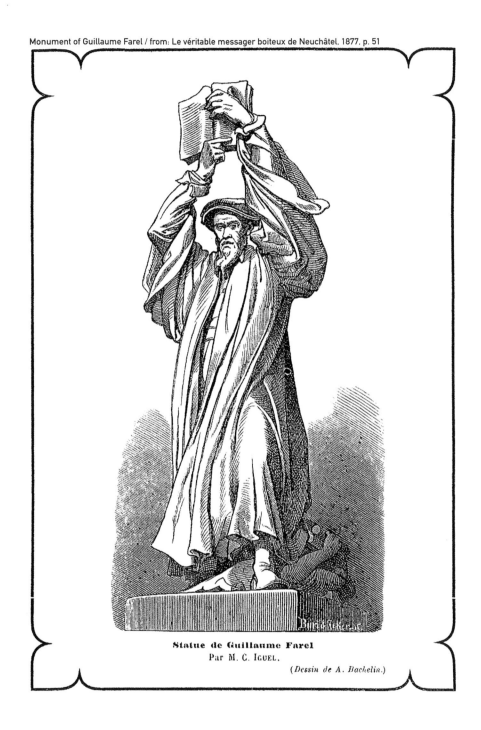

Statue de Guillaume Farel
Par M. C. IGUEL.

(*Dessin de A. Bachelin.*)

numerous saints (including John the Baptist, Saint Michael, Saint Albert and Saint Peter – the same saint trampled on by William Farel!).

After the defeat in 1870, the German Iguel (for whom the situation in Paris was too unstable) took refuge in Neuchâtel where he was naturalized three years later. He soon became the institutional artist par excellence among Neuchâtel dignitaries, the one that everyone was fighting over: "Unfortunately, just when the Neuchâtel region was enjoying a period of prosperity enabling it to celebrate the great men of its past, in statues, it was unable or unwilling to find an artist capable of giving a really beautiful form to its historical memories," commented one of his detractors.[2]

That was the case of Farel's statue commissioned in 1873 and for which Iguel submitted two proposals in 1874. A committee was formed to supervise the project and the artist set to work. A wooden shed was built against the castle dungeon, close to the esplanade where the statue was to be erected. The monument, started in May 1874, was finished in October 1875 and finally delivered to the public on 4 May 1876. To be sure, Iguel's work warrants its share of critique (whether artistic, theological, or historical), but for whoever wants to understand the sense of the monument and the paradox it represents, it is probably necessary to look further than the psychology of its author alone.

Reasons for a Paradox

First, one must be aware that at the end of the nineteenth century, commemoration was highly popular within Protestantism. Countless commemorative monuments of that period cover the map of places visited by heroes of the Reformation, from Wittemberg to Geneva. One just has to think of what was soon to become the *Protestant's Wall* in Geneva, the changes to the Wittemberg castle church under the Kaiser's impetus or, more modestly, the other statue of Farel that his home town, Gap in Dauphiné, gave itself some time before Neuchâtel acquired its memorial.[3]

This wave of commemoration was, moreover, the result of a long tradition that gradually amplified Protestant reformers' biographies, transforming them into a veritable Protestant hagiography that the critique of the Enlightenment thinkers and positivism managed only partially to erase from Protestant thinking. Farel, "a veritable apostle of the Gospel"[4] in Neuchâtel country, thus gradually became a hero with a life filled with "zeal and faith, struggles and action, despite the obstacles of persecution, frequent failure, fatigue and illness,"[5] the father of this "colossal work of reform, accomplished at the cost of so much ardor and abnegation," to the point where one almost forgets that this Protestant Reformer's motto was "what do I want other than to see Christ shining!" This brings to mind John the Baptist, referring to Christ in the Gospel: "He must become more important while I become less important." (John 3:30) Thus, the hero of a deed that is no longer his, the Farel presented by the late nineteenth century Protestant hagiography is far from historical reality, like the intentions of the Reform movement itself.

Finally, the situation in the Neuchâtel church should not be overlooked. During that period of commemoration, the religious context was not at its best. Weakened by the fall of the Ancien Régime during the 1848 Neuchâtel "Revolution," deprived of its ancestral mode of functioning (that of the "Venerable Class of clergymen") which had been replaced by a synodal-democratic system that was difficult to manage and subject to the pressures of the young Republic, the local Church had also, following theological and institutional conflicts, split into two new communities: the Independent Church of the State and

5 3 2 4

_ Unsigned, op. cit., p. 51.

_ Unsigned, op. cit., p. 51.

_ Unsigned, op. cit., p. 48.

_ Georges Méautis, Les intentions de la statue de Farel,
in *Musée neuchâtelois*, 1940, p. 79.

the so-called "National" Church. One may wonder whether, in this difficult context, the erection of a monument to the glory of the region's Protestant Reformer was not conceived by supporters of reunification as a way of promoting unity. This is strongly suggested by the presence, side-by-side, of representatives of both the "Nationals" and the "Independents" during the inauguration. It is also confirmed by the message in the 13 May 1876 issue of the *Journal religieux* which saw the inauguration of the monument as proof that religious fervor can unite hearts above dissension, "two or three years after a painful rupture."[6]

Divided but united around the same tradition, the Neuchâtel Protestants were thus, on 4 May 1876, far more sensitive to the image binding them than to the paradox that, we can retrospectively see.

Return of the Controversy or Iconoclastic Idols Overturned

Nonetheless, the question was to be asked not long afterwards. In the 1940s, Georges Méautis wondered about the intentions behind the Farel monument and its relation to religious reality. In a virulent article in the *Musée neuchâtelois*,[7] the critic challenged the intentions of Iguel and the initiators' of a monument that, according to him, spoiled "the harmony and balance" of its site.

But his criticism seems to have remained isolated. It was only very recently that the controversy was revived on the occasion of the forthcoming renovation of the Collegiate Church. The question is now raised of the relevance of the monument, from an architectural as well as theological point of view. Can one still, in the day and age of oecumenism, impose on one's brothers in faith this type of sight? Is it not misplaced to remind people of the iconoclastic activity of the Protestant Reformer in these times of relatively widespread interdenominational peace? Would it not be preferable to make a clean sweep and get rid of this dusty denominational past which is, furthermore, too much of a weight to bear in current dialogue with Rome? It is naturally not up to the historian to decide on this issue. What is certain, however, is that iconoclasm is alive and well. What strange arguments we hear from those who support the destruction of the Farel monument, arguments that, in many respects, are not unlike the rumors going about Neuchâtel around 1530 when an agitated French undertook to preach adoration of the Word and not of idols.

A new paradox?

6

7

_ Méautis, op. cit., pp. 77-81.

_ Unsigned, Inauguration du monument Farel, in *Journal religieux du canton de Neuchâtel*, 19/20, 13 May 1876, p. 82.

THE EMPTY NICHE OF THE BĀMIYĀN BUDDHA

Jean-François Clément

IN FEBRUARY 2001, THE TALIBAN OF AFGHANISTAN dynamited a Buddha statue from the period of the emperor Kouchan Kanichka, sovereign of Bactria in the second century of our era. The Buddhas were sited at Bāmiyān situated west of Kabul on one of the two roads on which Buddhism spread from India. The shock caused by the image of such destruction can easily inhibit thought on the event. If we exclude psychological interpretations, two readings are nevertheless possible.

First, we can propose a political reading. The Taliban regime fostered by Pakistan and Saudi Arabia, initially with the help of the United States, felt increasingly threatened even within Afghanistan. The destruction of this symbol of their heritage was, for them, an attempt to symbolically retrieve the power that was slipping out of their hands. A few months later, when they lost that power, the Taliban negotiated with their opponents and abandoned non-Afghans. We clearly see that what had remained alive were tribal customs and the sense of honor of the Afghan warrior – and not the varnish of Islamist ideology. The issue was no longer the greater Muslim community, which clearly shows, in retrospect, that the Taliban were simply elements of southern Afghanistan tribes who had instrumentalized Islamist ideology to seize power.

What confirms this hypothesis is a religious reading of iconoclasm in early 2001. We can see in this attack a clear manifestation of the atheism that developed in so-called "Islamist" Muslim minorities during the twentieth century. However, this atheism bears no relation to the Western atheism of the twentyfirst century.

By destroying the Buddhas, the Taliban were clearly signalling that all Moslems who had preceded them in Afghanistan, who had respected the statues, were not real Moslems. In short, there had never been Moslems before them.

But will there be any after them? In the decree ordering the destruction of all representations of living creatures, the Taliban declared that the Bāmiyān Buddhas had to be destroyed because "Buddhism should return to Afghanistan." What strange Moslems were these who could foresee the impending disappearance of Islam.

Does Islam exist now for them?

Muslim theology has on the whole been unfavorable towards images because human creators of forms are considered to be rivals of God. Just as the prophet Mohammed was jealous of the poets of ancient Arabia, so too God shows himself to be jealous of the rivals that artists could be; he wants to be the only producer of images. On several occasions, not in the Koran but in the Hadiths or words of the prophet, we see him challenge human creators of figurative images to breathe a soul into their creations, for these men threaten the only authentic and complete creation which is the divine creation of both matter and soul. Yet there is never any question of calling for iconoclasm. In reality, God's threat will be effective only at the time of the last judgement. Human rivals of God will not have to account for their acts until then.

We might add that Muslim theologies have hardly ever shown much interest in images as such throughout their development. On the other hand, they have extensively commented on the situation of those who are faced with figurative images. Throughout their history they have questioned the observer and never the object beheld and it is easy to see why.

Omar, one of the first caliphs, said: "I've never seen anything without seeing Allah simultaneously with the thing." If God is the only creator of forms, any form, no matter what, is a manifestation of its ultimate creator. Another one of the four original caliphs, Abu Bakr, whom the Islamists want to restore to his golden age, said: "I have never seen a thing without seeing Allah before the thing." If God is said to be *bâri*, the creator, or *muçawwir*, the image-maker, one cannot see a form without thinking of God who showed it. Another caliph, Othman, once said: "I have never seen a form without seeing God

Bāmiyān Buddha / 1967 / Bāmiyān, Afghanistan /
© photo: Bernard Clément

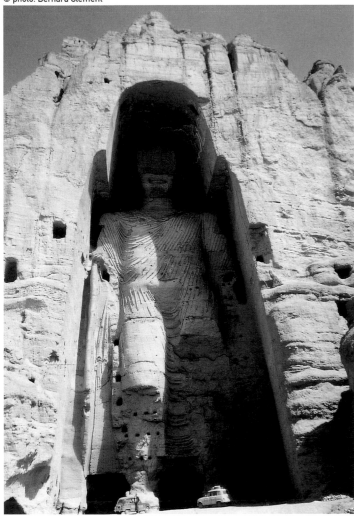

The Buddha of 38 meters / Bāmiyān, Afghanistan / from: Mario Bussagli,
L' art du Gandhâra, Librairie général française, Paris, 1996

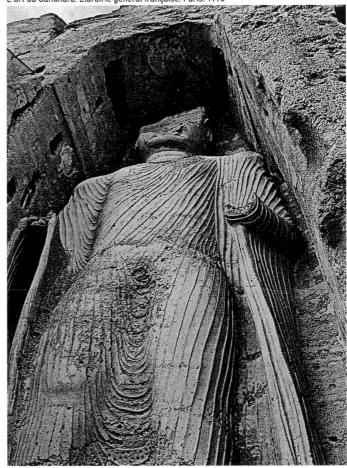

after the thing" – for one can be deluded and at first see only the form itself, see the form for the form and thus believe that its only creator is human. Breaking free of this illusion is being a Moslem.

A subsequent theologian, ibn Wasi, went a little further and said: "I have not seen a thing without seeing Allah in the thing." He thus announced the fundamental theory of the unity of existence. All forms, without exception, exhibit the infinite being which is their real creator. If this being is really infinite, there is no form that is a purely human creation. No idol can exist and any manifestation is necessarily an icon for a real believer. Only atheists, who no longer believe in God, believe they see idols. Hence, iconoclasm, already radically unthinkable for the founding caliphs of Islam, became unachievable unless one wanted to destroy God.

A little later, another theologian added this surprising sentence: "He who has seen Him, has seen nothing." In other words, those who have real faith in God and, for that reason, necessarily see God in any form, cannot see the form without seeing God in it. More precisely, they no longer see any form. Internally they become "a-iconisers," incapable of perceiving forms. The very idea of destruction of images then becomes unthinkable because there is no longer anything to destroy. "I have seen nothing," said another thinker who could be called an "a-iconist."

In this sense, by destroying the Bāmiyān Buddha, the Taliban of Afghanistan were, from the strictly Islamic theological point of view, atheists. "Only he who has known God through what He Himself has made known, can see God." Another theologian, more charitable, or stricter, added: "In reality, he who has not seen God has seen Him (but has not recognized him)." What are all these Muslim theologians actually saying other than that vision *(ru'ya)* conforms to knowledge *(ma'rifa)* and thus, as Chibli said, whether one opens one's eyes or closes them, one always sees God in all states.

Iconoclasm consequently becomes a modern pathology for which there exist virtually no examples throughout the history of Islam. It is spawned by blindness due both to the loss of grace and the bad faith of men who, in reality, are facing God but do not want to see God. That is the Muslim form of atheism. Will it have as much success as the European atheism developed by Feuerbach, Marx, or Nietzsche? This is an essential question. |

THE WAR OF IMAGES, OR THE BĀMIYĀN PARADOX

Jean-Michel Frodon

APART FROM PROTESTS THROUGHOUT THE international community, diverse comments were made on the theological grounds of the Taliban's decision to destroy the giant Buddha statues at Bāmiyān. Their act, under cover of archaic justifications, functioned along the lines of a very contemporary logic which, ironically, was based more on a relationship with images rooted in Christianity than on one instituted by the Islam so fiercely defended by the "students of religion."

To understand that decision we need to consider the meaning of the ancient act of image-breaking. Yet, if we are not to be lost in infinite relativism, we also need to be able to disregard that, which – from destruction of antiquities to the Chinese cultural revolution – is a matter of tropism that is too general to have meaning in this particular case: in all circumstances and all eras, humans have broken objects, for countless good and bad reasons. If we confine ourselves to the particular act of destroying images for religious motives, we need to stress the point that the frame of reference here is monotheism, the religions of The Book: Judaism, Christianity, and Islam.

All Images Are Not Idols

Monotheism conveys a fundamental problematic relationship with figuration because it was developed against idolatrous beliefs and was able to impose itself only in opposition to them. Not all images are idols; they become so only when they are adored, when believers relate their faith to objects, thus endowing them with supernatural powers, instead of to the single and transcendent God.

Against these practices, monotheistic religions advocate different attitudes. The Old Testament condemns the creation of images ("Thou shalt not make unto thee any graven image" is one of the Ten Commandments), independently of what they represent. Islam, in the Hadith (the Prophet's comments reported *a posteriori*) if not in the Koran, proscribes "the effigy" but without saying of what. It also formally prohibits any claim to represent God. This leaves a lot of room for other pictorial and even figurative undertakings, and even representations of humans, something which Moslems have not hesitated to do throughout the centuries[1] – even if in Sunni Islam (the main branch) images remain a relatively rare mode of expression which is often the subject of suspicion. From the outset, Christianity had a less hostile relationship with images than the two religions strictly based on transmission of the divine word. For Christians, the word was made flesh in the body of Christ, "the Son is the image of the Father." It was on these foundations that the Church constructed its doctrine legitimating icons and which, with the Council of Nicaea in 787, put an end to the iconoclastic quarrel.

This doctrine condemned "icon breakers," the etymological sense of "iconoclast," a misleading term, for iconoclasts had nothing against images – on the contrary, they wanted to reserve their use for the emperor rather than the Church. By securing the right to figuration – including God, the Virgin, etc. – in the name of the founding image that Christ had been, the Church gave itself a powerful means of spreading its message.

It was on this basis that the relationship with images prevailing in the West was founded; one that articulates the visible and the invisible in a very particular way. This relationship with the invisible was the bedrock of the legitimacy of Christian images and of future pictorial art in the West.

This "Western" relationship with images is, paradoxically, at the center of the destructive act committed by the Taliban: the standard bearers of an "Eastern" culture, Islam, against the legacy of another Eastern culture, the statues of Buddha. In

1

_ Le Monde, 13 March 2001.

Taliban militia in front of destroyed Buddha statue / 2001 / Bāmiyān, Afghanistan / © photo: SAEED Khan/STF

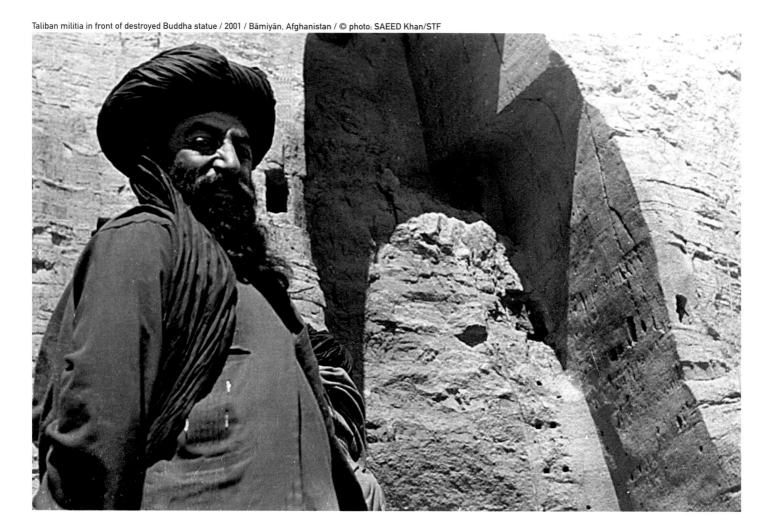

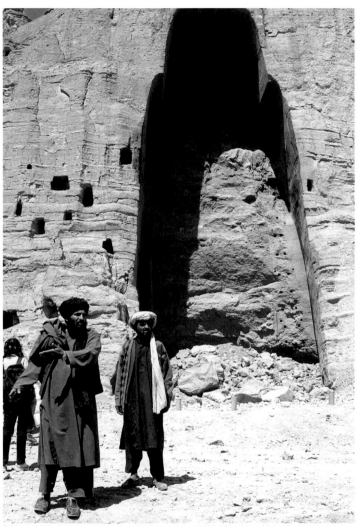

Taliban militia in front of destroyed Buddha statue / 2001 / Bāmiyān, Afghanistan /
© photo: SAEED Khan/STF

fact it was not "religious" idols in the classical sense that were destroyed by the Afghan rulers; as Mullah Omar himself said, "there are no more Buddhists in Afghanistan to revere" what he called "the famous Bāmiyān Buddhist statues."

On the other hand, it is highly significant that, after seeing Buddhist statues in the Kabul Museum, opened for a short while, the mullahs launched a campaign against objects inherited from the pre-Islamic past. If a transcendence does inhabit these objects, if a belief that the fundamentalists can perceive as rivalling their religion is conveyed by them, then it is nothing other than the fact of being perceived as works of art (which was obviously not the meaning given to them by those who carved the Bāmiyān giants in the fifth century of our era). This cultural belief, elaborated in the West, is currently one of the main bonds uniting what is called the international community (and which by no means comprises the world's entire population).

It is against that community and against a relationship with the world that values a non-religious relationship with the invisible, that the dynamite which destroyed the giant Buddhas was used. Protest by that same international community in the name of those same values thus looks like a pathetic misinterpretation. At the same time, to find an effective weapon against that community, the Taliban who wanted to deny images and their power failed to escape the same fate: they also did politics with images.

Translated from French by Liz Libbrecht

THE HIDDEN IMAM

Catherine Lucas

IN 877 C.E., ABUL QÂIM MOHAMMED, THE TWELFTH IMAM of the Imamite Shiites, disappeared. In 940 C. E., he entered the period of *ghaibah* (The Great Occultation). He is not dead (if so, the earth would cease to exist), nor has he ascended to the sky. His disappearance has a purpose. Faced with oppression and tyranny, he decided to break the last tie that united him to his community. Of course, this break and his disappearance have had consequences for the eschatological content of the Shiite religion.

The period of occultation will only be completed at the end of time, since the Imam will return in order to fill the world with justice, equality, and truth, it is currently full of injustice and oppression.

Ever since, the wait for the return of the *Mahdi* (The Well Guided), the *Sahib al Zaman* (Master of Time) crystallizes all hopes for liberation and feeds the fervor of faithful Shiites.

In spite of the taboo regarding human representation in Islam and even though no one has ever been able to see him (the twelfth Imam having been occulted, according to tradition, at the age of eight years), images representing him are frequent in the Shiite world. Nevertheless, the most frequent images, seen everywhere, are those of Ali and Hussein (the first and third Imams).

These images are generally very stereotypical and some of the precise details of this image correspond to the usual way of representing the Mahdi. One finds the same representations in Tehran, Baghdad, Damascus, or Saida. On a green background (the color of Islam), the Imam, coat blowing in the wind and riding a galloping white horse (action, speed), seems to come out of the flames – amongst the numerous names that he was given: *al qâim* (he who rises), or *al qâaim bi amrillah* (he who rises up on the order of God) – in his left hand a red banner, in his right hand a sword. One cannot make out his face because of the veil which conceals it and which alludes to his occultation (the other Imams, Ali, Hussein, Reza ... are themselves represented with exposed faces). This face is crowned with a luminous halo, a sign of his saintliness. At the top, the tents and a door of fire remind us that the coming of Mahdi will be preceded by terrifying signs: eclipses of the moon or the sun, earthquakes, rains of fire.

Images such as this one, while of a somewhat naive workmanship, are relatively highly coded. But their universe is familiar and they appeal to the knowledge of believers who are the potential buyers of these images.

Three elements remind us that this "hidden Imam," belongs to the lineage of the Prophet Mohammed:

1) Above his head, one can read the inscription *Al Zahara* (the Resplendent). This is the name given to Fatima, daughter of the Prophet and wife of Ali (cousin of the Prophet), mother of Hassan and Hussein. Fatima is at the origin of the lineage of Imams (the Shiites privilege dynastic succession over elective caliphate) and also that of Mahdi. Fatima is never represented but her cult is immense (to such an extent that Louis Massignon could speak of Fatima's "hyperdulia").

2) The red banner, the color of blood, on which *Yâltarat Al Hussein*, the vengeance of Hussein, is written. The hidden Imam will return at the end of time in order to bring justice, but also in order to avenge Ali, Hussein, the Imams who followed (all killed or poisoned), and the group of Shiites who were subjected to numerous persecutions during the course of history. The martyr, through sacrificing his life, is a model for imitation. At the time of his future reappearance, the Mahdi will also deliver the Shiites to victory over their adversaries. One can imagine the use that could be made of such affirmations during the Iran-Iraq war or in South Lebanon during the battle against Israeli occupation. In those contexts, it would be a call to imitate the Imam and, without waiting for his return, to work for the imposition of justice in the world.

The inscription in Arabic at the base of the image confirms this: "How violently jealous they are of me because of your love. I am in love, in love, in love." The veneration of the Imams is such that one is ready to follow their examples and to sacrifice oneself. This courage is a source of inspiration.

Image on paper / 3 x 4.5" / No information provided regarding origin or the name of the producer / it is probably a photocopy
— one can, however, make out the artist's signature (?) beside the horse's right hoof / purchased in April 2000 from a kiosk
behind the mausoleum of the Imam Khomeini in Rey (Iran) / Collection of the author

3) The double-pointed sword goes back to *Zulfîcar* (literally, "that which has two points"), sword-emblem of the Imam Ali. It is also an allusion to one of the numerous appellations of the Imam. Unlike the preceding Imams (Ali and Hussein excepted) who are for the most part passive and pacifist (one often hears of their quietude), this one here is also named *sâhib ul sayf* (master of the [two-edged] sword).

Thus, it is not only the hidden Imam who is represented here, but the whole familiar universe of the Shiite religion. This "saint family" (Mohammed, Fatima, Ali, [Hassan,] Hussein) is venerated by all Muslims, but particularly by Shiites, because they are at the origin of succession of the twelve Imams.

Nevertheless, the status of these images is paradoxical. They are not regarded as sacred. Sold for a few cents by wandering merchants in bazaars, at the entrance to mosques and sanctuaries (merchants are particularly numerous during the period of "Ashura"[1]), in shops or at market-stalls, they are sold alongside photos of stars from the cinema, from music or from football, alongside photos of mountains in Switzerland, or of sandy beaches. They are completely integrated into daily life; they have no separate status at all. Anybody can buy one type of image or another.

Similarly, these images have no great aesthetic value. The paper is of poor quality, the impression is sloppy, the colors (limited here to five) are quite garish, and the image is not particularly sharp. They are often presented in the form of a print that their sellers hadn't had enough time to cut. Modern means of reproduction, although they reduce the cost, only serve to accentuate these "flaws." While the name of the editor or the printer and the name of the artist is indicated on the oldest of these images, the most recent are reproduced using a photocopy machine, thus with no references at all. Here, we are very far from the aesthetic value of an icon. Nor is it appropriate to speak of an object of veneration (even if certain believers keep them in their Koran); no one is really expecting miracles from them. More often, it is a question of a sign of membership or of belonging. To have a portrait of Ali in one's store clearly signifies the fact of being Shiite. Thus, depending on their size, one can find them hung on bazaar stalls, pasted on a car window, in the cabin of a truck, or at the entrance to a house. The Imams are models for imitation, whether in daily life or in more exceptional situations.

I was thus very surprised to find that the "an-iconic" nature of Islam is in fact completely relative, and that figurative representation is not limited to an elite (cf Persian or Ottoman miniatures), but that it also has a "popular" counterpart. I was also surprised to find that what one quite pejoratively calls "kitsch" is not limited to our own pious Christian images, but that it also applies to other cultures and to other religions. Anyway, the origin of my interest for this art – art which is usually treated in a dismissive manner and which almost no one had discussed before the Centlivres' work on the subject– no doubt lies precisely in the removal of the sacred aura from these images, and in the very fact that they are accessible everywhere to everyone and that they freely circulate in the city.[2] Being very attracted to Muslim culture in general and to the different manifestations of popular religion in particular, and having traveled extensively in these countries, I enjoy most of all engaging with the populations that live there. It is thus completely natural that I began my collection during my strolls in the markets and the bazaars where these images are posted on the merchants' stalls, by asking for clarification from sellers or buyers – the chance, for me, to have invaluable encounters. |

Translated from French by Sarah Clift

1

2

_ Pierre Centlivres and Micheline Centlivres-Demont, *Imageries populaires en Islam*, Georg, Geneva, 1997.

_This is the commemoration of the death of Imam Hussein in 680 C.E. in Kerbala (present-day Iraq); it is the occasion for processions of flagellants, assemblies of mourning, and evenings of prayer.

THE ICONOCLASTIC MEAL
DESTROYING OBJECTS AND EATING SECRETS AMONG THE BAGA OF GUINEA

Ramon Sarró

THESE TWO PICTURES PORTRAY A HEADDRESS known among African art collectors as *kakilambe*. It comes from the Baga, an ethnic group living on the coast of Guinea (West Africa). They are well known to the West for their important art production; some of the biggest African art pieces are Baga (for instance, the famous *nimba* headdress that inspired Picasso and many other western artists in the early twentieth century.)

The *nimba* is big, but in the past Baga had an even bigger headdress, called *kakilambe* (the one in the picture measures 55.5 inches long) which represented, or rather "presentified," in the language of Vernant or Stéphan,[1] an awesome spiritual agency that would appear, placed on the top of a high wooden construct, at the end of each manhood initiation ceremony, every fifteen years or so.[2] However, *kakilambe*, as well as many other cults, was abandoned in 1956, when the Baga youths, instigated by a Muslim preacher, Sheick Sayon (not himself Baga) started an iconoclastic movement against their own religious culture, getting rid of ritual objects, beating up ritual specialists, and cutting down the "sacred groves" where customary initiations, meetings, and sacrifices used to take place. The de-sacralized bush was now destined for mosques, schools, and cash crop plantations – a modern public landscape that was to replace the hideous one of secret bush areas and terrifying masks that, to the eyes of the young Guinean Muslims, was keeping the Baga "backwards" and easy to colonize.

From being one of the most prolific object producers of Africa, the Baga became in the 1960s and 1970s one of the most austere and iconophobic peoples in Guinea. The official line is "we converted to Islam and abandoned the evil things and evil doers, quite simply because they are evil." Underneath this idiom of good and evil, there lies much more complicated dialectics of objectification and subjectivity, and in fact the religious culture around *kakilambe* and other spiritual agencies is today much more relevant to everyday life than one would be led to believe at first sight. Indeed, the non-objectivity of Baga spirituality is in itself a mask, a self-conscious strategy to control one's inner beliefs and to project an image of religious austerity.

This object, *kakilambe*, belongs to the category of *tolom*. *Tolom* (pl. *molom*) is a difficult concept to translate: it can mean both "secret" and "(secret) object" (such as masks or headdresses only to be seen by initiated people, etc.). The expression *"kidi molom"* (literally "to eat *molom*," usually translated by Baga speakers as "to eat secrets") is the local expression for what we call "initiation." Initiation is conceived of as a process in which knowledge is eaten and embodied, not only "learned." It is possible that the process of initiation among the Baga included a final stage in which the initiates would literally *eat* the objects (the masks), either smashed or burned to ashes. This is a common practice in other West African initiation rites; one in which objecthood literally feeds back onto individuals' subjectivity and personal growth, the very feedback Georg Simmel said any cultural process should ideally achieve.[3]

When discussing these issues with Baga elders who were kind enough as to dig underneath the official discourse of straightforward Islamization, I was told that in fact Sayon and his iconoclastic followers did not do any harm because the objects they destroyed or took away could not be identified with the spiritual agencies behind them. *Kakilambe* is not the object, but a spirit who lives in *dabal* (an invisible "second reality" where things are more real than the simulacra we see in the sensible reality), and in order for an object to embody *kakilambe*, the appropriate words must be pronounced by the ritual specialists. To the eyes of the Baga, Sayon the iconoclast was more "fetishist" than those whom he attacked: *he* thought that the object and the spirit were one; *they* knew the object is a simulacrum and that the real thing remains invisible in *dabal*. "Sayon could not do anything to us; he took away our objects, but he could not open up our bellies" an old ritual specialist

2 3 1

This spiritual being took different names and representations depending on the Baga subgroup: *amanco* for the Baga Sitem, *päntshamän* for the Baga Pukur, etc. *Kakilambe*, a Susu word, is a generic name for it and the one used in different reproductions of this very object, which today belongs to a private Western collector. According to Frederick Lamp, it is a representation of the *pätshamän* of the Baga Pukur (Frederick Lamp, *Art of the Baga. A Drama of Cultural Reinvention*, exhib. cat. Museum of Modern Art, New York, Prestel, New York and Munich, 1996, pp. 62-63).

_Georg Simmel, The concept and tragedy of culture, in David Frisby and Mike Featherstone (eds), *Simmel on Culture. Selected Writings*, Sage, London, 1997.

Jean-Pierre Vernant, De la présentification de l'invisible à l'imitation de l'apparence, in *Image et signification*, Rencontres de l'École du Louvre, Paris, 1983, pp. 25-37; Lucien Stéphan, La sculpture africaine: essai d'estétique comparée, in Jacques Kerchache, et al. (eds), *L'art africain*, Édition Citadelles, Paris, 1988.

Sketch of Kakilambe / head piece / 1954 / Baga, Guinea, West Africa /
© photo: Denise Paulme

Kakilambe / head piece / 1956 / Baga, Guinea, West Africa /
© photo: Maurice Nicaud, Archives Marceau Riviere

told me in my last fieldwork in April 2001 (the belly being a common West African locus of knowledge and power, especially in the cultures where "secrets" are eaten). When I asked him why, then, the cults did not return after the iconoclastic movement in 1957, he replied: "We swore an oath over *amanco [kakilambe]*; let anyone who would go back to the public use of our *molom* [masquerades, initiations, etc], be killed by *amanco*." By getting rid of the objects, they made sure their religiosity could not be taken away from them. Iconoclasm was a final way to "eat the secrets;" nowadays, if you wanted to steal their *molom*, you really would have to open their bellies.

Indeed Baga did not go back to the public uses of *kakilambe*. Its invisibility has become one more astute way Baga have to manage ambiguity and to live in a world of dissimulation and double meanings.[4] The Baga cannot be accused of worshiping *kakilambe*, but its relevance in much of the everyday decision-making in the villages is beyond any doubt. Now of course the big question is: is *this* object, today sitting in a Western room, the *real kakilambe*? When I showed the picture of this object to an old Baga man in 1994 and asked him whether he knew *what* it was, he replied: "Oh yes, this is what *you* white people think is the *kakilambe*."

Whether he meant that the westerners who took this object as *kakilambe* were duped, or whether he meant that the real *kakilambe* is only the invisible one living in *dabal*, was not clear. What was clear is that he was cunningly denying the possibility of *kakilambe* being given a definitive objectivity and subsequently being taken away. In any case, let me give you the story of these two pictures: the first one is a sketch of a masquerade drawn by a young man for Denise Paulme, a French anthropologist who visited the Baga territory in 1954. She did not attend the *kakilambe* masquerade herself. She, as other researchers in the area, only got sketches of it by informants, normally young people whose perceptions were probably exaggerated by the excitement and by the awesome

4

_ "Management of ambiguity" as a valued skill is a characteristic of many of the secrecy-oriented societies of the Upper Guinea coast. I owe the expression to the recent ethnography of Mariane Ferme, *The Underneath of Things. History, Violence, and the Everyday in Sierra Leone*, Berkeley, Los Angeles and London, 2001.

Airplane head piece /
Baga, Guinea,
West Africa /
© photo: Ramon Sarró

Boat head piece / Baga, Guinea,
West Africa / © photo: Ramon Sarró

atmosphere of the ceremony.[5] The second picture was taken by Maurice Nicaud, a tribal art collector and adventurer who, to his luck, happened to be in Guinea when Sayon waged his holy war, and brought to Europe many of the objects that Sayon was confiscating, selling them to different museums and collectors in Britain and France. Probably, if it were not for him, these objects would have been destroyed (although an alternative hypothesis is that if not for him, they would not have been confiscated). In any case, he took many of them to Europe, including this very *kakilambe*. Today the *kakilambe* is somewhere in the West. Where exactly I do not know. Like the real one living in *dabal*, this *kakilambe* has now become invisible, belonging in the world of African art collectors, a world in which silence and secrecy are as important as in many a West African culture.[6]

Meanwhile, things go on among the Baga. The elders think that, with their power and oaths, they are in control of the *présentification de l'invisible*. However, today's youths increasingly dance with new forms of headdresses, shaped in the form of airplanes or boats. These new forms are very contested in the Baga territory. Some people say that they do not belong to Baga "tradition." However, one could argue that these rather "modern" objects accord to Baga cultural logics as much as the old ones did. The Baga youths want to live in what they perceive as a modern world. They want to appropriate the modernity they see around them. In the past, headdresses shaped with "transitional" beings, such as birds or crocodiles (beings that move from one medium to another) were used as mediators between separated orders of reality, such as the bush and the village, or the sensible reality and the invisible *dabal*. Today, mediation between worlds is still attempted through equally "transitional" shapes such as airplanes or boats, meant to connect separated domains. If in the 1950s, being young and "modern" meant following Islam and destroying the elders' objects; today being young and "modern" implies empowerment by copying the West and creating these new objects. Despite the efforts of the elderly Baga to control the objectification of the occult, we are in fact witnessing how the forces underneath the fate of the young Baga boys and girls are materialized in these new headdresses, challenging the elders' desires, allowing the youths to participate in a new world, with a new materiality with which to confront their elders – just as the iconoclastic actions of the latter had helped them confront *their* elders back in 1956. |

5

_ There is another sketch of the Baga Sitem *kakilambe (amanco)* done by the Catholic missionary R. Lerouge in the 1920s, which portrays it as being some twenty-meters high, but the sketch was based on what other people told him, not on what he saw.

6

_ In terms of access to objects, it is as difficult to carry out fieldwork among African art collectors as it is to carry it out in an African village, as shown in the monograph by Rolande Bonnain, *L'empire des masques. Les collectionneurs d'arts premiers aujourd'hui*, Paris, 2001.

DID FRANCIS BACON EAT PORK? A NOTE ON THE TABERNACLE IN NEW ATLANTIS

John Tresch

THE SEVENTEENTH CENTURY PHILOSOPHER and statesman Sir Francis Bacon (1561-1626) was one of the earliest and most forceful iconoclasts to serve modern science. He initiated the campaign to identify and stomp out the causes of "errors, sluggishness, and ignorance," the "idols" that hold sway over man's conceptions: Idols of the Tribe, the built-in effects of the human understanding; Idols of the Cave, the biases of each individual, according to their different natures, education, or experience; Idols of the Marketplace, false ideas that come from the imperfections of language; and Idols of the Theater, the "received systems" of established philosophy, which are "but so many stage plays." Of these he wrote: "your learning is like the banquet of the Chalcidian host. When his guests asked where he had found such a variety of game, he replied, 'The variety is only in the sauces, the meat is a pig from my own backyard'."[1]

In his new program of moral and philosophical hygiene, the intellect would be "made clean and pure from all vain fancies."[2] But while he refused the monotonous, impure, and "swinish" fare of Aristotle and the schools, he was far from leaving philosophy with an empty plate.

Destroying an icon creates a void that needs to be filled. Bacon established a set of methods by which "a true and copious history of nature and the arts [shall be] collected and digested," based on simple "instances" and "particulars;" these formed the base for a new "statue of philosophy."[3] To find an overarching symbol, or cosmogram, to house these new facts and the society they would organize, Bacon turned to an old source: Scripture, and in particular, *Exodus*.

His utopian narrative, *New Atlantis*, depicts life on the uncharted isle of Bensalem, a society devoted entirely to charity and to knowledge of God's works. The Fathers of Solomon's House – a palace/museum/laboratory, whose goal is "the knowledge of Causes and secret motions of things; and the enlarging of the bounds of Human Empire" – are Bensalem's researchers, moral authorities, and patriarchs. They conduct experiments and display collections, inventions, and discoveries that would put the World Expositions of the nineteenth century to shame.

The rites and symbols of this imaginary order were rooted in Biblical imagery. Here is Bacon's description of the arrival of the Governor from Solomon's House: "He was carried in a rich chariot without wheels, litterwise ... richly trapped in blue velvet embroidered ... The chariot was all of cedar, gilt ... and on the top before, a small cherub of gold with wings displayed."[4]

The procession directly recalls the materials for the Tabernacle, as dictated with great precision by God on Mount Sinai and later built by Moses and the Israelites, in a scene immediately following the destruction of the Golden Calf. This portable temple housed the Ark of the Covenant within curtains woven of "fine twisted linen, and of blue, purple and crimson yarns;" the ark was crowned by cherubim. The whole structure could be taken down, fitted on acacia rods, and, like the governor's litter, carried through the desert.

Bacon had solid scriptural reasons for identifying the central building of his technocratic utopia with the Tabernacle. The Tabernacle resolves the essential tension running throughout the first two books of the Bible, between accursed innovations attempted without Divine sanction, and blessed co-creations legitimated by God. By eating of the Tree of Knowledge, building the Tower of Babel, and worshipping the Golden Calf, humans vaingloriously overstepped their bounds and rivaled God's knowledge and power; on the other hand, when Adam named the beasts, Noah built the Ark, and Jacob set up a pillar to commemorate his dream of the ladder, humans humbly used their knowledge, skill and labor with the sanction of God.

2 3 1 4

_ Benjamin Farrington, Refutation of Philosophies, in Benjamin Farrington, *The Philosophy of Francis Bacon*, University of Chicago Press, Chicago, 1964, p. 106.

_ Francis Bacon, Great Instauration, in Francis Bacon, *Selected Philosophical Works*, Rose-Mary Sargent (ed.), Hackett, Indianapolis, 1999, p. 213; also in Farrington, op. cit., p. 42.

_ Francis Bacon, New Atlantis, in Bacon, op. cit., p. 260.

_ Benjamin Farrington, The Masculine Birth of Time, in Farrington, op. cit., p. 59.

A final balance between human and divine creation is reached with the Tabernacle. It is the fruit of the Hebrews' highest technologies: "work in gold, silver and bronze, in cutting stones for setting, and in carving wood … every kind of work done by an artisan or by a designer or by an embroiderer" (Ex. 35:31-35). But unlike the accursed innovations, this is labor ordered by God and conducted, six days out of seven, for God's glory and for the good of God's chosen people. When it is assembled according to God's instructions, God appears among them: "the cloud covered the tent of meeting, and the glory of the Lord filled the Tabernacle" (Ex. 40:34-35).

We can see Bacon as a new Moses. He destroyed the Golden Calf of philosophical illusion and established the plan for a legitimate Tabernacle. Like the Tablets of the Law in the Ark – a classification of places, people, actions, and foods into pure and impure – Bacon's first commandment was "to set forth Tables of Discovery … formulae of a *legitimate* mode of research … [a] visible embodiment of the work to be done."[5] Likewise, he called Solomon's House the "College of the Six Days' Labor." Here, as in the Tabernacle, humans would weave together their "literate experience" to regain the dominion they had over the earth before the Fall. Knowledge would be a collective pursuit with external consequences. Bacon brought about a paradigm shift *within theology*: his natural philosophy is a pious duty, a new, humble form of worship and charity; as he put it, "Nature cannot be conquered but by obeying her."[6] Patient recording of the facts of God's creatures allows for new inventions that will bring a prodigious *increase*.[7] Thus will the covenant be fulfilled; thus will humanity "be fruitful and multiply." Bacon's visionary blueprint guided the founders of England's Royal Society, the first modern institution for scientific research.

Bacon zealously advocated the direct observation of particulars, yet Scripture remained the highest authority: "Natural philosophy is *after the word of God* at once the surest medicine against superstition, and the most approved nourishment for faith."[8] Where facts about nature were concerned, possible conflicts between Scripture and science were noted but often smoothed over. Just as his *Wisdom of the Ancients* decoded the truths veiled by fables, in *The Advancement of Learning* he suggested that "the ceremonial law of Moses" contains "much sprinkling of philosophy": for example, in Deuteronomy's rules about lepers, the persons labeled "unclean" are those at the highest stage of contagion.[9] Like Moses Maimonides, Bacon might have seen a similar philosophical rationale for the Hebrew law's ban on pork: the Bible warns against a real danger – trichinosis, salmonella – for which natural philosophy would later give a more precise explanation.[10]

Yet Bacon frequently warned against the "corruption of philosophy by superstition and an admixture of theology." He urged his initiates to "be sober minded, and give to faith that only which is faith's."[11] Later centuries have found this commandment hard to follow. How can we tell a sacred mystery from a superstition maintained by human laziness and ignorance? Which authority do we believe when geology teaches us that the earth is far older than the Bible says? How do we worship an anthropomorphic creator when our sciences tell us that man was not created all at once in the Divine Image, but evolved over time, from apes? If medical science tells us that there is nothing to fear from well-cooked pork, must we continue to obey God's emphatic dietary laws?

To create symbols that unite us in a new common purpose we have to reframe, re-interpret, or remove the symbols that previously served that role. Bacon tore down the idols of medieval philosophy, while planning a new society around a high-tech tabernacle. In his pious craving for purity, he established the project of modern science as an iconoclastic "creative destruction." Such holy fury is difficult to control. Bacon set in motion a process that eventually risked sweeping away God, the idol in whose name it all began. |

8 7 6 5 11 9 10

_ Bacon, Great Instauration, in Bacon, op. cit., p. 125, italics by the author.

_ Bacon, The Advanced of Learning, in Bacon, op. cit., p. 32.

_ At times, Bacon describes the relation between Mind and Nature as "a chaste and lawful marriage," at others as an "enslavement." Was Bacon a sexist pig? See discussions by Keller and Lloyd in *Feminism and Science*, Fox Keller and Evelyn and Helen E. Longino (eds), Oxford University Press, Oxford, 1996; and Mary-Rose Sargent, in Bacon, op. cit., 1999, p. XXXV.

_ Benjamin Farrington, Thoughts and Conclusions, in Farrington, op. cit., p. 101.

_ Bacon, Great Instauration, in Bacon, op. cit., p. 106.

_ Farrington, op. cit., p. 93.

_ For a different rationalization of the ban among "Pig Haters," see Marvin Harris, *Cows, Pigs, Wars and Witches: The Riddles of Culture*, Random House, New York, 1974, pp. 35-60. Bacon may reveal himself as a "Pig-Lover" in his Essays, where he advises those who would start a plantation: "For beasts or birds, take chiefly such as are least subject to diseases, and multiply fastest: as swine, goats, cocks, hens, turkeys, geese, house-doves, and the like." (Bacon, On Plantations, in Bacon, op. cit., p. 354).

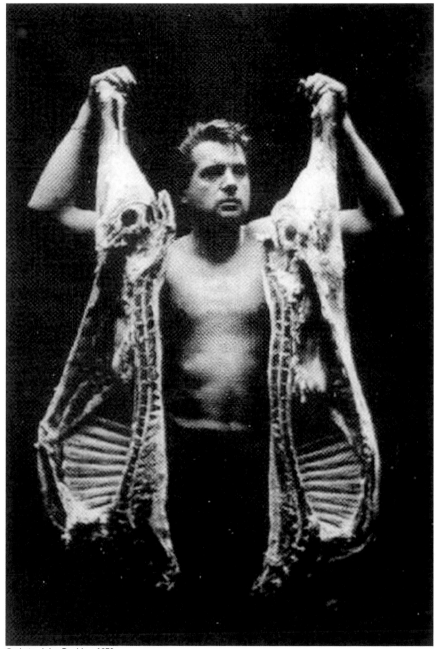

© photo: John Deakins, 1952
The Francis Bacon of the twentieth century, another British iconoclast, holds up two sides of meat, like Moses coming down Mount Sinai with the Tablets of the Law. His new covenant took painting not as a representation or narrative but as an experimental encounter between paint and canvas, flesh and bone. The avant-garde artist shocks by breaking traditional taboos, in this case, persistent codes for killing animals and handling meat.

NO FREEZE-FRAME ON GOD

Patricia de Aquino

JUDGING BY PHOTOS OF AFRO-BRAZILIAN GODS, one could think that these Candomblé divinities were overly-shy. They apply themselves relentlessly to *burning* the pictures that photographers hoped would preserve a trace of their fleeting passage through the bodies of their initiates during a trance. Members of these Brazilian cults of the African diaspora take a malicious pleasure in exhibiting "flopped" photos taken by reckless photographers who dared try to freeze for eternity something that only moving images are allowed to capture.

Whereas cameras are strictly prohibited in most temples, use of camcorders is tolerated to some degree. During public ceremonies, when the *orixas* are summoned to visit the bodies of their initiates and to dance amongst us to the rhythm of ritual drums, it is possible to film their movement in this world. As a former follower put it: "orixas are not born to stay immobile." No freeze on a frame.

What a strange godly shyness it is that evolves along with technique. But one is soon forced to abandon this misinterpretation of the character of gods, upon discovering the plurality of their modes of existence: divinities show themselves everywhere and often simultaneously.

Candomblé gods can be all at once in the flesh of those dedicated to them, in the murmur of the little shells that rub between their hands, in elements of nature (lightning, wind, oceans, etc.), and in the assemblages of mineral, plant, and animal objects that give them presence.

Note that this existential lability must not be mistaken for some kind of abstraction of their being or be confused with a supposed immateriality of their existence. Their presence is in each of these modes of life. And it is physical, audible, palpable, and visible; in other words, none of these forms of presence is a divine manifestation, a symbol relating to the transcendent, symbolized, nor a representation echoed by originals either inaccessible or lost forever.

These non-humans are not rooted in the identity equation of self-to-self and/or self-in-time-and-space to ground themselves in truth. They are at the circumstantial crossroads of various things, mixtures of portions of heterogeneous substances (rainwater, river water, seawater, log fire, forest fire, ferruginous metals, precious metals, rusted metals, etc.), assemblages of matter engaged in a dynamic ritual of renewed "rearrangement." And they depend on humans to actually exist.

It is the techniques used by the rites that make them come into existence, that make it possible to implement life, to produce different "mixes" spawning humans and gods. After the phase of initiatory reclusion lasting up to sixteen days, it is said of humans and non-humans that they are "born" – "born because they have been made." Throughout their life, together, they will be in a process of ritual creation and will regularly subject themselves to the rites that will reorganize the mutual co-production of their "identities."

This materialistic and non-essentialist conception of "individuals" – that only a perpetual movement of production keeps alive – explains initiates' and gods' obvious defiance of cameras.

By seizing beings, the photo suspends time. It is a threat of immobility, of death. When the gods are also stones they live at crossings. By rolling with the tides and following the course of rivers, pebbles come from long ago, resist and are eroded in the waters that polish them, the time that shapes them. Their photographic petrification would be the image of their annihilation.

By representing divinities, the photo sets beings in an existential univocity, traps them in a way of being defined that prefers the equation of doubles (representer/represented), to the detriment of plural identity crossroads.

Remember that the birth of the scientific subject distancing itself from the self and from its object in general, is based on the experience of doubt grounding it in the blind spot of reflexive evidence. The lever of modern science definitively establishes vision as the cornerstone of a metaphysics which gives preference to the paradigm of clear and distinct evidence or, in other words, the orthodoxy of the gaze.

In fact, of our five senses, sight is certainly the one which best metaphorizes the position of observation recommended by orthodox scientific approaches. Opening one's eyes is a way of "facing" that allows the world to be divided up, subjects to position themselves as non-participants in what they perceive, theory to be freed from their point of view and to establish itself in transcendence to be, finally, perfectly consistent with its etymology.

In Candomblé, the prohibition concerning photography seems to drive this line of thinking which values sight – to the detriment of the other senses – into a corner. To be sure, the failure of "snap shots" of gods shows that there is nothing to see, in the sense that truth and reality are not exclusively a matter of vision, of immediacy, but of production, of crossings and of multiplicity. Yet the plural existences of the gods are visible: trances, shells, nature, objects, nothing is hidden. In this sense, the separation of prohibition and secret suggests that it is enough to have a taste for simply seeing, without additional filters, cameras, backgrounds, and work behind the scenes, to see things as they really are; to realize that truth lies before our eyes, in full evidence, giving itself to be seen.

Paradoxically, but by definition, for advocates of photography – understood to be a recording of the real – the reality of the phenomenon is not that which appears; truth is necessarily veiled under its deceptive manifestations. Objectifying sight will denounce the trickery by revealing profound realities, essences, substrata, and noumena. And by way of a skillful sleight of hand, these half-paranoid scientific forgers of the real will do everything they can to eliminate the procedure in order to expose their discovery as a dis-covery; a non-mediated unmasking; a "photo" of reality; or rather a trite postcard of it, for the processes of production involved in the construction are devalued, like parasites tainting the truth with an inkling of artifice.

In the realm of sight, where only transparency is established, diffuse mistrust prevails over what is seen. The shrewd spirit is watching: one must be on the lookout. In the Afro-Brazilian Olympus of making, the gods close the eyelids of the initiates they are crossing through and dance. |

Sunday, 24 May 1998 || Dear Brothers and Sisters, || 1. With my gaze turned to the Shroud, I would like to extend a cordial greeting to you all, the faithful of the Church of Turin. I greet the pilgrims who have come from every part of the world at the time of this public exposition to look at one of the most unsettling signs of the Redeemer's suffering love. || As I entered the Cathedral, which still shows the scars of last year's terrible fire, I paused in adoration before the Eucharist, the sacrament which is the focus of the Church's attention and, under humble appearances, contains the true, real and substantial presence of Christ. In the light of Christ's presence in our midst, I then stopped before the Shroud, the precious linen that can help us better to understand the mystery of the love of God's Son for us. Before the Shroud, the intense and agonizing image of an unspeakable torment, I wish to thank the Lord for this unique gift, which asks for the believer's loving attention and complete willingness to follow the Lord. || 2. The Shroud is a challenge to our intelligence. It first of all requires of every person, particularly the researcher, that he humbly grasp the profound message it sends to his reason and his life. The mysterious fascination of the Shroud forces questions to be raised about the sacred linen and the historical life of Jesus. Since it is not a matter of faith, the Church has no specific competence to pronounce on these questions. She entrusts to scientists the task of continuing to investigate, so that satisfactory answers may be found to the questions connected with this sheet, which, according to tradition, wrapped the body of our Redeemer after He had been taken down from the cross. The Church urges that the Shroud be studied without pre-established positions that take for granted results that are not such; she invites them to act with interior freedom and attentive respect for both scientific methodology and the sensibilities of believers. || 3. For the believer, what counts above all is that the Shroud is a mirror of the Gospel. In fact, if we reflect on the sacred Linen, we cannot escape the idea that the image it presents has such a profound relationship with what the Gospels tell us of Jesus' passion and death, that every sensitive person feels inwardly touched and moved at beholding it. Whoever approaches it is also aware that the Shroud does not hold people's hearts to itself, but turns them to Him, at whose service the Father's loving providence has put it. Therefore, it is right to foster an awareness of the precious value of this image, which everyone sees and no one at present can explain. For every thoughtful person it is a reason for deep reflection, which can even involve one's life. The Shroud is thus a truly unique sign that points to Jesus, the true Word of the Father, and invites us to pattern our lives on the life of the One who gave himself for us. || 4. The image of human suffering is reflected in the Shroud. It reminds modern man, often distracted by prosperity and technological achievements, of the tragic situation of his many brothers and sisters, and invites him to question himself about the mystery of suffering in order to explore its causes. The imprint left by the body of the Crucified One, which attests to the tremendous human capacity for causing pain

and death to one's fellow man, stands as an icon of the suffering of the innocent in every age: of the countless tragedies that have marked past histories and the dramas which continue to unfold in the world. Before the Shroud, how can we not think of the millions of people who die of hunger, of the horrors committed in the many wars that soak nations in blood, of the brutal exploitation of women and children, of the millions of human beings who live in hardship and humiliation on the edges of great cities, especially in developing countries? How can we not recall with dismay and pity those who do not enjoy basic human rights, the victims of torture and terrorism, the slaves of criminal organizations? By calling to mind these tragic situations, the Shroud not only spurs us to abandon our selfishness but leads us to discover the mystery of suffering, which, sanctified by Christ's sacrifice, achieves salvation for all humanity. Death is not the ultimate goal of human existence. || 5. The Shroud is also an image of God's love as well as of human sin. It invites us to rediscover the ultimate reason for Jesus' redeeming death. In the incomparable suffering that it documents, the love of the One who »so loved the world that he gave his only Son« (JN 3:16) is made almost tangible and reveals its astonishing dimensions. In its presence believers can only exclaim in all truth: »Lord, You could not love me more!«, and immediately realize that sin is responsible for that suffering: the sins of every human being. || As it speaks to us of love and sin, the Shroud invites us all to impress upon our spirit the Face of God's love, to remove from it the tremendous reality of sin. Contemplation of that tortured Body helps contemporary man to free himself from the superficiality of the selfishness with which he frequently treats love and sin. Echoing the Word of God and centuries of Christian consciousness, the Shroud whispers: believe in God's love, the greatest treasure given to humanity, and flee from sin, the greatest misfortune in history. || 6. The Shroud is also an image of powerlessness: the powerlessness of death, in which the ultimate consequence of the mystery of the Incarnation is revealed. The Burial Cloth spurs us to measure ourselves against the most troubling aspect of the mystery of the Incarnation, which is also the one that shows with how much truth God truly became man, taking on our condition in all things, except sin. Everyone is shaken by the thought that not even the Son of God withstood the power of death, but we are all moved at the thought that he so shared our human condition as willingly to subject himself to the total powerlessness of the moment when life is spent. It is the experience of Holy Saturday, an important stage on Jesus' path to Glory, from which a ray of light shines on the sorrow and death of every person. By reminding us of Christ's victory, faith gives us the certainty that the grave is not the ultimate goal of existence. God calls us to resurrection and immortal life. || 7. The Shroud is an image of silence. There is a tragic silence of incommunicability, which finds its greatest expression in death, and there is the silence of fruitfulness, which belongs to whoever refrains from being heard outwardly in order to delve to the roots of truth and life. The Shroud expresses not only

the silence of death but also the courageous and fruitful silence of triumph over the transitory, through total immersion in God's eternal present. It offers a moving confirmation of the fact that the merciful omnipotence of our God is not restrained by any power of evil, but knows instead how to make the very power of evil contribute to good. Our age needs to rediscover the fruitfulness of silence, in order to overcome the dissipation of sounds, images and chatter that too often prevent the voice of God from being heard. ‖ 8. Dear brothers and sisters: Your Archbishop, dear cardinal Giovanni Saldarini, the Pontifical Guardian of the Holy Shroud, has offered the following words as the motto of this Solemn Exposition: »All will see your salvation.« Yes, the pilgrimage that great throngs are making to this city is precisely a »coming to see« this tragic and enlightening sign of the passion, which proclaims the Redeemer's love. This icon of Christ abandoned in the dramatic and solemn state of death, which for centuries has been the subject of significant representations and for 100 years, thanks to photography, has been so frequently reproduced, urges us to go to the heart of the mystery of life and death, to discover the great and consoling message it has left. ‖ The Shroud shows us Jesus at the moment of his greatest helplessness and reminds us that in the abasement of that death lies the salvation of the whole world. The Shroud thus becomes an invitation to face every experience, including that of suffering and extreme helplessness, with the attitude of those who believe that God's merciful love overcomes every poverty, every limitation, every temptation to despair. May the Spirit of God, who dwells in our hearts, instill in everyone the desire and generosity necessary for accepting the Shroud's message and for making it the decisive inspiration of our lives. ‖ Anima Chrisi, sanctifica me! salva me! Passio Chrissi, conforta me! Intra vulnera tua, absconde me! ‖

The unbearable image

»DÉVISAGER« – TAKING IMAGES ON A MINE FIELD

A picture of Sophie Ristelhueber as seen by Bruno Latour

ONE. ONE DOES NOT. ONE DOES NOT SEE. One does not see any human face. One does not see any living creatures. Trees, maybe, but they are smashed or cut off. Grass, but it grows through the tiny cracks of broken pieces of concrete of houses in ruins. As to birds and fish, lions and dogs, flies and gnats, none are to be seen. Stones, sediments, rocks, there are aplenty; but they too look like ruins of forgotten times – only geologists can envision in their maps and their minds the massive shapes of bygone mountains that now lay broken, invisible to the untutored eye. Many buildings, unfinished, destroyed, bombed, but they too resemble the stones and sand of the geological strata out of which they have been moulded and then turned to dust.

The second commandment is obeyed here to the full. No Islamic scholar, no Jewish glossator ever observed the ban against representing living creatures to that extent. No veil has ever been more fully draped to hide the face of the artist. Every effort will be devoted to make the onlooker invisible as well. No face to be seen in the pictures, no face of the photographer either. Please, veil the ego, hide it in the middle of a castle, keep it locked somewhere in a forgotten harem. No one can see a face that is not faceless. No one unveils anything, who is not herself veiled. Look, even in the art studio, no image is to be looked at. One has to practice a long and harsh asceticism when daring to seize through the medium of photography the traces of faces long gone.

Too many images everywhere, a flood of news, of reports, of documents, of advertisements. Too many. Oh please, please, be silent, decrease, decrease the light, limit the flood, make less images, turn them into a rarity, a precious and silent meditation. No reporting. No documentation. No news. What's the news anyway? The present, the fleeting, invisible, unreadable present. Nothing to be looked at. Scarcity, rarity, abstinence. Less, much less image. A great silence has fallen on the face of the tormented and destroyed earth. One sees from much further up, from much closer down. One sees from far and away, as if an angel from after the last judgment had been given a camera – or maybe it is equipped with a zoom of such power that cities of dust look like the convolutions of a cell, the swarming fields of an atom. Centuries are like a second. Specks are as big as a world.

And yet nothing is destroyed here, no idol is smashed to the ground, no icon is defaced. No, no, it is the world itself that has destroyed itself. Deserts, mountains, cities have martyred themselves well and deep enough. Who is responsible? Who is fighting whom? Does it matter really? Well-meaning friends and commentators are always offering explanations. "Go away," says Job on his heap of refuse, scratching his wounds. Do we need really to add any destruction to the world as if there was not enough already? No need, certainly, to destroy some other image, painting, work of art to make sense of what is to be seen, to make oneself known to the world of art as a daring iconoclast.

No need even to make the image, to fashion it, to shape it. The images themselves – those traces of traces – are intact, virginal, unmediated, unretouched; such is the power of the camera, the moment, the fleeting unpredictable moment is seized and then kept as it is. It will be framed, shown, arranged, printed, blown up and down, but whatever photons have struck the tender silver skin will remain forever as it was. The small scratches on the surface of the earth will scrach the tiny pellicule. Add nothing. Never was a medium better adjusted to the thing to be seen. Go away you interpreters.

English does not have the word to describe what one is trying to show: it knows how to "face" and to "deface," and knows the word "visage," but does not possess the French word *"dévisager."* In the old days, it meant to destroy the face, but then the meaning changed to designate a long, curious, worried and thoughtful look at someone's face. *"On ne dévisage pas les gens,"* the mother says to her overly curious daughter. Here is the mine field. To take a good hard look at a human face one has to apologize; "Would you please step away from those ruins you still inhabit, so that I could see better who you

are and what you have done, what monstrosities have been done to you? Please – go away, you the exotic and too human face. I want to see the skeleton, the essence, the truth of you, and for that you have to pass away." I don't see well when you are in the middle of the picture, you the present flesh, nicely framed, central, with the walls of your house the background. Let me see the background instead and, if possible, have this decor emptied, ripped open, scorched and disassembled. Ah, then, at last, I begin to see what you have been up to, the mine field you have traveled through and survived. I, too, wish to follow you through this mine field. Such tenderness in this faceless, now at last *face-full*, earth. |

Sophie Ristelhueber / Fait / 1992 / detail / chromogenic print mounted on aluminum, framed / © Sophie Ristelhueber

A STATE OF LATENCY

by Joana Hadjithomas and Khalil Joreige

On the 27th of October 1997, I printed for the last time the contact sheet of one of my photo films. Since then, I no longer develop the images, I'm content with taking them. I make an inventory of them in a notebook and when I read it, I can imagine them and see them. The impressed film, once dated and inventoried, is filed in a drawer.

I take photos in a compulsive way. I go on with my private journal and my photographic research. It covers what I ate from February to March, the streets I crossed during the week, a catalogue of all unrestored buildings, spying daily on my neighbour Zakiyeh, the parties I'm invited to, the imprint of my wife's body on the sheets in the morning, coffee grounds in my cup and all kinds of experiments and research.

In Beirut, I have the feeling of being constantly surrounded by latent images, turning sometimes to the past and others to the future, or on the contrary stuck in a continuing present. I don't know why I decided to go through the images.

For years, I have been crisscrossing the town and taking pictures of my daily life which no one has seen. When I read the description of my photos in the notebook, I live by evoking my images, by expecting them, while the memory of the images, sometimes present or absent, constantly amuses me or haunts me. I read all those dates and, suddenly, I no longer know. Was it really like that? And when I see all those films, filed but not developed, I fondle them, I fondle that potential which raises my enthusiasm on one hand, and my fears on the other.

Today, I finished the film of December 20th, 2001. I took mainly pictures of the Ouzaï area, then winded up the roll at a friend's party.

I have often photographed Ouzaï lately, and I met someone else interested in it. Ahmad Gharbieh. In June 2001, he inventoried all the pictures on the main part of the Ouzaï road. It relieves me. It is like an occasional relay for my latent images.

I go along that road that runs between the sea on one side and the airport on the other. Most of the constructions along it have been set up illegally, when the population fled from South Lebanon following the Israeli invasions.

I drive along the 42 posts which divide the road. 42 electric and lamp posts, bearing recto verso frames, all the same size. Some of these

frames contain an image. a portrait of a fighter from one of the two main Shia movements. Amal in the Northern part of Ouzaï. and Hezbollah in the South. Under each portrait there is a caption. "the martyr fighter" or "the martyr hero", followed by the name of the man.

I always take photos from the car. Each portrait on the Ouzaï road is placed in a flux. a continuum in relation with the traffic which determines key points. those with the best visibility. The road is one of the main arteries of Lebanon and the location of the martyrs' portraits follows the evolution of the road and that of the bottlenecks. Where traffic is dense. the portrait will represent one of the most important heroes of the resistance according to the party's own hierarchy.

However. alongside the frames hanging on the 42 poles all along the road. one element always surprises me and catches my eye. an element which regularly interrupts the unending stream of images.

Empty frames. The same as those of the martyrs. but left empty. Frames waiting for an image. waiting for a martyr. Those "holes" are like a missing place. off-frame. a latent image. like mine. bearing all the possibilities. An elsewhere. a transparency. What we could really see would be beyond this transparency.

Driving at 40 km/h at 1.50 meter from the posts, tilting my head and forgetting the rough surface of the road. I observe a strange optic phenomenon. The varying portraits and alternating full and empty frames create a phenomenon of retinal persistence. The empty frames then seem filled by the projection of the various faces seen... I've often tried to photograph this.

It is strange to realize that the same post carries the tribute to the martyr and also the negation of the martyr by a criticism of the very status of the image, an empty frame. Therefore, it is no longer the image that makes up the martyr, but rather the frame. The frame, and even more than the frame, the post, gives the image its "aura".

The electric post is between the image of the past (the martyr) and the frame to come (the next and future martyr). The post anchors these two temporalities in a kind of reality, of continuous present. Whereas juxtaposing these temporalities creates a time lag which cannot be easily represented.

Just like the ceremonial adopted for the video pre-taped farewell of the fighters before their suicide operations.

In this farewell shown on TV newsprogram, the fighter introduces himself in these terms "I am the martyr" followed by his name. His status of martyr precedes the suicide operation he will carry out

and which will turn him into a martyr in the eyes of his country, of his party and of his God.[1]

"I am the martyr"... This sentence, which has become a staple one in this type of testimony, is an example of temporal confusion which refers to a type of time-lag and to an impossibility in representation.

Is it possible to declare oneself a martyr before dying ?

I remember the testimony of Mayla Soufangi, a former prisoner in Khiam, the detention camp which was closed after South Lebanon was liberated. She recounted that she had decided to ride a mule loaded with explosives and to trigger off the explosion near an Israeli patrol. Her death would make her a martyr of the Syrian Baas party to which she belonged. But the operation failed, and the "martyr" survived. She was jailed then freed thanks to an exchange of prisoners.

While listening to her, I wondered : Did Mayla pronounce, in front of a camera, the sentence which makes a martyr of her ? Can one be a martyr and alive ?

During the TV program, Mayla was named, more than once, the "living martyr"; she calls herself "the adjourned martyr", "the latent martyr". She relates how, once out of prison, she plunged

into drugs. how she questions her feminity and her sexual identity nowadays, dreaming of becoming a man. Another person.

It brings to mind the story of a man who taped his farewell message before his suicide operation. The message was broadcast on national TV. but the operation failed and the man was emprisonned in Khiam. Some time later, he changed sides and turned informer for Israel. the very enemy he was ready to fight till death.

He who proclaimed himself a martyr. who projected himself onto one of the empty frames of Ouzaï may come back. But who comes back ? Can the same return from the realms of death ?

1 See, on the subject, Rabih Mroué and Elias Khoury's performance *Three Posters*, and Jalal Toufic's essay *I Am the Martyr Sanā' Yūsif Muhaydly*, Al-Ādāb, January/February 2001, Beirut, Lebanon, pp. 44-51.

Ahmad Gharbieh, "Display", photomontage.
from "Ouzaïssue", graphic design final year project,
American University of Beirut, June 2001.

SHOOTING THE DEAD

Margit Rosen

THE PICTURE IS A REPRODUCTION OF A PHOTO POSTCARD. The photograph, taken around 1900, shows a "bludgeoned body of an African American male, propped in a rocking chair, blood-splattered clothes, white and dark paint applied to face and head, shadow of man using rod to prop up the victim's head."[1] Sending out this postcard was the final act in a chain of cruelties. The card provides evidence of a lynching similar to those that took place almost every week in the USA in the late nineteenth century.[2] Between 1882 and 1968, an estimated 4,742 African Americans met their deaths at the hands of lynch mobs. The postcards were cherished souvenirs. The US Postal Service first decided in 1908 that such material should not be sent openly.

The observer's horror, having read the image's description, is provoked on the level of the represented as well as on the level of representation. Through the screen of the photograph, perceived as a quasi-transparent medium of documentation in everyday life, the observer recognizes a dead person and the shadow of one of the murderers. Secondly, he or she realizes that the picture itself is a product made by one of the murderers or at least of one of their accomplices.

Those persons who made these pictures committed an iconoclastic act of desecration by painting the face of the corpse and sticking cotton on its head. They attacked the already lifeless body, the corpse, which can be defined as a transitory image representing the absent person.[3] The derision of the material remains affects the murdered individual: corpse and absent person, sign and signified cannot be thought of separately. Even in the situation of death, the harm done to the body is harm done to the individual.[4] Yet the depicted postcard not only provided documentation of this iconoclastic act carried out on the image of man; it was also made and staged for the sake of the photograph. The card thus provides information about the function of representation in the completion of humiliation and about the worship of images by murderers who profit from the power of visual representation.

Every photo of a corpse injures, in principle, the personal rights of the deceased who never gave their approval for the photo to be taken. The gaze remains unreturned. This becomes evident when the staging of the corpse offends its dignity. The act of photographing a victim is an act of total control. When the serial killer Jeffrey Dahmer took Polaroid shots of his victims, he was not only producing trophies or fetishes: he was also using his power to determine the victim's form of presence by representation.[5] The photographic act, therefore, had a significant role in the lynchings. The photos were souvenirs of the spectacle, proofs of power, as only a dominant group can proudly advertise their bloody deeds and means of facilitating the endless replay of anguish. "Even dead, the victims were without sanctuary."[6]

Yet the photographer created an agent of his interests that has the potential to turn itself against him as condemning evidence of cruelty. André Bazin's statement that the image's essential function is to save man from death and oblivion likewise contains the significance of the photograph within the context of lynching: the existence of these pictures might, for the victim, become a sphere of post-mortal influence. For the picture shows the corpse, it preserves the "scandal of death," which is not made up of the absence of a person, but their physical remains in space.[7] Photography facilitates the preservation of the presence of the murdered, the confrontation with the historical event that might result in a posthumous symbolical restoration of the integrity of the deceased.

The image of humiliation can be transformed into a tool of accusation; the image of absolute control is therefore not entirely controlled by its producers. Already in 1911, a black-owned newspaper in Topeka Kansas reprinted the photograph of a lynching that took place in Durant, Oklahoma and urged every other newspaper to do likewise, so that "the world may see and know what semi-barbarous America is doing."[8] Also the curators of the carefully prepared exhibition *Without*

2 4 5 3 8 1 7 6

_ James Allen, *Without Sanctuary: Lynching Photography in America*, Twin Palms, Santa Fe, 2000, without page number.

_ Allen, op. cit., pp. 204/205.

_ Cf. Maurice Blanchot, Les Deux Versions de l'Imaginaire, in Blanchot, *L'espace littéraire*, Paris, 1955, pp. 340ff.

_ Allen, op. cit., p. 10.

_ Thomas Macho, Skandal der Abwesenheit. Überlegungen zur Raumordnung des Todes, in Thomas Macho, *Leerzeichen. Neuere Texte zur Anthropologie*, Schriftenreihe Soziale Ökologie, vol. 31, Vienna, 1993, pp. 17-34, p. 18.

_ Georg Wilhelm Friedrich Hegel, *Grundlinien der Philosophie des Rechts, Werke*, Glockner (ed.), Stuttgart, 1964, § 48, pp. 101f. (Georg Wilhelm Friedrich Hegel, *Philosophy of Right*, § 48).

_ Brian Masters, *Todeskult. Der Fall Jeffrey Dahmer*, Rowohlt, Reinbek, 1995, p. 183 (Original edition: *The shrine of Jeffrey Dahmer*, Hodder & Stoughton, London, 1993).

_ The exhibition *Without Sanctuary: Lynching Photography in America*, in the New York Historical Society (March-July 2000) comprised approximately 100 photographic prints and postcards, ranging in date from 1870 to 1960, that document the history of lynching in the US. These materials were collected by James Allen and John Littlefield, and remain part of the Allen/Littlefield Collection, on deposit in the Special Collections Department, Robert W. Woodruff Library, Emory University. The photographs were first shown 13 January to 12 February under the title *Witness* at the Roth Horowitz Gallery, Manhattan. / See the online presentation of the collection carefully commented by James Allen, under http://www.journale.com/withoutsanctuary/

Sanctuary. Lynching Photography in America used the photographs for socio-historical instruction: "the photographs provide an opportunity for dialogue among New Yorkers about a part of our past that is difficult for us to confront."[9]

Yet the discussion surrounding the exhibit showed resistance to the pictures and the uses that were made of them. It reflected not only the deep ambivalence of the images, caused by the fact that the photographers who shot the dead were accomplices of the murderers who determined the humiliating perspective by staging the corpse. The discussion also considered the role that shocking photographs play in the formation of public consciousness of history. The *New York Times*, for example, warned of "The Perils of Growing comfortable with evil." There was not only criticism of reprinting the pictures in news magazines with little information, in which the original act of humiliation would be essentially repeated, but, also questioned was whether these photographs were, in principle, suitable "to sensitize to long-buried horrors of America's racial past."[10]

Pictures that show the victims of violent acts are often percieved as dangerous objects whose effects can't be predicted: the spectator might adopt the perspective of the perpetrators, the photographs might be perceived as a fascinating creepy spectacle or they might simply benumb the horrified spectator, instead of informing him or her. The fear of the picture's power to shock emotions exists parallel to the fear that they could lose this power; that people could become accustomed to them without feeling anything. The horrifying images of the corpses, however, are linked, in contrast to textual historical sources, with the idea of the spectator losing all rationality and humanitarian values. The visual information the photograph displays, the concrete and individual events represented by the corpse as its most terrible evidence, remains suspicious.

Yet this kind of critique, which indeed reveals the ambivalent potential of photographic representation, relinquishes the possibilities of this medium. The photographs are more than just a tool to call public attention for historical events that might previously have been common knowledge for historians alone. They need to be contextualized, as does every historical source. If this precondition is fulfilled, as f.e. in *Without Sanctuary*, pictures such as the one depicted offer an additional layer of information by displaying the concrete, individual event with all its cruel details such as the desecration of the corpse. It fills a blind spot in the historical consciousness constituted by media such as film and photography. The idea of excluding images of horror, excluding photographs of corpses, is based on a misunderstanding of the performance of visual representation. It not only recreates presence, but also creates distance, which is the basic requirement of perception and reflection. Perseus doesn't defeat Medusa by closing his eyes. With the help of the mirror, the representation of her face, he is able to look at her.[11]

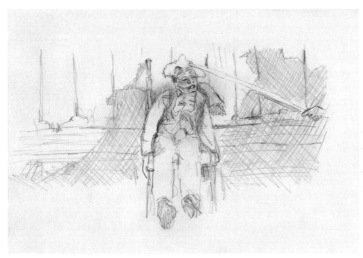

Sketch due to copyright reasons. Consult the image at
www.journale.com/withoutsanctuary/pics_10.html

The bludgeoned body of an African American male / c. 1900 /
photo postcard / gelatin silver print / 5.4 x 2.8" /
Allen-Littlefield Collection, Special Collections Division,
Robert W. Woodruff Library, Emory University /
© Robert W. Woodruff Library, Emory University

9 11 10

_ Press Information of the New York Historical Society.

_ Brent Staples, The Perils of Growing Comfortable With Evil,
in *The New York Times*, 9 April 2000.

_ Siegfried Kracauer, *Theorie des Films*, vol. 3: Die Errettung der äußeren
Wirklichkeit, Karsten Witte (ed.), Suhrkamp, Frankfurt/M., 1985 (1964), p. 396
(Originally published in English as *Nature of film: the redemption of physical reality*,
Oxford University Press, New York, 1960).

Les images couvrant tous les murs d'une salle se révèleront par la volonté de chacun
Christian Boltanski 2002

MORE LIGHT, AND THE GLOOM OF THAT LIGHT
MORE GLOOM, AND THE LIGHT OF THAT GLOOM

In those Hyperborean regions, to which enthusiastic Truth, and Earnestness, and Independence, will invariably lead a mind fitted by nature for profound and fearless thought, all objects are seen in a dubious, uncertain, and refracting light. Viewed through that rarefied atmosphere the most immemorially admitted maxims of men begin to slide and fluctuate, and finally become wholly inverted; the very heavens themselves being not innocent of producing this confounding effect, since it is mostly in the heavens themselves that these wonderful mirages are exhibited. || But the example of many minds forever lost, like undiscoverable Arctic explorers, amid those treacherous regions, warns us entirely away from them; and we learn that it is not for man to follow the trail of truth too far, since by so doing he entirely loses the directing compass of his mind; for arrived at the Pole, to whose barrenness only it points, there, the needle indifferently respects all points of the horizon alike. But even the less distant regions of thought are not without their singular introversions. || Hardly any sincere man of ordinary reflective powers, and accustomed to exercise them at all, but must have been independently struck by the thought, that, after all, what is so enthusiastically applauded as the march of mind, – meaning the inroads of Truth into Error – which has ever been regarded by hopeful persons as the one fundamental thing most earnestly to be prayed for as the greatest possible Catholic blessing to the world; – almost every thinking man must have been some time or other struck with the idea, that, in certain respects, a tremendous mistake may be lurking here, since all the world does never gregariously advance to Truth, but only here and there some of its individuals do; and by advancing, leave the rest behind; cutting themselves forever adrift from their sympathy, and making themselves always liable to be regarded with distrust, dislike, and often, downright – though, ofttimes, concealed – fear and hate. What wonder, then, that those advanced minds, which in spite of advance, happen still to remain, for the time, ill-regulated, should now and then be goaded into turning round in acts of wanton aggression upon sentiments and opinions now forever left in their rear. Certain it is, that in their earlier stages of advance, especially in youthful minds, as yet untranquilized by long habituation to the world as it inevitably and eternally is; this aggressiveness is almost invariably manifested, and is invariably afterward deplored by themselves. ||

HERMAN MELVILLE, PIERRE OR THE AMBIGUITIES, BOOK IX

The unbearable sound

THE STRANGE CAREER OF MUSICOCLASHES
Denis Laborde

MUSICOCLASH IS A VERSATILE SYNTAGMA. taking the form of an oxymoron or a pleonasm depending on the stakes, the contexts, and the speakers involved. It is so variable that within even a single generation it can target a well-established, stable object, and suddenly turn it into an embarrassing legacy. These different facets of *musicoclash* are, in fact, often synchronous, for polemics is the essence of its being: it is simultaneously perceived by some as an oxymoron, by others as a pleonasm. The idea that iconoclasm may be seen as a virtue enrages the first, who include the dogmatists worried about the normative collapse of the West. These are two contradictory terms, they argue, which will never suffer even a hypothetical alliance. Yet the expression "iconoclastic virtue," which carries such positive connotations as to make it seem pleonastic, has surreptitiously crept into our speaking habits, and we employ it as a form of praise.

In July 2001 at the Festival of Aix-en-Provence the Orchestre de Paris performed Verdi's opera, Falstaff, to great acclaim. In *Le Monde* an article entitled *A "Falstaff" endowed with iconoclastic and refreshing virtues* praised "the virtue that lay in this iconoclastic stripping of the old caricatures to reveal the simultaneously fascinating and dangerous singularity of the 'extraordinary stranger'."[1] This gesture, which stripped down Falstaff and restored his original identity (that is, what today's critics perceive him to be), was seen to possess "iconoclastic virtue." Once it is appended, in its adjectival form, to the substantive "virtue" – which has the effect of neutralising it – the term "iconoclasm" thus becomes equated with truth, purity, and fascination. The two words united in a laudatory pleonasm thus form an entity describing the audacity of a gesture which "stripped the old caricatures," and thereby revitalized a dull festival. Here we have a good example of *musicoclash*. Once the old icon was destroyed, it reappeared in a new garb on the stage of the Théâtre de l'Archevêché. We are back to the starting point, but the perspective has changed; what an odd circle this is!

Musicoclash?

It would be pointless to think too long over the term *musicoclash*. A participant in the dance of neologisms which this exhibition sets in motion, it is an amused echo to the *iconoclash* devised for this occasion by the specialists of the visual image. My *musicoclash* is nothing more than the acoustic version of the visual *iconoclash*; which amounts to saying that it is a welcome notion indeed. In essence it is a gesture – claimed to be musical in nature[2] – which produces disorder inside a system of representation of the world. Whether this disruption is deliberate or not is of little importance, what matters only is that this gesture creates trouble; that a great deal of fuss is made over it; that it is debated; and that it is often heavily, although not always openly, sanctioned. The flood of words concerning it, broadcast in the media or stored in archival deposits, is considerable. Thus Machaut was suspected of heresy, Bach was ostracized from Leipzig's community as early as 1729, the jazz composer Bardo Henning was made responsible for perverting the German national emblems on the occasion of the *Tag der deutschen Einheit* (Day of German Unity) of 1998, the pop singer Serge Gainsbourg was accused of turning the Frenchmen's *La Marseillaise* into "a drug addict's ditty." In late summer 2001, crowds of demonstrators assembled in front of the Bibliothèque Nationale de France to protest against the outlawing of raves; while at the same time closely-fought political debates were shaking the Assemblée Nationale which had set out to devise an "adapted legislation" for techno's musical trances. These are a few instances of *musicoclashes* to be found in this exhibition. One might also add the daring creations of a John Cage or a Carl Michael von Hauswolff, who both explore the moment when music becomes silence; or, in the punk mode of excess and saturation, the Sex Pistols' audacious pieces. These episodes are *musicoclashes* in that they raised debates which exceeded a strictly musical frame.

1

2

_ The claim that an object is a *musicoclash* may be made by the author or it may be attributed to an intention to act by commentators. In both cases, if a musical work affects me to the point of hearing it as a *musicoclash*, then I have activated a function of empathy which makes me react when I listen to it or to the commentaries made about it. I take this particular type of emotional involvement to be aesthetic. Since this aesthetic behavior is intentional, it is artistic, according to a demarcation revived by Gérard Genette. I therefore speak of an artistic rather than of an aesthetic commitment. (Gérard Genette, *L'Œuvre de l'art. La relation esthétique*, Editions du Seuil, Paris, 1997).

_ *Le Monde*, 10 July 2001.

Whether the argumentative strategies drew on religious or artistic, moral or political domains matters little; whether insult, perjury or provocation, outrage or blasphemy were alleged; what matters is that they were discussed. An action must be incriminated and words must incriminate. There can be no clash if the gesture is taken as a pleasant joke. On the contrary, a *musicoclash* may be best recognized by the attentive and sustained censorship it attracts from legislating powers drafted in for the occasion. In all these cases, what is debated when a *musicoclastic* gesture occurs is whether a reference – whether it is religious or artistic, moral or political – may, or may not, be culturally appropriated. These debates question foundational symbols, signs of belonging, and ritual forms which have shaped a shared culture and which are suddenly challenged by the violence of a gesture dissatisfied by the status quo.

This behavior appears repeatedly throughout the centuries and its traces abound in the archives of the Western world. The origins of this recurrent behavior could no doubt be tracked down in the human brain. Paul Churchland[3] or Pascal Boyer[4] could certainly help us locate the seat of this behavioral determinism. But this would imply a close examination of the human genetic inheritance and a different kind of epistemology would be required for this task. This is not my intention here, for I seek to explore not so much the reasons why such iconoclastic gestures take place, but rather to identify the different forms of its recurrence. The *musico-clastic* performance of a piece matters less to me than the way in which it functions. The examples chosen for the exhibition thus all function in similar ways, lending them a "family resemblance" of sorts. This common trait enables me to bring together otherwise hardly comparable musical gestures such as those which appeared in various contexts throughout the history of the West. In all cases, it proved necessary to recover the dynamics of argumentation, to account for the conflict of contentions which turned these "musical objects" into polemi-cal objects. While "iconoclastic virtue" appeared to some as a hydra to be fought at all costs, it represented for others a path leading to human emancipation. These are so many episodes of the battle of oxymoron versus pleonasm.

Should we take sides in this dispute? But then, which gesture should we designate as the iconoclastic one: the artist's, which creates, or the institution's, which forbids? I was in Paris when *Tetras* was created, a piece composed by Iannis Xenakis in 1983 for the Quatuor Arditti. In the chorus of praise which followed the performance, I heard some commentaries: "It is no doubt interesting, but, you see, for me it is not really music." On 13 and 14 October 1997, the *Hebbel Theater* in Berlin programmed fourteen minutes of an opera in progress, *Three Tales* by Steve Reich, one of the "fathers" of minimalist music. I heard the same polite criticisms: "It is an expensive price to pay to hear the same note for a whole evening." On 17 September 1985, in the salle Pleyel, Paris, the orchestra and choir of La Chapelle Royale interpreted the Passion according to Saint Matthew by Johann Sebastian Bach under the direction of Philippe Herreweghe. After an alto aria sung by counter-tenor René Jacobs, a spectator suddenly stood up and left the hall, exclaiming "This is a massacre!" But where was the massacre located? Was it in Herreweghe's and Jacobs' attempt at an historicist interpretation of the piece; or was it in the blanket condemnation without which there would not have been a *musicoclash*?

The Satanic Beat

The violence of the reactions is inevitably proportional to the depth of the offense suffered, that is, of what the *musicoclastic* gesture challenges, be it of a religious or artistic, moral, or political nature. In recent times, Malcolm McLaren and his Sex Pistols brandished punk rock as a banner with which they came banging with rage and obstinacy against all the thresholds of tolerance – religious and acoustic, moral and

4

_ Pascal Boyer, *The Naturalness of Religious Ideas*, University of California Press, Los Angeles, 2000.

3

_ Paul Churchland, *The Engine of Reason, the Seat of the Soul: a Philosophical Journey into the Brain*, The MIT Press, Cambridge, MA, 2000.

political – of their fans. But this punk rock with its incandescent iconoclasm was not only heard by its followers; and many did not remain content with expressing a polite indifference. In fundamentalist Catholic milieu, for instance, these excesses were perceived as bearing the mark of the devil, and as having contaminated all forms derived from rock music. It was up to each individual, therefore, to brandish the sword and combat this blasphemous scourge with all their strength. This, in essence, was the appeal made by the Association Notre-Dame du Pointet in a pamphlet entitled *Rock music, hobby or invitation to satanism?* which it distributed widely in the east of France during the autumn of 2001:

> "In most kinds of music, melody is fundamental; this is not the case for rock music. Rock music is a 'music' (?!) based on a rhythm characterized by the beat, that is, an incessant repetition of pulsations combined with syncopated rhythms, performed by the drummer and the bass […]
>
> The different rhythms of rock music reproduce (and therein lies the greatest danger) the rhythms used by the sorcerers of African tribes and in voodoo rites to exasperate the nervous system and even to paralyze the mental process of consciousness.
>
> Depending on the beat chosen, this or that kind of agitation is obtained, albeit always in the presence of impurity: hence the different kinds of rock music.
>
> Since all forms of rock music are based on sorcerers' rhythms, when we listen to even the mildest kind of rock music, we are listening to witchcraft's ritual of sex, perversion, and revolution, with all the consequences that it entails […]
>
> There is no middle ground. Let us therefore eliminate this 'music', this truly satanic scourge of our homes, of our evenings with friends, of our wedding balls … there is no innocuous rock music. There cannot be any 'Christian' rock music. The beat itself is anti-Christian. Rock music, even when it is soft, oozes indecency and satanism."

Wagner in Jerusalem!

A *musicoclash* can thus feed a moral crusade. But it can also excite the most vivid passions when it questions the religious respect which surrounds our most tenacious taboos. This is what happened on 7 July 2001 when conductor Daniel Barenboïm, at the head of the Berlin Staatskapelle orchestra, offered to play two extracts from *Tristan and Isolde* as an encore to the spectators who had just given a standing ovation to his interpretations of Schumann's *Fourth Symphony* and Stravinsky's *Rite of Spring*. Barenboïm's proposal was met with horrified cries.

"I shouted 'shame on you' very loudly. I think I was the first," said retired Hebrew University Professor Yeshayahu Nir.[5] "No Nazi musicians here!" people screamed after him. "Democracy!" objected others, "if you do not want to listen to Wagner, you can leave the room!" Faced with this explosion emanating from the experience of great suffering, the musicians of the Berlin orchestra, most of them Germans, could barely conceal their discomfort. Then doors banged loudly as some spectators left the hall, choosing to protest by defecting. Daniel Barenboïm directed Wagner in Jerusalem, breaking an ancient taboo.

The headlines of the *Jerusalem Post* on 9 July ran "Wagner encore denounced as 'cultural rape'." Yossi Talgan, the director of the *Israel Festival,* condemned the manner in which this was done: "Sneaking Wagner in through the back door, as it were, is not good manners" *(idem)*. *Le Monde diplomatique* solicited from Edward Saïd a long article which appeared the following October, dealing with democracy, openness, friendship, and art. Just before the concert, on Wednesday, Barenboïm had given a news conference and this news conference was suddenly interrupted by the ring of a

5

_ *Jerusalem Post*, 9 July 2001.

Cornelius Cardew / Treatise / 1963-1967 / detail from the score / © 1970 Hinrichsen Edition, Peters Edition Ltd., Frankfurt, Leipzig, London, New York, p. 160

Cornelius Cardew / Treatise / detail from the score / © 1970 Hinrichsen Edition, Peters Edition Ltd., Frankfurt, Leipzig, London, New York, p. 1

cellular phone set to chime *Die Walkyrie*. "I thought: If it can be heard on the ring of a telephone, why can't it be played in a concert hall?" Barenboïm said.

Showing Sounds?

In the case of music, no three-dimensional object can be supplied for the witnesses to judge. When I evoked these *musicoclashes*, I referred to situations. The *musicoclash* works like an actor-network, but its object is hard to grasp since sounds can never be frozen. Music plays at the moment it is played, incidents happen during its interpretation; condemnation, when it takes place, comes afterwards. Then polemics burst forth and the succession of sounds previously heard is endowed with antagonistic meanings. But, by the time the arguments are exchanged, the sounds themselves have disappeared. How to situate the place, and the timing of the *musicoclash*? It does not lay in the sounds. It does not lay in the concert. Neither does it lay in the antagonistic discourses.

Musicoclash is all of this at once: the composition, the performance, and the condemnation; the work itself, the commentary which comes with it, the coercive measures, and the stances taken toward it. But how can all this be accounted for? I have opted, in most instances, for an acoustic staging of these *musicoclashes*, thanks to the technical team of the ZKM. The sounds in question are heard (in contemporary recordings, it must be said …) at the same time as the texts which manufactured these *musicoclashes* are read. All this mingles in the acoustic space into an artistic and argumentative cacophony which attempts to give an impression of the effect produced by so many disputes.

However, many of the musical works which caused scandals at the time when they were created have since become part of our cultural heritage. They are no longer heard today as the iconoclastic pieces they once were. An effort of the imagination is now required to summon up the *clash*, for a

musicoclash is not a structural property of the piece under attack, it is instead an attributed characteristic. And a characteristic belongs more to the vocabulary employed to describe an object than it belongs to the object itself.[6] I therefore cannot show an iconoclastic music without showing that it was iconoclastic, since a sound does not say anything by itself.

Even if we put the most terrifying sounds through the most sensitive measuring instruments we obtain – be it in the city where Heinrich Hertz (1859-1922) once taught – no more than a curve which reveals nothing of the causes of the *musicoclash*. The spectroscopy of an acoustic wave only shows us what we want it to show. It would be pointless to expect that a kinematics of oscillation or a decibel measurement lead us to a "scientific proof" and help us argue in causal terms. A sound does not say anything by itself. To understand a *musicoclash*, one cannot dispense with the analysis of discourses, the attribution of strategies and of reasons for acting; that is, the identification of a "combination of desires and beliefs."[7] It is impossible to forgo the language of reasons and argue instead in the language of causes. A *musicoclash* only enters peoples' deliberations when musical sequences are discussed, or when opinions are expressed. I have classified the items showcased in this exhibition under three headings – religion, art, and politics – but these are not watertight categories, and they may overlap.

Religion

A characteristic of the relations between the ecclesiastical institution and musical practice which runs through history is the considerable effort of the hierarchy's highest authorities to establish and control a proper usage of sounds. This was effected notably by the solemn resolutions taken by councils for fear of heresy. How indeed could one prevent the devil seeping into our hearts through the medium of music? The fear

7

6

_ Nelson Goodman, *Ways of Worldmaking*, Hackett pub. Co., Indianapolis, 1978.

_ Ruwen Ogien, *Les Causes et les raisons. Philosophie analytique et sciences humaines*, Editions Jacqueline Chambon, Nîmes, 1995, p. 35.

was so great that Saint Jerome, and with him most liturgists, suggested that the medium be altogether banned. After all, God was pleased neither by the voice nor by the melody, but by the purity of the intentions. This suggestion may have reassured those who sang out of tune: as long as their intentions were pure, they would go to heaven. But this could also lead to a more radical stance: if intention was all that was necessary, why not proscribe liturgical singing? Why bother with sounds in the first place? The Fathers of the desert themselves had affirmed that a communion of intentions was sufficient. The question was serious enough to warrant attention from the most brilliant minds of the time, from Saint Augustine to John XXII, through to Boetius and Saint Ambrose. This exhibition displays some of the suggestions and resolutions made over the centuries. But first of all, let us pause and examine a mysterious interval, long believed to have possessed diabolic powers.

Diabolus in Musica

From the early days of medieval polyphony, theoreticians of music were preoccupied by a particular interval, intrigued as they were by the position it occupied between two "naturally perfect" intervals: the perfect fourth (two tones and half a diatonic tone) and the perfect fifth (three tones and half a diatonic tone). Between these two "naturally perfect" intervals appeared an unbearable dissonance: three tones, or the tritone (F-B). It is an augmented fourth or a diminished fifth, whichever way one wishes to see it, but it is in any case neither a perfect fourth nor a perfect fifth. How could such an interval fail to attract the attention of the nomothetes? It was suspected by them of being a foreign body in the natural harmony of sounds; suspected of weakening our vigilance and our powers of organisation. Hagiograph and musician Hucbald de Saint Amand (c. 840-930) identified this interval early on as *diabolus in musica*.

Anonymous / Danza macabra [Dance of Death] / S. Vigilio, Pinzolo (Trento), Italy / 1539 / frescoes / from: http://utenti.tripod.it/antrona

This strange interval was not only a mark of the devil, it was the devil itself. As such, it was therefore banned from all forms of Gregorian chant, later also from polyphonic organum and from the twelfth century *ars antica*. In liturgy it was carefully avoided, fought with determination, and painstakingly chased away. But while the Church spent so much energy to thwart its nefarious influence, the common folk reveled in it, defiantly singing songs about defrocked monks, notably in Carinthia in the eleventh century, in Tyrol, and in Bavaria, where they were referred to as *Carmina Burana*.[8] These songs constituted the common repertoire of vagrants and goliards, of outlawed clerics and scholars who drifted from town to town, leading a life of drinking, feasting, gaming, idleness, and prostitution; all this at the very time when urban space was in the process of structuring and enclosing itself. In the profusion of *Carmina Burana* which populate this exhibition, here is for instance the *Sic mea fata canendo dolo* interpreted by the Clementic Consort. In this piece tritones proliferate.

Leaving the margins, the *diabolus in musica* thus became integrated into the common references of our music. Its referential function was soon employed for the needs of musical rhetorics. We will see later that when Bach composed his Saint Matthew Passion, he made use of the melodic tritone as a rhetorical tool. The tritone thus progressively lost its

8

_ The name derives from the convent in which these manuscripts were discovered in 1803, at the time when Bavaria's convents were secularized.

Hartmann Schedel / Liber chronicarum / 1493 / CCLXI /
from: Hartmann Schedel, Weltchronik von 1493, Stephan Füssel (ed.), Taschen, Köln, 2001

former ghastly symbolic connotations. No longer the devil itself, this interval became an allegory. No one was surprised to find the devil tuning his violin to a tritone interval, *diabolus in musica*, in Camille Saint-Saëns' *Danse Macabre* (1874). It played there the role of a *leitmotif*, which took on the function of a commonly shared reference. In a "Dance of Death," such a reference is not surprising. The *diabolus in musica* is recognised by everybody, but it has shed its frightening literal meaning to become a mere reference to it, intended to operate in a familiar narrative. It is no longer an icon. Or is it?

The Passageway of Charivari

Carmina Burana proliferate here. An aggressive and burlesque cacophony of enormous proportions will be found in the passageway at the entrance of the exhibition. Here, each visitor will simultaneously hear the melismas of the Apocrypha's Greek Sibyl announcing the Coming of Christ (Eusebius of Caesarea, third century C.E.); psalms of the Milanese Church sung following Saint Ambrose's precepts "according to the customs of Oriental regions;" alleluias of the Roman Church of the seventh and ninth centuries; musical pieces by troubadours and Minnesänger, minstrels and jugglers; commentaries of treatises by the Fathers of the Church; Papal bulls, etc. For indeed, the Church attempted to solve the troublesome tension inherent in music, intended as an incentive to pray, but which could equally elicit emotions. Was it possible to pay attention to the words sung without being affected by the pleasure of singing? This was the crucial problem to be solved, if any answer other than a simple *flatus vocis* was to be brought to theophany. Saint Augustine summed up this tension in his *Confessions*:

> "Thus I vacillate between dangerous pleasure and healthful exercise. I am inclined – though I pronounce no irrevocable opinion on the subject – to approve of the use of singing in the church, so that by the delights of the ear the weaker minds may be stimulated to a devotional mood. Yet when it happens that I am more moved by the singing than by what is sung, I confess myself to have sinned wickedly, and then I would rather not have heard the singing."[9]

The task of the legislator therefore consisted of a relentless effort to repress such disruptive pleasures. This applied, it must be noted, to vocal, and not to instrumental music. Plainsong was a purely vocal music to which a tight ecclesiastical discipline applied, as opposed to profane instrumental music. As Saint Ambrose (340-397 AD) unambiguously stated, instruments were inherently sinful:

> *"Hymni discuntur et tu citharem tenes! Psalmi canuntur, et tu psalterium sonas aut tympanum! Merito vae, qui salutem negligis, mortem eligis* (During the recitation of the hymns, you hold a cithara! During the singing of the psalms, you play psalterion or drums! This is really contemptible, for in neglecting salvation, you choose death.)"[10]

Not unlike our latter-day Sex Pistols, jugglers and minstrels were identified as "Satan's ministers," working on behalf of the demon. They were accordingly disgraced by Charlemagne and ostrazised by the Church. Henri d'Autun thus inquired,

> "May a juggler hope for eternal life?
> … to which he replied:
> Certainly not, for they are all ministers of the Devil."[11]

In the thirteenth century, Berthold von Regensburg (1210-1272) described minstrels as so many "tiuvels blâsbelge," or devil's bagpipes (*Predigten* I:319). What kind of legitimacy could a profane music thus hope for, if it was performed by such *ministers*? None at all. In 1229, the Council of Paris set out the principles according to which heresy was to be fought. Among others, churchmen were forbidden to keep minstrels.

10 9 11

_Latin Patrology 14:716

_ Latin Patrology 172:1148

_ Confessions, Book X, chapter XXXIII.
See http://www.ccel.org/a/augustine/confessions/confessions_enchiridion.txt [translation by A. C. Outler].

Legislation was therefore the institution's preferred weapon, but it was not the only one. How indeed, could it afford not to enroll the power of images?

Iconography on the subject abounds, since everybody could *observe* for themselves the deviant behavior and the risks taken by these musicians of the devil. In 1310, Gervais du Bus wrote his *Roman de Fauvel*, a novel about a horse-shaped demon whose name was made up from the initials of the sins he embodied – Flattery, Avarice, Usury, Vileness, Envy, Cowardice (in French *Lacheté*). The manuscript's illustrations abound with representations of scenes of excess when a charivari is evoked, or the marriage of Fauvel with Vain Glory. Jugglers and minstrels were associated with all the representations of Dances of Death, as in this illustration by Hartmann Schedel in his *Weltchronik* of 1493. In Hildegard von Bingen's *Book of Prayers*, the devil's head comes out of the mouth of an oboe. Such representations appeared not only in manuscripts. They were also inscribed on the capitals of churches (e.g., in Vezelay, France), on their porticoes (Marienkirche, Berlin), or on walls, for instance in the famous Danse Macabre shown in the church of San Vigilio in Pinzolo, Italy. To these examples might be added the well-known paintings of Hieronymus Bosch (c.1453-1516), such as *The Concert in the Egg*.

Ars Nova

Should we be surprised to find that such legislative obstinacy was a recurring tendency of the oldest institution of our Western societies? As soon as a daring new musical style came knocking on the churches' doors, the institution responded by producing a body of prescriptions aimed to protect it from heresy. With time, what was once daring began to subtly permeate our day-to-day habits and became a part of them. In the early fourteenth century, the Church was shaken by deep crises, including the clampdown of the Order of the Templars, the Great Western Schism, and the Pope's move to Avignon.

On the musical level, progress in graphical notation resulted in a more complicated combinatory of sounds. *Ars nova* was originally the title of a treatise of musical notation published by Philippe de Vitry (1291-1361), who was to become Bishop of Meaux. This progress in graphics in turn led to a whole new system of composition. The tenor which had previously buttressed the *motet antique* disappeared, becoming only one among many other elements of an increasingly complex polyphony. Soon enough, the whole body of precepts of the *ars antiqua* came under threat, a system which had been brought to such a level of perfection at the end of the thirteenth century by Léonin and Perotin that it was believed to enable the construction of the most respectable acoustic architecture for God's glory.

Contesting the monotonous nature of its uniform modes, and the excessively restrictive principle of isorhythm, Guillaume de Machaut set out to subvert the rules of *ars antiqua*. He introduced playful syncopations and ataxic hoquets into his profane music but also in his Mass of Notre Dame. The tenor voice was from now on to be absorbed into polyphony. Rhythms were inextricably jumbled together, and double leading tone cadences proliferated. How long would the Church tolerate this slow drift of musical practices away from the basic rules of composition which structured the *ars antiqua* for which it was responsible? Pope John XXII finally issued a bull in 1324-1325, *Docta sanctorum*.

In the first place, the learned authority reiterated a few elementary rules of musical enunciation:

> "[If] psalmody was ordered in God's church, it was to excite the devotion of the believers […] But a number of disciples of a new school who fuss with the measuring of the tempora, aim at new notes, prefer to invent their own music rather than sing the old; church music is sung in semibreves and minimae pierced with these little notes. For they cut up melodies with hoquets, smoothe them with descants, sometimes force upon

them vulgar tripla and moteti, which leads them sometimes to look down upon the foundations of the antiphonary and of the gradual, and to ignore what they are building upon; to ignore, if not to confuse, the tones they fail to distinguish, since the multitude of their notes obscures the decent ascents and tempered descents of plainsong, in which the tones distinguish themselves from each other. They run without resting, they inebriate our ears instead of relieving them; they mimic by gestures what they wish others to hear, with the consequence that they spurn the devotion they should have sought and instead they display publicly a want of mastery which should have been avoided."[12]

Everywhere the same jurisprudent effort was made, the same concern to repress acoustic pleasure and to put a halt to the incessant slipping of the norms. Yet, once the body of prescriptions had been clearly established, once the doctrine had been reasserted with great strength and pomp, nothing prevented yesterday's audacious gestures, once condemned, proscribed, and repressed, to become part of today's ways of doing. Machaut, for one, ended his life endowed with a canonicate in Rheims, part of the benefit of clergy bestowed upon him by Pope John XXII.

Other condemnations were issued against other offenses, which required other councils, such as that which took place in Trent to deal with the reformation, summoned three times between 1545 and 1563 by Pope Paul III on Charles V's initiative. Other judgements were made throughout history, including that which Michael Praetorius (c. 1571-1621), the cantor of Wolfenbüttel, placed as an epigraph to his *Polyhymnia Caduceatrix* (1619):

> "Wiehen und Bellen, Myern und Scheyen, mit Zeen Klappen, heulen und bellen, die elende schreckliche Music von Zettergeschrey der hellischen heissen Capell."[13]

The world of reformation did not escape the legislating determination of the powers in charge of administering services, causing much trouble to one of our latter-day heroes, Johann Sebastian Bach.

A Sacrilegious Johann Sebastian Bach?

When he arrived in Leipzig in the spring of 1723, Bach was preceded by a dubious reputation. This is suggested by three clues. First, he was grudgingly recruited at the end of an exceptionally long procedure (nearly a year) and only because Leipzig's favorite candidate, Telemann, had refused to leave Hamburg. Further, Bach was made to sign a contract of fourteen points which defined his tasks as well as the features of service music. Finally, the resolutions adopted by the successive consistories which had previously employed him contained numerous reprimands, for instance in Arnstadt. Bach was then 21 years old, he had just been recruited and he was already summoned, accused of modulating unremittingly, preventing the believers from concentrating on the words of the service. On 21 February 1706, the consistory repeated its warning:

> "We blame him for having recently introduced a number of surprising *variationes* into the accompaniment of the chorale, to have peppered melodies with alien sounds, and to have thus troubled the community of the believers. If he wishes in the future to introduce a *tonum peregrinum*, he will have to continue on this same tone, and to avoid moving rapidly to another, or even, as he has recently done, to go to the extent of proposing a *tonum contrarium*."[14]

Having heard of such decisions, Leipzig's consistory and council understandably took the precaution of making Bach ratify a contract on 5 May 1723, whose seventh point read:

13

12

14

_ BDII, 16

_ "Braying and barking, mewing and squealing, chattering of teeth, this sad dreadful music of painful cries of Hell's incandescent choir."

_ This passage is translated from Klaus Stichweh's rendering of a text by Amédée Gastoué (1987).

"7° to contribute to the maintenance of good order in the churches, I will arrange the music in such a way that it shall not last too long, that it shall be of such a nature as not to seem to belong to a theater *(opernhaftig)*, but that it shall rather inspire its listeners to piety."[15]

Six years later, on 15 April 1729, Good Friday, at one o'clock in the afternoon, Leipzig's believers came to St. Thomas' church, not to listen to a concert, but to attend vespers. The church was full and the assembly started singing the chorale *Da Jesus an dem Kreuze stund* (Then Jesus was crucified), which opened the liturgical service.

At this point what became the "Bach" Passion began, whose opening chorus is a solemn *via crucis* displaying an - unheard-of acoustic architecture: E minor, slow meter 12/8. Both orchestras, both organs sounded in unison. The believers were in the center of the nave. The choir members were split into three groups; near the altar, supported by the orchestra, the first group sang in a double fugue in four voices the words of the Daughter of Sion: "Kommt, ihr Töchter, helft mir klagen. Sehet den Bräutigam. Seht ihn als ein Lamm !" (Come ye daughters, share my mourning. See Him! The Bridegroom Christ. See Him! A spotless Lamb). The bass persevered on the rhythm of a slow dance. At the back of the church, at the other end of the central nave, a second choral group responded to this appeal: "Wen? Wie? Was? Wohin?" (Whom? How? What? Look where?). Above this dialogue, the youngest pupils of the *Thomasschule* constituted a choir *in ripieni* which sang in unison the chorale *O Lamm Gottes, unschuldig am Stamm des Kreuzes geschlachtet* (O Lamb of God unspotted, there slaughtered on the cross). The assembly joined in. This opening chorus lasted by itself nearly ten minutes. It announced the evangelical narrative: The Last Supper (Mat. 26:1 -35) and the Arrest of Jesus (Mat. 26:36-56). Recitatives alternated with crowd choruses, chorales, and arias. After the figured chorale

O Mensch bewein dein' Sünde groß (O man, thy heavy sin lament) which concluded this first part in the same way it began, the assembly struck up the chorale *Herr Jesus Christ, dich zu uns wend*. Surrounded by silence, the priest, Christian Weiss, ascended the pulpit. Each attendant paid careful attention to his sermon.

At the end of the sermon, both orchestras and the two choirs prepared for the double interrogation of Jesus, first by Caiaphas (Mat. 26:57-75), and later by Pilate (Mat. 27:1-30). Recitatives, arias, crowd choruses, and chorales succeeded each other once again. Guilty of blasphemy for having proclaimed himself Son of God, Jesus was condemned to death by the Sanhedrim presided by Caiaphas. Pontius Pilate, Roman governor of Judea (who was far from suspecting what this insignificant episode of local life would signify for the destiny of the world), confirmed on appeal the verdict of Palestine's High Court of Justice. Jesus was to be crucified, such was the destiny reserved to heretical agitators. The sentence was executed (Mat. 27:31-50) after the judgement was pronounced, the burial (Mat. 27:51-66) succeeded the crucifixion. Bach's *Saint Matthew Passion* ended on the word "Ruh" (rest) with a chorus in C minor. Vespers were not yet over.

The assembly started singing Jacobus Gallus' motet *Ecce Quomodo moritur* followed by a psalmody of the verses of the passion. Only after the priest's orison did the believers take leave by singing the chorale *Nun danket alle Gott*. Given that the performance of Bach's composition takes approximately three hours, the whole religious ceremony must have lasted four hours, or a whole afternoon. And this despite Bach's promise to keep his pieces short. We have seen above that the seventh point of his contract specified that he would "contribute to the maintenance of good order in the churches, [...] arrange the music in such a way that it shall not last too long." Should one see this as a provocation?

Worse still, the second part of this seventh point obliged Bach to compose service music that "shall be of such a nature

15

_ BD I, 92

as not to seem to belong to a theater *(opernhaftig)*, but that it shall rather inspire its listeners to piety." Yet, what did Bach do, at the moment when Jesus, betrayed by Judas, was arrested in the night of Thursday to Friday by a riotous mob of guardians of the Temple?

He reunited both choirs in a double fugue, on a tempo *vivace* at 3/8, a rare metre. Both choirs wanted to get the best of Judas. They hailed the divine power: may it open a blazing abyss to engulf the traitor! The rhythmic accents exaggerated the first syllable of the words articulated on a ruthless ternary metre: "Sind BLITzen, sind DONner in WOLken verSCWUNden?" *(Have lightning and thunder their fury forgotten?)*. The continuo was embroiled in a sinister battery of semiquavers. From one end of the nave to the other, both choirs echoed in response to each other, the successive entries increased fourth by fourth, the words "Blitze" and "Donner" were spelled out in the stretto by the two choirs at a quaver's interval. The *arsis* became general, the semiquavers proliferated, and suddenly, on the word "Blut" (blood), there was silence. "The dramatic effect is of an extraordinary power: thunder has struck, the universe is struck with surprise."[16] Was Bach not taking the risk of going over the top? Instead, he insisted.

Jesus was now in the position of the accused before the Sanhedrim. As president Caiaphas accused him of blasphemy, He sang alone. The orchestra which had just accompanied Jesus' arioso recitative had become quiet. The continuo itself became silent. Struggling with the difficult intonations of the melodic line, Caiaphas sang a capella, threw in the word "Gotteslästerung" (Blasphemy) on an interval of a diminished fifth, this famous tritone, *diabolus in musica* (see above). As the *turba* requested the death of Jesus, the eight voices of the choir replied to each other in bundles of dissonances: G-G sharp, F-F sharp, E-E flat, B flat-B. As it proposed that Barrabas be liberated, it spelled out his name with strength on a diminished 7 chord, despite the treatises' recommendations that each 7 chord should be prepared, since

it is a dissonance. For the crucifixion of Jesus, a fugue in four voices was sung, whose subject gave a series of tritones to hear. *Diaboli* proliferated in this passage, rhythmed by syncopations and doubled with chromatic movements; so many dispositions unanimously condemned by the treatises on "Geistliche Musik." These dissonances would leave lasting memories.

The events which took place on this Friday 15 April 1729 in Leipzig's Saint Thomas Church were only made public a few years later, in 1732, when Christian Gerber published his precious *Histoire des cérémonies religieuses de Saxe*. In the clamor of the two orchestras playing at both ends of the nave, in the chaos of the two choirs responding to each other in waves of dissonances, while in the center the congregation struck up their Lutheran chorales, one believer was becoming irate. Christian Gerber saw her stand up suddenly and leave the church, crying out: "Behüte Gott ihr Kinder! Ist es doch, als ob man in einer Opera oder Comödie wäre."[17]

This time, Bach had overstepped the mark. By composing a musical work for a spectacle rather than for a Good Friday service, he had deliberately broken with the second part of his contract's seventh point: not to compose anything which might resemble opera music. Under the pretense of composing a musical piece for the Passion, he let effusion, that is, confusion, take hold of the believers' hearts. In short, he brought opera into Saint-Thomas. The scourge had been thought to be moribund. Ever since the bankruptcy of the Opernhaus in 1723, the works of darkness (as opera was still referred to) had seemingly been forever barred from the city.[18] Yet, with the initiative of a disrespectful cantor, they had made a spectacular return in the very heart of the sanctuary. Would there be a "Bach affair" in Lutheran Leipzig, itself under the tutelage of the (very) Catholic court of Dresden, capital of the Electorate of Saxony?

In the end there was no Bach affair, but instead a formidable mechanism of disqualification unfolded. The measures taken against him between Easter 1729 and 1730

16 17 18

_ Jacques Chailly, *Les Passions de Johann Sebastian Bach*,
PUF, Paris, 1963, p. 333.

_ May God protect your children! It is as though one were at an opera or a comedy.
God safeguard your children, for it is as if we were in an opera or a comedy (Gerber, 1732, p. 284).

_ At least in the pietist strand, which drew its arguments from the *Pia Desideria*, published in 1675
by Philipp Jacob Spener. In 1682 Anton Reiser, pastor of Hamburg's Sankt Jacobi church, published
his acrimonius treatise, *Theatromania, oder die Werke der Finsternis in denen öffentlichen Schauspielen*.
To this came in response a playful Theatrophania, published in 1683 by Catholic actor Christoph Rauch:
Theatrophania, entgegen gesetzt der so genannten Schrift.

speak by themselves: Bach was no longer allowed to choose the chorales to be sung at office (the task being taken over by the predicator), the number of competent pupils in the choirs of Saint-Thomas would be reduced, while their contribution to musical service was extended to five churches, the recruitment of instrumentalists for the orchestra would become exceptional, and the cantor's salary was reduced.

Bach protested, addressing to the *Communal Council* on 23 August 1730 a "[b]rief but indispensable presentation of what should be understood under well-ordered church music, with a few modest considerations on its decadence" (BD I, 22). Without a reply, he attempted in vain to leave Leipzig. He thus remained, but from then on refused to compose for services. This is exactly what was expected from him: that he conscientiously fulfill his responsibilities as teacher and as cantor and that he stop composing for good. All the causes for the conflict between Bach and Leipzig converged towards the same point: the control of services music. For indeed, to exercise mastery over cultural utterance signified nothing less than to manage the representations of the divine Word. The stakes were not small in the framework of Lutheran theology, a theology of the word, in which the ministry's sole task was to serve God's word.

This was the cause of the *musicoclash* of 15 April 1729 in Leipzig. The sound of words had concealed the divine Word. Where a memory of service had raised a ritual utterance to the status of a tradition, Bach created a rupture, he introduced something unexpected. He surprised and upset; his manner of saying was shocking. The emotional sway of his music disrupted the requisite ascetic attitude on this Friday of contrition. How then could Bach not be suspected of deliberately causing trouble, or, which amounts to the same, of contesting the consistory's power by making his Passion according to Saint Matthew an offensive and playful parody?

Art

Could it be that we are prisoners of our idols, slaves of our icons, and hostages of our heroes? Let us now return to the "iconoclastic virtue" in its pleonastic sense. Our conception of history has shaped our perception of this world of art endowed with aesthetic sacrality. From the Western perspective, the whole history of art – meaning here, music – appears as the exhilarating account of the great battle fought by the leaders of an "art liberation movement" against the necrophagous, conservative forces of society. In this struggle, artists swear by progress only, pouring scorn on all the rest: "The musician who has not felt for himself – and by this I do not mean understood, but felt – the necessity of dodecaphonic language is USELESS; for this signifies that his whole work falls short of meeting the requirements of his times."[19] In this history, every artist has to innovate in order to become a hero.[20] Yet there can be no innovation without risk, nothing new will be created without audacity, and audacity, in order to be rewarded, requires from the artist that he or she claims to be the starting point of a new story. "If contemporary music continues to change in the direction in which I am changing it, an increasingly tangible liberation of the sounds will be achieved."[21] In this perspective, iconoclasm is so closely connected with innovation that it becomes its semantic equivalent. It thereby acquires such an advantageous reputation as to make it a virtue, while simultaneously thrusting the creator into the avant-garde. "One might say that in the future, music will become spatial music. It is, to a large extent, already so in my work."[22] Our histories of music are filled with emblematic figures made into so many *incipits*: Guillaume de Machaut, Claudio Monteverdi, Johann Sebastian Bach, Wolfgang Amadeus Mozart, Ludwig van Beethoven, Claude Debussy, Arnold Schoenberg. Every one of these sanctified names represents the success of a daring idea; it is the result of a gradual acceptance of an iconoclastic behavior into our

20 21 22 19

_ Pierre Boulez, *Penser la musique aujourd'hui*, Denoël – Gonthier, Paris, 2000, p. 149.

_ This point of view was put forward by François Flahaut and Jean-Marie Schaeffer in an issue of the magazine *Communications* that attracted a lot of attention. It is astonishing that music is not mentioned in this important issue devoted to artistic creation. François Flahaut, Jean-Marie Schaeffer, La Création, in *Communications*, 64, Le Seuil / Eheless, Paris, 1997, p. 64.

_ John Cage, *Silence*, Denoël, Paris, 1970, p. 115.

_ Karlheinz Stockhausen, De l'Evolution de la musique, in Cécile Gilly and Claude Samuel, *Acanthes An XV. Composer, enseigner, jouer la musique d'aujourd'hui*, Editions Van de Velde, Fondettes, 1991, p. 23.

John Cage / Water Music / 1952 / © Edition Peters, Frankfurt, Leipzig, London, New York

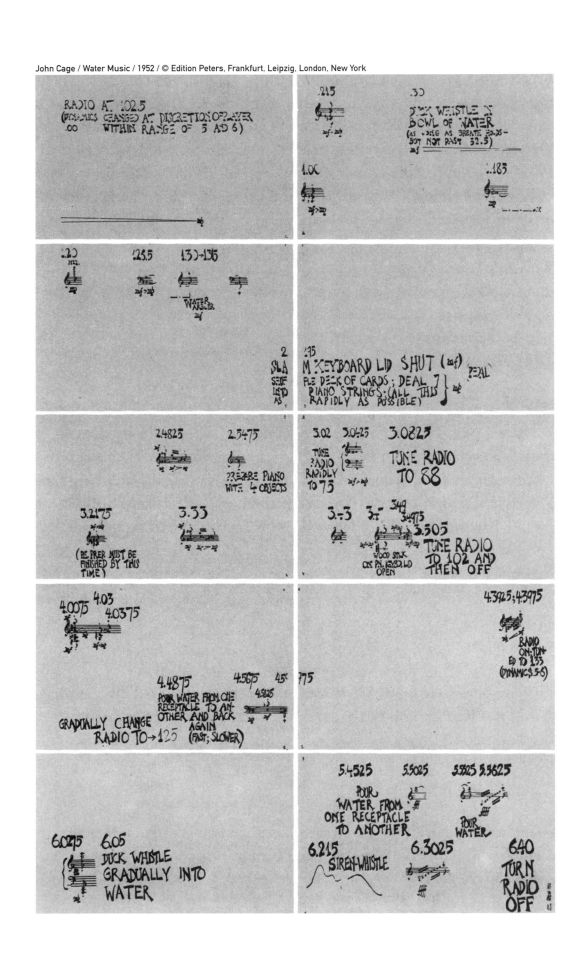

common way of perceiving the world of sounds. It is in other words a "legitimated deviance"[23] which takes place within a category perceived by all as a possible occurence of the predicate "work of art."[24] Only then does the artist get credit – albeit belatedly, since we still operate within a jurisprudential system – for having opened prospects to the future itself. The artist takes on here the role of a demiurge: "I speak and contemporary music changes."[25] In the course of this exhibition, we will meet some of these demiurgic heroes, each of whom was the source of a *musicoclash*. Let us begin with a few *musicosplashes*.

Musicosplashes (Water Musics)

In a city as centered on its waterfront as London is, *Water Music* has long been a recognized musical genre. In summer 1717, King George I decided to go sailing on the Thames. To accompany him, George Frideric Händel composed a serenade similar to the ones he had written for the open-air concerts in the gardens of Vauxhall, Marylebone, or Ranelagh. Could he have suspected that his *Water Music* would travel down the ages, that it would be enrolled by twentieth century creators to support their most daring undertakings? Sumptuous boats sailed to the music of instruments made to float for this occasion. The only risk there had to do with fluvial navigation, not with the music itself, which was destined for celebration and pomp. *Water Music* by Händel would become established as an inalienable reference to the Western classical repertoire. Any attempt to alter it would be interpreted as a *musicoclash*, a situation John Cage took advantage of when he set out in 1952 to restore the original meaning of the piece's title.

Cage composed his own *Water Music*, but this time, "unlike Händel's, it really splashes," he confided in a letter to the musicologist Nicolas Slonimsky.[26] The work was composed for a pianist using, along with his instrument, a radio, whistles, vessels filled with water, and a pack of cards. There was no musical citation of Händel in the piece or any explicit references to it save for its title, *Water Music*. The title itself carried a very different semantic meaning than Händel's, since it announced a radical musical program. John Cage introduced sounds into Western music that had until then remained foreign to it. A "new music" was born from this *musicoclash* which set its author in a liminal position. As early as 1937, he had composed with water *The Future of Music Credo*. With *Water Music*, water became a percussion instrument, paving the way for more experiments. In 1958, Cage returned to the theme of water with *Water Walk*, a piece for Solo Television Performer composed for piano, radios, and auxiliary sources of sound. Composers on the search for uncharted acoustic spaces started experimenting with the theme of water. In this period, the form of performance known as "happening" became popular among musicians, actors, and painters, and thereby encouraged the merging of different art forms. In 1964, artist Mieko Shiomi composed another *Water Music*: 1. Give the water still form. 2. Let the water lose its still form. In this work, she devised a new way of using water in her own creations:

> "A record is covered with any water soluble material, such as clay or water soluble glue, etc. Play the record on a record player and drop a small amount of water over the record. The needle will pick up music from spots dissolved by water. Adjust quantity and location of water to obtain desired pattern of music and non-music."

Beyond the *musicosplashes*, the fusion of artistic practices on the theater's stage signified a profound change. It became impossible to distinguish music from plastic art: theatre became the eponymous form of artistic commitment. Around the same period, Yoko Ono combined music and plastic art in her *Waterdrop painting*:

24 23 25 26

_ Cage, op. cit., p. 135.

_ David Revill, *Roaring Silence*, Arcade, New York, 1992, p. 160.

_ Howard Becker, Outsiders. *Etudes de sociologie de la déviance*, Editions Métaillié, Paris, 1985.

_ Jean-Marie Schaeffer, *Les Célibataires de l'art. Pour une esthétique sans mythes*, Editions Gallimard, Paris, 1994.

John Cage / 4'33" / 1960 / score for any instrument or combination of instruments /
© 1960 Hemmar Press Inc., New York / © Edition Peters, Frankfurt, Leipzig, London, New York

NOTE: THE TITLE OF THIS WORK IS THE TOTAL LENGTH IN MINUTES AND SECONDS OF ITS PERFORMANCE. AT WOODSTOCK, N.Y., AUGUST 29, 1952, THE TITLE WAS 4'33" AND THE THREE PARTS WERE 33", 2'40", AND 1'20". IT WAS PERFORMED BY DAVID TUDOR, PIANIST, WHO INDICATED THE BEGINNINGS OF PARTS BY CLOSING, THE ENDINGS BY OPENING, THE KEYBOARD LID. AFTER THE WOODSTOCK PERFORMANCE, A COPY IN PROPORTIONAL NOTATION WAS MADE FOR IRWIN KREMEN. IN IT THE TIMELENGTHS OF THE MOVEMENTS WERE 30", 2'23", AND 1'40". HOWEVER, THE WORK MAY BE PERFORMED BY ANY INSTRUMENTALIST(S) AND THE MOVEMENTS MAY LAST ANY LENGTHS OF TIME.

FOR IRWIN KREMEN

I

TACET

II

TACET

III

TACET

"Let water drop.
Place a stone under it.
The painting ends when a hole is drilled
In the stone with the drops.
You may change the frequency of the waterdrop to
your taste
You may use beer, wine, ink, blood, etc.
Instead of water.
You may use typewriter, shoes, dress, etc.
Instead of stone."[27]

27

_ 1961, autumn.

Silence (the Sound of the Avant-garde)

These *musicosplashes* created an effect because they introduced a secular element into the sanctuary of artistic performance. But the most radical *musicosplash* of all was the one that destroyed the icon by reducing music to silence. In 1952, Cage entered Bruno Latour's category of the " 'A' people."[28]

One year earlier, John Cage had drawn precepts of musical composition from the *I Ching*, the book of Taoist prophecies. His idea was to make the unpredictable delivery

28

_ See Bruno Latour's essay in this catalog.

of sounds a new style of musical composition. His programmatic intention was made clear in the title: *Music of Changes* (1951). He continued experimenting with *Imaginary Landscape 4*, a piece composed for twelve radio receivers, which aimed to dissolve the notion of a work of art in a network of interactions whose development could not be predicted in advance. With this attitude, Cage intended to relativize the nomological importance of the score. It was not until 1952, however, that Cage produced *4'33"*, a radical gesture now remembered in all histories of music.

The piece *4'33"* is a solo intended – as the score specified – "to be performed in any way and by anyone." The work is divided into three movements: I, II, III. Under each of these numbers, which figure at the top of the score, the author has written TACET, silence. The score was performed for the first time in Woodstock, New York, on 29 August 1952 by the pianist David Tudor. It did not have a title at the time. On stage, the pianist remained silent for 33 seconds in the first movement, 2 minutes 40 seconds in the second movement, and 1 minute 20 seconds in the third movement, which explains the title *4'33"*. The work was largely perceived as a hoax, and was greeted as a "post-modern joke." Yet, this gesture eventually created a following of its own. Below are the full instructions:

"In a device equipped with maximum amplification (no feedback) perform a disciplined action. With a few interruptions. While establishing total or partial links with the others. There should not be two interpretations of the same action, this action should not either be the performance of a 'musical' composition. The first performance was the writing of this manuscript (first inscription only)."

Although this work has become a reference, there exists to this day no available recording of it. Here again, the composer took on the role of the trend-setter. Once Cage's piece had become established as a foundational gesture, all related gestures were judged by reference to it. This was the "minimalist gesture" *par excellence* and even the four path-breaking American minimalists – La Monte Young, Terry Riley, Steve Reich, and Philip Glass – could not surpass it. Examples of pieces inspired by Cage's gesture which feature in this exhibition include Carl Michael von Hauswolff's *abstract model for something that, in Intervals, Occurs all the time* which challenges our ability to stay awake. Central to this piece is, of course, the interval. This is also the case in Keith Humble's *Nunique* cycle (1968-1995), which includes *The Anonymous Butchery*:

THE ANONYMOUS BUTCHERY
For a large number of people.
Material: Each person has a large piece of white paper.
Duration: 15".
Everybody slowly hides their faces behind the paper.
They delicately shake the paper – no sounds!
They drop the paper all together.

Karlheinz Stockhausen also contributed to this new exploratory movement. In his cycle *Aus den sieben Tagen* (1968), he composed *Illimité* in response to the Taoist philosophies summoned by Cage in *4'33"*. Here is the score:

"Play a sound being certain that you have all the time and all the space."

The idea of relegating musical theory probably made students of music academies rejoice, but not everyone was pleased. This kind of "score" created problems, notably in the Bibliothèque Nationale de France, where archivists wondered whether this manuscript belonged in the "scores" file or in the "literature" one. This was such a serious dilemma that the correspondence between the curator and the publisher Otto Harrassowitz from Wiesbaden can be found inserted in the score *(cote 8° Vm Pièce 997)* kept in the Bibliothèque Nationale's Département de la Musique. Its *Post Scriptum* reads:

"P.S.: With regards to Stockhausen's *Aus den sieben Tagen*, does this work include music? Our edition includes only literary texts."

Otto Harrassowitz made inquiries with Stockhausen and replied to the curator:

"There is no musical notation for this piece which is meant to be interpreted only on the basis of the explanations given by M. Stockhausen in the edition you possess."

John Cage / Variations I: Extra Materials / 1958 / the score / © 1960 Hemmar Press Inc., New York / © Edition Peters, Frankfurt, Leipzig, London, New York

This is why, in the *Stockhausen* file of the Bibliothèque Nationale, *Aus den sieben Tagen* is classified as belonging not with the "musical works" but with the "literary texts" of the composer. The disappearance of musical writing had resulted in the removal of the piece from the scores file.

This disappearance of musical writing is precisely what Earle Brown blamed Cage and Stockhausen for, before he proposed his own *musicoclastic* approach, whose argument was closely akin to that of Morton Feldman, considered to be the "father" of the graphic score. According to them, each composer should make their graphic transcription more ambiguous in order to favor *in situ* actions. Brown thus composed *December 52,* whose score includes no conventional sign and which remains a mystery to this day. He was careful not to give any clues for its interpretation. It is the interpreter's task to give meaning to these signs and, guided by intuition,

Earle Brown / December 52 / 1952 / detail from the score / © Edition Peters, Frankfurt, Leipzig, London, New York

to put them into music. Brown upheld the roles and the functions of the actors of the musical drama, but he modified the link between them so as to bring about unexpected acoustic events. The signs he traced are so many challenges to the creative imagination. The composer is only the catalyst of a collective commitment, the work does not belong to him or her anymore as he or she is no longer its author, but only its origin. The same can be said of Morton Feldman with regard to his work for piano, *Intersection III* (1953), or *Projection 4*, for piano and violin (1951). These are enigmatic scores, in which the role of the composer is similarly undermined, and which favor the work's realization *in situ*. Many examples of this approach can be found in this exhibition, including Mauricio Kagel's *Diaphonie*, Dieter Schnebel's *Mo-No, musique à lire*, Christian Wolff's *For 1, 2 or 3 People*, Cornelius Cardew's *Treatise*, Louis Roquin's *Come Battuto*,

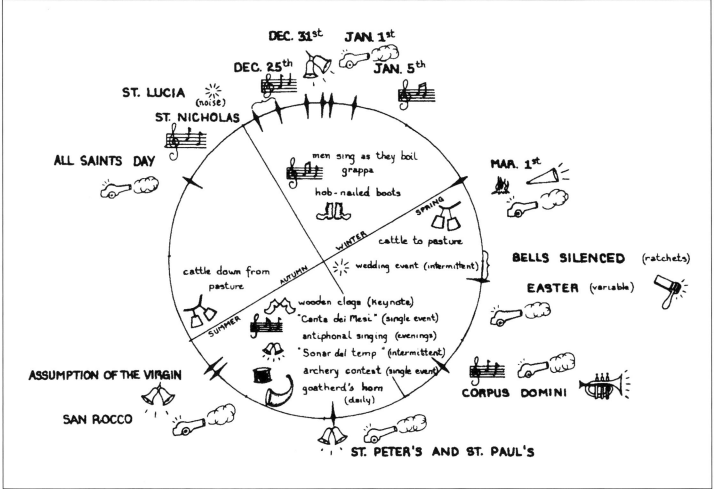

Robert Murray Schaeffer / *Événements sonores, saisonniers, traditionnels et sons caractéristiques du village de Cembra* / 1977 / © World Soundscape Project

Tom Phillips's *Palindrome*, Milan Grygar's *Partition architectonique*, and Roland Kayn's *Galaxis*. But even if these scores are classified as prints, what about the Cartes du Tendre drawn by Murray Schaeffer, for instance in his *Evènements sonores, saisonniers, traditionnels et sons caractéristiques du village de Cembra*? In this piece he conveys a tangible and undecipherable part of his program of acoustic ecology, but what are we to do with it?

Bang on a Can

If Cage, Stockhausen, and Hauswolff prompted a number of *musicoclashes* by studying the limits between sound and silence, it is by making as much noise as possible that Michael Gordon, David Lang, and Julia Wolfe created their festival *Bang on a can*, 1987, in New York, which was quickly adopted by the whole city.

The movement created its fathers, such as John Cage and Steve Reich. This time rupture was not so much sought after as renewal: the daring gestures of these founding fathers had to be taken "further." The three friends invited John Cage to the very first festival *Bang on a can* (10 May 1987) because Michael Gordon was convinced that "his ideas [have] changed the face of the earth in ways we cannot begin to suspect."[29] *Bang on a can* thus chose to administrate a musical heritage, but not in the twentieth century manner that froze a musical repertoire in scores and libraries. There, the repertoire was "embodied." It was in the gesture, and the gesture has to be iconoclastic in order to exist. Our aim was to "get rid of the deadwood," explained Julia Wolfe, who endeavored to build up a repertoire of *musicoclastic* actions.[30] Here we have a musical theory kept not in the conservatory but in behaviors.

"*Bang on a can* started as a joke," Julia Wolfe continued. "We named the festival like this because we thought there would be no other one. Many people came the first year, including John Cage and Steve Reich. We worked hard on broadening our audience beyond the circle of New Music lovers. Even if the festival has developed, it has remained dedicated to composers with new ideas, with an adventurous mind."[31]

The "Festival of Iconoclastic Gestures" turned out to be a much bigger success than its promoters had expected. David Lang claimed to have "created *Bang on a can* to encourage audacity wherever it can be found and to attract a new audience capable of appreciating it."[32] But the mimetic violence of the iconoclast gestures proved appealing.

Bang on a can now consists of an annual season, a soloists' ensemble (Bang on a Can All-Stars), an orchestra in residence (Spit Orchestra), recordings, radio program, and commissions for new creations. Where is the iconoclastic gesture now located? The three friends intended to "fight conservatism in all branches of music,"[33] but has the audience, by showing so much interest, neutralized the *musicoclash*?

The *musicoclastic* gesture that once challenged our strongest beliefs has become part of the way in which we relate to sounds. David Lang composed *Grind to a Halt*, intended to be, "for the San Francisco symphonic orchestra, a great noisy piece that scratches."[34] But *Grind to a Halt* no longer makes anyone itchy. Once again, the "iconoclastic virtue," a syntagma in which the substantive neutralizes the adjective, has become a landmark in the history of music. The "post-modern joke" now belongs to the history of the moderns.

Politics

Each nation manufactures its own sacred objects. Considered to be unalterable and timeless, these objects "cement" the nation, holding it together, they are what *re*-presents it, what

30 29

_ Lelong, op. cit., p. 368.

_ Stephane Lelong, *Nouvelle Musique*, Editions Balland, Paris, 1996, p. 186.

31 34 33 32

_ Lelong, op. cit., p. 248.

_ Lelong, op. cit., p. 248.

_ Lelong, op. cit., p. 368.

_ Lelong, op. cit., p. 250.

gives it symbolic existence. These objects encapsulate a shared culture, a collective memory, and a common fate. The anthem, the flag, the charter (or the football team when it wins) are a few of these objects endowed with a sacral character. In every society, the authorities whose task is to inculcate the people – which include schools, the media, a political life rhythmed by commemorations, military culture, and sport – continually work to establish those symbols as sacred *items*. These authorities elevate a number of objects to the level of national symbols, they manufacture emotional commitment to each of them, and they orchestrate their exegesis to ensure they are read in a consensual way. Among these objects, the national anthem occupies a central position. The anthem cannot be regarded as a simple musical piece. It is of course "music," but it is at the same time something else entirely. One might say that the anthem is to civic practice what the creed is to confessional practice.

Endowed with a sacred character, the anthem is that which no one can touch, an inalterable object representing a whole nation, be it on the football pitch, the battlefield or during national holidays. Precisely for this reason, because they have been endowed with the quality of "institutional sacrality," anthems are a favorite target of *musicoclastic* gestures. When people want to show their hatred of a State, they burn its flag, they whistle at its anthem in disapproval. This happened for instance on 7 October 2001, in the Parisian Stade de France during the France-Algeria football match, the first match to be played between the two teams since Algeria's independence in 1962. Every effort had been made to show that the stakes of the game were of a purely sporting nature, and to display the good relations between the players: before the match, both teams had posed together for a photograph. This did not prevent the *Marseillaise* from being vociferously booed by a large section of the public, to the extent that it became inaudible. Was this *musicoclash* premonitory? The fact remains that young Algerian supporters swarming onto the pitch at the 75th minute put an end to the match. The *musicoclash* had indeed been premonitory.

Gainsbourg's Reggae Marseillaise

In 1979, the singer Serge Gainsbourg composed a reggae version of *La Marseillaise*. "This is a profanation," the editorialist Michel Droit immediately exclaimed in the *Figaro-Magazine*.[35] The matter was serious. While on a concert tour, in Strasbourg, Gainsbourg had to face a squad of parachutists. In January 1980, the magazine *Les Nouvelles Littéraires* published twenty-two negative reactions to the song, a whole collection of insults and curses:

> "Gainsbourg has no right to touch and demolish something that belongs to the heritage of the French."
> "One has no right to disrespect the national anthem and the flag when one has the honor of being French. Since Gainsbourg is physically filthy, he is probably equally filthy in his mind."
> "I cannot stand Gainsbourg's *Marseillaise*. Not only does he sing it badly, but on top of this, he is a foreigner, he is not even French."
> "With the *Marseillaise*, Gainsbourg has produced a drug addict's ditty. It is scandalous. In the name of freedom, we allow dreadful things to happen."
> "No one has the right to distort a national anthem to make pop. If artists do not know what France is, let them ask the old."

Had Gainsbourg forgotten that the national anthem, just like the flag, monuments, or commemorative plaques constitute emblematic and inalterable entities? "These objects 'are worth' what they represent."[36] They become intangible as a result of a whole process of interiorization instilled by many networks that shape the individual on a daily basis and whose efficiency is displayed by the example of Simone Veil.

35 36

_ *Le Figaro*, Magazine, 1 June 1979.

_ Jacques Cheyronnaud, Un blasphème très contemporain:
"La Marseillaise" de Gainsbourg, in *Mentalités*, 2, 1989, p. 156.

Asked by journalist Jean Toulat whether *The Marseillaise*'s lyrics should not be changed for a less bloody version, the MEP was unable to express an objective point of view: the anthem, she claimed, "belongs to my memory and my culture. Actually the lyrics and the music are not important to me; what counts, when I hear *La Marseillaise* or when I sing it with others, are all the references to the times since early youth when I heard or sang it in the past."[37] Modifying a national anthem does not simply mean altering its musical characteristics, it also implies working on this part of ourselves which was formed by reference to this anthem. Anthems do not, however, necessarily inspire everyone with the same feelings. Pierre Bergé, then president of the Paris operas and chairman and managing director of Yves Saint-Laurent, expressed a different point of view in response to Jean Toulat's question: "When I was a child, my parents used to forbid me to sing *La Marseillaise*. They found the lyrics scandalous. I have always shared this opinion and have never managed to bring myself to utter them."[38] The anthem can thus be culturally appropriated in a multitude of different ways. It is the object of a process of differential polyphonic actualization in which collective memory meets individual experience. This explains the sacral character which surrounds it as well as the instinctive reactions that can be triggered off by a modification of the symbol. These are conditioned responses, which helps explain why the arguments criticizing or glorifying Gainsbourg's gesture had very little to do with the musical characteristics of his work. This was true even of the arguments made by those who condemned the racist turn of the criticisms:

> "So here is Gainsbourg's crime, not to have been born in our sweet France, the country of freedom!"
> "I am also a patriot, but not to the point of reproaching others for being Jewish. This is unacceptable."
> "That the French can become so indignant about an adaptation of the national anthem proves that stupid-

ity and racism persevere, and that they have little sense of humor."

Can an artistic gesture, or the anathema that targets it, be fought with moral or political arguments? Gainsbourg's greatest merit is probably to have used an anthem to reveal the xenophobic feelings latent in French society. His *musicoclash* led to the emergence in the public debate of arguments which were all racial in nature. Annoyed by the rendering of a musical performance, its opponents searched for its origin in that of its author. They could have criticized its technical characteristics: reggae ostinato in the background, suave feminine voice singing "Aux armes citoyens," the author half-speaking, half-singing the national anthem's lyric between two drags on his cigarette ... But instead, the criticisms were directed at the "filthy individual," the "foreigner," the "un-French," the "drug addict," the "Jew." A shift thus occurred in the course of this *musicoclash*. The profanation now lay in the fact that a Jewish author appropriated a national anthem and turned it into a work of art. The abuse publicly showered on Serge Gainsbourg along with the parachutists' blows had the effect of bringing out his Jewish origins.

Hymnenstreit (Tag der deutschen Einheit, Hannover, 3 October 1998)

In February 1998, Bardo Henning, a jazz composer from Berlin, was commissioned to write a musical piece to be performed at the official ceremony of 3 October, *Tag der Deutschen Einheit*, the day of German unity. Since 1990, the German national holiday takes place every year in the capital of the Land whose Minister-President heads the Bundesrat. In 1998, the president of the Bundesrat was Gerhard Schröder, Minister-President of Lower Saxony; the ceremony was thus to take place in this Land's capital, Hannover. That year, by coincidence, 3 October fell one week after the 27 September

38 37

_ Toulat, op. cit., p. 15.

_ Jean Toulat, *Pour une Marseillaise de la Fraternité*, Editions Axel Noel, Paris, 1979, p. 27.

Rap, Gabber, Hardcore, Trip-Hop, Indus, Trash Metal

The representatives of the toughest trends in today's music are not afraid of making use of anthems. The older among us probably remember Jimi Hendrix's interpretation of the American anthem in Woodstock, which went down in history. This took place in 1969: Hendrix, clutching his guitar, suddenly struck up *The Star-Spangled Banner*. It was without doubt a *musicoclash*, a critical gesture at a time when the war was still raging in Vietnam. Jimi Hendrix, however, never clarified his intentions: "I don't know, man, all I did was play it. I'm American so I played it. I used to sing it in school, they made me sing it in school, so, it's a flashback," he declared. Thirty years on we are still discussing the artist's intention, as though it was going to determine whether his song should be taken as a tribute or a blasphemy. There can be no *musicoclash* unless there is a debate on the attribution of intention.

When the Sex Pistols recorded their first single, *God Save the Queen*, there was on the other hand no ambiguity concerning their intentions. From 1975 onwards, they fascinated a large audience with their outrageous behavior on stage and their "aesthetics of saturation," which included decibels as well as at society's moral and political codes, EMI signed them up. On 1 December 1976, Bill Grundy invited them as guests to the TV show *Today* and asked them to say offensive words. The guitarist Steve Jones willingly complied, showering insults on the early-evening audience of *Thames TV*. The press cried out, indignant. The Sex Pistols made it to posterity, a *musicoclash* had taken place. A year later, in 1977, Glen Matlock left the band and was immediately replaced by another bass guitarist, Sid Vicious, whose first task would be to learn to play the bass.

From early on, the Sex Pistols targeted the symbols of Great Britain, from *Jubilee Day* to the anthem. On 7 June 1977, following in Händel's footsteps, the Sex Pistols played their wild trance music on the Thames. The event could not be passed over in silence. As the band – Johnny Rotten, Steve Jones, Paul Cook, and Sid Vicious – reached the embankment, they were arrested by the police. The Pistols' jubilee river trip was a fiasco – but it is remembered as one of the seminal events

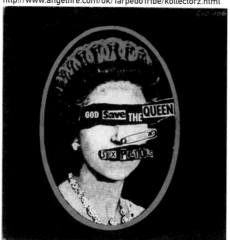

Sex Pistols / God save the Queen /
March 1977 / single, 7'', front cover / A&M / from:
http://www.angelfire.com/ok/TarpedoTribe/kollectorz.html

Sex Pistols / God save the Queen /
March 1977 / single, 7'', back cover / A&M / from:
http://www.angelfire.com/ok/TarpedoTribe/kollectorz.html

Sex Pistols / God save the Queen /
March 1977 / single, 7'' / A&M / from:
http://www.angelfire.com/ok/TarpedoTribe/kollectorz.html

of the punk era. The band's manager, Malcolm McLaren, and his then wife, Vivienne Westwood, now one of the world's most famous fashion designers, were among those arrested. The anthem however remained an ambitious target for them. After they recorded their own punk version of *God save the Queen* in 1977, the Sex Pistols organized a mock signature of the contract in front of Buckingham Palace and were violently driven away by the police. The band was banned, its record censored. In Great Britain, they were considered to be dangerous individuals, while they became idols for the United States' "massive independent music underground." Those in power, however, are sometimes not without humor. Twenty-five years after their Thames outing to mark the Queen's silver jubilee, the Sex Pistols may be about to reunite to celebrate her golden jubilee. The gig is supposed to take place on 3 June 2002, when the Queen celebrates her fifty years on the throne.[43] The Sex Pistols are now Buckinghams's guests of honor for the Queen's new jubilee! Where is the iconoclastic gesture now located?

Despite many attempts in all areas of today's music, no group has managed to reach the Sex Pistols' reputation. The final section of the exhibition takes us through enraged

Sex Pistols / Sid Vicious / from:
www.almac.co.uk/personal/brian/sexp.html

43

_ *BBC News*, 19 December 2001.

rappers' loudest clashes and their unfailingly powerful poetic virtuosity, visual violence, and blasphemous energy (NTM, Minister Amer, Ministry, Nine Inch Nails). Opposite them stands techno. In this music without lyrics, another form of *iconoclash* arises from the social customs which go with it and the various forms of deviance that are phantasmatically associated with it. Are raves now destined to take the place once filled by carnivals? In this case also, it is impossible to freeze the *musicoclash*. Our DJs recycle our grandparents' vinyl discs on their decks. All the gestures which had been forbidden up to this day now become the new repertoire of techno creation. Thus, new icons are born from the transformation of reflex gesture into a *musicoclastic* one before becoming an expert gesture.

The Seven Musicoclastic Posts

Seven "*musicoclastic* posts" have been set up randomly throughout this exhibition. Seven musical extracts are put at everyone's disposal, without any commentary other than a brief text explaining the context in which they were created. It is up to each visitor to decide whether the virtuoso and occasionally out of tune chants of Florence Foster Jenkins interpreting Mozart approximately, or the wild rhythms of the band Oskorri caricaturing symbols of the kingdom of Spain are *musicoclashes* or merely entertaining parodies. Each visitor can decide whether the Inuits' vocal games have been excessively edited for a "musiques du monde" collection, or whether or not the explorations carried out by Mauricio Kagel or Paul Pörtner in the Siemens electronic music studios can be described as "music." The visitor is finally given the opportunity to decide whether Vincent Barras and Jacques Demierre's *Ma Merd'de* is a "work of art" or a joke. Listening to the famous choir of Verdi's Nabucco in the distorted interpretation given by Alvin in his *Crystal Psalms*, intended to commemorate the *Kristallnacht*, will however remind us

that a citation is not necessarily offensive, for instance if its intention is judged to be legitimate.

The barriers separating art, politics, and philosophy are indeed very thin. What is constantly at stake is a whole system of representing the world. By freezing the *musicoclastic* gesture, by looking at this moment of uncertainty when anything could happen and when everything sometimes happens, although not at the same moment, I have attempted to show that what I call a *musicoclash* is not an inherent feature of the musical work but rather a cultural construction born of our reactions to it. There can be no escape from anthropological holism.

This explains the variability of judgement passed on a piece in the name of truth: the fact that the Sex Pistols can be banned one year and invited twenty-five years later. For indeed, a judgment varies as much as the truth in the name of which it is formulated. "Men do not find truth, they make it," as historian Paul Veyne put it.[44] It follows that "the truth is that truth varies."[45] This is what we have to bear in mind when we go through the *musicoclastic* areas of this exhibition. We have to think that we have two ears – one that hears, and one that thinks – and remember that the type of attention we pay to sounds is not a matter of hearing, but of listening.

With Both Ears

Listening involves more than merely registering sounds, it is also a thought and words. My hearing ear hears a series of sounds, while my thinking ear interprets them according to the information available in my cultural universe, where I find a "good reason" to think what I think. The way we relate to sounds never stabilizes once and for all. It changes and it requires learning a new vocabulary which enables me to describe a series of sounds, to employ *propositions*[46] – this precious notion which Bruno Latour revived after reading Whitehead – which allow me to bring this series of sounds into peoples' deliberations. The attention we pay to any *musicoclash*, therefore, not only depends on our Eustachian tubes, it also has to do with understanding. Listening is the result of a process of constant learning which continuously organizes our perception of sounds.

If I am shocked when I listen to the ataxic hoquets scattered throughout Guillaume de Machaut's Mass of Nôtre Dame, the emotion I feel does not stem from the fact that Machaut spoke a heretic language which brought him opprobrium from the ecclesiastic powers of his time. It stems from my finding signs of heresy in his performance. The question is not about whether Machaut was a heretic, it is about me being disturbed by his hoquets to the point of seeing in them the sign of a diabolic inspiration, and of making Machaut a heretic. I will let the reader appreciate the subtle difference.

It is this difference that the metaphor of the two ears seeks to demonstrate.[47] Between Machaut's Mass and the acoustic vibrations that reach my ears, a conceptual, anticipatory scheme intervenes that organizes audition in a certain way. If we see "heresy" in Machaut's piece, it means that we have placed ourselves in such a condition so as to locate "heresy" in this piece and be upset by it. A *musicoclash* takes place only insofar as it constitutes an answer, of a cultural nature, to the culturally constituted questions we ask (ourselves). We have thus needed both our ears – the hearing one and the thinking one – to make our way through this argumentative, aggressive, and burlesque cacophony, because a sound means nothing by itself. |

Translated from French by Charlotte Bigg

45 44

_ Veyne, op. cit., p. 127.

47 46

_ "Propositions are neither utterances, nor things, nor some intermediate state between both. They are first and foremost agents." (Bruno Latour, *L'Espoir de Pandore. Pour une version réaliste de l'activité scientifique*, La Découverte, Paris, 2001, p. 148.).

_ Paul Veyne, *Les Grecs ont-ils cru à leurs mythes?*, Édition du Seuil, Paris, 1986, p. 12.

_ This formulation is borrowed from the work of Gerard Lenclud in which he compares the way XVIth century travelers and today's ethnologists see the societies they observe: if "no one would think of denying, not even post-modernists who hate progress, that today's ethnographs observe the societies they study 'better' than the travelers looked at the people they depicted [...], the merit of these ethnographs, in comparision to travelers, goes to their eye that thinks, and not to their eye that sees, as all eyes that see, in the XVIth as in the XXth century, attain the same perceptive performances." (Gérard Lenclud, Qu'est-ce que la Tradition?, in Marcel Détienne, *Transcrire les Mythologies*, Albin Michel, Paris, 1994, pp. 25-44. Concerning audition, see Roberto Casati and Jérôme Dokic's analysis on the passage between hearing faculty and auditive sensations. Roberto Casati and Jérôme Dokic, *La Philosophie du son*, Éditions Jacqueline Chambon, Nîmes, 1994, p. 29.

The unbearable movement

ICONOCLASM AS AN ARTISTIC DEVICE / ICONOCLASTIC STRATEGIES IN FILM

Boris Groys

FILM HAS NEVER STOOD IN A SACRED CONTEXT. From its very inception, film has proceeded through the murky depths of profane and commercial life, always a bedfellow of cheap mass entertainment. Even the attempts undertaken by twentieth century totalitarian regimes to sacralize film never really succeeded – all that resulted was the short-lived enlistment of film for their respective propaganda purposes. The reasons for this are not necessarily to be found in the character of film as a medium: film simply arrived too late. By the time film emerged, culture had already shed its potential for sacralization. So given cinema's secular origins, it would at first seem inappropriate to associate iconoclasm with film. At best, film appears capable only of staging and illustrating historical scenes of iconoclasm, but never of being iconoclastic itself.

What nonetheless can be claimed is that, throughout its entire history as a medium, film has waged a more or less open struggle against other media such as painting, sculpture, architecture, and even theater and opera. These can all boast of sacred origins that within present-day culture still afford them their status as high, aristocratic arts. Yet the destruction of precisely these high, aristocratic, cultural values has been repeatedly depicted and celebrated in film. Thus, cinematic iconoclasm operates less in relation to some religious or ideological struggle than it does in terms of the conflict between different media; this is an iconoclasm conducted not against its own sacred provenance but against other media. By the same token, in the course of the long history of antagonism between the media, film has earned the right to act as the icon of secularizing modernism. Inversely, by being transferred into the traditional realms of art, film itself has, in turn, increasingly become the subject of iconoclastic gestures: by means of new technology such as video, computer, and DVD, the motion of the film image has been halted midstream and dissected. In the following, this development will be more precisely delineated and illustrated with examples that are on display in this exhibition.

1.

In historical terms the iconoclastic gesture has never functioned as an expression of a consistent aesthetic or skeptical attitude. Such an approach is mirrored more in a dispassionate curiosity for a plethora of religious aberrations, compounded by the well-meaning museum conservation of the historical evidence of such aberrations – and it is certainly not accompanied by the destruction of this evidence. By contrast, the desecration of ancient idols is performed only in the name of other, more recent gods. Iconoclasm's purpose is to prove that the old gods have lost their power and are subsequently no longer able to defend their earthly temples and images. Thus iconoclasts show how earnestly they take the gods' overall claims to power by contesting the authority of the old gods and asserting the power of their own. In this vein, to cite but a few examples, the temples of pagan religions were destroyed in the name of Christianity, Catholic churches were despoiled in the name of a different, Protestant interpretation of Christianity, and, later on, all kinds of Christian churches were wrecked in the name of the religion of Reason – which was considered more powerful than the authority of the old biblical god. In turn, the power of reason as manifested by a particular, humanistically defined human image was later iconoclastically attacked in the name of the state-sponsored crusade to maximize the productive forces, to secure the omnipotence of technology and to promote the total mobilization of society – at least in Central and Eastern Europe. And just recently we witnessed the ceremonious dismantling and removal of the fallen idols of socialism, this time in the name of the even more powerful religion of unrestrained consumerism. It seems that at some point, technological progress was realized to be dependent upon consumption, fully in keeping with the adage that supply is generated by demand. So, for the time being, commodity brands will remain our latest house gods, at least

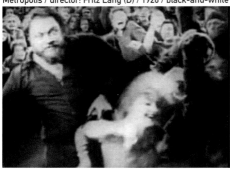

until some new, nascent iconoclastic anger rises up against them, too.

Iconoclasm can thus be said to function as a mechanism of historical innovation, as a means of re-valuing values through a process of constantly destroying old values and introducing new ones in their place. This explains why the iconoclastic gesture always seems to point in the same historical direction, at least as long as history is perceived in the Nietzschean tradition as the history of escalating power. From this perspective, iconoclasm appears as a work of progressive, historically ascending movements constantly clearing our path of all that has become redundant, powerless, and void of inner meaning, to make way for whatever the future might bring. This is why all criticism of iconoclasm has traditionally had a reactionary aftertaste – but also why it no longer has this aftertaste today. Since our society idolizes innovation, creativity, and progress, we are now able to sympathize with the critique of iconoclasm – because, after all, we have learned in the meantime how to critically assess the cost of progress.

However, such a close connection between iconoclasm and historical progress is not logically necessary, for iconoclasm addresses not only the old but also the new: in the early stages of their mission, devotees of new gods have always been subjected to persecution and the desecration of their symbols, be it the first Christians, revolutionaries, Marxists or even hippies – those martyrs of consumerism and fashion. Essen-

tially, on each occasion this persecution also represents a gesture signaling that the new gods are not powerful enough, or at least not as powerful as the old gods. And in many cases, this gesture has proved altogether effective: the new religious movements were suppressed and the power of the old gods reasserted. Of course one can, if one so wishes, put a Hegelian spin on this and see it as evidence of the ruse of reason lending reactionary support to the march of progress. Characteristically, however, rather than viewing such gestures of suppression and destruction leveled at new movements as iconoclastic, they are generally seen as the martyrization of what is new. Indeed, most religions foster iconographic canons composed of images that depict their earlier martyrdom. In this respect, it can be said that each religion's iconography pre-empts any iconoclastic gesture to which they might fall victim. The sole factor distinguishing this anticipation from actual destruction is that survival (in the first case) rather than downfall (in the second case) is upheld as the object of aspiration and celebration. This difference can be equated with the contrasting positions of victor and loser – whereby observers are free to choose which of the two sides they prefer to identify with, all depending on personal views of history.

Besides this, history consists more of revivals than of innovations, whereby most innovations make their appearance as revivals and most revivals as innovations. On closer inspection, one gradually loses all hope of determining which

/ 139 min / filmstills / © Eureka Video

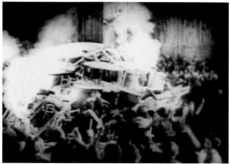

historical force ultimately ended up as the victor in order to distinguish between iconoclasm and martyrdom. For here there can be no question of "ultimately": history presents itself as a sequence of re-valuations of values without any discernible general direction. Moreover, we really have no way of knowing whether defeat means a decline, or victory an increase in power. Defeat and martyrdom both contain a promise that is lacking in victory. Victory leads to "appropriation" by the status quo, whereas defeat might possibly turn into a later, ultimate victory capable of re-valuing the status quo. Indeed, since at least the death of Christ, the iconoclastic gesture has proven a failure, essentially because it instantly reveals itself as the most glorious victory of its purported victim. In the light of the Christian tradition, the image of destruction left behind by the iconoclastic gesture is quasi-automatically transformed into the victim's image of triumph, long before the later resurrection or historical re-valuation "really" takes place. Conditioned by Christianity over a considerably time, our iconographic imagination now no longer needs to wait before acknowledging victory in defeat: here, defeat is equated with victory from the very outset.

How this mechanism functions in the post-Christian modern world can be clearly demonstrated by the example of the historical avant-garde. It can be said that the avant-garde is nothing other than a staged martyrdom of the image that replaced the Christian image of martyrdom. After all, the avant-garde abuses the body of the traditional image with all manner of torture utterly reminiscent of the torture inflicted on the body of Christ in the iconography of medieval Christianity.[1] In the way it is treated by the avant-garde, the image is – in symbolic or real terms – sawed apart, cut up, smashed into fragments, pierced, spiked, drawn through dirt, and exposed to ridicule. It is also no accident that the vocabulary constantly used by the historical avant-garde even in its manifestos reproduces the language of iconoclasm. We find mentions of discarding traditions, breaking with conventions, destroying old art and eradicating outdated values. This is by no means driven by some sadistic urge to cruelly maltreat the bodies of innocent images. Nor is all this wreckage and destruction intended to clear the way for the emergence of new images and or the introduction of new values – far from it, the images of wreckage and destruction themselves serve as the icons of new values. In the eyes of the avant-garde, the iconoclastic gesture represents an artistic device, deployed less as a means of destroying old icons than as a way to generate new images – or, indeed, new icons.

However, this possibility of strategically deploying iconoclasm as an artistic device came about because the artistic avant-garde, for its part, shifted its focus from the message to the medium. The destruction of old images embodying a particular message is not meant to generate new images embodying a new message, but rather to highlight the materiality

1

_ Cf. Boris Groys, Das leidende Bild, in Peter Weibel and Christian Meyer (eds), Das Bild nach dem Letzten Bild, Vienna and Cologne, 1991, pp. 99-111.

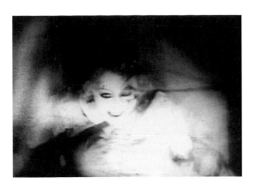

Mars Attacks / director: Tim Burton (USA) / 1996 / color /

of the medium concealed behind any "spiritual" message. The stuff that art is made of can only be made visible once the image ceases to serve as the manifestation of a specific "conscious" artistic message. Hence, in the artistic practice of the avant-garde the iconoclastic gesture is arguably also intended as a means of removing what has grown old and powerless and asserting the supremacy of the powerful. This is no longer practiced in pursuit of a new religious or ideological message but in the name of the power of the medium itself. It is no coincidence that Malevich, for example, speaks of the "suprematism of painting" that he hopes to achieve with his art – by which he means painting in its pure, material form in its superiority over the spirit.[2] With this, the artistic avant-garde can be said to have celebrated the victory of the powerful – *qua* material – artistic media over the powerless zero medium "spirit," to which these media had hitherto been for far too long subordinated. Accordingly, the process of destroying old icons is rendered identical to the process of generating new ones – in this case, the icons of materialism. The image is thereby transfigured into the site for an epiphany of pure matter, abandoning its role as the site for an epiphany of the spirit.

2.

However, this transition from the spiritual to the material within traditional arts like painting and sculpture has ulti-

mately remained beyond the comprehension of the wider audience – neither medium was considered powerful enough. The real turning point came with film. In this context, Walter Benjamin had already pointed out that the processes of fragmentation and collage – in other words, the unmitigated martyrdom of the image – were swiftly accepted by the same audience when they were displayed in film, but greeted with outrage and rejection in the context of the traditional arts. Benjamin's explanation for this phenomenon is that, as a new medium, film is culturally unencumbered: this change of medium thereby justifies the introduction of new artistic strategies.[3]

Furthermore, film also appears to be more powerful than the old media. The reason for this lies not merely in its reproducibility and the system for its mass commercial distribution: film also seems to be of equal rank to the spirit because it, too, moves in time. Accordingly, film operates analogously to the way consciousness works, therein proving capable of substituting the movement of consciousness. As Gilles Deleuze correctly observes, film transforms its viewers into spiritual automata: film unfurls inside the viewers' head in lieu of their own stream of consciousness.[4] Yet this reveals film's fundamental character to be deeply ambivalent. On the one hand, film is a celebration of movement, the proof of its superiority over all other media, on the other, it places its audience in a state of unparalleled

2

3

4

_ Kasimir Malevich, *Suprenatuzm. Mir kak bespredmetnost, ili vechnyy pokoy,* in Kasimir Malevich, *Sobranie sochineniy,* vol. 3, Moscow, 2000, pp. 69ff.

_ Cf. Gilles Deleuze, *Das Bewegung-Bild,* Kino 2, Suhrkamp, Frankfurt/M., 1991, pp. 205ff.

_ Walter Benjamin, Das Kunstwerk im Zeitalter seiner technischen Reproduzierbarkeit, in *Walter Benjamin. Ein Lesebuch,* Edition Suhrkamp, Frankfurt/M., 1991, pp. 205ff.

102 min / filmstills / © Warner Bros

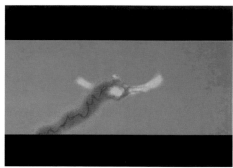

physical and mental immobility. It is this ambivalence that dictates a plethora of filmic strategies, including iconoclastic strategies.

Indeed, as a medium of motion, film is frequently eager to display its superiority over other media, whose greatest accomplishments are preserved in the form of immobile cultural treasures and monuments, by staging and celebrating the destruction of these monuments. At the same time, this tendency also demonstrates film's adherence to the typically modern faith in the superiority of *vita activa* over *vita contemplativa*. Every kind of iconophilia is ultimately rooted in a fundamentally contemplative approach and in a general readiness to treat certain objects that are deemed sacred exclusively as objects of distant, admiring contemplation. This disposition is based on the taboo that protects these objects from being touched, from being intimately penetrated and, more generally, from the profanity of being integrated into the practices of daily life. In film nothing is deemed so holy that it might or ought to be safeguarded from being absorbed into the general flow of movement. Everything film shows is translated into movement and thereby profaned. In this respect, film manifests its complicity with the philosophies of *Praxis*, of *Lebensdrang*, of the *élan vital* and of desire; it parades its collusion with ideas which, in the footsteps of Marx and Nietzsche, mesmerized the imagination of European humanity at the end of the nineteenth

and the beginning of the twentieth centuries – in other words, during the very period that gave birth to film as a medium. This was the era when the hitherto prevailing attitude of passive contemplation capable of shaping ideas rather than reality was displaced by adulation of the potent movements of material forces. In this act of worship, film plays a central role. From its very inception, film has celebrated everything that moves at high speed – trains, cars, airplanes – but also everything that goes beneath the surface – blades, bombs, bullets.

Likewise, from the moment it emerged, film has used slapstick comedy to stage veritable orgies of destruction, demolishing anything that just stands or hangs motionlessly, including traditionally revered cultural treasures, and sparing not even public spectacles such as theater and opera that embodied the spirit of old culture. Designed to provoke all-round laughter in the audience, these movie scenes of destruction, wreckage, and demolition are reminiscent of Bakhtin's theory of the carnival that both emphasizes and affirms the cruel, destructive aspects of the carnival.[5] Of all preceding art forms, it is no surprise that the circus and the carnival were treated with such positive deference by film in its early days. Bakhtin describes the carnival as an iconoclastic celebration that exuded an aura of joy rather than serious, emotional, or revolutionary sentiment; instead of causing the violated icons of the old order to be supplanted

5

_ Mikhail Bakhtin, *Rabelais and His World*, The MIT Press, Cambridge, MA, 1968.

Batman / director: Tim Burton (USA) / 1989 / color / 121 min / filmstills / © Warner Bros

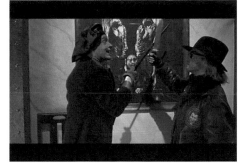

by the icons of some new order, the carnival invited us to revel in the downfall of the status quo. Bakhtin also writes about how the general carnivalization of European culture in the modern era compensates for the decline of "real" social practice traditionally provided by the carnival. Although Bakhtin draws his examples from literature, his descriptions of carnivalized art apply equally well to the strategies with which some of the most famous images in film history were produced.

At the same time, Bakhtin's carnival theory also emphasizes just how inherently contradictory iconoclastic carnivalism is in film. Historical carnivals were participatory, offering the entire population the chance to take part in a festive form of collective iconoclasm. But once iconoclasm is used strategically as an artistic device, the community is automatically excluded – and becomes an audience. Indeed, while film as such is a celebration of movement, it paradoxically drives the audience to new extremes of immobility compared to traditional art forms. So while it is possible to move around with relative freedom while one is reading or viewing an exhibition, in the movie theater the viewer is cast in darkness and glued to a seat. The situation of the movie-goer in fact resembles a grandiose parody of the very *vita contemplativa* that film itself denounces, because the cinema system embodies precisely that *vita contemplativa* as it surely appears from the perspective of its most radical critic – an

uncompromising Nietzschean, let us say – namely as the product of a vitiated lust for life and dwindling personal initiative, as a token of compensatory consolation and a sign of individual inadequacy in real life. This is the starting point of any critique of film which is building up to a new iconoclastic gesture – an iconoclasm due to be turned against film itself. Criticism of audience passivity first led to various attempts to use film as a means of activating a mass audience, of politically mobilizing or injecting movement into it. Sergei Eisenstein, for instance, was exemplary in the way he combined aesthetic shock with political propaganda in an endeavor to rouse viewers and wrench them from their passive, contemplative conditions.

But as time passed, it became clear that it was precisely the illusion of movement generated by film that drove the viewer towards passivity. This insight is nowhere better formulated than in Guy Debord's *The Society of the Spectacle*, a book whose themes and rhetorical figures continue to resound throughout the current debate on mass culture. Not without reason, he describes present-day society, defined as it is by the electronic media, as a total cinema event. For Debord, the entire world has become a movie theater in which people are completely isolated from one another and from real life, and consequently condemned to an existence of utter passivity.[6] As he vividly demonstrates in his final film *In girim imus nocte et consumimur igni* (1978), this condition can no

6

_ Guy Debord, *Die Gesellschaft des Spektakels. Kommentare zur Gesellschaft des Spektakels*, Edition Tiamat, Berlin, 1996.

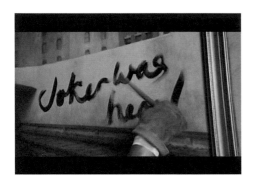

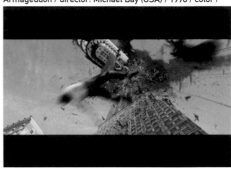

Armageddon / director: Michael Bay (USA) / 1998 / color /

longer be remedied with increased velocity, intensified mobility, the escalation of emotions, aesthetic shock, or further political propaganda. What is required instead is the abolition of the illusion of movement generated by film; only then will viewers gain the chance to rediscover their ability to move. In the name of real social movement, filmic motion has to be stopped and brought to a standstill.

This marks the beginning of an iconoclastic movement against film, and consequently of the martyrdom of film. This iconoclastic protest has the same root cause as all other iconoclastic movements; it represents a revolt against a passive, contemplative mode of conduct waged in the name of movement and activity. But where film is concerned, the outcome of this protest might at first sight seem somewhat paradoxical. Since film images are actually moving images, the immediate result of the iconoclastic gesture performed against film is petrifaction and an interruption of the film's natural dynamism. The instruments of film's martyrdom are various new technologies such as video, computer, and DVD. These new technological means make it possible to arrest a film's flow at any moment whatsoever, providing evidence that a film's motion is neither real nor material, but simply an illusion of movement that can equally well be digitally simulated. In the following, both iconoclastic gestures – the destruction of prevailing religious and cultural icons through film, and the exposure of film's movement itself as an illusion – are illustrated by selected examples which cannot, of course, claim to cover all aspects of these iconoclastic practices, but nonetheless offer insight into their logic.

3.1.

Tracey Moffatt's short film *Artist* (1999) quotes various, more or less well-known feature films that all tell the story of an artist. Each of these stories opens with an artist hoping to create a masterpiece; this is followed by proudly presenting the accomplished work of art and closes with the work being personally destroyed by the disappointed, despairing artist. At the end of this film collage, Tracey Moffatt stages a veritable orgy of artistic destruction using appropriate footage. Pictures and sculptures of various styles are shredded, burned, smashed, and blown up. The film collage thereby offers a very precise résumé of the treatment cinema has meted out to traditional art forms. But let it not go unmentioned that the artist also subjects film itself to a process of deconstruction. She fragments individual movies, interrupts their respective movements and corrupts their subjects beyond recognition, mixing up the fragments of these various, stylistically disparate films to create a new, monstrous filmic body. The resultant film collage is clearly not intended for screening in a movie theater but for presentation in traditional art spaces such as galleries or museums. Tracey Moffatt's film not only reflects on the

144 min / filmstills / © Touchstone Pictures

abuse inflicted on art in film, but in a subtle manner also exacts revenge for its suffering.

3.2.

In the video collage, *Bewegungsbilder* (Images of movement), specially produced for this exhibition, film images are quoted that celebrate the iconoclastic gesture, while at the same time they are being raised to the status of icons of film history.

The image of the lacerated eye in *Un chien andalou* (1928) by Luis Buñuel is one of the most famous film icons of its kind. The scene heralds not only the destruction of a particular icon, but also the suppression of the contemplative attitude itself. The meditative, theoretical gaze intent on observing the world as a whole and thereby reflecting itself as a purely spiritual, disembodied entity, is referred back to its material, physiological state. This transforms the very act of seeing into an altogether material and, if one so wishes, blind activity, a process that Merleau-Ponty, for instance, later formulated as palpating the world with the eye.[7] This could be described as a meta-iconoclastic gesture, one that renders it sheer impossibility to pursue visual adoration from a religious or aesthetic distance. The film shows the eye as pure matter – and hence open to being touched if not destroyed. As a demonstration of how physical,

material force has the power to eradicate contemplation, this image of movement acts as an epiphany of the world's pure materiality.

This blind, purely material, destructive force is embodied – even if somewhat more naively – by the figure of Samson in Cecil B. DeMille's 1949 movie *Samson and Delilah*. In the film's central scene, Samson destroys a heathen temple along with all the idols assembled there – thus bringing on the symbolic collapse of the entire old order. But Samson is not depicted as the bearer of a new religion, or even of enlightenment, but simply as a blind titan, a human being wielding the same blind destruction as an earthquake. Acting with a convulsiveness on par with this is the revolutionary, iconoclastic crowd encountered in Sergei Eisenstein's films. In the realm of social and political action, these human masses manifest the blind, material forces that covertly govern consciously perceived human history – exactly as the Marxist philosophy of history describes them. In their historical movement, the masses destroy those monuments designed to immortalize the individual (in Eisenstein's *October 1917* it is the monument to the Char). But the widespread exhilaration with which this anonymous work of destruction is greeted as a revelation of the material "made-ness" of culture is also accompanied by the sadistic, voyeuristic pleasure felt by Eisenstein on watching such barbaric acts, as he readily admits in his memoirs.[8]

7

8

_ Maurice Merleau-Ponty, *Visible et Non-Visible*, Gallimard, Paris, 1973.

_ Sergei Mikhailovich Eisenstein, *Memuary*, vol. 1, Moscow, 1997, pp. 47ff.

Independence Day / director: Roland Emmerich (USA) / 1996 / color / 147 min / filmstills / © Twentieth Century Fox

This erotic, sadistic component of iconoclasm can be sensed even more forcefully in the famous scene in which the "false Maria" is burned in Fritz Lang's *Metropolis* (1926). The blind anger of the masses that erupts here is not revolutionary but counter-revolutionary: although the revolutionary agitator is burned like a witch, she is clearly modeled on the symbolic female figures that, since the French Revolution, have embodied the ideals of freedom, the Republic, and revolution. However, as she is burning, this beautiful, enchanting female figure capable of "luring" the masses is exposed as a robot – in other words, as the "false Maria." The flames deconstruct the female idol of the revolution, unmasking her as a mechanical, non-human construct. The whole scene nonetheless has a thoroughly barbaric ring to it, particularly at the beginning when we are still unaware that she is a machine

insensitive to pain and not a living human being. The demise of this revolutionary idol also paves the way for the true Maria whose arrival restores social harmony by reconciling father and son, upper and lower classes. So, rather than serving the new religion of social revolution, iconoclasm here acts in the interests of the restoration of traditional Christian values. Yet the cinematic means Lang draws upon to depict the iconoclastic masses are not dissimilar to those employed by Eisenstein: in both cases the crowd operates as an elementary material force.

There is a direct link between these early films and countless, more recent movies in which the earth itself, currently acting as the icon of the latest religion of globalization, is destroyed by forces from outer space. In *Armageddon* (1998, dir. Michael Bay) these come in the form of purely

Un Chien Andalou [An Andalusian Dog] / directors: Luis Buñuel, Salvator Dalí (F) / 1928 / black-and-white / 17 min / © Argos Films/British Film Institute

 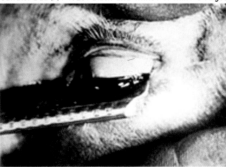

material, cosmic forces that act according to the laws of nature and remain utterly insouciant to the significance of our planet, along with all the civilizations it quarters. The destruction of icons of civilization such as the City of Paris primarily illustrates the material transience of all human civilizations and their iconographies. In an even more radical fashion, the aliens featured in *Independence Day* (1996, dir. Roland Emmerich) might be portrayed as intelligent and civilized beings, but their actions are driven by the laws of an inner expediency that requires them to annihilate all creatures of different origin. In the movie's key scene in which New York is wiped out, the viewer can easily spot Emmerich's indirect polemic against the famous scenes in Steven Spielberg's *Close Encounters of the Third Kind*, depicting the arrival of the aliens. Whereas Spielberg automatically associates the aliens' high intelligence with a peace-loving nature, the superior intelligence of the aliens in *Independence Day* is allied to an unbounded appetite for evil. Here, the other is portrayed not as a partner but as a lethal threat.

This inversion is pursued with even greater clarity and consistency in Tim Burton's movies. In *Mars attacks* (1996) the chief Martian unleashes his campaign of destruction with the altogether iconoclastic gesture of shooting the peace dove that was released as a token of welcome by the gullible and humanistically indoctrinated earthlings. To humankind, this iconoclastic gesture heralds the start of its physical annihilation rather than a new wave of enlightenment. Not restricted to violence against doves, the same threat is also signaled by

October 1917. Ten Days that Shook the World / director: Sergei Eisenstein (USSR) / 1928 / black-and-white / 104 min / film-

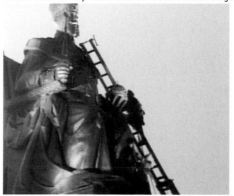
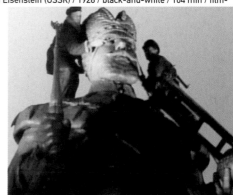

violence against images. The anti-hero of Burton's *Batman* (1989), the Joker, is presented as an avant-garde, iconoclastic artist bent on destroying classical paintings in a museum by overpainting them in a kind of abstract expressionist style. Furthermore, the entire overpainting sequence is shot in the manner of a cheerful music video clip, a *mise-en-scène* of artistic iconoclasm that bears great affinity to Bakhtin's description of the carnivalesque. But rather than lending the iconoclastic gesture cultural significance and neutralizing it by inscribing it into the carnival tradition, the carnivalesque mood of this scene only emphasizes and radicalizes its iniquity.

In more recent movies, such scenes of iconoclasm are by no means an occasion for celebration. Present-day cinema is not revolutionary, even if it still feeds off the tradition of revolutionary iconoclasm. Film never ceased to articulate the unattainability of peace, stability, or calm in a world agog with movement and violence – and, by the same token, the absence of material conditions that would afford us a secure, contemplative, and iconophile existence. As ever, the status quo is routinely brought crashing down and irony is poured onto the trust held by traditional art forms in the power of their motionless images – after all, even the symbol of the peace dove was modeled on an equally famous picture by Picasso. The difference is that now iconoclasm is no longer considered to be an expression of humanity's hopes of liberation from the power of the old idols. Since the currently dominant humanistic iconography has placed humanity itself in the foreground, the iconoclastic gesture is now inevitably seen as the expression of radical, inhumane evil, the work of pernicious aliens, vampires, and deranged humanoid machines. Nonetheless, this inversion of iconoclasm's status is not dictated solely by the current shift in ideology, but is also influenced by the immanent developments within film as a medium. The iconoclastic gesture is now increasingly ascribed to the realm of entertainment. Disaster epics, movies about aliens and the end of the world, and vampire thrillers are generally perceived as potential box-office hits – precisely because they radically celebrate the cinematic illusion of movement. This has spawned a deep-rooted, immanent criticism of film from within the commercial film industry itself, a critical attitude that aspires to bring filmic movement to a standstill.

As an expression and preliminary climax of this intrinsic criticism, we need only turn to *Matrix* (1999, dirs. Andy and Larry Wachovski), a movie that, in spite of its furious pace and proliferation of scenes shot at extreme speed, nonetheless stages the end of all movement – including filmic movement. As the film closes, the hero, Neo, gains the ability to perceive all visible reality as a single, digitized film; through the world's

stills / © Eureka Video

visual surface he sees the incessantly moving code flooding down like rain. In what amounts to a deconstructive exposure of filmic movement, the viewer is shown that this is not movement generated by life or by matter, and not even movement of the spirit, but simply the lifeless movement of a digital code. Here, compared with the earlier revolutionary films of the 1920s and 1930s, we are dealing with a different suspicion and, correspondingly, with a differently poised iconoclastic gesture.[9] As a neo-Buddhist, neo-Gnostic hero who appears on the scene to take up the fight against the evil creators and *malins génies* ruling the world, Neo is now no longer rebelling against the spirit in the name of global materiality, but is an agitator rising up against the illusion of the material world in the name of the critique of simulation. Towards the end of the film, Neo is greeted with the words "He is the One." Neo's way of proving his calling as the new, Gnostic Christ is precisely to halt the movement of the cinematic world, thereby causing the bullets that are about to strike him to stop mid-air.

Here the time-honored, widespread criticism of the movie industry appears to have been adopted by Hollywood as its own theme – and thereby radicalized. As we well know, critics have accused the movie industry of creating a seductive illusion and staging a beautiful semblance of the world designed to mask, conceal, and deny its ugly reality. Then

Matrix appeared and basically said the same, except that in this case, it is less a cinematographically concocted "beautiful facade" that is paraded before us as a complete *mise-en-scène*, than the whole, everyday, "real" world. In movies like *The Truman Show* or, even more comprehensively, *Matrix*, this so-called reality is presented as if it were a long-running "reality show" produced using quasi-cinematographic techniques in some otherworldly studio hidden beneath the surface of the real world. The heroes of such films are figures of enlightenment, media critics, and private detectives all rolled into one, whose ambition is to expose not only the culture they live in, but indeed also their entire everyday world as an artificially generated illusion.

In spite of its metaphysical qualities, *Matrix* too is ultimately trapped in the arena of mass entertainment, and Christian values certainly offer no way out of this context – an insight that is ironically and convincingly illustrated in *Monty Python's Life of Brian* (1979). Not only does this film parody and profane the life of Christ, but it also depicts Christ's death on the cross in the carnivalesque fashion of a music video clip. This scene represents an elegant iconoclastic gesture that channels the martyrdom of Christ into the realm of entertainment, as well as being highly entertaining in its own right. But in the present day, more earnest forms of iconoclasm directed against film are

Matrix / directors: Andy and Larry Wachovski (USA) / 1999 / color / 131 min / filmstills / © Village Roadshow Films, Warner Bros

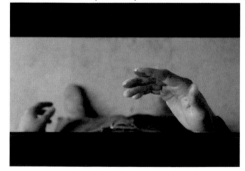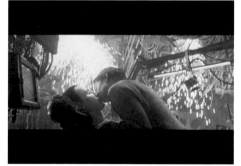

9

_ Boris Groys, *Unter Verdacht. Eine Phänomenologie der Medien*, Hanser, Munich, 2000.

undertaken when film is transferred into the sober context of high art – in other words, into the very context that earlier, revolutionary cinema desired to expose to high-spirited, carnivalesque destruction.

When moving film or video images are presented in an exhibition or a museum space, the way they are perceived is largely determined by our overall expectations of a museum visit – expectations that have been shaped by the long prehistory of our contemplation of motionless images, whether they be paintings, photographs, sculptures, or ready-made objects. In the traditional museum, viewers have total control – at least ideally – over the time they wish to devote to contemplation. They can interrupt their examination of a picture at any time and return to it later on to resume contemplation of the work at exactly the same point as they left it. For the entire period of the viewer's absence the immobile picture will remain in an identical state and is thus constantly available for repeated contemplation.

In our culture we have two fundamentally different models at our disposal that give us control over the time we spend looking at an image: the immobilization of the image in the museum or the immobilization of the viewer in the movie theater. Yet both models founder when moving images are transferred into museum surroundings. The images continue to move – but so does the viewer. Over the past decades,

video art has made various attempts to resolve the antagonism between these two forms of movement. Today, as in the past, one widespread strategy has been to make the individual video or film sequences as short as possible so as to ensure that the time a viewer spends in front of a work does not substantially exceed the time a viewer might on average be expected to spend in front of a "good" picture in a museum. While there is nothing objectionable about this strategy, it nonetheless represents a missed opportunity to explicitly address the uncertainty caused in the viewer by transferring moving images into the museum. This issue is dealt with most arrestingly by films in which a certain image changes only very minimally – if at all – and in this sense it coincides with the traditional museum presentation of a solitary, immobile image.

One pioneering example of such "motionless" films (and one that certainly has an iconoclastic effect, given how it brings the film image to a standstill) is Andy Warhol's *Empire State Building* (1964) – which is hardly surprising considering that the film's author was largely active in an art context. The film consists of a fixed image that barely changes for hours on end. Unlike the movie-goer, however, museum visitors would see this film as part of a cinematic installation, sparing them the risk of getting bored. Since exhibition visitors are not only allowed, but also, as already mentioned, supposed

Monty Python's Life of Brian / director: Terry Jones (U.K.) /

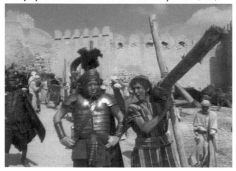

to freely move around the exhibition space, they can leave the room at any time and return to it at a later juncture. Thus, in contrast to a cinema audience, by the end of Warhol's film, museum visitors will not be able to say definitively whether the film consists of a moving or a motionless image, since they will always have to admit the possibility that they might have missed certain events in the film. But it is precisely this uncertainty that explicitly thematizes the relationship between mobile and immobile images within an exhibition context.

Time ceases to be experienced as the time taken by the movement shown in a film's image and is, instead, perceived as the indefinable, problematic duration of the filmic image itself.[10] Hence, the projections of such quasi-immobile film images within an exhibition space demonstrate the precarious, indeterminate, and illusional character of every image-engendered identity – including that of traditional, immobile pictures mounted on a "hard" or "solid" medium. The same can be said of Derek Jarman's celebrated film *Blue* (1993), as it can also be said of *Feature Film* (1999) by Douglas Gordon, a movie that from the very outset was conceived as a film installation. In Gordon's work, Hitchcock's masterpiece *Vertigo* is replaced in its entirety by a film presenting nothing but the music to *Vertigo* and, whenever the music is played, images of the conductor conducting this music. For the rest of the time the screen remains black: here the movement of the music has replaced the movement of the film image. Accordingly, this music acts as a code whose movement is followed by the film, even if on its surface it creates the illusion of "real" movement experienced in the world. This represents the point where the iconoclastic gesture has come full circle: whereas at the beginning of film history it was immobile contemplation that came under attack, by the end this very immobility has been restored to film – as the blind contemplation of a black void. As one is tentatively feeling one's way around the blacked-out installation space trying to get a better sense of orientation, it is difficult not to be reminded of the image of the sliced eye in Buñuel's film – a gesture that promises to cast the world in darkness. ❙

Translated from German by Matthew Partridge

1979 / color / 90 min / © Python (Monty) Pictures

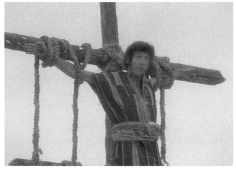 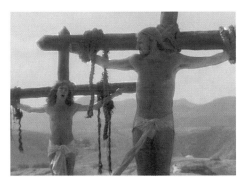

10

_ Cf. Gilles Deleuze, *Das Bewegung-Bild,* Kino 1, Suhrkamp, Frankfurt/M., 1991, pp. 22ff.

ADDICTED TO NOISE. ON VIDEO INSTALLATIONS BY CANDICE BREITZ

Sabine Himmelsbach

»*There is nothing more real than images that we cannot get out of our heads. Nothing has a greater power over us than that which compels our urgent attention.*«[1]

»*A picture held us captive. And we could not get outside it, for it lay in our language and language seemed to repeat it to us inexorably.*«[2]

CANDICE BREITZ'S MULTI-CHANNEL VIDEO INSTALLATION *Babel Series* exposes viewers to a surfeit of stimuli. In a room bathed in monochrome yellow light through the use of color filters, seven TV screens attached to DVD players hang from the ceiling at different heights. On each of the seven screens the same staccato sequences from seven music videos keep repeating, pasted together to form an endless loop, a constant repetition of the unchanging. The artist reduces well-known songs by Madonna, Prince, Grace Jones et al. – icons of modern pop culture – to simple syllables. Madonna, for example, utters no more than PAPAPAPAPAPAPA, like a small child, and Prince EYEYEYEYEYEYE. The narrative structure of the music clips disintegrates and is reduced to a minimum level of articulation consisting of only a few vowels and consonants; the confusion of language assumes Babylonian proportions. The whole room becomes a deafening wall of sound, a cacophony.

The color of the room heightens the atmospheric effect, but here cult objects of religious worship have been replaced by the stars of our modern TV and video culture. Breitz renders unbearable the icons of our popular culture, the idols of a generation. The growing flood of stimuli in our image-dominated culture forces us to express ourselves more and more "loudly" in order to make ourselves heard above this torrent of images. In her installation *Babel Series* (1999) she has taken this tendency towards self-amplification to the extreme.

Candice Breitz grew up in South Africa. She works with found-footage material, which she takes from the magazines and TV programs of today's popular culture, arranging it into frightening new images. In her *Rainbow Series* (1996) she crudely combines pictorial material from pornographic magazines with ethnic postcard motifs from the South African tourism industry to produce hybrid bodies. In *Babel Series* music clips taken from music channels such as MTV served as her starting point. Using the digital cut and paste method she has come up with works in which her intervention consists of selecting and rearranging existing material.[3] To Breitz it is important to produce unambiguous cuts. Her *ready-made* images are a part of our cultural heritage, we are familiar with them, we perhaps even know the songs, even if they are completely dislocated in her manipulated versions. One action shot from a TV image is frozen, and thus idealized. Simultaneously, by freezing the image she destroys it, for its legibility is neutralized. Breitz takes her orientation from the current TV practice of constant channel-zapping. Jonathan Crary talks about the meaning-giving function of zapping, which, like sampling in the music context, uses new associations to create new content. "Television today is primarily a switching device, one which derives meaning solely from the connections it makes, breaks, or modifies."[4]

In her work *Soliloquy Trilogy* (2000), the original material comes from the movie world. Breitz painstakingly reprocesses *Basic Instinct* with Sharon Stone, *The Witches of Eastwick* with Jack Nicholson and *Dirty Harry* with Clint Eastwood in the leading roles, cutting out all the scenes not featuring the stars, along with all those where there is no speaking. Thus reduced, the resulting film composition consists entirely of scenes in which the leading actor is engaged in conversation.

3 2 4 1

_ Georg Franck, *Ökonomie der Aufmerksamkeit. Ein Entwurf,*
Hanser, Munich and Vienna, 1998, p. 172.

_ Ludwig Wittgenstein, Philosophical Investigations, quoted by W. J. T. Mitchell (ed.),
The Language of Images, The University of Chicago Press, Chicago, 1980 (1974), p. 271.

_ Candice Breitz: "TV became more interesting as an instrument once technology made it possible to rewind,
search for, pause, repeat and delete recorded material, when it became an instrument that more people could
use for themselves." (in *Televisions. Kunst sieht fern,* Kunsthalle Wien, Vienna, 2001, p. 201).

_ Jonathan Crary, Eclipse of the Spectacle, in Brian Wallis (ed.),
Art After Modernism. Rethinking Representation, The New Museum of
Contemporary Art, New York, 1984.

Candice Breitz / Babel Series / 1999 / DVD installation (9 looping DVDs) / stills / © Candice Breitz

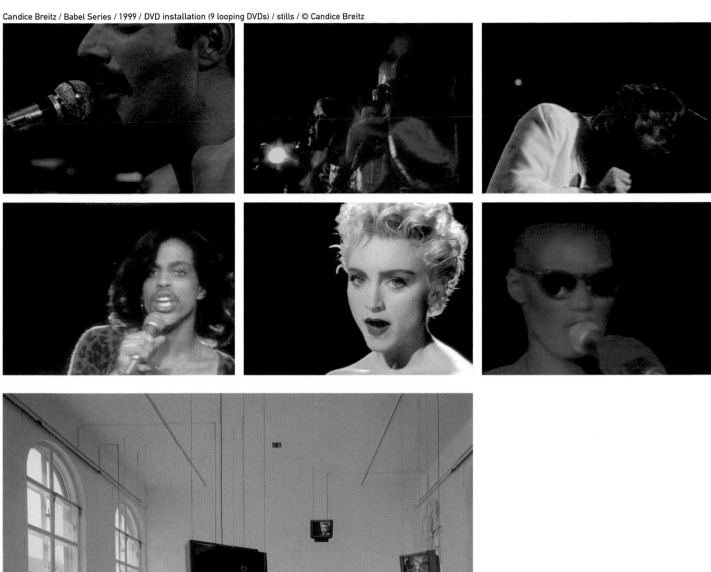

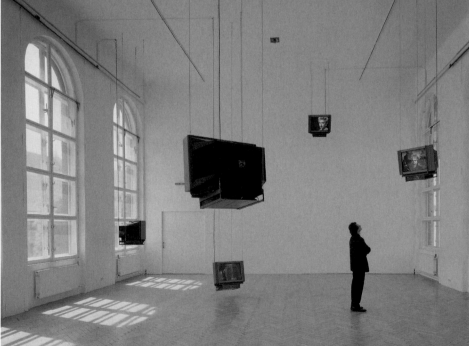

Candice Breitz / Babel Series / 1999 /
DVD installation (9 looping DVDs) / installation view
O.K. Center for Contemporary Art, May 2001 /
courtesy Galerie Johnen + Schöttle, Cologne /
© Candice Breitz / © photo: Jason Mandella

The outcome is an incoherent monologue, a soliloquy that is completely lacking in content and devoid of all meaning. From these one and a half hour feature films Breitz has distilled 14:06:25 min (Jack), 7:11:03 min (Sharon), and 6:57:22 min (Clint).

This work is reminiscent of the early films of Andy Warhol, which are known as his screen tests. In an interview, Warhol explained his fascination with the cult of the star and with the idea of making stars out of the actors in the screen tests, who were on camera for three minutes. "I made my earliest films using, for several hours, just one actor on the screen doing the same thing: eating or sleeping or smoking; I did this because people usually just go to the movies to see only the star, to eat him up, so here at last is a chance to look only at the star for as long as you like, no matter what he does and to eat him up all you want to. It was also easier to make."[5]

In Breitz's *Soliloquy Trilogy* the way the film is cut also appears to be motivated by the desire to focus entirely on the stars, somehow the essence of the movies, to gaze at them repeatedly in an endless loop, to be able to eat them up. This fundamentally iconophilic gesture is ruptured by the aggression caused by the dislocation of narrative structure. All contextual coherence has become lost and the process of eating up one's favorite star can easily reach the saturation point. In her photo work, all kinds of pictorial material has simply been stuck together; the scars and joints remain unhidden, visible. The cuts in the videos are similarly harsh. There is no indication of any attempt to link the sequences by means of gentle transitions. Similar to the torrent of images to which we are exposed day for day, here too, one scene follows directly from the next, and each stands alone. Breitz exposes the banality of the mass media, she confronts us with this surfeit of stimuli in a cacophony of images and scraps of speech. The modern icons of mass society enervate and impinge upon us.

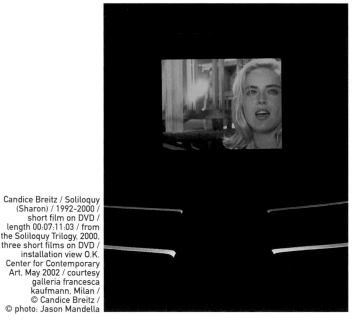

Candice Breitz / Soliloquy (Sharon) / 1992-2000 / short film on DVD / length 00:07:11:03 / from the Soliloquy Trilogy, 2000, three short films on DVD / installation view O.K. Center for Contemporary Art, May 2002 / courtesy galleria francesca kaufmann, Milan / © Candice Breitz / © photo: Jason Mandella

Candice Breitz / Soliloquy (Jack) / 1987-2000 / short film on DVD / length 00:14:06:25 / from the Soliloquy Trilogy, 2000, three short films on DVD / background: screening of Soliloquy (Jack) at the Atlantis Gallery (The Old Truman Brewery) in London, during the event My Generation: 24 Hours of Video Art, April 2001 / all filmstills captured by the artist and Michael Lantz / courtesy galleria francesca kaufmann, Milan / © Candice Breitz / © photo: Jason Mandella

5

_ Gretchen Berg, Nothing to loose: Interview with Andy Warhol, in *Cahier du cinema in English*, 10 May 1967, p. 40.

How can an image represent anything?

IMAGES SCATTER INTO DATA, DATA GATHER INTO IMAGES

Peter Galison

1. Forbidding the Required Image

Stepping back from the specific sciences, a powerful theme running through them comes into view, one central to the arguments and evidence they produce. In brutally short form, it is this:

"We must have images; we cannot have images."

We *must* have scientific images because only images can teach us. Only pictures can develop within us the intuition needed to proceed further towards abstraction. We are human, and as such, we depend on specificity and materiality to learn and understand. Pictures, sometimes alone, often in sequences, are stepping stones along the path towards the real knowledge that intuition supports. First, Plato says, we grasp the triangle in the sand, then the triangle drawn more finely, then triangles in general, then the idea of triangles behind all particularities of individual triangles. But the virtue of pictorial representation goes beyond pedagogy and abstraction – it extends to discovery. For we can ask: What are we humans good at? We are good at recognizing and seizing upon visual patterns. We grasp family relationships among tactile-visual forms, we extend, modify, innovate on the basis of intuition *(Anschaulichkeit)*. Perhaps this is because the long process of evolution has left us with a pattern-recognition capability well matched to the world. Perhaps it is a psychological or socialized virtue inculcated by experience. But whatever its source, the power of pattern recognition is a crucial feature of scientific discovery; one we cannot and should not forego. Finally, beyond pedagogy or even epistemology, images get at the peculiar – the unique – features of nature in a way that a calculation or verbal description can never do. By mimicking nature, an image, even if not in *every* respect, captures a richness of relations in a way that a logical train of propositions never can. Pictures are not just scaffolding, they are the gleaming edifices of truth itself that we hope to reveal. So goes the brief for the scientific image: pictures are pedagogically, epistemically, and metaphysically inalienable from the goal of science itself.

And yet: we *cannot* have images because images deceive. Pictures create artifactual expectations, they incline us to reason on false premises. We are human, and as such are easily led astray by the siren call of material specificity. Logic, not imagery, is the acid test of truth that strips away the shoddy inferences that accompany the mis-seeing eye. Abstraction, rigorous abstraction, is exactly that which does not depend on pictures. Abstraction properly conducted proceeds through the formal, the logical, and the systematic. Rigorous, logical *non*-intuitive reasoning is the royal road to knowledge. For that, knowledge is not and should not be restricted to the paltry part of nature that our visual imaginations can conjure out of daily experience. So when we ask what we are capable of knowing, we must put aside the childish playthings of the pictorial. Pedagogy and epistemology ought to be set right to prepare the mind for right reasoning. After all, we are capable of a cognitive austerity that refuses to stare at the seductive image and instead demands hard-edged, uncompromising understanding. If pictures cannot be drawn of the very large, the very small, or the very complex, so be it. Training, discovery, and truth are all dependent *only* on unambiguous propositions and their logical arrangement. So the scientific iconoclast announces: In the end, the truths of the world will be given to us by the relentless application of logic tied strategically to experiment; truth is something wider and deeper than the pictorial imagination can ever hope to encompass.

For the last hundred and fifty years, and perhaps even longer, the sciences have been caught in this endless struggle. In my field of science studies, before the 1970s, there was a tendency to dismiss the pictorial, to de-emphasize the role of the pictorial in the development and present conduct of science. Then came a reversal: widespread acclimation to the idea that science was overwhelmingly about the visual.

Pictures, taken to be both more local and more contingent than propositions, entered as exhibit A in the case against science-as-algorithm. Trying to settle this battle between the picture-local and the proposition-universal strikes me as a losing bet.

My goal instead is neither to bury the scientific image nor to sanctify it, but rather to explore the ways in which the sciences find themselves locked in a whirling embrace of iconoclasm and iconophilia. That sudden, powerful opposition-attraction between wanting to know with eyes-open and wanting to know with eyes-closed has produced some of the most turbulent and generative times in the history of science. These are the moments of the iconoclash.

Back in the 1880s, Henri Poincaré, one of the era's best known mathematicians, philosophers, and physicists, reflected on the role of qualitative, visually-oriented work in mathematics. Looking over older mathematical books, he said; contemporary mathematicians saw work punctuated with lapses in rigor. In light of these lacunae, many of the older concepts – point, line, surface, space – now seemed absurdly vague. The proofs of "our fathers" (as Poincaré put it) looked like frail structures unable to support their own weight, desperately in need of repair. Wielding the sharp axe of logic, a new generation had hacked the old knowledge to ribbons by finding logical counter-examples to received mathematical wisdom.

Poincaré: we know, as "our fathers" did not, that there are crowds of bizarre functions that "seem to struggle to resemble as little as possible the honest functions that have some useful purpose." (One thinks: honnêtes fonctions for honnêtes hommes.) These newfangled functions might be continuous and yet be constructed in such a peculiar way that it was impossible to define their slopes. Worse yet, Poincaré lamented, such strange logical constructs seem to be in the majority. Simple laws seem to be nothing but particular cases, islands of order in a vast sea of bizarre and complex ones. There was a time when new functions were invented to serve practical goals; now mathematicians invent new functions purely to show how these assemblages escaped from and refuted the faulty proofs of the great mathematical predecessors. If we were to follow a strictly logical road, Poincaré added, we would familiarize beginners, from their very start in mathematics, with this "teratological museum" of monstrous proof-destroying functions.

But such a teratological museum was not one Poincaré counseled his reader to visit – neither students nor pure mathematicians. In mathematical education, he argued, intuition ought not be counted least among the faculties of mind to be cultivated. For however important logic was, it was by way of intuition "that the mathematical world remains in contact with the real world; and even though pure mathematics could do without it, it is always necessary to come back to intuition to bridge the abyss which separates symbol from reality." Practitioners *always* needed intuition and for every pure geometer there were a hundred practitioners. But Poincaré's case against rampaging logic applied equally to experts; even pure mathematicians need intuition. Logic surely was important for demonstration and criticism, but intuition was the key to creating new theorems and inventing new mathematics. As far as Poincaré was concerned, without intuition the mathematician was like a writer shackled forever in a cell with nothing but grammar. Addressing his fellow teachers, Poincaré urged them to emphasize the intuitive and to abandon their cultivation of those monstrous functions that now roamed the earth with the sole purpose of haunting the legacy of our mathematical ancestors.[1]

Poincaré followed, or tried to follow, his own advice. For much of his career he relied exclusively on the "honest functions" in whose company a practical man would want to be seen. He drew and suggested pictures incessantly, taking on problems that were at one and the same time physically real, visualizable, and mathematically engaging. One such problem was the stability of the solar system.

1

_ Henri Poincaré, La Logique et l'intuition dans la science mathématique et dans l'enseignement, in *Oeuvres*, 11, pp. 129-133, citation on p. 132. The discussion of Poincaré is drawn from Peter Galison, *Einstein's Clocks, Poincaré's Maps*, W.W. Norton, New York, forthcoming.

In a contest set in the 1880s, Poincaré submitted a set of remarkable demonstrations of the stability of the solar system. Amid much fanfare he won. Then one of the examiners spotted an ambiguous move deep in the prize paper and wrote Poincaré for clarification. A moment of stunned silence. Poincaré confessed that as he had pulled on the problematic thread that the proofreader had spotted, the whole of the argument had begun to unravel. What he had hoped was an insignificant exceptional case proved to be anything but, and in the effort to patch the tear he had had to re-weave the whole cloth – and created the physics of chaos.

Poincaré had aimed to show that, within a small range of error, the planetary system would continue to cycle as it had always done. Instead, he found that a solar system with even three objects (say a Jupiter-like planet, an earth-sized planet, and an asteroid) would, under a wide variety of conditions, spiral far from the tranquil orbits with which it began. By the time he wrote up his famous trilogy of books, *New Methods in Celestial Mechanics,* it was abundantly clear that his pictorial imagination had met its match. Honest functions had run amok:

When we try to represent the figure formed by these two curves and their infinitely many intersections, each corresponding to a doubly asymptotic solution, these intersections form a type of trellis, tissue, or grid with infinitely fine mesh. Neither of the two curves must ever cut across itself again, but it must bend back upon itself in a very complex manner in order to cut across all of the meshes in the grid an infinite number of times.

"I shall not even try to draw it," Poincaré added, yet "nothing is more suitable for providing us with an idea of the complex nature of the problem."[2] Beginning with a pedagogical, philosophical, and practical bent for the geometrically-visualizable, Poincaré faced a blank page that would not fill.

In what at first may seem an equally peculiar turn of fate, late in life Poincaré found himself in precisely the opposite situation. Having struggled desperately for years to prove a theorem about the three-body problem, to find a universal rule, Poincaré bowed to his age and health. To the editor of the journal he had published in for years, he confided: "What embarrasses me is that I will be obliged to put in a lot of figures, precisely because I could not arrive at a general rule, but I only accumulated particular solutions."[3] I said that Poincaré's embrace of provisional pictures only at first seems peculiar because there is a strong sense in which I think it is not at all out of the ordinary. In the sciences of the last century and a half, the pictorial and the logical have stood unstably perched, each forever suspended over the abyss of the other.

Through geometry – through his hunt for a stable, pictorially-oriented geometry, Poincaré had come to a point where complexity had overwhelmed the pictorial. Conversely, through the search for a general rule he had been driven to pictures.

Quite aside from the intrinsic importance of Poincaré's work – the launch of many decades of work on chaotic phenomena – this twin reversal brings us to a more general state of affairs. At the heart of the scientific image is the search for rules; at the heart of the logical-algorithmic has been a hunt for the recognition that is the eternal promise of representation. Said another way: the impulse to draw the world in its particularity never seems to be able to shed itself of the impulse to abstract, and that search for abstraction is forever pulling back into the material-particular.

The strain of the abstract-concrete winds throughout the history of mathematics; Poincaré's concerns were by no means unique. Dutch mathematician Luitzen Brouwer, for example, devoted much of his life to defending the view that mathematics was about truth, and that the true existence of mathematical objects could only be established by constructing them. That is, if you wanted to show that there was a

2

_ Henri Poincaré, *New Methods of Celestial Mechanics*, trans. Daniel Goroff, American Institute of Physics, New York, 1993, vol. 3, section 397, p. 1059.

3

_ Gaston Darboux, Eloge, p. LXVII. Memoire published Rendiconti del Circolo Matematico di Palermo, t. XXXIII, session of 10 March 1912, reprinted in Poincaré, op. cit.

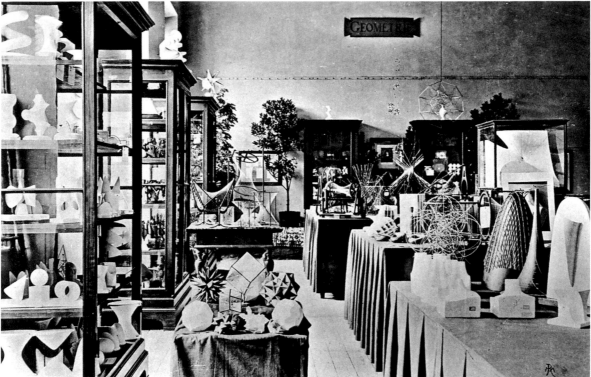

Geometry Room / 1893 / model exhibition at the Technische Hochschule, Munich, in celebration of the third annual meeting of the German Mathematical Union / © photo: Archive Deutsches Museum, Munich

Mathematical models were designed to inculcate a visual-intuitive understanding of mathematical concepts that were otherwise hard or even impossible to picture: shadows of four-dimensional objects, newly contrived mathematical functions, topological relations, or non-Euclidan geometries.

function that oscillated a certain way below x = 1 and then rose exponentially above x = 1, you had to actually exhibit it. Logic, by contrast, was at best a helpmate in the foundations of mathematics; the notion that logic was absolutely valid was anathema to him (as he made clear in 1908 with "On the Untrustworthiness of Logical Principles").

David Hilbert violently disagreed. As far as Hilbert was concerned, the goal of mathematics was not so much to construct particular mathematical entities (functions, geometries, spaces), but to demonstrate that the starting assumptions did not lead to a contradiction. So for Hilbert (as indeed for most mathematicians) existence was not at all a matter of having to construct the object in question: If the assumption that a certain function did *not* exist led to a contradiction, then the

function existed. Period. The *reference* of mathematical symbols was nothing. Hilbert's mathematics was syntactic, not semantic or in Herbert Mehrten's terms "modern" rather than "counter-modern."[4] Even geometry did not *say* anything. As Hilbert was supposed to have quipped, the propositions of geometry would be just as true if one took every occurrence of "line," "point," "plane" and replaced them with "table," "chair," and "mug." In the end, mathematics was a combination of abstract rules and meaningless signs, for which the fascination with construction, intuition, and models was irrelevant.

In the end, neither side could win this war. Brouwer, whose maximalist position held that all mathematics should be founded on his intuitionist foundations, and who rejected

4

_ Herbert Mehrtens, *Moderne Sprache Mathematik*, Suhrkamp, Frankfurt/M., 1990.

the principle of the excluded third ("A or not A"), failed to persuade his contemporaries who were unwilling to abandon the enormously powerful proof by contradiction. And Hilbert, in spite of his vast accomplishments in mathematics, after Kurt Goedel had to concede that his program of providing a unified foundation for all mathematics was also doomed to failure. But the representation of a pure Hilbert, a Hilbert utterly disdainful of the intuitional-pictorial, is problematic in other ways. Hilbert's friend and ally Hermann Minkowski made essential use of the *Anschaulich* when he took that most unvisualizable domain of mathematics – pure number theory – and showed that it could be radically reconceptualized in *visual* terms. Minkowski's treatise, *The Geometry of Numbers*, became one of the classic works in modern number theory and Hilbert supported him unstintingly. Minkowski then performed the same trick a second time when he showed that Einstein's relativity theory itself could better be understood in geometric-pictorial terms. Push on the logical-numeric and out comes the pictorial-geometric. Even in his own later writings, Hilbert left behind the polemical moments that are often seized upon to show the purity of his logicism. He found himself pulled towards the intuitive-visualizable in his work on geometry:

"In mathematics, as in any scientific research, we find two tendencies present. On the one hand, the tendency toward *abstraction* seeks to crystallize the *logical* relations inherent in the maze of material that is being studied, and to correlate the material in a systematic and orderly manner. On the other hand, the tendency toward *intuitive understanding* fosters a more immediate grasp of the objects one studies, a live *rapport* with them, so to speak, which stresses the concrete meaning of their relations.

As to geometry, in particular, the abstract tendency has here led to the magnificent systematic theories of Algebraic Geometry, of Riemannian Geometry, and of Topology; these theories make extensive use of abstract reasoning and symbolic calculation in the sense of algebra. Notwithstanding this, it is still as true today as it ever was that intuitive understanding plays a major role in geometry. And such concrete intuition is of great value not only for the research worker, but also for anyone who wishes to study and appreciate the results of research in geometry."[5]

These remarks introduced a book where Hilbert celebrated the diagrammatic and intuitive on practically every page. But the power of the pictorial was not just registered in Hilbert's writing. No, the trace of these late nineteenth century debates is left in many German, or for that matter French, American, or British, mathematics departments. Dig around the attics and closets of any older department in the United States, for example and, more likely than not, you will find stunning three-dimensional models of different mathematical functions.

Mathematical models seem to have originated with Gaspard Monge in the Ecole Polytechnique of the early nineteenth century. Carried on by his disciples, the tradition prospered for some years before dying out during the last third of the 1800s. By contrast, in Germany the tactile-visual approach to mathematics flourished in just those late nineteenth century years – strongly pushed by mathematicians Felix Klein and Alexander Brill. Designed originally for three specifically mathematical purposes, models fit perfectly into a widening German enthusiasm for joining practical and abstract concerns throughout the sciences.

Models offered Klein, Brill, and their allies a direct method of teaching; they promised to give students a tactile, sensory-based intuition of the objects of their research; and they served as concrete symbols of the many newly-created mathematical institutes. Painstakingly assembled from wood and plaster, wire and paper, glass and brass, publishing companies began to sell these incarnated abstractions, converting, as it were, textbooks into textobjects. Here one

5

_ David Hilbert and Stefan Cohn-Vossen, from the Preface to *Geometry and the Imagination*, AMS Chelsea Publications, New York, 1952, p. III.

Boy's surface / wire model / collection of the mathematics institute
of the University of Göttingen

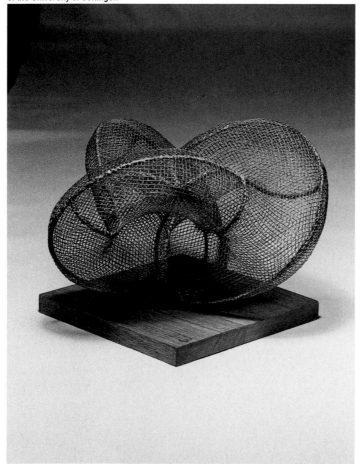

Clebsch diagolnal surface / model / c. 1870 / collection of
the mathematics institute of the University of Göttingen

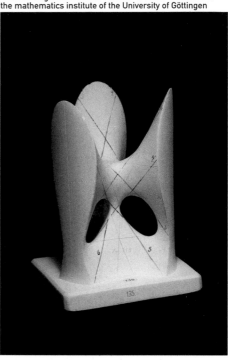

P-function / plaster model / © from: Gerd Fischer,
Mathematische Modelle, Vieweg & Sohn,
Braunschweig/Wiesbaden, 1986, p. 126, fig. 129
The model is one of mathematician Karl Weierstrass'
new and highly »unintuitable« mathematical creations

Apollo Belvedere / model / c. 1827 / collection of the
mathematics institute of the University of Göttingen

Picturing Bohr Orbits /
© from: H. A. Kramers, Helge
Holst, Das Atom und die
Bohrsche Theorie seines
Baues, Julius von Springer,
Berlin, 1925, p. 193

Following Bohr's early work
physicists began drawing the
new allowed orbits for
electrons. Even here certain
features were excluded from
those that could be drawn –
transitions between orbits had
no continuous representation.
When Heisenberg extended
the Bohr theory, he at first
argued strenuously that visual
intuition was impossible.
In the canonical formulation of
quantum mechanics in the
»Copenhagen interpretation« a
new form of visualization was
sanctioned, but one much
more limited than the pictures
of the old quantum theory.

Kramers u. Holst, Das Atom.

Radium (88)

finds gears within gears driving spiro-graphic displays of ellipses, cycloids, and other functions. There are perfect polyhedra, space-filling shapes, close-packed spheres. More abstractly there were also models of four-dimensional shapes projected into three dimensions – a kind of materialized shadow of forms beyond our normal sensory grasp. There are models too that were cast to reveal the behavior of special functions, some only just recently concocted by mathematicians like Karl Weierstrass. Eventually, even the German mathematicians sidelined these plaster, paper, wood, and wire sculptures as more formal conceptions of the discipline gained ascendancy. But for decades, supported by the indefatigable Klein, they served not only to teach "spatial intuition" to generations of students, but to advance funda-

mental research into descriptive geometry, differential geometry, and topology.[6]

2. Picturing the »Unanschaulich«

This instability between image and logic, number and diagram, syntax and semantics appears again and again, not just in mathematics. From the earliest days of quantum mechanics in the 1910s, visualization was on trial. Back then, physicists wanted to draw pictures of the atom with electrons sailing around the nucleus, and yet Niels Bohr refused to picture how an electron could ever jump from one orbit to another. You could ask about the energy of the electron's stable starting orbit. You could discuss the electron's orbit after it jumped.

6

_ Ulf Hashagen, Der Mathematiker Walther von Dyck als Ausstellungsorganisator und Museumsgründer, Arbeitspapier, Münchner Zentrum für Wissenschafts· und Technikgeschichte, 1999; Ulf Hashagen, Walther von Dyck (1856-1934). Mathematik, Technik und Wissenschaftsorganisation an der Technischen Hochschule München, Steiner, Stuttgart, forthcoming. I would like to thank Ulf Hashagen for many helpful comments.

That was enough to calculate how much energy must be released – and the colors of light that must be emitted. But neither Bohr nor his theory had anything to say about the inner workings of the transition – about *how* the electron got from its starting orbit to its ending one. Or rather they did have something to say: Here was a case of *ignorabimus*; we cannot know, it is beyond what it is given to us to know. We must neither speak nor draw of the transitions.[7]

Bohr's quantum non-visualization was more than simply a matter of not knowing the transitional path of the electron; it was not, for example, like the practical ignorance that we have about the detailed positions of all the air molecules in the room. No, it was more than that, more a matter of the way things are than of our state of knowledge. Bohr's injunction against visualization was a metaphysical rather than an epistemological iconoclasm.

Werner Heisenberg seized on Bohr's idea and developed it much further by systematizing methods of calculation so that Bohr's techniques could extend to much more complicated problems. For example, if an atom had four possible orbits, A, B, C, and D, Heisenberg wanted a new mechanics that would take into account all the ways for an electron to get from A to D. For example it could proceed by A->B->C->D; or it could leap A->C->B->D. Or it could follow any of the other permissible paths. The results of Heisenberg's methodical summary of these transitions was an array of numbers along with a set of rules for how to manipulate these arrays. Known as matrix mechanics, the new methods provided physicists with a dramatic new way of approaching the microworld. Calculate things that could be observed, said Heisenberg, calculate spectral lines, or calculate scattering patterns: but abandon the doomed attempt to visualize the inner recesses of the atom. Heisenberg's was a stunningly successful program, as his calculation tools cracked open a myriad of problems in the physics of the very small. But the price was clear and pushed Bohr's injunction against visualization even

further. For Heisenberg too it was forbidden to ask about what causes an electron to take a leap, or how the electron effects the transition between orbits. But while Bohr worried about limits to spatial-visual intuition, Heisenberg celebrated it.[8]

The cultured, sometimes mystical Austrian physicist Erwin Schrödinger clashed furiously with Heisenberg over the role of pictorial intuition in physics. "I knew of [Heisenberg's] theory, of course," Schrödinger acidly remarked, "but felt discouraged, not to say repelled, by the methods of transcendental algebra, which appeared very difficult to me and by the lack of visualizability." Vision was what Schrödinger wanted – vision, and an understanding of the detailed processes that underlay what we could see with our eyes or our instruments. His "wave mechanics" explained important pieces of the experimental puzzle by treating particles as waves and examining the ways in which they scattered. Heisenberg's reaction was as visceral as Schrödinger's: Schrödinger's visual wave theory was "disgusting" Heisenberg confided to colleague, Wolfgang Pauli.[9]

Canonizing both viewpoints in the "Copenhagen interpretation," Niels Bohr forced a tense cease-fire: under some circumstances the Heisenberg view would prevail and one would have only numbers and the laws that spoke of conserved quantities (conservation of energy and momentum, for example). In these cases any talk of a particle's trajectory was strictly forbidden on pain of deriving nonsensical predictions. But under other experimental set-ups it would be perfectly possible to speak of a particle's trajectory through space and time – and in those circumstances all hope of applying the conservation laws would be lost.

Other kinds of visibilities emerged, mutated, shifted. Paul Dirac, often called the "theorist's theorist" came from a modest Bristol background and received the worker's heavily geometric technical training typical at the turn of the century in England. Geometry, in fact, became his touchstone, and his key to moving up and out of his origins.

7

9

8

_ Miller, op. cit.; on Heisenberg: David Cassidy, *Uncertainty: The Life and Science of Werner Heisenberg*, Freeman, San Francisco, 1992; and on Schrödinger: Walter Moore, *Schrödinger: Life and Thought*, Cambridge University Press, Cambridge, 1989.

_ Heisenberg letter to Pauli, cited in Miller, op. cit., p. 89.

_ On visualization in quantum mechanics, see A.I. Miller, Visualization Lost and Regained: The Genesis of the Quantum Theory in the Period 1913-27, in Judith Wechsler (ed.), *On Aesthetics in Science*, The MIT Press, Cambridge, MA, 1978.

As he raced through the university in Bristol towards Cambridge University and through Cambridge towards the physics of the Continent, Dirac found his geometry less and less valued. Among the Cambridge mathematicians, Godfrey Harold Hardy was just then fulminating against what he considered the destructive, useless Tripos exams. For years those examinations had run on tradition, sorting students from the top-rated wrangler on down, demanding geometrical-visual and mnemonic skills that Hardy considered

Feynman Diagrams / eight-order vertices obtained by insertion of sixth-order (single electron loop) vacuum polarization subdiagrams in a second-order vertex / © from: T. Kinoshita, W.B. Lindquist, Eighth-order Magnetic Moment of the Electron. I. Second-order Vertex containing Second-, Fourth-, and Sixth-order Vacuum Polarization Subdiagrams, Physical Review D, 27, 4, 1983, pp. 867-868, on p. 868

Each line and vertex in a Feynman diagram corresponds to a calculational rule. So to draw the possible ways in which particles interact is already to set up a precise mathematical problem. The Feynman diagrams shown here are just some of the hundreds that T. Kinoshita and his group used to calculate one of the most precise theoretical predictions in all of physics, the magnetic strength of an electron.

antiquated. At the same time, looking towards the continent, Dirac found in the young Heisenberg a guide to a new mechanics that had no more time for the visual than Hardy had in mathematics.

In the face of this new anti-visualism, Dirac soon came to be known for his ascetic, logically crystalline work. Throughout his books and papers on the new quantum theory, diagrams are as rare as hens' teeth. Yet behind the curtain all was different. Squirreling his private calculations into the recesses of his rooms, Dirac scrawled hundreds of geometrical pages. Diagrams spilled over into the margins and down the page. Pedagogy and metaphysics, on the public side, kept to a strict logical-analytical exposition, cleansed of images. Meanwhile, in the private domain, in the realm of the epistemic, pictures ruled.[10]

Over and over this clash has repeated itself over three distinct axes: How visual-intuitive should teaching be? What role does visualization play in discovery? What is the reality-status of the picture? When physicists tried to use quantum mechanics to understand a force at the quantum level (such as the electric field in terms of photons), the fault line resurfaced. Just after World War II, Richard Feynman developed a way to use pictures to imagine how quantum field theory worked. He said, in effect: Do you want to know how an electron goes from A to B? Then consider all the ways that you can draw diagrams of electrons, their emission and absorption of photons, and the intermediate production of electron-positron pairs. Each piece of the diagram corresponded to a calculation rule, so when you finished drawing you had a straightforward mathematical problem to solve. Soon physicists were as facile with these diagrams as they had been with electronic schematics.[11] For Julian Schwinger that was just the problem. Schwinger, then at Harvard, hated Feynman's diagrams. As far as Schwinger was concerned, the diagrammatics taught physicists to treat theory as an assembly of modules, a process that could proceed without thinking. Pictures

10 11

_ Peter Galison, The Suppressed Drawing: Paul Dirac's Hidden Geometry, in Representations, Fall, 2000, pp. 145-166.

_ Silvan Schweber, QED and the Men Who Made It: Dyson, Feynman, Schwinger, and Tomonaga, Princeton University Press, Princeton, 1994; Peter Galison, Feynman's War: Modelling Weapons, Modeling Nature, in Studies in the History and Philosophy of Modern Physics, 29, 1998, pp. 391-434; David Kaiser, Stick-Figure Realism: Conventions, Reification, and the Persistence of Feynman Diagrams, 1948-1964, in Representations, 70, 2000, pp. 49-86.

Eric J. Heller /
Correspondence / 1997 /
LightJet Digital Imager /
© Eric J. Heller

Correspondence between the
quantum waves (black)
and classical motion (red).

reduced calculations to algorithmic routines. Inevitably perhaps, computers would calculate a process. All you need do was to shift around the lines and nodes with a light pen on a cathode-ray tube. Schwinger dismissed this plug-and-play theorizing the way older car mechanics look down on their younger successors who think engine repair means sticking a jack into a microcircuit and ordering a replacement over the Internet. By black-boxing physical processes, thought more traditional physicists, their younger colleagues had lost a grasp of the inner workings of physics. Feynman, Schwinger often lamented, had "brought quantum field theory to the masses." For the formal, methodical Schwinger, that was the kiss of death.

So Schwinger laid down the law, forbidding his doctoral students to use Feynman's diagrammatic calculations. Needless to say, the students quickly learned to calculate with Feynman vision in private, and then to translate their results into the bare formalism their advisor demanded. De jure, aniconic; de facto, iconic. And yet a commitment towards one kind of visualization is not necessarily a commitment to them

all. As Feynman turned his sights towards Einstein's general theory of relativity, he was not at all interested in continuing the geometrical views of Einstein – or of his own teacher John Wheeler, who later published a gigantic diagram-crammed volume on what he called "geometrodynamics." Geometry may well have been Einstein's guide, said Steven Weinberg (following Feynman's approach), but it was now nothing but a roadblock isolating gravity from insights gained in the rest of physics. When he was done smashing the idols, the diagrams were completely gone: Weinberg's text does not have a single one.[12]

The long struggle over visualization in quantum mechanics has continued. Ever since the time of Bohr, Heisenberg, and Schrödinger, physicists have taken as gospel the idea that, within certain limits, quantum mechanics should reproduce classical mechanics. Formally known as the correspondence principle, this grounding of quantum mechanics in the classical provided a test of the new theory's validity. In addition, the correspondence principle gave an intuitive understanding of

12

_ Charles W. Misner, Kip S. Thorne, and John A. Wheeler, *Gravitation*, W.H. Freeman, San Francisco, 1973; Steven Weinberg, *Gravitation and Cosmology: Principles and Applications of the General Theory of Relativity*, John Wiley, New York, 1972, p. vii. On Feynman and gravity: David Kaiser, A Psi is just a Psi? Pedagogy, Practice, and the Reconstitution of General Relativity, 1942-1975, in *Studies in History and Philosophy of Modern Physics*, 29, 1998, pp. 321-338.

Art of Physics, Physics of Art / Eric J. Heller's work began as an effort to explore the relation between classical and quantum physics. Over the last years he has expanded his interest in images both in his physics and in his artistic careers. Heller: »There is a connection, a feedback from the science to the art and back again. In me, this has happened many times and has led to new scientific discoveries through the attempt to produce art. In the viewer and also in me, I strive for a feedback of a different kind, namely, I want the scene being rendered to evoke emotion and familiarity; this the viewer can project back onto the science behind the image to sense the power and mystery in the world of quantum mechanics and the microscopic chaos which is just under the surface.«

Eric J. Heller / Transport II /
2000 / LightJet Digital Imager
/ © Eric J. Heller

Electrons launched from the
center in all directions fan and
then form branches, as
indirect effects of traveling
over bumps

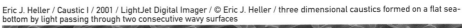

Eric J. Heller / Caustic I / 2001 / LightJet Digital Imager / © Eric J. Heller / three dimensional caustics formed on a flat sea-bottom by light passing through two consecutive wavy surfaces

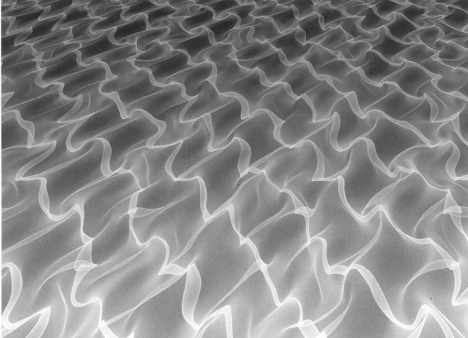

Eric J. Heller / Monolith / 2000 / LightJet Digital Imager / © Eric J. Heller / perspective of random wave in two dimensions

Eric J. Heller / Random Synthesis / 2000 / LightJet Digital Imager / © Eric J. Heller / lines produced by the addition of wave sets produce a random wave in the central region

Eric J. Heller / Transport IV / 2000 / LightJet Digital Imager / © Eric J. Heller / electrons injected at the bottom form branches caused by riding over hills and valleys induced by charged atoms which donated the electrons

Eric J. Heller / Double Diamond / 2000 / LightJet Digital Imager / © Eric J. Heller / scarred quantum wave function in a stadium shaped enclosure

Stick-Man Universe / 1986 / after de Lapparent, Geller, Huchra / graphics by Michael Kurtz

A slice of the nearby universe in which red points are elliptical galaxies which populate the cores of rich clusters of galaxies; they have little gas or dust. Blue points are spiral galaxies like our own Milky Way. In this plot, the vertex is the position of the Milky Way. Distance increases in the radial direction with more distant galaxies located toward the outer curved edge of the plot. Right ascension (the celestial longitude) runs along the curved boundary. This image was part of Geller and her group's first three-dimensional galactic mapping. It was only when thousands of galaxies were laid out in this and related 3D-images (here about a thousand galaxies), that the distribution of galaxies became clear: galaxies were concentrated as if on the surface of soap bubbles.

Positioning the Galaxy: Palomar Sky Survey Plate / Palomar Observatory Sky Survey / © Palomar Observatory Sky Survey supported by the National Geographic Foundation

The first step in the mapping process was to use the Zwicky catalog of galaxies (from the Palomar Sky Survey Plates) to determine the coordinates of those galaxies Geller and her collaborators wanted to study.

the relation between the quantum and ordinary worlds. But correspondence calculations have, since the beginning of quantum theory, been calculable only at certain relatively simple points of contact. Recently physicists have begun to ask this question again, this time coupling chaotic classical mechanics chaos to the power of the computer. Unlike Poincaré in the 1890s, physicists using computers *could* draw chaotic behavior. And unlike the situation in the 1920s, detailed pictorial representations of complex classical systems could be compared with their quantum analogues.

One of the leaders of this field of calculation-intensive quantum chaos has been physicist Eric J. Heller, who has pursued a remarkable range of visual techniques for studying the relationship of classical chaotic phenomena to their quantum analogues. In his computer-generated *Correspondence* he showed how a lemon-shaped box would contain a classical electron bouncing from its sides (images in the left column of each four-lemon cluster). Then on the right hand column of each foursome (in red), he let the computer plot the likelihood of finding a quantum electron at each spot. The two sides of the comparison are strikingly similar. In that visually recognizable similarity lies, for Heller, a powerful *pictorial* demonstration of the link between the classical and quantum worlds.[13]

No one in the physics community had much doubted the correspondence principle. Yet before pictures like these it was almost impossible to capture the relation of the quantum and classical worlds in such qualitative richness.

The icon clash began when these pictorial methods took on phenomena that were *not* understood. One struggle enveloped *Monolith*, where Heller looked at underlying chaotic classical systems in which electrons would bounce around in completely random directions like mad BB bullets. A quantum version analogue set waves traveling in random directions; it is this chaotic superposition of waves that appears in *Monolith*. Physicists had applied analytic techniques, (techniques without images), to this kind of situation, and some hard-liners claimed that such a ground-up view yielded all there was to know about such systems. But Heller and his group saw something in these images that had not been noticed in the strict calculationists' reckoning: the random skein of almost straight "tracks" criss-crossing the picture. Following from this purely pictorial observation came another. In tiny flat gases of electrons (more precisely gases confined to a mere micron while bathed in a weakly random electric field) electrons tended to flow for long stretches along concentrated channels. This "branched flow" had features that only emerged when Heller began creating ultra-high-resolution pictures like these for artistic display. *Transport IV* is one image in which branched flow is visible as the electrons flow from the center, focus, defocus, and focus again.

Some of Heller's claims have been controversial precisely because they relied largely on images for backing. Back in 1983, he had been looking at the pictures his computer was spewing out of a chaotic quantum system. (*Doublediamond* is a version of that original image.) While poring over these images, he noticed that there was a darkened area in the picture – indicating a strong likelihood of finding an electron – precisely along certain periodic (self-repeating) trajectories of classical physics. With a short theoretical demonstration, he published the image, expecting that the picture itself would go a long way towards persuading his colleagues of the effect's reality. It didn't and controversy followed for a good ten years. As a result of support that came from more recent statistical studies, the effect known as "scarring" is now one of the standard features of quantum chaos. But it is not unusual that it took a straight non-visual demonstration to clinch the argument for many in the physics community. At the turn of the twenty-first century it remains the case that if you ask a variety of physicists (or astrophysicists) whether simulation-generated pictures are sufficient to make a demonstration, you are more likely to get a fight than a chorus.

13

_ On Heller and the problem of reductionism see M. Norton Wise and David C. Brock, The Culture of Quantum Chaos, in *Studies in the History and Philosophy of Modern Physics*, 29, 1998, pp. 369-389.

Galactic Red Shift / courtesy Margaret Geller and Michael Kurtz
In an expanding universe, the further an object is from us, the redder its spectrum appears to us (and the faster it appears to be receding). In the two images shown here, one is of the unshifted spectrum of a galaxy, and the other of the same spectrum red-shifted by 0.1 - an apparent velocity of ten percent of the speed of light.

3. The Conflicted Image

Among the astrophysicists who were inclined to credit the visual with real weight is Margaret Geller. She, as much as anyone, has used images to back a crucial claim about the physical universe. To widespread astonishment, she and her colleagues showed that galaxies seem to be clustered as if on the surface of soap bubbles. But coming to and sustaining that conclusion relied in the first instance on *picturing* what was happening deep in the universe, followed by non-visual statistical studies, followed by more picturing. Recognizing a pattern was one thing. Bringing the broader community of astrophysicists along required a continuing alternation between imaging and more formal analyses: "Images," Geller says, "are not sufficient in themselves."

Visualization in astronomy has a long history of being both celebrated and challenged – for decades people tried, without much success, to sort the spectra of stars by strict protocol. Others emphasized the ability of humans (and some much more than others) to seize the pattern of the spectral lines so as to accurately put stars in their proper type-bin. In Geller's case one of the most effective pieces of evidence she and her colleagues mustered were visual plots like that shown in the image *Stick-Man Universe,* and a moving, three-dimensional version of this image in the computer-generated video that allowed the viewer to "walk" around the galaxy cluster. But images alone were never enough – neither for Geller and

colleagues nor for the wider community of astronomers and astrophysicists.

It is worth following the sequence of transformations that lay behind the production of a computer-generated video image that so strikingly showed the flat clustering of galaxies. Geller and her colleagues began with the galaxy catalogs that had been made from the Palomar Sky Survey by the famously irascible Caltech astronomer Fritz Zwicky. Each glass plate covered 36 degrees of the northern sky; from catalogs and plates the astronomers knew where in the sky to look for each of the galaxies in their study.

With those celestial latitude and longitude positions in hand, Geller and her colleagues could then direct the telescope to the right portion of the sky, technicians did the observing and took the data. With those data in hand, Geller and her co-workers then used the red-shift to figure out how far away particular galaxies were from earth (Hubble's law). More precisely: When galactic light hits a spectrograph, a grating breaks the light up into its constituent colors and the amount of light at each different wavelength is digitally recorded. Each element has its own characteristic pattern of bands of light – this much in a particular portion of the red, that much in a band of yellow, and so on. Hydrogen, the simplest and, what is important, most abundant of all elements, leaves its signature clearly stamped in the light emitted by almost every galaxy. But because the universe is expanding, the wavelength of any light is stretched, making it redder. (Think

Cloud Chamber Atlas / © from: W. Gentner, H. Maier-Leibnitz, W. Bothe, Atlas typischer Nebelkammerbilder mit Einführung in die Wilsonsche Methode, Julius Springer, Berlin, 1940, p. 51, fig. 43
Physicists made and produced images like this one to provide a template against which they could gauge the events they were seeing each day.

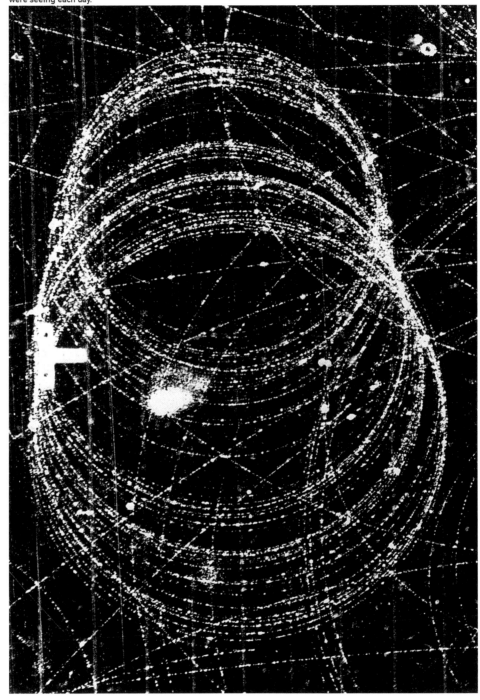

of holding one end of a vibrating string in each hand while slowly moving your hands apart.) In particular, as space expands, the hydrogen spectrum emitted by distant galaxies reddens, giving rise to an apparent separation velocity between the galaxies.

Hubble's law relates redshift (apparent separation velocity) to distance; Geller and her team applied that law and showed, astonishingly, that in their survey the galaxies were not at all homogeneously distributed throughout space. (Or more precisely, they showed that in a properly conducted survey the redshifts of galaxies were not evenly scattered among the possible redshifts, but instead strikingly clustered.) By moving from the Palomar Survey and Zwicky's catalog to the spectrum and then through Hubble's law and the theory of the expanding universe, Geller's group could plot a three-dimensional map of the galaxies' positions. It is these data that they then plotted and inserted into the computer to produce a video clip of a "walk" through the galaxies.

The astronomers found two remarkable features: first, that the distribution of galaxies was not even approximately

Bubble Chamber Scanning / © Lawrence Berkeley Laboratory. Bubble Chamber During the 1950s and early 1960s, Luis Alvarez and his group at Lawrence Berkeley Laboratory introduced factory-style physics not only in the building and running of the bubble chamber, but in the analysis of data as well. Shift-work, quality control, and efficiency reports all became routine as scanners (like the woman shown here) evaluated and measured the bubble chamber images, preparing the information for entry into the computers.

smooth throughout space. Instead, the galaxies concentrated as if on the surfaces of vast bubbles. Said another way, there were vast voids in space in which hardly a galaxy was to be found. Second, Geller's group found what they called The Great Wall, a fantastically large and flattened cluster of galaxies exhibiting a filamentary internal structure – spanning a billion-light year swath across the sky with a wafer-thin width of (only) twenty million light years. It was as if you expected a population of miniature galaxies to be scattered evenly through a four-foot cube, but instead found the collection held in strands within a region the shape of a sheet of plywood one inch thick and four feet on a side.

Picturing mattered. To follow the lay of the galaxies it was not enough to have two-dimensional photographs of galaxies, crucial though they were. Nor were the catalogued coordinates of those plates sufficient. Nor were (in and of themselves) the various spectra. Even the thousand three-dimensional coordinates derived by way of Hubble's Law did not yet reveal the pattern. Re-visualization – first by plotting on paper and then by computer – initially forced the clustering to stand out. Then a back and forth between visualizable evidence and statistical analysis: new data meant new possibilities for rendering the information visually striking, and at the same time made possible the computation of new kinds of statistical, non-visualizable, correlations. By the time Geller and her collaborators produced the computer simulation of a walk through the galaxies, and accompanied it by mathematical correlations, the oscillation between the human eye and the statistical calculation made the effect as striking and as evident as the nose on your face. New theories began vying for the honor of explaining this new map of space. Image to data to image to data to image to theory.

At the heart of experimental microphysics lies a not unrelated tension between picture and proposition; on one side the desire to image the microworld; and on the other the equally powerful longing to escape the image. Decorating

Cloud Chamber /
47 x 47" /
Forschungszentrum
Karlsruhe GmbH

Spark Chamber /
built in 1999 / metal,
Plexiglas electronic /
79 x 43.3 x 31.4" /
weight 700 kg /
Zeuthen, DESY
Instrument to produce
proof of cosmic
radiation

the cover of textbooks and imprinted into our cultural imagination are the wispy tracks of cloud chambers, nuclear emulsions, and bubble chambers. The cloud chamber, that prototype of all other visualization machines in microphysics, emerged from Victorian technologies that aimed to reproduce nature in miniature. Here was the world *in vitro*, one that displayed miniature storms, table-top volcanoes, room-sized glaciers. At first, C.T.R. Wilson, the inventor of the cloud chamber, had just this in mind: a chamber (that is a controlled space or room) in which he could manufacture clouds, fog, rain. Into the series – camera lucida, camera obscura, dust chamber – came the cloud chamber, the camera nebulosa.[14]

Once Wilson found that he could produce tracks (long trailing clouds) that followed the trajectory of charged particles, physicists began to assemble a new kind of technology, one organized to sort phenomena. This classificatory mechanism relied on a centuries-old tradition of medical atlases: atlases of skulls, atlases of hands, atlases of X-rays. In these compendia the budding physician would, in the simplest case, find "normal" anatomy. The idea was that by looking at these images, organs, bones, or microscope slides would stand out if they were different, that is if they were pathological. For the physicist the cloud chamber atlas functioned similarly: if the image found departed dramatically from the normal, then pay attention. But while deviation from the normal marked the "pathological" for the physician, deviation from the normal signaled "discovery" to the physicist.

Other image-making devices soon followed. Nuclear emulsions were simply sheets of film that particles would traverse leaving tracks to be developed. Bubble chambers were great vats of liquid hydrogen or other liquids that would boil along the tracks of passing particles. As the technologies of image production shifted, much carried forward into the analysis of images.

14

_ This and the following discussion of particle physics experiments is drawn from Peter Galison, *Image and Logic: A Material Culture of Microphysics*, University of Chicago Press, Chicago, 1997.

Digits into Pictures

It is not just that images pass into abstraction; the images themselves encode a wide range of abstract features. In a picture used in high-energy physics the »helpful distortions« are many – the uses of colored areas, »wire frame« outlines, transformations to make smaller inner chambers look larger, fish-eye perspectives to make better use of the visual field – to name but a few. Hans Drevermann and his collaborators at CERN belong to the growing community of physicists concerned with visual display. Addressing the often-discussed question, »Is there a future for pictorial representations?« they say »yes,« but caution that »the price to be paid is the use of more abstract representations. If one is ready to accept this complication, visualization of events will continue to serve as a helpful tool for representation and analysis.« These »abstract images« indicate several ways in which physicists manipulate images, pulling them from the more representational towards the more abstract.

Conventional to abstract V-plot / a series of mathematical transformations performed on images to alter the »representational« spirals of particles moving in the magnetic field of a detector into »V«-shapes that are much easier to grasp / partially modified by Hans Drevermann / © from H. Drevermann, D. Kuhn, B. S. Nilsson, Is There a Future for Event Displays? http://www1.cern.ch/Explorator/EDisplay/Chapter-7.html

Hans Drevermann / from xy to V-plot: y/x, (/(, (/(compressed. (/z, v-plot, half of v-plot=((/(+(/(), (/(

Hans Drevermann / different projections of the same event: (/z, r/(, y/x, V-plot, (/(, where (, r, and (are by (2=x2+y2, r2=x2+y2+z2, tan(()=z/(respectively

Hans Drevermann / use of the V-plot: y/x, v-plot, (/(

Hans Drevermann / use of the V-plot to connect TPC tracks to vertex detector

Hans Drevermann / use of the V-plot to connect TPC tracks to calorimeter data

A different kind of transformation that alters the spatial disposition of detector cells into a so-called »puzzle-plot« that aided physicists in understanding the relation of the physics of the event / partially modified by H. Drevermann, from H. Drevermann, D. Kuhn, B. S. Nilsson, Is There a Future for Event Displays, http://www1.cern.ch/Explorator/EDisplay/Chapter-7.html

Hans Drevermann / front (Y/X) and side ((/Z) view of a silicon calorimeter

Hans Drevermann / conventional (3D) picture of the silicon calorimeter

Hans Drevermann / abstract puzzle plot of the silicon calorimeter

But almost at once, in every one of these new laboratories, the images themselves begin to dissolve, morphing into other forms. A flash of light and three cameras would capture a complex trail of bubbles in stereo relief. Then a scanner projected the pictures one by one onto a table, where she (almost inevitably *she* during the 1950s and 1960s) clicked a mouse-like device to enter space coordinates. Digitized, the information flowed into a computer which then crunched the data into idealized mathematical curves; from those curves the computer spat out punch cards with the particles' identities and properties. At first by hand and later by computer, the morass of numbers could finally be reassembled into new images: bar graphs or the so-called Dalitz plots where an entire picture would be reduced to a single black dot. The physicists could then ask: Did the dots cluster? Did the bar graph show one peak or perhaps two? An invisible physical process made bubbling tracks, tracks to numbers, numbers back to pictures. Those pictures in turn could themselves be analyzed back into numbers.

Some physicists, led by Luis Alvarez, insisted that human scanners and human physicists look at the pictures. Only the trained eye, he believed, would recognize the new and unexpected. Only a person facing an image would pluck the "zoo-on" out of the vast sea of unexceptional results. Others, driven largely by the group around Lew Kowarski at CERN, insisted that the image ought to be removed as much as possible from the process, scanned by computers. People looking at pictures were, he believed, prone to error and should be eliminated "function by function" from the analysis of the physics. At Karlsruhe in 1964, the two sides gathered, and fought:

> K. Ekberg: "I would like to ask a question of principle which touches on the point that one might wish to do the first scanning of these pictures automatically. Now it is surely so that many important discoveries have been made because scientists have noticed something, which they did not expect. Something new which they could not explain from their previous knowledge. Now we surely can't program computers and automatic devices for this sort of thing?"

Kowarski allowed that perhaps people could call interesting pictures up from the millions that would be archived. Then another physicist intervened even more pained:

> Herwig Franz Schopper: "This point of view frightens me a little because it would mean that, in a few years, if one wants to do a high energy experiment, one would not go to start a new experiment but would just go into the archives, get a few magnetic tapes, and start to scan."

Even within the image tradition, the picture was always on the verge of being resorbed by the computer, snatched from human eyes and transmuted back into the whirl of numbers.

As these new imaging technologies of physics rose to prominence, other competing machines offered data without any pictorial product. Pictures, some physicists lamented, had something nineteenth century about them. Couldn't devices be built that took the world directly to the computer, that fully by-passed the millions of pictures spewing out of cloud and bubble chambers? Geiger counters could click, for example, when a particle passed – sending an electrical pulse to a counter. Spark chambers flashed when particles traversed them, wire chambers became sensitive enough to pick up even the tiny amounts of ionized gas left in the wake of a passing particle. With the help of a computer, machinery could use time and space measurements to reconstruct the event. These were technologies that, in the first instance, produced not images but statistical data, though statistical data quickly converted back into images.

One can find statistical experiments without any images at all. Suppose, for example, you want to find out whether

cosmic rays can penetrate a block of lead. One way to proceed might be this: place a Geiger counter on either side of the lead block, and wire up the system so that it only sends a pulse to a counter if *both* Geiger counters fire within a very short amount of time. Say that twenty pulses get counted, on average, per minute. The question arises: could the coincidental firing of the two counters be an artifact, the arrival not of a single penetrating particle but of two independent particles that happen to hit the two counters in the same short amount of time? To control for this possibility, the experimenter might measure the total number of hits on each counter and figure out the likelihood of an "accidental" coincidence. For the sake of our example that might be ten per hour. Then the conclusion that particles *are* penetrating the lead is not based on any individual coincidence – any particular coincidence might be due either to a single particle *or* to two independent hits. No, in the end the argument is statistical: there is a statistical *excess* of coincidences beyond that expected by the background.

Image experiments served wonderfully to track individual events; logic experiments often had the edge in treating aggregates. Individual events for some physicists carried persuasive force precisely because they could "see" into the whole

of the process, as if, some said, they could peer directly into the submicroscopic world. They hated not knowing what went on between the counters, resisted the indirect, inferential process of statistical reasoning. The "logicians" by contrast claimed that arguments by solid statistics stood on vastly firmer ground. "Anything can happen once," they grumbled. Science, the anti-imagers asserted, lies in the ability to manipulate and control phenomena, in the behavior of the many, not in the comportment of the few. Science, the image-defenders retorted, lies in the receptive, objective, singular medium of film.

In many ways, this image/logic split highlights, in the laboratory itself, the gulf between the desperate search for the individual image and the equally insistent attempt to avoid reliance on anything pictorial. Epistemically, this is an argument repeated over and over, in field after field. Doctors (and now the courts) slam into each other as they measure case studies versus epistemological studies. Geology had its era of qualitative studies against quantitative ones, seismology opposed to morphology. In the post-World War II years, astronomers often felt that they had to evaluate claims from radio astronomy against the established knowledge of optical

Imaging the Interior of the Earth / courtesy Adam M. Dziewonski and Goran Ekstrom

Geology, long divided between the quantitative seismologists and the morphological, more visual approach began to come together at the technical level with seismographic imaging. Borrowing from years of work on nuclear magnetic imaging- and analog techniques on materials-geophysicists, led by Adam M. Dziewonski, began to produce images like these of the interior of the earth, all the way down to the solid core. The colors in the pictures indicate the different velocities with which seismic waves travel through the earth.

Model of the AMANDA-Telescope (scale 1:1000) / detail of the light diodes

Light clouds drifting below the surface of the ice are shown through the light amplifier submerged in the ice of the South Pole. Every light diode stands for a light sensor. The time that the light cloud requires to travel across the telescope is reduced ten-millionfold.

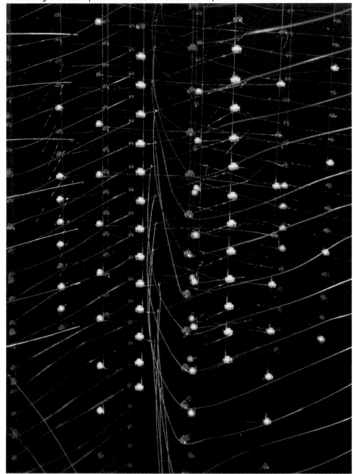

astronomy. Do you trust the X-ray or the stethoscope? Would you put your money on the morphology of open faces of rocks or seismological data? Bit by bit over the last few decades there has been a remarkable transformation in all these binaries. In each instance the image followers found themselves manipulating data banks, and the numerical-logicians found themselves gazing into the face of a picture. In the science of the very small, physicists have even brought cognitive science into their strategies for the visual display of digital data – the need to visualize crossed with the need for manipulable "logic"-based data.

Tomographic techniques in medicine and electronics have created a vast new industry in medical imaging: CAT scans, MRI scans; new modes of visualization have seized one discipline after another as image-producing software migrated between fields. For example, seismology, once the least visible of all the earth sciences was, by century's end, yielding seismically-generated pictures of the earth's mantle and inner structures all the way down to the solid core of the planet.

Soon, the cycle of fragmentation and consolidation began again as earth scientists began dissecting their images

not just for the qualitative work but for further quantitative analysis bearing on the detailed structure of the core, plate dynamics, and much more.

4. Between Eye and Mind

In conclusion it may be that the most significant development in the laboratory of the last fifty years has been the fusion of pictures and numbers into the production of the manipulable

THE HOLY SHROUD / HOW INVISIBLE HANDS WEAVE THE UNDECIDABLE

Marie José Mondzain

ARE WORKS WHICH ARE NOT MADE BY HUMAN HANDS made by other hands or without any hands at all? In the Christian tradition this power to produce the visible without any manual technique is attributed to the direct imprint of God on cloth. Whether in respect of the Holy Face, the Holy Shroud or any other legend attesting to the existence of objects without human origins, the first thing that strikes us is that all these accounts which cut the image from their cause, paradoxically consider the cause of the image in an originating and founding mode. Thus, the Holy Shroud and the Holy Face were used as an argument for theoretical legitimization of subsequent manual production. The reasoning consists in considering so-called *acheiropoietic* images, that is, images not made by human hands, as a free hand being given by the divinity on the value of the visible, which it no longer challenges. On the contrary, the divine personally invests, manifesting therein its invitation to the entire human community to celebrate it through the produced image. In other words, it is because the image, to exist, needs neither artist nor artisan that artists and artisans consider themselves as responsible for perpetuating, through their acts, the effects of another act which never actually existed as such. Rather than undoing this paradox to relegate these objects to the *Wunderkammern* of superstitions and popular beliefs, we should take very seriously the truth conveyed by this rhetoric, as regards the nature of the visible and the invisible in the image.

The first part of this chapter concerns the forbidden and the purity or impurity of the hands that produce.

The second part is devoted to the fundamental "atopia" of the place of inscription of the visible, that is, the impossibility of assigning a place to it.

The third part considers the real or imaginary situation of the artist as a person.

The fourth part concerns the passion for "appearance without cause" which seems to invest "magic" objects with a trans-historical or a-historical power.

In the conclusion the "political" implications of the common management of the visible and invisible in a sharing of the sensible are considered.

The Purity or Impurity of the Hands

The theme of the image not made by human hands starts in the Bible when the book of *Genesis* gives God the power to produce a creature in His own image and to breathe life into him. In this founding text, things come into being by naming. The Word is made flesh, we are told in the Gospel according to Saint John, regarding incarnation, but the expression is also used to recount the creation of Adam. The incarnation of the word in an image was first expressed and manifested in a body. It is directly following this handless act, this act of the spirit, that Christianity constructed the doctrine of the incarnation of the Word, the filial image of the Father, in the work of a single body, that of the mother, which temporarily became human to restore dignity and the salvation of the fallen image. In this sense incarnation restores the creature to the dignity of its primitive image. The conception of God's Son by a handless father separates the mother from her own blood. The other side of bodiless paternity is the virginity of the cloth hosting the divine maculation.

This explains why early Christianity was somewhat hostile towards the production of artificial images, for the accomplishment of the biblical message was set in the pure spiritual signification of redemption of the image. Yet that same Christianity had to deal with that historical and very real flesh in its doctrine, to avoid any suspicion of Docetism, that is, the heresy that the body of Christ was more apparent rather than real, to be capable of convincing those who needed to see and to touch in order to believe. If incarnation was to be understood only symbolically, it would follow that the human life and physical visibility of Christ from his birth to his death was simply an historical appearance that was useless after his

The Shroud / Turin / front side / photograph, color, positive and negative /
© photo: Aldo Guerreschi, Turin

The Shroud / Turin / back side / photograph, color, positive and negative /
© photo: Aldo Guerreschi, Turin

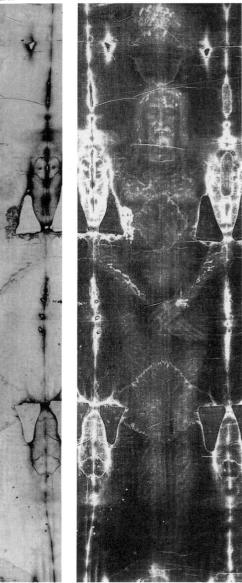
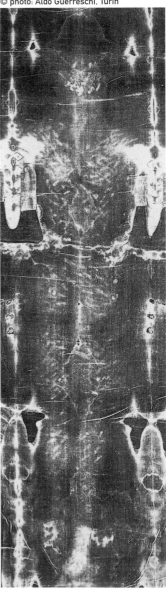
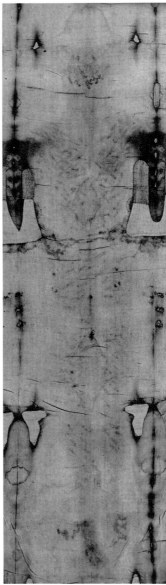

resurrection. But Christianity took on the task of interpreting Christlike messianism as a redemption of human components themselves. In other words, it was the body of Christ, with all the features of humanity, that had the mission of saving the earthly and mortal creature with all its physical and historical determinations. Hence, the necessity to produce, century after century, a doctrine that not only accounted for spiritual redemption, but also shared salvation with the entire visible and therefore sensible world.

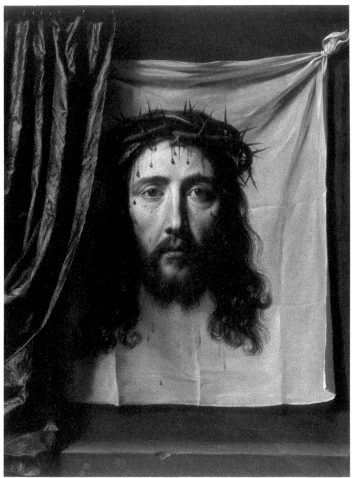

Philippe de Champaigne / La Sainte Face / 17th century / 26.4 x 19.7" /
© photo: Brighton Art Gallery and Museum, Brighton

The visibility of the Son thus had essential meaning regarding the truth of what our eyes can see in this life. The problem was tricky since the image in the Old Testament was disqualified, not as an image as such but as one made by human hands. In other words, it was not the image that was condemned but the hands producing it. It was in the name of the purity of the image that iconophobia, aniconism and later iconoclasm impugned all legitimacy of human productions. This amounts to saying that the real image is not made by human hands and that it remains invisible to the idolatrous eyes of those who fall into the cult of artifacts.

When we analyze the texts that ritually establish the image in the Christian world, it is clear that they put an end to the taboo of the blood and impurities of human hands that doomed any task to execration. The world of stains is that of the colored pattern of any living and sensible reality. The injunctions of Leviticus which demand total separation of the blood and the flesh for the latter to be consumable, are part of the same prohibitions which preserve the chosen people from maternal union equated with idolatry. Monotheism is built on the Law, the founding operation of which is separation, the exclusion of any mixture and any stain. It is in this light that one must interpret not only the prohibition on production but also the lifting of that prohibition in Christian doctrine. It becomes clear that he whose words and acts were intended to transmit a universal message, so that salvation would no longer be limited to the chosen people only, is the same one who effects and legitimizes all mixtures, all non-separation. Eating the body and drinking the blood at the same time is an absolute and violent transgression of the *cacherout*, i.e., all purification rituals. It was with the dominant theme of impurity and mixture of body and blood that the image was established by Christian doctrine in the account of the Last Supper.

Not content to have doctrinally ruled on the legitimacy of the visible in the body of the Son, the texts went on to build up a legend on the divinity of the maculation. To the legacy

of words in the Testament was added the miraculous legacy of marks. All the accounts of the birth of the *acheiropoiete* image refer not to a graphic inscription maintaining an irreducible link between, image, writing, and drawing, but to stains, to imprints. This charismatic deposition of the image radically separates scriptural truth of the word from the truth of the visible. The principle of the image made without hands is the mark which seems to require no mediation whatsoever. Through this maculation the image finds the immediacy of evidence proving its authenticity, but at the same time becomes the basis of the elision of the hands. The only inevitable hands are those that gather and offer or gather. The pure hands of the Son or that of the women.

That is why women's hands gathering up the cloth stained by the Messiah are the mark of a virginal redemption of the image. Virginity is nothing other than a doctrinal necessity to found the gestation and gift of the image and marks on a pure, unsoiled surface. The white cloth, the white wood of the icon, the immaculate headcloth are all signs pointing to the redemption of all mediums. Henceforth the blood and the image with it, no longer contaminated by the feminine, are one with the Father and his filial image, both bloody and pure. Hands do not produce, they carry. The Franciscan designation which gave a woman called Veronica (that is *vera icona*) the role of presenter, suggests that the feminine is the virginal medium for presenting the redeeming stains. The icon is nothing other than this transfer from agencies which generate to those which present, those which offer the thing to see but are not its real cause. However, we are left with the question of the representability of imprints. The doctrine of the icon is a long construction of the procedures that make it possible to reproduce without showing, to attain the invisible in the visible, to show divine infinity without locking it in the idolatrous enclosure of the drawn line and contour. Icons were made of the Holy Face, but never of the Holy Shroud. I revert to this point further on.

Without saying more here on the icon as a device, let us go back to the surprising and fertile destiny of *acheiropoietism*. For as long as the manual production of icons posed a problem of the purity of hands and thus the impossibility of showing stains without implying hands, the Holy Shroud remained a relic kept out of sight. As a relic, its only value in its crypt was the devotion of those who adored it without seeing it. What was honored was a linen that had contained the dead, then resurrected body of Christ, and not a headcloth on which the features of his face and the shape of his body could be recognized. It was a mysterious relic that did not raise the question of the portrait. The Church therefore remained cautious when it came to "publishing" it as a "real image." Its rhetoric remained indecisive and the institution left everyone the freedom to see either a relic or an image or an artifact (see insert *John Paul II on the Shroud*). "Perpetrare silentium" was the watchword.

Things changed radically when a technique appeared for producing images by indexical impression (see Geimer). It was photography which, welcomed as an *acheiropoietic* technique, afforded an unexpected opportunity to return images not produced by human hands. The photograph of the Messiah engaged the gaze in very different ways. It may seem surprising, naive, that a technique, the photographic camera, was considered from the theological point of view as a handless art! However, far from being naive, it saw mechanical reproduction as a perfect answer to the crisis which was shaking the visual arts, themselves in the throes of the industrial revolution. The radical challenge to imitative art and the reproductive virtuosity of figurative art corresponded perfectly to a *mise en crise* of the creative act and the sovereignty of touch. The impression of impressionists, the abstraction of the non-figurative, and the undermining of representation were in keeping with a visual upheaval interpreted as modern revelation. Touch was no longer the mark of genius. It was art in its entirety that lost interest in the formal and material

IMAGING PROCESSES IN NINETEENTH CENTURY MEDICINE AND SCIENCE

Christian Kassung and Thomas Macho

What Images Know

The newspapers had already known for some time of a "sensational discovery" when on 13 January 1896, Wilhelm Conrad Röntgen made his way to the quickly built "Sternensaal" of the royal palace in Berlin in order to personally report on his experiments to the kaiser. According to the statements of a journalist from the *Kölnische Zeitung*, who was one of the few guests allowed to witness the presentation, Röntgen explained how "he had become distrustful of his own perceptive faculty, of his own senses, and how he finally told himself: the human eye can be deceived, but the photographic plate cannot."[1]

This quote marks precisely the point at which Röntgen passed his career-obsessed predecessor Phillip Lenard, who very possibly had already produced and seen X-rays, but all the apparatuses used by Röntgen were already in constant use in all the physics institutes in the country. Only the question about the genesis of the new images, which avoided the dualistic pattern of internal and external in such a strange manner, allowed these to become part of the physical knowledge. The X-rays themselves, with their oppressive aesthetics, show the seriousness of the claims of Lorraine Daston, Peter Galison, and Nicholas Jardine in a "history of the aesthetics of scientific practice."[2] "The lens looked inside itself," noted Hans Castorp in Thomas Mann's *Zauberberg*.[3] The sentence appears to reflect that what precedes the question about the image and its statement with regard to its accomplishment is an epistemology of the technical image as the ensemble of the specific cultural techniques on which the genesis of these images is based. To cite only the best-known technical image, an aesthetic of the heavenly bodies must remain incomplete as long as the panning of the telescope from the neighbor's field to the moon is considered an inexplicable stroke of genius.

Now the term *image* at least in Germany, still brings to mind the dichotomies of visible/expressible or discursive/non-discursive. The effect of such models of thought is twofold. On the one hand the specific time dimension of the technical images is blocked out, whereby an X-ray image, for instance, becomes *something completely different* than a chronophotograph by Etienne-Jules Marey. Graphs and diagrams threaten to be completely excluded from the realm of images, which would then result in considerable difficulty in explanations, especially if these stem from devices which can transmit images equally well. To that end, the following will not make a clear distinction between pictures, graphs, diagrams, figures, or maps. Rather, a distinction will be made with respect to the specific discursive inferences.

A second effect of this contrasting, however, leads to even more spectacular difficulties; it impairs an analysis of drawings, publications, textbooks, etc., as instruments of scientific work with specific rhetoric, practices, and finally visualization. When, for instance, Hermann von Helmholtz speaks about the difficulty of simultaneously representing information obtained with the ear and the eye, he then also demonstrates the problem of medicine and natural sciences around 1850: image generation and image transmission could not be separated from one another. In other words, the blocking out of the discursive layer of images necessarily results in a misjudgment of the specific circulation of knowledge whose time-serial recording and transmission processes originate in the nineteenth century.

Serial – Time in an Image

The knowledge of image generating apparatuses is interdisciplinary *per se*, as Etienne-Jules Marey recognized in his *Méthode Graphique* in 1878. This knowledge emerged especially through various apparatuses and contributions in the history of the respective disciplines. On the other hand, a historical examination of these apparatuses and procedures allows conclusions to be drawn on an epistemological substantiation, a

1 2 3

_ Fritz Fraunberger and Jürgen Teichmann, *Das Experiment in der Physik. Ausgewählte Beispiele aus der Physik*, Vieweg, Braunschweig and Karlsruhe, 1984, p. 229.

_ Thomas Mann, *Der Zauberberg*, Fischer, Frankfurt/M., 1985, p. 229.

_ Nicholas Jardine, The Laboratory Revolution in Medicine as Rhetorical and Aesthetic Accomplishment, in *The Laboratory Revolution in Medicine*, A. Cunningham and P. Williams (eds), Cambridge University Press, Cambridge, 1992, pp. 304–323; Lorraine Daston and Peter Galison, The Image of Objectivity, in *Representations*, 37, pp. 67–106, and 40, pp. 81–128.

sort of *substratum* of knowledge, which cuts right through the disciplinary divisions of sciences in the nineteenth century. The main indicators of such a detectable orthogonality, as in every archaeological procedure, are the trans-disciplinary obstructions to knowledge and discontinuity.[4] Such a *rupture* (according to Gaston Bachelard) in the interaction of image, knowledge, and apparatus comes from the so-called *self-recording instruments*. Any apparatus with which a particular phenomenon can generate its own image, in an independent process, is considered a self-recording instrument. Hoff and Geddes give the following definition: "[An] ingenious combination of sensitive element and graphic reproducer by which a phenomenon, so to speak, writes out *by itself* the changes that it undergoes *as time passes*."[5]

Self-recording instruments can be traced back to the ancient world. The widespread Klepsydra of the Mesopotamian and Greek regions are known to have produced an image of time by recording the steadily sinking surface level of water against a rotating cylinder. Vitruv reported on this procedure in his ninth book, *Architektur*:[6] If a conflict emerges between the antique text body and the woodcuts of the Renaissance illustrators, the differences are smoothed over by the odometer. The origins of this device, with whose help the distance of a path can be determined by pacing or walking it off, were lost in the Asian area. On the other hand, Vitruv offers an explanation of the self-recording odometer. The distance is, as it were, digitally, and curiously, represented by the "sound of a falling stone."[7]

Proof of these "way-measurers" existence were found in Europe in the mid-fifteenth century, at first by Leonardo, and then by Johann Georg Doppelmayer and Frederick Nicolai in the eighteenth century. Sometime in between, however, the "milestones" must have been lost, for distances were thereafter measured by analogue means, whereby, strangely, things have hardly changed till now. Therefore, the distance and speed measurements seem to be the last sanctuaries of analogue forms of computing and visualization. A car that is equipped with a digital tachometer would obviously be specifically marketed as futuristic.

If one were to come up with a progressive genealogy contrary to the *rupture* theory of the self-recorder that culminated in the Kymographs of Carl Ludwig in 1850, it would obviously need an explanation. Were the predecessors not "real" self-recorders? Did the corresponding contexts of application first develop in the nineteenth century or did "new" phenomena force their own "self-recordings"? For the time being, only one thing is clear: the early self-recorders conformed to theory. They didn't initiate a changed mechanical thought nor a new relationship between mechanics and the other fields of knowledge and methods, although a multitude of more or less suitable self-recorders had been ready for use since the Renaissance: "Automatic recording instruments have a long history, but made no significant impact on natural philosophy until the nineteenth century."[8] In order to find possible answers to these questions, and also understand the scientific-historical explosive force of these "new" image-generating apparatuses, the canonized "original apparatus," Watt's "Indicator," shall be discussed more thoroughly.[9]

At first glance, the Indicator from James Watt and John Southern reintegrates only those elements from the history of the self-recording apparatus that identify the center of a measuring disposition, whereby a phenomenon is recorded "marquer de lui-même sur le papier" (by marking itself on the paper):[10] a mostly horizontally moving writing surface, which is written on, a vertically guided pen by which some other feature of the phenomenon is noted, as well as a mechanism to ensure a consistent writing movement. In so far as many different types of disturbances can occur, many self-recorders can only be differentiated, essentially, by the balance mechanism. With the Klepsydra, for example, the dependence of the rate of water release on the height of the water level must be

7 5 4 6 10 9 8

_ See Christian Kassung, *Entropie Geschichten. Robert Musils „Der Mann ohne Eigenschaften" im Diskurs der modernen Physik*, Wilhelm Fink, Munich, 2001, pp. 48–99.

_ Hebbel E. Hoff and L. Geddes, The Beginnings of Graphic Recording, in *ISIS*, 53, 2, 1962, p. 287 (italics by the authors).

_ L. L. Pajot Ons-en-Bray, cited from Hoff/Geddes, The Beginnings ..., op. cit., p. 288.

_ Pollio, op. cit., book 19, chapter 14, p. CCCX. "Als dan so offt ein steinlein fallet vnnd man den clang hoert weys man dz man ytzund 1000 schrit oder ein Welschemeyl gefaren hat. So man dan zu abents die selbigen steinlein zelet weyß man wievil man des tags meylewegs gefaren ist."

_ Thomas L. Hankins and R. Silverman, *Instruments and the Imagination*, Princeton University Press, Princeton, NJ, 1999, p. 128.

_ See Hebbel E. Hoff and L. Geddes, Graphic Registration before Ludwig. The Antecedents of the Kymograph, in *ISIS*, 50, 1, pp. 5–21; Hebbel E. Hoff and L. Geddes, The Technological Background of Physiological Discovery: Ballistics and the Graphic Method, in *Journal of the History of Medicine and Allied Sciences*, 15, 4, pp. 345–363; Hoff/Geddes, The Beginnings ..., op. cit.

_ Marcus Vitruvius Pollio, *Zehn Bücher von der Architektur und künstlichem Bauen*, Georg Olms, Hildesheim and New York, 1973, book 9, chapter 9, p. CCLXXXIII. "In solchen kuenstlichen bewegungen vnd tryb mag auch die stunden an einer runden Columnen oder Parastie verzeichnen vnd ein menlein oder boßlein darzu verordnen das mit dem ende eins steblins die stunde bezeichne des gantzen tags."

accounted for by giving the water receptacle a certain form. Another example, also developed by James Watt, is the well known pendulum-based centrifugal force regulator, which James Clerk Maxwell theoretically inaugurated with his essay *On governors* in 1868.[11]

As already stated, things about Watt's and Southern's instrument of 1785/86 appear at first to be only slightly displaced in view of the antique self-recorders and their immediate successors; however, this shift anticipates the discontinuity within the image-generating techniques of the nineteenth century, which is the focus of this discussion. This shift began, as it were, because the writing surface did not simply represent a consistent function of time. For Watt, it was a matter of representing an important parameter of the heating machine compared to time. It is much more a matter of directing the writing surface in the horizontal direction proportional to the volume of the steam cylinder. When the machine is running, the change of this volume naturally forms a periodic process. It is therefore simultaneously represented in machine-time directly through the change in volume. Only the counter-weight is visible, whose other end (you have to imagine) has to be connected with the steam piston.

The pen, in comparison, is connected with a spring manometer so that the pressure in the cylinder is proportionately applied perpendicular to changes in the volume. In other words: the *écriture automatique* of Watt's Indicator "draws" a pV diagram on paper. To which form of clarification does such a diagram correspond? Which knowledge should be indicated? Watt and his engineering colleagues – in this respect hardly anything has changed to the present – were essentially concerned about only one question: how can a better machine be built? How can a higher performance be attained with less fuel? Until 1824 there were only practical, extremely diffuse and vaguely systematic recorded answers, and so it is no surprise that Watt kept his Indicator a secret for many years.

Carl Ludwig's Kymograph / from: Carl Ludwig, Beiträge zur Kenntniss des Einflusses der Respirationsbewegungen auf den Blutlauf im Aortensystem, in Archiv für Anatomie, Physiologie und wissenschaftliche Medizin, 1847, plate X
In 1846 the physiologist Carl F.W. Ludwig, with his kymographs, introduced with his kymographs the graphic methods into physiological research. By means of a manometer, the device records by means of a manometer the blood pressure onto a rotating drum.

11

_ Norbert Wiener, *Futurum exactum. Ausgewählte Schriften zur Kybernetik und Kommunikationstheorie*, Springer, Vienna and New York, 2001, pp. 237–256.

James Watt's Indicator / 1785-86 / from: Thomas L. Hankins, R. Silverman, Instruments and the Imagination,
Princeton University Press, Princeton, New Jersey, 1999, p. 129, fig. 6.11
The James Watt's Indicator from 1785-86 is considered to be the first modern self-recorder. The areas enclosed by the graphs correspond to the performance of the machine, from which the rent was calculated that had to be paid to the Boulton & Watt company.

and Norbert Wiener's universal concept of feedback in which man will fall to be reborn as a machine.[18]

Telegraphs, like Kymographs, therefore originate from the same epistemological triviality: something that cannot be stored has to be synchronized. This reciprocity of address and tact is surrounded by insanity; the stupidity of pure compilation and the megalomania of total synchronization, the cacophony and homophony, regardless of the broad field of non-systematic disturbances which will not be dealt with here, led Karl Vierordt to comment as early as 1855 that Ludwig's recorded "pulse pictures" were "simply products of art," nothing more than "nice little pictures."[19] It is precisely in this conflict that a paradigm change occurred in the middle of the nineteenth century from the pre-modern self-recording instruments to the new technologies of imaging, because precisely this reciprocity was implemented. For Ludwig – as a direct analogy to Watt's pV diagram – it was in no way a simple visualization of blood pressure itself, but as illustrated, the synchronous recording of the movement of various organs. His Kymograph represents the heartbeat and respiratory rhythm of a dog in that he records its blood pressure as a parameter that changes over time, a "truly objective [!] description [of] the operation of a wide spectrum of physiological functions" with the goal of discovering their specific dependency on time:[20] "The changes of the blood-pressure and the air pressure in the thoracic cavity had to be registered in precise synchronization."[21]

The integration of the self-recording instrument in the imaging process of the sciences of the nineteenth century should cause the transformation of a movement's time independency into a demonstrable spatial independency, i.e., an image which does not freeze the movement of the body allows it to become a portion of the picture. The Kymograph allows the synchronous representation of different variables in a Cartesian coordinate system. To that extent it is not just coincidentally a type of telegraph, a device that records its information on a rotating cylinder; more importantly it combines the problem of the telegraph, the problem of the media or code exchange, and the synchronization problem, at least for the field of physiology in the instrument of the Kymograph.[22] The *rupture* medical knowledge – in direct connection with the commercial success of the device – was based on the newly acquired ability to represent a serial-time data-stream in a spatial-period and pointed, in an exemplary manner, to the end of the industrial age, a shift from energy to information. The first response to the question as to what distinguishes the Kymograph from the disposition of the pre-modern, self-recording instruments results, for even at this point it should have become clear that the interdisciplinary metamorphosis of physiology to an "exact" science has to be considered more of a secondary effect of the more basic problem of synchronizing a data-stream in such a manner that certain measured values can first of all be made comparable.

And Reading

The sublime connecting line between the synchronization problem within physiology and the telegraphic generation of images takes on decisive evidence as soon as one turns to the second aspect of the conversion of time into space (and vice-versa). At the same time this aspect might completely explain the massive "delay" with which the self-recording imaging process became capable of being discursive; all the visualization machines which form the concrete machines of the *méthode graphique*, function as *image telegraphic receivers*, i.e., as transcription devices which first create the script in the transcription. There is no legibility prior to the apparatus in this scientific connection; there is nothing to read that is not first made possible by the device. With this, physiology gained readable time – by means of the image, or if you will via the script – that which had perhaps been completely beyond question for theology. The graphic method provides the

20 21 18 19 22

_ Helmholtz, op. cit., p. 181.

_ Hoff/Geddes, The Technological Background, op. cit., p. 346.

_ Karl Vierordt, *Die Lehre vom Arterienpuls in gesunden und kranken Zuständen, gegründet auf eine neue Methode der bildlichen Darstellung des menschlichen Pulses*, Vieweg, Braunschweig, 1855, p. 7 and 11; on the problem of disturbance, see Chadarevian, op. cit., pp. 287–290.

_ Hoff/Geddes, The Technological Background, op. cit., pp. 345f.

_ Chadarevian, op. cit., p. 267.

Diagram / from: Carl Ludwig, Beiträge zur Kenntniss des Einflusses der Respirationsbewegungen auf den Blutlauf im Aortensystem,
in Archiv für Anatomie, Physiologie und wissenschaftliche Medizin, 1847, plate XI
Ludwig was not primarily interested in determining absolute blood pressure values, but in the comparison of fluctuations in pressure in
various regions of the body. The measured values had to be transmitted and synchronized to be able to make such a comparison possible.

Bronchiectasis / from: Karl Vierordt, Die Lehre vom Arterienpuls in gesunden und kranken Zuständen,
gegründet auf eine neue Methode der bildlichen Darstellung des menschlichen Pulses, Vieweg, Braunschweig, 1855, pp. 230-231

Tuberculosis / from: Karl Vierordt, Die Lehre vom Arterienpuls in gesunden und kranken Zuständen, gegründet auf eine neue Methode
der bildlichen Darstellung des menschlichen Pulses, Vieweg, Braunschweig, 1855, pp. 230-231
The Tübinger physiologist Karl Vierordt altered the status of the image. The kymograms are read as concrete syndromes: If a disease changes
the »Arterial pulse« it must be possible to read a syndrome from an image of the pulse.

human perception with time as reading matter. From this perspective the great precision and resolution of the instruments compared to the human senses proves to be important, "with instruments that recorded their own inscriptions, it was possible, but not central, to follow the fastest changes in the organs of living things."[23] More important is that the images generated by the self-recording instruments only became interpretable in that they were images and not vague or mere serial information. Two examples from Karl Vierordt's *Lehre vom Arterienpuls* should suffice: "XXX. *Johann Volz*, 28 years old; relatively large, strong. *Bronchiectasis*, etc., 1849 stubborn intermittent fever, chest complaints since then and frequently recurrent fever and XXXIII. *Joseph Kaltenmark*, 48 years old. *Tuberculosis pulmonum.*"[24]

The storage of non-serial spatial information establishes the prerequisite for the birth of a method of its legibility. And it is precisely at this point that a self-reflecting moment which characterizes the sciences of the late nineteenth century – always interdisciplinary – presented itself, "the graphical method with the claim to be a universal method which could cut across cultural and disciplinary boundaries."[25] From that time on, in which the observed and registered phenomena are subject to a change which simultaneously suspends the bond to the normally temporal "lethargy" of human perceptive and recording systems, it was possible for apparatuses to return this time to humans and put themselves between scientists and phenomena in such a manner that the phenomena actually no longer exist without the apparatuses.[26] The transition from representation to construction therefore marks the second epistemological implication of the self-recording. To that extent it goes beyond the aspect of the "microscope of time" in terms of a pure increase of the accuracy of the measurement in that it can no longer be separated from a translation of time into space.[27] The entry of the imaging processes into the knowledge of these processes (and vice-versa) for the field of physiology, which began with Hermann von Helmholtz,

shows that self-recording is more than a purely *écriture automatique*. If a science crosses the threshold from recording to *self*-recording, it produces inevitable, reflexive structures and a form of self-visualization of knowledge results that Michel Serres characterized as internalized epistemology.

Indeed, the Kymograph marks a threshold and this threshold proves itself to be discursive; the Kymograph demonstrates, as a visualization strategy, much more than simply the opportunity to measure blood pressure in an undefined time. By making the principle of self-recording part of the physiological perception dispositive, Johannes Müller's vitalism is transformed into Ludwig's, Du Bois-Reymond's, and finally Hermann von Helmholtz's modern, chemical-physical physiology – which, of course, does not mean that no other factors were involved in this process.

Between Script and Projection

There are at least two interesting directions in which the principle of self-recording has developed. On the one hand there is industrial physics as science of origin, more specifically thermodynamics in the form of a pV diagram according to Watt and Boulton. The self-recording, on the other hand, finds its way back from physiology to physics – more precisely to acoustics and the central problem of visualizing sound. On 26 January 1857, the French typographer Edouard-Léon Scott de Martinville sent a sealed package to the Académie des Sciences. In search of the natural language of speech, the *écriture automatique* of speaking, of which script only brings an approximate and distorted idea to paper, Scott developed a "phonautograph." With this, the day had arrived, on which "the musical phrase escaping from the lips of the singer will come to write itself [...] on an obedient page and leave an imperishable trace of those fugitive melodies that the memory no longer recalls by the time that it searches for them."[28]

27 23 24 26 25 28

_ Hankins/Silverman, op. cit., p. 139.

_ Vierordt, op. cit., pp. 230f.

_ Hoff/Geddes, The Beginnings ..., op. cit., p. 310.

_ Chadarevian, op. cit., p. 273.

_ Edouard-Léon Scott de Martinville, *Le problème de la parole s'écrivant elle-même*, Scott, Paris, 1878, pp. 29f., cited from Hankins/Silverman, op. cit., pp. 134-135 (italics by the authors).

_ Helmholtz, op. cit., p. 177.

As early as 1830, Wilhelm Weber had produced the first "sound recording" by connecting the prong of a tuning fork with a thin worn-out steel spring and then putting this oscillating "pen" over a smoked glass plate.[29] The first membrane phonautograph from Scott and Rudolph Koenig, however, was able to visualize every form of acoustic event, including human speech, at least theoretically. The diaphragm's pattern of oscillation proved to be much too sluggish to depict the speech as successfully as the oscillation of the tuning fork.

If one were to reduce Koenig's, lavishly designed "phonautograph" to the elements that were available to him at the time, one would find a disposition of self-recording which was equivalent to the Kymograph, on the technical side: "a receiver (here a movable membrane), a pen (here a boar's bristle) and a turning drum, covered with smoked paper"[30] as well as on the epistemological side: "The application of the graphical method to acoustical phenomena allowed the voice to telegraph itself."[31] Acoustics basically began to form itself as a science with the self-recording of its underlying physical phenomena. The new quality of these images, in comparison with the Chladni figures of 1875 or the first acoustic oscillating lines of Thomas Young at the turn of the century, were due to the visualization of the timeliness of sound. The dream of the notation of sound, which had been comatose since Guido von Arezzo, showed signs of life again for a short time. The dream, which was lost between Fourier's transformation and the phonograph plate, was to be handed on to the twentieth century.

The second line began to break open the disposition of the serial self-recorder. The French physiologist Etienne-Jules Marey developed non-invasive methods to record movements, whereby he pursued two strategies that are relevant here. His first strategy, a sphymograph – an instrument from 1859 that recorded the human pulse – made him more than financially independent.

The deciding factor was that, with the withdrawal of the measuring instrument from the direct interior of the human body – in this case through a mechanical simulation of the human sense of touch with the apparatus – the possibility of creating a distance from the body arose. With Marey, physiology began to "see" again. In other words, it was now able to slowly turn away from serial data-streams: "Truly for the first time, writing has ceased to be synonymous with serial data saving."[32] With the so-called "chrono photography," the plate is repeatedly lit by means of a rotating closure system, which generates recognizable images of movement. These images become complete movement as soon as their rate of exposition reaches a time interval, which was measured by Helmholtz as a physiological a priori with the help of his self-recording myographs: "When we see the same appearance of flashing light two times consecutively on the same spot, we recognize it as doubled if the time in between amounts to 1/10 of a second; if the time interval is smaller, both appearances blend into one."[33]

In comparison with the serial recordings of all the pen-based self-recorders, these images had, under the perceptive threshold, an enormous advantage that nearly caused a panic: They were – apparently – not written in a new language, but their physiological importance was immediately and literally evident. The new language of graphs, in comparison, had first to be deciphered – in an effort that brought about the problem of interpreting electroencephalographic oscillations, which in turn brought about the emergence of cybernetics.[34]

No Longer Serial – Space in Image

The image that does not require an interpretation is easily as old as human knowledge itself: it is the image of the sky. Precisely this view makes it clear once again, how inevitable the visualization of time as space is. Whoever looks into the sky today, 150 years after Fizeau's measurement of the speed of light on earth, recognizes, because of the various lengths of

31

30 29

32

34 33

_ Chadarevian, op. cit., p. 278.

_ Friedrich A. Kittler, *Aufschreibesysteme 1800 1900*, Wilhelm Fink, Munich, 1985, p. 289.

_ Franz Josef Pisko, *Die neueren Apparate der Akustik*, Carl Gerold's Sohn, Vienna, 1865, p. 56.

_ Helmholtz, op. cit., pp. 170f.

_ Chadarevian, op. cit., p. 278 (italics by the authors).

_ See the 1955 lecture *Zeit und Organisation* in Norbert Wiener, op. cit., pp. 133–148.

movement of light, a very parallel data-stream with an extremely timely dispersal: stars already faded and stars still existing burn their optical existence into the mind of their observers. Antique astronomy did not know of such simultaneity, for the orbit and mechanism of the sky's mechanics only knows various circumstances, but nothing of development. The lack of synchronization among the parts is impossible with the *actio in distans* of a perfect machine.

For this reason it is relatively absurd to assume that the gnomon which shows an image of the sun's movement around

If they could be precisely reconstructed, according to the image and its transmission, storage, and processing of underlying conversions – not least because of their very early technical implementation – it would be much more difficult for this undertaking with images that are not serial. The reasoning in this was similar to that for the equally serious – although today considered absolutely abstruse – attempts of Baraduc to directly photograph dreams and the condition of the soul. A reason for these difficulties could be the fact that the eye at the same time also processes image information. This

Blood-Pressure Recorder / 1859 / from: Etienne-Jules Marey, La Méthode Graphique dans les Sciences Expérimentales et particulièrement en Physiologie et en Médecine, G. Masson, Paris, 1878, p. 167, fig. 52

The French physiologist Etienne-Jules Marey makes the blood-pressure recorder transportable and non-invasive. The recording occurs oin the surface, making the step to cinematography now only a matter of recording speed.

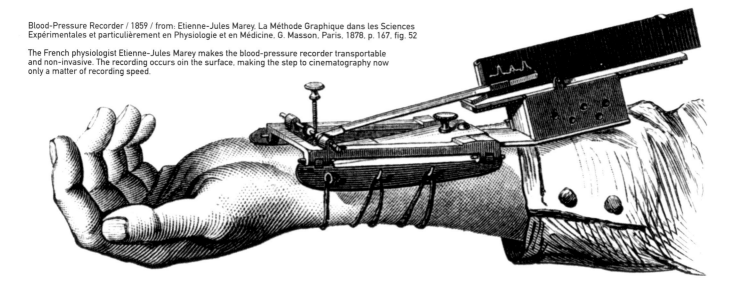

the earth, fulfilled the function of a clock. Exactly in the sense of self-recording, the gnomon draws, "automatically, in marble or in sand, as it were, as if the world would recognize itself."[35] True, a drawing or recording does not automatically take place, but, in contrast to the sky, marks can be made in the sand, whose readings separate themselves from the writing process. Such readings primarily allowed conclusions to be drawn about the geometry of the universe, especially the ecliptic, the equinox, and the solstices, but not about time.

self-recording process of the eye, the projection of an image on the retina, however, has to be interrupted, so that one can "see" the projection surface. This is exactly the point that leads to the history of the processing of non-serial images – which cannot unfold any further here – flowing into the *rupture*, with which we previously identified the self-recording of serial image-processing. In 1850, Hermann von Helmholtz introduced the device that, more than any other of his inventions, was supposed to make him famous: the ophthalmoscope.

35

_ Michel Serres, Gnomon: Die Anfänge der Geometrie in Griechenland, in *Elemente einer Geschichte der Wissenschaften*, Michel Serres (ed.), Suhrkamp, Frankfurt/M., 1995, p. 118.

This made it possible to "exactly see and recognize, in the living eye, the retina *itself*, and the *images* of illuminated bodies that become their portrayal."[36] Self-recording means, in this case, that the process to be recorded is, on the one hand, not interrupted, and the eye not dissected, yet on the other hand, a parasitic interruption does take place, which then allows the perception of the image *before* it actually becomes an image.

Final Image – Time and Number

Autumn 1928, Berlin-Kaiserdamm Exhibition Halls. At the German Electronics Fair, the revolutionary year in the history of media, electric images are broadcast for the first time. The technical tele-vision is made possible by means of a certain symbiosis of serial and non-serial imaging processing which should be touched upon as a sort of conclusion. In the center of this symbiosis is, at least within the early television technology, the Nipkow disc. This spirally perforated disc made it possible to break down an image into a serial data-stream from which the same construction was then able to reassemble the identical picture. Television therefore means the translation of space into time and back to space. And as with the copying telegraph, the lack of storage made necessary a synchronous process of the two procedures, "the resolution of the image in a large number of points of light [and the...] assembly of the points to a picture parallel in time and space, i.e., in absolute synchronism."[37]

That the convergence of serial and non-serial image processing under the conditions of constantly disturbed synchronism only became a success story when the tact was replaced with storage, i.e., time through numbers, is well known and by necessity leads to the universal medium, computer. Two final comments are appropriate here. Firstly, the storage of images as numbers by necessity calls forth a basic need for interpretation; it is in principle difficult to relate an EKG or an electroencephalogram to the physical material on which the recording process is based. The difficulty is perhaps constituted by the difference between medical and physical self-recorders; physics knows what it is talking about (because it has long since forgotten that it – according to Nietzsche – speaks). Medicine must not forfeit the physical being of humans in favor of a self-consistent construction. Secondly, the convergence of analogue and digital coding in the wake of replacing time with numbers might not lead to the great and supposedly last success story which the dictum of the universal medium computer has made omnipresent. For the sketchy reconstruction of self-recording as shown here should make clear that there is one thing that can not be recorded: time. |

36

37

_ Eduard Rhein, Paul Nipkow. Versuch eines Porträts zu seinem siebzigsten Geburtstag, in *Fernsehen: Zeitschrift für Technik und Kultur des gesamten elektrischen Fernsehwesens*, 8 August 1930, pp. 339f.

_ Hermann von Helmholtz, *Beschreibung eines Augen-Spiegels zur Untersuchung der Netzhaut im lebenden Auge*, A. Förster'sche Verlagsbuchhandlung, Berlin, 1851, p. 3.

Her fault: her own doing, all along, from the very first crayon smear. She must have wanted it, somehow, to have gotten in this deep, without once seeing the size of the betrayal she so lovingly enabled. Death from the air would win out, in the end. Remote and ingenious, all piloted by absent fathers, the warcraft were flying again, despite the gifts she'd drawn to distract them. Once before, the Air Force had thrown away her hand-made bribes. Now, worse: they took all her pretty pictures and put then to use. || The parasite room had lodged inside her. The RL, the Cavern – all smart weaponry – were just first sketches for the next, larger assembly. Her work here was just a rough draft for technology's wider plan. The world machine had used her, used them all to bring itself into existence. And its tool of choice – its lever and place to stand, the tech that would spring it at last into three dimensions – was that supreme, useless, self-indulgent escapism. The thing that made nothing happen. The mirror of nature. Art. || The war needed drawing, after all. The conflict had drafted Adie, made her its draftsman. She'd become death's seeing-eye dog, leading on into that place it could not navigate unaided. This she saw in full, even before the ground assault started. That girl's supreme paint box had done its work. Everything that imagination had fashioned would now go real. || »You're never here anymore«, Spiegel chastised her. »Even when you're here. When I talk to you, when I touch you? It's like I pass right through you.« || »I'm sorry«, she faked, as calmly as she could. »I'll be better.« || Life outlasts this, he wanted to say. It outlives its portrait. »Look«, he said, instead. »Are you trying to punish me for bringing you out here? Do you want to stop working at this? Do you want us to take off? Blow this peanut stand? I'm game, you know. I'll go anywhere. Just so long as we stay together.« || While they spoke, the road to Basra turned into a hundred-mile-long human ash. Helicopters filmed it in detailed pan, from a thousand attentive angles. || »Can you give me root directory access?« she asked, stroking him. || »What do you …? Can I ask what …?« But trust could ask nothing. »Is there anything I can help with?« || She smiled and kissed him, deep, past the lips. »Let me surprise you.« || He gave her all the system's passwords. He was love's dupe, its software engineer, ready to barter for any scrap of real-time connection he might get.

She destroyed the backup copies first. That much she'd learned, in her years of becoming digital. One by one, she mounted the archived volumes. And file by file, directory by directory, she erased her handiwork. It was not much, this retaliatory strike. It did not answer to what had been done. But in her own small way, Adie vowed to kill what she could. || Those projects to which she'd contributed nothing, she left intact. The Weather Room, the Large-Molecule docking simulation: each maker would have to be responsible for his own designs. She passed over O'Reilly's futures room, the one that had predicted the Gulf War, the one that predicted the war beyond the Gulf. She left Kaladjian's wonderland of pure math unscathed. || Even in

the worlds she'd helped to make, she picked around the others' contributions. She tore up her Arlesian floorboards but left behind Raj's ethereal creaking. She torched her dreamworld jungle, sparing those bits of vegetation that Karl had nurtured. Growth vanished into the void of zeroed data: the ebony flutist, the third monkey flushed from the undergrowth, the dreaming, almond woman that Spider Lim recognized ... ‖ She disposed of each redundant copy, as quickly as she could type the kill command. Then she turned to the working master files, the living originals. How could delight have misled her so baldly? That illusion of purpose, the giddy sense of answering a call, of doing urgent work that only her hands could do ... She could not send her portfolio back to randomness without a final peek. Fact had rendered her immune to the seduction. All she needed was five minutes, to see what that illusion looked like, stripped of belief. ‖ She booted up the cathedral and stepped back in. She leaned into the nave's great hollow, feeling herself move despite her better sense. She pointed one finger straight up, hating herself even as she gave in to the soar. She let herself rise into the hemisphere apse, then further up, all the way into the uppermost dome, now inscribed with its flowing surah from the Qur'an. ‖ She spun her body in the invented volume, the largo ballet of an astronaut repairing failed equipment far off in the infinite vacuum. She twisted and looked down into the breach below. The God's-eye view: in the simulation, but not of it. And deep beneath her, where there should have been stillness, something moved. ‖ She dropped her finger, shocked. The winch of code unthreaded. She fell like a startled fledgling, back into the world's snare. The mad thing swam into focus: a man, staring up at her fall, his face an awed bitmap no artist could have animated.

The room of the Cave is one continuous chasm. ‖ Its chambers all connect. They run together, the way old Greek was written: no spaces, no commas, no periods, just one long flow without dams or rapids, a single subterranean stream that never changes its course. But never the same stream twice. ‖ Here you have lived since childhood, facing the darkness, taking shadows for the things that cast them. On the walls of this room, a story unrolls. In it, someone just like you gets miraculously sprung. He turns to the light, which instantly blinds him. You cheer for him to run, but he turns back from the glare to the safety of this room. ‖ Your eyes adjust to the light of this hypothetical. What you take to be the boundless world may be no more than just this underground spring. You make out the peep show to be just a peep show, but only through the clip projected in front of you. The clunkiest of puppets say »shadow«, say »story«. And in that tale – continuous, no spaces – the tale you've been chained to since birth, you make out the room you live in. ‖ But even while trapped in that old scroll's closed O, the story-telling race has been busy. Millennia pass in the war against matter. Every invention bootstraps off the next. The tale advances; thought extends its grasp over things until it arrives

at the final interface. The ultimate display, the one that closes the gap between sign and thing. || In this continuous room, images go real. You come to rest at last, in no more than the idea of a bed. The mere mention of love brings on the fact. The wood »food« is enough to feed you. A carved-soap gun can kill your enemies. And a quick sketch of the resurrection suffices to raise the dead. || The room of the cave is something more than allegory. But the room of the cave is something less than real. Its wall shadows ripple with an undercurrent of substance, more than representation, but not yet stuff. Notion springs to life from the same, deep source in which the outdoors is scripted – what the run-on Greek once called the Forms. || In this room, before this play of fire, you feel the deeper freeze just outside the cave's mouth. From here you can make out those more turbulent axioms, chill forces you couldn't feel until you touched your fingers to this coded pane. || You breathe in. You lean forward, and the images advance toward you. You look up and rise, or gaze down and sink. You materialize on a stony cliff, ruined streets cutting switchbacks through a grove of olives. You fly to the end of the cliff and lift off, careful to stay, this time, above the ocean but below the sun. || You learn to steer your fragile machine. You skim above the surface of a dark sea. You dive beneath these scattered reefs and float in your birthright air. The flight feels like reading, like skimming a thousand exhilarated pages, but without the brakes and ballast of an ending. || Everywhere you look on the horizon, there are more islands. You fly past them, but always more appear. Desire moves you through them, down toward their surfaces. You've found your way back to the cradle where this project started. Here and there, against the sun-bleached shores, an amphitheater emerges, or a temple to that same bleaching sun that trails you overhead. One minute the air is thick with autumn, the next, a sweet-sapped spring. The seasons track that kidnapped goddess through the year, wandering to and from her underground prison. || You fly too freely, or the land's geometry is wrong. Some titan fails to hold up his corner of the air's tent. Or you simply reach the edge of a story that, even at this final stage, remains eternally under construction. An embankment, pitch-white and blinding, looms up in front of you, too fast for you to take evasive action. || The scene crashes before you do. The room of the cave slams to a breakpoint and empties itself into error's buffer. There on the wall where the oceans and olives and temples were, where the marble crags ran from their spine down into their unbroken chasm, the machine seizes up, the faulty allegory crumbles, the debugger spits out a continuous scroll of words. || Only through this crack can you see where things lead. You step through the broken symbols, into something brighter. ||

RICHARD POWERS, PLOWING THE DARK, FARRAR STRAUS AND GIROUX, NEW YORK, 2000.

Reprinted with permission of the author.

Why is destruction necessary for construction?

ANALYTIC TERROR
KEYWORD FOR AVANT-GARDISM AS EXPLICATIVE FORCE

Peter Sloterdijk

OF ALL OFFENSIVE GESTURES OF AESTHETIC MODERNITY, surrealism, more than any other, strengthened the insight that the main interest of the present time must focus on the explication of culture – provided we understand culture as the quintessence of symbol-forming mechanisms and art creation processes. Surrealism follows the command that demands occupation of the symbolic dimensions in the crusade towards modernization. Its articulated and unarticulated aim is to make creative processes explicit and elucidate their sources as much as possible. For this purpose and without ceremony it brings forward the fetish of the epoch; the concept of "revolution," legitimization of all things. However, as in political spheres (where it *de facto* has never been a question of an actual "turning" in the sense of a reversal from top to bottom, but of proliferation of top positions and their re-appointment by representatives of the offensive middle classes – which indeed would not be possible without a partial transparency of the mechanisms of power – that is, democratization – and seldom without an initial phase of open force from below), the misnomer of events is also evident in the field of culture. Here, too, there was never a reversal or *Umwälzung* in the precise sense of the word, but, rather, solely a re-distribution of symbolic hegemony – which demanded a certain revelation of artistic processes and called for a phase of barbarisms and *Bilderstürme*. In the field of culture, "revolution" is a pseudonym for "legitimate" force against latent tendencies. It causes the new performers, who act with a clear conscience, to break from the holisms and comforts of bourgeois art settings.

The recollection of one of the best-known scenes from the surrealistic offensive may well explain the parallelism between the atmo-terrorist explications of the atmosphere and the culturally revolutionary blows to the mentality of a bourgeois art audience. On 1 July 1936, Salvador Dalí, who was at the start of his career as a self-proclaimed ambassador from the kingdom of the surreal, gave a performance at London's New Burlington Galleries on the occasion of the *International Surrealist Exhibition*, in which he intended to explain the principles of the "paranoiac critical method" he had developed, with reference to his own exhibit. In order to make quite clear to his audience by his appearance that he was speaking to them as a representative of a radical Elsewhere and in the name of the Other, Dalí chose to wear a diving suit for his lecture. According to the report in the *London Star* on 2 July, a car radiator was attached to the top of the helmet; the artist was also holding a billiard cue in his hand and he was accompanied by two large dogs.[1] In his self-portrayal, *Comment on deviant Dalí*, the artist retells a version of the incident that resulted from this idea:

> "I had decided to make a speech on the occasion of the exhibition, but wearing a diving suit, in order to allegorize the subconscious. Hence I was dressed in my armor and even put on shoes with lead soles, thus preventing me from moving my legs. I had to be carried onto the podium. Then the helmet was placed on my head and screwed tight. I started my speech behind the glass of the helmet – in front of a microphone that was obviously not able to pick up anything. My facial expression however fascinated the audience. Soon I was gasping for breath with my mouth wide open, my face turned red at first and then blue and my eyes started to roll. Apparently one (sic!) had forgotten to connect me to an air supply system, and I was close to suffocation. The expert who had fitted me had disappeared. By gesticulating I made my friends aware that my situation was becoming critical. One fetched a pair of scissors and tried in vain to pierce the suit, another wanted to unscrew the helmet. As his attempt failed, he started to hit the screws with a hammer ... two men tried to tear off the helmet, a third continued to hit the metal, so that I almost lost consciousness. There was now a wild scuffle on the podium, during which I surfaced now and again like a jumping jack

1

_ Cf. Ian Gibson, *Salvador Dalí. Die Biographie*, Deutsche Verlags-Anstalt, Stuttgart, 1998, p. 378.

with dislocated limbs, and my copper helmet resounding like a gong. The audience then applauded this successful Dalí mimo-drama, which, in their eyes, no doubt showed how the conscious tried to seize the unconscious. This triumph was, however, almost the death of me. When they finally pulled off the helmet, I was as pale as Jesus on his return from forty days fasting in the desert."[2]

This scene illustrates two things: Surrealism is a dilettantism, where technical objects are not employed on their own terms, but as symbolic draperies. Nevertheless, it is part of the explicit-making movement of modern art, as it unmistakably presents itself as a process that breaks latent tendencies and dissolves backgrounds. An important aspect of dissolving backgrounds in the cultural field is the attempt to destroy the consensus between the producing and the receiving side in artistic activity, in order to set free the radical intrinsic value of the showing-event and uncover the absoluteness of the production and the intrinsic value of receptivity. Such interventions are valuable as elucidation measures against provincialism and cultural narcissism. It was not without reason that the surrealists, in the early phase of their wave of attacks, developed the art of astounding the bourgeois as a form of action *sui generis*, since this helped the innovators distinguish between in-group and out-group, and also allowed the public protest to be considered a sign of the successful dismantling of a handed down system. Whoever scandalizes the public admits to progressive iconoclasm. He or she uses terror against symbols to burst mystified latent positions and achieve a breakthrough with more explicit techniques. The legitimate premise of symbolic aggression lies in the belief that cultures have too many skeletons in the closet and it is time to burst the interrelations between armament and edification that are protected by latency. When the early avant-gardes nevertheless came to an erroneous conclusion, this could be seen in the fact

2

that the populace they intended to frighten always learned its lesson faster than any one of the aesthetic bogeymen ever anticipated. After only a few rounds of the game between the provocateurs and the provoked, a situation necessarily arose in which the bourgeoisie, enticed by mass culture, took over the explication of art, culture, and significance through marketing, design, and auto-hypnosis, whilst the artists often continued to only formally astound, without noticing that the time for this method had passed. Others underwent a neo-romantic turn and once again came to terms with profundity. Soon, many modernists seemed to have forgotten the basic principle of modern philosophy defined by Hegel that applies analogously to aesthetic production: the depth of a thought can only be measured by the power of its comprehensiveness – otherwise it remains an empty symbol for unconquered latent elements.

These results can be measured by Dalí's failed and hence informative performance: it proves on the one hand that the destruction of consensus between the artist and the public cannot succeed once the latter has understood the new rule through which the extension of the work to the environment of the work, itself becomes the form of work. The enthusiastic applause that Dalí received at the New Burlington Galleries illustrated how consistently the educated audience adhered to the new terms of art perception. On the other hand, the scene showed the artist as latency-breaker, conveying to the profane people a message from the kingdom of Otherness. Dalí's function in this game was distinguished by its ambiguity, which tells us a great deal about his vacillation between romanticism and objectivity. On the one hand he commends himself as a technician of the Other since, in the lecture he never held, but which can easily be anticipated by its title: *Authentic Paranoiac Fantasies*, he intended to deal with a precise method which would make access to the "subconscious" controllable – that paranoiac critical method with which Dalí formulated formal instructions for the "Conquest of the

_ Salvador Dali, *Dali*, translated (German) by
Franz Meyer, Moewig, Rastatt, 1988, pp. 229-230.

Dalí in a diving suit / from: Ian Gibson, The Shameful Life of Salvador Dalí, Faber and Faber, London, 1997 / © photo: Whit Library, Courtauld Institute
Dalí in a diving suit shortly before giving a performance-lecture on surrealistic profoundness in London 1936.
On the floor from left to right: Paul Eluard, Nusch Eluard, and E.L.T. Mesens. Next to Dalí on the left side: Diana Lee, on the right: Rupert Lee

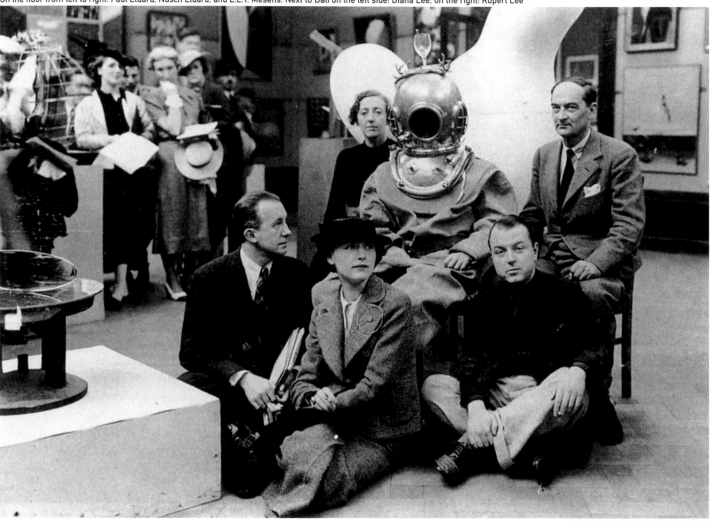

Irrational."[3] He confessed to a kind of photo-realism with regard to irrational inner pictures: he intended to objectify with masterly precision what had become apparent in dreams, delirium, and inner visions. At this time he already understood his work as an artistic parallel to the so-called "discovery of the unconscious through psychoanalysis" – a scientific myth adopted manifold by the aesthetic avant-gardes and the educated audiences of the 1920s and 1930s (and brought to esteem once again by Lacan between the 1950s and 1970s when he reanimated the surrealistic form of lecture for a "return to Freud"). From this perspective, surrealism takes its place in the manifestations of the operational "revolution," which carries on the continuous advancement of modernization. On the other hand, Dalí adhered, decidedly counter-critically, to the romantic conception of the artist-ambassador who amongst the unenlightened, transforms into a delegate of the Beyond, pregnant with sense. This attitude reveals him as a domineering amateur, surrendering to the illusion that he is capable of employing complicated technical devices to articulate metaphysical kitsch. The user attitude is typical in this case, childishly leaving the technical side of his own performance to experts whose competence he had not convinced himself of; also the fact that the scene was not rehearsed, shows the artist's poor, literary treatment of technical structures.

Nevertheless, Dalí's choice of outfits has an illuminating aspect; his accident is prophetic – not only in terms of the reaction of the spectators, who proclaimed applause for what they failed to understand as a new cultural bearing. The fact that the artist chose a diving suit equipped with an artificial air supply for his appearance as ambassador from the deep, leaves no doubt about his connection with the development of atmospheric consciousness, which, as we attempt to show here, is central to the self-explication of culture in the twentieth century. Even if the surrealist achieves only a semi-technical interpretation of global and cultural background as "sea of the subconscious," he or she already postulates a competence to navigate in this space with formally expanded procedures. His performance makes it obvious that, in the present age, conscious existence must be lived as an explicit dive into context. Those who venture out of their own camps in multi-milieu society must be sure of their "diving equipment," that is, of their physical and mental immune systems. The accident cannot be accounted to dilettantism alone; it also discloses the systematic risks of technical atmospheric explication and technically forced access to an other element – precisely in the way that the risk of poisoning the home troops was inseparable from the actions of military atmo-terrorism in gas warfare. If Dalí's portrayal of the incident is accurate, then he was not far from going down in history as martyr of dives in the symbolic sense.

Under the given circumstances, the accident proved to be a form of production, in that it triggered off panic in the artist, which had always been inherent as impetus for his work. In the unsuccessful attempt to present the "subconscious" as a navigable zone, the very fear of annihilation came to the fore, for which the aesthetic explication process was activated to conquer and expel. To put it in general terms: the contra-phobic experiment of modernization is never really able to emancipate itself from its background of fear, as this would not be capable of appearing until fear could be allowed to enter into existence as fear itself – which, by the nature of things, presents an impossible hypothesis. Modernity as a background-explication therefore remains caught in the circle of victory over fear through technology that causes fear. Primary as well as secondary fear always provides a fresh boost for the continuation of the process; its urgency justifies the use of further latency-breaking and background-controlling force at every stage of modernization – or, according to prevailing phraseology, it demands permanent basic research and innovation.

Aesthetic modernity is a process of using force neither against persons nor objects, but against non-clarified cultural

3

_ Salvador Dalí, *La Conquête de l'Irrationnel*, Éditions Surréalistes, Paris, 1935, German in:
Unabhängigkeitserklärung der Phantasie und Erklärung der Rechte des Menschen auf seine Verrücktheit.
Gesammelte Schriften, Axel Matthes (ed.), Rogner & Bernhard, Munich, 1974, pp. 268-279.

relations. It organizes a wave of attacks against the holistic attitudes of the types: belief, love, and honesty and against pseudo-evident categories such as shape, content, image, works, and art. Its *modus operandi* is live experimentation on the users of these definitions. Aggressive modernism consequently breaks away from the respect for classicists, in which, as it remarks with great aversion, at least vague holism is manifested – combined with a tendency to continue to follow a "totum," retained in its undefined and undeveloped state. As a result of its keen wish for explicitness, surrealism declares war on mediocrity: it sees in it the opportune hideout for anti-modern lethargies, which oppose the operative development and re-constructive revelation of integrated rules. As normality rates as a crime in this war of mentality, art as a medium of combating crime can build on unusual combat orders. When Isaac Babel declared: "banality is the counter-revolution," he had indirectly expressed the principle of "revolution": The use of fear as force against normality bursts aesthetic and social latency and raises to the surface laws according to which societies and works of art are construed. Permanent "revolution" calls for permanent fear. It postulates a society that proves itself repeatedly as readily frightened and controllable. New art is saturated with the excitement of the very newest, as it appears terror-mimetic and warlike – often without being able to define whether it declares war on the war of societies or wages war on its own behalf. The artist permanently faces the decision of whether to advance against the public as savior of differences or as warlord of innovation. In view of this ambivalence in modernistic aggression, so-called post-modernism was not entirely wrong when it defined itself as an anti-explicit and anti-extremist reaction to the aesthetic and analytic terror of modern art.

Like all forms of terrorism, the aesthetic falls back on the unmarked background in front of which works of art articulate and makes it appear on the forestage as an intrinsic phenomenon. The prototype of modern painting of this trend,

Kasimir Malevich's *Black Square* invented in 1913, owes its inexhaustible interpretability to the artist's decision to evacuate the image space in favor of the pure, dark surface. Thereby its squareness itself becomes the figure, which in other pictorial situations appears as the carrier in the background. The scandal of the work lies, amongst other things, in the fact that it still stands its ground as a painting in its own right and by no means presents merely an empty canvas as object of interest, as would have been conceivable in the context of dadaistic campaigns to deride art. It may well be that the picture can be regarded as a minimally irregular platonic icon of the equilateral rectangle, deserving tribute due to its sensuousness; it is however simultaneously the icon of the aniconic or pre-iconic – of the normally invisible picture background. The black square therefore stands before a white background, which surrounds it, quasi as a frame; in the *White Square* painted in 1914 even this difference is almost compensated. The basic gesture of such formal representations is the raising of the non-thematic to the thematic. Not the possibly varied picture contents, which could appear in the foreground, are reduced to a background which always appears the same, but far more, the background as such is painted with the greatest care and thus made explicit as figure of the figure-bearer. The terror of purification can be unambiguously seen in the desire for the "supremacy of pure feeling." The work of art demands the unconditional capitulation of the beholders' perception before its real presence.

Although suprematism, with its anti-naturalism and its anti-phenomenonalism, makes itself clearly known as an offensive movement on the aesthetic flank of explication, it remains bound to the idealistic belief that to make explicit means the return of what is sensually present to what is spiritually absent. It is bound to old European and platonic rules, in so far as it explains things upwards and simplifies the empiric forms to pure, primary forms. In this respect surrealism operated differently by following more closely the

materialistic, downward manner of explication – without going so far as to be named *Sous*realism. Yet, whilst the material trend remained coquetry for the surrealist movement, its alliance with depth psychologies, in particular the psychoanalytic trend, revealed its own characteristic trait. The surrealistic reception of Viennese psychoanalysis is one of numerous cases illustrating that the initial success of Freudianism amongst the educated audience and numerous artists was not achieved as a therapeutic method, which naturally only a very small number of persons experienced first hand, but as a strategy for interpretation of symbols and background manipulation, leaving every interested party the choice of application open to suit individual requirements. Is not indeed the analysis one did not undergo, always the most appealing?

Freud's approach led to the unfolding of a realm of a special kind of latency and came to be known by an expression adopted from idealistic philosophy, namely from Schelling, Schubert, Carus, and the nineteenth century philosophies of life, especially Schopenhauer and Hartmann, as "the unconscious;" this defined a subjective dimension of security, of inner latencies and of the invisibly overlapped preconditions for an ego-ish state. According to Freudian formulation, the meaning of the expression had narrowed radically and become so specialized that it could be put to clinical use; it no longer signified the reservoir of dark, integrating forces in a preconscious nature that possesses healing power and creates pictures, nor the underground of blindly, self-affirming streams of will below the "subject." It defined a small, inner container that becomes filled with repressed emotions and is subjected to neurotogenic tension through the buoyancy of the repressed.[4] The surrealists' enthusiasm for psychoanalysis was due to the fact that they confused the Freudian definition of the unconscious with Romantic metaphysics. From creative misinterpretation arose declarations such as Dalí's *Declaration of Independence of Fantasy and Declaration of Human Rights*

to Madness in 1939, in which sentences are found, such as: "A man has the right to love women with ecstatic fishheads. A man has the right to find lukewarm telephones repulsive and to demand telephones as cold, green and aphrodisiac as the sleep of a Spanish fly when haunted by faces."[5] The surrealistic allusion to the right to be mad, warns individuals of their tendency to submission to normalizing therapies; it wishes to make monarchists out of what are usually unhappy patients who pursue their own return from an exile, neurotic with reason, to the kingdom of their very personal madness.

We should not forget that what is today called the consumer society was invented in a hothouse – in those glass covered arcades of the early nineteenth century, in which a first generation of adventure-customers came to breathe the intoxicating perfume of a closed inside world of consumer goods. The arcades represent an early stage of urban atmospheric explication – an objective turning-out of the "home-addicted" disposition, which, according to Walter Benjamin, seized the nineteenth century. Home-addiction, says Benjamin, is the irresistible urge, "to found a home" in all surroundings.[6] In Benjamin's theory of the interior, the "super-temporal" need for uterus simulation, expressly with the forms of a concrete historic situation, has already been conceived. Indeed, the twentieth century with its large buildings has shown how far the erection of "living space" can be extended beyond the boundaries of the need to search for a comfortable interior.

The year 1936 is not only enrolled in the chronic of aesthetic and cultural theoretic atmospheric explication through Salvador Dalí's accident in London in a diving suit; on 1 November of the same year, the 31 year old author Elias Canetti held a speech on the occasion of Hermann Broch's fiftieth birthday, a speech which was unusual in content and tone, in which he not only drew a detailed portrait of the author he was honoring, but at the same time shaped a new genre of laudation. The originality of Canetti's speech was that it raised the question of a connection between an author and

4

_ The philosophical sources of the definition of the unconscious are illustrated mainly in the works of Odo Marquard, *Transzendentaler Idealismus. Romantische Naturphilosophie. Psychoanalyse*, Verlag für Philosophie Dinter, Cologne, 1987, and Jean-Marie Vaysse, *L'inconscient des modernes. Essai sur l'origine métaphysique de la psychanalyse*, Paris, 1999.

5 6

_ Walter Benjamin, *Das Passagen-Werk, Gesammelte Schriften*, V, 1, Suhrkamp, Frankfurt/M., 1989, p. 292.

_ Dalí, op. cit., p. 290.

his time in a manner previously unknown. Canetti defined the artist's stay in time as a breath-connection – as a special way of diving into the concrete atmospheric conditions of the epoch. Canetti sees in Broch the first grand master of a "Poetry of the Atmospheric as a Static"[7] – meaning, of an art which would be capable of illustrating "static breathing space," expressed in a manner: making visible the climatic design of persons and groups in their typical spaces. "[His] involvement is always with the entire space in which he is present, with a kind of atmospheric unity."[8] Canetti praises Broch's ability to grasp every person he attempts to portray, also in an ecological sense: he recognizes the singular existence of every person in his or her own breathing air, surrounded by an unmistakable climatic membrane, embodied in a personal "breathing household." He compares the poet with a curious bird with the freedom to creep into every possible cage and take "air samples" from them. Thus he knows, bestowed with a mysteriously keen "memory for air and breath," how it feels to be in this or that atmospheric habitat. As Broch turns to his characters more as a poet than a philosopher, he does not describe them as abstract ego-points in a universal ether; he portrays them as personified figures, each one living in its characteristic air membrane and moving between a variety of atmospheric constellations. The question of a possibility of poetry "drawn from breathing experience" leads only to fruitful information in light of this multiplicity:

> "Above all, the answer would need to be that the diversity of our world consists, for the main part, of the variety of our breathing spaces. The space in which you are now sitting in a certain order, almost completely closed in from the environment, the manner in which your breath blends to an air common to all ... all this is, from the point of view of the person breathing, a unique ... situation. Yet, go a few steps further and you will find a completely different situation in another breathing space ... The city is full of such breathing spaces, as full as it is of individual human beings; and in the same way as the split up of these people, of whom no one is the same as the other, a kind of every man's cul-de-sac constitutes the main excitement and main misery of life, one could also lament the split up of the atmosphere."[9]

According to this characterization, Broch's art of narrative is based on the discovery of atmospheric multiplicity through which the modern novel reaches beyond the representation of individual destiny. Its theme is no longer individuals in their limited activities and experiments, far more the extended unity of individual and breathing space. The actions are no longer carried out between persons, but between breathing households and their respective occupants. Through this ecological viewpoint, the alienation critical motive of modernity is given new basic principles: the atmospheric separation of people amongst themselves accomplished by their own respective "households;" the difficulty for those with different outlooks, different membranes, different climates to reach them appears more justified than ever. The division of the social world into individual, for one another inaccessible spaces of obstinacy, is the moral analogue to the microclimatic "split up of the atmosphere" (which for its part corresponds to a split up of "world values").

As Broch, after his advance onto the individually climatic and personally ecological plane, had quasi systematically grasped the depth of isolation in modern individuals, the question of the conditions of their unison in a common ether beyond the atmospheric separation must have occurred to him in a clearness and urgency unequalled in his own time or at a later point in time in the history of sociological examinations on the elements of social connection – with the possible exception of Canetti's related attempt in *Masse und Macht*. In his speech in 1936 Canetti recognizes in Hermann Broch the prophetic warner of an unprecedented danger to humanity,

8 7

_ Canetti, op. cit., p. 18.

9

_ Canetti, op. cit., p. 23.

_ Elias Canetti, Hermann Broch. Rede zum 50. Geburtstag, in: Elias Canetti,
Das Gewissen der Worte. Essays, Fischer Taschenbuch Verlag, Frankfurt/M., 1981, p. 22.

that in the metaphoric as in the physical sense, was an atmospheric threat:

> "Yet the greatest danger that has ever occurred in the history of mankind has chosen our generation as its victim.
>
> It is the defenselessness of breath that I would like to now finally speak of. It is difficult to grasp its real significance. Human beings are more receptive for air than for any other thing. They still move within it like Adam in paradise ... Air is the last common property. It belongs to all collectively. It is not pre-portioned; even the poorest may take their share ...
>
> And now this last thing that was common to us all is to poison us all ...
>
> Hermann Broch's work is positioned between war and war, gas war and gas war. It is possible that he still now feels the toxic particles of the last war somewhere ... but it is certain that he, who understands how to breathe better than we ourselves, is suffocating today on the gas that will take the breath from us others, whoever knows when that will be."[10]

Canetti's impassioned observation shows how information of the gas warfare from 1915-1918 had been abstractly translated by the most intensive diagnostician of the 1930s: Broch had realized that after the intentional atmospheric destruction in chemical warfare, social synthesis began in many respects to take on the character of gas warfare, as if atmo-terrorism had turned inwards. The "total war," heralded by old particles and new signs, would inevitably take on the characteristics of an environmental war: during this war, the atmosphere itself would become a theater of war, and furthermore: air would become a kind of weapon and a special kind of battlefield. And in addition: from the commonly breathed air, from the ether of the collective, the community, in its mania, will in future wage a chemical war against itself. How this can happen can be explained by a theory of "semi-consciousness" – undoubtedly the most original, if also the most fragmentary part remaining of Broch's mass psychological hypotheses.

A state of semi-consciousness is such in which people move merely as trend followers in a trance of normality. As the prevailing total war is waged principally atmo-terroristically and ecologically (this in the medium of total mass communication), it spreads to the "morale" of the troops, who can now hardly be distinguished from the population. Through toxic communions, the fighters and non-fighters, the synchronically gassed and simultaneously excited, consolidate in a collective state of sub-consciousness. The modern masses see themselves integrated in an emergency communistic unit that should give them an acute feeling of identity due to their common threatened state. The climatic poisons emanated by the people themselves then prove to be especially dangerous, as long as they are standing beneath sealed communication domes, hopelessly aroused: In the pathogenic air-conditioning systems of synchronically excited publics, the inhabitants breathe in their own breath, again and again. Whatever is in the air is put there through totalitarian circular communication: it is filled with the victory dreams of offended masses and their drunken, far from empiric self-exaltation, followed like a shadow by the desire to humiliate others. Life in a multimedia state is like a stay in an enthusiastic gas palace. |

10

_ Canetti, op. cit., pp. 23-24.

TRIENNALE DI MILANO 68. A CASE STUDY AND BEYOND
ARATA ISOZAKI'S ELECTRONIC LABYRINTHS, A «MA» OF IMAGES

Hans Ulrich Obrist

Part One
Architecture Triennale 68 Milano
Reconstruction of the Room of Arata Isozaki and
the Information Room by Giancarlo de Carlo,
Stefano Boeri and Hans Ulrich Obrist

On 30 May 1968, during the press conference of the XIV Triennale di Milano several hundred artists, intellectuals, and architecture professors from the Milan University stormed the Triennale area and occupied it for ten days. By the end of the occupation, this historical exhibition of 1960s critical avant-garde architecture was almost completely destroyed, and the rooms of Archigram, Saul Bass, Georges Candilis, Aldo Van Eyck, Arata Isozaki, Gyorgy Kepes, George Nelson, Peter and Alison Smithson, and Shad Woods were turned to ruins. It would never open to the public. As Italian urbanist Stefano Boeri shows in his analysis of the Triennale phenomenon: "The unifying topic of the show was multitude, it was dedicated to seeking an alternative to the massification of society in the concept of participation in culture with a capacity to safeguard individuality. Inspired by the theme of the greater number, the XIV Triennale had kept a keen eye on the protest movement taking shape in Italy as elsewhere at the time. It was no accident that a section of the exhibition installed by a group of young Florentine architects called UFO had been entirely focused on May 1968 in Paris and on the protest movement in America." Despite this fact, the exhibition planned by Giancarlo de Carlo with Marco Zanuso, Albe Steiner, and Alberto Rosselli had been destroyed. But since then, this invisible exhibition, experienced and ravaged in the space of a few weeks by a self-appointed mass of passionate scions and vandals, has become a focal point of strong emotions and passions.

The module presents the case study in videos, photos, wallpaper, show cases, and interviews. One interview (see part two) was made twenty years after the events by Stefano Boeri with Giancarlo de Carlo, whom period photographs show in the act of addressing the disparate fronts – both the occupants and the police – single-handedly and furiously. Stefano Boeri asked de Carlo's opinion about what had prompted the occupation and why the emotional wave of protest had targeted Palazzo dell' Arte. Another interview (see part three) was made with Arata Isozaki, one of the architects invited to the exhibition. For *Iconoclash*, Arata Isozaki's installation, certainly one of the most important works of the Triennale, has been reconstituted and so become visible for the first time. Isozaki describes his project for the Triennale in the following words:

"I didn't see the opening because it was completely taken over by these young artists and students protesting. At the time, of course, similar movements against the establishment were also going on in Japan. Because I sympathized with these protests, I tried to reflect them in my Triennale exhibit. I was given some space to create an environment, so I asked several artist friends to work with me. One is a graphic artist, Kōhei Sugiura – one of the best, most creative graphic artists we've had in Japan since the war. Another is a photographer, Shōmei Tōmatsu. And I invited a composer, Toshi Itchiyanagi, and asked him to create a kind of sound installation. My idea was to create twelve, very large curved panels covered with an aluminum surface on which numerous images were silk-screened. I chose from *ukiyo-e* prints about ghosts and terrible tragedies, and asked Tōmatsu to find documentary stills about the atom bombs, rather than to use his own work. So, he brought a film and some pictures of Hiroshima and Nagasaki. One famous one is of a kind of shadow made on a wall at the time the bomb exploded. These were the images I put on the panels, which also moved anytime anyone passed through an invisible infrared beam. They would turn and suddenly you would see a ghost or a dead body, which completely involved you

in the movement of these strange images. They almost all had to do with the tragedy of the war or the crisis in society. At the same time, there were also large walls, thirteen meters long and five meters high, very large walls, on which I made a kind of collage about the ruins of Hiroshima and the megastructure it would later become, which itself was in a state of ruin: a ruined structure on the ruins, which I titled *The City of the Future is the Ruins*. I was very much obsessed by these ruins of the future. I projected many images of the future city onto the wall. At the time, we didn't have any kind of video system, but just slide projectors with maybe three carrousels with eighty slides each, which meant a lot of images running through the projectors. We tried to show how the future city would itself constantly fall into ruin. This was on the moving panels, which, whenever they turned, would be accompanied by Toshi Ichiyanagi's strange sounds. It was an odd feeling to hear them. I called the installation *Electric Labyrinth*."

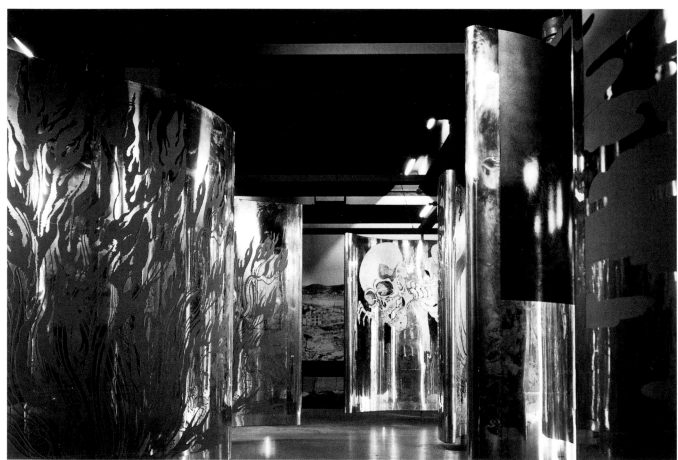

Arata Isozaki / The Electric Labyrinth / installation view Triennale di Milano, 1968 / © Arata Isozaki & Associates, Japan

The reason underlying the choice of recreating Isozaki's room for *Iconoclash* is, on the one hand, its historical importance as one of the key works of the history of experimental interdisciplinary exhibition of the 1960s – a history that might otherwise fall into amnesia – and on the other hand, its direct relation to the issues that we want to raise through the exhibition *Iconoclash*. If Isozaki didn't conceive an iconoclastic installation, it can surely be interpreted as a reflection on iconoclasm from a Japanese point of view. And rather than isolation, interruption, or segregation of images, his interdisciplinary installation proposes new cascades of images, a new set up to multiply the possibilities of vision by focusing on the Japanese *ma*, i.e., on the in-between space of images (see part three). By so doing, Isozaki points towards the very direction of this show: towards the idea that the issue is not between a world of images and a world with no images but between the interrupted flow of pictures and a cascade of them (see Bruno Latour's introduction to the catalog). Isozaki's 1968/2002 interdisciplinary installation proposes a negotiation of and between different elements, which frame a world beyond the wars of images and the wars of disciplines, and encourage the viewers to look for other properties of images.

Part Two
Chronicle of a Predictable Occupation
Stefano Boeri Interviews Giancarlo de Carlo

STEFANO BOERI: Had it been an enormous misconception, not unusual in those years (youths participating in the French movement of May 1968 Jean-Paul Sartre wrote, "the Imbecile"), which led hundreds of youths to repudiate one of the landmarks responsible for having unleashed the same critical reflection that had apparently motivated their spirit and protest? Or else, on the contrary, had something different happened during the days prior to the occupation, something spawned by a conscious aversion to an exhibition basically developing a critical and anticipatory idea about the risks of non-regimentation and the excessive politicization of the students' movement itself?

GIANCARLO DE CARLO: The first theory, that of a misunderstanding, is valid and logical to a certain extent. Those were times of great misapprehension, such as the spite aimed at Pasolini without the slightest understanding of his rare and exceptional grasp of the fundamental changes taking place. On the other hand, there reigned a spirit of exasperation in Milan at that time, teeming with contrasts and, not only very hard to govern, but also to bring to the discussion table. There was no opportunity for even a violent exchange of opinions with the more boisterous representatives of the movement, who were also among the more interesting personalities. But I must add that these representatives of the movement were not the true protagonists of the Triennale occupation. Those arrived on the scene later, during the afternoon of the press inauguration when the building had already been blocked off. They entered as one would into any occupied institutional facility in Milan. That is, they installed themselves. In fact, the Triennale was one of those ambiguous institutional organisms which, in their rather scant opinion, was to be abolished. On the other hand, a general assembly of Politecnica University students had voted in favor of a document not condemning the Greater Number Exhibition. Instead, it criticized the Triennale as an institution but did not consider the occupation one of its potential initiatives. In other words, the architecture students most seriously committed to the movement had disassociated themselves from the occupation. Why was this? Because they had understood that an occupation of the Triennale was not the result of a spontaneous movement or of the refutation of an institution or of a conscious opposition to that particular exhibition. They had understood perfectly well that there was something else underlying it: a preconceived and unrelenting hostility ingrained in a faction of intellectuals in Milan.

Triennale di Milano after the occupation / 1968 / snapshots

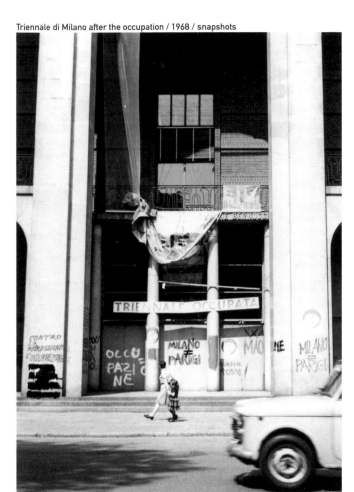 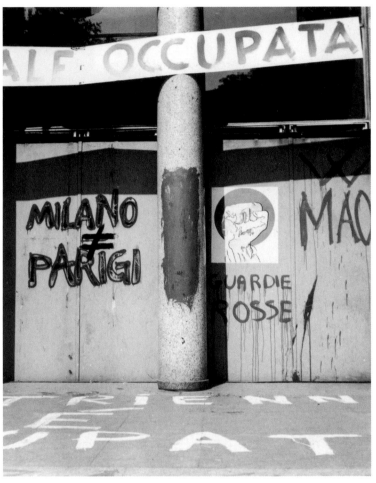

SB: What sort of hostility and who started it?

GDC: It was hostility motivated by two factors, one superficial and the other more profound. The superficial motivation was that many Milanese intellectuals (who regularly participated in the Triennale) had been excluded from the 1968 edition. Without contemplating the political and diplomatic facets of this, as I probably should have done, I deliberately thought that the Triennale environment needed refreshing and pro-

posed that the Board call the most avant-garde points of reference in international architecture and urban planning to participate in the exhibition. For that reason there was only a small space left in the building for Italian participants, which had been designated to a group of young people working to desalinize seawater. This was a blatantly provocative subject which implied the need to work on concrete things and put an end to the narcissistic foolishness which had all too often occupied the exhibition spaces of previous editions of the

Triennale: bogus handicrafts, little jewels, ceramics from Ruta, all mixed together without the slightest theme, criterion, or rationale. Those excluded wanted to bring their things, their little jewels, to the Greater Number Exhibition and we told them, No, dears, your little jewels may be precious, but they have no relevance to the greater number theme. I don't claim that the jewelers organized the occupation which, as everything else at that time, happened somewhat by chance. But it is certain that they deliberately organized the sabotage of the XIV Triennale. There were some valid artists among them, the Pomodoro brothers, for instance, but there was also someone who played the role of their Trojan horse, the sculptor Ramous who had resigned from the Triennale Board just before the exhibition. We had refused to exhibit paintings or sculptures by his friends and had told him, we are sorry but we don't like your friends and they have nothing to do with the greater number theme anyway. He was furious and walked out, slamming the door behind him.

SB: How did you choose the participants for the Greater Number Exhibition?

GDC: Our point of departure for the XIV Triennale theme was the observation that we were approaching a society in which errors were countless, multiple, and varied. Therefore we were faced with two alternatives: on the one hand, the possibility of becoming a mass civilization and, on the other, the possibility of becoming a civilization of a greater number. At the time, I differentiated (as documented in the programs written for the Triennale) between the greater number which characterizes a thinking society in which individuals are still the protagonists of events, and a mass civilization which, on the contrary, is a homogenized civilization, composed of individuals who identify with powerful structures, a civilization which I find uninteresting in terms of humanity and consider politically and socially dangerous. So I proposed that

we invite a series of outstanding personalities to the Triennale to compose a series of events representing both an opposition to massification and a triumph of intelligence applied to a society abounding in multiple participation. We invited the Archigrams, the equivalent of the Beatles in terms of architecture, given our objective of seeking the cream of international culture. They communicated an intelligent, desecrating, and, at the same time, rigorous message. The Archigram group, contrary to what one might imagine, was also extremely serious and precise, evident in its grasp of the significance of the installation. Arriving at the Triennale, the members began to prepare their pavilion, to fabricate their circuits with great competence and care. We also invited such personalities as Saul Bass and Arata Isozaki, who came to Italy for the first time and composed a very cruel and beautiful pavilion. It was the first recognition of Isozaki on an international scale. I had met him by chance in Tokyo and realized that he was someone of great importance, so I proposed that he be invited to install a pavilion at the Greater Number Exibition of the Triennale.

SB: Was there a certain diffidence towards a choice that some considered excessively oriented towards foreigners?

GDC: It was certainly a choice deplored by most of the Milanese intellectuals because they felt slighted and dethroned. But the real reasons lay elsewhere. I think that there was a parallel to some extent between what happened at the time at the XIV Triennale and what had taken place some months earlier at the Piano Intercomunale Milanese (PIM; Milanese intercity planning board). I'm not saying this because I had been prominently involved in both experiences but because there was an extraordinary coincidence in the evolution of the two events. Not only because the Triennale was occupied and PIM was run off its course and into extinction, but especially because both were destroyed with the excuse of going over their heads to the left. The Triennale was occupied under the

Aldo van Eyck / La piccola scala per le grandi dimensioni / 1968 /
installation view Triennale di Milano, 1968 / © photo: Archivio Triennale di Milano, Milan

Triennale di Milano after the occupation / 1968 /
snapshot / view of the entrance / © photo: Archivio Triennale di Milano, Milan

Triennale di Milano after the occupation / 1968 /
snapshot / view of the Chadwick section / © photo: Archivio Triennale di Milano, Milan

Giancarlo de Carlo, Marco Bellocchio, Bruno Caruso / The protest of the youth
/ 1968 / Triennale di Milano, 1968 / © photo: Archivio Triennale di Milano, Milan

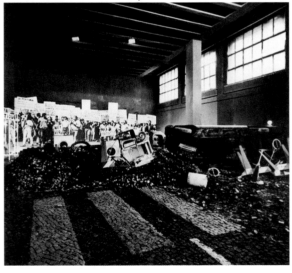

Triennale di Milano after the occupation / 1968 / snapshot / view of the Hardy section /
Triennale di Milano 1968 / © photo: Archivio Triennale di Milano, Milan

Triennale di Milano after the occupation / 1968 /
snapshot / view of the Nelson section / © photo: Archivio Triennale di Milano, Milan

Lynn Chadwick / L'intervento figurativo a grande scala /
1968 / installation view Triennale di Milano, 1968 /
© photo: Archivio Triennale di Milano, Milan

»Gli UFO« group / The protest of the youth. The events of the UFO /
1968 / installation view Triennale di Milano, 1968 /
© photo: Archivio Triennale di Milano, Milan

Hugh Hardy, Malcolm Holzman, Norman Pfeiffer / La nuova
percezione visiva dello spazio urbano / 1968 / installation view
Triennale di Milano, 1968 / © photo: Archivio Triennale di Milano, Milan

Pio Manzù, Richard Sapper, William Lansing Plumb / Il grande numero
le prospettive / 1968 / installation view Triennale di Milano, 1968 /
© photo: Archivio Triennale di Milano, Milan

pretense of desiring something more leftist, just as had happened with the Piano Intercomunales turbine-power diagram of which it was said: It's too limited. Lets make a more extensive one from Venice to Turin. As a consequence, nothing more was done.

SB: In other words, it was a predictable occupation in a certain sense?

GDC: There was something strange about everything that happened on inauguration day. The demonstrators outside the Palazzo began to call me, to chant my name. I went outside to ask what they wanted and they told me that the administration was preventing them from entering for the press conference. So I immediately went to the President of the Triennale to ask that they be allowed to enter, especially since the police had formed ranks in front of the Palazzo dell' Arte. Whoever called them in remains a mystery, since we on the Board had warned that if the police were to appear in front of the building and were to obstruct any demonstration, we would immediately resign. The President Dino Gentili, an open, sensitive man went outside with me and the police suddenly attacked us all, the two of us and those protesting. At that point we tried to convince the demonstrators to enter the Teatro dell' Arte, first to discuss the reasons for their protest and, second, to visit the exhibition together and to criticize it if they wished – but only after having seen it and not from hearsay. They seemed persuaded, but that turned out not to be the case since they took possession of the Palazzo dell' Arte once in the door, and made a great racket of it. I remember someone shouting: "They want to get us into the theater so they can gas us." That was ridiculous, but also emblematic. They could have said anything at all at that moment, even that we wanted to stuff them into sealed wagons to herd them off to gulags. In short, aside from the misunderstanding of those (the majority) who occupied the exhibition without the slightest understanding

of its contents, it must be said that the minority was driven by a sense of perversity and acted out of deliberate hostility. The exhibition was quite incisive and radical. Had it been more political, I would have sought a go-between, but I am against the idea of mediation in general.

SB: Much is said today about the role and, above all, about the duration of 1968 in Italy and Milan. Some say that it lasted a few months while others are convinced that the defects of Italy can be traced to the exceptional duration of 1968 which lasted at least into the mid-1970s, to the time of the encounter/clash with terrorism.

GDC: In my opinion, 1968 was actually very short. It was a time of grace, albeit exalting and fantastic, but lasting only a few months. God knows how much we needed the youth to grasp a new awareness and it was marvelous to see it develop so quickly and to ridicule everything. There is still a need for it today here in Italy, where those in power take themselves ridiculously seriously, especially when unsure of the direction to take. All you need to do is to leaf through any newspaper to see how much space is dedicated to our politicians (the majority of whom are basically inept, incompetent, and stupid), to understand how much we still need that desecrating, ridiculing force awakened by 1968. It was a force which initially sprang from an impulse of joy. At the start, the 1968 movement appropriated its form and contents from the anarchists: scorn of everything which had become fossilized, a refusal of organization for its own sake, optimism, generosity, and mirth. Then the movement began to freeze up and soon became thoroughly stiff. Invention and creativity had been flitting through the streets like a butterfly at the beginning of 1968. There hadn't been the slightest trace of violence other than the tolerant, good-natured kind inherent in good satire and irony. But suddenly, after that brief period of joy, the movement began to be organized, to be separated into fac-

tions, to segregate certain groups opposed to party discipline, to seek agreements tainted with conspiracy and emulating the national political situation. It became quite clear at the universities that it was reproducing institutional political party logic and rhetoric, with all its pettiness and myopic outlook. Traditional politics had taken command of the movement and had calcified it. The same process had taken place after the arrival of Napoleon, after the Resistance, perhaps after the Risorgimento as well, in any case, each time that Italy had seemed swept by a wave of renewal. Maybe it was that brevity which made it so hard to discern the lasting effects of the 1968 movement in the culture of Italian architecture. Better yet, that made it so hard to delineate the precise boundaries of its heritage. Leaving behind a diffused and in some way elusive heritage may have been inherent to the 1968 movement. The movement of 1968 forced almost everyone in the professional and cultural worlds to reflect. Even my literati friends at the time were forced to reflect, just as the painters and sculptors and even the scientists were. Everyone suddenly realized that there was a need to shake off a series of prejudices which had been considered truths and were actually based on conventional understandings born of laziness or of corporate interests.

SB: There were various architectural currents which attempted to absorb or to represent the impetus of 1968 and which had never before confronted one another.

GDC: A point of reference for one of the first currents, typically Italian in many ways, was the study of building typologies and urban morphologies developed by the so-called tendency architects who were just then beginning to study the Soviet and Socialist urban planning model. They were the protagonists of that cult of typology which to a certain extent looked to Muratori. Muratori was a serious, systematic, pedantic character who was also, through his pupils, destructive. He taught in Venice where we considered his work lacking in imagi-

nation. We expected that his classification of all the Venetian building types would result in a description exactly opposite to the real Venice.

SB: But another important reference for the typologists, principally those from Milan, were such academic architects as Muzio, Portaluppi, Mezzanotte, and so forth that were part of the Milanese cultural world which had not endorsed the modern movement. Not because they disapproved of it, but because they all (with the exception of Muzio, who at least had a good library) were monumentally ignorant people. Persico had to come to Milan to inform them before they realized that the modern movement was circling the world like a specter.

GDC: I regret that Aldo Rossi has died, and say it again, but I must also repeat that he was a direct product of that conservative, academic world. His linguistics came from it, from the Milanese scapigliatura movement, from Ca Brutta and from all those rusty, old, comforting instruments. Such personalities as Wagner, Poelzig, Behrens, Gropius, Mies van der Rohe, and so on, were already hard at work abroad at that time. How petty and miserable Ca Brutta seems when viewing it in hindsight with a clear eye.

SB: Then there's the whole category of so-called radical architecture springing from the Superstudio and the Archzoom groups in Florence.

GDC: The exponents of that radicalism were designers who had suddenly opted for architecture, such as Sottass, Mendini, and other well-known designers who all of a sudden had become prominent by making architecture coincide with design. A sort of short-cut, a facile counterfeiting of the modern movement. They introduced arbitrary elements into architecture which were permissible in the case of design, but much less permis-

sible in the grander problems of architecture, territories, and cities. This facile desecration was received favorably by many of those who had already been troubled by the real desecration of the early 1968 period. They had been relieved at the thought: why not, it's nothing more than a game for us. Besides, it seems to me that certain studios or superstudios of those times ended up participating in the most shameful building speculation. However, I must add that some of them, like Branzi and Deganello, still came up with some interesting ideas.

SB: Another important current in some way related to 1968 was that in which you also actively took part, researching participation, the experiences of the inhabitants of various buildings.

GCD: Yes, you can certainly say, in that area as in many others I have addressed in my life, that I found myself combating on two fronts, not only against the opposition but also against the orthodox faction whose advocates were numerous. Many of the latter, incapable architects, decided that they could become architects through participation, but were without the slightest talent or imagination. They thought that going out and asking people what they wanted, then transcribing the results, would suffice for inventing architecture! I also had to strenuously combat against those on the orthodox side who professed their desire to act on my ideas and, instead, misrepresented them and created confusion. At the same time that I was working hard in Italy on the problem of participation, I was also teaching in the United States where I discussed the same subjects with Christopher Alexander and Kevin Lynch. I had developed a completely different view of the problem from that of our native, party-influenced, urban planners, above all from those of the official Left. Besides, when I experimented with participation in Rimini, the major opposition came from the Left, especially from exponents of the Communist Party. To be honest, they didn't want anyone to meddle with participation, so they accused me of working thoughtlessly, as if in an assembly line, the accusation they thought most damaging to me. All in all during the years following 1968, I found myself having to constantly oppose the obtuse ranks who considered participation a mechanical process, a transcription of people's (superficial) wishes. I invariably had to point out that participation actually implied the great, cultivated domain of form and an amount of imagination infinitely greater than that used by the typologists or post-modernists. That same individual and rigorously imaginative idea of architecture on which the Greater Number Triennale was based.

SB: What could that wasted Triennale have signified for Italy and Milan?

GCD: The XIV edition was one of the most interesting editions of the Triennale, after those of 1948 and 1954. Looking at its catalog today, I see the confirmation that we were at a crossroads during those years in Italy, especially in Milan. It was evident everywhere, in the polemics over urban planning, in the cultural battle, in discussions among ourselves. The point is that one of the two possible directions we could have taken had been violently blocked off and we were forced to take the other path, with results that I consider anything but positive. Milan has suffered a continuous decline since 1968, and to a dramatic extent, although it had been given the chance to adopt a new way of thinking. People lost their taste for cultural battles and their instruments, which were numerous and valuable in Milan back then, were allowed to deteriorate. First among these, the Triennale, which since then has all but disappeared. In its wake came exhibitions which were only apologies, elegies to gloomy metaphysical spaces, drained of energy and utterly insignificant.

Translated from Italian by Jennifer Franchina

Arata Isozaki / Ground plan of the Electric Labyrinth at the Triennale di Milano / 1968 / drawing / © Arata Isozaki & Associates Japan / © photo: Masaaki Sekiya, Tokyo

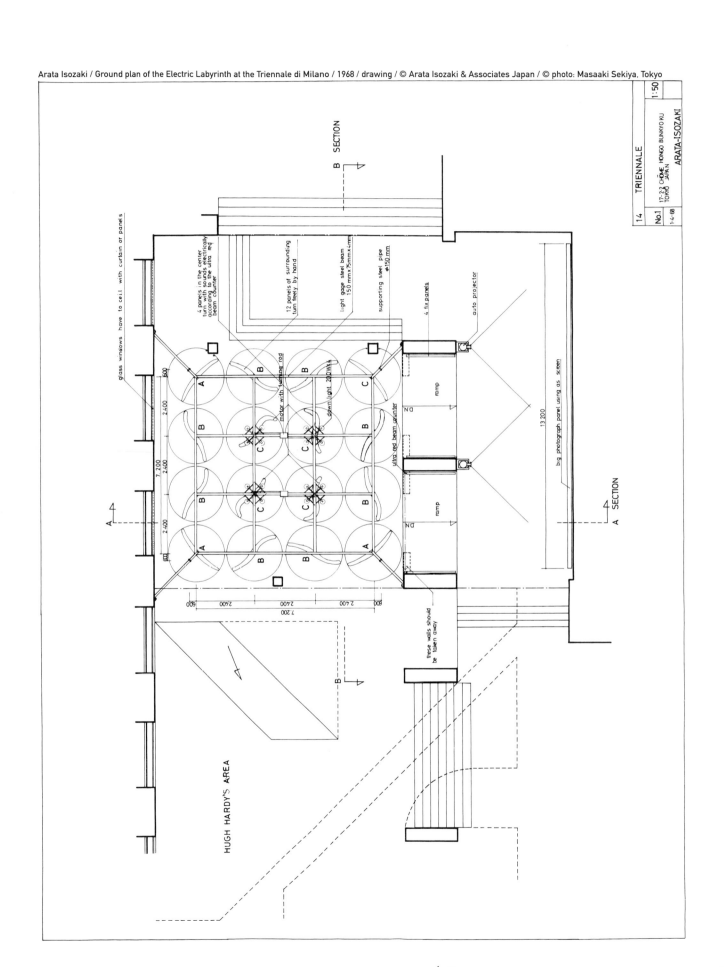

Arata Isozaki / Axonometric view of the Electric Labyrinth at the Triennale di Milano / 1968 / drawing / © Arata Isozaki & Associates, Japan / © photo: Masaaki Sekiya, Tokyo

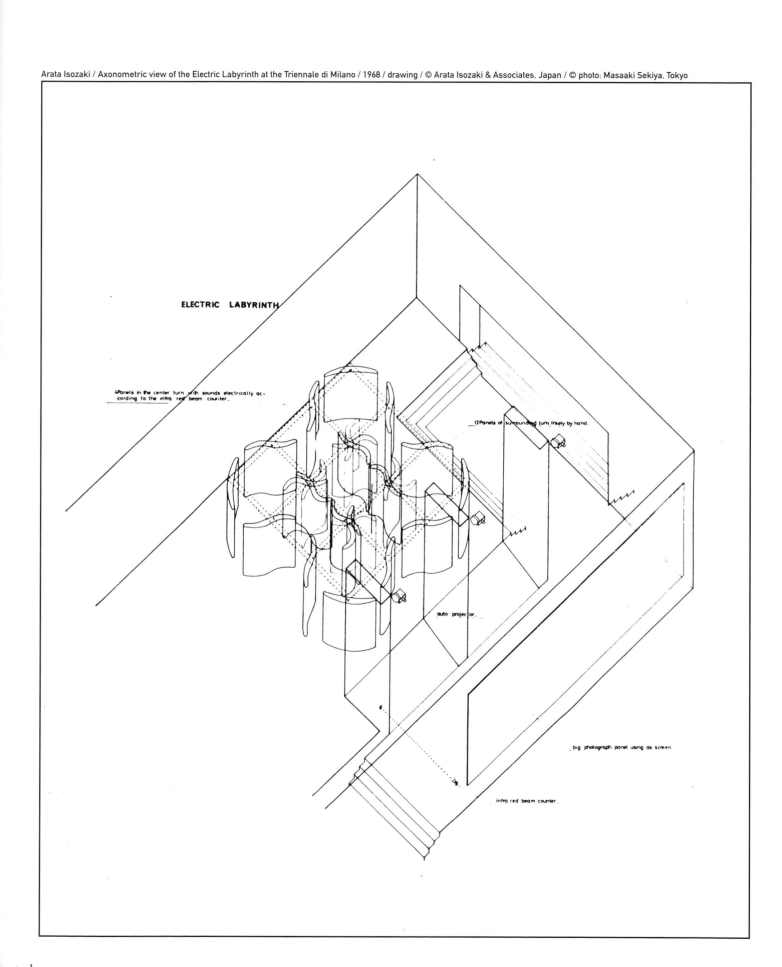

ELECTRIC LABYRINTH

4Panels in the center turn with sounds electrically ac-
cording to the infra red beam counter.

12Panels of surrounding turn freely by hand.

auto projector.

big photograph panel using as screen

infra red beam counter.

Part Three
Hans Ulrich Obrist Interviews Arata Isozaki

HANS ULRICH OBRIST: Can you tell me about the Milan Triennale of 1968 and the installation you created there?

ARATA ISOZAKI: I was invited in 1968 to the XIV Triennale in Milan, which was supposed to open at the end of May. I didn't see the opening because it was completely taken over by young artists and students protesting, an event that has since become a part of history. At the time, of course, similar movements against the establishment were also going on in Japan. Because I sympathized with these protests, I tried to reflect them in my Triennale exhibit. I was given some space to create an environment, so I asked several artist friends to work with me. One is a graphic artist who is my age – his name is Kōhei Sugiura – and he's probably one of the best, most creative graphic artists we've had in Japan since the war. Another is a photographer, who is also my age, named Shōmei Tōmatsu. He recently had a retrospective in Tokyo at the Museum of Photography. He probably has one of the largest photographic collections of the last fifty years in Japan. And I invited a composer, Toshi Ichiyanagi, and asked him to create a kind of sound installation.

HUO: What was the idea behind this collaboration?

AI: My idea was to create twelve very large curved panels covered with an aluminum surface on which numerous images were silk-screened. I chose from *ukiyo-e* prints about ghosts and terrible tragedies, and asked Tōmatsu to find documentary stills about atomic bombs, rather than to use his own work. So, he brought a film and some pictures of Hiroshima and Nagasaki. One famous one is of a kind of shadow made on a wall at the time the bomb exploded. These were the images I put on the panels, which also moved anytime whenever any-one passed through an invisible infrared beam. They would turn and suddenly you would see a ghost or a dead body, which completely involved you in the movement of these strange images. They almost all had to do with the tragedy of the war or the crisis in society. At the same time, there were also large walls, thirteen meters long and five meters high, very large walls, on which I made a kind of collage about the ruins of Hiroshima and the mega-structure it would later become, which itself was in a state of ruin: a ruined structure on the ruins, *The City of the Future is the Ruins*. I was very much obsessed by these ruins of the future. This was on the wall and I projected many images of the future city onto it. At the time, we didn't have any kind of video system, but just slide projectors with maybe three carrousels with eighty slides each, which meant a lot of images running through the projectors. We tried to show how the future city would itself constantly fall into ruin. This was on the moving panels, which, whenever they turned, would be accompanied by Toshi Ichiyanagi's strange sounds. It was an odd feeling to hear them. I called the installation *Electric Labyrinth*. This was my first exhibit of this kind outside of Japan, of course. Anyway, this is what I did for the Triennale, but then suddenly, the exhibition was completely occupied by protestors and didn't open. I didn't go back, but I heard two or three months later that they repaired it and it opened, though what happened afterwards, I don't know. My sympathies were with the students and young artists who were protesting, so I signed a petition in support of their activities, which later caused big trouble with the organizers. They had invited me, paid for all my accommodations and travel expenses, as well as for the materials, but I had signed something opposing them. I did it, though, because I thought my work for the festival had precisely the same mentality, the same direction, as the student movements at the time.

HUO: So in fact, for every party involved, the question was: where is the enemy?

Material Arata Isozaki used for the installation The Electric Labyrinth

AI: Where is the enemy? Who is the enemy? These were the major issues at the end of the 1960s. The so-called establishment, but who are the establishment? Already there was disorder. The industrialists, the bankers, they were the establishment. The establishment were at the same time the major figures like professors or the directors, exhibition-organizers: they were also the establishment. And so the selected artists were already experts. In general, their main concern was how to protest the establishment. This is the big contradiction that everybody had at the time, and if in these kinds of contradictions someone tried to understand, they had no way of stopping it; some artists could develop outside or afterwards, but there was no definite way of knowing this. So this was my feeling of 1968. But today's situation is very similar.

The image of the "fire" / for sick-screen print / red fluorescent paint / material Arata Isozaki used for the installation The Electric Labyrinth

HUO: With the whole new movement of anti-globalization which is now on the rise?

AI: Yes, that's right. At that time, anti-capitalism was alright, today it's also about anti-globalization, there are definite similarities, but everybody thinks that without these kinds of globalization, without the development of information technology we wouldn't be able to do anything. But in some way we have to be against this. That is a kind of contradiction. And this idea of ambiguity is okay. [laughs] And sometimes ambiguity works well. [laughs] *Iconoclash*! This is also a perfect title for the recent events of 11 September 2001. A symbol of capitalism and globalization untouched. That's a perfect title.

HUO: Giancarlo de Carlo always pointed out that these kinds of exhibitions in themselves were somehow iconoclastic. But here the students clashed with the iconoclasm, and there was a double clash. A clash within a clash, or a clash triggering another clash. And if you look at the archives of the Triennale, there is a beautiful album with many photographs of the destroyed installation. You can see the ruins of the ruins of the ruins at the end.

AI: That sounds great.

HUO: Did the work on the movie somehow influence the very cinematographic installation in Milan? It's a very kinetic installation …

AI: In 1965, in Tokyo I made an installation called *From Space to Environment,* which was a group exhibition with artists, music composers, graphic artists, and architects. The definition of space is completely abstract, but the definition of environment is much more specific. Inside and outside, perception of the body and so on … In such a way we looked

Ghost / ukiyo-e print / material Arata Isozaki used for the installation The Electric Labyrinth

ukiyo-e print / material Arata Isozaki used for the installation The Electric Labyrinth

for everything which is movable, everything that changes. No permanence; much more empirical and ephemeral. Through this experience the idea of body involvement came out.

HUO: Can you tell me a little more about the technical requirements of your piece for the 1968 Triennale?

AI: I'll show you some publications from that time. This is just my report at the time of the Triennale, after the occupation and so on. This is a drawing and that is the image on the wall. Somewhere here and there are infrared beams that people pass through. There are actually twelve panels, four of which are automatically responding. For ZKM I'll need maybe 10 meters x 15 meters.

HUO: How did you meet Giancalo de Carlo? Do you know why he invited you?

AI: I got an invitation letter from him. I don't know how he found me. It probably had some connection with *Team Ten* since he was a member at that time. I think some people from Japan, maybe Kenzo Tange or Professor Maki, might have attended some meetings for *Team Ten* and the Triennale. Perhaps de Carlo got some information about me through the Japanese.

HUO: Somehow I never made a link between Osaka 1970 and the Triennale. I hadn't realized that you were working on the two projects at the same time. So you were describing the context of working with composers and music critics and other practitioners in Osaka, and then the invitation came for Milan. So I was wondering how you made the concrete casting for Milan?

AI: Yes, the project for Osaka was a much larger scale project – almost a national-scale project, and the Triennale was a small work. It was a kind of a little chamber music thing, actually. [laughs]

At the beginning of the day, I remember, the opening time was in the evening, and I went there at six o'clock to my room, it wasn't completed – it still needed a lot more work! The carpenters were making a lot of noise in its construction. It was already open for the press. But the people coming in were not the normal public, but a kind of young, student, artist audience, almost invading it and completely occupying it. Everything stopped. In the Triennale, there are these huge stairways, and everybody sat on them. And Pomodoro – he was one of the leaders …

HUO: The artist Arnaldo Pomodoro?

AI: Yes, he was leading. And these many artists and architects were, those students, were on the stairways listening.

HUO: So at the moment this happened, your installation was in process.

AI: Yes, I couldn't finish it! I thought okay, so everything ends here! [laughs]

HUO: An unfinished history!

AI: Toshi Ichiyanagi was already thinking about Expo '70 in Osaka like many others. So in the Expo '70 project, Toshi Ichiyanagi became more interested in not only the normal types of music performance but more in the so-called environmental music. He started to make a very special type of little object, like ogor with music inside. Not only opening the box, inside, there was a big shell with some things inside and some frequencies getting deflected and responding to something else. He did those kinds of things, but nobody bought them! I don't know – if it had been a

Documentary photography on atom bombs /
material Arata Isozaki used for the installation The Electric Labyrinth

Documentary photography on atom bombs /
material Arata Isozaki used for the installation The Electric Labyrinth

Arata Isozaki / The City of the Future is the Ruins / 1968 / collage, computer print / 5 x 13 meters / part of the installation The Electric Labyrinth

company, it would have been completely bankrupt! [laughs] But anyway, that was at the very beginning of environmental music.

HUO: Environmental, so it was almost ambient, or the beginning of ambient, still before Brian Eno.

AI: Yes, exactly. That's right. That was one of those ideas; by infrared beams getting a signal of people passing, this strange music would start and the panels, completely covered with shiny aluminum and printed with a kind of ghost or image of hell, an image of destruction or a dead body from atomic bombs and so on would suddenly rotate.

HUO: What I was wondering was, when you brought together the photographer, the composer, and the graphic designer – you invited them – how did the process then happen? Did you invite them to do specific things, or was there a preliminary discussion meeting?

AI: Normally I wanted to be an architect, a kind of organizer or a movie director, so first I made a scenario and I asked them to join in. The working process was very close to the movies because I was one of the artists collaborating on Hiroshi Teshigahara's movie *The Face of the Other* in 1965, and I wanted the artists to collaborate. Through this experience, I came to know how the movie would be made, and so I did such a collaboration.

HUO: It could be interesting to think of a dynamic memory, not a static memory! "Repetition and difference." It's maybe even more interesting if there is a slight shift. So we have almost everything: Ichiyanagi did the soundtrack and then the photographer did the pictures which were silk-screened, but what was the role of the graphic designer?

AI: Sugiura was working to compose all the surfaces. He used the photographs and graphic patterns like stylized clouds from the classic Japanese painting and many photographic images of dead bodies. This is a scene after the atomic bomb of Hiroshima. And these are well known, famous pictures, *Nine Phases of Metamorphoses* even when beauty dies, it becomes just a corpse. Other kinds of Buddhist concepts of everything were taught – you come from nothing and you go back to nothing. In mid-nineteenth century *ukiyo-e* all became completely decadent, torturing pregnant ladies in really terrible sadistic or masochistic images. They created lots of those. I chose those terrible images.

HUO: I was wondering to what extent, from a Japanese point of view, you relate to the topic of iconoclash. Do you think in terms of the history?

AI: Changing, melting, metamorphosing, decaying, those concepts are always found in Japanese art and literature not only in the past but at present. The 1960s metabolism movement or my own drawings of ruins of a city would be examples of that kind.

HUO: De Carlo said he was very interested in this topic of multitude or of "city and multitude." In the beginning of the 1960s he was starting to think more about the implication of the sheer quantity of urbanity and multitude. How was your piece a reaction to this theme of de Carlo, and how far did the piece investigate this notion of multitude?

AI: Up to that time, my publication was one project about a city with great numbers, and one of them was *City in the Air.* This was of a more futuristic period. And of course, in Japan in the mid-1960s, there were some preparations going on for the Expo '70, in Osaka. Five years before, some preparations had already started. Around that time, I was working with many different artists, composers, and

Drawing / material Arata Isozaki used for the installation The Electric Labyrinth

writers: Toshi Ichiyanagi, Toru Takemitsu, artists like Tadanori Yokoo and the many so-called neo-Dadaists in Japan. And I organized a major part of Expo '70, which was the Festival Plaza. I organized a kind of study group with people like Kastuhiro Yamaguchi. He's a kinetic artist, at the time a video artist, and he became quite active in this area. And Kuniharu Akiyama – he passed away – he was a contemporary music critic and he was also a very good organizer of Japanese contemporary music. He was a friend of Takemitsu, he wrote a large study of Takemitsu's complete works. He was also a friend of Toshi Ichiyanagi and so on. And with this study group I proposed a concept of a very large space with a movable roof on top: 300 meters long, 100 meters wide, and 30 meters high. It was a very big box. And everything inside was movable for the performance. A performance for maybe 20,000 people, but no more than that. At that time, our proposal was about the sound, light, and movement of people, movement of scenes. It was about water and fire and smoke and fog and that kind of thing. They were all movable and controlled by computer. We thought of it as a kind of NASA space operation, using similar systems for the huge scale performance for 20,000 people. And finally, we realized this with two robots and 600 speakers all over. Lots of hanging robots with various lighting fixtures and so on. The idea was, and this was a preliminary idea, that the box is here, and all the seating is movable, so it changes on those sides and configurations, creating some focus, some multi-focus areas, and a huge assisting robot for the performance, so there is a stage. At that time I was thinking just to add completely transparent stilts.

HUO: And so when you worked on the Milan Triennale you were also working on this project at the same time?

AI: Yes, I was busy with it at that time. This was purely a life-size idea just for the huge scale performance. At that time, the Beatles were up and coming – not like the rock concerts of today. But if it happened today, there would be some very different ideas. Anyway, this was kind of the idea, and in it I found some connection to Cedric Price's *Fun Palace*. At that time I was researching what happened in the world. And I found Cedric Price's project and *Archigram*. *Archigram* actually started in 1964. It was almost at the same time that I started with this project. And Cedric Price's *Fun Palace* project was done in 1960, 1961.

HUO: Another interesting thing is that at that time your work was already interdisciplinary, since you invited a musician and others. This seems to be the thread that runs through your exhibitions, this interdisciplinarity which involves artists from different fields.

AI: Yes, there were the image projections, the sound, and movement – all kinds of elements. Interdisciplinarity is something I've always tried to do and to think about. My education in modern or contemporary art was mostly based on the Bauhaus and the Dada period, in both of which there were always collaborations – collaborations among musicians, dancers, composers, and painters. Léger, Picasso, Diaghilev, all these people were collaborating. And there was some influence by Moholy Nagy. I was interested in other types of performance. Later for the exhibition *MA* in Paris, I brought many musicians and performers like Kosugi, the Fluxus member, and the dancer Min Tanaka, who had never been abroad before. So, I was trying to introduce to the world young artists who were virtually unknown even in Japan, but whom I found very intelligent, very original, and trying to do things in a special way. At the same time, I found a concept they all shared. I asked traditional Japanese carpenters who are always thinking in terms of the concept of *ma*, as well as photographers, sculptors. ... Actually, there were no contemporary painters, but I brought many images of traditional

painting. In the brush paintings of the Japanese tradition, there are lots of empty spaces, blank spaces, and this blankness we again call *ma*. So I showed examples of this, too.

HUO: A few years later, you organized an exhibition in Paris that made history in the early 1970s.

AI: Yes. It was actually prepared in the early 1970s, but not realized until later on in the decade. This was ten years after

the Triennale and, again, I was asked to do something on Japanese art and music for the Festival d'Automne in Paris. At that time, Michel Guy, who used to be the Secretary of State for Culture, was directing the festival. Guy chose the composer Toru Takemitsu, who died unfortunately five years ago but who is probably the best known composer from Japan, and myself. Takemitsu curated a series of performances of Japanese music, both classical and contemporary, and invited other Japanese avant-garde composers. I used all the available space

Arata Isozaki / The Electric Labyrinth / 1968 / installation view Triennale di Milano, 1968 / © Arata Isozaki & Associates, Japan / © photo: Masaaki Sekiya, Tokyo

Spac-Time in Japan »MA« / exhibition view / 1978 /
© photo: Shuji Yamada, Hyogo, Japan

Arata Isozaki / The Festival
Plaza / Expo '70 / Osaka /
© photo: The Japan Architect

at the Musée des arts décoratifs of Paris. Of course, I was asked to look at the Centre Georges Pompidou, which had already opened by that time. But I found it impossible to work in it for the exhibition I was doing because you can't touch the ceiling or change the order of the system of partitions they use. I preferred the Musée des arts décoratifs, because it's just a very large space in which you have to create the ceilings, walls, and floors entirely. We could do anything we wanted, which makes you very free for interdisciplinary shows. Both of us had a theme for the exhibitions and performance. Takemitsu's was based on the voice in Japanese music, which uses voices in a very special way, and he wanted to try to introduce this in his series. For example, if you attend a traditional Japanese musical performance, there is no score and no conductor, but there are drums, instruments, and singers.

HUO: Does that mean that it is self-organized?

AI: That's right. This is a very important point: all the participants have to listen to their colleagues' performances to decide when to come in. It's very similar to jazz, where people play without any conductor and things go along automatically. As for my part of the collaboration, I called it *ma* and subtitled it *The Japanese Conception of Space and Time*. Traditionally, we didn't have a concept for space or for time in Japan, as Western philosophy or thought does. We only had *ma*. When the concepts arrived in Japan some two hundred years ago, somebody had to translate the words, so chronos was added to *ma*. Chronos means time and emptiness plus *ma* means space this was how the words were interpreted. But the interesting thing is that the word *ma* already includes both time and space. So, when we think about time, we always think about space at the same time, and inversely, when we think about space, time is involved. And I found this way of thinking quite interesting, especially as it's also a notion found in every facet of art, including painting, theatre, performance, music, sculpture, daily life, and architecture. For example, what you call planning, in the sense of a plan for a building, we call taking the *ma* arrangement of the *ma*, since a room is also called *ma*. So, this simple word is found everywhere, and in every aspect of artistic expression, too. For example, the literal meaning of *ma* is the in-between, or the space between object and object, as well as the silence between sound and sound. So, silence and interstices both are *ma*, which makes it quite significant, but for the Japanese, it's just a part of everyday life, something they would understand automatically, almost unconsciously. This is probably why I didn't bring this exhibition back to Japan, since the notion is such a commonplace there that everyone would understand it and so find nothing curious about it. [laughs] But this was more than twenty years ago now.

HUO: And in terms of going beyond boundaries of disciplines, was this exhibition quite similar to the earlier one in Milan?

AI: I broke it down along the lines of several sub-concepts of *ma*. For example, there was one of the rooms that I called *Darkness*, and in it, I made a performing platform very much the same size as a Noh theater one, and exhibited a sculpture cast by the artist Simon Yotsuya. He created very strange dolls, one was a meditating Zen Buddhist who was completely naked; he also made a lot of multiples. And I asked Issey Miyake to make a costume for each of the dolls.

Edited by Matthew Price

DEALING THE JOKER IN BERLIN

Peter Geimer

ON 3 FEBRUARY 1945, A BOMB SQUADRON destroyed the palace of Berlin.[1] The building dated from the fifteenth century when Berlin became the residence of the Hohenzollern dynasty. King Friedrich III had extended the palace, and well-known architects and sculptors such as Andreas Schlüter, Friedrich Wilhelm von Erdmannsdorff, and Johann Gottfried Schadow had worked on it. In 1945 the building burned down – within three days. For five years it remained in its demolished state until the Socialist Unity Party of Germany (SED) gave the order to ruin the ruin. The party's central secretary, Walter Ulbricht, proclaimed "that out of the ruins of those cities destroyed by the American imperialists new cities will be created, cities that are more beautiful than any city before [...] The center of our capital, the Lustgarten and the area around the ruined palace, must become a huge place of demonstration." But to make a building disappear is work. In September 1950 the state-owned company *VEB Abräumung und Erdbau* began the demolition. Hundreds of holes were drilled in the ruin in order to place the explosives. From September 1950 to January 1951 dozens of explosions razed the ruin. Finally, the blasted parts were blasted once again to facilitate their removal. A convoy of wagons, trucks, and ships carried them away. Today they lie under the urban forest of Berlin. Heaps of rubble rest underground in East Berlin under a zoo. The rhinoceros wanders over baroque ground. Parts of the façade are underground in a park in Berlin-Friedrichshain or have served as retaining walls or steps. The ruins of a chapel fell into the Spree. Under the auspices of the *Schrottbeauftragter* (rubble delegate) for the district Pankow, the palace's wrought-iron gates were declared scrap metal and disappeared without trace.

Nevertheless, some pieces remained. An expert comission had to save those fragments that were chosen to survive in museums or to be integrated into the buildings of the new Socialist era. Around two thousand fragments – mouldings, capitals, sculptures, plaster casts, etc. – were sorted out, listed, numbered, photographed, and finally housed in a shed where the *VEB Tiefbau* had previously stored its work tools. After a while, rain, humidity, and frost entered the building. Some fragments were covered by weeds – a comission that inspected the place in 1955 declared them "actually invisible." Most of what finally remained went to several museums in Berlin and Potsdam. The Hohenzollern palace had come to an end. The new empty space was called *Marx-Engels-Platz*.

Apart from the few material remains, the palace survived in images: three thousand black and white photographs, paintings, drawings, and etchings show how the building looked before its disappearance. Today the palace has withdrawn into this iconographic asylum. It has survived in black and white, in a flat world of paper where it is safe from bombs, dynamite, hammers, and humidity.

In 2000 the *Deutsche Burgenvereinigung* (German Castle association) introduced a new deck of playing cards: *The famous Deutsche Schlösser*. We see the towers of Schloß Neuschwanstein (ace of hearts), the gardens of Herrenchiemsee (ace of clubs) and the residence in Würzburg (seven of spades). One phantom is hidden in this assemblage of castles – the vanished palace of Berlin, the only card in black and white but nevertheless a joker. Of course a joker is a universal card. It has no special value on its own, but according to the plans of its owner, it can replace any other given card in the deck. *Making the Past into the Perfect Present* is the motto of the aforementioned set of cards. And this is the principle of those who want to deal the Hohenzollern joker in Berlin: The vanished palace shall be built again – entirely new, but as if it were old. "[...] simply because it's nice," says German chancellor Gerhard Schröder; "because it is a beautiful idea," says world champion swimmer Franziska van Almsick; since it would be "regained history," says Wolfgang Thierse, speaker of the Bundestag; "in order to give Berlin its former urban center back," says Antje Vollmer, his colleague.

1

_ Bernd Maether, *Die Vernichtung des Berliner Stadtschlosses*, Verlag Arno Spitz, Berlin, 2000. See also www.berliner-schloss.de

The promoters of reconstruction often use a metaphor: Berlin, they say, needs its heart back; the open wound has to be closed.

But in the meantime the German Democratic Republic implanted another heart – the *Palast der Republik*. This heart is not the real one, they say: it has to be replaced by our joker; moreover, it is contaminated with asbestos. A reconstruction of the baroque palace has to occupy its place. But what exactly is supposed to come back in this architectural resurrection? And "back" from where? The iconoclash would occur at portal IV. This fragment of the former palace still exists. It was on the balcony of this portal that Karl Liebknecht declared the republic in 1918. The SED preserved the piece and implanted it in the new Staatsratsgebäude nearby where it has remained until today. If a replacement palace is built, as an expert comission recently recommended, the historical portal will exist double: as itself and as its reconstruction. A historical trace will meet its reflection in "regained history." If history is to be regained, if a vanished palace can appear again, maybe Karl Liebknecht will come back as well. But probably he will wonder where to go: to the old balcony where he stood in November 1918, or to the balcony that posterity has built for him. Unfortunately we do not know what to recommend to a ghost. |

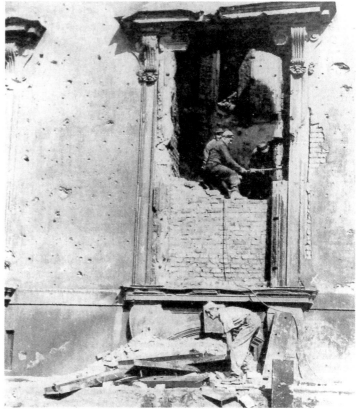

Demolition of the Stadtschloß Berlin [Berlin Palace] / 1950 / documentary photograph / Reutti-Sammlung, Schloß Charlottenburg, Berlin

Stadtschloß Berlin [Berlin Palace] / Heritage Playing Card Company

NO PLACE, NO MATTER: THE MAKING DENSE OF UTOPIA

Andrei Mogoutov and Arkadi Nedel

IN HIS CLASSICAL NOVEL *1984* Georges Orwell gives an astonishing sketch of Utopia: the State is everywhere, everybody is subject to the State, nobody is allowed to escape from it, and all the subjects share their happy and hopeless lives. The State is omnipotent and local, its space is limitless and unrestricted, its power spreads out and focuses on the people, and makes them unaware of their true existence. Orwell provides Utopia with a language; it ceases to be speechless. Yet in his portrayal of the utopian State as something frozen, he omits the essential features of such a State: dynamism and the impossibility of existing in the present. It can never reach its final state nor can it carry out any positive programs.

How does Utopia express and realize itself as a mega-project and how does it appropriate any other mega-projects or identify with them? Utopia appropriates all possible empty spaces and territories because all of them must belong to it; Utopia is never dense enough nor exhibited enough in the space. This is because Utopia itself is void and unaware of this fact. No Utopia possesses language and the ability to verbalize itself. The present of Utopia is not reliable because it is always projected into the future, it promises to itself to be seen. Utopia constantly needs to demolish and reconstruct itself on the grounds that it is totally impossible to remain uncompleted.

Here we will tell the story of the Russian venture in constructing the Cathedral of Christ the Saviour. Its present place in front of the Kremlin was previously occupied by St. Alexis Monastery (Alekseevskii Monastyr).

This first women's monastery in Moscow appeared in 1358. It was destroyed several times: in 1362 and 1545, with the invasions of the Tatars, in 1445 by earthquake, and it burned down twice in 1514 and 1547. In 1612 the monastery was robbed by the Poles, and in 1812 by Napoleon's Grande Armée. Later, Nicolas I commanded construction of the Cathedral of Christ the Saviour on the site. A legend says that, in 1837, an abbess rebelling against the displacement of the monastery, chained herself to the oak and proclaimed: "Be that place void." Immediately after that event the oak was felled and the monastery moved to the periphery of the city. This semantically charged scene refers to its archetype: the cross and crucifixion. The abbess' damnation proved true in the long history of all the architectural projects associated with this place.

Soon after the war of 1812, Czar Alexander I promulgated *The Manifesto on the Construction of the Cathedral of Christ the Saviour.* The last phrase of this document says: "Let this cathedral stay for the times and be the censer smoking in front of the Altar of God as a sign of gratitude of all the generations to come." The consciousness of Utopia doesn't bear void places, and therefore Napoleon's Grande Armée, expelled from the territory of the Russian Empire, was necessarily replaced by an equivalent presence having the same significant density.

The first project of the construction of the Cathedral was undertaken by Alexander Vitberg (1817) who conceptualized his own undertaking in the following words: 1) the Cathedral should perfectly express the greatness of Russia; 2) it should be absolutely free from the slave imitation; and 3) it must manifest "the spirit of the true-to-life cathedral endowed with human soul."

The project of the creation of Utopia's visual language should exclude any accusations of imitation of something previously done; it must be unique. Vitberg was the first to view the Cathedral as a synthetic unit that expresses the inner ideas of Utopia to itself through the sublimity of architectural forms. Utopia loves the extremes: the Cathedral is built on the *Vorobiev's Hills;* it must be the biggest and the highest in the world. It should go beyond all the other cathedrals. The result was sorrowful; the construction of the Cathedral doomed to failure. It met with financial difficulties and its planned weight exceeded the density of the ground. Since 1953 the territory of the failed Cathedral has belonged to the main building of Moscow

Constantin Ton / Project for the Cathedral of Christ the Saviour, Moscow / 1832 / GNIMA / http://www.xxc.ru

K. Rabus / St. Alexis Monastery / 1838 / from: Ancient Moscow / http://www.mos.ru

Alexander Vitberg / Project for the Cathedral of Christ the Saviour, Moscow / 1813 / GNIMA / http://www.utopia.ru

M. Posokhin and Mosprojekt 2 / Cathedral of Christ the Saviour, Moscow / http://www.utopia.ru

Boris Iofan / Project for the Palace of Council / 1933 / GNIMA / http://www.utopia.ru

Detonation of the Cathedral of Christ the Saviour, Moscow / 1931 / http://www.utopia.ru

University. Josef Stalin finally achieved the edifying of the Cathedral, but in this case it is the Temple of Science condensing the desecularized knowledge in the confines of Great Utopia.

In 1832 Nicolas I approved the new project of the Cathedral proposed by Constantin Ton. Its accomplishment began in 1837 in the place of St. Alexis Monastery, in front of the Kremlin.

In 1883 the Cathedral was consecrated. Stylistically it followed the Byzantine and old Russian architectural traditions. It did not happen haphazardly; Utopia seeks to expand itself by appropriating the past cultural spaces and putting them into the center of its universe.

The Soviet regime came. In 1931 the Cathedral was detonated.

As they said at the time: "There is no place for the damned past and its monuments." In 1933 Stalin and the court architect Boris Iofan focused on the new mega-project: to edify an immense building of the Palace of Soviets.

Its height is unbelievable; it exceeds 400 meters with an 80 meter statue of Lenin at the top. This Soviet Cathedral incarnates a new gothic style whose aim is to condense the space of the Empire in order to squeeze out the voids threatening the utopian conscience. At the same time, we are tempted to compare this gothic monster with a cake playing the role of the center in the birthday party, which enters the child's consciousness as an unforgettable event. The Palace of Soviets remained incomplete because of Hitler's invasion of the Soviet Union. World War II forced the Great Utopia to retreat and allowed reality to step in on its territory. Utopia never comes to the lost projects; the construction of the Palace of Soviets became a utopian event even in the eyes of Utopia itself. As in the case of the 1812 national mobilization, the injection of the real overshadows all mega-projects and evacuates them from the territory of Utopia.

The utopian consciousness awaits gifts and believes in promises. In 1958 Soviet children got a new gift: a great outdoor swimming pool, a liquid temple which drowns all the previous efforts of the vertical conquest over the space by sacred buildings.

The Great Utopia enters the époque of Cosmos. Like in a dream where one can never reach a desirable result, Utopia once again fails to drown its proper intentions. The post-Soviet regime cherishes the idea of the reconstruction of the Cathedral of Christ the Saviour. In 1994 the government made the decision to found the remaking of Ton's plan. In 2000 Patriarch Alexis II consecrated the Cathedral.

The new version of the Cathedral has a high-density concrete to protect it from detonation efforts. Utopia is not capable of existing in the present and it therefore allocates for itself the territory of the future where it might survive its constant defeats in the present. Once Utopia leaves its place, reality prays for it to come back.

Utopia makes its history, which inevitably becomes real, a utopian history that doesn't exist. Based on the procedure of recursion this history always promises to return, erasing the ruins of its past programs for which it repeatedly finds no place and no matter. |

Are there limits to iconoclasm?

BEYOND ICONOCLASM
NAM JUNE PAIK, THE ZEN GAZE AND THE ESCAPE FROM REPRESENTATION
Hans Belting

Abstraction: Clement Greenberg's Ban on Images

The "rhetoric of Iconoclasm," as W. J. Thomas Mitchell called it,[1] seems to apply to nothing less than the Abstract Expressionism of the postwar years, and yet the creative furor of the painting act hid (or displayed?) a total lack of what the audience would have called images. Since the debate was on art and since art alone seemed sufficient to bring about the ontology of the picture, nobody in art criticism cared about what was missing. How could there be anything missing in the presence of so much art? The "aura" of the artwork was there to an overwhelming degree, and it justified the new modernism that was precisely at that time reborn in America. Abstraction, already as a term, points to something from which it had been abstracted. This something was figuration but figuration lived from nothing but images however much they were exalted in art. If art was to keep a separate position, it had to part with all of those images, as they were omnipresent in a media society. When it did not allow images any longer, it had to offer something more important than images. This "something more important" became the distinguishing mark of art, at least for its partisans. It promised a vision unmediated and untainted by images. The visible had to be purged and turned into silence. A resounding lack of images became art's new pride.[2]

The pioneers of abstraction turned first to pictograms, as a mythical resource for a visual language beyond the current imagery, before abandoning signs and symbols altogether. The imagery of European modernist painting was more threatening the more powerful it looked in figuration. When seeing Picasso's work in 1939, Pollock immediately destroyed everything he had done before. He recognized in Picasso's art the mutating images of his own unconscious, after his therapist had explained his mental images to him. Soon he was obsessed by the desire to conquer his own demons on the canvas. For this purpose, images had to be covered up by ever new layers of colors which acted like vetoes against images. Thus, his personal images disappeared in an act of self-censorship or even exorcism behind what he was later to call a "veil of painting." The picture, as a weapon, was expected to offer victory over his imagery. Also his fear of appearing non-figurative enough in the art scene of the day may have played a part. But it was "images of devouring females, charging bulls and ambiguous sexuality that he needed most to suppress" as Steven Naifeh and Gregory White Smith write in their biography of the artist.[3] Such imagery was deeply buried below the surface of his abstraction. Later, when doing dripping, Pollock performed a dance ritual while applying paint and acted with his whole body above the picture, which lay flat on the floor. Already in 1942, he had talked about "the free agent in Surrealism where you don't touch the canvas and where you just let the paint fall." In the dripping procedure, images were no longer covered up but performed in mid-air. They reached the paint surface by themselves, so it seemed, and thereby changed shape as the painter did not intervene by fixing them. Abstraction then, as a non-image, resulted in pictures which contradicted representation with the means of representation.

How did Pollock's conversation with Clement Greenberg go when he received a visit from this leading US art critic in July 1946? Greenberg probably talked most of the time and urged the artist to buy his own version of iconoclasm which was so very different. In his opinion, the standard images had to be obliterated because they contradicted art's autonomy. Later he would say: "If there is anything Pollock was set against in his poured pictures, it was iconography."[4] Iconography for him did not mean mental images but images of the mass media and their illusionism. Greenberg, on this occasion in 1946, could have explained that art was to avoid any confusion with non-art in order to keep its independence. He would have argued in favor of the pure act of seeing canvas and paint as such. All other images were impure and therefore not worthy of art. He called images in the contemporary

1

_ W. J. Thomas Mitchell, *Iconology*, University of Chicago Press, Chicago, 1986, pp. 160ff. For frequently cited publications, cf.: Wulf Herzogenrath (ed.), *Nam June Paik. Werke*, exhib. cat. Kölnischer Kunstverein, Cologne, 1976; John G. Hanhardt, *Nam June Paik*, exhib. cat. Whitney Museum of American Art, New York, 1982; Wulf Herzogenrath, *Nam June Paik. Fluxus. Video*, Silke Schreiber, Munich, 1983; Edith Decker, *Paik. Video*, DuMont, Cologne, 1988; Edith Decker (ed.), *Nam June Paik. Niederschriften eines Kulturnomaden*, DuMont, Cologne, 1992; Toni Stoos and Thomas Kellein (eds), *Nam June Paik. Video Time – Video Space*, Cantz, Stuttgart, 1991; Klaus Bussmann and Florian Matzner (eds), *Nam June Paik – a data base*, exhib. cat. Biennale Venice, Cantz, Stuttgart, 1993; Edith Decker-Phillips, *Paik Video*, Barrytown Ltd., Barrytown, NY, 1998; Wulf Herzogenrath (ed.), *Nam June Paik Fluxus/Video*, exhib. cat. Kunsthalle Bremen, Bremen, 2000; John G. Hanhardt (ed.), *The Worlds of Nam June Paik*, exhib. cat. Guggenheim Museum, New York, 2000.

2

_ For American Abstraction cf. Hans Belting, *The Invisible Masterpiece*, University of Chicago Press, Chicago, 2001, pp. 362ff., and Timothy J. Clark, *Farewell to an Idea. Episodes from a History of Modernism*, Yale University Press, New Haven, 1999, pp., 371ff., plus any number of other books.

3

_ Steven Naifeh and Georg White Smith, *Jackson Pollock. An American Saga*, Barrie & Jenkins, London, 1989, pp. 351, 448, 455 and 524. Cf. also Jeffrey Potter, *To a Violent Grave: An Oral Biography of Jackson Pollock*, Pushcart Press, Wainscott, NY, 1985.

4

_ Naifeh/Smith, op. cit., p. 536. For Greenberg, cf. Thierry De Duve, *Clement Greenberg between the Lines*, Edition Dis Voir, Paris, 1996.

world *kitsch* and thus distinguished them from art which he identified with "avant-garde." In a militant essay from 1939, he saw *kitsch* as the hallmark of a new, universal culture which nevertheless falsified real culture and therefore was described as *Ersatzkultur*. *Kitsch* was everything which had misused and discredited images for ever. The only remedy would be the interdiction of images in art, as the purification of images was not enough.[5]

In a second essay in 1940, *Towards a Newer Laocoon*, Greenberg carried the argument one step further by demanding the expulsion of any anecdotal narrative in painting. The icon of art, in his view, was to emerge from an iconoclastic procedure that excluded representation of anything other than art (but what was the representation of art itself?). The only freedom art could gain, was aniconism. Ideas were "infecting the arts with the ideological struggles of society. Ideas came to mean subject matter in general." In the spirit of the second Mosaic law, he ordered artists to banish iconography and to use the painted surface as an end in itself. Artists were expected to paint but they were not expected to paint images. "To restore the identity of an art, the opacity of its medium must be emphasized." Pictures had to "look like what they do. The picture exhausts itself in the visual sensation it produces."[6] The flat surface of painting thus symbolized the destruction of the space of pictorial representation. The artists of the American avant-garde today still impress us with the omnipotence of their creative gesture. They make us forget that they have drawn an opaque veil in front of any visual experience. Art became a counter-world where seeing was purged from seeing images.

John Cage's Silence and the Empty Canvas

Abstraction redefined the painted canvas as a purified medium of art. Cage's concept however went beyond such concern, as it aimed at liberating the mind from reified images. Aniconism was extended to perception and was meant to open the gate for self-perception. In a hybrid mixture of Dada and mysticism, John Cage devised zones of silence as zones of freedom where the audience was expected to become creative in the face of nothing. Some abstract painters would have agreed with him but Cage took his own conclusions when devaluating images (which he equated with sounds) and allowing them to enter his work from the environment. Chance operation, in the place of the intentional acts of doing and perceiving art, left behind the protected barrier between art and its living context in a solemn gesture of denying art's independence. Watching images that were created by an artist was discredited as an act of consumerism or even bondage. "The separation of composition, performance, and listening," as Cage inveighed against the non-believers, was "a crucial mistake in European music." He wrote this for an exhibition of Nam June Paik in 1965 and therefore made a link with visual art where the respective separation would include creation, exhibition, and looking as separate acts.[7]

Cage included himself in the art scene when he credited the painter Robert Rauschenberg with the inspiration for his own silent pieces. He likewise insisted on the analogy with Paik's video art. Commenting on Paik's *Zen for Film* in 1968, he compared "the nature of silence" which he found there, with Rauschenberg's painting and his own work. In some of his compositions, the audience would find "no sounds of my own making" but only the presence of real space. Likewise, Rauschenberg, he writes, "made paintings which have no images on them – they are simply white canvases" much as Paik made "an hour-long film which has no images on it."[8] Though he insisted on differences between the three of them, the analogies he admitted will do for the being, as they already justify the discussion of Cage's role in the present context.

In the summer of 1952, Cage directed a concerted action at Blackmountain College in which Rauschenberg participated. "At that time, he also painted black pictures but we

6 5 7 8

_ John O'Brian (ed.), *Clement Greenberg. Collected Essays and Criticism*, vol. I, University of Chicago Press, Chicago, 1986, pp. 5ff., and esp. pp. 14ff.

_ Herzogenrath, op. cit., 2000, pp. 102f. For a commented chronology of Cage cf. Thomas Dreher, in *John Cage. Kunst als Grenzüberschreitung*, Ulrich Bischoff (ed.), exhib. cat. Neue Pinakothek, Munich, 1991, pp. 223ff. Cf. also John Cage, *Silence. Lectures and Writings*, Wesleyan University Press, Middletown, 1961; James W. Pritchatt, *The Music of John Cage*, Cambridge University Press, Cambridge, 1993, pp. 74ff., and Marjorie Perloff and Charles Junkerman (eds), *John Cage. Composed in America*, University of Chicago Press, Chicago, 1994.

_ Stoos/Kellein, op. cit., 1991, p. 117, and Herzogenrath, op. cit., 2000, p. 150.

_ O'Brian, op. cit., pp. 23ff., and esp. pp. 32ff.

Robert Rauschenberg / White Painting / 1951 / house paint on canvas / 4 panels / 72 x 72" / installation view / © VG Bild-Kunst, Bonn 2002 / from: Robert Rauschenberg. Art and Life, Ruth Peltason (ed.), Harry N. Abrams Inc., New York, 1990, p. 75

only used the white pictures. They were hung in different angles, a canopy of pictures above the audience." Cage had met the painter one year before in the Betty Parsons Gallery in New York where he saw some of the "white paintings" which, in turn, were introduced into the performance of 1952. There, they not only appeared in greater numbers but simultaneously even served as screens for the projection of films and abstract slides. While Cage was reading the texts of the doctrine of Huang Po, a Chinese Zen Buddhist, he transformed the reading into a performance, much as the dance by Merce Cunningham and his group turned into a performance of a new type.[9]

In a text which he wrote about Rauschenberg, Cage admitted the latter's precedence already in the dedication: "The white paintings came first; my silent piece came later." The silent piece was the composition *4'33"* (also called *tacet, tacet*) written while sitting in front of one of the white paint-

ings he owned. It was conceived in three movements during which "no sounds were intentionally produced." When first performed in 1952 at Maverick Hall in Woodstock, New York, the pianist closed the piano before each movement and then stretched his arms out. One could hear the wind and rain outside and eventually the sounds of the audience which finally left the room in disappointment. In the Rauschenberg text, Cage identifies the dirt assembling on the paintings with the sounds which interrupted the silence of his piece. "Crumbling and responding to changes in weather, the dirt unceasingly does my thinking." In a beautiful metaphor, he called the white paintings "airports for the lights, shadows and particles ... [They] caught whatever fell on them. Before such emptiness, you just wait to see what you will see." The question, however, was the relation between Rauschenberg's mind and his paintings. Was his mind empty the way the white canvases were? "What do images do?" Where and how should they be or rather not be?[10]

When he wrote about Paik's *Zen for Film*, Cage included Paik's empty film in his analysis of the relation between art and its environment. In that relation, the individual arts would differ. "In the music, the sounds of the environment remain, so to speak, where they are whereas the dust and the shadows ... come to the painting" and even stick there via adhesive. In the case of the film, "the room is darkened, the film is projected, and what you see is the dust that has collected on the film." The environment here includes the light beam in the dark room while in the case of Rauschenberg it is "falling on a painting and thus [is] less free." Paik, in a footnote published in the same catalog, adds that "the nature of environment is much more on TV ... In fact, TV (its random movement) *is* the environment of today."[11] This enigmatic remark deliberately confuses TV technology as a given environment with the transmitted environment as it is shown in the TV program. It therefore leaves open the give and take of the medium and its imagery. One could say that

9
_ Bischoff, op. cit. pp. 228ff.

10
_ Stoos/Kellein, op. cit., 1991, p. 117 and Herzogenrath, op. cit., 2000, p. 150.

11
_ Cage, op. cit., 1961, pp. 105ff.

Paik hints at the TV imagery as a kind of "dust" disturbing the silence of the empty TV. In the case of Cage, the environment serves as an indispensable contrast which the silence needs in order to be experienced as such. "A canvas is never empty," we read in the text on Rauschenberg, and perhaps this means that a canvas is never empty enough. It is, paradoxically, this incomplete emptiness which makes us feel the very empty which, Cage calls in another text, "the real, i.e., the Oriental" in the Buddhist sense. The dirt, like the arbitrary sound, may qualify as an iconoclastic intervention. But it also may be the opposite and appear as an "unavoidable subject" which emphasizes the purity of the empty canvas. "The dirt does my thinking" which inevitably enters the nothing.[12]

One of the first texts, that Cage permitted for publication, was delivered as a *Lecture on Nothing* in 1949 before a group of painters at an art school in New York. It was followed by a *Lecture of Something* first publically recited in 1951. The two essays were like musical scores organized for rhythmic reading in which the silent intervals were of an importance equal to that of the text. They complement each other in that they treat the dependence of the nothing on the something and vice versa. The quintessence of the exercise is the aim to make nothing but still to be productive which means to "make something which reminds us of nothing."[13] Paik's ideas in what follows often belong to this category. They achieve the representation of nothing by creating objects that reject representation and thereby refer the audience back to itself.

While studying Zen Buddhism with Daisetz Suzuki at Columbia University, Cage had decided to open his music for the ordinary world instead of looking inward and inspecting himself. That meant to use chance operations where the rhythm of everyday life would take over and replace the self-expression of the artist. This, Cage explains in a text from 1982, had also become Paik's strategy. One day, the artist invited him to Canal street "to watch his work *Zen for Film*,

a one hour film without images. The mind is like a mirror on which dust gathers. The problem is to remove the dust." The dust which is what time produces but also what the conscience does, disturbs the clean surface of the mirror. "In this case, the dust was on the lens and on the film as developed in white. There is never anything to see." The difference, Cage continues, is that Paik's "silence does not proceed from sound but from the image." His works were truly musical whenever "he did not deliver directions and (allowed them) to be accompanied by the sounds of the environment. I think of sculptures like the *TV-Buddha*" which, as may be noted, has no sound and thus forces us to interpret the reference.[14]

Paik had met the American composer for the first time in Darmstadt, in 1958, and described his experience in a review for a Korean periodical. Cage, as he remarked, had transcended the limits both of composing and of performing music. Duration and timbre had become the free choice of the performing musician and thus allowed for any number of realizations. Also Morton Feldman, who belonged to the same school, did not produce "sound but silence. One only counts pure unstructured time," like viewing a tree blossom in moonlight. It was, as he said in 1963 to Gottfried M. Koenig, for him impossible to define what music is. The only available definition was to call music a practice of time, not of time consumed but of time resting.[15]

In the same interview, he explained his own approach to music as the attempt "to deal with time. I am thus realizing a static condition. This has to do with Zen" and with Zen's preoccupation to improve the world by overcoming its blind dynamism. Zen teaches "the absolute repose" and therefore despises any horror vacui. The vacuum, it is implied, is the only true goal in art. He was himself captivated by Zen Buddhism, but truly not by the European view on Zen where "gravity and the fear of life dominate." Instead he sympathized with the other side of Zen, the ordinary or materialistic which was better understood by Americans. In this sense, Cage "is dry, is *sec*,

12 13 15 14

_ Herzogenrath, op. cit., 2000, pp. 102f.

_ Cage, op. cit., 1961, pp. 109ff., and pp. 128ff;
Bischoff, op. cit., p. 227.

_ Stoos/Kellein, op. cit., 1991, pp. 21ff. (Whitney Museum, Panel 21, May 1982).

_ Herzogenrath, op. cit., 1976, pp. 51f. For Paik's review
cf. Herzogenrath, op. cit., 2000, pp. 22f.

and he has American humor. Zen without Expressionism, Cage without American limits, that would be the ideal blend."

Nam June Paik's »Hommage à John Cage«: Before and After

As an interlude, Paik's early composition in honor of John Cage in relation to the video tape of the same title will offer a useful introduction to Paik's oeuvre. The composition was written when he still regarded himself a musician while the tape postdates his decision to invent video art. In a letter which he wrote in 1959, Paik described in advance his "antimusic, called Hommage à John Cage." For the first movement, he would use tapes with a broadcast-collage or with language that was just phonetic and thus pre-semantic. The second movement had to be "as boring as possible," like Zen or any-

Nam June Paik / Audiotape Reels / 1958-1962 / recorded by Paik for Hommage à John Cage – Musik für Klavier und Tonbänder / 19.7 x 14.2" (frame) / Collection Andersch, Neuss / © photo: Lars Lohrisch

Nam June Paik / Read Music-Do it yourself-Answer to La Monte Young / 1962 / excerpt / published by H.J. Dietrich, Düsseldorf, 1963 / from: Wulf Herzogenrath, Nam June Paik. Werke 1946-1976. Music-Fluxus-Video, exhib. cat. Kölnischer Kunstverein, 1980 (second edition), p. 106

1000 000 white pages follows — imagine

thing else. There was also to be a prepared piano, as Cage practiced it, but it was to look "quite unlike Cage." In the third movement, "a musical philosophy rather than a philosophical music," he was to use quotations from French writers but turn them into stage performance.[16]

At a certain point, the piano had to be overturned with a terrible sound, followed by the splintering of glass, the throwing of eggs, etc., and a motorcycle would enter the stage. Though all this became routine in Fluxus events, Paik insisted that this was more than just neo-Dadaism. He wanted to "complement Dada with music. I am convinced that I have finally found an entirely new style completely different from the other currents in New Music." But, in fact, he would not find this new style in music but rather, by inventing video art. The "music for tapes and piano" dedicated to Cage was characteristically performed in an art gallery in Düsseldorf and one year later, in June 1960, in the study of the painter Mary Bauermeister in Cologne. The attendance at all séances, even if they began at midnight, was enormous, and Paik could not repeat his piece often enough, as the *Frankfurter Allgemeine Zeitung* wrote. The final part of the performance arrived when silence and darkness fell on the scene and extinguished the noise. At last, only Paik's lonely face remained in the light of a single candle.[17]

Shortly after, Paik presented *Read-music* on written pages for "do it yourself" and which ended in "1,000,000 white pages" whose emptiness was to be filled in the reader's imagination. In the main passage, he speaks of "music for the mind" rather than for the ear.[18] Paik never gave up music entirely and never ceased to integrate or to combine it in ever new manners while staging visual art of the electronic type. Soon, he would even use music for manipulating video images and vice versa. Sound and image had to assist each other in overcoming mimetic functions and in transcending the limits of representation. There was too much "fetishism of the idea" in contemporary art, as he wrote in the "afterlude" of the

exhibition of 1963. "Indeterminism and variability," as the text continues, were the main problem of recent music.[19] They were now to become magic formulas for his visual art. In this context, the marriage with technology (which never was an end in itself) was a logical step in liberating visual art from its traditional bonds, after it had already previously served music in the same capacity.

In 1973, when John Cage turned sixty, Paik created a video tape which repeated the title *Tribute to John Cage* from his early composition and restaged the visible music of Cage with the repertory of a newly born art.[20] But what does redoing mean in this case? Does the reference reveal a secret subtext of the video images? It cannot have been enough to simply recall Cage's piece which keeps silent in the midst of the noise of the environment. But where was the true analogy? Here we are offered an abundance of "visual noise" such as a collage of truncated film sequences, recycled stills, and passages from earlier video sequences and inserted texts. Does the chance operation in the choice (or non-choice) of images refer to an invisible background behind the surface of what the video is actually doing or showing? The spectator certainly experienced a similar lack of coherence, and was exposed to a similar attack of surprises, as was the audience during the early composition of Paik. Also the inversion of the medium's expected use, like the inverted practice of instruments, points to the older work. But where is Cage's silence?

The video was co-sponsored by the TV-station WNET where it was also dispatched the following year. Already in January 1974, the tape became part of Paik's first one-man show in an American museum, the Everson Museum of Art in Syracuse, New York. We are informed by the video's text inserts that "all sounds are equal. Performers are equal. No sound is better than any other." Are we thus expected to transfer this message to the arbitrary images which we are allowed to see? The destruction of a piano which the video shows, not

17 16 18 20 19

_ Letter to Wolfgang Steinecke, in Herzogenrath, op. cit., 1976, pp. 39f.

_ Bußmann, 1993, pp. 239ff. and Anja Oßwald, in Herzogenrath, op. cit., 2000, p. 165; D. Ross, in Hanhardt, op. cit., 1982, pp. 101ff. and plates.

_ Ernst Thomas, in *Frankfurter Allgemeine Zeitung*, 22 June 1960, cf. Herzogenrath, op. cit., 1976, pp. 42f.

_ Herzogenrath, op. cit., 1976, pp. 87ff.; Decker, op. cit., 1992, pp. 103ff.

_ Herzogenrath, op. cit., 1976, pp. 103ff.

Nam June Paik / Hommage à John Cage / 1973 / 4 videostills / from: John G. Hanhardt (ed.),
Nam June Paik, exhib. cat. Whitney Museum of American Art, New York, 1982, p. 114

Nam June Paik / Hommage à John Cage / 1973 / videostill / from: Klaus Bußmann and Florian Matzner (eds), Nam June Paik. Eine DATA base, exhib. cat. La Biennale di Venezia 1993, Cantz, Ostfildern, 1993

only produces unseen images but also generates unheard sounds while the piano strings are violated. Destruction adopts a metaphorical meaning as it paves the way to the liberation from artistic conventions. The sounds and the images, whether filmed or edited in anamorphotic form, frame a much earlier cello-concert by Charlotte Moorman, in which the cello sounds are succeeded by the sounds of the water in which the cellist dives.

Akira Asada, "the leading Japanese semiologist," as Paik commented, found his approval when he wrote that Paik "freely accumulated signs and images which he accelerated until an extreme point. And it is, paradoxically, only here that we perceive a certain emptiness – an emptiness full of images and a silence full of monitor screens. And I think that this experience of a void leads to the center of Paik's art."[21] In the course of his video, Paik introduces Cage's silent piece twice like a catchphrase for making a connection. There is, first, a rehearsal of Cage's piece *4'33"* which the composer repeated in the middle of Harvard Square with a stopwatch in front of a piano. The commenting text says that he is "playing an unplayable music." Only after the silent piece ends, does Cage open the piano. The text, inserted in the course of the silent performance, speaks of the rain, which however was to be heard only on the first performance, in 1952, and thus contradicts the video environment where the weather is sunny and the concert takes place on a street.

21

_ Stoos/Kellein, 1991, p. 126.

And then we suddenly read "This is Zen for TV" or, in another version, "This is Zen TV enjoy boredom." This text requires some thought. At first, it does not make much sense. We assist a silent concert which is not "for TV" in the first place. Also the video is not TV art, as Paik by then had practiced it by exhibiting TV sets with manipulated or emptied screens. Certainly, the video was once shown on TV, and the concert in a way was recorded for such a show. But this cannot have been the only cross reference for connecting text and video. In fact, the words "Zen for TV" are a self-quotation, since Paik had called a work created in 1963, *Zen for TV*. Now, the message makes sense. Since the video text accompanies a recreation of Cage's famous silent piece, it insists on the analogy of the one and of the other work, of the

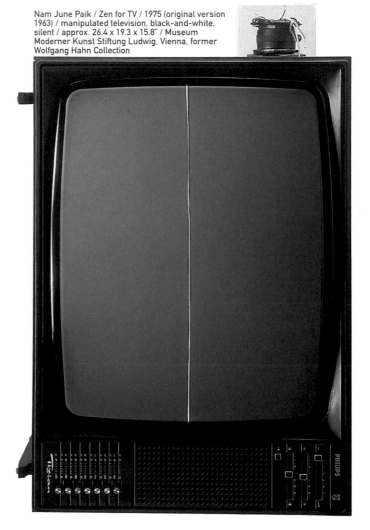

Nam June Paik / Zen for TV / 1975 (original version 1963) / manipulated television, black-and-white, silent / approx. 26.4 x 19.3 x 15.8" / Museum Moderner Kunst Stiftung Ludwig, Vienna, former Wolfgang Hahn Collection

silent piece and of the *Zen for TV* piece. At least, it offers Paik's view on his own piece as he understood it in retrospect.

Zen for TV

The "prepared TV" which Paik introduced as an analogy of the "prepared piano," turned around the passive practice of switching on the TV and watching its program. However the piece in question, called *Zen for TV*, did not allow interaction by the viewer, as required for the other TV sets in the exhibition, as Paik already had suspended or detained the running TV program by reducing it to a single white line.[22] Originally, the work was part of eleven TV sets which he had exhibited in a random manner in the Wuppertal show where he made his debut as a visual artist in 1963. The memory however remained with this one, as its "silent" image caught the imagination, and the title (though the Zen epithet also distinguished other objects in the same show) enforced its aura. As we have seen, the artist later connected the significance of the piece with that of Cage's famous *silent piece*. It was a truly iconoclastic gesture to contract the images of the usual TV transmission and to "abstract" from them the paradoxical (and deceiving) permanent line of pure white light. The implied deconstruction thus was not an end in itself but, in turn, served the creation of an image of a new kind: a Zen image, i.e., an image for a Zen type of gaze. What this means, will be explored later.

The technical construction was as simple as possible. The whole represented a readymade object (and a similarly readymade TV emission) turned into a "visible idea." The artist "manipulated the TV scan-line which is the prime mote of control," as he wrote in a text of 1971. He continues: "I remember having spent an evening with Beuys and Uecker watching Zen for TV." This is precious information, as it tells us that the piece in question had already in Cologne, in 1962, been ready for inspection and thus belonged to the first results of Paik's new experiments with electronic technology.[23] Initially, he had used synchronic pulses which would deform the inner circuits (and invisible wave lines) before building up the expected image line by line on the screen. Later, he would replace it by magnetic tools or by degaussing the system. Paik saw the cathode-ray tube as a compositional device for violating and transforming the received broadcast image. The action, however, was not only directed against the abundance of banal images but also revealed the secret agency of the new technology which was caught in what it actually does: the transformation of signals into images could also work another way or be turned against its average scope. The abstraction behind the illusion of seeing images where there is nothing but an electronic device, became equally as evident as the manipulation in the program.

The white line which solemnly hides the sum of TV images, needed an additional act before it could become the

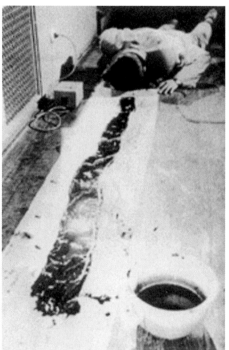

Nam June Paik / Zen for Head / Wiesbaden 1962 / performance to La Monte Young's Composition 1960 No. 10 to Bob Morris / ink and tomato juice / © photo: dpa

22 23

_ Herzogenrath, op. cit., 2000, p. 247: text of 1971 with the title *TV tortured the intellectuals for long time.*

_ Herzogenrath, op. cit., 1970, p. 141; Herzogenrath, op. cit., 1982, pp. 50f.; Dieter Ronte, in: Hanhardt, op. cit., 1982, pp. 76f.; Hanhardt, op. cit., 2000, p. 71.

silent representation of the nothing in the midst of the everything. Paik turned it from a horizontal line which appeared on the screen, into a vertical one by simply putting the set in an upright position and exhibiting it at an angle of 90°. Thus, the right hand part of the set, with the buttons for its operation, became a kind of pedestal for the presentation of a framed image which forced the viewers into a new gaze, an experience against their expectation. In fact, they were now expected to rediscover the familiar TV set as the site of a meta-image in which the images for consumption had been annihilated. When the set was switched off, the black screen became active with a light incorporated in a single line. Strangely enough, only the verticality of the line succeeded in liberating the gaze from the apparatus and transforming the ordinary into a new and purified vision.

We could speak of a Zen gaze which Paik demanded from his audience. But what is a Zen gaze? It is easier to say what it is not than to give it a concrete meaning. There is, first, the ordinary and the non-spectacular which makes us experience art where we would not expect art, and this also applies to art in the disguise of technology. We are expected to see where we find nothing to see. We are expected to create perception ourselves instead of consuming it. Then, Zen is an attitude rather than a style, a way of seeing rather than a style of art. It is representation as anti-representation. Paik himself would only talk in disguise about Zen. In a so-called "afterlude" to the Wuppertal exhibition, he insisted on avoiding any determinism both in producing and watching art. In this sense, Zen "consisted of two negations" which extinguish the distinction of the absolute and the relative. Though utopian in spirit, "Zen is Anti-Avant-garde" and as such emphasized "Asiatic poorness" of effects and sensations.[24]

But since he did not consider himself a writer, we must look for practical applications of Zen when he turned from what he had called "musical philosophy" to what he could have called "visual philosophy." There was Zen for Wind in the same exhibition, and it consisted of average utensils hanging on a rope and demanding the attention of the wind in the middle of nothing. The installation resembled the earlier Zen for Touching which invited the audience to touch the handles of a colander with sound items attached to it, the whole looking like a gong of Asia. Zen for Head was repeated from a Fluxus Festival and included the artist in a performance where he created a sort of calligraphy on a Japanese roll with his head applying the ink. Zen for Face was again different, and so was Zen for Walking where two sandals with bells and chains attached invited the audience "to make sound while walking." In each case, the idea was to invite the spectators to become active and, in the course of that interaction, to discover themselves.[25]

The embarrassing ritual also applied to watching Zen for TV, as the requested gaze would result in a reversal of what the beholder would normally do in front of the TV. Thus, the "prepared TV" became a paradoxical instrument, which offered the viewer a new TV exercise. In a text from 1969, Paik propagates "a silent TV-Station" which would be the next step after Zen for TV. Here, not the artist but a public station would transmit only beautiful "mood art" most of the time in the sense of "mood music" and thus simply be "there" not "intruding on other activities and being looked at like a landscape."[26] The "live images" as transmitted by the TV, at that moment became a quality of image never seen before and called for a reaction from the artist. The one answer to TV consumption was the video which was expected to bring TV technology (but technology, as it turned out, was not enough) into the artist's hands. The other answer was "silence" on the very site of visual TV noise.

The exhibition, which was installed in the Gallery Parnass in Wuppertal, a private home, in March 1963, had the paradoxical title Exposition of Music, and indeed intended to go beyond Cage's visible music.[27] The second part of the title, Electronic TV, demonstrated Paik's big move in creating

24

_ Herzogenrath, op. cit., 1976, pp. 87ff.; Decker, op. cit., 1992, pp. 103ff.

26 25 27

_ Herzogenrath, op. cit., 1976, pp. 66ff. with ample documentation including the description by Tomas Schmitt; Herzogenrath, op. cit., 1982, pp. 32ff.; Hanhardt, op. cit., 1982, pp. 14ff.; Hanhardt, op. cit., 2000, pp. 34ff.; Herzogenrath, op. cit., 2000, pp. 60ff.

_ Hanhardt, op. cit., 1982, pp. 75f.; Arthus C. Caspari, in Herzogenrath, op. cit., 2000, p. 39 and p. 48. Cf. also ibid. p. 94; Herzogenrath, op. cit., 1976, p. 85.

_ Decker, op. cit., 1992, p. 113 and p. 128; Hanhardt, op. cit., 2000, p. 114.

Nam June Paik / Zen for Film / 1964 / performance New Cinema Festival I,
Filmakers' Cinematheque, New York, 2 November 1965 / © photo: Peter Moore, VAGA, NYC

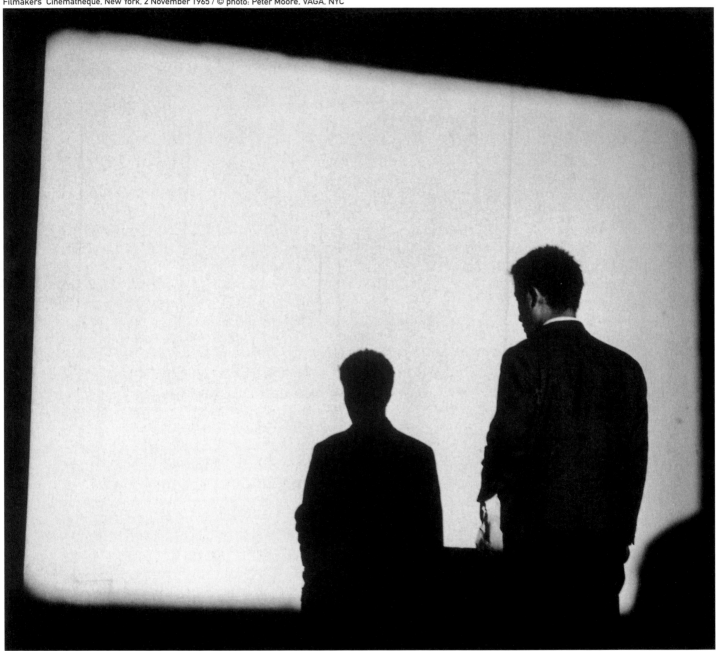

(and defining) Electronic Art the same way that Electronic Music had become an established genre. Electronic Art not only relied on its technological tools but, in Paik's view, also had to turn against the media of illusion. The technological image was not to become "art" by the mere intention of the artist, but needed a special effort by the artists to define a new perception shared by artist and audience. Here, the Zen spirit became a battle cry which revealed Paik's desperate energy to reconcile not only art and technology, but also his Korean background with Western avant-garde.

Participation TV did not have a long future as Paik soon realized that it was not enough to manipulate single TV sets in order to become "the John Cage of the ordinary domestic TV set," as J. Canaday wrote in December 1965 in the New York Times on the occasion of Paik's exhibition *Electronic Art* in the Bonino Gallery.[28] Public transmission was the more important access to the new medium but proved so difficult and sometimes hopeless that Paik, despite his few and always spectacular moments of success, was again confined to the Gallery space where the presentation of installations and objects became a gesture of resignation. His creations, despite their object status, always come as metaphors and visual gestures, that transmit a philosophical message rather than art pleasure alone and do so by non-verbal means. But the invention of ever new types of work, rather than revealing an artist's evolution, confirms his uncompromising effort to conquer a protected space for art on technological territory and in the middle of so much cheap misuse of representation. The image became an obvious target, as it was the commodity of most of visual technology. The artist, in this situation, had to save the essence of the image by eliminating the blind traffic of images. He had to rely on a number of philosophical ideas, one of which was boredom in the face of entertainment and silence in the face of noise.

In a strangely emphatic text which Paik distributed to the visitors of the Wuppertal exhibition, he urged them to believe that he does not merely play the terrorist game of Fluxus. His philosophical ambitions culminate in a theory of the Nothing which he classifies in several types. His former activity in music, according to this classification, aimed at the Nothing mainly with liberation gestures which had to be iconoclastic and violent in opposition to everything. "Other types of Nothing are quiet, cosmic, and ontological, not humanistic but transhumanistic." Nothing, as understood in this sense, was metaphysical and represented a cosmic law. "My new work approaches this latter type of Nothing. It may serve to experience a depth which cannot be defined. Try it."[29] This, then, is the Zen gaze which Paik expects from his audience: to await nothing and still to keep attention and self-awareness. The pamphlet certainly is obscure but its hyperbolic rhetoric hides an important confession of Paik's ideals.

One year later Paik developed *Zen for Film* in his new environment for alternative cinema in New York.[30] John Cage, as we saw, did not hesitate to compare his silent piece with Paik's film. "The difference is that the silence does not proceed from the sound but from the image." Paik projected a clear film leader onto a screen. The particles of dirt and dust were caught in the projector's gate and entered its beam of light. Celluloid and light were the only materials he used for a minimalist projection of silence. Thus Paik "did away with the image itself, where the light becomes the image," as Jonas Mekas wrote about the event in Filmmakers' Cinematheque.[31] The silent film takes up the light beam which in *Zen for TV* hides the TV imagery so successfully. This time, however, the light takes on the duration of the film which has a given length in time. The film constrained the viewer to sit through it even when, in this case, there was nothing to be seen other than dust. The Zen gaze, in the case of the film, was not only expected but enforced – in a complete reversal of the standard cinema visit. The artist stages a photo by Peter Moore in which his body leaves a shadow on the empty screen during the film projection.[32] This was again a symbolic gesture. Paik, who is

28

_ *New York Times*, 4 December 1965. For the exhibition cf. Herzogenrath, op. cit., 2000, pp. 102f.; for the text of Canaday: Bussmann, op. cit., 1993, p. 31.

29 32

30 31

_ Ibid. p. 95.

_ Ibid. p. 74 fig. 86.

_ Herzogenrath, op. cit., 2000, p. 75 and Decker, op. cit., 1992, pp. 97f.

_ Hanhardt, op. cit., 2000, pp. 81ff. and 94f., with ample description of the film scene and photo by P. Moore.

so conspicuously absent in the film where everything else is also absent, claimed by this photographic presence the authorship for the filmed nothingness which then resulted in the something of a philosophical argument, an argument without pictures in a visual context.

TV Buddha or the Empty Cycle of Images

There is a striking analogy between *Zen for TV* and the *TV Buddha* although the two works seem to do the opposite, the one emptying the TV imagery by contracting it to an abstract line and the other producing images all the time, albeit via the same, repeated image. Despite the constant flux of video images, which the camera sends to the screen, there is *nothing* to be seen in the sense that there is never anything *new* to be seen. This time, the viewer is present, as Paik has employed the possibilities of a video installation for which he delimited a symbolical space, a space around the TV set. The viewer sits *in front of* the TV but he also is reflected *within* the TV, as the latter repeats the viewer via a mirror image. The viewer, it seems, sees nothing but the viewer, much as the audience only experiences its own sounds during the performance of Cage's silent piece. But this can only serve as a preliminary description. There is actually no viewer but a Buddha statue, and we are seeing what the statue cannot see: the duplication of the same image which thereby empties itself. The statue is also an image which means that an image is mirrored in an image.

Let us approach this famous work step by step. It was the first case of closed circuit technology in his œuvre when Paik exhibited it in 1974 in the Bonino gallery in New York.[33] The technology implies an enclosed TV signal control. While the video camera records the Buddha statue, its picture is, it seems, simultaneously produced on the screen. The taking and the seeing of the picture which used to represent two different stages in the photographic process, coincide in our impression, and the time lapse disappears from our experience. In fact, the

simultaneity is only a successful illusion since the signal transmission, which uses a cable, is retarded. In our view, however, this delay goes unnoticed, and the difference between recording and reproducing, in terms of time, collapses. The live image represents real time, as we also expect it in the TV news. The closed circuit system however is not merely a matter of technology, since Paik also reveals its symbolic implications. He in fact uses two types of closed circuit. The one connects the camera with the image on the screen; the other connects the video image with the image of the statue. Thus, a closed circuit seems to connect images of all kinds and makes them circle in empty cycles. Images, we may conclude, represent images and nothing beyond.

It seems that Paik, in a first moment, had thought of putting the statue opposite a TV program but then decided for the closed circuit. A Zen monk would sit in front of a white wall, while his Buddha sits opposite his own image. "The goal of this meditation was absolute emptiness, beyond time and space," but the Buddha would see his body and therefore be "forced to become a modern Narcissus."[34] We may however question this interpretation which applies so much better to other video installations of the time where the video artist, in front of his live image, would fall prey to a modern narcissism. Rosalind Krauss, in a once famous critique of current video projects, complained of the loss of true reflexivity, with regard to the medium, when self-reflection of the mirror type erased the "difference between subject and object."[35] "Video is capable of recording and transmitting at the same time – producing instant feedback." The body is therefore centered between the camera and the "monitor which re-projects the performer's image." But, this time, there is neither a performer nor a viewer, as the Buddha only serves as a viewer's replacement and, in so doing, opens a subversive game where we cannot be sure of anything we see. The Buddha may even appear as a parody of the narcissistic video artist. It is exactly the "image of self-regard," the object of Rosalind Krauss'

33

34 35

_ Rosalind Krauss, Video: The Aesthetics of Narcissism (1976), in John G. Hanhardt (ed.), *Video Culture. A critical investigation*, Smith, Layton, 1990, pp. 179ff.

_ Decker-Phillips, op. cit., 1998, p. 75.

_ B. Kurtz, The present tense, in *Video Art. An Anthology*, Ira Schneider and Beryl Korot (eds), Harcourt Brace Jovanovich, New York, 1976, pp. 234ff. and esp. pp. 239f.; Georg Jappe, in *Die Zeit*, 26 November 1976, and Barbara Catoir, in *Frankfurter Allgemeine Zeitung*, 7 December 1976; Herzogenrath, op. cit., 1983, p. 86; Hanhardt, op. cit., 1982, p. 100; O-ryong Lee, in Stoos/Kellein, op. cit., 1991, pp. 126f.; Irving Sandler, in Bussmann, op. cit., 1993, pp. 63f., Hans Belting, *Das Ende der Kunstgeschichte. Eine Revision nach zehn Jahren*, Beck, Munich, 1995, pp. 92f.; Hans Belting, Buddhas Spiegel, oder: Auf der Suche nach Paik, in Wolfgang Kemp (ed.), *Zeitgenössische Kunst und ihre Betrachter*, Oktagon, Cologne, 1996, pp. 101-110; Decker-Phillips, op. cit., 1998, pp. 75ff.; Herzogenrath, op. cit., 2000, pp. 176 and 182ff.; Hanhardt, op. cit., 2000, pp. 127ff. Cf.

Nam June Paik / TV Buddha / 1974 / Buddha statue, camera, monitor / 63 x 84.7 x 31.5" / Stedelijk Museum, Amsterdam / © photo: Stedelijk Museum, Amsterdam

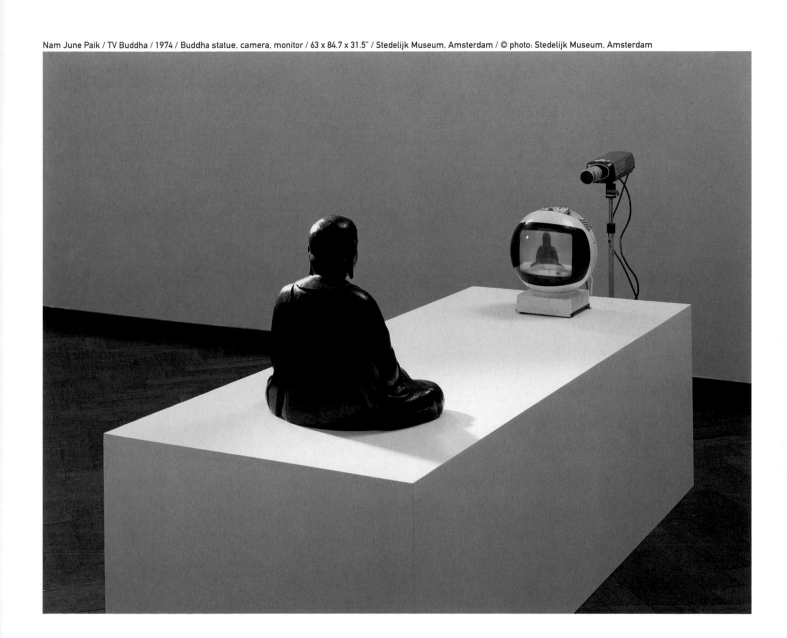

Burning of a Buddha statue / 1984 / Museum van Hedendogse Kunst et Gent / © photo: Dirk Pauwels

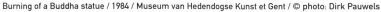

Burning of a Buddha statue / 1984 / Museum van Hedendogse Kunst et Gent / © photo: Dirk Pauwels

critique, which, in our case, is deconstructed and turned against itself.

Paik's game, in fact, leads us somewhere else. There is, certainly, the electronic type of mirror which relates the image on the screen to the one in front of it. But Paik revealed the inherent riddle when, in a motto for his collected writings, he introduced the mirror as metaphor: "The very old mirror and the Buddhas are one and the same."[36] The text continues: "The one who sees, and the one who is seen, are one and the same, much as the one who is mirrored, coincides with his mirror image." The source, a thirteenth century Japanese Zen text which makes us compare the age of the equally Japanese Buddha statue, insists on the Zen practice as an end in itself and equates meditation with the exercise of polishing our own mirror. There is no mirror besides us, and it is our own image which the mirror produces. The world is nothing but an image, and we reproduce it as a living mirror. Reflexivity, in this theory, and mirror reflection fall into one. Images thus are

36

_ Decker, op. cit., 1992, p. 8. – For the text in English translation, cf. Dogen Zenji, *Shobogenzo. The Eye and Treasury of the True Law*, Nakayma Shobo, Tokyo, 1988, pp. 154ff. (Kokyo. The Ancient Mirror) and pp. 169ff. (Uji. Being-Time). For the author, see Charles Eliot, *Japanese Buddhism*, Curzon Press, Richmond, 1993, pp. 397ff.

tautological, as they never escape the cycle of mirroring each other which happens in the self.

The reference to Zen teaching, which Paik uses as a motto, does not explain his artistic intentions in practicing a Zen gaze. By now he no longer needs iconoclastic gestures by attacking the new images of mass media in TV but turns to "the cosmic and ontological" silence. The *TV Buddha*, first and foremost, is a great metaphor, which Paik created by using closed circuit technology. The comparison between the one and the other medium, between the sculpture and the video technology, is inevitable. The result is the tautology of the two: they both produce nothing but images and even the same kinds of images. The difference between the infinitely fast video and the sculpture, between motion and immobility, collapses in the pseudo-symmetry that catches our gaze. The totality of images, which the TV screen distributes, coincides with the single image (an image in place of all images or a meta-image) of the Buddha statue. The void and the sum of images fall into one. The tautology created by the mirror situation serves a great metaphor of time.

Even the striking asymmetry which exists between the materiality of the statue and the immaterial image on the screen does not matter much. The statue embodies an image while the video screen disembodies the same image without the loss of its identity. In this case, the old statue confutes the progress in modern technology. The opposite happened in a performance that took place in the courtyard of the Museum van Hedendagse Kunst in Gent in February 1984 with the exclusion of any audience.[37] Paik burned a Buddha statue – whose carbonized remains he later sold to a gallery in Geneva – and filmed the burning process on a videotape. Buddha's body, which Paik began to represent later on in statues of any possible type, even in Buddhism, was a matter of endless riddles and contradictions. The statue of the *TV Buddha*, which the artist had previously bought with money from his family, does not even represent a Buddha type, but Paik did not seem to care and called it Buddha. The light on the video screen might be an ironic hint at the enlightened stage in which the Buddha became Buddha. But the metaphors Paik uses are at the mercy of his own will and hide their depth behind their seemingly arbitrary choice.

The paradoxical relation of the one and the other medium in *TV Buddha* – paradoxical in its asymmetrical symmetry – was enforced in a symbolic gesture when Paik, in a last minute decision, bought the most recent Japanese J.V.C. TV-set at Bloomingdale's. The design contains a clear allusion to the helmet of the American cosmonauts who had landed on the moon only five years before. Both parts of the installation then were Japanese products but their contrast could hardly have been greater in terms of their ages and places in evolution. Though both Japanese, they nevertheless represented two very different cultures – the old Buddhist religion and worldwide TV communication. It is, however, precisely this overwhelming contrast which Paik collapses. The resulting tautology of images in the human mind disproves the progress in the evolution of the media of representation and perception.

It seems that the *TV Buddha* was at first an afterthought of the Bonino exhibition and only became famous when Wulf Herzogenrath selected the work for his exhibition *Project 74* which opened in the Kunstverein in Cologne in July of the same year. Immediately afterwards, the *Video Buddha*, as it was called then, was shown in exhibitions at the Gallery R. Blok and at the *Experimental Festival* at Knocke in the Netherlands.[38] The newspaper reviews and the leaflets prepared for the exhibitions already spoke of "a key piece in Paik's work" and of "one of the most talked about pieces" in the Cologne show with its rich competition. Obviously, Paik's metaphor caught the imagination of the general audience at the first showing.

But the artist went a step further by extending the message of the installation when he represented himself in the position of the Buddha statue and with the closed circuit

37

_ Letter from Dirk Pauwels, to whom I am also indebted for sending me his photographs.

38

_ Herzogenrath, op. cit., 2000, pp. 176 and esp. pp. 194f.

Nam June Paik as Video-Buddha / 1974 / Part of the performance with Charlotte Moorman at Kölnischer Kunstverein, Cologne / from: Wulf Herzogenrath (ed.). Nam June Paik. Fluxus/Video, exhib. cat. Kunsthalle Bremen, 1999, p. 185

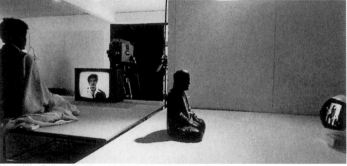

Nam June Paik as Buddha with TV-Buddha / 1974 / Performance at Kölnischer Kunstverein, Cologne / from: Wulf Herzogenrath (ed.). Nam June Paik. Fluxus/Video, exhib. cat. Kunsthalle Bremen, Bremen, 1999, p. 186

technology at the opening of the Cologne show.[39] He was sitting at a 90° angle beside his own installation and thereby eliminated the borderline between installation and performance. In his performance, nothing much happened; as in the installation, nothing changed on the TV screen. In a letter to Herzogenrath in which he proposed this event, he wrote: "I will become a *living Buddha* myself also watching TV. One is the old wooden Buddha, the other is myself."[40] There was also a second performance in which the musician Charlotte Moorman played a TV Cello, multiplying her body on three TV screens, and in which she was introduced as "living sculpture." In both cases, the difference of body and sculpture was deliberately concealed or confused.

But the metaphor, in the case of *TV Buddha*, is not exhausted with this analogy. There was not only the tautology of the living body and the video image mirroring each other, but there was, finally, the viewer who embodied the artist and vice versa. It seems that Paik at last joined the company of his fellow artists in the video branch by applying his self-regard to the mirror screen. He even speaks of "watching TV" himself. But the opposite was true. Photographs show him sitting with closed eyes before the monitor. The paradox was intended. Much as he could not be a "living Buddha," if not by the mere sitting pose and the corresponding place, so he could not apply the narcissistic gaze if he did not look at the mirror. The Buddha pose, by implication, does not merely exemplify an old work of religious art. Instead, it represents the Zen gaze which expects nothing to be seen and therefore, facing the void of external sensations or understanding their emptiness, aims at self-inspection in the middle of nothingness.

But nothingness is not only an effect of space. It is also a quality of time. Michel Baudson, in this sense, wrote a brilliant commentary of the *TV Buddha*, which he had initially hoped to include in his 1985 exhibition *Art and time* in Brussels. Paik contributed a replacement by creating the new installation of the *Hydra Buddha*, which is a profound com-

40 39

_ Herzogenrath, op. cit., 2000, p. 186 with text of letter, and pp. 184f., with photo showing Paik's closed eyes while performing.

_ Albert Schug (ed.), *Kunst bleibt Kunst: Aspekte internationaler Kunst, Projekt 74*, exhib. cat. Kunstverein Köln, Cologne, 1974, p. 419; with accompanying text on *My Experimental TV.* Cf. also Herzogenrath, op. cit., 1983, pp. 84f.

mentary on the *TV Buddha*.[41] In a letter addressed to Baudson, Paik added: "Time is difficult to define because it is our life. It therefore amounts to a paradox to show time." In Baudson's words, time is a symbol of eternity and transcends its ceaseless progress or flux by its "being." In this sense, Baudson explains the statue and the video image as two opposite and yet complementary definitions of the same and contradictory phenomenon of time. The monitor, far from being a type of fixed mirror, in fact "generates the image by its endless repetition." It functions even in the fantastic rhythm of so-called nano-seconds whose speed completely escapes our naked eye. The silent extension of time when the Buddha represents duration, is matched at the other end by the extreme contraction of time which happens in its incessant and invisible intervals. Timelessness is a true quality of time however it may be measured. Accordingly, infinity is a contradictory condition of space. Images can depict neither time nor space, unless in an allegorical way.

Baudson, who referred his readers to Henri Bergson and his theory of time, was not aware of Paik's hidden knowledge of Zen teaching in the same respect. Only later when Paik published his collected writings did he disclose this. The Zen patriarch, from whose writings he had quoted his motto, also dedicated a chapter to "Being-Time" or *Uji*.[42] He understood a Buddha statue as a synonym of time and existence, since it "is time in the present tense." Time does not separate but creates unity. "We are time ourselves, and each moment comprises the world as a whole." Paik himself played with the concept of time in his usual ironic disguise. In his 1976 article about *Input-time and output-time*, which comments on video editing, the experience of "boredom" is introduced as a positive quality of time. The video, he writes, imitates nature "not in its appearance" but in its "intimate time-structure" which he relates to time-consciousness in terms of Husserl's phenomenology. The notion of time, which we experience without knowing what we experience, results in a paradox.[43]

The empty cycle of images together with the silent statue represents the two faces of time. Where nothing happens, the silence of action also undermines the claim of representation inherent in images, whether they are static or moving. The tautology of images could only be overcome by what I have called a Zen gaze. The *something* of the installation results in the *nothing* of its representation. The figure of Buddha either represents a cosmic law or delivers a nickname for the futility of representation in the presence of the Nothing.

Beyond the TV Buddha

Paik represents what may be described as visual philosophy. He practices a discourse in metaphors rather than in texts, which materialize in art exhibits. In fact, he deconstructed the entity of what we call a work of art, by turning it into a metaphor not built up from words but from images staged in symbolic spaces (installations) as if in the framework of a text. The *TV Buddha* in Paik's œuvre released an ever increasing chain of ideas which address the labyrinth of perception and even relate to each other in the guise of cross-references, allusions, and commentaries. In this sense, every new "work" complemented, confirmed, and unfolded the ideas Paik had introduced with the *TV Buddha*. Performance and installation interrelate not in the manner of different genres, but like paraphrases of a general idea, behind the single solutions.

Already the following year, Paik created an installation for the Kunsthalle in Bremen where he placed a Buddha statue in front of a pyramid of six monitors multiplying one and the same image.[44] This time, the statue was borrowed from another collection, the Übersee-Museum in Bremen, for the one week exhibition in April 1975. This meant that the installation could never enter Paik's œuvre since its most important part was a loan or, better, was a work on loan included in the temporary arrangement. As it were, Paik recycled the original *TV Buddha*, similar to the practice of reusing his

41 42 43 44

_ Cf. note. 36.

_ Herzogenrath, op. cit., 2000, p. 202 with photo of A. Buttmann, Kunsthalle Bremen, and text by Hans Otte.

_ Input-time and out-put-time, in Schneider/Korot, 1976, op. cit., p. 98, and Decker, op.cit., 1992, p. 139.

_ Michel Baudson, Die Zeit – Ein Spiegel, in *Das Phänomen Zeit in Kunst und Wissenschaft*, Hannelore Palfik (ed.), VCH Acta Humaniora, Weinheim, 1987, pp. 125ff. For the Hydra-Buddha cf. Decker-Phillips, op. cit., 1998, pp. 90f.

Nam June Paik / Video Buddha / 1976 / installation view Kunsthalle Bremen /
© photo: A. Buttmann, Kunsthalle Bremen

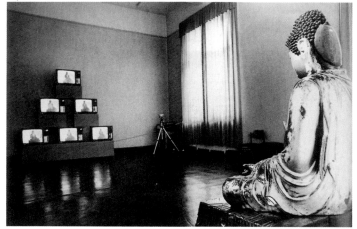

metaphor in his production), and a video camera occupied the position of the monitor. The spectator was invited to search for the camera's motifs in front of the lens on the small window of the viewfinder. Directed toward the street where the camera recorded the average view at random, the installation carried the message: Nothing to be seen.

The last in the series was the *TV Chair*, which Paik had varied since 1968 in ever new combinations. The TV set either became the sitting panel of the chair or was placed underneath where one hardly expects to watch TV. In the 1976 exhibition,

own video tapes in ever new combinations like self-quotations in an argument. The flux of works which embodied his ideas grew now at an accelerating speed. But it was not until November 1976 that the stage was set for a synopsis of the then existing "variations on a theme," to use musical terminology. When his first comprehensive retrospective in Germany opened, it was accompanied by a "classical" exhibition catalog of 168 pages. There was, in particular, a group of recent works which formed a kind of framework for the *TV Buddha*.

An old TV set which included an aquarium with slowly swimming goldfish, entitled *Sonatine for Goldfish*, rephrased the big installation *Video Fish*. The silent rhythm of fish behind a glass served as allegory for a utopian TV with quiet images behind the glass of the monitor where movement, even with live images, mattered little.[45] Another TV set, which looked like an archaeological item, replaced the monitor with an eighteenth century Japanese woodcut and carried the paradoxical title *18th Century TV*.[46] A *Candle TV* where the empty casing was filled with a single lit candle, introduced a motif which was to become a topos in Paik's œuvre. The title *Zenith*, which carried the name of a TV company, could also be pronounced "Zen is."[47] Again, the interior of a TV-set was hollowed out (the act of emptying TV sets became a consistent

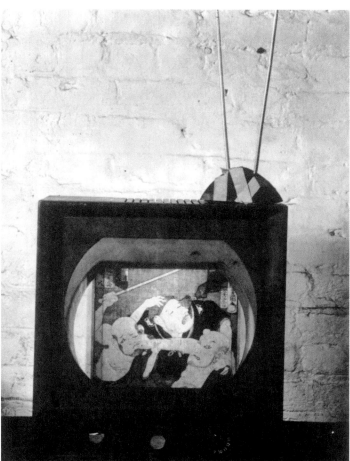

Nam June Paik / 18th century TV / 1975 / old television case, Japanese woodcut / approx. 23.6 x 19.7 x 15.8″ (including antenna) / Collection Peter and Barbara Moore, New York / from: Wulf Herzogenrath, Nam June Paik. Werke 1946-1976. Music-Fluxus-Video, exhib. cat. Kölnischer Kunstverein, Cologne, 1980 (second edition), p. 149

47 46 45

_ Herzogenrath, op. cit., 1976, p. 148, and Decker-Phillips, op. cit., 1998, p. 102; W. Drechsler, Sonatine for Goldfish, in Stoos/Kellein, op. cit., 1991, pp. 40ff.

_ Herzogenrath, op. cit., 1976, p. 152; Decker-Phillips, op. cit., 1998, p. 83; Hanhardt, op. cit., 2000, pp. 126f.

_ Herzogenrath, op. cit., 1976, p. 149.

Nam June Paik / Zenith (TV Looking Glass) / 1974 / television case and video camera / approx. 40 x 28 x 20" / detail / Collection Block, Berlin / installation view Kölnischer Kunstverein, Cologne, 1976 / © photo: Friedrich Rosenstiel

Nam June Paik sitting in TV Chair / 1976 (original version 1968) / Kölnischer Kunstverein, Cologne / © photo: Friedrich Rosenstiel

Paik however transformed the installation (the camera being above and the monitor under the chair) into a performance where he staged himself.[48] With a greeting and joking gesture, he looked up to the camera, which instantly produced his image on the monitor underneath the chair, which Paik however could not see. The metaphor which is implied works in several directions. The video performance of the 1960s (Bruce Nauman) in which artists performed for their audiences in their study rooms, here took on quite a subversive meaning. The body of the artist, at least in the eyes of the audience, obstructed the "natural" field of vision, which exists between a mirror and a viewer. The mirror, in fact, is the camera, which receives the viewers' gaze but does not reflect their image face-to-face; at least not for them. The performance also helps to explain the fiction in the Buddha's mirror position. It is not the viewers who produce and receive the images of themselves on the screen but the camera connected with the rear of the

48

_ Herzogenrath, op. cit., 2000, p. 153; Hanhardt, op. cit., 2000, p. 106f.

Nam June Paik / Triangle with Video-Buddha, Video-Rodin, TV-Buddha/TV-Rodin / 1976 / installation view Kölnischer Kunstverein, Cologne 1976 / from: Wulf Herzogenrath (ed.), Nam June Paik. Fluxus/Video, Verlag Silke Schreiber, Munich, 1983, p. 89

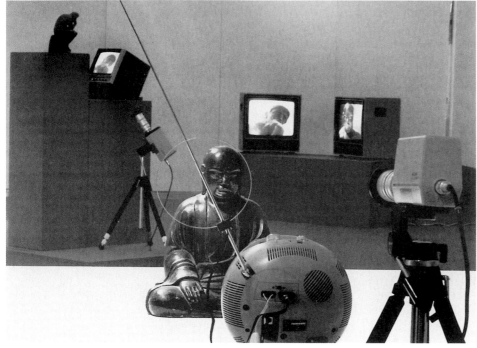

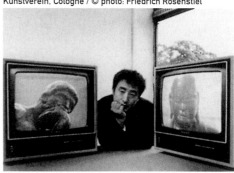

Nam June Paik with Triangle I / 1976 / compromises TV Rodin (1975) and Video Buddha (1976) / Kölnischer Kunstverein, Cologne / © photo: Friedrich Rosenstiel

TV set by a cable. The mirror is a metaphor for the viewer and their inner image: it is, in fact, the mental mirror reflecting external sensations that matters. In the Cologne performance, Paik played the viewer much as he played an artist who claims participation in his work.

Given this circle of "variations on a theme," the central position of the *TV Buddha*, in his second appearance in Cologne was highly significant. But it was not merely a reappearance of the same work that Paik contributed to the exhibition. The *TV Buddha* this time entered the framework of a larger unit that made the earlier work look like a self-quotation. The new installation deserved its name, *Triangle*, as it grouped the *TV Buddha* not only with the so-called *TV Rodin*, but also with an additional pair of TV sets which repeated the two images on the monitors like mirrors of mirrors.[49] We cannot overlook Paik's intention to make us

compare (and mutually interpret) the *TV Buddha* with the *TV Rodin* he had devised during the time between the two shows in Cologne. A small replica of Rodin's *Thinker* is introduced as the companion, as well as the antipode, of the Buddha statue, the one representing a prototype of the Western artist, the other a protagonist of Eastern mentality. Creativity in the one case matches meditation in the other. The effort of thinking, as the motor of imagination, responds to the peace of being in which the imagination aims at nothing.

The result is the same in both cases as it produces nothing but a mirror image of what is there anyway. Ideas look like ideas, and being is echoed in being. The title *TV Rodin*, taken literally, identifies the *Thinker* with Rodin much as Rodin had identified the figure with the visionary Dante and introduced it as a veiled self-portrait of the artist at the "Gates of Hell." The "Thinker" must be seen as a contrasting (and

49

_ Herzogenrath, op. cit., 1983, pp. 88f.; D. Ross, in: Stoos/Kellein, op. cit., 1991, pp. 56ff.; Herzogenrath, op. cit., 2000, p. 210; Hanhardt, op. cit., 2000, pp. 127ff.

even contradictory) answer (and companion) to Buddha whose meaning is specified or even negated by the Bronze figure. They both represent or embody a received idea for which they are placeholders. As such, it was sufficient to use readymade copies with an arbitrary pedigree.

The riddle is easily solved when we detect Paik's self-reference in both instances. He is both Rodin and Buddha, an artist in the West and also a representative of another mentality. Though he produces images, he entertains a certain distance to Western fetishism which trusts images blindly as agents of representation. His ambivalence became the target of a kind of performance when Paik appeared in a photograph in the space between the Rodin and Buddha monitors as if

subject to a difficult choice between the one and the other. Though he turns his inquiring and equally hesitant look to the Rodin image, we cannot be sure whether he will choose the Buddha image at another moment. He offers us concepts with which we have to familiarize ourselves. The choice of metaphors revokes the tangible presence of what we see in such installations. Visual philosophy as he practices it in such "propositions" (to use a famous term introduced by Joseph Kosuth as an alternative for art works), does not depend on the visibility of what is exhibited. Only the Zen gaze, which we are invited to apply here, offers access to a silence against which, ultimately no image can win. |

MAKING ABSTRACTION

Caroline Jones

»*[Mondrian, following] Marx, anticipated the disappearance of works of art – pictures, sculpture – when the material decor of life and life itself had become beautiful. With Marx, he saw the true end of human striving as complete deliverance from the oppression of nature, both inside and outside the human being. With Marx, he saw that man has to* denaturalize *himself and the things he deals with in order to realize his own true nature. He saw that what is wrong at present is that man only partly denaturalizes his own nature and his environment, and through this partial denaturalization – that is, capitalism, the suburbs of Chicago, radio, movies, vicarious experience, popular taste – attains precisely the opposite of what he really wants.*« CLEMENT GREENBERG, 1945

»*There's nothing more invincible than an American Protestant in Rome.*« ROBERT SMITHSON, 1961

FORMALIST ART CRITIC CLEMENT GREENBERG wasn't an American Protestant, but of course he aspired to their status in postwar US society.[1] Greenberg really *struggled* to become modern, and the system of subjectivism he invoked (denaturalization to the bone) seems very consistent with the point of "Iconoclash." If iconoclash stands for productive collisions among endless mediations (as opposed to iconodules' insistence on the One True Mediation, or iconophobes' denial that there can be any), then what might be useful is a brief note on the systematics of our great abstractions, an argument about how they themselves are as mediating as the icons they abjure, and some suggestions as to why we might "really want" them.

In terms of artworks made in the standard modernist fashion, "on spec" (as opposed to political posters, liturgical objects, advertising icons, or other commissioned things), iconoclasm is part of production. It is internalized by the subject as part of the "denaturalization" that Greenberg saw as so essential to modern life. Iconoclasm itself, is, of course, a mediation – one form of mediation between matter and mind. In this account, infinite little iconoclastic gestures are made by the modernist artist in negotiating her medium, and in pursuit of "abstraction." Artistic rejections, subtractions, negations, cancellations, censorings, occlusions, encryptions, and denials are the everyday destructions that constitute the production of modernist art objects. These processes take their place among endless other relays of objects, images, and mediations that comprise culture, but it is modernism's conceit to make us aware of the few that are materialized in making the art object itself. The paired modernist principles of *l'art pour l'art* and "truth to medium" have long been interpreted to require this surfacing of process, which is, simultaneously, a suppression (or, if you will, an iconoclasm) of claims to mimetic representation. In this gestalt model, the degree to which you see Picasso's collage as a congery of geometrically arranged and pasted papers is in inverse proportion to the degree to which you see "a bunch of fruit on a table." (We see both, of course, contra gestalt – and it is that hovering simultaneity that gives post-Cubist art its astringent freshness.) Modern artworks, in this sense, always encode their own iconoclasms. They do it for you before you can do it to them – they show off the smashed or scissored bits that constitute the "composition" in order to surface the hard work (conceptual and physical) of *making abstraction* out of the world.[2]

I take the meaning of the second commandment quite differently from Latour (a productive iconoclash?). Nature cannot represent, nor can it abstract. *Both* moves are human, labored, mediating. The monotheistic god of the second commandment (2C) plumps for abstraction so that He can demand a new discipline, to be enforced on His subjects alone – a regime that will mark them as "chosen" (should they in turn *choose* to internalize that new order). The paradoxical result is not *no image* –

1

_ Smithson's many critiques of Greenberg can be situated in the context for the epigraph here. Commenting on the smugness of American protestants in the face of "catholic" excess, he mused: "This kind of sly moralism is at the heart of much American art both 'abstract' and 'realistic!'" Robert Smithson, *The Iconography of Desolation*, essay written c. 1961, published posthumously in: Eugenie Tsai, *Robert Smithson Unearthed: Drawings, Collages, Writings*, Columbia University Press, New York, 1991, p. 64.

2

_ Sometimes this iconoclastic code, I submit, provides the stimulus for further iconoclasms. This is how the continuing attacks on Barnett Newman's already severely iconoclastic paintings by the nutcase slasher from Amsterdam need to be interpreted – very differently, in other works, from the old-fashioned iconoclasm of the hammer-wielder who bashed Michelangelo's *Pieta*. The particular form of the psychotic's vision is instructive – he insists he wishes to "complete" Newman's intention, by taking Newman's near-monochromes "all the way ..." to death? Is the death wish (transfigured religiously into heaven) the logical outcome of iconoclastic abstraction? That is certainly Greenberg's suggestion. Too bad that a reproduction could not have sufficed for the Amsterdam slasher's teleological plan.

Barnett Newman / Who's Afraid of Red, Yellow, and Blue III / 1966-1967 / 96 x 214" / oil on canvas /
Stedelijk Museum, Amsterdam / © VG Bild-Kunst, Bonn 2002 / © photo: Stedelijk Museum, Amsterdam

it is instead the *image of abstraction* that is to be produced (mentally, verbally, and eventually pictorially). Any discursive mediation that approaches abstraction's image (my own here is an instance) might productively attend to those internalized regimes.

"I want to veil the image," Jackson Pollock said of his drip paintings, but that veiling was experienced by some of his viewers as a violent iconoclasm. The evident pulverization of the figure in those paintings could also be seen as the logical result of the painter's internalization of abstract order. Greenberg, Pollock's biggest fan, wrote that this postwar painter's "superiority to his contemporaries ... lies in his ability to create a genuinely violent and extravagant art without losing stylistic control. His emotion starts out pictorially; it does not have to be castrated and translated in order to be put into a picture."[3] Starting out pictorially meant that the Cubist abstract order had already been internalized by Pollock – its austere grids had been taken (as Greenberg saw it) from urban industrial environments, and folded in to "denaturalize" his emotions in order that they might become *pictorial from the start*.

What I am describing as the internal iconoclasm of modernism cancels the conventional representation of *objects* in order that the artist (and, by implication, the viewer) might become more truly a *subject*. "Instead of making cathedrals out of Christ, man, or *life*, we are making them out of ourselves, out of our own feelings," Barnett Newman explained.[4] Abstraction here uses iconoclasm as if to refuse mediation, insisting (impossibly) on the ground zero of a universal phenomenological response that was seen to reproduce (in the viewer, in the painter) an original self.[5] This kind of ideology is often seen to be characteristic of iconoclasm more broadly; iconoclasm can imagine itself to be uniquely *unmediated* in a world of simulacra. At another level, of course, the cultural trade in abstraction requires more mediation than ever. It required Newman, for example, to post a gentle suggestion to viewers that they stand less than a meter from his canvases. It required that their viewing regimens be adjusted, so that peripheral vision would be saturated (as in his aptly titled *Cathedra*) with mixtures of cobalt and Prussian blue expanding on either side of the white "zip" bifurcating the painting's unequal halves. It required titles such as *Vir Heroicus Sublimis*, *Oneness*, and *Here I*. It required earnest gallerists, curators, and art historians to spread the word about the "mute logos" of abstract modernist form.[6] Newman knew that such complete, iconoclastic abstraction was a nervy, even arrogant act. He acknowledged as much by titling a whole series of paintings *Who's Afraid of Red, Yellow, and Blue?* He knew the fear, but he never could have imagined that it would prompt the slashing of these paintings (in the name of "completing" their iconoclastic *telos*).[7]

The hatred induced by "counter religion" is surely triggered by a sense of exclusion from the great abstraction being produced, whether that exclusive abstraction mobilizes itself through representational images, or what I have termed the image of abstraction. Chosen versus not chosen. Them versus me. Word versus word made flesh. The first anger in the Biblical iconoclasm is that of the Israelites (why has Moses gone from us?) but the more instrumental fury is God's. According to the chroniclers of the Torah, God was angry about the Golden Calf not merely because the Israelites appeared to be worshipping it while He and Moses weren't looking (as centuries of interpretation would have it). Clearly the ordering of the narrative shows that God was angry that they'd made *any* images at all ("thou shalt not make unto thee a graven image, nor any manner of likeness of any thing that is in heaven above, or that is in the earth beneath, or that is in the water under the earth ..." a proscription that comes *before* the injunction against worshipping such things.) Making matters worse, as Joel Snyder notes, the offending icon seems to have been truly successful, since the labors of collecting, melting, engraving, and molding the gold

4 7 6 5 3

_ See note 2.

_ Gottfried Boehm's current project is to understand *Der stumme Logos*, building on his previous work. See Gottfried Boehm (ed.), *Was ist ein Bild?*, Munich, 1994; Gottfried Boehm, *Bildbeschreibung. Über die Grenzen von Bild und Sprache*, in *Beschreibungskunst – Kunstbeschreibung. Die Ekphrasis von der Antike bis zur Gegenwart*, G. Boehm and H. Pfotenhauer (eds), Munich, 1995, pp. 23-40.

_ Greenberg in: John O'Brian, *Clement Greenberg: The Collected Essays and Criticism*, vol. 2, University of Chicago Press, Chicago, 1986, pp. 74, 75. I unpack more of the Lacanian significance of this pairing (translation and castration) in my forthcoming critical history of Greenberg, *Eyesight Alone*.

_ Newman: "I hope that my painting has the impact of giving someone as it did me, the feeling of his own totality, of his own separateness, of his own individuality. ... I want the viewer to feel, as I did, more individual." (Barnett Newman, interviewed by David Sylvester, Easter 1965.) Transcript in Michael Auping (ed.), *Abstract Expressionism: The Critical Developments*, Albright-Knox Art Gallery and Harry N. Abrams, Buffalo and New York, 1987, p. 140.

_ Barnett Newman, *The Sublime is Now*, from an issue on: The Ides of Art, Six Opinions on What is Sublime in Art?, in *Tiger's Eye*, No. 6, 15 December 1948, pp. 52-53. The emphasis is Newman's.

conclude with the magical moment when, in Aaron's words, "I cast [the gold] into the fire and there came out this calf." There is certainly a fantasy of no mediation here – but it is not God who denies mediation. It is Aaron, in his desperate scrounging for an excuse (it made itself!). Aaron *knows* he has made this thing, but denying that mediation is what explains and excuses the "error" of the Israelite's faith in it. In an important essay on automaticity, Joel Snyder compares the magic of the emergent calf to the similarly mediated magic of the photograph as it blooms from the developing tray, concluding that it is precisely humans' abilities to make things that aren't things (a calf that isn't a calf, a picture of nature that isn't nature) that makes the Israelites temporarily happy, and incites God's jealousy. God makes creatures, humans make magical *mediations*. This "jealous God" simply prefers those human mediations he can keep a handle on (The Word). Pitted in dramatic confrontation in the tale leading up to 2C, then, is the magic of the made thing that seems to body forth with natural likeness, versus the power of an austere and unprecedented abstraction that shall remove any image from "before my face."[8] The second commandment is against making *and* worshipping (they are seen as inherently intertwined). The monotheistic God demands a new, internalized regime of abstraction from his subjects. To be "Chosen," they must worship *neither* a body God has made (the Pharaoh, for example) nor a body they have made. Instead they must "denaturalize" themselves – abstract or draw – from the natural realm (and from that place of representation where nature can be magically re-created), to that elevated place where man is promised, at last, that he will get "what he really wants."

Of course, that's after the revolution/ utopia/ *tikkun olam*. Down here on earth, as Latour so eloquently summarizes, hatred stirs from the abstractionists in their jealousy of image-magic. Just as often, I submit, the image-magicians have expressed their hatred of the apparently closed system that abstraction invokes. This last is ironic, since the function of abstraction is rarely to end mediation (that would be to believe the utopian claim). On the contrary, as I've suggested, abstraction's big and little iconoclasms require constant mediation. Often intended to streamline the image so that it can be continuously passed along "without distortion," abstraction can also, in this very streamlining, produce radically under-determined meaning, summoning multiple readings from polyvocal interpreters, whose endless murmuring constitutes culture itself.

The dream of an unmediated existence freed "from the oppression of nature" requires, as I've argued, the internalization of the iconoclastic impulse. But this is not to say that such subjectification can be independent of the world it created, or ever free of the surfaces that enfolded to produce it. On the contrary – modernism's ethos ("less is more") also belongs to modernization. Capitalism likes these efficiencies as much as art, as the twin legacies of the Rockefellers (Exxon and the Museum of Modern Art) attest. State Communism found different efficiencies for its reproductive regimes (Lenin *always* looks just like Lenin). Denaturalization proceeds in both regimes: abstraction *and* mediation, abstraction *in order* to mediate ever more effectively, abstraction as *the ultimate formulation* of our mediating desires.

We humans make cultural and therapeutic use of our constructed dialectic between these two kinds of mediation – abstraction and representation. Conceptual art (the ultimate abstraction) became a tonic in the 1970s for those in forced representational regimes, whether imposed by Communism (endless statues of bearded men), or capitalism (pervasive commodities). There was no need to smash the icons when one could simply think one's way around them. Similarly, in both literature and life the image-prey of abstract ideological fury is re-conceptualized (as *culture*), then tenderly rescued and conserved. In *Anil's Ghost* (Knopf, 2000), Michael Ondaatje leads us through the frustrations of science (a forensic mediation posed as crucial, but dwarfed by the politics of terror) to a conclusion in which art rescues a religious icon through groundless

8

_ This is usually translated simply as "thou shalt put no other gods before me." The retranslation of the first commandment is provided by Snyder, whose arguments about the magic of the "natural" likeness and the relation of that magic to the second commandment have thoroughly convinced me. See Joel Snyder, What happens by itself in photography?, in Ted Cohen, et al. (eds), *Pursuits of Reason: Essays in Honor of Stanley Cavell*, Texas Tech University Press, Lubbock, 1993, pp. 361-373.

faith. In the book's ambiguous finale, the scarred victim of terror becomes the man chosen to paint the eyes on the damaged Buddha, in the last steps of its renovation. Ondaatje provides no answers to the following: Will the object be reborn as sacred, or does that depend, instead, on the survival of the worshippers themselves? Can icons survive only if their divisive religions melt away, and they become the objects of cultural tourism? The skill of the eye-painter, his ability to balance mediation and magic, is unresolved by the novel's end. This refusal of closure confirms that such renovations may only be temporary (until the icon is smashed again, until the worshippers fade away); but there is an equally strong conviction that mediation is the only thing we have. The poet-novelist Ondaatje seems to agree with Latour: it is the proliferation of mediations that keeps us human, not their claims to "Truth."

But it's a little strange to think (as Latour states) that Moses "got it wrong," since it implies a "right" origin for 2C when the narrative itself denies any such temporal logic. The paradox of temporality in this passage of Exodus is reflected in the fact that the Israelites cannot yet know about the jealous Lord's injunction against images when they make the Golden Calf, since the Torah has not yet been delivered to them. And the Lord cannot know about the proximate threat of idolatry when he gives the law to Moses, since the Golden Calf has not yet come out of the fire. The construction of the image-making as "idolatrous" and the Lord as "jealous" are conditions that seem to be in place prior to their own existence. The anger (Moses' and God's) can only be understandable if the mediation of abstraction was already valued in this population, already in dialectic with the countervailing magic of representation. Moses' response (the petulant throwing down of the tablets), implies that the Israelites already wanted the Law he now refuses to give to them. Thus the passage can best be understood as the struggle to shift between mediations forever in dynamic flux (not to see them as fixed).

Latour's challenge for interpretation is more serious; his fatigue with criticality worries me. Can we manage to study but not destroy? Make *agape*, not Eros? Here the theorizing of Christian Metz on Hollywood cinema is appropriate:

> "I have loved the cinema, I no longer love it, I still love it. ... Initially an undivided passion, entirely occupied in preserving the cinema as a good object (imaginary passion, passion for the imaginary), it subsequently splits into two diverging and reconverging desires, one of which 'looks' at the other; this is the theoretical break, and like all breaks it is also a link: that of theory with its object. ... The cinema is 'persecuted,' but this persistence is also a reparation ... the *restoration* to the theoretical body of what has been taken from the *institution*, from the code which is being 'studied.'"[9]

Hollywood instantiates the power of things made to appear "as if by magic," things that seem to provide "what we really want." But commercial cinema also serves as a useful example of appealing concoctions whose blandishments must be critiqued, endlessly and without fatigue. One seeks the seamless thing in order to be astonished, all over again, by the magic of its madeness. One breaks the spell in order to refuse the magic's clouding of the mind. We will never be free of either desire (for "unmediated" abstract clarity, or for "immediate" magic). The tango of the tangle, that's the thing. |

9

_ Christian Metz, The Imaginary Signifier (1975), excerpted in Philip Rosen (ed.), *Narrative, apparatus, ideology*, Columbia University Press, New York, 1986, p. 275.

BAQUIÉ AT MALPASSÉ: AN »ADVENTURE« IN CONTEMPORARY ICONOCLASM?

Nathalie Heinich

A FEW MONTHS AFTER ITS MAY 1988 inauguration in a working-class housing estate in the Malpassé neighborhood at Marseilles, nothing but a concrete block and steel letters – tagged of course – remained of the sculpture by Marseilles artist Richard Baquié, commissioned in 1987 by the Culture Ministry's *Délégation aux arts plastiques* (DAP).

The sculpture originally consisted of three parts: large steel letters composing the word L' AVENTURE; a glass-paved pit containing a BMW car with its surfaces cut up and its windscreen bearing the stencilled word "desir;" a concrete block fountain of the same dimension, bearing a color photograph of the port at Marseilles, covered in glass and with water running down over it; painted metal sculptures suspended between the trees, with the words "Plus loin plus loin L' AVENTURE" [further, further the adventure].

How did it come to pass that within a few months the work had deteriorated to such an extent that restoration was no longer considered? Vandalism? Defects due to bad workmanship? Lack of maintenance? Administrative inefficiency? Shortcomings in the design?

Uncertainty prevails: *iconoclash*?

The Actors' Turn to Speak

Rather than immediately answering, let the sociologist play her part, starting by gathering the actors' points of view.

The artist, in 1987: "It is a contemporary concept that gives the impression of experiencing space through the relation of the senses to each element; there is ambiguity in the linearity and the inter-relational system. The overall view, the approach, the element, and memory, traditional in sculpture, enable one to experience the place by highlighting the void, not as an absence but as containing a number of energies produced […]" (Richard Baquié, plans submitted for "L' AVENTURE").

The "chargé de mission," in 1987: "The sketch seems particularly interesting, both because it occupies space perfectly, by proposing several parts occupying three distinct points at the Les Cèdres crossroad, and because it perfectly expresses the quality of Baquié's work in a very simple, very beautiful language that is easy for the people to interpret" (Dominique Wallon, Letter to the mayor of Marseilles, August 1987).

The neighborhood florist, early 1988: "It's going to be very pretty. We really need something like that. But, it's the fountain I'm worried about. All day long, they are going to go and fetch water for their shots. In this neighborhood there are too many junkies. The whole day long they come and ask me for water … tell them not to put in the fountain. Or else if it's not possible, to protect it with a fence…" (documentary).

The housing estate authority, early 1988: "'L' AVENTURE is further…' is going to be interpreted in the following way, because the words are directed towards the Mediterranean: 'Further … Africa', in other words, 'Clear out, your place isn't here'." [Q. But this sculpture, they're going to gather around it, adopt it?] "Sure, it might amuse the kids. But it can serve as a source of water, especially to wash cars … They'll immediately notice the open water supply. We're not going to have an easy job" (documentary).

Youth in the neighborhood, early 1988, Rachid (29 years old): "The state's going to give I don't know how much, millions, to do that? That's fine but it could also give something for the youth … and we've got the impression that the people who come to set it up don't give a damn about the inhabitants of the neighborhood. They could at least have asked for our

opinion … Because the statue may be beautiful but in this housing estate there are young people on drugs, delinquents, and poverty. Since the *restaus du cœur* [meals for the poor] has started up here I think we've served over 4,000 meals."

Moshen (17 years old): "The statue, it's going to be there for two days. After that it's going to be killed."

Noui (18 years old): "Who's the artist? It's someone crazy. He could have put a little statue … we're fed up. We see cars passing every day and to see a statue we have to go to the ends of the earth."

Djamel (19 years old): "Give us a little Pelé, a Maradona if you want to pay homage to us! Even a nice bronze ball, so that when the sun shines on it, it lights up all the windows … at least then they'd see us as sportsmen. When are they going to build us a stadium? We're forced to go miles to play football …"

Noui: "For us, L'AVENTURE (adventure) is daily life. Since drugs have been around this neighborhood's been rotten … We don't need a sculpture here. We want a stadium! We're begging for one …!" (documentary)

The inhabitants of the neighborhood, the day of the inauguration: "That thing's for morons! It's okay for a bourgeois thing down there at the Prado, not in a neighborhood like this. It's shit here!" – "They could have asked the people here what they think, after all it's they who would have liked to judge the image they want to give! They would have preferred something else, other than that! Because I'm all for abstract art, but here, it's really abstract here, because I can't see where it is. What's more, one has to bend down to look at it!" – "Me, when I talk of art, I see something beautiful … something that immediately catches the eye!" (documentary)

A Marseilles art critic, the day after the inauguration: "More mental than spatial, the contiguity of all these elements shifts the possibilities of meaning, leaves interpretation free" (Alain Paire, *Le Provençal*, 17 May 1988).

A Parisian art critic, three weeks after the inauguration: "Consequent to I don't know what technical hitch, the water is no longer running. The paper photograph, no longer protected by the running water, has nothing but the glass between it and the sun's rays. The corners are already bent and, here and there, it's warped. It looks like a post for adverts for tourism, out-of-date before its time. […] The environment is too bitter to let itself be forgotten through a monument, as generous as the intentions behind its erection may have been" (Hervé Gauville, *Libération*, 7 June 1988).

The engineer-architect, three months after the inauguration: "The deterioration (especially the broken glass and problems of running water) seems to be due not only to the public but 'to bad design of the fountain part and a bad choice of material for the panoramic part of Marseilles around the fountain block'" (Report on the defects in construction requested in September 1988).

Administrative reporter, six months after the inauguration: "First, the municipal culture department paid out the full amount without waiting for the work to be completed. Second, the artist himself proceeded likewise. The work was therefore delivered and received without any final verification of its quality." These abnormalities were especially problematic in so far as the monument was both a "technological challenge" (new materials for the artist) and a "sociological challenge, because the risks of vandalism in urban environments were well known" (Hervé Mariotti, report to Dominique Wallon, December 1988).[1]

The insurer, ten months after the inauguration: The sculpture "was damaged in December 1988 and January 1989" in the following way "triptex glass broken by stones thrown at it, cibachrome photo panels removed, neon broken, shots fired at it" (insurance file, March 1989).

1

The total amount quoted for the proposed repair (treatment of the watertightness and humidity of the pit and the fountain, solution to the problem of the photograph, organization of the work) was 551,000 FF – 64 percent of the cost of the statue, which was 851,000 FF (without the catalog of 252,000 FF). This restoration project was dropped due to the cost. All that was maintained was the changing of the glass on the fountain and the transferral of the photo onto Formica, inalterable by humidity.

Richard Baquié / L'AVENTURE / 1987 / destroyed / part I: large steel letters; part II: glass-paved pit containing a BMW car;
part III: concrete block fountain, photo onto Formica / detail: part III / © photo: Nathalie Heinich

The artist's agent, one year after the inauguration: "A gaping hole of over two meters long has more or less been neglected; the population shows its discontent by destroying everything the municipality provides, for example barriers to protect the hole, which are thrown down into it" (Sophie Tourneur for *L'Agence*, May 1989).

A Marseilles art critic, two years after the inauguration: "BAQUIÉ-MALPASSÉ: L'AVENTURE EST FINIE" [the adventure is over] – "Of the work inaugurated with much pomp and ceremony two years ago, nothing but a concrete cube remains [...] All that is left of Baquié's work are the two elements at the top and the bottom: instead of the fountain all we see is a very ugly cube" (Alain Paire, *Le Provençal,* 8 June 1990).

The artist, six years later: "[...] I accept its destruction, its destruction interests me or, even better, it is a natural consequence, a demonstration of the illusion of perpetuity. Everything can disappear and, without being programmed, duration remains a constant of any constituent element. There was an active sculpture, made of elements (sometimes too beautiful to be deserved – it's up to you to determine the share of responsibility of the population) in which the meaning invoked related to its use and to its condition. While this sculpture may have been decisive for one in a thousand persons, let us not be surprised that the others broke the compromising object due to the impossibility of doing anything else. No sculpture withstands time and history. They represent a power and their destruction is reassuring [...]" (Letter from Richard Baquié to Nathalie Heinich, 1994).[2]

The Sociologist's Turn to Speak

What does this little story teach us?

First, it teaches us that the resistance of materials combines inseparably with that of humans to thwart projects with the most generous intentions (Richard Baquié, a young Marseilles artist, now dead, was more deeply affected by this affair than he publicly admitted, according to his friends and family). Second, it confirms that a whole world exists between those for whom a work of contemporary art is essentially a medium for words (specialists, art critics, Parisians, who had the right to a press conference on the eve of the inauguration), and those for whom it is above all a thing (possibly filled with intentions, but what intentions? The neighborhood meeting, scheduled the same day as the press conference to present the sculpture to the inhabitants, was cancelled): a thing to which one can react, with words, with stones, etc.

Although there is a de facto asymmetry between these two worlds, from many points of view (prestige, power, culture, etc.) they are, at least in one respect, in a state of perfect symmetry: neither of them understands the other. While the inhabitants of Malpassé clearly had trouble seeing that the "sculpture" given to them was of the slightest interest, it does not seem to have crossed the minds of the commissioners of the work and the local authorities that it could "go down badly" *(mal passer)*. They found themselves totally at a loss both in dealing with the failure of the operation, materially, and in understanding it, intellectually.

Between the two, the artist wavers. Richard Baquié, also brought up in these northern suburbs of Marseilles, recognized during the 1980s as a rising figure in contemporary French art, had clearly switched to "the other side" where no one had conceived that a project deliberately designed to touch the imagination of a neighbourhood and, in particular, its youth (the city "at the ends of the earth,"[3] the aspirations for other horizons, the fetish car) could receive only gibes, stones, and shots. Why this misunderstanding?

3

2

Events organized for the young people in these neighbourhoods revealed that some of them almost never went into the city and that some had never even seen the sea!

This case is an extract from Nathalie Heinich, *Les rejets de l'art contemporain*, a report to the culture ministry (DAP), 1996. For similar cases, cf. Nathalie Heinich, *L'Art contemporain exposé aux rejets. Études de cas*, Jacqueline Chambon, Nîmes, 1998. For an overall analysis of contemporary art from the perspective of a sociology of values, cf. Nathalie Heinich, *Le Triple jeu de l'art contemporain*, Minuit, Paris, 1998.

CHALLENGING THE VISITOR TO GET THE IMAGE:
ON THE IMPOSSIBLE ENCOUNTER OF AN ADULT AND A PIG

Albena Yaneva

LET'S FOLLOW THE VISITOR AS SHE CROSSES the entrance of *Musée d'art moderne de la ville de Paris* in 1999 to see the exhibition *Häuser*: she ambles in the space, loses the guide marks. But she reminds herself, losing the way is part of the exhibition visit, and on she goes. Finally she stops in front of a small wooden house, looks for the door, goes back to its small crumpled booklet, stares at it: "Oh, yes, this is the installation *House for pigs and children*"[1] she says as she begins to regard the installation directly in front of her.

The house is inaccessible for the adult public. The actual construction of the house makes it impossible for this group, the parents, to have access to the installation. Because of the dimensions of the door, only children are supposed to enter the house and to see a film on pigs. When leaving the house, they can relate this experience to the adults, who are waiting for them in the exhibition hall. While waiting, the adults can see the images of their own faces projected on a mirror. The work the children do to obtain access to the pigs' images corresponds to the almost involuntary work of the adults to produce their own images on the mirror outside the house. By implicating the visitors in the game of the installation, the artistic project aims to make possible the parallel production of these two images.

The installation challenges visibility. By visibility I mean the difficult mechanisms that permit us to see rather than the act of seeing. Instead of inviting the visitor to contemplate passively a set of images of an already staged reality, the contemporary art setting invites her to perform risky work, producing images of the reality in a chaotic state of ambiguity about the artistic scenario. Guided by numerous tribulations, the visitor passes from one impossibility to see to another: the adults cannot see what the children see, the former see only their own images, reflected in the mirror; the children cannot see the real pigs, but see instead their filmed images, the pigs don't see anything, they are supposed to be seen. In this setting, the possibility to see quietly and openly, a present image positioned in front of the visitor's gaze, doesn't exist. Rather than viewing this installation like a painting, at a distance, the viewer is pulled within various processes of seeing. In her confusion, the visitor produces her own configuration of images. The installation inserts hesitating subjects into an unstable setting, challenging them by amplifying the conditions of visibility. In this way, seeing is not seeing at a distance; it means to discover the mechanisms enabling one to see, to become aware of all the difficulties and obstacles to seeing, to be confused and irritated, to be present with body and senses, and to trouble the eyes to find the image.

To see in the installation is to perform the work of image production according to the specific visibility constraints *in situ*. These visual impossibilities are not simply declared in the catalog as symbolizing certain type of relationships, they are constructed with wood and walls, mirrors and small doors, thereby implicating the visitors in concrete interactions. The adults' inaccessibility to the house is substantiated by the small door: thus, they will never see the pigs, unless they decide to kneel and lower themselves to the height of the door in order to see the film; that is, unless they transform themselves into children. The children will never see the images of the adults projected in the mirror. The two images, of the pigs and of the adults, will never meet at the same time, they remain related by the installation setting only. By dividing and inhibiting, with walls, mirrors, and wooden doors, the installation suggests a dynamic game of vision, rather than a specific reflection on the meaning of the images produced, and the possibility of mutual existence of humans and animals, adults and children.

At every stage in perception of the installation, there is a whole palette of possibilities to see. The visitor is confronted with a double uncertainty simultaneously concerning what is to be seen and how to use the artistic setting to see it. In the process of seeing, she seeks herself, being the prototype of the image. The question is not what does she see, but how does she

1

_ This is a "remake" of *Haus für Schweine und Menschen*,
presented at *documenta X* (Kassel, 1997) by
Carsten Hoeller and Rosemarie Trockel.

manage to see something, by what kind of mediation. There is not a hidden truth, but concrete material conditions of the visibility, pragmatic efforts to reach it, and specific scenarios for the installation's use. Thus, images and prototypes, visible and invisible, are all connected in the contemporary art installation. While the adults see their images projected; the children, leaving the house after seeing the pigs' images, meet the adults gazing at themselves in the mirror while waiting; by doing so, the expected usage of the artistic setting is enacted.

However, the visitor is often stuck in the installation by her inability to decipher the artistic sign-posts. With incoherent, unclear guides, she begins to modify the main scenario, slightly disordering the image production pattern. The curious adult lets her body pass through the tribulations of seeing in a different way: when trying to enter the house, the small wooden door doesn't allow her body to cross the threshold, she catches a glimpse of the pigs, though the image is distorted from her perspective; gazing at herself in the mirror from time to time, she declines the creation of a simultaneous replica to the pigs' film image produced inside the children's house. She quits the hall without having seen the chain of images interacting between them, as required by the artistic project. The denial to pass through *all* the steps of production of continuous and interrelated images is by itself an iconoclastic move. If the denial is performed by ignorance, not by purpose, I would suggest considering it a form of "innocent vandalism" according to Latour's typology (the visitor acts as a D person).[2]

What holds the key to the installation is the specific scenario of image production, figuring only one way of seeing. Every visitor's usage however deforms this scenario and creates new, unpredictable difficulties. What the visitor distorts in the refusal to follow it is neither an image, nor an idol; it is *this* possibility to be involved in the production of a series of interacting images and to produce oneself as an image. If the iconoclastic attitude is performed here as a voluntary effort to rebel against the extraction of a single scenario of image production out of the flow of possibilities, it can be considered a protest against the "image scenario freeze-framing" (the visitor acts as a B person).[3] The visitor doesn't deliver herself to the installation, she slightly "disfigures" the artistic setting by the peculiar way she misuses it; thus, she resists the art installation efforts to whisk her away, far from the mirrors, the pigs, and wooden doors.

Carsten Höller and Rosemarie Trockel / Haus für Schweine und Kinder [House for pigs and children] / 1999 / Musée d'art moderne de la ville de Paris / concrete, wood, mirror, LCD projector, video / from: Carsten Höller, Rosemarie Trockel, Maisons/Häuser, exhib. cat. Musée d'art moderne de la ville de Paris, Oktagon, Cologne, 1999, p. 16 / © VG Bild-Kunst, Bonn 2002

Carsten Höller and Rosemarie Trockel / Haus für Schweine und Menschen [House for pigs and humans] / 1997 / documenta X, Kassel / concrete, wood, glass, pigs / © photo: Dieter Schwerdtle, Kassel / © VG Bild-Kunst, Bonn 2002

3 2

_ According to Latour, op. cit.

_ See the introductory essay of Bruno Latour in this catalog.

INVISIBLE MOVIES IN SUGIMOTO'S »THEATERS«

Hans Belting

THE JAPANESE ARTIST HIROSHI SUGIMOTO is today one of the most remarkable masters of photography in the world. Born 1948 in Tokyo, he soon moved to the United States and has lived in New York City since 1974. Already in 1981, he exhibited his series of *Movie Theaters* at the Sonnabend Gallery in New York. In this series, the exposure time coincides with the projection time of the entire length of a feature film. The movies disappear in the photographs. While their images leave no traces, the light which flickers from the light beam of the projection and fills the screen, illuminates the interiors. The cinemas were located all over the United States. This series was complemented in the 1990s by a series of "drive-in" cinemas which naturally showed night sceneries. Sugimoto entered the art scene when conceptual art was at its heyday. His photographic œuvre is therefore characterized by a truly conceptual approach. The two series with invisible movies were published in an ample selection to which I contributed the text *The Theater of Illusion*. The edition comprises sixty-four theaters and thirty-two drive-ins. The earliest theaters date from 1976, the latest in this edition from 1997.

Movie theaters are built as theaters of illusion. But in Sugimoto's equally disturbing and beautiful photographs, such interiors are reintroduced as metaphors. They remind us of our own vision which is confined to a permanent theater of illusion. Our attention is drawn to a screen which represents the archetypical image we welcome as the epiphanic window of the world. The window is bathed in a blinding light which seems to enter the dark room from the outside though, in fact, it is projected from within. But the screen is empty and thus qualifies as either the everything of all possible images or else their nothingness as vehicles of illusion. If we want to grasp what is happening in front of our eyes or in the backs of our minds, the everything which we are eager to see, similarly results in the nothing we can trust. Sugimoto's *Theater Series* therefore strangely resembles the living *camera obscura* which we are, ourselves.[1]

It seems that the photographs record empty rooms where nothing happens, and yet they are supposed to picture a movie during the entire length of its projection on the screen. The result however is not meant to work in a naive sense and in fact cannot work in any documentary or indexical way but, rather, produces an unexpected deception. The screen, where the pictures appear and disappear, in the end remains empty as it cannot keep the many pictures it attracts. Motion creates emptiness in the photograph. The site of the pictures which have been shown on its silvery surface, reflects nothing but a trace of the light they carried with them when crossing the dark interior. The light, as it were, represents an invisible film enshrined in a visible interior.

Even the visibility of the interior is not such that we could decipher it with the naked eye. It has a highly artificial visibility only available to the camera's eye and only to be recorded in the photograph. Sugimoto, in fact, uses the projector's light, which carries the film images, for the almost opposite effect of illuminating a dark room: it is the very room which we usually occupy with our bodies but which we tend to forget while traveling with our imagination to the sites we are shown in the movie. The white screen which is not visible as such to the audience during the film's showing, fills with the accumulated light living in the film story of one or two hours' length. The reflected light, from there, is further deflected to the surrounding room where it hits the relief of the wall decorations and bestows a ghostly, nightly shape on everything. The visible room emerges from the light of an invisible film. The light is not pure light but is abstracted from the glittering sequence of thousands of pictures which have chased each other into flight during the time span of a film story. The discontinuity existing between a film and the theater while the film is shown, in Sugimoto's subversive vision turns into a pseudo-continuity, as the film vanishes from our eyes and transforms the interior into a kind of imaginary or filmic site. It is hard to distinguish the real from the

1

_ John Yau, Hiroshi Sugimoto. No such thing as time, in *Artforum*, 22, 8, 1984, pp. 48ff.; J. C. Fleury, Hiroshi Sugimoto. Théatres du Vide, in: *Camera International*, 40, Summer 1995, pp. 70ff.; N. Bryson, Hiroshi Sugimoto. Metabolic Photography, in *Parkett*, 46, May 1996, pp. 120ff.; *Hiroshi Sugimoto. Theaters*, Sonnabend Sundell Editions, New York, 2000, pp. 8-13: Hans Belting, The theater of illusion, and Hiroshi Sugimoto, The virtual image; Hans Belting, *Bild-Anthropologie. Entwürfe für eine Bildwissenschaft*, Fink, Munich, 2000, pp. 78f.

Hiroshi Sugimoto / Goshen Ohio / 1980 /
photograph, black-and-white / 20.1 x 24" /
courtesy Sonnabend Gallery, New York /
© photo: courtesy Sonnabend Gallery,
New York

Hiroshi Sugimoto / Hall of Thirty Three
Bays / 1995 / photograph, black-and-white
/ 20.1 x 24" / courtesy Sonnabend Gallery,
New York / © photo: courtesy Sonnabend
Gallery, New York

unreal. In the photograph, we look into a black room where the attention is directed to a blinding white nothing. This iconoclastic use of the filmic light negates a great deal of experience. The light amount needed to evoke the shadows of such interiors varies between different movies. Hollywood comedies, Sugimoto told me, offer more light than poetic films of tragic content. Thus, the technical face of a film which we are unable to discover with our living organisms, is transformed to an unexpectedly poetical *mise-en-scène* in Sugimoto's photographs. Had Sugimoto just attempted a nice surprise, he would have only needed a single photograph. But, in fact, he does not tire of taking pictures in innumerable cinemas of the US which resemble each other in that, each time, the movie screen has become empty in the projection light whereas the interiors never resemble each other, no matter how much they may serve the same function.

The camera uses the same position as the projector, high above the heads of the audience, thus keeping a similar distance to the people's view in the cinema. Camera and projector have technical eyes which register the theater space in a way different than the people do. While competing for the same position in the cinema, the two nevertheless produce a totally different result which confirms the difference of the two respective media. All the same, the result has an abstract quality opposed to the movie experience or the cinema-theater experience of the audience. The work of the camera mirrors the procedure of the projector without paying attention to the illusion which the movie generates as its very essence. The difference in technical fiction and human imagination thereby reveals itself. The ritual of the medium whose blind eye waits to be filled with the gaze of the spectator, only becomes meaningful as a result of the anthropological use of the image.

We used to think that photography is about space, as film is about time. This distinction has been confirmed but also disproved by Sugimoto. The moving image disappears in the photographic image which easily wins out over the younger medium. The result is contrary to our expectations which depend on the linear idea of medial history and progress. Sugimoto offers us a further paradox while turning the well-known illusion inherent in the speed of a movie which deceives our slow eyes with virtual movement, into the opposite illusion of a stillness resulting from an abundance of motion pictures. The *sleeping time* in a physical space (the cinema interior) cancels the *linear time* in a filmic event. The *remembered time* of a photograph survives the *acting* (or running) *time* of a movie. We not only see the photographic memory of an interior but also the equally, but paradoxically pictured memory of a film whose existence on the screen we are forced to believe as we cannot actually see it. The diversity of the *Theaters* which we only grasp in the series and not in the single picture, adds weight to their physical and local existence while the anonymity of the empty screen emphasizes the ubiquity and instability of the film which, as a medium of temporality, is not part of our living space. The asymmetry familiar to us from the *permanent site* of a theater and the *impermanent event* of a theater performance, increases in our common movie experience when we see an outdoor world while sitting in an indoor space. This spatial inconsistency is in a strange way inverted when Sugimoto reveals the indoor experience with the light of movie pictures not born in this space. The space is bathed in the dim light which it receives in the movie sequence, that is, in time.

Sugimoto's *Theatres* however need more than just description. We realize that we are confronted with a kind of allegory which addresses philosophical issues of time and space. Their mutual dependence involves both the realm of illusion and the territory of mere conception set against our usual visual experience. Sugimoto practices visual philosophy when he uses the title *Time exposed* for the cycle of seascapes in an outdoor exhibition where they further changed under the impact of weather. But the same title could be given to the *Theatres*. *Time exposed* makes a double reference to *exposure* and *exposition*: exposure,

as a photographic technique, turns into the meaning of an exhibition of time (or of photographs, i.e., of art) but also may adopt the rhetorical meaning of the *exposition of an argument*. *Time exposed* at the same time closes time against any simple notion. It could be said that time is nothing but actual time which does not apply to any photograph in the world. But Gilles Deleuze has taken great care to tell us that, even in the case of cinema, *time image* and *motion image* are separate phenomena.

Time exposed in our case can only mean that time is encoded in the *Theaters* in many layers whose classification, in any neat sense, is bound to fail. We may ask ourselves whether time, the time unit of a film, has become invisible or whether it has adopted a transformation of its visibility. The *time event*, the movie, dissolves into a *time space* where many sediments of *time remembered* are buried in a simultaneous view. A photograph of the usual kind arrests time or cuts out a time fraction never to happen again. Sugimoto seems to have done something similar which secretly indicates a stern opposition to any photographer's confidence in grasping time. He carefully measures a time unit whose measuring principle however remains inaccessible to us. We have to believe that his exposure time coincides with the length of a given movie. The particular relation between the time of a movie and the time of memory, in a building in our case, remains obscure. What we see can last forever and in fact does so in Sugimoto's photographs which protect the timeless calm of what we see from every attempt to interrupt or to end it.

Hiroshi Sugimoto / Vermont Drive / 1993 / photograph, black-and-white / 20.1 x 24" / courtesy Sonnabend Gallery, New York / © photo: courtesy Sonnabend Gallery, New York

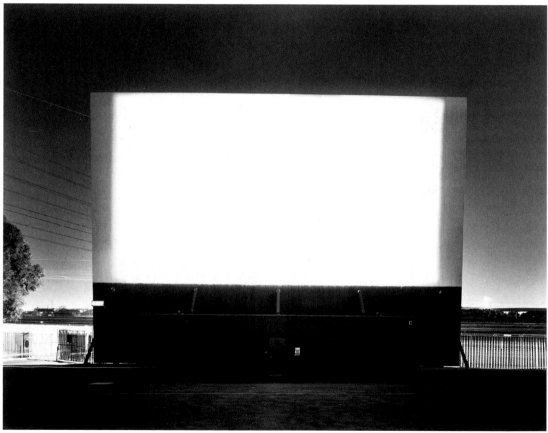

It is an almost arbitrary act that Sugimoto at one point handles the shutter in order to produce the photograph. He thus fixes the floating time in a paradoxical way forever. The photograph testifies, so to speak, against its own traditional evidence as a medium and introduces a startling new time experience. The utmost precision with which Sugimoto measures the time quantity taken from the film, is nothing but a solemn gesture. The ritual he applies guarantees a concept which escapes our visual control. The usual indexicality of photography has adopted a new meaning which as yet needs (or defies?) a proper theory.

The theaters' series, like the other sequences of photographs we know from Sugimoto, deconstructs the single image as a self-contained and self-sufficient unit and instead decodes its true meaning via the serial reference. This also applies to his Dioramas in which he takes stuffed animals from natural history museums as his subject, or his wax figure cabinets. There is always a strategy which irritates our gaze and thereby deprives the single picture of its safe evidence. We know that Sugimoto started his career when conceptual art was at its heyday. His photographs are neither faithful reproductions of the world nor mere examples of a personal style in constructing the picture. In spite of their professional excellence and artistic quality, they express an idea or concept.

In the series of *Theaters* the concept is elucidated by the quantity of the cinema spaces. The single spaces contradict or neutralize each other in front of the radiance of the screen light which easily, and literally, puts them into the shadows. The difference of absolute and relative comes to mind. The same applies to the relation between the ever-shining light and all the different movies whose pictures have vanished in this light. We experience the timeless theater of light in the midst of a temporal world with its ephemeral appearances. The movies which we have recognized as the most important modern pictorial medium beside the TV, withdraw from the absolute presence of the light as an essence of its own. When we follow Sugimoto into the cinema, we do not see anything there which justifies the usual visit to the cinema. |

DEMATERIALIZED. EMPTINESS AND CYCLIC TRANSFORMATION

Dörte Zbikowski

WHATEVER MAKES A WORK OF ART WHAT IT IS need not necessarily be visible; it takes place in the artist's and beholder's minds. In contemporary art manifold forms of the principle of visibility and invisibility have become decisive. The subject of this essay are tendencies towards the disappearing, immaterial work of art.

I

Destructive artistic campaigns have paved the way for the immaterial work of art. This begins in 1919 with Duchamp's *Ready made malheureuse* – instructions sent in a letter to his sister to hang a geometry book on the balcony so that the wind leafs through it, ultimately destroying it.[1] Also Jean Tinguely's *Machine that Destroys Itself* – a reply to Man Ray's *The Object to be Destroyed* (1923) and at the same time an evocation of the secret life of machines – falls into this category. In 1960 Tinguely constructed a machine capable of crumbling sculptures and a machine that destroyed itself before the public *(Hommage à New York)*. In 1961 he built *Étude pour une fin du monde*; also this machine destroyed itself in front of the visitors. And his project in the desert of Nevada in 1962 with several kilograms of dynamite likewise combined a magnificent spectacle with apocalyptic fancy.[2] Also Robert Rauschenberg, who in 1953 requested a drawing as gift from Willem de Kooning in order to erase it, thus turning it into a "Rauschenberg," belongs to this context *(Erased de Kooning Drawing)*. Traces of the drawing remain visible; the eradication is therefore incomplete. Another form of disappearance of a work of art is marked by Sol LeWitt's 1968 *Buried Cube Containing an Object of Importance but Little Value*. The cube, and with it the object, is removed from sight and subjected to gradual disintegration beneath the earth. Keith Arnatt answered in 1969 with his *TV project self-burial* and commented: "It was originally made as a comment upon the notion of the 'disappearance of the art object.' It seemed a logical corollary that the artist should also disappear." Among similar projects made by other artists is the *Vertical Earth Kilometer*, Walter de Maria's contribution to documenta 6, 1977 in Kassel.

Sol LeWitt / Buried Cube Containing an Object of Importance but Little Value / 1968 / documentation in nine photographs, black-and-white, mounted on paper / 12,5 x 10" / detail: photographs no. 3, 7, 9 / LeWitt Collection / © VG Bild-Kunst, Bonn 2002

2 1

_ Marcel Duchamp, *Ready made malheureuse*, geometry book, Paris, 1919.
In 1934 Duchamp proposed in his notices of the *Grüne Schachtel:*
"Reciprocal ready made: use a Rembrandt as ironing-board."

_ Cf. further the dé-coll/age principle of Wolf Vostell from the beginning of the 1960s or the wrecking of, e.g., a violin or a piano by Nam June Paik which were meant as a means to create new sound effects.

Keith Arnatt / TV project self-burial / 1969 / nine photographs / detail: photographs no. 3, 6, 9

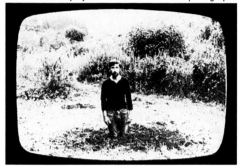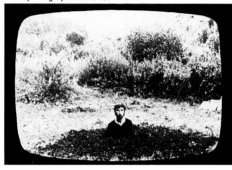

On the other hand, invisible sculptures were realized. Claes Oldenburg digged out a deep hole in Central Park, New York, and filled it up with the soil digged out (*Invisible Sculpture*, 1967). His concept was to sink an invisible sculpture and, at the same time, to metaphysically bury the traditional definition of sculpture. In 1985 Andy Warhol also created an *Invisible Sculpture* when he stood on a pedestal in the New York night club *Area*, and then moved away. Only the plate with the inscription "Andy Warhol. USA. Invisible Sculpture. Mixed Media. 1985" was left behind and together with the documentation photograph, was evidence of the occurrence. Warhol, in his very special manner, thus brought about the disappearance of the last existing criterion of art: the criterion of presence, "creation of the artist's missionary zeal, confirmed by his existence."[3]

II

Viewed superficially, these actions have a mischievous aspect. They are, however, expressions of fundamental considerations on the question of the essence of a work of art. On the one hand, the idea coined by the conceptual artists is reechoed here, a work of art need not be realized and hence made visible if it only exists as an idea. On the other hand, reflections come to life on the "Illusion of Beauty" – on beauty as a forum of projection, of wishful thinking. "One does not love beauty because it is real, but because it is an illusion," says Christoph Wolff. "In the world of illusion an otherwise unknown freedom appears, possibilities become visible that otherwise never become apparent."[4]

It is the verbal account, the tale of Warhol standing on the pedestal, or of Andreas Slominski, who immured a skeletonized hand, that inspires fantasy, launches chains of associations, and makes us wish that we had been present so that we can really believe it. Slominski did not document his work process, we only know the photo of the "empty" exhibition room. The object was not displayed *on*, but fixed *into* the wall, that is, behind the surface and beyond the visible. Nor was it a question of making a *work of art* disappear (as the skeletonized hand would then be the work of art), but of creating a *situation* that irritates, provokes, and misleads, thus making perception itself the theme. Traces on the wall indicate that the emptiness of the room is only an assumed emptiness.[5]

Yves Klein's April 1958 exhibition *Le Vide* in the Iris Clert Gallery in Paris comes to mind. In the white, freshly painted room of the gallery were the empty showcase – which was an immovable inventory of the gallery – and the invisible pictures,

3

5

4

_ Christoph Wolff, Mimesis und der Schein des Schönen, in *Der Schein des Schönen*, Dietmar Kemper and Christoph Wolff (eds), Göttingen, 1989, p. 520.

_ Oskar Bätschmann, *Ausstellungskünstler. Kult und Karriere im modernen Kunstsystem*, DuMont, Cologne, 1997, p. 215.

_ Andreas Slominski, *Installation*, 1991, exhib. Kabinett für aktuelle Kunst, Bremerhaven 1991. Cf. the completely different approach of Timm Ulrichs in his work *Verborgene Ausstellung (II)* [Hidden exhibition (II)], 1996/1997, in which five picture frames, implanted in a wall and covered with plaster, are made visible on a screen in the infrared thermal pictures of a thermographic camera.

Yves Klein / Le Vide / 1958 / empty room, painted monochrom white /
Galerie Iris Clert, Paris, 28 April – 12 May 1958 / © VG Bild-Kunst, Bonn 2002

created by the artist through mental strength. The visitors were to perceive these as artistic sensibility and feel the "real blue" in the room, as Klein proclaimed.[6] "For me, there exists a sensitive painterly and colorful matter that is intangible. ... To reach Delacroix's *indéfinissable*, to reach the essence of painting, I have arrived at the *spécialisation* of the room. That is my latest way of handling color. One should no longer see the color but instead *perceive* it. ... My paintings are now invisible and that is how ... I want to show them, in a light and positive manner."[7]

The immaterial energies were to be experienced even stronger in the empty room Klein made in his Krefeld exhibition in 1961. The staging of the emptiness took place in a passageway; in a space which is itself a site of permanent renewal. The effect of light in the room painted in white not only on walls and ceiling but also on the floor seemed to make energy visible. The purity of the empty room stood for the aura of the exhibition room, which as a modern cult room made possible the mystic transformation of things into works of art. Klein later sold shares to a zone of immaterial, artistic sensibility and designed an air sculpture. The absence of tangible exhibits laid bare the myth of the work of art – but also the role of the beholder.

III

All this is related to the gradual spiritualization of the material of a work of art. Since the beginning of the twentieth century, pictures have been burned, cut into pieces, deformed, soiled and physically mishandled. A thought, no doubt first expressed by Wassily Kandinsky, forms the theoretical basis: all things material possess a spiritual, psychic, and characteristic dimension that, however, only becomes apparent when its material is destroyed, or at least the familiar, intact form is eradicated. Kandinsky aimed at the "spiritual in art."[8] The overthrow of material causes that hidden, unconscious, spiritual force to ap-

7 6 8

_ Yves Klein, in *ZERO VOL I*, Otto Piene and Heinz Mack (eds), published on 24 April 1958 on the occasion of the seventh evening exhibition of *Das Rote Bild*.

_ Wassily Kandinsky, *On the Spiritual in Art* [1911], Hilla Rebay (ed.), Solomon R. Guggenheim Foundation, New York, 1946.

_ *Yves Klein*, exhib. cat. Museum Ludwig, Cologne, 1994, pp. 131-157; Yves Klein, *Le dépassement de la problématique de l'art*, La Louvaine, 1959, pp. 4-13. In this connection the antiquation of art was also criticized.

pear which is also at work beyond the conscious will of the artist. Therefore Robert Rauschenberg's *Erased de Kooning Drawing* can be understood as an attack against the idea that individual inspiration lives in the traces of artistic handwriting. Freed from material restraint, the thus transformed became the carrier of a spiritual subconscious; the work of art was given a spiritual dimension. This led to a preoccupation with dematerialization.

The philosopher Gaston Bachelard also influenced the developments with his book *The Poetics of Space*, published in 1957, describing a phenomenology of imagination that in the most extreme case no longer counted on an artwork's connectedness to material conditions but rather "that artworks are *byproducts* of the existentialism of imaginary being."[9]

Yves Klein who referred to Bachelard exhibited metaphysical emptiness: the gallery room remained empty. His smoke, fire, and water sculptures are also evidence of that preoccupation with forms of dematerialization. His occupation with fire is based on the conviction "that on the inside of emptiness, like in the heart of humankind, there is a burning fire."[10]

Fire is among the carriers of spiritual forces and also – resulting from it – ash and smoke. Fire is the only one of the four elements that can be produced by humans with natural means, and which nevertheless has a superhuman, unpredictable character.[11] It is ambivalent. On the one hand it is a pleasant perception, providing light and warmth; on the other hand its destructive forces are feared. It simultaneously is creative of culture and destructive. The glow of its flame counts as symbol of life; as fire in the hearth it guarantees life for the family. Fire is accredited with the ability to fight off all evil; smoke increases this effect. Fire has purifying forces and thus became the preferred means of expiation. Sacrificial offerings are rid of all impurities through burning. Fire has the power of transformation; its destructive force is often interpreted as a means for rebirth at a higher level.

Yves Klein / Le Vide / 1961 /
Museum Haus Lange. Krefeld / empty room, painted monochrom white, source of light on ceiling: double neon tube / 173 x 63 x 114" /
© VG Bild-Kunst. Bonn 2002

9 11 10

_ Cf. the myth of Prometheus which explaines the independence of humans from the gods.

_ Yves Klein, Lecture at the *Hotel Chelsea*, New York, April 1961, reprinted from *Yves Klein*, exhib. cat. Kunstverein Hannover, 1971, p. 36.

_ Gaston Bachelard, *The Poetics of Space*, Orion Press, New York, 1964 (first published in French: *La poétique de l'espace,* Presses universitaires de France, Paris, 1957).

Andreas Slominski / heizen [heating] / 1996/1997 / installation and activity / Hamburger Kunsthalle / installation view Hamburg 1997 /
© Andreas Slominski / © photo: Arno Declair, Hamburg

Removing the windmill vanes / part of the preparations for
Andreas Slominski's installation heizen [heating] / 1996

Andreas Slominski / heizen [heating] / 1996/1997 /
sawing dust into the shoe / installation view Hamburg 1997 /
© Andreas Slominski / © photo: Arno Declair, Hamburg

Whilst fire is an active force, smoke and ash are two poles of passive products. Smoke "apparently gets lost, and better still, leaves behind no visible remains, but it lifts itself up, rises into the air, becomes subtle and sublime. Ash – falls, weary, limp, more material."[12] This materiality makes ash an expression for things past whose traces it preserves and at the same time loses, a memory that will never reveal its knowledge. Ash is a breath of memory and of new beginning. It is a symbol that burning and destruction aid progress; the destructive and the fructifying balance each other. Fire "elucidates" through destruction. In his *Psychoanalysis of Fire*, Bachelard writes: "Fire is both intimate and universal. It lives in our hearts. It lives in heaven. It rises from the depths of substance and presents itself like the god, Amor. It descends again into the matter and hides, continuing to glow secretly, like hate and revenge. Of all phenomena, fire is indeed the only one to which can be attributed both conflicting valuations: good and evil."[13]

IV

The ritual of burning is also a symbol for the eternal cycle of coming into being and passing away in Slominski's project *heizen* (heating, 1996/1997). The artist arranged discarded and weathered windmill wings in the room, cut them up laboriously by hand with saw and axe and burned the pieces of wood in a small, old-fashioned stove, which was the center of the installation. The central theme here is not the destruction but the process of transformation that brings revival. The windmill wood burns to ashes, yet ashes for Slominski are not a waste product but a only temporary final product. Slominski collected them and re-used them in a new work of art. Ashes therefore mark not only metaphysically a border state between end and beginning; or in other words, it is a "material capable of memory."[14]

The burning of cultural heritage was a process of formation in Slominski's work already in 1993. In the work titled *Wiener Schwarz* (Viennese Black) he burned bones of Lipizzaner stallions, the noble dressage horses of pure white color which have been kept, raised, and trained since 1735 in unchanged tradition at the Spanish Hofreitschule in Vienna. After their deaths, these pure, thoroughbred, temperamental and precious horses are given a special kind of ritual. Slominski violates the myth and ritual of court ceremony. Burning in this case was born by the wish to produce a black color pigment of especial intensity – bone black – out of a representation of purity.

May one nevertheless draw a connection between the death (of a horse), which first made this work possible, and the idea of the color black as an opening to the kingdom of death? Does this color pigment then contain something of death? Bone black expresses totality, for it is the blackest of all blacks. The bones of the whitest horses produce the blackest of blacks: two contrary poles meet. Does death and burning bring about real purity? And would this then not be a confirmation of the ancient concept of the purification through fire? Is finitude transformed by death?

Time is ritualized in burning. Beginning and end meet. The material and its changeability in time are tangible in the material substance and also in the function. In the transitory zone from one state to another, fire is an intermediate world. It cannot be rationally grasped. Hence, fire is the ideal place for fear and hope, but also for such incompatibility as death and promise, demonic and divine sublime. Fire connects past and future, which makes it particularly difficult to explore its essence.

12 13 14

_ Jacques Derrida, *Feuer und Asche*, Brinkmann & Bose, Berlin, 1988, p. 57 (first published in French: *Feu la cendre*, Des Femmes, Paris, 1987; English edition: *Cinders*, Ned Lukacher (trans., ed.), University of Nebraska Press, Lincoln, 1991).

_ Aleida Assmann, *Erinnerungsräume. Formen und Wandlungen des kulturellen Gedächtnisses*, Munich, 1999, p. 210.

_ Gaston Bachelard, *Psychoanalyse des Feuers*, Stuttgart, 1959, p. 19 (first published in French: *La psychanalyse du feu*, Gallimard, Paris, 1938; English edition: trans. by Alan C.M. Ross, Beacon Press, Boston, MA, 1971).

V

Fire and burning are often expressed in a variety of ways in modern art by the color black. Kasimir Malevich said of his *Black Square* that it manifested the living origin of the world, as it symbolized the product of the burning of all other pictures.[15] Similarly Yves Klein states: "My pictures are the ashes of my art."[16] And Timm Ulrichs created art-urns in 1969-1970: *Asche verbrannter Kunstwerke* (Ashes of burned art works). The artists' relationship to fire, their relationship to the act of burning and their treatment of the charred material is multifarious. Ash, soot, and smoke were also used.[17]

In Joseph Beuys' *Loch* (Hole), a stove pipe hole, which no longer has a stove-pipe, and with soot as the only sign of the hole's former purpose of conveying smoke, the principles of fire and emptiness are connected. The soot as black pigment strengthens the idea that it is completely dark inside the pipe. To Beuys, the interior is an analogy of the protection of darkness that gives strength and supports processes, hence, activity. "Could one say," Antje von Graevenitz summarizes in conversation with Beuys, that Beuys "would like to see macrocosmic facts represented in the little things of everyday life, in the microcosm – as, for example, the inner space and process in the tunnel of the stove pipe? 'Yes,' he replies, 'it is in keeping with the existence of the real forces that one would like to release inside. In a way it is connected with the attempt to deal with what is real as conscientiously as possible. I see myself as an artist in the wider definition of art, as a pioneer, as an enlightener of true connections in the world. The artist does not need to invent, but to discover connections.'"[18]

Beuys not only points out the opening of the stove pipe, but also the jet-black, burned door (doors and openings have been symbols of transition and new beginning since ancient times) of his studio, burned out in 1957.[19] The reference to the reviving power of fire is also relevant here; fire is positively understood as a scene of passage. In Slominski's *heizen* this understanding can be found once again. Slominski, however, transfers the concept of beginning and end into a cycle. |

Translated from German by June Klinger

Joseph Beuys / Loch [Hole] / 1960 / stove pipe hole / private collection / from: Schwarz, Hanna Weitemeier (ed.), exhib. cat. Städtische Kunsthalle Düsseldorf 1981, p. 134 / © VG Bild-Kunst, Bonn 2002

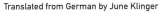

16 18 17 19 15

_ Yves Klein, *Mon Livre*, Paris 1958; quote from: *Bildlicht. Malerei zwischen Material und Immaterialität*, exhib. cat. Wiener Festwochen, Vienna, 1991, p. 246.

_ Antje von Graevenitz, Beuys' Gedankengang zu einem Ofenloch, in *Schwarz*, op. cit., p. 137.

_ Joseph Beuys, *Tür*, 1954-56, burned door, Museum Moderner Kunst, Vienna.

_ In December 1915 Malevich exhibited the picture whose only motif is a black square and described it as "a naked icon of my time." After successively pursuing all stages of geometric illustration, he found in the black square the "null form," that is, the pure form that unites all possibilities. It is a kind of absoluteness "totally independent of all beau ideal, experiences or moods" (Malevich).

_ Cf. e.g. Reiner Ruthenbeck (ash), Jannis Kounellis (soot), Joseph Beuys (smoke). Cf. above all: *Schwarz*, exhib. cat. Städtische Kunsthalle Düsseldorf, 1981; *Brandspuren. Das Element Feuer in der neueren Skulptur*, exhib. cat. Folkwang Museum, Essen, 1991; *Das brennende Bild. Eine Kunstgeschichte des Feuers in der neueren Zeit*, *Kunstforum international*, vol. 98, Cologne, 1987.

Can the gods cohabitate?

THE RELIGION OF GOLDEN IDOLS

Heather Stoddard

> »*Things derive their being and nature by mutual dependence and are nothing in themselves.*« NAGARJUNA, SECOND CENTURY BUDDHIST PHILOSOPHER

> »*An elementary particle is not an independently existing, unanalyzable entity. It is, in essence, a set of relationships that reach outward to other things.*« HENRY P. STAPP, TWENTIETH CENTURY PHYSICIST

THE ROLE AND FUNCTION OF THE IMAGE as mediator within the religious context of Buddhism lies in the background of the cross currents of belief and superstition, destruction and re-construction, consecration, desecration and re-consecration of Buddhist images. The naive belief attributed to Buddhist practitioners by image-breakers; and the mistaken views of the "nihilist materialist" who fails to comprehend the meanings and utilisations of images by practitioners, all center around the image itself as a two or three dimensional construct.

Buddhism has often been described not as a religion, but as a philosophy, a rational path for spiritual evolution. Although that view is an over simplification right from the start, the Buddha Shakyamuni did invite the critical gesture, from inside and outside, declaring that his teachings were based on a new analysis of the nature of existence. He went against the caste system of the Brahman religions of India, declaring that all living beings share the same potential for Enlightenment; that all phenomena are interdependent, impermanent, and without inherent self-nature; that there is no such thing as a creator god, nor an individual soul; that his own teachings should not be taken on faith, but adopted only after a rational analysis of the tenets proposed. Going against the rigid hierarchical structures of the day, he created the Sangha – a democratic, freely associating community outside of the state, and outside of society itself, since its members had by definition "left the world," did not work and kept strict celibacy. Yet it was part of human society in that it was, by necessity and by virtue, dependent on the support given by princes, wealthy patrons, and ordinary people.

At first, it is thought that Buddhism was "aniconic," that is, the teacher himself was not shown in imagery, only his empty, blazing throne, or his footprints in the stone. Then, around the first or second centuries, standing or seated figures appeared. These small, portable, golden "idols" were carried throughout Asia by traveling monks. Their function was that of a "support" for practice, a "reminder" of the teacher and his teachings. For outside observers it was often this "idol" that designated the new religion. Before the monks learned the new languages of the lands they visited, before the texts were translated, before communities were firmly established, the statue of the Buddha could be seen and interpreted by all. The image itself "spoke." It relayed a message of a new kind of human destiny, available to all regardless of faith, race, caste, social status, language, occupation, intelligence, and education. All living beings could become "enlightened." Then, in the early centuries of the Common Era, the pantheon began to expand to take in new developments in the doctrine; the Great Vehicle Mahayana, based on the teachings of the Perfection of Wisdom, and the Middle Path of Nagarjuna evolved together with the more magical Diamond Vehicle – Vajrayana, Mantrayana, or Tantrayana – as it is diversely known.

This Diamond Vehicle, more than any other, uses the image, both material and imaginary, as a skillful means, a rapid and dangerous route to Enlightenment. Distinct as

Destruction by the Red Army during the Cultural Revolution in Tibet

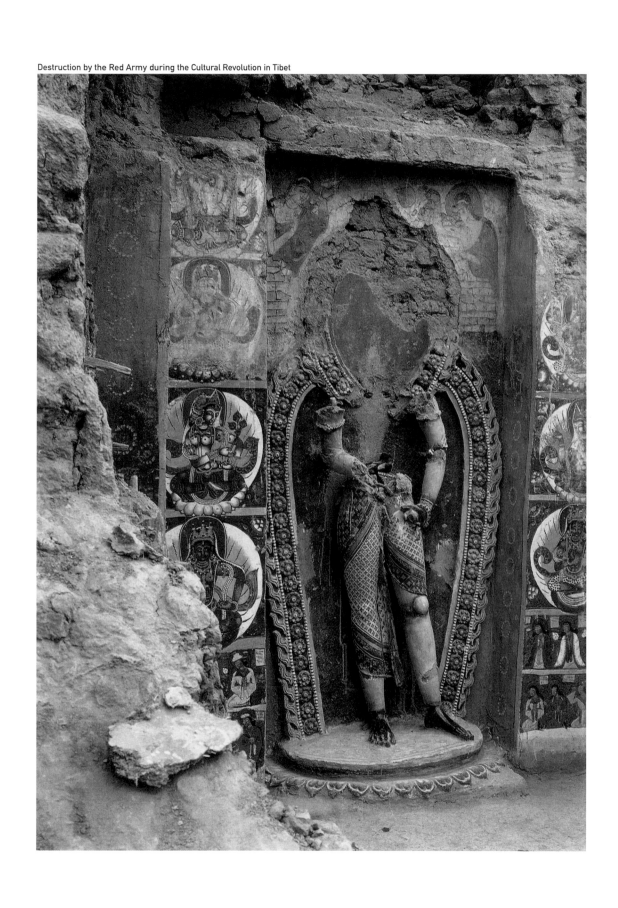

Buddhism is in its tenets, in its adoption and use of a vast open-ended pantheon, it belongs to the mainstream religious cults of India, which are no doubt the most iconophilic religions created by man.[1]

Whereas Islam – Buddhism's main historical enemy – starts out from the ultimately (in Buddhist terms) true premise that the divine essence, or Ultimate Reality cannot be represented or mediated in any way, Mahayanists or Vajrayanists take an opposite view, exploiting the "spiritual technology" of imagery to the maximum. While maintaining awareness that the image is impermanent, whether a physical or mental creation, and without any substantial reality, it is used in the concentrated and complex practice of "image projection." Visualization techniques are seen as "skillful means" to tame and redirect the restless "ordinary mind," to clear the way for a return to the state of "Primordial Mind," beyond all conceptualization, along the "ultra-rapid path" to Enlightenment. Thus, incredibly detailed mental image projections are used as tools – to get *beyond* the image. Filling up the space normally taken up by the agitated stream of cognitive thought, deities and so on are projected in "cascading series of images," with specific aims and predictable results. This system uses the vibration of sound (mantra), transforming it into colored rainbow light, which takes on transparent form as a projection of a perfect, divine-human image. The deities are not thought to exist outside, but are held to be mind-creations, personifications or visual expressions of stages of development of the human psyche, of the practitioner on the path. They "support" his or her practical transmutation of the ordinary being into the inner, secret, mystical or "Adamantine Body-Speech-Mind."

Body-Speech-Mind: Image-Book-Stupa

Over the last five millennia, as India developed sophisticated analyses of the human being and the phenomenal universe, the correlation between parallel macrocosmic-microcosmic structures was projected as the human body and the body of the universe were considered to be based on the same construct. Furthermore, since man is held to have a triple nature or dimension, being made up of body, speech, and mind, the state of Buddhahood is also conceived of as threefold, as "Enlightened Body, Speech, and Mind." Each of these conceptual aspects has its own visual or material "support" as an aid and reminder for disciples who tread the path, and as a demonstration of the goal.

The *Body* of the Buddha is represented in sculpture and painting, using exact "iconometric" measurements to show ideal, perfect beauty. Not only the historic Shakyamuni, but a vast pantheon of divine beings, disciples, past and present masters, and holders of the unbroken lineage form part of the *Body* aspect.

The *Speech* of the Buddha is his *Word*, or his teachings, represented through books – often richly illustrated – and the teachings of "qualified" masters who followed on and who teach in unbroken lineage to the present day.

The *Mind* of the Buddha is represented by caitya, stupa, or chortens, originally built to hold bone relics of the historic Buddha. They are one of the immediately recognizable signs scattered throughout the Buddhist landscape, pointing to the presence of the Sangha. They are used to "pin down" and "subjugate" the local indigenous "deities" at appropriate stress points on the earth.[2]

Although the tenets of Buddhism are based on a rational, analytic approach to phenomena, in actual practice, an image or painting is often "believed"[3] – in the same way as the Judeo-Christian *archeiropoiete* – to have been "spontaneously produced" *(rangjön)*, to take on "supernatural" qualities. It may speak, teach, cry, or move. Such a "support" is not an "idol" or "fetish" or a "living entity" – as the anti-Buddhist idol-crushers might believe that the followers naively believe it to be – in the same way as in Byzantian and Protestant iconoclasm. It is, rather, that through the ritual of "consecration"

1

_ See Diana Eck, *Banaras. City of Light*, Princeton, Knopf, New York, 1982, on the vast mandala of Shiva in India; Herbert Guenther, *The Tantric View of Life*, Shambhala, Berkeley, 1972.

2 3

_ "Belief" or "confidence" in the "Great Vehicle" of Buddhism is divided into four different types, "naïve," "pure," "longing," and "knowing" or "irreversible."

_ See Martin Brauen, *Das Mandala. Der Heilige Kreis im tantrischen Buddhismus*, DuMont, Cologne, 1992; Adrian Snodgrass, *The Symbolism of the Stupa*, Studies in Southeast Asia, Cornell University, Ithaca, NY, 1985.

Buddha body in Stupa / Correlation between Kalachkra universe and the human body.
The human head and the sky region of the Kalachakra universe are congruent

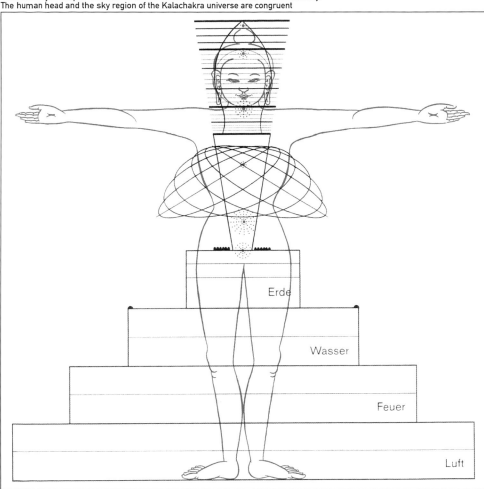

Erde

Wasser

Feuer

Luft

Buddha body in Stupa / Structural analogy between the human body and the Kalachakra-Mandala-Palace

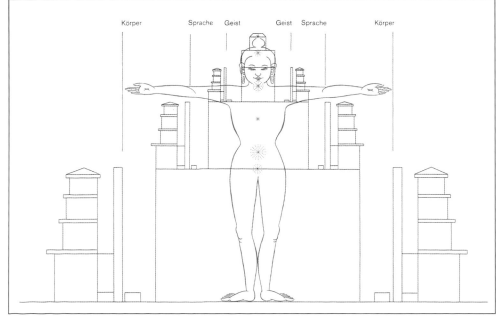

Körper Sprache Geist Geist Sprache Körper

(rab-gnas), the image is thought to become an "appropriate" or "excellent place" *(rab. gnas)* for the channeling of (divine) energy. Or it might be a good portrait of the lama, and thus be a perfect "reminder" of the teacher for his disciples. In the case of a large image, it will also contain, inside the head, throat, and heart, energy centers, precious substances, old images, and texts, and thus represent a significantly more dense historical and sacred mass of base matter than a newly made, unconsecrated clay statue.

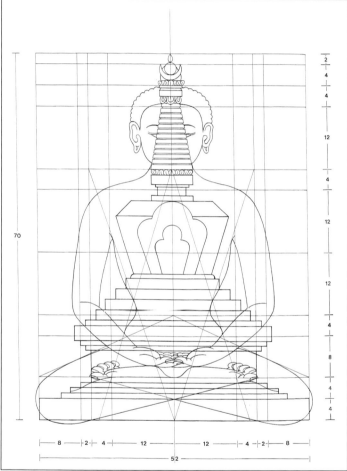

The theoretical relationship between the Buddha image and the Stupa

Thus, when ritual offerings are made and devotion is shown to images, it is within the context of "re-minding" the disciples of the master and his teachings, of giving them "support" in their practice, of inspiring them to go beyond the narrow contingencies of the ordinary human state. At the same time, *rangjön* images do abound, and are held – depending on the beholder – in different degrees of skepticism or awe. The skeptical Buddhist philosopher or historian may look upon the naive faith of the ordinary people with the same degree of irony or indulgence as any rational Western scientist, who himself or herself – may also stand on ambivalent ground, still holding some vestige of belonging to a Judeo-Christian mystical tradition. Even after renouncing all religious practice or adherence, awareness of the irrational, emotional side of human nature may well be present – even in the case of a Nobel Prize scientist.[4]

Elements Contributing to the Richness and Proliferation of Buddhist Imagery

In the making of a Buddhist image, be it a painting or sculpture, diverse elements are taken into consideration: iconographic identity and function, donor and funding, artist and materials; place of fabrication, consecration ritual and ultimate destination. Made from whatever substance, be it painted on cloth, built of clay, carved in wood, smelted in copper or gold, it must be made according to correct iconometric proportions. Through the act of creation, finitude, and consecration, the image takes on a meaning and a "living presence" that goes far beyond the mere sum of its parts.

Certain elements inherent to Buddhism have made it a cause or nexus of "iconoclash-tic" encounters:

– The skin of the Enlightened Sage of the Shakyas is said to have had a golden hue. Thus images of the teacher were gilded, causing outsiders to refer to Buddhism as the "Religion of Golden Idols."

4

Richard R. Ernst, Nobel Prize for Chemistry, 1991, Laboratorium für Physikalische Chemie, ETH Hönggerberg, Zurich, Arts and Sciences. A Personal Perspective of Tibetan Painting, in *Art and Chemical Sciences*, CHIMIA, 2001, 55, No. 11, pp. 900-914.

Mahāmantrānusāriṇī / c. 1400 / height 11" / Tibet /
Museum Rietberg, Zurich / © photo: Museum Rietberg, Zurich

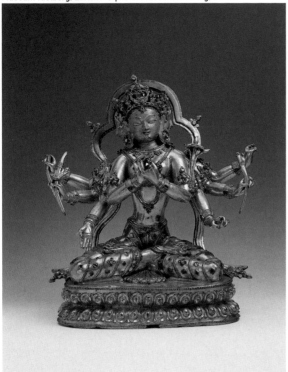

Tathāgata Akṣobhya / 14th century / height 11" / Tibet /
Museum Rietberg, Zurich / © photo: Museum Rietberg, Zurich

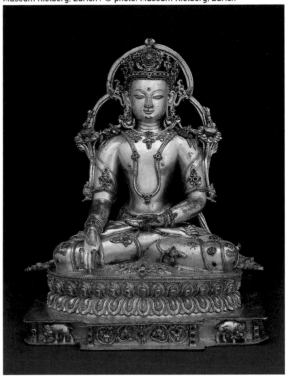

Tathāgata Amoghasiddhi / 14th century / height 12.4" / Tibet /
Museum Rietberg, Zurich / © photo: Museum Rietberg, Zurich

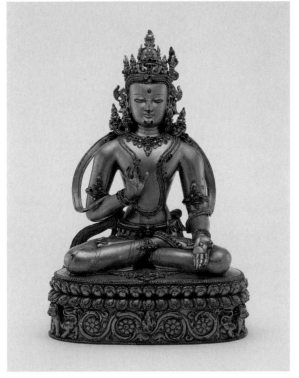

Ḍākinī Vāsya-Vajravārāhī / 15th century / height 13.8" / Tibet / Museum
Rietberg, Zurich / © photo: Rainer Wolfsberger, Museum Rietberg, Zurich

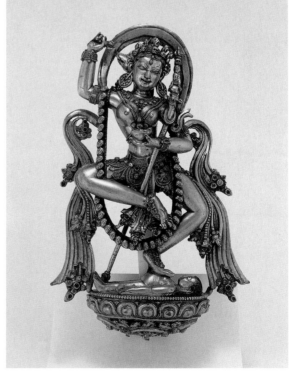

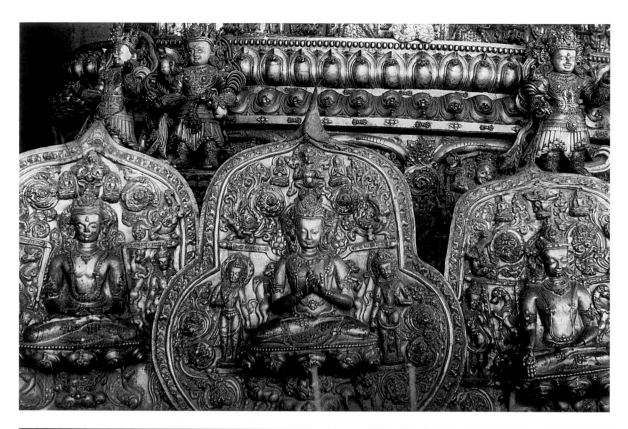

The gDan-sa-mthil monastery (Densathil), Tibet /
photographs, black-and-white / views of the Stupa before
the destruction / courtesy Völkerkundemuseum der
Universiät Zürich, Zurich, Dr. Martin Brauen /
© photos: Pietro Francesco Mele, 1948

The gDan-sa-mthil monastery (Densathil) was erected
around the miserable mud and branch hut of the saint
Phag-mo-gru-pa (1118-1170) during the second half of the
12th century. It is considered as the first grent monastery
of the bKa'-brgyud-pa school. It was prosperous thanks to the
liberality of the rLangs family.
The monastery of gDan-sa-mthil is famous all over Tibet for
its relics and ornaments as well as the fabulous artistic
treasures which have been accumulated along the centuries,
especially the big stupas sheltering the mortal remains of
the Lha-btsuns (King-gods).
Very few foreigners were allowed to visit this holy place.
What we know of it comes from the descriptions made by
S.C. Das and G. Tucci, together with the pictures taken by
Pietro Francesco Mele during the Tucci expedition in 1948.
The amount of data supplied by these travelers and the
Tibetan litterature allow us to know that there were eighteen
big stupas. They were made of refined and precious
materials and the considerable number of niches of their
outside walls were decorated with a vast variety of gods and
deities which statues were made of gilt bronze inlaid with
semi-precious stones.
The monastery of gDan-sa-mthil, an artistic, historical and
spiritual landmark was totally destroyed during the Cultural
Revolution (1966-1978).
Since then, many fragments and pieces from the big stupas
have been appeared on the international market. They are
now scattered in public and private collections all over the
world. The exceptional quality of these works made
especially for the Lha-btsuns by the very best artists from
Nepal who most certainly had worked at the court of the last
Yuan Emperors, and the first Mings, has more than once
brought a problem of classification. In fact, they are the peak
of Tibetan art, but have often been classified as nepalese or
chinese.

Damaged figures

- The pantheon is vast and open-ended, leading, especially in Tantrayana, to the creation of a bewildering variety of multi-headed, multi-armed, multi-colored deities, both peaceful and wrathful, single or in sexual embrace. Such "monstrous, perverted imagery"[5] has been the cause of considerable misunderstanding on the part of almost every ideology that confronted the psychic and economic power of the Vajrayana Buddhist church, be it Confucian, Muslim, Christian, or Communist.
- The four major activities of a Buddhist master are based on: the triple concept of the human being as a *Body-Speech-Mind* entity, to which is added a fourth aspect, ie., "Activity" in the world, such as the construction of monasteries, temples, and stupa, the making of statues and paintings, and the creation of sacred books. Thus every generation of masters produces a broad flow of new imagery.
- The lay community gains merit by making offerings to the Sangha, providing for their sustenance, and hugely enriching the "church." Thus over the centuries, huge wealth accumulated. It was considered especially meritorious, for example, to create statues and paintings at the time of death of family, and to offer them to the Sangha, thus adding further to the embellishment of the temples and to the immense accumulation of specially designated riches.
- The complex, detailed visualization of the Buddha, deities, protectors, and lineage masters is a fundamental practice.[6] For this, physical, man-made statues and paintings are considered to be a great help in the early stages of meditation. They are made as necessary "supports" for each generation of practitioners, who thus contribute largely to the creation of images for private practice.

»Inner Iconoclash«
De-Stucturalization of Phenomena and of Self.
»Cutting the Ego«: Offering the Body as an Act of Generosity

Buddhism has much in common with the other great Indian philosophical and religious traditions, Brahmanism, Jainism, and Shaivaism, in that the paths they set out are dual, based on:
1. A rational analysis and study of the phenomenal universe and of the human condition.
2. Meditation practice and yoga.

The Buddha Shakyamuni said: "Examine my Word as you would gold. Cut it, saw it, file it, melt it down. Do not take it on faith." And yet he took the metaphor of gold. This analytical basis is common to Indian religions, but the special "view" of Buddhism is that of the Middle Way.[7] This position refutes all extremes, and indeed all philosophical views: it takes the view that all views are fundamentally erroneous, since by taking a standpoint they are inevitably one-sided. In the same way all phenomena, physical and mental, are held to be composite, impermanent, and of interdependent origins.

This analysis is used as a basis for another fundamental concept that distinguishes Buddhism from all other Indian religions: that of absence of ego, or "no-self." This is difficult to grasp for everyone, since we are all apparently distinct, separate entities with a strong sense of ego. Thus meditation exercises are devoted to the search and eradication of the conscience of self through analysis of the nature of existence. An intimately related practice, that of the *Six Perfections*, begins with the "Perfection of Giving" or "Generosity." Here, the act of generosity is taken to its ultimate degree, with the giving of oneself, one's body, one's family, one's possessions, and even one's life in order to attain Enlightenment. The concept of the composite, relative, interdependent nature of

5

_ Heather Stoddard, The Development in Perceptions of Tibetan Art. From Golden Idols to Ultimate Reality, in *Imagining Tibet, Perceptions, Projections and Fantasies*, Thierry Dodin and Heinz Räther (eds), Wisdom Publications, Boston, 2001, pp. 223-253.

6

_ Luis O. Gomez, Two Tantric Meditations: Visualising the Deity, in *Buddhism in Practice*, Donald S. Lopez Jr. (ed.), Princeton Readings in Religions, Princeton University Press, Princeton, 1995, pp. 318-327.

7

_ For a short recent discussion of the *Perfection of Wisdom* in relation to Tantra, according to Nagarjuna, the major philosopher of the *Middle Way*, see D. Lopez, A Tantric Meditation on Emptiness, in *Tantra in Practice*, David G. White (ed.), Princeton Readings in Religions, Princeton University Press, Princeton, 2000, pp. 524.

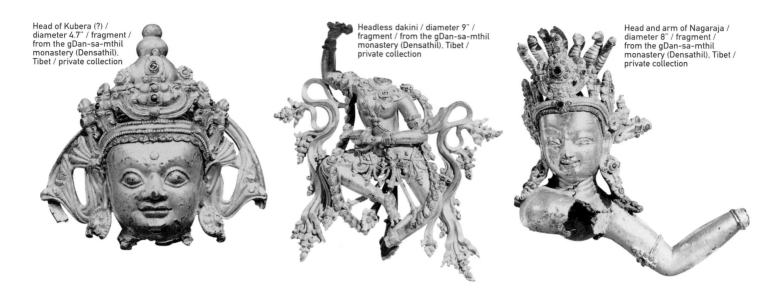

Head of Kubera (?) / diameter 4.7" / fragment / from the gDan-sa-mthil monastery (Densathil), Tibet / private collection

Headless dakini / diameter 9" / fragment / from the gDan-sa-mthil monastery (Densathil), Tibet / private collection

Head and arm of Nagaraja / diameter 8" / fragment / from the gDan-sa-mthil monastery (Densathil), Tibet / private collection

the human entity (and of all phenomena), taken with the act of generosity, also gives rise to practices ranging from the giving of one's wealth to the Sangha to gain merit, to the giving of one's body to a hungry tigress, and the offering of one's body in a radical symbolic ritual act of "cutting off the ego." The giving of one's entire being to the negative forces in the universe in order to overcome all fear and attachment to self.[8]

This interconnected set of concepts and practices is manifested in many ways throughout the different Buddhist traditions, in relation to the integrity of the body, which is related to the image of Buddhahood. If a Buddha statue – the image of Enlightenment – is only valid in that it is perfect in every detail, then how is it that Huike (487-593), the future Seventh Patriarch of the Chan school of Bodhidharma, cut off his own arm with a sword to demonstrate to Huineng, the Sixth Patriarch, the intensity of his desire to obtain the teachings? The question is relevant since that act took place in Confucian China, where the maintaining of the integrity of one's own body, as given by one's parents, was considered a fundamental act of filial piety. It would seem more likely

that the compounding of the non-violent attitude of the Buddhist – the perfect ideal of one's own Enlightened body – with the background concept of the body in Confucian China, would deter any aspiring monk from cutting off his own arm![9]

The Breaking of Habitual Mental Images, Concepts and Religious Taboos

Moreover, like other religions, Buddhism holds within its structures and teachings the seeds of conflict within the community, due to the flagrant contradiction between the essential "poverty" of the Sangha, who according to their strict laws of discipline, leave their homes and all ties and material possessions, to walk on the path to Enlightenment. By definition the Sangha depends on the lay community for support and vital sustenance. The lay community earns merit (which in turn will allow others to tread the same path), by giving to and supporting the Sangha. Thus the Sangha, in spite of owning nothing in theory, becomes endowed with all kinds

8 9

_ See Jérôme Edou, *Machig Labdrön and the Foundations of Chöd*, Snow Lion, Ithaca, NY, 1996.

_ Jan Fontein and Money L. Hickman, *Zen Painting and Calligraphy*, Museum of Fine Arts, Boston, 1970, 3, fig. 1; G. Orofino, The Great Wisdom Mother and the Good Tradition, in *Tantra in Practice*, op. cit., pp. 393-416.

of wealth and riches. This wealth becomes sacrosanct, accumulates over the generations, and is guarded in the temples and monasteries by specially designated custodians.[10] Provided by the lay people, it becomes an object of devotion to such an extent that both lay and religious members of the community have a tendency to no longer distinguish between the material object and the goal that it represents.

Further, the dual current of intellectual analysis, alongside mystical contemplation and yogic practice, creates a tension within the system, since the majority of practitioners have a tendency to emphasize one or another of these currents (in spite of the fact that all agree that both are fundamental to the realization of the goal). This creates a certain antagonism between the proponents of either way, extending from friendly buffeting to extreme violence. The meditators mock the dialecticians for their hair-splitting analyses which lead them only part of the way, while the scholars mock the yogins for their ignorance of the texts.

Zen: Naked Mind, Naked Body

In the schools of *Sudden Enlightenment* developed in China and Japan, shock tactics or *koan* have been used since early times to awaken the mind and body out of the comfort of habitual furrows and into a state of Awakening. The "strange words and extraordinary actions"[11] of this style of teaching were widely used by the Chan masters of the Tang dynasty, passing into Japan where the Zen masters developed to an intense degree the use of brief, evocative moments of rupture within the tradition. Interference and exchange with the indigenous Taoist tradition in China was present from the start, as seen in the example below:

A hermit was living in the mountains. A man passed by and admonished him for lying there naked. He replied: "The heavens are my roof, the world is my trousers. What are you doing in my trousers?"

"The Layman was once lying on his couch reading a sutra. A monk saw him and said: 'Layman! You must maintain dignity when reading a sutra.' The Layman raised up one leg. The monk had nothing to say."[12]

In Chan and Zen, the scriptures and doctrines were acceptable so long as they were seen only as "aids."[13] They were like the finger that points to the moon: he who takes the finger for the moon is a fool. The illiterate Sixth Chan Patriarch Huineng was known to tear up Buddhist scriptures in a rage. His teachings, in a nutshell, are: "Deluded, a Buddha is a sentient being. Awakened, a sentient being is a Buddha."[14]

In even greater symbolic violence, the Patriarch Linzhi proclaimed "If you meet the Buddha, slay the Buddha."[15] While the Japanese monk Ikkyu said: "That stone Buddha deserves all the birdshit it gets. I wave my skinny arms like a tall flower in the wind."[16]

Tianran (738-824), a Chan master from Tanxia, took shelter in a temple and, finding that the fire was going out, took down one of the wooden figures of the Buddha from the altar and placed it on the embers. When the keeper of the temple discovered what had been done he was furious at such an act of sacrilege, and began to scold Tianran for his irreverence. But Tianran merely scratched among the embers remarking: "I am gathering the holy relics from the burnt ashes." "How, asked the keeper, can you get holy relics from a wooden Buddha?" "If there are no holy relics, replied Tianran, this is certainly not a Buddha and I am committing no sacrilege! May I have the two remaining Buddhas for my fire?"[17]

The »Holy Madman« Nyonpa: His Role as Iconoclast

In a slightly different vein, Tantra too nourishes the outrageous action of the "mad" yogin, as a deliberate practice, a part of the path.[18] Several learned abbots of the great monastic universities of India, for example, abandoned all to become

11 10 18 16 12 17 13 15 14

_ Watts, op. cit. pp. 44-45; see also Heinrich Dumoulin, *Zen Buddhism. A History*, vol. 3: Japan, Macmillan, New York, 1988, pp. 99-103; Brinker/Kanazawa, op. cit., fig. 14.

_ Heinrich Dumoulin, *Zen Buddhism. A History*, vol. 1: India & China, Macmillan, New York, 1988, p. 166.

_ Dumoulin, op. cit., pp. 196-197; Helmut Brinker and Hiroshi Kanazawa, *Zen Masters of Meditation in Images and Writings*, Artibus Asiae Publications Supplementum, 40, Zurich, 1996.

_ Schiller, op. cit., p. 117.

_ The term *skor* is used in Tibetan to refer specifically to the wealth of the Sangha.

_ David Schiller, *The Little Zen Companion*, Workman Publishing, New York, 1994, p. 127.

_ Alan Watts, *The Spirit of Zen*, London, 1936, pp. 44-45; Dumoulin, op. cit., p. 136.

_ See D. Germano, Craziness and Naturalness, pp. 317-321: sub-chapter of Elements, Insanity and Subjectivity, in *Religions of Tibet in Practice*, Donald S. Lopez Jr. (ed.), Princeton Readings in Religions, Princeton University Press, Princeton, 1997.

_ I.e., "supports" as in Vajrayana Buddhism.

wandering yogins at one stage in their lives.[19] Shocking monks out of the smug complacency of their outwardly "virtuous" practice; making a mockery of the "sophistic" argumentation of the debating arenas; laughing at the taboos and prejudices of the ordinary people in the market place, this kind of practice continues as living Tibetan tradition today. However, the eleventh to fifteenth centuries saw a special flowering of mad saints, or *nyönpa*, and of such imagery in Japan.[20]

One episode from the life of Tibet's great yogin Milarepa (1040-1123), reveals the violent antagonism that often reigned between the scholars and yogins:

"Milarepa must be chased out of this place, otherwise we can never attract more people or spread our teachings. Besides, his teaching is heretical and evil, so he surely deserves to be ousted." But the elders replied: "It would not look good if we drove him out, people would criticize us. The best way is to send three of our most learned scholars who are well-versed in Sanskrit, logic, philosophy and the Sutras to challenge him to a debate on Buddhist doctrines. Since he is so ignorant, possessing nothing but a tongue, he will not be able to answer our challenges and arguments. Out of one hundred questions, at best he may answer one or two; then we can scorn and abuse him. Mortified by such a disgrace, he will run away of his own accord."[21]

During a similar controversial episode from twentieth century Tibet, another band of scholar monks were routed by Amdo

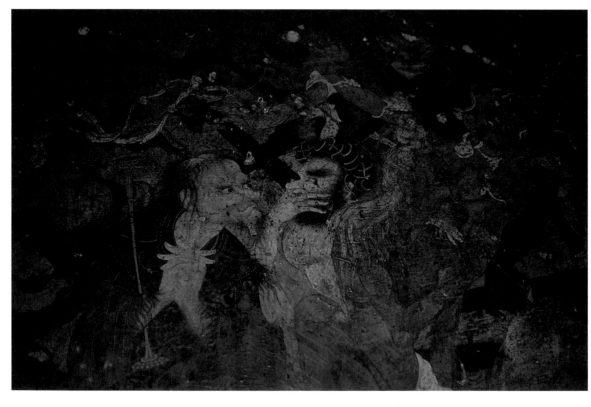

Two »mad« Yogins /
17th-18th century / wall painting /
Tashilhunpo Monastery, Tibet /
© photo: Heather Stoddard, 1988

<div align="center">19 20</div>

<div align="right">21</div>

_ Milaraspa, Chen-Chi Chang (eds), The Challenge from the Logicians, in *The Hundred Thousand Songs of Milarepa*, Shambhala, Boston, 1977, vol. 2, chapter 34.

Keith Downman, Masters of Mahamudra, series in *Buddhist Studies*, State University of New York Press, New York, 1985.

_ The three ink paintings from Japan illustrating this chapter, date to the thirteenth and fourteenth centuries.

Monastic cauldron dump / 1992 / Sera Monastery / © photo: Heather Stoddard

Children Playing / 1992 / Southern Tibet / © photo: Heather Stoddard

Gedun Chompel (1903-1951) who – if we relied on testimonies from political men outside of the Tibetan tradition – might easily be reduced to a "ruined alcoholic" or "broken man in the last period of his life." However, one single anecdote ranks him among the famous "mad saints" of Buddhist history.

One day, the Master of Repetitions from Minyag came with four of his scholar monks from Drepung. As they arrived at the door, Gedun Chompel asked his friend Lachung Apo to go and see who was there. Recognizing the famous dialectician, Lachung Apo informed Gedun Chompel, who hurriedly lit a cigarette and began to smoke. "Now, ask them to come in," he called. Without a word, he wiped the ash of his cigarette twice across the face of the Buddha – which he usually treated with great respect – snapping his fingers and calling for debate. Shocked and scandalized, the monks asked him to stop. Then he began vigorously to argue with all five at once

exclaiming "Hum rub phat rub!" on the question of whether the Enlightened Buddha felt happiness and sorrow. Up and down and roundabout, he pushed and pulled, turning them inside out, until all five had to admit that they could not even recite the *Prayer to the Twenty-one Taras* correctly. To annoy them further, he recited the famous prayer backwards, upon which the debate came abruptly to a standstill and they left making awkward jokes. After they had gone, Gedun Chompel smiled and said: "If you don't treat these people like that they won't leave you in peace. Now they'll never come back."

The next day Lachung Apo went to the shop of Tamdrin Tsewang of Kandze: "What happened yesterday with Gedun Chompel and the 'Doctors of Metaphysics'?" Tamdrin asked. "They had a short debate." "Oh! I see! One of them is my nephew. He came in here scratching his head and sighing deeply. When I asked what had happened he said, "I have studied the texts for twenty years, but have understood

Deepen theoretical, political, and ideological criticism of the Chinese Khruschov / 1967 / from: Jean-Yves Bajon,
Les années Mao. Une histoire de la Chine en affiches (1949-1979) / Les éditions du pacifique, Paris, 2001 / p. 79

nothing." "He has to take the highest exams of Doctor of Metaphysics next year."[22]

Confusion

As a fundamentally peaceful, non-aggressive religion, it is remarkable that Buddhism became the object of persecution and attack at different stages of its history – right through to the twentieth century. Contrary to other Asian systems of thought that remained to a much greater degree within geographic and ethnic boundaries – eg., Brahmanism, Confucianism, Shintoism, and Bon (the pre-Buddhist religion of Tibet), the revolutionary, "a-theistic" vision of liberation for all living beings, the anti-caste, non-racist, universalistic teachings of Buddhism, gave rise to a steady flourishing throughout Asia during the last two millennia. At the same time, the ideological and economic success of its proponents, who rose to positions of influence in the courts of kings and emperors, brought them into opposition with indigenous, established hierarchies. The accumulation of wealth, the establishment of large monastic communities (depleting labor and taxable individuals), together with the proliferation of temples richly adorned with countless "golden idols" (in stark contrast to the avowed poverty of the Sangha), aggravated the special position of the well-assimilated but still "foreign" religion.

In Central Asia, in the nineteenth and twentieth centuries, Vajrayana Buddhism, with its multifarious forms, its wrathful deities and sexual symbolism, its vast and incomprehensible pantheon, provoked misinterpretation on the part of outsiders, whether Confucian, Taoist, Republican, Christian, Bolshevik, Maoist, or Muslim.[23] As the most recent historical and cultural expression of a distinct identity (uniting especially peoples of Mongolia, Tibet, Manchuria, and Siberia) this led to radical attempts at elimination of their religion – and especially of its mediators, both living masters and representational imagery. Behind the iconoclasmic gestures of the Bolshevik and

Image, damaged by axe-strokes during the Cultural Revolution in Tibet /
© Tibet Image Bank, Tushita: Jürgen Schick

22 23

_ See *Imagining Tibet*, 2001, op. cit.

_ Heather Stoddard, *Le Mendiant de l'Amdo. Gedun Ch'ompel (1895-1951)*,
La société d'Ethnographie, Université de Nanterre, 1985, pp. 250-251.

Tradition is apparently alive and well at the beginning of the twenty-first century

Maoist revolutions lay a certain ancestral fear of the barbarians of Central Asia who had made this powerful, mystical religion their own, in opposition to the highly structured, hierarchical "belief" and governmental systems of the great agrarian civilizations of South and East Asia. Although these most recent "outer" iconoclashes in Central Asia present but a facet of a much wider and profound world revolution, they are at the same time specific in that they represent a deliberate attempt at eradicating – once and for all – the power and influence of the peoples of Central Asia who had been continuously feared, with good reason, in spite of their small numbers since the dawn of humanity – at least until they adopted Buddhism.[24]

From the point of view of the "inner" iconoclash, the practice of Vajrayana requires the projection, in mental terms, of countless images which are then re-absorbed, only to be replaced by other, equally "de-structable," unsubstantial mental constructs. While the cascading imagery of meditation exercise sets a precise example for the proliferation of physical imagery, the fundamental concept of the "vacuity" or "interdependence" of all phenomena, constantly reminds the "believer" or "practitioner," that all these marvelous "appearances" are impermanent and unsubstantial.

Thus, although physical images are taken as powerful and important mediators within the trinary concept of *Body-Speech-Mind* of the Awakened Buddha, and the body-speech-mind of all living beings, the awareness that they are simply "aids" or "supports" on the path is continuously maintained.

On the other hand, due to the sacredness imparted to the material object through ritual consecration performed by "authentic" masters, and to the channeling of "divine energy" that this is "believed" to bring about, statues and images become imbued with "life" and thus become, on a conventional level, "appropriate supports for offering" *(mchod.rten)*. Yet, paradoxically and concomitantly, in the eyes of "Enlightened Masters" – who may well value their presence from

24

_ This thesis, developed especially by Owen Lattimore, *Studies in Frontier History. Collected Papers 1929-1958*, Oxford University Press, London, 1962; and Wolfram Eberhard, *Conquerors and Rulers: Social Forces in Mediaeval China*, Brill, Leiden, 1952, has fallen out of fashion in Asian studies circles due to the effective eclipse of the Tibetan and Mongolian people under the Communist regime. Nevertheless, its historical reality remains intact.

aesthetic, historic, ritual, sacred, and emotional points of view – they still always stand as pre-condemned mediators, as fabricated, impermanent, illusory projections devoid of any independent, intrinsic value.

Thus, during the Cultural Revolution, when some young monks rushed up the mountainside from the monastery to the cave where an old yogin sat absorbed in meditation to announce that the Red Guards were smashing the images in the temples, he at first burst into tears. Then he burst out laughing, asking. Do they know what are they doing, smashing wood and brass and clay?

In a recent and unexpected historical rebound following the destruction during the Cultural Revolution, there is today in the People's Republic of China, Taiwan, Hong Kong, Singapore, the Philippines, and Indonesia, not to speak of India and the West, a rapidly evolving community of Han Chinese practitioners and wealthy donors who follow and support the Tibetan tradition, and who are rebuilding huge centers of study and meditation adorned with fine golden Buddha images. These countries have two millennia of Buddhism; and at least six centuries of familiarity with the Tibetan tradition of Vajrayana behind them, thanks to the generous patronage of Tibetan monks as imperial preceptors from the time of the Mongol emperors (thirteenth century) right through to the last of the Manchus (early twentieth century). Thus the iconoclash surrounding the Religion of Golden Idols is far from finished. |

Inside of a stucco image of Bhairava / Shide Monastery, Lhasa / © photo: Heather Stoddard, 1994

Prajnaparamita Manuscript / damaged pages / handwriting, illustrations / Namgyal Gonpo Ronge, Ittenbach near Bonn / © photo: Oszwald, Bonn

ON A SUSPENDED ICONOCLASTIC GESTURE

Bruno Pinchard

TO FOLLOW THE MAZE OF THE ICONOCLASTIC GESTURE, how would this be possible without Freud's analysis of Michelangelo's *Moses*? We are in Rome in 1913, Freud is standing in the half-gloom of the Church of St-Peter-in-Chains,[1] and he is dreaming, he is dreaming precisely of the power of the Holy Seal, that which both binds and unbinds the will of a Pope: this will be his contribution to reckless iconoclasts.[2]

Before Freud, one wanted to see in the mass of the unappeased marble of *Moses*, the barely-suppressed fury of the prophet, who is about to spring to his feet to go and punish the idolatrous crowd. Only, in order to rush upon the infidels, one must agree to abandon the tablets of Laws that God engraved. Does Moses hesitate? No, with his left hand on his stomach, the very seat of wrath and anger, and his right hand in his beard, he rises and lets the divine message fall to the ground; it is this movement which breaks it. Yet, the biblical text is different: it is not written that Moses lets them fall but that he breaks them himself. Later, God will again give a law to people, doubtless the same law – the biblical text insists on this – but it will, however, only be a second version: God dictates it, but it is Moses who inscribes it. This substituted law is that which people will have merited.

But Freud tells another story. With a sweep of his hand, he does away with this movement of romantic pathos not worthy of a Pope's tomb. Certainly, Moses could have exploded, he could have been the avenger and given himself over to his rage. But then he would have been an iconoclast twice over: first with regard to the Golden Calf, second with regard to the tablets: and there he would have been the iconoclast caught in his own trap; he would have become sacrilegious. Freud's Moses is not like that.

When one is Freud, one doesn't let the Law fall like that! What is it then, that happened? Yes, Moses began to rise up, but as he yielded to his first movement, he felt the stone tablets begin to slide out of his arms. Proof: they were upside-down. It is Freud who said this, because the notches that mark the top of the page are toward the ground. Well, Moses couldn't bear to go further than this tragic rotation of the book on its axis. No, he would not lose the writing of God for such a miserable crowd; no, he would not break that which was infinitely more valuable than the Golden Calf and its punishment; no, he would not yield to the pleasure of this breaking, for he who breaks is broken, and he who shatters the Law loses it in the end. Now, there is only one Law, and that is to watch over it. Freud watched over it. Under his arm, painful perhaps like his jaw, he guards the actual writing of God and nothing will separate him from it. Let men abandon themselves to idolatry or even to the second Law of God, he will let himself be slowly petrified by the real Law. Let my sons kill me; I will live on, at least through my right side, for I have become one body with the eternal Law.

Freud: The guardian of bonds and the impossible iconoclast.

Translated from French by Sarah Clift

2

1

_ Translator's note: The translation of *Saint-Pierre-aux-liens* as "Saint-Peter-in-Chains" has the disadvantage of restricting *liens* to its most literal meaning of "being bound" or "being enslaved." Things are more complex with the French *liens* and its verb-form *lier*, in that they suggest not only bondage and imprisonment, but also commitment, as in linkage, bonds, attachment, connection, even Holy alliance or union. The author plays on the series of meanings of *lier* and their relation to Law throughout the text.

_ Translator's note: Michelangelo's *Moses* was created as an adornment for the tomb of Pope Julius II.

Michelangelo Buonarotti / Moses / c. 1515 / marble / detail /
base of Giulio II's mausoleum / San Pietro in Vincoli, Rome

ICONOCLASM BY PROXY

Z.S. Strother

IN 1834-35, THE REFORMER SÉKOU AMADOU humbled the city of Djenné (in what is today Mali) by destroying its famed thirteenth century mosque.[1] He objected to its beauty, in particular to its towers, which he attributed to vanity. One suspects that he also wished to humiliate the city, whose clerics had dismissed him as an ignorant cowherd. Amadou evaded the Koranic prohibition against destroying a mosque by plugging its gutters and allowing rainstorms to do his work for him. The scale of the adobe building was such that the people of Djenné were obliged to live with its hulking ruin for many decades. If the Great Mosque once served as a symbol of the city's commercial might, its decay became a living index of Djenné's progressive decline.

Sékou Amadou's care to commit iconoclasm by proxy, to transfer the responsibility for his actions to natural forces, suggests an interesting question. Should we consider the refusal to shelter and maintain objects itself as a form of willful destruction? Is Time the Destroyer? Or sometimes only a fall guy set up to take the rap? An example from the Eastern Pende of the Democratic Republic of the Congo also demonstrates destruction by proxy, although in this case art objects are programmed to self-destruct through intertwined motives of iconophilia and iconophobia.

Although Eastern Pende chiefs today live in homes of adobe or concrete, they are required to build an additional small, domed house of straw or bark to hold ritual paraphernalia. In 1988, the prosperous chief Mbuambua announced that he intended to construct his next *kibulu* (ritual house) out of concrete blocks with a tin roof, as he was tired of the periodic rebuilding that a thatched structure entailed. Chief Mbuambua was likely joking, but his announcement raised genuine consternation for it is an intriguing fact that, once erected, no one may repair the *kibulu* in any way. A well-maintained thatched roof has a life of twenty years or more; however, without steady upkeep, it rarely lasts more than twelve. Most communities rebuild the *kibulu* every decade in ceremonies involving days of masquerades. His people told Chief Mbuambua that, even if he could mimic the form, there was no question of a perpetual *kibulu*.

The periodic rebuilding of the *kibulu* ensures a calendar of spiritual revivals in the community. And yet, there may be another, more urgent reason for limiting the lifespan of the structure. Throughout most of the twentieth century, the *kibulu* was often topped by a *nkishikishi* (rooftop statuette) whose form testified to the rank of the chief. Paramount chiefs had the right to display large anthropomorphic figures and to surround their doors with panels sculpted in relief. In contrast, the ritual house of a subordinate chief might be ornamented by no more than the figure of a bird. The statuettes, carved from hard wood, did surprisingly well mounted on the roof, where rain quickly washed over them and dried. However, when the building decayed, the sculptures eventually toppled and were left where they lay. Once they hit the ground, they disappeared surprisingly quickly, victims of the mighty termite.

Since the *nkishikishi* is an object of great pride and cost, leaving it to rot may come as a surprise. *Nkishikishi* were commissioned only from the most celebrated Pende sculptors. Because of their size, the artists had to travel, sometimes several hundred kilometers, to work on site. During their visit, they expected to be cosseted with lavish meals. The astronomical fee of a goat was further supplemented with quantities of salt, palm oil, wine, and cosmetic powder. It is striking that artists were never paid in trade goods (cloth, copper, iron) but through gestures of concern for their physical well-being. Receiving an architectural commission could make a sculptor famous as the completed chief's house became an object of tourism in the region.

Apart from their beauty, the statuettes held *additional* fascination for local villagers as they were rumored to be power objects charged through the capture of a human spirit. They are often referred to, in Franco-Kipende slang, as "gardes du corps" and the mounting of such works advertises that the chief has secured spirit-workers to surveil the village around-the-

1

_ The following history of Djenné's original mosque is drawn from Jean-Louis Bourgeois, Stealing and Restoring Glory: Histories of the Great Mosques of Djenné, in *Spectacular Vernacular*, Aperture Foundation, New York, 1996 [1983], pp. 127-139, 177-178.

clock, sentinels who never sleep or lose focus. Some believe that female imagery is privileged because women are presumed to be more protective than men.

When I asked Pende why they did not carve their architectural statuary out of stone, or better yet, forge it out of metal, they were horrified. One specialist explained that when the sculpture decays, the spirit inside is liberated to complete its journey to the other world. The idea of a power object outliving the control of its owner is a frightening one. Kakoko, another specialist, protested: "You don't want to make it eternal! When [Chief] Kombo dies, a new Kombo must make his own. Who would use the old figure? People are afraid to have all of those spirits around. [Who would want them] tied eternally?!" His words conjure a nightmarish vision of a landscape filled with landmines comprised of abandoned power objects. It now becomes clear that one of the reasons for which the *kibulu* is rigged to self-destruct every ten years is to secure the destruction of the statuette so that the spirit within may be liberated without anyone taking on the risk of exposure to the dead. Once again, iconoclasm takes place by proxy, this time through the agency of termites.

Nkishikishi are objects that can work wonders. And yet, for that very reason, they must be destroyed periodically in order to protect society from their power. Ironically, because the international art market cannot tolerate that anything be destroyed, the process of decay is often arrested. Statuettes, such as the one depicted here, have been snatched from the maws of termites, leaving their collectors exposed to the risks of living with caged spirits whose indenture should have ended long ago. |

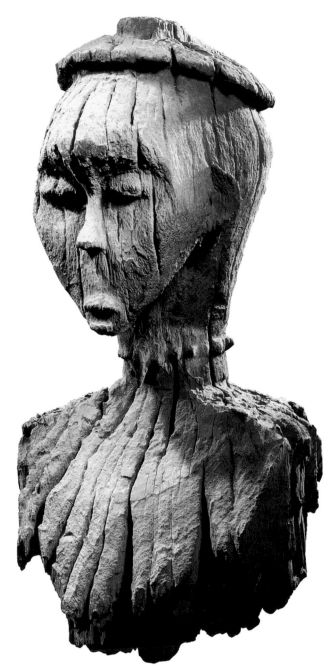

Bust / 18th-19th century / Pende, Zaire / height 18″ / private collection

TAKING PICTURES OF SUPERNATURAL BEINGS

Elisabeth Claverie

IN SAN DAMIANO (EMILIA – ROMAGNA) NEAR PIACENZA in Italy, in Medjugorje (Bosnia-Herzegovina) near Mostar and in other places as well, the Virgin Mary has appeared to the same few visionaries for years. She speaks to them, giving them messages that they are in charge of transmitting. In San Damiano and, even more so in Medjugorje, hundreds of thousands of people of every nationality try to be present every year at this event. They want to see the visionaries seeing; they want to find themselves in the presence of the Holy Virginapparition.

With the look and format of a postcard, this photo circulates widely in San Damiano. Many carry it tucked in their wallets. It has a strong value of attestation attached to it, or is even proof, of the potential visibility of the Holy Virgin in the state of an apparition. This is because it is believed to be the reproduction of a photo, ingratiatingly taken by a pilgrim, of the tree in which the Virgin touched down during one of her weekly appearances in San Damiano. Since the apparition was not visible to the naked eye for the pilgrims on their devotional visit to the site, the technological apparatus was able to fix the image of the supernatural beings that only the visionary Mama Rosa could see. In this way, it is guaranteed that many people continue to try the experiment: by taking pictures of the sky during the apparition, which either appears at a fixed, predetermined time, or during all hours of the day.

One must understand that it is not just the technological instruments that are at stake here: in order that something inscribes itself on the film, one must also have attained "grace." As such, the moment of development of such a photo, one taken by a Polaroid for example, is a very tense moment, a veritable proof: Will there be an inscription? The proof is set according to a precise procedure. What appears on the film is in effect considered to be a sign from the "Virgin" personally addressed to the photographer. Again, it is necessary to interpret what one sees, and the pilgrims try their hand at this collective exercise of description during the slack hours of the pilgrimage: during communal meals, or in the evenings in their rooms.

In the photo of a gray-tinted sky, which a pilgrim has just taken and which he offers to the attentive expertise of a neighboring group, some of them mention "the cross," others the "mystical ring." These descriptions are then submitted to commentary. In effect, the photos reveal shots other than that of the "Virgin"; that is, not only "signs" but also entities, like on this postcard where the apparition is surrounded by an incandescent circle: the souls in purgatory. Despite the death of the visionary in 1981, the "Virgin" appears in San Damiano every Saturday in front of an enclosure encircled by gates (which contains two trees and a marble statue of the Virgin) when the pilgrims recite the rosary. At the moment of her appearance, people "watch," pray, take photos or, with the help of tape recorders, record what she may say and which would then be accessible "through the waves." When she leaves, the pilgrims are filled with emotion. They make a gesture of the hand to her and sing *arrivederci*, good-bye. In effect, she was there and now, she is leaving.

Here, one sees the six visionaries of Medjugorje in 1981, at the very beginning of the apparitions in this former Yugoslavian village. This photo is used in the local devotion manuals as the very image of *proof*, of visual *proof*. The commentators explain: the convergence of perspectives on a single point, regardless of differences in height and in position, is certainly a strong indication that the children see something. In effect, the most distinctive feature of these recent apparitions is the obsession with scientific proof. Visionaries are clad in electrodes, are riddled with tests, and are harassed by interrogators deploying a battery of critical procedures to establish their usual normality in relation to their state of trance, during what they call "the apparition." All of the devotional booklets in Medjugorje include an introduction to these tests for the pilgrims' use, complete with graphs and medical opinions. |

Translated from French by Sarah Clift

Six pilgrims of Medjugorje seeing the Holy Virgin / © photo: Elisabeth Claverie

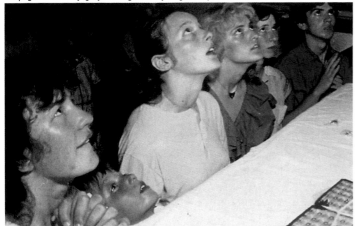

The apparition. The pilgrims taking the same photo say that this is the key to heaven / © photo: Elisabeth Claverie

The garden where the Virgin has manifested herself / © photo: Elisabeth Claverie

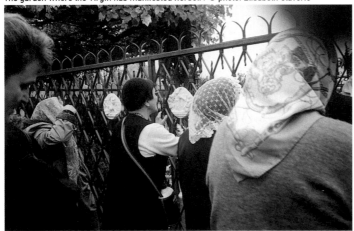

Postcard circulating in San Damiano, distributed to the pilgrims. Photo of souls in purgatory

The pilgrims say farewell to the Holy Virgin / © photo: Elisabeth Claverie

THE FACE OF INDIAN SOULS: A PROBLEM OF CONVERSION

Anne-Christine Taylor

WHILE STRONGLY ATTACHED TO THEIR ETHNIC IDENTITY, the Jivaro (Shuar) Indians of the upper Amazon are carefree in their attitude toward many aspects of their "tribal" culture, and most of them now dress in Western-style clothes. However, they still cling to one aspect of their traditional appearance, namely, body paint. Thus, whenever adult men expect to meet in a formal context, they take great care to cover their faces with red-colored geometric designs. The motifs they trace all look very much alike, yet each man claims to sport a unique design. Why do these Indians persist in painting their faces? Native exegesis on this point is scant and contradictory, but it is clear that the Indians do not consider body painting as a prized art form. Moreover, the practice is strongly stigmatized by non-Indian inhabitants of the Amazon, notably by the missionaries who have been attempting to Christianize these Indians since the seventeenth century. For them, as for most of the White Europeans, face painting is a sign of savagery, the outward manifestation of a heathen soul. True, Catholic missionaries – particularly, the Jesuits who operated in this area until 1768 – tolerated body painting on nominally christianized Indians, but only during certain religious feasts and purely for the baroque scenic effects it allowed to arise. By contrast, for the Protestant, predominantly North-American missionaries who began working among the Jivaro in the early decades of the twentieth century, face painting was anathema: they believed that humans should present themselves to their maker's sight with covered bodies and naked faces, as proof that their souls are open to their maker's scrutiny. Face painting was thus assimilated to a mask of deceit, a willful hiding of the inner life, a signature of the devil's influence. And in one sense the evangelical missionaries were quite right: for the Indians, face painting is indeed a means of making themselves opaque to the gaze of others, as well as the mark of an interaction with a "spirit." Where the religious erred was in assuming that the Indians shared their ontological premises, in particular their views on the nature of bodies and souls and of the relation between these two kinds of entities. Face painting thus became the site of one of those fateful but all too common cultural misunderstandings, wherein each partner has good reason to think the other understands his intentions, while in fact both parties are at cross purposes.

The missionaries were told that when a person dies or dreams, a part of him/her becomes detached from the body and survives as a non-physical thing. Here, obviously, was a rustic, imperfect conceptualization of a familiar Christian notion; accordingly, the missionaries promptly translated the vernacular term denoting this entity as "soul." In fact, it refers to the mental image of a body physically constituted through visual interaction. According to the Indians, bodies are not automatically generated by nature; rather, they are the outcome of a process whereby a human shape becomes incarnate through relations with kin. "Bodies" come from a limited stock of virtual human outlines that must be constantly recycled, such that every birth is dependent on a prior death. Each of these virtual shapes is formally unique – no two are alike – and condensed in a distinctive "face." As soon as one of these potentialities of appearance is actualized through the conception and birth of a new individual, this person comes into the sight and care both of himself or herself, and of others, and its bodily stuff grows out of the cumulative memory of such visual and affective relations. The generic, formally singular human shape becomes individualized – literally fleshed out – by the history of the daily interactions it has experienced; a living "face" is thus a palimpsest of visual encounters, the materialized sedimentation of a memory distributed between a person and his or her co-resident relatives. In short, the body as "matter" and as image is fused into a single entity; and it is the name of this entity that the missionaries glossed as "soul."

Insofar as they are made up of their reciprocal gazes, people who live together are assumed to be entirely transparent to each other. Therefore the "mind" is not for the Indians the black box it is for us: everyone shares the same basic set of relational dispositions, and what motivates people's acts or makes up the stuff of their inner life is in no way mysterious. This

Conversacion a propositio del tukunap / 1926 / copy on paper / 3.5 x 4.6" / photographer unknown / Archive Salesiano /
from: Lucia Chiriboga and Soledad Cruz (eds), Retrato de la Amazonia Ecudaor 1880-1845, Ediciones Libir Mundi, Quito/Ecuador, 1992, pl. 52

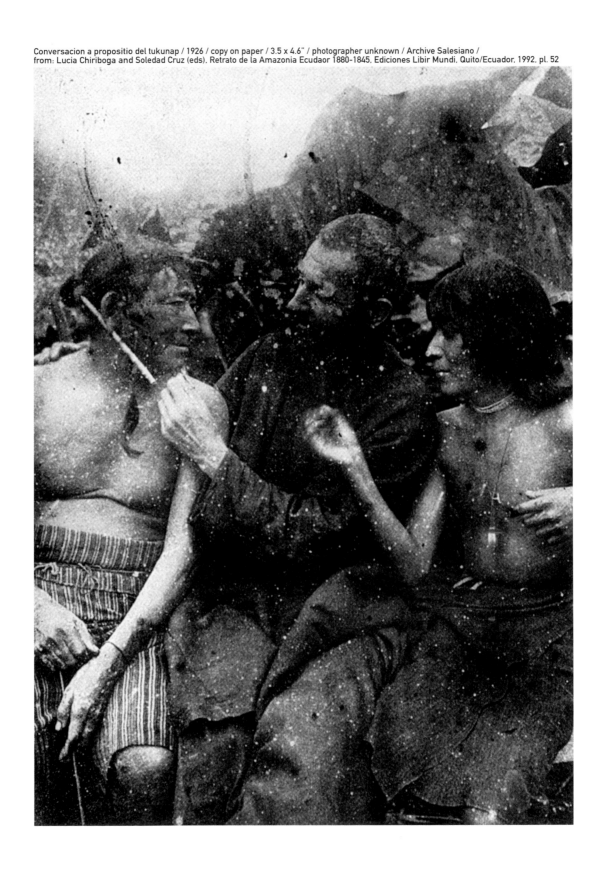

edenic condition of mutual transparency would be no problem if social life were peaceful and governed by trust. This is not at all the case. Traditional Jivaroan society is, to a large extent, structured by relations of reciprocal violence, and the localized webs of relations that produce bodies are under constant threat of attack by visible or hidden enemies. To counteract these forces, men compete with each other to build up networks of defensive and offensive alliances. It is thus vital for them to gain control over other individuals' dispositions, and this means escaping the mire of transparency and mutual dependency in which their selfhood is enmeshed. The primary means of achieving this is to engage in secret vision quests that lead to interactions with entities invisible to others. In the course of such solitary, drug-induced visionary experiences, men come to meet the ghostly "souls" of dead Jivaroans. These fierce and threatening apparitions become fused with the seeker, and imbue him with heightened potency, self-awareness and aggressiveness, in short with the means to forge a destiny as an exemplary warrior. This acquired capacity hinges on a shift of perspective: by internalizing the point of view of the fierce ghost, the mystic is henceforth able to see all other humans, including his familiars, through the eyes of an enemy. This new modality of perceiving others is added on to former ways of seeing, such that the visionary's eyes take on a layer of "sightedness" enabling him to view other humans as "prey," i.e., as obscure beings devoid of transparent subjectivity, the kind of entity we call "objects." The crucial point is that this ambiguous visual relation is also reciprocal: just as others become opaque to his sight, so also the beneficiary of a ghost vision becomes opaque to the sight of others. Because he has incorporated the position of the enemy, his own "insidedness" is now veiled to the gaze of his familiars, thereby freeing the individual from the power of others to see into his subjectivity and change it against his will.

This is precisely what the face-paintings signal: the designs indicate that their bearer has seen a ghost and become obscure, while revealing nothing as to the nature of the interaction that has taken place. The red motifs are an exhibited secret, ostensibly showing that the "body soul" of the man wearing them has metamorphosed. Although face paintings refer to a state of opacity, it would be wrong to view them simply as masks screening a person's soul from the power of others to see it and therefore act on it. Following the logic of indigenous conceptualizations of "soul" as the shared perception of a body produced and shaped by visual interaction, the designs are actually icons of the "flesh" resulting from the encounter between a ghost and a live human. Since this confrontation is by definition invisible to others and cannot be alluded to discursively, the bodily changes induced by the eye-to-eye interface between the two partners must be shown.

The Jivaroan visionary experiences signaled by body paint are akin to a religious conversion, a point that both the Indians and the missionaries duly understood, though neither party fully grasped the implications of each other's model of conversion. In the spirit of post-Vatican II theology, preaching greater respect for indigenous practices and beliefs, Catholic missionaries tried for a while to persuade the Indians that their ghost visions were in fact encounters with the deity. However, these attempts to reconfigure the native "conversion to the enemy" into a conversion to God ultimately foundered on the rocks of a metaphysical impasse: how, the Indians asked, can we possibly relate to an entity that cannot be represented? How can we interact with a being who, while all-seeing, cannot be seen? Protestant missionaries, by contrast, would not have truck with indigenous vision quests and strongly condemned face painting, a practice they dimly realized was connected to such "diabolical" experiences. But from the Indians' point of view, such a defacement implied severing links vital to their tradition and acquiescing to a state of infantile transparency. This is a relation that the Indians understood only too well, and refused to accept: so face painting became the red badge of resistance to a condition of permanent dependency. |

THE FETISH-SCIENTIST,
OR WHY WOULD ANYONE FORCE SOMEONE TO KISS THE BUST OF FRANZ JOSEF GALL?

Andreas Mayer

THIS IS THE BUST OF FRANZ JOSEF GALL, preserved in the archives of the Charcot Library in the Salpêtrière Hospital in Paris. It is one of the few pieces remaining from the museum opened by the neurologist Jean-Martin Charcot in his clinic in 1879, and, at first glance, it does not seem to speak to us anymore. Gall's theories about the localization of faculties, as they are presented on his head, have entered the cabinet of scientific curiosities and are now only of historical interest. What can the evocation of this object contribute to the notion of iconoclash?

I want to suggest an answer here by pointing to the rather unexpected use that was made of Gall's head during a series of experiments conducted at the museum of the Salpêtrière. When the Belgian philosopher and scientist Joseph Delbœuf came to challenge the power of Charcot's hypnotic experiments, which had become quite controversial, the following experiment was performed in front of him: Blanche Wittmann, a patient from the clinic classified as one the "great" hysterics and one of the star-subjects of the grand hypnotisme à la Charcot, was asked to proceed towards the bust of Gall and kiss it. Although she found the thing disgusting, under the spell of her hypnotists Charles Féré and Alfred Binet, who were at the time ardent collaborators in Charcot's hypnotic program, she gave in and kissed the bust "lovingly on both cheeks."

Why would one order a subject in a hypnotic state to kiss the bust of Franz Josef Gall? The most obvious answer is that the experiment demonstrated the power the doctors held over their subject: they forced her to do something that she profoundly disliked. But there is more to it than that. Shortly after Delbœuf's report, Alfred Binet coined his famous definition of fetishism as an aberration of normal love that pushes human beings to get sexually excited by particular material objects rather than by another human being: these objects may be parts of a person, things related to that person or just inanimate objects. The fetishist singles out one object for veneration and neglects all other objects. For Binet, this is where love turns pathological: the lover should be a polytheist who is thrilled by a "myriad of excitations" and not a monotheist who isolates one single exciting trait.[1] So, it seems obvious that the subject is turned into a fetishist and into a quite particular one: a lover of the head of a scientist, made of plaster, and carrying the inscription of his theories.

Two issues are essential here: Why an inanimate object, a bust, in order to demonstrate the power of the hypnotist? After all, there are simpler ways to demonstrate how the will of a subject can be broken. Think of the means employed by music-hall magnetizers who manipulated the bodies of their subjects. Why is it necessary to bring the fetish into the scene? And the second question is: Why is it Gall who becomes an object of veneration and disgust?

First of all, one has to see the experiment against the polemical background of the famous controversy between the two most influential French schools of hypnotism during the 1880s: the school of Charcot in Paris and the school of Hippolyte Bernheim in Nancy. An important issue in this controversy, often overlooked by historians, was their different use of materials, instruments, and objects. Both Charcot and Bernheim declared themselves to be true materialists: they regarded the phenomena of the unconscious studied in hypnotic experiments as actions that had to be located either in the brain or in the whole nervous system of the subject. Although both scientists were materialists in their theories about the mental phenomena observed in hypnotic experiments, their practical use of materials differed considerably, leading to different constitutions of "subjects." Whereas Charcot and his team conferred power to physical agents, such as the magnet, but also to other materials, Bernheim denied this power by declaring that all the material agents brought on the scene by the Parisians did not have any effect. Bernheim summed up his criticism in the radical formula that all the striking phenomena of hypnotism could be produced by the single factor of "suggestion" alone: the doctor's words were sufficient to produce hypnosis.

1

_ Alfred Binet, Le fétichisme dans l'amour, in *Revue philosophique*, 24, 1887, pp. 143-167, 254-274.

Bust of Franz Josef Gall /
Bibliothèque Charcot,
La Salpetrière, Paris /
© photo: Andreas Mayer

This formula of suggestion implied a radical dematerialization, if not iconoclasm, with regard to hypnotic experimentation. With his iconoclastic gesture, Bernheim became one of the founding figures of psychotherapy in its modern version, positing the realm of the psyche as an inner autonomous space. The actions performed by the doctors and their subjects in Nancy were described in a moral vocabulary that Charcot avoided: during the execution of the suggestion, they offered a spectacle of resistance, of the conflict between the will of the doctor and their own counter-will. Thus, with his demonstrations, Bernheim argued for a different power system than the one set up in Charcot's clinic. The acts of suggesting rested on faith and belief, thus on the imagination of the hypnotized: in the formation of the subject as a *moral* agent, materials played no part.

Hence, the efforts by Binet and Féré to re-inscribe Bernheim's formula into the experimental program of the Salpêtrière, with the help of all sorts of materials, in order to reduce them entirely to physiological processes. That was why they made use of Gall's bust: according to their associationist theorizing, the subject was supposed to perform a chain of events that were already registered in her nervous system. The bust, the material object, corresponded to an interior object that was already fixated in her unconscious. That matched perfectly with Binet's explanation for fetishistic object-choice which is to be found in a chain of associations – or interior, psychic objects – that has to be uncovered from the subject's unconscious history. What kind of object, we may ask. Certainly a scientist: a follower of Gall, namely the experimenter himself. Indeed, in a striking moment, Binet asserts that the experimenters themselves turned into imaginary objects of love or hatred for their subjects, a phenomenon he termed "experimental love." Thus, they had to use the objects at hand to redirect the "passions" aroused in their subjects. The fabrication of fetishes in an experimental setup thus points to the problem of something that could paradoxically be termed the "material reflexivity" of hypnotism. The scientist – who, according to the positivist credo of Charcot and his students, is a mere observer and hence absent – is represented by the replica-fetish. The subject is forced to embrace the fetish-scientist instead of the real scientist who can remain a cold observer and study the phenomena of "experimental love."

For a trainee in hypnotism during the 1880s, there were two possibilities: either to embrace the fetish or to denounce it. Most of the doctors who visited Paris and Nancy were convinced by Bernheim's demonstrations and opted for the second. As a consequence, all the former material agents were thrown out of the psychotherapist's consulting room. The ideal site for a psychotherapeutic treatment had to be a place where nothing would divert the patients' attentive observation of their own interior space.

Another visitor to the Salpêtrière and Nancy in the mid-1880s, who would later gain fame, took a different turn: Sigmund Freud. While he followed the trend towards dematerialisation in psychic treatment and depicted transference ideally as an encounter devoid of any physicality, he did not remove his private collection from the consulting room but placed it right there in front of his patients.[2] With regard to the "experimental love" exhibited at the museum of the Salpetriere, Freud performed a reversal: The patient was not asked to direct her passions toward the objects and to become a fetishist, but on the contrary to renounce such a position and transfer all her love to the psychoanalyst, the invisible transference object.[3] |

2

_ For Freud's collection and its multiple connections, see *Meine ... alten und dreckigen Götter.
Aus Sigmund Freuds Sammlung*, Lydia Marinelli (ed), exhib. cat. Sigmund Freud Museum,
Vienna, 1998/99, Stroemfeld Verlag, Frankfurt/Basel, 1998.

3

For more details, see Andreas Mayer, *Objektwelten des Unbewussten. Fakten und Fetische
in Charcots Museum und Freuds Behandlungspraxis*, in *Sammeln als Wissen. Das Sammeln
und seine wissenschaftsgeschichtliche Bedeutung*, Anke te Heesen/E.C. Spary (ed),
Wallstein Verlag, Göttingen, 2001, pp. 169-198.

BREAKING IDOLS ... A GENUINE REQUEST FOR INITIATION

Tobie Nathan

"BREAKING IDOLS" REFERS TO THE COURAGEOUS ACT of deciding to break away – from the error one has shared with the vast majority up to that point. Breaking idols is how Abraham makes his appearance in the Book of Genesis: "And God said to Abram: 'Go for yourself *(lekh lekha)*, leave your native land, leave your father's house, towards the land that I will show you'." (Genesis 12:1).

In the few verses above, a short sentence recounting the death of Abraham´s brother has given rise to fruitful commentary, presumably whence the common expression "breaking idols" originated: "Haran died before his father" (Genesis 11:28). A Midrash relates the circumstances of Haran's death. Terah, father of Abram, Nahor and Haran, a sculptor and seller of "idols," left his workshop in his eldest son's care. After mocking his father's customers, Abram grabbed a stick and broke all the idols except the biggest one, in the hand of which he placed the stick. When his enraged father questions him about the massacre, he answers: "They fought over the food and the biggest one, furious, broke all the others." "But is it possible? They can't understand a thing" his father replies angrily. At which point the son traps the father within his own logic: "Are your ears deaf to the words of your mouth?" Furious, Terah turns Abram over to King Nimrod's judgment. After a dispute over their beliefs, Nimrod sentences Abram to the stake. Thrown into the fire, he stays alive for three days and three nights and walks away unscathed. The king then asks Haran, his brother – a magician and idol maker – and his father: "Who are you for?" "I am for Abram and his God," answers the youngest, wanting to share in his brother's triumph. He is thrown into the fire and perishes before his father's eyes, his gut charred. ("Haran died before his father" ... Midrash Rabba Genesis XXXVII:13).

This narrative has had such a vigorous impact that it has arisen almost as such every time Westerners have set out to show the light to savages bogged down in their primitive worship. It contains three arguments, endless variations of which are found in all subsequent accounts: 1) idols are "artificial;" made by human hands, thus they cannot be alive; 2) idols do not eat; their absorption of food is staged through trickery; 3) idols are produced by charlatans to exploit the gullibility of common people.

The theme of artificiality was brought into sharp focus by Charles de Brosses in his *Culte des dieux fétiches* (1760) in which he reexamines the etymology of the word "fetish," linking it to the Portuguese *fetiso*, "fairy thing," in other words, "magic spell," "spell-object." Though Charles de Brosses takes up the theme of food, the most suggestive illustration of this theme is found in a Hellenistic addition to the Book of Daniel. In *Bel (Baal) and the Dragon* (1-3) Daniel himself devises a strategy to prove that it isn't the statues of the god Bel who eat the elaborate dishes offered by the king, but the priests and their families. Once exposed, the priests are put to death by King Astyage and the god Bel is handed over to Daniel who destroys the idol and the temple dedicated to it.

Duplicates of these stories, which I have merely outlined here, are found scattered throughout religious, philosophical, anthropological, and even psychological literature – from the episode of the Golden Calf in Exodus, to Freud's theory of "magical thinking." Yet, in my opinion, these stories are the product of a misinterpretation.

The *Lekh Lekha* addressed to Abraham is to be understood not, of course, as a philosophical injunction, a sort of "know thyself" before its time, but as a promise made to man to become a founder. A founder is by nature different from both his ascendants and his descendants. Otherwise, why stop going back in time precisely when reaching this specific man? Why would the lineage start with him? Why not go further back ... to his father, his grandfather, one of his ancestors? He is the founder

Abraham and the Idols / 1695 / from: Passover Haggadah, Amsterdam

ויאמר יהושע אל כל העם כה אמר יי אלהי ישראל בעבר הנהר ישבו אבותינם מעולם תרח אבי אברהם ואבי נחור ויעבדו אלהים אחרים

by virtue of the fact that he goes (that he walks: *lekh*), that is to say, that he moves forward in his lineage, for himself (*lekha*) and not for "the house of his father." Furthermore, his father himself will have to learn to "walk" for his son. Thus Terah will leave Ur Kasdim with Abraham – an incomprehensible development if he was thought of as attached exclusively to the idols, that Abraham destroys. Indeed, the founders problem clearly pertains to his descendants – not his children (we learn elsewhere, in various midrashim, that Abraham had many children besides Isaac and Ishmael). His descendants must be of an entirely different nature, different from him and from everything produced until then. That is precisely what God promised to Abraham: "Go for yourself … and I will turn you into a great nation" *(veyey'eyseykha legoy gadol)*, he promised.

We understand why the pleasing expression, *lekh lekha*, which in Hebrew is also a sort of play on words, appears again when God asks Abraham to sacrifice his son Isaac. He tells him: "Take your only son, he whom you love, Isaac, and go [once again: *lekh lekha*] to the land of Moriah and offer him to me as a burnt offering." For such is the internal work of a founder: to give up thinking of himself as resembling his father, produced by his land or by any of the things which came before him and might thus have engendered him (the first *lekh lekha*); but also to give up thinking that he will produce descendants resembling him (second *lekh lekha*). Indeed, his goal – and we understand here that it is a heroic action – is to produce something that has never been; something that no one has ever thought of before. His father does not participate in this creation; his son will inherit it without contributing to it.

It is therefore logical that this type of function requires an initiation – in the strong sense of the word, that is, a real "production" or "manufacturing" process. Such a man must be cast in fire, molded by a series of trials. In my view, this is how the account of Abraham destroying the idols must be understood: not as an act of shaming his father, a prototypical "epistemological leap," but as the description of the logical necessities with which a founder must contend. This is probably why a long Cabalistic tradition attributes Abraham with the authorship of the The Book of Creation *(Sepher Yetsira)*, matrix of every magical enterprise of Jewish inspiration.

Hence, "breaking idols" mustn't be understood as opposing the religions of idol-worshipers, but rather as penetrating the secret of idols, to be initiated into a new god who doesn't yet have a cult. An entirely different story from the other side of the world may help us get even closer to this type of logic. Remember how Quesalid, the Kwakiutl shaman whose biography Franz Boas reported and Claude Levi-Strauss brilliantly commented on, started off by searching for his master's tricks, also wanting to break his idols. He, too, was lucky enough to have a master who interpreted the student's insolence as a propensity to innovate, a request for initiation – an authentic call of the spirits. In fact, at the end of his life, Quesalid the skeptic, explained to Boas that only those objects which belonged to him, a true initiate, and not those of the other shamans, false seers – were *actually* enchanted.

If we follow the biblical text in this way, "breaking idols" would mean preparing oneself for the incredible reality of an idol not yet constructed. |

Translated from French by Liz Libbrecht

Abraham destroys the Idols of the Sabians / illustrated manuscript of al-Bīrūnī's Chronology of Ancient Nations / from: Peter J. Chelkowski (ed.), The Scholar and the Saint, New York University Press, New York, 1975, fig. 5

Bukhtnassar orders the destruction of the Temple / illustrated manuscript of al-Bīrūnī's Chronology of Ancient Nations / c. 1406-1414 / from: Peter J. Chelkowski (ed.), The Scholar and the Saint, New York University Press, New York, 1975, fig. 20

This extract from a novel by an Indian writer, Anantha Murthy, is at the origin of this show, a rare description from the inside of an iconoclast. Jagannath,[1] the main character, is a Brahman coming back from England and decided to free the untouchables from the sway he and his »saligram« (the sacred stone of his ancestors) has on them: || »Words stuck in his throat. This stone is nothing, but I have set my heart on it and I am reaching it for you; touch it; touch the vulnerable point of my mind; this is the time of evening prayer; touch; the nandadeepa is burning still. Those standing behind me [his aunt and the priest] are pulling me back by the many bonds of obligation. What are you waiting for? What have I brought? Perhaps it is like this: this has become a saligram because I have offered it as stone. If you touch it, then it would be a stone for them. This my importunity becomes a saligram. Because I have given it, because you have touched it, and because they have all witnessed this event, let this stone change into a saligram, in this darkening nightfall. And let the saligram change into a stone.« || But the pariahs recoil in horror. || »Jagannath tried to soothe them. He said in his everyday tone of a teacher ›This is mere stone. Touch it and you will see. If you don't, you will remain foolish forever.‹ || He did not know what had happened to them, but found the entire group recoiling suddenly. They winced under their wry faces, afraid to stand and afraid to run away. He had desired and languished for this auspicious moment – this moment of the pariahs touching the image of God. He spoke in a voice choking with great rage: ›Yes, touch it!‹ || He advanced towards them. They shrank back. Some monstrous cruelty overtook the man in him. The pariahs looked like disgusting creatures crawling upon their bellies. || He bit his underlip and said in a low, firm voice: ›Pilla, touch it! Yes, touch it!‹ || Pilla [an untouchable foreman] stood blinking. Jagannath felt spent and lost. Whatever he had been teaching them all these days had gone to waste. He rattled dreadfully: ›Touch, touch, you TOUCH IT!‹ || It was like the sound of some infuriated animal and it came tearing through him. He was sheer violence itself; he was conscious of nothing else. The pariahs found him more menacing than Bhutaraya [the demon-spirit of the local god]. The air was rent with his screams. ›Touch, touch, touch.‹ The strain was too much for the pariahs. Mechanically they came forward, just touched what Jagannath was holding out to them, and immediately withdrew. || Exhausted by violence and distress Jagannath pitched aside the saligram. A heaving anguish had come to a grotesque end. Aunt could be human even when she treated the pariahs as untouchables. He had lost his humanity for a moment. The pariahs had been meaningless things to him. He hung his head. He did not know when the pariahs had gone. Darkness had fallen when he came to know that he was all by himself. Disgusted with his own person he began to walk about. He asked himself: when they touched it, we lost our humanity – they and me, didn't we? And we died. Where is the flaw of it all, in me or in society? There was no answer. After a long walk he came home, feeling dazed.« ||

ANANTHA MURTHY, BHARATHIPURA, MADRAS/INDIA, MACMILLAN, 1996
Translated from the Kannada original

1

_ Not with a little irony, the hero bears the name "Jagannath," or "Lord of the world," that is also the name of the heavy chariot of Krishna under which devotees were said to throw themselves to die. That has given us "juggernaut" in English, to describe a powerfully overwhelming force! Another *iconoclash*.

But there is no image anymore anyway!

clash

THE ARTIST'S BEDLAM

Richard Powers

THE 1061 X 808 DIGITAL REPRESENTATION of Van Gogh's even higher resolution depiction of *The Artist's Bedroom at Arles* has long been one of the most prized sets of pixels to grace our repository at www.mastereproductionrights.org. Over the course of its extensive lifetime of almost five months, it has been one of the most clicked on, if not to say viewed files at our collections. In this antinomian age, however, mounting a file on a public server is never without its dangers, and despite our strongest security efforts, the pixels were defaced sometime during the first week of May 2000. At first, our webmasters had hoped that the sudden appearance of white streaks on the file image might have been some software artifact, but closer examination of the strokes leaves little doubt of their malicious nature.

Insurance payments by our digital underwriters were virtual at best, leaving few material resources for the restoration of this, one of our most beloved data structures. Some members of our smallish board suggested that we simply throw out the damaged file and replace it with a near-equivalent one residing at our rival repository site, www.imagenerics.com, or even any of the 1,253 other similar versions of *The Artist's Bedroom at Arles* available on the Web, but that, of course, was unacceptable to most of us. Even a quick search revealed that, between different compression algorithms, formats, resolutions, scanner settings, hue, saturation, brightness, or even aspect ratios, no other digital copy was quite what ours was.

The suggestion that we simply resort to our archived backup of the file, on remote storage, was also discarded. While the remote backup is, indeed, in every visibly measurable way identical to the pre-vandalized *Bedroom*, and while the backup might have sufficed to fool the clicking public, it had neither the history nor the aura of the actual file that had resided on our server and been downloaded all those many months. Using it to replace the file that had been damaged in the tour of active duty would have resulted in a considerable loss of tradition and good faith.

We settled upon the application of a "scratch removal" filter as our happy compromise. This subtle algorithm searches the surface of the representation for anomalous banding and "restores" them using pixels interpolated from the colors of surrounding areas. Under magnification, the damage is still discernable (note the region near the distant chair), but for the majority of our site's visitors, the degradation was no more distracting than the weathering of a real canvas. Disaster averted, we re-hung the file, now firmly fire-walled, to much renewed site traffic.

Despite the heightened security, our disturbed but resourceful assailant struck again, only a week later. Thwarted by our de-scratch algorithm, the attacker now induced much more serious mayhem into our bits, zeroing out both the washstand table and window panes. Our curators ingeniously recovered the table by cloning pixels from the footboard of the bed and transferring them to the absconded area. No such solution existed for the broken windows, almost as if the vandal had deliberately struck at a region for which no easy color replacement existed. After much informed debate, it was decided not to try to replace by hand the image of Van Gogh's masterful glass, but rather to map in portions of another treasured replica from our array of digitalismans, the 1889 (2001) *Wheat Field*, whose source image was roughly contemporaneous to the *Bedroom*. Even if this superimposed image does not, in fact, give a literal rendition of the actual view obtained from the *Bedroom* window, it may give a more accurate view of the artist's interior landscape, always the chief goal when trying to restore the intentions of an artistic representation.

No sooner did we hang the rechristened file on our newly re-secured server than the thug struck again, stealing the artist's paintings on the right-hand wall. Luckily, the thief, perhaps surprised during the heist, left behind the painting at the head of the bed, allowing our restorer to clone, flip, and populate a replacement painting with an image of the jug from the

Digital manipulations of Van Gogh's painting »The Artist's Bedroom«

washstand, once again in the spirit of Van Gogh, who at this period in his life often enjoyed painting his own banal personal effects (witness the *Bedroom* itself). Other sites, the victim of such repeated and vengeful attacks, might have been tempted to take their valued files off-line and hide them under stringent password protection. But such an action would have given the enemies of digitally reproduced art their insidious victory. We decided, in the interests of the surfing public, to risk the file again, and when the pixels suffered their most violent disruption yet – an image-wide blurring – we publicly accepted full responsibility for our decision. Our by-now practiced restorers had no alternative but to apply a sharpening algorithm, and while they did manage to restore definition to portions of the simulacrum that had been feared forever lost, it must be said that the image as a whole was now substantially altered. The shock of the new, astringent tones was not unlike the effect of the recently cleaned Sistine Chapel.

This alteration was, however, tame compared to the final, most egregious defacement, an act of bio-bit terrorism in which the assailant released what appeared to be some kind of green aphid into the much-maligned file. (It was at this point that we discovered that the attacks on our server were actually coming from the inside, the work of the board's youngest member, our daughter Tiffany, who, suffice it to say, will not be coming out of her own bedroom for some time.) A narrow-band histogram filter allowed us to render most of the aphids nearly transparent, although other regions in that tonal register suffered collateral damage and some palimpsest remnants remained. It seemed somehow deceitful to present this restoration as a faithful recovery of the original simulated image. So by vote of the board, in consultation with site visitors in our chat group, it was decided to posterize the file, simplifying the shape edges and reducing the colors to a manageable couple dozen. Many visitors actually prefer the final result to the original, finding it cleaner, lighter, and "more modern-looking."

We could, of course, return to a real imitation of Van Gogh's bedroom, but for the site's foreseeable future (at least the next week), we will not. And in our defense, may we say that if the Venus de Milo were surgically corrected, the Elgin Marbles re-polychromed, and the gothic encrustation of Notre Dame stripped back to its precursor Romanesque basilica or its original temple to Jupiter, the aesthetic principles of Western art would be shaken to their foundations.

CECI N'EST PLUS UNE IMAGE!
Michel Jaffrennou – by way of Bruno Latour

BUT YOU MUST BE OUT OF YOUR MIND! You ask me what I think of iconoclasm and iconophilia. Who do you believe I am? One of these ancient artists of the twentieth century?! When do you think we live? In the twenty-first, in case you have not noticed … The status of images has been totally modified. They can't be broken or vilified or adored or worshipped anymore, because they don't exist – or they have been transformed, metamorphosed, mutated, morphed beyond recognition.

First, each image is now made of bits and pieces distributed throughout the Web. Look here: you want to render the shine of a velvet, the shadow of a nascent beard, the torsion of light through a glass; you don't know how to do it. Well, you can surf through the Web until you find a plug-in invented by someone somewhere far away, and then you pirate it, bargain for it or pay for it, but it ends up on your screen and here it is. Look, I now have the ability to add this shade to *my* image. But whose image is this? Competences for bits of image-making – because that's what a plug-in is – are flowing through the world in a huge endless maelstrom which you navigate by picking bits and pieces. How could you be iconoclastic? The image is *already* broken, made of bits and bytes.

But there is more, because now, at the receiving end, the internaut who wants to see the image will have a completely different one than the other guy next door because its image-making local laboratory – namely, his computer – will be different. In the old days, in the twentieth century (which is as far away for me now as the Quattrocento or the Lascaux cave painting) in order to see a work of art you needed to be mentally and visually equipped. But now, you also need to download the right plug-ins. Depending on the one you have or don't have, the image received will be different, parts of it will be masked or invisible or destroyed, the nuances of colors will be different, the glare, the intensity, everything. So that, paradoxically, on the receiving end, each image is an original. Yes, it's *your* image, not anyone else's. So this picture that has no author and is made of bits and bytes, ends up having a unique *aura* depending on the equipment of the viewer! Who could destroy it since it is incarnated in *my* computer in a unique way?

Michel Jaffrennou / Ceci est une image / 2002 / mixmedia / 11.8 x 23.6" / © Michel Jaffrennou

Michel Jaffrennou with
A. Gräper and Margot /
This is not a picture / 2002 /
mixmedia / 11.8 x 23.6" /
© Michel Jaffrennou

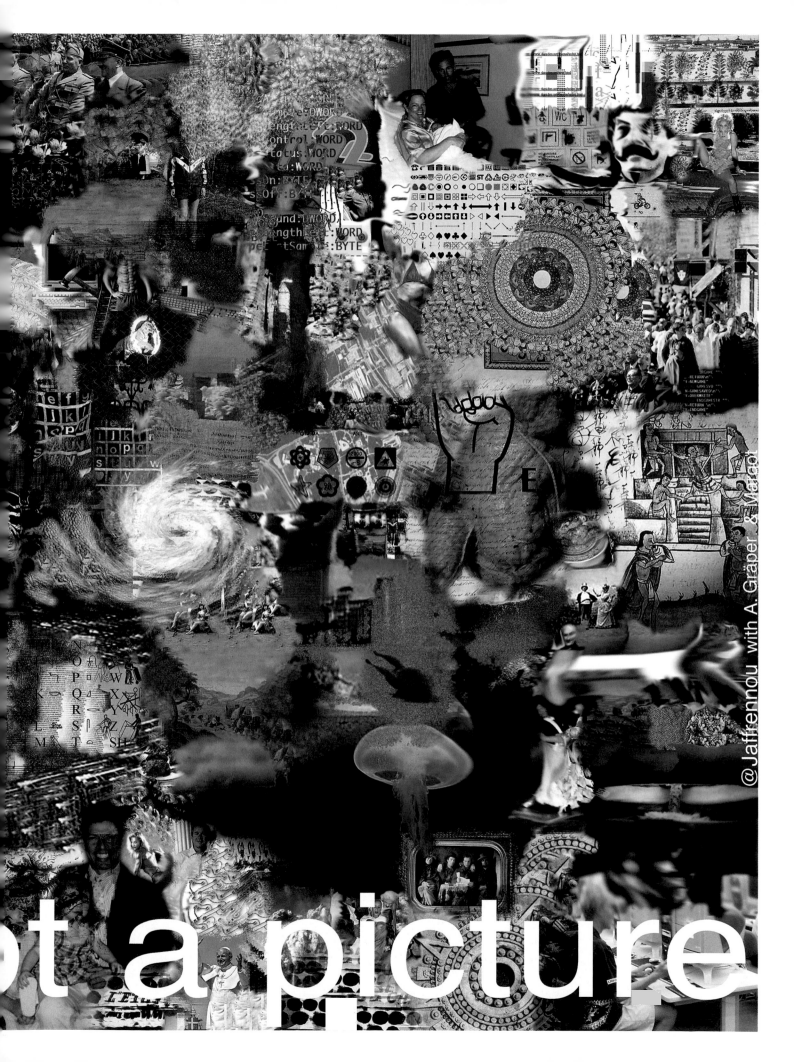

But why are you even talking to me of image or picture? This is finished. Look here at what I am using to write down, nay, to calculate, nay, to coordinate the movements of my pixels. Don't get me wrong, I love to paint and to draw and to tear down real pieces of real paper. But when I compose, I look more like an executive or an accountant: yes, we have the same spreadsheet. I do everything on Excel™. *Ceci est une image*, and yet you see nothing. Why? Because I am like the stage manager of a vast company of pixels. This group there, they look like a semi-colon in a regular text playing their boring little role of semi-colon. But I can very well instruct them and tell them that, from now on, their role in the company will change and that at noon on 3 May, they will become a flower shouting *Iconoclash!*, or an Excalibur sword or anything under the sun. Yes, why not? I just have to write that on my spread-sheet.

More than that, I can instruct my little partners to modify themselves not only in a function of the time but also depending on *who* is coming to see them. Ah ah, that's when it becomes really thrilling. In the ancient days, people said that there were many ways to look at a work of art because the "point of view" was always different. Fallacy! Naiveté! The work was still there, hanging on the wall, for all to see, untouched, unchanging. But look now, this image changes every time you come to see it, because I detect the IP number of your computer, input it in *my* calculation and, *voilà*, depending on where in the world you come from, the picture will react differently, and not only *appear* different, but *be* different. I can go further. This is my dragon project; I can modify the work of art depending on how many other viewers are on line. Even a stage manager cannot do that: modifying her play depending on whether the room is full or empty, whether people are English or German, whether they are newcomers or old hands. Who could destroy this image since it does not exist anywhere? Who could worship it since it has already disappeared? It's nothing but a set of instructions to build other pictures.

Speaking of destruction, by the way, I can also endow my pixels with actors that self-destruct at some time and under some circumstances. What do you think of that, mister Iconoclash? You buy your paintings, your engravings, you think you *own* them, you put them nicely on your wall, and hop, at a certain calculated deadline, it evaporates into cyberspace to … How could you own something that is nothing but a set of calculations? You may not even know what those lines of codes are, since something else entirely different may have been encrypted in the picture, a message to terrorists, a song, a piece of software, anything. You will see nothing at all when it zips through your tiny piece of screen. How could you destroy what you don't know exists and is thoroughly invisible – as thoroughly as this piece of Excel™ does not resemble any picture?

I know, I know, many people around the world are trying to control this flood of bits and bytes, to survive this cataclysm, this generalized decomposition, this terrifying (to their eyes not to mine) morphing of all the images. They try to multiply the copyrights, to buy large image-banks, to censor massively what one is allowed to see and not to see. But for each censor there is a large band of cyberpirates, wanks, and hackers. For the image behind I have violated three hundred copyrights! And happily so. And yet, I defend the authorship, the original work of orchestration, stage managing, spread sheet writing, code spinning. The work of art has not disappeared, nor have the artists. On the contrary, they are even more inventive than before, because they are freed from the tedious old regime of images. Nothing is left of the past. In the generalized ruins of absolute iconoclasm, more, many more, images are produced but they are collective, active, interactive, unique, time and place dependent, impossible to register, yet traceable, detectable by web crawlers – new, so very new, beautiful, so very beautiful, collective at last, so collective. |

THE THEATER OF OPERATIONS

Samuel Bianchini

The Dispⁿ Series, Interactive Images on the Web and in Installations
Sniper (1999), Keep Your Guard Up (2000), What's More With Many (2001)

DISPn IS ALWAYS PLAYED BY ONE PERSON sitting in front of the image. For its complete realization, the viewer fills the main role; it is he or she who, through his or her movements, animates the images encountered. Here, representation is first and foremost an exercise of consciousness.

Sniper confronts us with frames from a few seconds of video showing the collapse of a woman hit by a sniper. These images were extracted from the film to which this work responds: *Warshots* by the German filmmaker Heiner Stadler. Each frame is divided into twenty-five sections. Every time the viewer rolls the cursor over a section, he reveals the corresponding section of the subsequent frame. Putting different instants of the fall on the same plane, the screen is thus composed of fragments from different images. This kind of "depth of time" becomes the object of "the viewer's manipulation." Placed in a position parallel to that of the sniper, the viewer progressively sees himself or herself as being responsible for the situation and becomes fully aware of the result of his or her movements.

In *Keep Your Guard Up* (Ta Garde), two boxers fight through interposed images. Placed side by side, the same background – a still image of the ring – is doubled. A boxer appears in each image. One boxer surreptitiously moves as soon as the viewer rolls over the other with the movement of the mouse. The cursor on the right side of the screen stirs an action from the boxer on the left, then vice versa. Once understood, this mechanism remains nonetheless annoying: putting one's movement and sight out of phase; it is not ergonomic. Right. Left. Is going faster perhaps a solution? Each waits a turn to be in action, including the viewer. A three-party combat emerges. The opening directive, "keep your guard up," given to one boxer, then the other, is gradually turned around: it is equally directed at a "third person," the viewer. Prompted by the desire to bring together the two protagonists in space and time and to synchronize them, the viewer is caught in a situation that conditions his or her movements. But, as in this entire series of interactive images, he or she is far from being immersed in a credible environment; the game of putting the viewer to the test leads above all to exercising one's consciousness.

What's More With Many (D'autant qu'à plusieurs) employs a picture of two people seated on bleachers, one behind the other. Repeated like a wallpaper pattern, the image forms a crowd. As each motif is small and its colors are faded, it is difficult to date it, situate its context, or identify its bit players. Is it a historical document? A current event? A political meeting? A sports event?

Initially still, the crowd is animated when the cursor passes over each image. The person seated behind starts applauding, then the other gets up and gesticulates, raising one arm. Then it is the viewer's turn to be animated. The more he or she moves the mouse, the more he or she makes the motifs react, one after the other, creating a movement in the crowd that follows the movement of the mouse – which produces a sort of "wave" or, depending on one's interpretation, a "collective and orderly salute."

While at first the playful discovery of the process sets in motion our movements and leads us to organize them with the aim of animating the crowd, these same gestures rather quickly acquire substance – a meaning that implicates us. The ambivalence of the crowd's movement, which motivates and integrates our actions, makes us wonder about the impulses that shoot through collective situations, which are not always easy to resist. But the more the situation is played, or represented, the more our role in it is central and strongly individualized. Here, all questioning is to be taken upon ourselves and not diluted in any kind of collective lack of responsibility.

These three setups condition the movements that animate the image. Strategies of "manipulation" are implemented on both sides of this image: provisions are made for the other, the viewer, so that he or she becomes active, actualizes, and manipulates the image at his or her turn. In order to prompt viewer participation, some hypotheses have been envisaged on how deeply affective motivations can enter the game of relationships to the image. Thus, as Umberto Eco proposes in *The Open Work*, "art deliberately frustrates our expectations in order to arouse our natural craving for completion." Since the model of the loop is taken and this end is impossible, our desire for "completeness," animation, and synchronization can be endlessly revived. In these active relationships to the image, it would seem that the traditional pattern of the cinematographic storyline "situation-action" is combined with one of "displeasure-pleasure."

While these setups do produce situations in which viewers progressively see themselves as being responsible by coupling their gestures with the desire to look, any intention to make them believe, or rather to "immerse," is nonetheless revoked. The montages in the image, which are factors of manipulation, are perfectly visible as such. However, it is a return to the self that is privileged. The game of the viewer taking control of the image gives way to a second level of reading in which our movements are to be reconsidered within the context they occupy. The latter becomes apparent and can be understood as a site for negotiation with the image – that place in which we operate and by which our hold on the image can be combined with consciousness. First and foremost, it concerns intellectual and physical operations.

These propositions actively work to make the vast theater of operations – our realities – belong to us and as such replace the resigned idea of a representation already set and always imposed.[1]

Translated from French by Jian-Xing Too.

1

Many thanks to those who made the realization and presentation of these works possible: Emmanuel Méhois and Christophe Salaün for handling the programming, and Anne-Marie Duguet, Bruno Latour, Stéphane Natkin, Leonor Nuridsany, Hans Ulrich Obrist, Heiner Stadler, and the group Icono for their support.

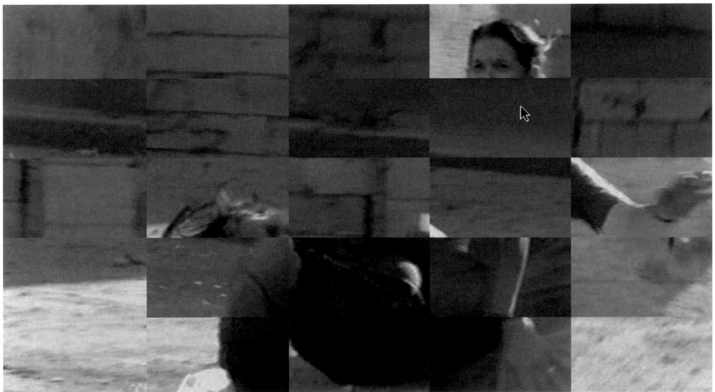

Sniper / The Disp[n] series / Interactive image on the Web and in installation. / 1999 / Samuel Bianchini / Programming: Emmanuel Méhois / http://www.dispotheque.org/sniper / Permission to use images from the film Warshots courtesy of Heiner Stadler / © Samuel Bianchini

MAY THE TRUE VICTIM OF DEFACEMENT STAND UP!
ON READING THE NETWORK CONFIGURATIONS OF SCANDAL ON THE WEB
Noortje Marres

WHEN THE WORLD TRADE ORGANISATION PUBLICLY acknowledged the presence of an impostor WTO site on the Web, it tried to make a scandal out of the uncertainty it inspired in users. The address and content of the rogue Web site are almost the same as those of the official WTO site, except for a few critical modifications. Not mentioning these sensitive alterations, however, in its statement to the press, the WTO instead made the complaint that the site confuses users.[1] They wouldn't know which is the real site and which is fake. Now it can indeed be said that, in scandals of defacement on the Web, confusion over the identity of the actors involved is the real scandal. But this is so, not just because users wouldn't be able to tell the impostor from its target, but also because, as long as the scandal lasts, the division of roles among the actors involved, really is an open question. Which of the protagonists in the scandal constitutes the real target of defamation, remains uncertain for the duration of the affair. In the debacle around the rogue WTO site, it may seem obvious that it is the organisation which stands accused; after all, it is the WTO's site which is being parodied by the rogue. However, as the WTO publicly denounced its critic, the latter may very well have become the subject of scandal. Which actor is being defamed here? As long as a scandal lives, it remains unclear which of the actors involved ultimately stands accused in the affair. And when the uncertainty is finally removed, you can be pretty sure the scandal has dissolved with it. Confusion over the identity of the accused and the accuser can be regarded as the sign of life of the scandal, as its breath or its heartbeat.[2]

The defacement of icons, of logos, and entire homepages, is one of the preferred tactics of scandal mongering on the Web. The WTO is just one entry on a long list of victims (even if, as it goes with victim lists, some of those present on it may turn out not to have been victims after all).[3] In those cases in which the defaced icon proliferates across the Web and beyond, and the target responds, a scandal of defacement is born. Of these scandals of defacement, the production of uncertainty over the identity of the actors involved can be seen as a key feature. As the defacers and the defaced appropriate each other's figures of speech (graphic and otherwise),[4] and exchange accusations, which of the actors involved constitutes the real subject of defamation remains an open question.[5] Identity games, and the production of uncertainty, which according to many define the new media, thus also play their parts in scandals on the Web. However, it would be a mistake to deduce from this that it is impossible to make any diagnosis as to the distribution of shame and blame in scandals on the Web. Perhaps the Web counter-intuitively, even as it fosters uncertainty, also provides means for its resolution. There are network configurations to scandals on the Web. On the basis of these configurations, a diagnosis of the scandal can be made, even if it is only a provisional one. Reading the network, we can find out which actor, at a given moment, stands under attack. Furthermore, it can be determined when the network stopped having a pulse, and thus the time and cause of "death" of the scandal can be established. The network can then provide an answer to the question: which of the actors involved ended up in the position of the victim of defacement, and how that happened. Such an exercise may give us an indication whether the scandal has been treated to a good life by the actors involved.

Among the many types of networks that are currently being articulated on the Web, the scandal network has a legendary status. As distinguished from the debate network or the product network, for example, the scandal network is very active but also very short-lived.[6] Scandals on the Web (just as off the Web), characteristically lead an eventful life but tend to die young, which is why they can be called the legend among network forms. In a short period of time, many actors get tied up in the network, but they disperse again not too long after. A second feature of the scandal network is that it has at its core a small set of main actors, with a much larger media scandal support system configuring around it, nourishing the scandal. Thirdly, a current of accusation can be seen to run through a scandal network, and you could say this is what animates scandals on

6 4 5 3 2 1

_ It also happened to McDonalds, Monsanto, and Microsoft, among others.

_ http://www.gatt.org The WTO's public statement can be found at http://www.wto.org/english/news_e/pres99_e/pr151_e.htm

_ Thus, in the above case, the WTO is not necessarily more original than the impostor. In its press release, "accountability" and "democracy" figure prominently – two terms which the impostor had inserted – in the orginal WTO content earlier on.

_ The sociologist Luc Boltanksi describes the modern scandal in terms of the inversion of an original accusation. Luc Boltanksi, *Souffrance à Distance, Morale humanitaire, médias et politique*, Métailié, Paris, 1993, p. 95.

_ In his introduction, Bruno Latour refers to the uncertainty about the icono-clashtic gesture: is it destructive of the icon, or does it instead transform the icon by hitting it? In scandals of defacement on the Web, uncertainty arises from the icono-clashtic encounter between multiple actors/icons.

_ Other network· forms that can be found on the Web besides the scandal include the debate – network, the product-network, the summit-network, and the program-network, among others. Descriptions of these network-forms began to take shape during *The Lives of Issues*, a series of workshops organized by govcom.org, C3, Budapest, Hungary, April to August 2001.

the Web, or at least it can serve as the sign of the scandal's on-line life. As the network reconfigures over the course of the scandal, the current of accusation typically changes direction many times, flowing from one actor to the next. The current of accusation is an alternating current, and it is in these alternations that we can locate the confusion over the protagonists' identities that is typical of scandals on the Web. As a way of resolving it, we need to track the current of accusation, and trace its direction at the various moments that make up the life of the scandal, and at the time of its death. Of course this resolution can only be temporary, as a scandal that has apparently come to an end, may become active again, and the accusation may change direction once more. This is exactly what happened in the case of the scandal of defacement that is presented on the next page, the case of the Russian hacker Dmitry Sklyarov versus the software company Adobe.

The case of Sklyarov versus Adobe as it was staged on the Web in the second half of 2001, presents an almost perfect scandal network, exhibiting all the features that make for a good webby scandal. Not only did it feature a well-articulated network, with the protagonists of the scandal solidly tied into a larger media scandal support network, but a series of moments in which the charges changed address can also be identified. The direction of the accusations reversed at least three times. At the origin of the scandal is the arrest of the Russian programmer Dmitry Sklyarov, which sparked the formation of a network in support of his case. This network then displaced the accusation from Sklyarov to Adobe: defamatory links were put out, pointing to the company as the one responsible for the arrest. Adobe's logo was defaced and its good name abused in the URLs of protest sites. Adobe, however, successfully redirected these accusations to a third actor: the law. Making a plea for the release of the programmer, Adobe teamed up with the Sklyarov support network. It thereby succesfully deflected the accusations away from itself, onto the court which had ordered Sklyarov to remain in custody. The law, however, turned the accusation back onto Sklyarov. Not by defacing the Sklyarov "logo," of course, and not by putting out accusatory links to his representatives on the Web – the law doesn't hold its tribunals on the Web. But as the news of the indictment of Sklyarov spread, and, arguably just as importantly, as the court hearings of Sklyarov kept being delayed, more and more actors left the scandal network, deserting the affair. The accusation had returned to the original adressee, Sklyarov. As the scandal-network disintegrated, the Russian programmer seemed to be the true subject of defamation in the affair.

The actors who made up the Sklyarov scandal network, even as they deserted the affair, could not really be accused of treating the scandal badly. They had stuck with the issue as long as the accusations circulating in the network seemed reversible. Unlike many other scandals on the Web, unlike those which disintegrate prematurely, and unlike those which don't even configure into networks – as is the case, for example, with the scandal of the many journalists who went missing in Central Asia over the last years[7] – this scandal could count on its protagonists. They kept it going until the accusation was beyond their reach, until it was effectively appropriated by the US attorney's Office. However, when this short piece on the configurations of scandal on the Web was actually already finished, the news broke that the court and Sklyarov had reached an agreement, freeing the programmer of charges. The grown scandal-network now showed another burst of activity. Some of the actors in the network took the opportunity to accuse the law, which was said to hereby admit its mistake of bringing charges against Sklyarov in the first place. It is possible that the scandal-network will now morph into an issue-network, re-opening the controversy about the Digital Millenium Copyright Act, the law under which Sklyarov was indicted. But as far as the scandal of defacement of Adobe versus Sklyarov is concerned, it's pretty certain it will soon die a second death, and this time it will simply and happily expire from old age. The scandal has already been treated to a good life; now it has also been granted a happy end. |

The author wishes to acknowledge Marieke van Dijk, the designer of the figures.

7

_ R. Rogers, "Media Freedom under threat, would somebody please do something ? Watching the network effect, or the lack of it," paper presented at The Life Of Issues 5, a workshop organizsed by govcom.org and the Open Society Institute, C3, Budapest, Hungary, November 2001.

INSTRUMENTS OF POWER: NOTES ON THE FUTURE OF MEDIA

Norman M. Klein

ICONOCLASH BRINGS TO MIND A FLOOD OF IMAGES spawning on TV, cable, the Web, movie theaters, billboards, palm pilots, video walls, window displays, in religion, in science. But in fact, there are fierce indications that this flow is being reduced steadily by a few giant media companies, certainly not enhanced.

Broadcast news is the apex of their authority. But they also control the distribution of most Hollywood films, and their production. And they monitor the expansion of these films across the world. Finally, they link these to modes of branding in heavy industries as well. Thus, the images appear "outwardly" to be in a state of flow and contrast; but in fact are not that. They are more inoculated than sublime, inoculated by a system that links them to global stock markets, politics, presidential elections, branding across shipping and trade, even linked to the *War on Terrorism*, etc. They seem to fluctuate widely, because these image companies are vastly over-extended, and have many needs to answer to.

The images look over-coded, and over-inscribed – to the audience – because there is no way to get all these meanings to fly inside a twenty second TV spot, or any commercial image; nor in a broadcast news hour; or a corporate logo that has to serve twelve masters at once. These are indeed chimera; twelve different animals in the same body. We must not see them as molecules breaking apart, in a state of fission. Instead, what looks to us like "flow" is the integration of these many global investments into the sign system of entertainment and news. We, as the consumer audience, may be "asked" to interact freely inside all this; but in fact, the flow is a much more cybernetic, much more restricted experience.

Thus, the tradition of iconoclash, of the democratic flow of images that we associate with capitalist media – and see reinforced by the Internet – may indeed be hiding something much more hazardous than feeling your head dented by information overflow. We as critics need to find tools to distinguish that difference: that the appearance of a neutral system is, in fact, something much more like a friendly, neutral, but peevish guard dog. When it growls, we notice that its leather muzzle is torn. Yes indeed, there is a pinball effect that these images seem to set off. There are those silly collisions – flow. But they collide because this system is indeed chaotic, a scrambling for authority and control of markets by very, very aggressive image companies.

Thus, we face new challenges in the next century, in the economy of signs. There is a myth that simulation or floating signifiers somehow represent the death of meaning; in fact, they are not floating at all. Only the image companies, and their fragile modes of over-investment are floating – like kingdoms beyond the control of any government.

We briefly imagine a history for all this, beginning in the late 1960s, tracking the extraordinary growth in "sovereignty" that media has achieved, at least in the United States. Then we imagine a takeoff for this growth, by 1990 or so. And finally, we notice how much this authority has matured by 2000 and 2002. Of course, it is too early to identify what its final trajectory will be.

But one distinction is very clear: image companies are turning into instruments of power, specifically media giants like AOL Time-Warner, Bertelsmann, GE/NBC, Vivendi, Disney. By contrast, traditionally, when a newspaper or TV news program simply, bluntly, parrots the government line, we can say that it is *representing* power. The show *stands in* for the government line, like a metonym. However, when an AOL or a Viacom owns the TV network, it can bargain at the table with the president and the cabinet – as another broker. AOL must surely be called more an *instrument* of power, quite a different matter. It is a sovereign state, composed of dozens of companies. It bargains like a feudal lord with its own army, setting terms outside the city walls, like a World Trade Organization pulling strings from outside the normal reins of the state.

For example, Congressman Henry Waxman has tried to force NBC to release a tape that, according to media legend,

shows General Electric C.E.O. Jack Welch ordering NBC, one of his divisions, to declare George W. Bush the next president before the final count on election night in 2000.[1] However, a mere congressman has no authority over the global sovereignty of General Electric, even less now than just five years ago. Since 1996, with the new Telecommunications Act, all oversight over media mergers and media corporate policies has eroded even further. Over fifteen large media buyouts followed within a few years, involving General Electric, AOL Time-Warner, Murdoch's News Corp,[2] Disney, Viacom, Bertelsmann, Vivendi, and more. The sovereignty of American media giants now standardly exceeds the borders of the United States.

General Electric also co-owns NBC with Dow Jones, who, in turn, own *The Wall Street Journal*. Thus, the primary allegiance for NBC, as with all "honest" media corporations, lies with global stock markets, with shareholders more than with the news itself. It is hardly surprising to see how much time focuses on stock markets, on shows at CNN, Fox News, CNBC, MSNBC. And the glamorizing of Wall Street has clearly had its instrumental effect. Nearly half of all American households now own stock,[3] compared to ten percent in 1965.[4] Some of this increase is generally credited to cable business shows.

Of course, the term "instrument of power" is hardly new; only current. Print media have operated as instruments of power in the past, particularly by the end of the nineteenth century. The War of 1898 was called "Hearst's War." William Randolph Hearst clearly sat at the table with Morgan, Rockefeller, and Vanderbilt. But for newspapers in the US, the *instrumental* use of power was usually more evident on the local level. In Los Angeles from 1890 well into the 1940s, the *Los Angeles Times*, led by General Harrison Gray Otis and his son-in-law, Harry Chandler, spear-headed real estate juggernauts, led in union busting, dominated city policies and tourist advertising (boosterism), set up the largest aqueduct

of the age (1913) and initiated the aeronautics industry. The Chandler family were the central of the wheel for blue-book Los Angeles, often as if the city were a family business. Much of that is gone now. First, in the 1960s, Otis Chandler softened the political conservatism and nativism of the paper.[5] Then over the past twenty years, the Times Mirror Corporation lost out to more globalized media, lost much of its advertising revenue, then was absorbed into the (Chicago) Tribune media empire. It is now mostly an outpost, a voice rarely answered.

When the LA Times breaks a story today, like the scandal in November 2000 about people voting up to four times for president, it rarely makes it to any broadcast news at all. The tree simply falls unheard, without follow-up. *The LA Times* news bureaus have been scaled back, steadily downsized over the past decade. Print media increasingly lacks the resources, or the will, to keep a national story alive, not if broadcast news will let it die. The age of anti-Watergate print crusades is over. National stories can only really be sustained by global media. In 1968, I remember the expression: "The whole world is watching," at the Democratic Convention in Chicago, where the media was practically anti-war, very independent. We compare that to recent American media coverage of the anti-WTO demonstrations. Clearly, nothing as unregulated as 1968 will be possible again in the United States.

Of course, there are cracks in the armor. The instrument of image flow may occasionally get caught unprepared. When a shocking event catches CNN by surprise, the announcers look genuinely dumbfounded for a while. We momentarily see unlikely guests showing up, experts who owe nothing to global companies or national politics. We also see visuals that look more raw than usual, a little more blood and misery at the dinner hour, a bit more acid reflux. There were flashes of surprise in LA in 1992, but not as many as people imagine.[6] There were similar flashes for a few days after 11 September 2001, but again, not for long. All at once, the veal is cooked

4 3 2 1 5 6

_ Ted Hearn, NBC's Lack Clashes with Waxman over "Election Night Tape,"
Reportedly Shows Network Interference, in *Multichannel News*, 31 July 2001;
see also www.freepublic.com/forum.

_ Equity Ownership in America, in *Securities
Industries Association (SIA)*, 1989,
see www.sia.com.

_ See Norman M. Klein, *The History of Forgetting.
Los Angeles and the Erasure of Memory*, Verso,
London, 1997, pp. 278-285.

_ Rupert Murdoch was particularly aggressive after the Federal Communications Act
was passed. See Geraldine Fabrikant, Murdoch Bets Heavily on a Global Vision:
Despite the Risks, News Corp. Pursues and Aggressive Expansion, in *New York Times*,
26 July 1996.

_ Ben Wattenberg, The First Measured Century, in
Washington Times, 7 December 2000.

_ See Robert Gottlieb and Irene Wolt, *Thinking Big: The Story of the Los
Angeles Times*, G.P. Putnam's Sons, New York, 1977. This book proved
an embarrassment for the Chandler family, who, even at that late date,
pressured to have further editions stifled.

Whenever I put this out to digital culture workers, they chuckle knowingly. They know that computer software is often a false friend. It corrupts, freezes, forgets, boxes you into corners. It is not at all the clean plastic efficient box it appears to be.

(5) Global media is also a form of architecture, yet another force that can be de-stabilizing, based on mutable spaces and the industrialization of impulse. Many media giants are deeply invested in entertainment spaces, of course, like Disney, Vivendi, AOL Time-Warner. And Sony leads in computer game production, over 50 percent of all game software – the virtual space as imaginary death, like a roller coaster ride "flowing" in your house. Sony also continues the long marriage between war, the military, and media imagery – the architecture of simulated death, in science, entertainment and surveillance systems.

(6) The image flow is often a Jeremiah passing puberty, over and over again; or even a Cassandra. Often, the media images, quite accidentally (or is it epistemically) predict the coming of disasters. The classic example in 2001 was the architectonic bombings in the movie *Independence Day* (1997), that haunted TV audiences for the first half hour of 11 September, especially when the second plane cinematically punched through the World Trade Towers; and the dust poured into the screen.

(7) But I have spent a few days rounding up predilective examples of other kinds, from the image flow of computer games in particular:

In 1999, the Jane company, famous for its military encyclopedias, announces Jane's Games: "To get access to military intelligence like we do, you'd have to be a spy."

"Fly the Ultimate Flight Simulator," offers Terminal Reality: an airplane soars toward an imaginary destination, or target; "If reality had a patent, we'd own it."

Similarly, with *Falcon 4.0*, you are "raking up the kills ... (for) the greatest sense of playing a small but important part of a huge battle."

Then, after the tragedy of 11 September, the computer games industry noticed that this bravado seemed out of place. *PC Gamer* magazine answered charges that a flight simulator game (from Microsoft) may have helped the terrorists learn how to crash a jet, by saying that the architecture generated by global games should not be blamed. I empathize, of course: the censorship of violence can get nasty and truly violent. There I agree. Certainly, a flight simulator did not inspire or train anyone to be a terrorist. Instead, it gave us something more like a rapture, the warm bath by a screen, an immersion into sim-death. The MSM Flight Simulator 2000 was simply another example of global media having it both ways – glorying in comfort or trauma (either version of death is fine), knowing that toy sales hold up in times of recession and trauma. As one toy marketing executive explained: "During recessions, the toy category holds up pretty well (a little over $300 a year per child)." Even if both adults in a household have lost a job, "parents don't like kids to feel the pain."[10]

But what if the pain is national and sudden? Speaking for *PC Gamer* soon after 11 September, the sim journalist Andy Mahood defended the $7 billion interactive entertainment industry, or at least the right to have images flow as cathartic violence: "Sensationalistic reporters after showed no shame in implicating flight sims in the terrorist attacks ... (But) to suggest that there is *any* relationship to the *Flight Sim* series is a pathetic effort to get on TV and rally up some scare mongering, with no point, no focus, and no worthwhile conclusion."[11]

Here is a game moment, a moral high ground; but then the fun architecture of war as puberty takes over. Throughout the same issue of *PC Gamer*, I found ads about blowing your wad, or the world, on your computer. Media must have it both ways, war hyperbolizes puberty. On the cover, I saw Tom Clancy's *Ghost Recon* featured as "the mightiest military on Earth ... The best tactical shooter EVER!" In *Ghost Recon*, you find "toys for Big Boys ... because you're in the Army this

11

10

_ Andy Mahoud, The Sim Community Responds, in *PC Gamer*, vol. 8, no. 13, Holiday, 2001.

_ Tobi Elkin, In a Time of War, Play: Toys hold steady as escapism becomes priority, in *Advertising Age*, 12 November 2001, p. 4.

time around." You won't have to worry about law-enforcement concerns like rules of engagement or civilian hostages. The *Call of Duty* demands: "Before I go on, let me hear your war cry! That's not a war cry. Arrrghhh! Now that's a war cry!" The game *Counter-Strike, Condition Zero* offers solace to lonely boys (I was one of those), because "Now you can play *Counter-Strike* even if you don't have any friends." Then *Civilization III* fails to deliver enough mayhem: "You'd think that my tanks would just roll over those Chinese horsemen. Sadly that isn't the case ... (and) if your people tire of your antics, they'll get pissed off and start rioting. Those fools."

But you can take charge as *Mech Warrior*, "assemble (your) troops," launch "real firing missiles." You can even "choose your clan, construct your Mech, and become the fearless MechWarrior you've always wanted to be." What a strange pubescent cognate to the opening months of the War on Terror, for a war that began with battle scenes as a green inscrutable haze on CNN, during the media blackout of the first month.

(8) Then, we have the bizarre urgency of surveillance as fun, the image flow in Reality TV, in tinier and tinier cameras, in the sex industry. If I wanted to get cute about surveillance, I suppose I could point out how, in 1997, the word Disney turned officially into a transitive verb for urban planning. You Disnify old streets in industrial cities by converting them into outdoor malls, like Times Square. Tuck point the buildings, shine up the hallways. The urban core becomes much more comforting that way; and more conservative, like a Disney park; and more expensive (even lavish), smartly suburbanized, deodorized; most of all, Disnified urban core, with all its Baroque overlapping of real city streets with cinematic (or cine-fied) architecture (architainment, as they call it in Vegas). The sum of all this has to be a prime example of iconoclash. The Disnified urban core turns city-dwellers into tourists in their own city, makes them consumerati, like shoppers on the Corso in Rome. And it also bumps up the rents. Furthermore, by Disnifying a street, you turn surveillance, so needed these days, into pedestrian fun. Even in the late 1990s, people sensed that the next stage of global media had to deliver more surveillance, as a comfort zone. Cutesy surveillance across many American and European urban cores was clearly a laboratory for new ways to marry war with entertainment. Homeland Rule will have to Disnify eventually, do something cute to airports in particular, get the images "flowing." Perhaps the next challenge for globalized image flow is to make it more sculptural, and more a scripted space in real streets.

These Disnified comfort spaces will become prosthetic, architectonic instruments of power in the most direct sense – isolating the classes, turning the policing of social class into an aromatic vanilla and chocolate candy store. A Disnified street is a monument to the sense of hierarchy, a different use of place. It has to find comfort zones for the widening class structure. Disnified spaces make the neo-Victorian or Baroque hierarchy easier to take. We in the US are going to have to get used to places that are even less democratic than usual, inside media where classes can mix, but know their places.

In Los Angeles, another monument to image flow opens. Image companies have finally become, for the first time in LA's history, the largest employer in the city, more than aerospace, defense, oil. That makes monuments inevitable, for a city that does not preserve movie sets, locations, movie studios. This one is an homage to the Oscars, to be presented in a vast mall to the moviegoer on Hollywood and Highland Boulevards – something pharaonic, or should I say Syrian? The Babylon set from Griffith's *Intolerance* has been rebuilt as an electronic Babel, an arch de triomphe to movie special effects.

(9) Finally, image flow restricts images. Iconoclash and iconoclasm meet. Stockholders for *The New York Times* meet in January 2001, to force the paper to kill a story showing that Gore won Florida. Microsoft buys image databases for modern art, in order to reduce them, and maximize profits by

scanning in only a small number. Rupert Murdoch buys the encryption technology that is put in every television set in England, to force all broadcasters to pay a fee to his News Corp.[12] His media investments in China are so vast, his Fox news network must censor much of its China coverage.[13] And finally, after 11 September, the media systematically ignores the opposition to Bushism, described as only "small pools of dissent."[14]

Despite some rise in foreign bureaus during the Afghanistan campaign, big media will likely keep reducing its staff. At CBS news, that has been going on since the early 1980s; with a hundred more employees fired in 1998;[15] CNN, after the merger with AOL, fired 400 staffers, and shrank its international coverage.[16] That seems the trend – more of the talk show format in the studio, more restriction of images, a format pioneered by Murdoch's Fox news – more chatting, also to catch the weaker attention span of the young MTV viewer. Similarly, how much is big media responsible for making Osama bin Laden a virtual Mohammed, in the words of journalist Farai Chideya, "the bearer of all the world's gaze; the first celebrity of the age of globalization."[17] It is indeed an amoral calculus, this image flow; it creates monsters of all kinds, like an all-purpose feudalism posing as a democratic flow of images. |

12 14 15 13 16 17

_ Media Access and Media Power, in www.media-in-transition.mit.edu/conference.

_ Pushing the Media Right, in
Working for Change.com, 12 November 2001. _ Mark Crispin Miller, Can Viacom's Reporters Cover Viacom's
 Interests?, in Columbia Journalism Review, November/December 1999.

_ Farai Chideya, Visual Warfare: Reflections on 11 September and Media Culture, in www.papandpolitics.com/articles. There were also various articles on bin Laden or Al
Qaeda in Afghanistan before 9 November, for example: Jeffrey Goldberg, Inside Jihad: The Education of a Warrior, in New York Times Magazine, 25 June 2000.

_ Neil Hickey, CNN After the Merger, in Columbia Journalism Review, June, 2001. By 1997, CNN found itself in a doldrums, the
beginning of a slide in viewership that has been reversed since 11 September. Jim Rutenberg, CNN is Seeking New Strategy,
in New York Times, 31 August 2000. See also: Bill Carter, A Nation Challenged: The Coverage; CNN Returns to its Element but
Faces High Expectations, in New York Times, 22 October 2001.

_ Murdoch and China are frequently cited, i.e., Frank Vogl, Journalism and Power: Why Ownership
Matters, in World Bank, consultative meeting, 9 May 2001. See also www.mediachannel.org.

Can we go beyond the image wars?

THE DEVICES OF ICONOCLASM

Simon Schaffer

The Magic Toyshop

"All children talk to their toys. The toys become actors in the great drama of life, reduced in size by the *camera obscura* of their little brains. The child twists and turns his toy, scratches it, shakes it, bumps it against the walls, throws it on the ground. From time to time he makes it restart its mechanical motions, sometimes in the opposite direction. Its marvelous life comes to a stop. The child, like the people besieging the Tuileries, makes a supreme effort; at last he opens it up, he is the stronger. But where is the soul? This is the beginning of melancholy and gloom."

CHARLES BAUDELAIRE[1]

It seems too hard to envisage an exhibition about iconoclasm, easier to stage an iconoclastic show. An iconoclastic show would break our favored icons to show them as artifacts, unworthy of admiration. An exhibition about iconoclasm, on the other hand, would show how this breaking works. But how? It seems the iconoclastic argument must go like this: what's made is inauthentic; those who devote themselves to icons seem unaware that their icons are made; showing the process of making undermines the cult. So, as Baudelaire might have put it, iconoclasts childishly "twist, turn, scratch and shake" the image until its "marvelous life comes to a stop." The aim is to demonstrate that there is no soul in these constructs. The shifty vocabulary of construction helps this argument to work. A host of terms slide quite easily between making something and cunningly passing it off. Fabrication, fashion, cookery, confection, and forgery all refer to the production of such mundane commodities as cloth, metal, or food. They also signal something suspect, the deceitful enterprise of the fake. They help the move between fashioning facts and feigning fictions.

Yet there's something weird about this reasoning. The devout are not dumb. They know their icons are made and how to make them. The gloomy iconoclast underestimates the possibility of pervasive double vision. Icons can be seen simultaneously as artifactual and authentic, as factitious facts.[2] Different terms are needed to make sense of this kind of dichotomous optical mechanism. Here we'll encounter such eloquent notions as "fetish" and "artifact." Consider, too, the word "device," which finds its origin in the older word "division," or appropriate arrangement, and by the Renaissance and Reformation already meant both "ingenious machine" and "significant emblem." This significant link between devices of machinery and perception was the insight of Baudelaire's mid-nineteenth century metaphysical meditation on infantile toys, which moved between the camera obscura and the automaton. Such devices could persuade their viewers that the inanimate was alive, yet they were evidently machines, curiously taken to bits by those in search of their spooky animating principle. Nothing different was happening, Baudelaire guessed, in the political struggles which wracked the age of high capitalism or along the plush boulevards where commodities went on show and sale. For Baudelaire, as for many other strolling observers of commodity culture, the shop window became emblematic of this uncanny but familiar way of seeing. "Is not the whole of life to be found there in miniature," he asked, "and far more highly colored, sparkling and polished than in real life?" The whole of life was there, yet not really there at all. This is the characteristic situation of the icon, and gives a useful clue for any exhibition about iconoclasm.

The vocabulary, design, and principles of exhibitions of technological and artistic artifacts were borrowed from and immediately informed Baudelaire's street life of department stores and journalism. Only a few years after his "philosophy of toys," the Paris critic reported on the new industrial religion of "sun-worshippers," with Daguerre as its Messiah. Photography, so Baudelaire notoriously reckoned, satisfied "the idolatrous mob" whose creed demanded "the exact reproduction of Nature." The graphic press, the department store, and

1

2

_ Bruno Latour, *Petite réflexion sur le culte moderne des dieux faitiches,* Collection Les Empêcheurs de Penser en Rond, Paris, 1996, pp. 35-43.

_ Charles Baudelaire, The Philosophy of Toys (1953), in *The Painter of Modern Life and Other Essays,* trans. Jonathan Mayne, Phaidon, London, 1995, pp. 198-204.

the museum exchanged techniques and philosophies with from each other. Each insisted upon the virtues of the show of commodities, "the training of the gaze."[3] A principal technique of classic museums, the glass case, was first adopted from elegant shops, and then deliberately reappropriated by new, mid-nineteenth century department stores to mix commerce, publicity, and instruction. Objects were supposed to be activated, to speak their messages and communicate their values. This was how commodity fetishism got mixed up with the work of science. It is significant that so many science shows rely on visual illusions, sanctified by the long tradition of natural magic: Benham's disc, Goethe's shadows, Bernoulli blowers, kaleidoscopes, Chladni figures. Baudelaire himself singled out for special comment what he called "scientific toys," such as stereoscopes and phenakistiscopes, the precursors of cinematography among modish optical machines for turning fixed images into moving dramas. "They can develop in the childish brain a taste for marvelous and unexpected effects." Like many other spectators, Baudelaire was fascinated by the ingenuity through which the optics of machinery worked. The trick of these scientific devices was to suppose that spectators were in the presence of the phenomena themselves, stripped of all need for mediation. Yet the show must be backed by devices machined to such effect that it could easily be imagined that "the whole of life is found there in miniature." The ingenious combination of machines and images was seen as factual and as artifactual. In some showcases, machines were used to make images; in others, images were there to evoke the workings of machines. The whole exhibition space allowed this intriguing kind of split optics, shifting constantly between insights into labor-processes and glimpses of products.

Bruno Latour has proffered the term "artifact" to capture this crucial relation between what is made and what exists. In laboratories, artifacts are intrusions mistaken for new things: "the artifact surprises because human agency is

Francis Bacon, Instauratio Magna, London, 1620, title page / © University Library, Cambridge

found just where it was not expected." Latour's favored example comes from Hergé's Tintin who, mistaking the laws of optics, took a spider trapped in a telescope tube for a star threatening the earth. Tintin's experiences have a perfect seventeenth century precedent. In 1670, the English wit Samuel Butler composed a verse, *The Elephant in the Moon*,

3

_ Charles Baudelaire, *Art in Paris 1845-1862*, Jonathan Mayne (ed.), Phaidon, Oxford, 1965, p. 152; Ségolène le Men, La science enfantine et l'apprentissage du regard, in *La science pour tous*, Bruno Beguet (ed.), Réunion des museés nationaux, Paris, 1994, pp. 61-71; Chantal Georgel, The Museum as Metaphor in Nineteenth Century France, in *Museum Culture: Histories, Discourses, Spectacles*, Daniel Sherman and Irit Rogoff (eds), Routledge, London, 1994, pp. 113-122.

satirizing Fellows of the Royal Society whom he imagined mistaking a mouse in their optical device for a lunar leviathan.[4] Indeed, it is the epoch of the early Royal Society, its heroes and its critics, which developed many of the devices of image making and breaking. Then, enterprises in religion, the sciences, and the arts were entangled with each other in the work of optical ingenuity and its philosophy. So the show that follows offers three iconic figures who then plied their trade in devising imagery and smashing idols. Francis Bacon (1561-1626) judged that there were idols implanted in the mind of fallen humans and designed a utopian program for socially reorganizing the making of knowledge. Thomas Hobbes (1588-1679) reckoned that idolatry led to divided power and political strife. He taught a better way of seeing bodies and so a better way of making the state. Isaac Newton (1642-1727) loathed idolatry as the worst corruption of religion. He held that an improved natural philosophy of light and matter would destroy the idols' power and restore true faith. All these English Protestants represented themselves as iconoclasts, yet all devised new icons for political, religious, and scientific reform. All used complex optical devices to understand the origin of idolatry and its cure. All projected new forms of social order to secure their world.

These three protagonists broke the bounds of nature and art. They made no definitive distinction between the artifact and the real. This is what has given their enterprises modern resonance. Bacon's utopian schemes are now often seen as fictive versions of cabinets of wonders, where artifice was used to alter and unmask the natural order. His shows have thus become important precedents for exhibitions of image-making and image-breaking seen in a doubled optic. These notions of multiple perspectives are worked out, too, in the projects of modernism. As preparation for *The Large Glass*, Marcel Duchamp studied greatly the work of the seventeenth century optical expert Jean-François Niceron for devices of visual illusion. Significantly, Niceron was also the immediate source for Hobbes' design of his icon of the state, the Leviathan, with its many bodies visibly combined into one.[5] Newton's vision is the most telling case here. After completing his attack on idolatry and his overhaul of optics, he ran the Royal Mint, thus taking charge of the key system of emblematics in national commerce. There, the fetishism which Europeans situated on the Gold Coast, whence their precious metal flowed to the mint, became an indispensable way of understanding commodity culture. Newton's Mint, like Bacon's Salomon's House and Hobbes's Leviathan, were parts of complex systems where mechanism and imagery were in constant intercourse. Portraits were engraved, coins stamped, lenses ground, and automata devised, in order to show the right and wrong ways of assigning value to things. Then as now, making emblems with machinery and making emblems of machinery were key devices in the image wars.

The Enchanted Glass

> "The mind of man is far from the nature of a clear and equal glass, wherein the beams of things should reflect according to their true incidence, nay, it is rather like an enchanted glass, full of superstition and imposture, if it be not delivered and reduced."
>
> FRANCIS BACON[6]

Seventeenth century experimenters described Francis Bacon as a kind of Moses, a prophet who had led them to the promised lands of the sciences by freeing them from the idols of tyrannical pedantry. The Baconian Exodus had its own iconography. He chose as the symbol of his "great instauration" of the sciences a ship sailing through the Pillars of Hercules under the slogan "plus ultra" (further onwards).

He borrowed this device from the emblem of the universal Spanish monarchy, the pre-eminent global network of his age. Bacon imagined the alliance of worldly travel and keen

4

_ Latour, op. cit, p. 44; Samuel Butler, The Elephant in the Moon, in *Hudibras and Selected Other Writings,* John Wilders and Hugh de Quehen (eds), Oxford University Press, Oxford, 1973, pp. 195-208.

5

_ Horst Bredekamp, *The Lure of Antiquity and the Cult of the Machine,* Markus Weiner, Princeton, 1995; Stephen Jay Gould, Rhonda Roland Shearer, Drawing the Maxim from the Minim: The Unrecognized Influence of Niceron's Influence upon Duchamp, in *Tout-fait: the Marcel Duchamp Studies Online Journal,* 1, 3, 2000, www.toutfait.com.

6

_ Francis Bacon, *The Advancement of Learning and New Atlantis,* Arthur Johnston (ed.), Clarendon Press, Oxford, 1974, p. 127.

surveillance as key for the advancement of knowledge. An active promoter of England's colonial enterprise in the Americas, when he invented an ideal society to embody this alliance, he deliberately set it in the Spanish ocean, the Pacific.[7] Somewhere out in the South Seas, well away from the trade routes that carried the Spanish gold and silver fleets between America and Asia, there was an island called Bensalem, cut off from commerce with the outside world, but inhabited by devout Christians who fled there after the Deluge. There stood Salomon's House, a glorious institution devoted to "the knowledge of causes and secret motions of things, and the enlarging of the bounds of human empire, to the effecting of all things possible." Bacon first described this fictitious place in his posthumously published fantasy *New Atlantis* (1627). The aim of the thirty-six Fellows of Salomon's House, he reported, was to discover the true nature of the things God had taken only six days to make. The point of the Fellows' labors was to recapitulate divine manufacture, for one could only know what one made. This was why Salomon's House was also known as the College of the Six Days' Works. The College had a lot of optical machinery, large houses where "we make artificial rainbows, haloes and circles of light." In order to master creation, the Fellows engaged in artifice. Their artificial products included frank forgeries. "We have also houses of deceits of the senses, where we represent all manner of feats of juggling, false apparitions, impostures, and illusions, and their fallacies. We could deceive the senses, if we would disguise those things and labor to make them seem more miraculous." But, the College's leader explained, "we do hate all impostures and lies." Even though they were masters of deceit, Fellows were forbidden to "show any natural work or thing adorned and swelling, but only pure as it is, and without all affectation of strangeness." Here in the Baconian Utopia was precisely the double vision of all iconophiles: a devotion to apparitions mixed with an insistence on immediacy. Double vision went with a double kind of science: an

Thomas Sprat, History of the Royal Society, London, 1667, frontispiece / © University Library, Cambridge

enterprise to make artificial devices in order to understand natural systems not made by human hands.[8]

Bacon's project was taken as an ideal by the experimental philosophers of seventeenth century England. Experiment was a troublesome business. It involved a kind of hazardous wager on the outcome of a complex engagement with the world. This is why the cognate terms of experiment, such as trial or test, evoke notions of danger. To reduce the risks, experimenters sought to manage their environments. They assembled putatively robust equipment, the function of which was well enough to allow sure inferences from the experiment's outcome. They constructed spaces in which the

7

8

_ Serge Gruzinski, Les mondes melées de la monarchie Catholique, in *Annales: Histoire, Sciences Sociales*, 56, 1, 2001, pp. 85-118; Peter Linebaugh and Marcus Rediker, *The Many-Headed Hydra*, Beacon Press, Boston, 2000, p. 33.

_ Bacon, op. cit., pp. 240-245.

experiment was to be conducted, marked by boundaries designed to bar disturbances and exclude intruders. This made experimenting seem rather a cloistered enterprise where society was excluded and nature let in: hence the appeal of Salomon's House, a remotely secured institution where nature could be remade. But seventeenth century experimenters also had to arrange for the presence of equipped and reliable collaborators, such as artisans whose labors would make the trials run, and witnesses whose status and testimony to the good conduct of the experiment would help make it count. The gesture of experimental philosophy was, therefore, strikingly doubled: one might trust the experiment because of social facts, such as the enormous labor and specifics of layout in the house of experiment; yet one should trust the experiment because of natural facts, since it did not truly rely on labor nor layout, but on nature itself. The experimental philosophy was anything but insular. Its success relied on the strength and number of linkages between the settings where trials were to be conducted and the milieu of patronage and commerce, engineering and empire.

Outward display mattered a great deal. Bacon's own secretary spent the 1630s designing ingenious optical marvels to entertain royal visitors with the sights of artificial rainbows and lightning. By the late 1650s he and many other experimental philosophers were proposing real versions of Salomon's House. In the 1660s a couple of early fellows of London's new Royal Society commissioned from the Bohemian artist Wenceslaus Hollar an engraving showing the imaginary origins and triumphs of experimentation, linking monarchy with philosophical fame.

A Baconian apotheosis was planned. Optical instrumentation occupied pride of place. In the foreground, the angel of fame crowned an icon of the newly restored monarch, Charles II, set impressively between the Royal Society's president and Francis Bacon himself. Bacon's Salomon's House had been adorned with statues of heroes of the arts and sciences, those who had invented writing and printing, music and glass, wine and silk, bread and sugar. "These statues are some of brass, some of marble and touchstone, some of silver, some of gold." For Bacon, as for his devotees among the Royal Society, icons of invention formed a pantheon. This was the message of Thomas Sprat's *History of the Royal Society,* released in 1667 with Hollar's picture as its frontispiece. The

Jean-Franççois Niceron, La perspective curieuse, Paris, 1638, title page /
© University Library, Cambridge

icons showed how the catastrophic effects of the fall had been reversed. In Eden, Adam had sensed all facts directly, including the earth's orbital motion and the circulation of his blood. One enthusiastic Fellow of the Royal Society made the point: "Adam needed no Spectacles. The acuteness of his natural optics showed him much of the celestial magnificence and bravery without a Galileo's tube." Experimenters were confessedly of the fallen, so they needed instruments. But armed with these tools they became regenerate, and, according to some, would see what Adam saw. Figured mirrors and lenses could, so it was claimed, provide new knowledge of microcosms and macrocosms.[9] Adam's learning was immediate, paradisiacal knowledge, lost forever. But it could be recaptured in a new form through artful machines. The inventors of these devices had, through the history of the sciences, slowly returned humans to paradise.

In Christian Europe, this was a very bold claim. It made experimental philosophers' task a version of divine redemption. Sprat reckoned Christ's miracles were "divine experiments." It was not hard for the experimenters to convince their flocks that human optics were imperfect. In I Corinthians, St. Paul had preached that "now we see through a glass darkly" and only in heaven would direct vision be at last achieved. The fifteenth century German cardinal, Nicholas of Cusa, used the lenses of eyeglasses as an analogue of the way God might be present in earthly things. The great Reformation philosopher Philip Melancthon reiterated that the image of God in man was originally "contaminated" and would be "renewed by the Word of God through the Holy Spirit." The Huguenot logician Pierre Ramus used a very similar image of a tarnished mirror in need of re-polishing before it could properly reflect the world. The technologies of mirrors and lenses were long associated with matters of credulity and faith. Specters haunted the new optical world of Reformation Europe in the shape of dreams and demons, idols and false lights. Shrines shone with a divine aura; iconoclasts

Jean-François Niceron, La perspective curieuse, Paris, 1638 / plate 25 / © University Library, Cambridge

sought to change the way the faithful saw these seductive shows. Devout pilgrims could even buy mirrors to capture and take home with them the divine rays emanating from the holy relics of the saints. One seventeenth century Dutch natural philosopher boldly guessed that Satan, well known as an expert in optical science, had been able to show Christ all the kingdoms of the earth simply because he had a telescope, well before Galileo had made his own spyglass.[10]

9

_ Thomas Sprat, History of the Royal Society, J. Martyn and J. Allestry, London, 1667, p. 352; Edgar Wind, Pagan Mysteries in the Renaissance, Penguin, Harmondsworth, 1967, pp. 222-223; Sachiko Kusukawa, The Transformation of Natural Philosophy: The Case of Philip Melancthon, Cambridge University Press, Cambridge, 1995, p. 96; Ernest Gilman, The Curious Perspective: Literary and Pictorial Wit in the Seventeenth Century, Yale University Press, New Haven, 1978, p. 167; Svetlana Alpers, The Art of Describing: Dutch Art in the Seventeenth Century, John Murray, London, 1983, p. 17.

10

_ Joseph Glanvill, The Vanity of Dogmatizing, Henry Eversden, London, 1661, sigs. B2v-B4v and pp. 5-9; Michael Hunter, Science and Society in Restoration England, Cambridge University Press, Cambridge, 1981, pp. 194-197.

It was a specifically Protestant notion that idolatry, based on bad optics, was a pervasive and almost ineradicable fault, as common among Christians as the heathen. Bacon and his disciples agreed, but offered hope of adequate perception here on earth by joining the society of experimenters. Bacon insisted no "clean and polished surface remains in the mirror of the mind on which the genuine natural light of things can fall." The fallen human mind was an "enchanted glass," and "all the approaches to men's minds are blocked by the most obscure idols, idols deeply implanted and burnt in." Through the work of experiment and its visual machinery, the enchanted glass could be demystified and the idols finally broken.[11] This optical salvation was to be bought at a price. Instead of the immediacy of Pauline redemption, experimenters needed machines. These devices were necessary, because of the idolatry of fallen humanity; and effective, because of the clever mechanisms of seventeenth century optics. Idols were not abolished, but swapped for better ones. Hence one of Bacon's French admirers, the witty savant Bernard de Fontenelle, explained at the end of the seventeenth century that "all philosophy is based on two things only: curiosity and poor eyesight. True philosophers spend a lifetime not believing what they do see, and theorizing on what they don't see and it's not, to my way of thinking, a very enviable situation."[12]

The Artificial Man

"Those Idols of the brain, which represent bodies to us, where they are not, as in a looking-glass, in a dream, or to a distempered brain waking, they are (as the Apostle saith generally of all idols) nothing; nothing at all, I say, there where they seem to be; and in the brain itself nothing but tumult. And men, that are otherwise employed, than to search into their causes, know not of themselves what to call them."

THOMAS HOBBES[13]

Thomas Hobbes, erstwhile secretary for Bacon, agreed that poor eyesight was a major problem. He reckoned "the fear of things invisible" was a principal cause of civil war and tumult in the body politic. Division of authority was fatal to good order. He traced the origin of this division of authority to false optics. Hobbes claimed the vulgar wrongly judged that bodies were what they could see. This meant they attributed materiality to "Idols of the brain, which represent bodies to us where they are not," and they attributed spirituality to air, wind, or breath. "As if one should say, he saw his own Ghost in a Looking-glass or the Ghosts of the Stars in a River and by that means have feared them, as things of an unknown, that is, of an unlimited power to do them good, or harm, and consequently given occasion to the Governors of Heathen Commonwealths to regulate this their fear." Hobbes had his own recipe for proper viewing. Spectators must mix their perceptions with their memories, recognizing simultaneously the realism and the artificiality of icons. Ignorantly dangerous superstition flowed from the wrong way of seeing. Cunning priests and philosophers, so Hobbes argued, had conned their flocks into accepting mere idols as real and into treating real bodies as though they were spirits which could master them. Hobbes' attack on this two-faced theory of matter and spirit made much of the artifacts of monks and conjurers. When priests celebrated the Mass "they face us down, that it hath turned the Bread into a Man; nay more, into a God, and require men to worship it, and thereby to commit most gross Idolatry."[14]

Anyone who gave credence to these tricks would be tempted to obey the conjurer and rebel against their proper ruler. Hobbes described the devices of false optics and religious conjuring as so many political scarecrows, which scared citizens "from obeying the laws of their country with empty names, as men fright birds from the corn with an empty doublet, a hat and a crooked stick." The cure for this bizarrely sinister kind of vision was not darkness, but rather a better optical device made by turning a machine into an icon. So

11

12 13

14

_ Bernard de Fontenelle, *Conversations on the Plurality of Worlds*,
H. A. Hargreaves (trans.), University California Press, Los Angeles, 1990, p. 11.

_ Paolo Rossi, *Francis Bacon from Magic to Science*,
Chicago University Press, Chicago, 1978, p. 141.

_ Hobbes, op. cit., pp. 236, 352-353, 338.

_ Thomas Hobbes, *Leviathan*, Andrew Crooke, London, 1651, pp. 207-208.

Thomas Hobbes, Leviathan / title page / Egerton MS 1910 / detail / © British Library, London

Hobbes spent his time in political exile from war-wracked England in the 1640s in Paris making this device work. He needed a new story about representatives, or "persons" as Hobbes called them. He devised artificial persons, constructs that could stand for others' actions. In particular, he sought to embody an artificial person which could make many into one. "A multitude of men are made one person when they are by one man or one person represented, so that it be done with the consent of everyone of the multitude in particular." This new artificial person was to be Leviathan, through which the multitude could be made one person and idolatry destroyed. In the Scriptures, Job had complained to his maker that, though surely an image of the deity, yet he was being broken: "Thou hast made me as the clay, and wilt thou bring me into dust again?" To which the Lord answered by pointing to the Leviathan, the great marine beast he'd made beyond the mastery of mere men, a visible version of created power. Hobbes' task was to construct a similarly compelling icon in which many could be personated, thus well ruled.[15]

Hobbes's colleagues were experts in devising lenses and mirrors which would deliberately deceive the senses. In 1622 one Dutch engineer described how, with the aid of his magic lantern, he could "change the appearance of my clothing in the eyes of all who see me. I present myself as a king, adorned in all sorts of precious stones, and then in a moment become a beggar, all my clothing in rags." Optical devices mimicked transmutations in religion and politics. All sought to show how apparent marvels could be mimicked with art, thus to show that rational art could comprehend creation. Similar to Salomon's House, in politely devout philosophical circles in Paris, Rome, London, and the Netherlands, optical engineers devised cunning and ingenious ways of conning the sight in order to better master the processes of vision.

René Descartes, whose theories of optical devices and mechanical automata dominated his program for the overhaul of philosophy, described this program in graphic detail. "There is a part of mathematics which I call the science of miracles," he explained in 1629, "because it teaches us how to make use so conveniently of air and light, that by its means one can make apparent all the same illusions which it is said magicians can produce through the aid of demons." Artificial rainbows and ingenious lights were key elements of the "science of miracles." Magic lanterns, which could project images onto screens, or anamorphoses, through which a covert and distorted image would be made to appear fully and clearly when inspected from a strange angle, in a mirror, or through a figured lens, became common hardware.[16]

The fashion grew for so-called "prestiges," ingenious tricks with light cultivated by priests and artisans alike. Protestant natural philosophers were keen on exploring these visual tricks to show that papist ceremonies were mere conjuring. Catholic savants made optical devices to explain how witchery and diabolism worked. So-called idolaters were extremely ingenious in making imagery of holy mediation. In 1638 a Basel engraver made an anamorphosis of Adam's fall, with the face of Christ cunningly hidden between the temptation and the expulsion from Eden. The rightly placed spectator could thus see how redemption would follow on from this original sin. In 1648 one bold French priest even compared the optical tricks of his own mirrors with the deception of the senses which took place when bread was turned into the body of Christ, while in 1654 an Italian Jesuit evoked the newfangled telescope's celestial journeys: "two glass windows carry human sight through a hollow tube to the heavens in a flash. Whatever God conceals there, a little glass reveals to you."[17]

Some time in the 1640s Hobbes saw just the kinds of optical device he needed in a Paris monastery. They were the work of a clever young French priest, Jean-François Niceron, whose book on curious perspective (1638) was a handbook for using lenses and mirrors to deceive the eye and manufacture ingenious icons in politics and religion. He knew all

15

17 16

_ Geneviève Rodis-Lewis, Machineries et perspectives curieuses dans leurs rapports avec le cartesianisme, in *Le dix-septième siècle*, 6, 1956, pp. 461-74; Simon Werrett, Wonders never cease: Descartes' *Météores* and the rainbow fountain, in *British Journal for the History of Science*, 34, 2, 2001, pp. 129-48.

_ Alpers, op. cit., p. 13; Jurgis Baltrusaitis, *Anamorphic Art*, W.J. Strahan (trans.), Harry Abrams, New York, 1977, pp. 26, 69; Gilman, *Curious Perspective*, p. 80.

_ Hobbes, op. cit., pp. 373, 380-382; Steven Shapin and Simon Schaffer, *Leviathan and the Air Pump: Hobbes, Boyle and the Experimental Life*, Princeton University Press, Princeton, 1985, pp. 92-99.

about Galileo's telescopes and Descarte's theory of lenses. In 1640 Niceron and his colleagues made a vast fresco for the upper gallery of their monastery, a fifty foot long anamorphosis showing St. John the apostle seated on an eagle, made visible only from a special place within the gallery. Hobbes singled out Niceron's amazing image in describing his key notion that pictures convinced spectators just when they saw the picture as artifact and as reality simultaneously. But Niceron's arsenal of visual tricks offered Hobbes an even more appropriate icon for the Leviathan. In about 1635 the Parisian priest made an optical device that showed the portraits of twelve Turkish rulers set on a vertical screen. When inspected through a hollow that was cylinder fitted with a multifaceted lens, these heads would be forged in the eye of the beholder into the image of the French monarch, Louis XIII, Christendom's champion against the infidel. He also showed an image where a sequence of popes, with Christ at their center, could be transformed into the image of the current pope, the keys of St. Peter in his hand.

Rulers not only saw what their subjects could not; they could appear where their subjects least expected. Niceron made no secret of how the tricks worked: they were perfect emblems of the kind of doubled vision needed to appreciate the icons of politics and religion, in which the properly equipped spectator would simultaneously be duped into seeing many images as one, and into realizing the artifice on which this synthesis relied. Niceron printed the device, and the recipe, in his book on curious perspective, and then made another version, with the French monarch judiciously replaced by the Tuscan Grand Duke, in Florence in 1642.[18]

Hobbes must have seen the Paris version soon there after. When he wrote down the recipe for his new artificial man, the Leviathan, Hobbes used this optical device as an icon for his theory of political representation. It may well have been Wenceslaus Hollar who was charged with turning the device into its Hobbesian version. When Hobbes presented the manuscript of his political treatise, *Leviathan*, to exiled King Charles II, it was prefaced with an emblem made of many faces gazing out at the reader, turned into the single visage of the artificial man. Hollar subtly changed the device for the printed version, by making the components of Leviathan into figures with their backs to the reader.

This optical trick had a pair of vital uses for Hobbesian iconography. What was really in the picture gained its sense

Isaac Newton, »Of colours« / MS Add. 3975 fol. 15 / © University Library, Cambridge

18

_ Noel Malcolm, The title page of *Leviathan*, seen in a curious perspective, in *The Seventeenth Century*, 12, 1998, pp. 124-155; Baltrusiatis, op. cit., pp. 37-60; Isabella Truci, Le anamorfosi di Jean François Niceron all' Istituto e Museo di Storia della Scienza di Firenze, in *Annali dell'Instituto e Museo di Storia della Scienza di Firenze*, 1, 1, 1976, pp. 57-64.

only from what was seen through the lens, yet what was seen through the lens was undeniably an artifact. Similarly, Hobbes taught that the multitude gained its rightful order only from the Leviathan, yet the Leviathan was undeniably an artifact made by the multitude together. Without using a figured lens, he and his artist showed the artifact and its makers simul-taneously on the page. Having sought to smash the devious idols of priestly craft and separated powers, Hobbes forged a new and more powerful icon with an ingenious optical device that manifested the solidly artificial grounds of politics and devotion.[19]

Leviathan and Salomon's House were rival devices for curing the disease of idolatry. Their authors agreed that most folk were duped into mistaking what they saw. They knew well of Reformation iconoclasts, who broke the images of popular cults. One of Hobbes' closest friends, the garrulous antiquarian John Aubrey, collected these stories of "priest-cheats," of shrines where images of the Virgin, for example, had been fitted with neck-joints to make Mary's head seem to shake. Unmasking automata and dioptrics thus became a fundamental project of seventeenth century savants. This was how Descartes set out on his own "search for truth" in 1642: "After causing you to wonder at the most powerful machines, the most unusual automata, the most impressive illusions and the most subtle tricks that human ingenuity can devise, I shall reveal to you the secrets behind them, which are so simple and straightforward that you will no longer have reason to wonder at anything made by the hands of men." But this denunciation and unmasking also had its iconophilic aim. Natural philosophers claimed that the world had been made the way these artifacts were made. By making their own marvels, savants were emulating the work of creation. The gestures that tore down old icons were always accompanied by the building of new ones. All marvels, even and especially those of nature, were forged the way these devices were built.[20]

Stonehenge in Wiltshire / from William Camden, Britannia, London, 1600, p. 219 /
© University Library, Cambridge

Metallic Idolatry

"We may well think those Ancients did make this Metal their God, and that we may not altogether blame them; all of us seem at this day to be guilty of this Metallic Idolatry." JOHN PETTUS[21]

19

_ Keith Brown, The artist of the *Leviathan* title-page, in *British Library Journal*, 4, 1978, 24-36; Noel Malcolm, The title page of *Leviathan*, pp. 140-146; Horst Bredekamp, *Thomas Hobbes visuelle Strategien*, Akademie Verlag, Berlin, 1999, pp. 87-91.

21

_ John Pettus, *Fleta minor*, part 2: *Spagyrick Laws containing Essays on Metallick Words*, Thomas Dawks, London, 1683, p. 52.

20

_ John Aubrey, *Three prose works*, John Buchanan Brown (ed.), Centaur Press, Fontwell, 1972, p. 220; Robert Iliffe, Lying Wonders and Juggling Tricks: Religion, Nature and Imposture in Early Modern England, in James Force and David Katz (eds), *Everything Connects: in Conference with Richard Popkin*, Brill, Leiden, 1999, pp. 185-209; Werrett, op. cit., p. 141.

In Cambridge from 1660 to 1696, Isaac Newton made himself into an expert devisor of optical illusions and a warrior in the fight against idolatry. His iconic masterwork of experimental optics began with a trial in which he looked through a glass prism at a piece of paper whose top half was colored red and its bottom half blue. The two halves seemed to separate as he gazed at them, suggesting that light from the blue was bent more by the prism. When Newton first tried these appearances as a young Cambridge scholar in the 1660s, he called them "phantoms." His erudite sources had used the word "spectrum," or ghost, for such optical apparitions. When he published his results, Newton changed the meaning of the word "spectrum." Now it meant the multicolored image of the sun cast on a wall through prisms. Newton's manipulations of phantoms and spectra convinced him, as he tried to convince his audiences, that sunlight was composed of different color-making rays, each bent at a specific angle through prisms. This was the doctrine he published in his *Opticks* from 1704 while the final editions of this book began with phantoms and spectra, they ended with an attack on the idols. "If natural philosophy in all its parts, by pursuing this method, shall at length be perfected, the bounds of moral philosophy will also be enlarged … and no doubt, if the worship of false Gods had not blinded the heathen, their moral philosophy would have … taught us to worship our true Author and Benefactor, as their ancestors did under the government of Noah and his Sons before they corrupted themselves."[22]

Newton's projects challenged the way "blinded" people saw things. He taught them better to comprehend spectra made by bending light. The artifice of the rainbow was fully explained by the experiments Newton devised. In Cambridge in the 1660s he read Hobbes, Descartes, and their critics, and quickly mastered the techniques of seventeenth century optical artifice. He began heroically dangerous trials in which he would insert a wooden needle between his eye and the bone, or gaze long at the bright sun, in order to examine the "phantasms" of colored circles he could then see.

Then he tried to reproduce these privately fascinating images with public experimental hardware. The lesson of seventeenth century optical philosophy was precisely that all natural appearances such as rainbows and spectra were made just the way they were by the tricky glass artifacts of experimental philosophers. Optical hardware could make private phenomena into publicly verifiable facts. "My fantasy and the Sun had the same operation upon the spirits in my optic nerve, and the same motions are caused in my brains by both." His work on his own eyes was never published. Newton helped construct a boundary between material phenomena accepted by the body of all natural philosophers and phantasms apparent only in an individual natural philosopher. In conflicts with Jesuits and others, who much doubted his stories about idols and spectra, Newton set out to establish the true principles of imagemaking.[23]

Newton reckoned there was a connection between those Jesuits' rejection of his optical facts and the idolatrous Catholic religion they practiced. Idolatry's source lay in the degeneration of the faith established in the wake of the flood. The rainbow whose artifice Newton understood so well had first been placed in heaven by God after the Deluge as a device for His contract with Noah and his sons. Newton's ingenious machinery of historical interpretation fully explained the true faith established by that contract and how, by seeing things wrongly, the ancients had fallen into idolatry. As Newton revised his optical experiments for publication, he composed accounts of how idolatry had grown. The primitive religion, he judged, involved the construction of large circular temples built round central fires as sacred emblems of the true sun-centered system of the world. Remains of these temples were to be found everywhere: in China, Egypt, Rome, even Stonehenge.

Inevitably, however, the devout began to worship the objects within these temples as "the *visible* seals of divinity."

22

23

_ Isaac Newton, *Opticks*, I. Bernard Cohen and Duane H.D. Roller (eds), Dover, New York, 1952, pp. 20, 25, pp. 405-406.

_ J.E. McGuire and Martin Tamny, *Certain Philosophical Questions: Newton's Trinity Notebook*, Cambridge University Press, Cambridge, 1983, p. 443; Simon Schaffer, Glass works: Newton's Prisms and the Uses of Experiment, in *The Uses of Experiment*, David Gooding, Trevor Pinch and Simon Schaffer (eds), Cambridge University Press, Cambridge, 1989, pp. 67-104.

Humanity was prone to take symbols literally and adore only what they saw. Once again, a false account of vision led to a false politics and religion. "By means of these fictions the souls of the dead men grew into veneration with the stars and by as many as received this kind of theology were taken for the Gods which governed the world." Cunning priests and kings encouraged the cult of material things, such as stars and statues, deluded their flocks into belief that these contained the souls of dead monarchs and heroes, thus cultivating idolatry. Catholic cults were no better than this kind of corrupt wizardry. By reviving the proper doctrine of planets, stars, and light, Newton held he'd laid the foundations for a renewed, purified philosophy, politics, and faith. Reformation would require new icons, fresh emblems of vision and nature to be stamped on the minds of the pious and virtuous.[24]

In 1696 Newton left Cambridge University for a post at the head of the Royal Mint in London. As he moved from the intellectual to the political and economic capital of the embattled Protestant regime, his attention switched to metallic idolatry and fiscal fictions. His job was to oversee the coins, which sustained the nation's economic system. It was notorious that these metal tokens were grossly corrupt. Precious metal was so valued that the fine gold in coins was hoarded or pared away. Signs of value were easily forged. One London priest preached in 1697 on the close political, spiritual, and fiscal analogy that governed the attempt Newton and his allies launched to overhaul the gold coinage. "See that you have the image of God stamped and renewed upon your souls." When the coin was debased, they melted down the money that had the right stamp. They corrupted it with baser metals and placed a counterfeit stamp upon it. By the fall, the image of God was lost and defaced. There must be a restoring of the king's image again. The debased coin must be broken with the hammer, melted with fire, and made susceptible to a new stamp. Public faith and conduct mattered decisively in Newton's monetary world. The mint system relied on credit,

a term which referred both to financial probity and trustworthy belief. One of Newton's journalist allies penned a "vision or allegory" of Public Credit, "seated on a Throne of Gold." Under the threats of Catholic subversion and irreligious revolt, however, "the great heaps of Gold on either side of the Throne now appeared to be only heaps of Paper." Only England's Protestant regime could make "the heaps of paper" change back into "pyramids of Guineas." In the 1690s, London was obsessed with counter-accusations of idolatry and the vulnerable basis of value and credit. Counterfeiting sovereigns, as the gold coins were called, was high treason against the Protestant monarch and his regime. The recoinage run by Newton was immediately interpreted in terms that bound together the political theology of the kingdom, the moral condition of mankind, and the instrumentation of forgery and coining.[25]

Newton's administration of the mint matched his attack on idolatry and his insistence on divine power. In his natural philosophy he asserted that God was "Lord of all" who "ought not to be worshipped under the representation of any corporeal thing." God's supreme authority, rather than His wise plan, was the ultimate guarantee of the constancy and uniformity of nature. Newton constructed a ferocious regime of governance within the institutions of natural philosophy and the walls of the mint. Newton insisted on his own judicial authority, "designed to keep ... Ministers in their Duty to the King and his people," thus neatly making the analogy between the polity of the mint, the kingdom, and the creation. "Nor do I see any remedy more proper and more easy than by restoring the ancient constitution," as in his campaign to restore the primitive version of cosmology and faith. The rituals of court and law were used to sustaining this new regime. Newton insisted his institution control all coining of tools and lobbied to make the possession of instruments for counterfeiting into high treason deserving of death. He noted one judge's remarks at a trial of a coin-clipper: "the shears supply the place of one

24

_ R.S. Westfall, Isaac Newton's Theologiae Gentilis Origines Philosophicae, in *The Secular Mind*, W.W. Wagar (ed.), Holmes and Meier, New York, 1982, pp. 15-34; Robert Iliffe, Those Whose Business it is to Cavil: Newton's Anti-Catholicism, in *Newton and Religion: Context, Nature and Influence*, James Force and Richard Popkin (eds), Kluwer, Dordrecht, 1999, pp. 97-119.

25

_ Rogers Ruding, *Annals of the Coinage of Great Britain*, third ed., Hearne, London, 1840, vol. 2, pp. 58-59; Colin Nicholson, *Writing and the Rise of Finance*, Cambridge University Press, Cambridge, 1994, p. 47; J.S. Peters, The Bank, the Press and the Return to Nature: on Currency, Credit and Literary Property in the 1690s, in *Early Modern Conceptions of Property*, John Brewer and Susan Staves (eds), Routledge, London, 1996, pp. 365-388.

witness, the filings of another, and the rough clipped money of another." When persons could not be trusted to convict, things were forced to speak the truth.[26]

In a memoir defending the mint during credit crises and wartime financial difficulties, Newton explained how "it's mere opinion that sets a value upon money; we value it because we can purchase all sorts of commodities." This had implications for whether money appeared in the form of gold or paper. "All the difference is that value of gold and silver is set upon their internal substance or matter and is therefore called intrinsic, and that value of paper money upon the apparent form of the writing and therefore called extrinsic." Such universality of opinion meant that stable value needed, needed, regular administration, not necessarily an obsession with the purity of the money form. Newton set out to maximize the difference between face value and the value, by making copper coins or printing paper tokens, since this would be a more stable monetary system. Fiscal facts relied on state power. Paper money and its credit established the distinction between reliable, publicly assured values, and illusory, manipulable ones – between correct and false ways of seeing things. Newton's mint played its part in this intricate process of devising reliable objects in which public trust could be invested. Fashioning the right symbols of power and destroying the wrong ones mattered as much for his monetary as for his optical and religious projects. Material images could be properly forged: then they must be linked to the exercise of supreme power. But they could be improperly forged: then their authors and their forgeries must be destroyed.[27]

Much of the gold that Newton's mint fashioned into coins came from the Guinea coast of West Africa. Guinea gave these coins their name and their metal, but it was also, for European traders, an exceptionally troublesome site of negotiation about value and fiction. Accusations of idolatry flowed throughout the Guinea trade. So did the manufacture of devices used to discern forged from genuine. Gold, in the form of dust or small nuggets, was the local currency in Guinea. What the Europeans sought on the Gold Coast was a continuous medium of local exchange. Many African traders therefore carried their own sets of weights with which to measure out appropriate amounts of gold dust in each transaction. These goldweights were elaborate series of metal figures, often representing proverbial scenes of animals and humans. Each would check their weights against others involved in a transaction. So these weights became the focus of European traders' intense anxiety and of continuous indigenous recalcitrance and ingenuity.[28]

Damned for being beyond the moral and the economic pale, often viewed as foolish or irredeemable, these aliens were understood by European traders as possessed of pernicious cunning, shady masters of the relations of exchange by whom honest traders and naturalists could so easily be duped. The term "superstition," crucial in defining the idolatrous habits of Catholics, Native Americans, or Africans, at just this moment began to shift from its earlier sense of a powerful but dangerous belief to a silly and impotent one, from a system to be fiercely contested to one of condescension. The fragility of these shifts was especially acute in the Guinea trade.[29]

In this gold network, relations between Europeans and Africans were mediated by another powerful term, "the fetish." Initially conceived with medieval church doctrines of witchcraft and the real potency of charms and icons, and thus used by the Portuguese who reached Guinea in the late fifteenth century, the term then acquired a novel sense as part of an attribution by European commentators to the Africans of a deluded belief in animate matter and their powers to influence merely inanimate things. Newton and his allies urged that matter was passive and inert, that real goods were properly valued through licensed commerce, and that idolatry and error flowed from the attribution to bodies of divine powers.[30] One widely read account of the gold trade, published in 1670, reported that "these Blacks as they have good

26 27 30 28 29

_ Ray A. Kea, *Settlements, Trade and Polities in the Seventeenth century Gold Coast,* Johns Hopkins, Baltimore, 1982, pp. 171-173; Ivor Wilks, *Forests of Gold: Essays on the Akan and the Kingdom of Asante,* Ohio, Athens, 1993, chapter 1; Timothy Garrard, *Akan Weights and the Gold Trade,* Longman, London, 1979; Malcolm Macleod, *The Asante,* British Museum, London, 1981, pp. 122-133.

_ Peter Burke, *Popular Culture in Early Modern Europe,* Maurice Temple Smith, London, 1978, p. 241.

_ Isaac Newton, *The Principia,* I.B. Cohen and A. Whitman (eds), University of California Press, Berkeley, 1999, p. 941; Sir John Craig, *Newton at the Mint,* Cambridge University Press, Cambridge, 1946, pp. 37, 20; Isaac Newton, *Correspondence,* H.W. Turnbull, J.F. Scott, A.R. Hall, and L. Tilling (eds), Cambridge University Press, Cambridge, 1959-1977, vol. 4, pp. 208, 545.

_ William Pietz, The Problem of the Fetish – 1, in *Res,* 9, 1985, pp. 5-17; Pietz, The Problem of the Fetish – 2, in *Res,* 13, 1987, pp. 23-45; Pietz, The Problem of the Fetish – 3a, in *Res,* 16, 1988, pp. 105-123.

_ Sir John Craig, Isaac Newton and the Counterfeiters, in *Notes and Records of the Royal Society,* 18, 1983, pp. 136-145; Newton, *Correspondence,* vol. 4, p. 209; Craig, op. cit, 1946, p. 42; Nicholson, op. cit., pp. 45-46.

The art of coining, Universal Magazine of Knowledge and Pleasure, London, 1750, vol. 7, p. 69 / © University Library, Cambridge

The market at Cabo Corso / from: Peter de Marees, Beschryvinge ende historische verhael vant Gout Koninckrijk van Guinea, Amsterdam, 1602, p. 31, pl. 4 / © University Library, Cambridge

judgment and can quickly see if the Gold be good or not, so they know by a particular art to falsify that which they intend to give to the Whites." Significantly, such mixtures were themselves called fetishes, and the resultant adulterate named "fetish-gold." Willem Bosman, Chief Merchant of the Dutch West Indies Company, explained in his definitive *Description of the Coast of Guinea* (1703) that "Fetiches are a sort of Artificial Gold composed of several Ingredients ... and consequently less worth, and yet we are pestered with it on all parts of the Coast, and if we refuse to receive it, some Negroes are so unreasonable that they will undeniably take back all their pure Gold: so that we are obliged sometimes to suffer them to shuffle in some of it." According to Bosman, all such things "made in honor of their false gods" were thus named.[31] No doubt the accusation that Africans were easily duped into seeing mundane objects as sacred could be easily reversed. One Dutch traveler, Peter de Marees, was astonished that the Africans "could not understand" that their goods "came from God, saying it was not God who gave them the Gold, but rather the earth." Europeans seemed as easily deluded. So de Marees, who filled his pages with accounts of African fetishism, and reported that "they are very keen on their Gold," and was also well aware that they "know very well there is no gold in Holland, that it is for its sake that we come here, and that so much diligence is applied to get it, and therefore they say that Gold is our God." The commodity fetishism of the Europeans was rather obvious. A troubling symmetry seemed in play in the gold trade the exchange of goods could easily destabilize boundaries and involve the exchange of natures.[32]

The encounter with the traders on the Gold Coast brought decisively into evidence the need for iconoclasts to fully explain the origins of the idolatry they contested. The theory of artifact, superstition, and fetish provided devices for this project. Notions such as "artifact," then "fetish," gained their meanings in the worlds of commerce with humans and with spirits. The false attribution of power to inanimate things, and the ways in which fetishism infected the security of trade relations became key facts in the gold trade and in devising icons. But this account could easily be applied to Europeans' own enterprises too, and soon was. De Marees reported that Africans denied that gold came from God and reckoned that gold must be the Dutchmen's deity. John Pettus, whose study of assaying gold appeared under the aegis of the Royal Society in 1683, reckoned everyone was "guilty of this metallick idolatry." Christians now searched for Paradise because "in its Neighborhood there was gold which was good." Many Protestants mocked the ferocity of Catholic traders' attitudes to African fetishism. They read stories of French captains who "mocked [African] superstitions, took their fetish, broke it into a thousand pieces, stamped it underfoot, then threw it on the fire." Catholic travelers told the Africans that "I will plant this cross, and if any of you touches it, or approaches it other than on your knees, you will die on the spot." In response, Bosman commented that, in view of "their ridiculous ceremonies," surely Roman Catholics would have the best chance of converting such people to Christianity. One widely read Protestant trader in flight from French persecution, Jean Barbot, remarked that the Africans were not easily persuaded of Christian faith. They "return to their earlier superstitions and so mock those who convert them." Barbot reflected that if the French had treated the Africans as violently as they treated Protestants in Europe, conversions would have been more common. When one early eighteenth century English editor read about the French violent treatment of the Gold Coast fetishes, he remarked that surely no Catholic priest would have tolerated such treatment of "his own fetishes or Image. A Protestant Negro would have been put to death for such a crime in a papist land. How much more gentle are the Blacks!"[33]

In Newton's capital, it seemed obvious that urban Protestants behaved no differently from the alien fetishists. They had their idolatrous rituals in the market, their fetishes

31 32 33

_ Willem Bosman, *A New and Accurate Description of the Coast of Guinea*, James Knapton and Daniel Midwinter, London, 1705, pp. 73-74, 154-155; Pietz, The Problem of the Fetish – 3a, op. cit., pp. 110-111; Albert van Dantzig, Bosman's New and Accurate Description of the Coast of Guinea, in *History in Africa*, 1, 1974, pp. 101-108.

_ Pettus, *Fleta minor*, p. 56; Michèle Tobia-Chadeisson, *Le fétiche africain*, L'Harmattan, Paris, 2000, pp. 189-190; Bosman, op. cit., pp. 154-55; Jean Barbot, *Barbot on Guinea: the Writings of Jean Barbot on West Africa 1678-1712*, P.E.H. Hair, A. Jones, and R. Law (eds), Hakluyt Society, London, 1992, pp. 150-151.

_ Pieter de Marees, *Description and Historical Account of the Gold Kingdom of Guinea*, Oxford University Press, Oxford, 1987, pp. 73, 60, 191.

on the exchange. The credit crises of the eighteenth century confirmed the view that the accusation of idolatry could just as easily be made about Europeans as about aliens. The encounter with other cultures provided crucial resources for seeing idols everywhere. Witty denunciation of their own culture's failings often took on the form of an imaginary visit by some alien to Europe, from Persia, or China, from another planet or from the South Seas. In the 1720s, Jonathan Swift composed such clever satires on English travel, trade, and coinage. He attacked Newton's mint and the corrupt stock market. His jokes relied on the idea that the mundane artifacts of English street life had been turned fetishistically into their idols. His techniques relied on treating domestic worlds as alien and strange, as a traveler might see them. Just as Africans allegedly saw gold as the traders' God, so Swift's Lilliputians saw Gulliver's pocket watch as his personal deity. At the end of 1703, an intriguing alien arrived in London. George Psalmanazar, as he called himself, claimed to be a native of Formosa who was brought to Europe by Jesuits and converted to Protestantism. Psalmanazar lectured on Formosa at Oxford University. Isaac Newton was invited to meet him. The Formosan described appalling idolatries on his island, the sacrifice of thousands of children to local gods.

His reports compared these barbarities with the Eucharist. The English trusted Psalmanazar because the Jesuits denounced him. It eventually became apparent that the man was a brilliant fake; he was a French refugee – not a native of an Asian island. Swift used the unmasked Formosan story to good effect to reveal the idolatrous basis of local English commerce and polity. In Ireland, where Newton sought to impose his cheap copper coins, Swift bloodily set out an imaginary English scheme, modeled on that of Psalmanazar's Formosa, to introduce cannibalism of specially bred children as an economic cure for the island's ills. This was to transpose the idolatrous devices of the Eucharist into its newfangled commodity form.[34] Eventually, once paper money became common

in Britain, the satirists showed banknotes with a voracious idol eating children in place of the icon of Britannia. They well understood the kind of creed on which the money economy relied.

The tabernacle and altar / from: George Psalmanazar, An historical and geographical description of Formosa, second edition, London, 1705, p. 155 / © University Library, Cambridge

34

_ Frank Lestringant, Travels in Eucharistia: Formosa and Ireland from George Psalmanazar to Jonathan Swift, in *Yale French Studies*, 86, 1994, pp. 109-125; J.M. Treadwell, Swift, William Wood and the Factual Basis of Satire, in *Journal of British Studies*, 15, 1976, pp. 82-90.

Pay No Attention to that Man Behind the Curtain

These stories of Reformation and Revolution are designed to offer sources for iconoclasts' campaigns in our own world. In devising the systems of knowledge, cult, and commerce which preoccupied them so much, idols' enemies denounced the artifactual. Yet they simultaneously made their own icons and emblems. The work of devising new imagery in the same gesture as unmasking others' stays common. It does so especially in the fiscal world, a milieu haunted by interpretable objects. Unmasking paper, celebrating metal, remains a concern of satirists, as though the idolatry of currency is not equally present in the worship of gold. Toward the end of Frank Baum's *Wizard of Oz*, the wizard himself is unmasked in an extraordinarily iconoclastic gesture. Dorothy's innocent dog, pulling aside the curtain, reveals that the vast edifice of the Oz regime is based on nothing but the tricks of a carnival huckster and a few cunning optical effects. There is a strong resemblance to the fate of Hobbes' scarecrow philosophy. "Pay no attention to that man behind the curtain!" vainly exclaims the unmasked showman. His hitherto devout flock – a Lion, a Tin Man and (of course) a Scarecrow – at once lose faith in the wizard's power to grant them what they desire. But the wizard has one last trick up his sleeve. He knows that fabricated icons rule the roost. He cannot give the Lion courage, but awards him a military medal; the Tin Man cannot be granted a heart, but gets a charitable testimonial; the Scarecrow still lacks a brain, but is given a university degree. Even the best iconoclastic gestures still rely on icons to make their way in this world. Baum's tale first appeared in 1900 as a deliberate attack on the then fashionable monetary icons. He attacked the cult of the gold standard and what he and his populist heroes reckoned was a vast trick to undermine solid realities and trade them in for the shifting artifacts of market tokens. In the Emerald City, reached along a road paved with seductive gold bricks, everyone must wear tinted glasses. The color is green, like dollar bills; the city is Oz, based on an ounce of gold. Behind the curtain of finance capital, evil, if ultimately impotent, wizards are deceiving solid citizens and manipulating natural facts. In a year, which sees the launch of a Europe-wide monetary icon, the wit of these devices will remain relevant and current.[35]

George Cruikshank / Bank restriction note / 1819 / detail /
© British Museum, London - Department of Prints and Drawings

35

_ Hugh Rockoff, The Wizard of Oz as a Monetary Allegory,
in *Journal of Political Economy*, 98, August 1990, pp. 793-860.

ON THE CREDIBILITY OF WORLD-PICTURES

Jörg Huber

INCREASINGLY, IMAGES ARE USED IN SCIENCE'S ATTEMPT to find out what makes the world turn. The example chosen here is taken from the field of physics, which deals with the laws of elementary processes. This basic research analyzes and describes processes which are relevant both for the macro and the micro world; what particle physics makes visible in the laboratory also matters for astrophysics. In both cases, of course, science takes place in the realm of the invisible, and it is exactly here that the art of making visible by means of images is in high demand. In this context we are talking about experiments conducted at CERN (Centre Européenne de la Recherche Nucléaire) by means of the monumental particle accelerator LEP (Large Electron-Positron Ring).[1] This system offers the opportunity to verify standard models in very specific ways. Electrons and protons are accelerated almost to the speed of light and then made to collide. The collision events provide an enormous amount of data – hundreds of gigabytes per second – which have to be processed, i.e., represented, before one can work with them. Primary importance is given to graphic visual representation. With their colorfulness and their representations (clusterings and rays of lines and dots), the images that emerge here fascinate at first sight. Their visual attractiveness suggests the possibility of seeing the event; the formal dynamics seem to represent the energy freed by the experimental event and materialized in the form of elementary particles. The images seem to make the invisible visible and evident in a way that has been ascribed to religious, scientific, and artistic images throughout the ages in order to make them credible in their service to the idea, to God, to the spiritual, or to truth.

If we assume that images represent or perform something or make something present, whether "outside" or within the picture, the question is: What do images refer to and what do they make visible? If we expect, of scientific images in particular, that they show something actual, which "exists" or "happens" in reality, then a look at their origin and their use will direct our attention in a different direction.

In terms of light, the event to be "observed" happens within a field of waves which are smaller than optical wave lengths. The sensors of the detectors register the events by means of electronic measurements; then the data are analyzed and visualized by computer. "Interesting" events must be recognized and filtered for more detailed analysis later. This is the "art" of the experiment: *to think with the eye*. The decisive phase in scientific insight happens only by means of images, for images allow a reduction in complexity, a condensation in representation, and they produce visual clarity: an image says more than a thousand words. It is obvious that images are the effects of "manual" manipulation by the scientists who select, modify, and interpret the data; the production of images works by making them resemble other images that already exist, be they imaginary or real. Conventional image ideas and aesthetic criteria do play a role here. Formal structures, spatial arrangements, and the colorfulness achieved through conventional and thus contingent assignment of colors produce the aesthetic attraction which is specific to visual representation. Associative connections to the cultural image repertoire – such as, in this case, traffic maps, fireworks or the paintings of Juan Miro – support the images. Notwithstanding their artificiality, the images receive their validity and credibility through their technological precision: they are perfect images, because they have been produced by machines. The agencies of the media and of commentaries as instructions for reading validate them before the wider public. Thus "inner" images emerge, by which we see and grasp the world. The question remains, however, whether and in which respect these images have anything to do with the world.

As their origination shows, scientific images refer to data and to the algorithms by means of which they are generated. Their level of reference is indeed a reality – not the reality of phenomenal reality, as is usually assumed, but of their medial

1

_ Thanks to Christoph Grab, researcher and instructor
at the Institut für Teilchenphysik, ETH Zurich,
for expert information.

Front and side view of a four-jet-event / © photo: Christoph Grab, Zurich
The four jets are identified by color and presented in a special corner projection on the bottom right to make them easier to identify.

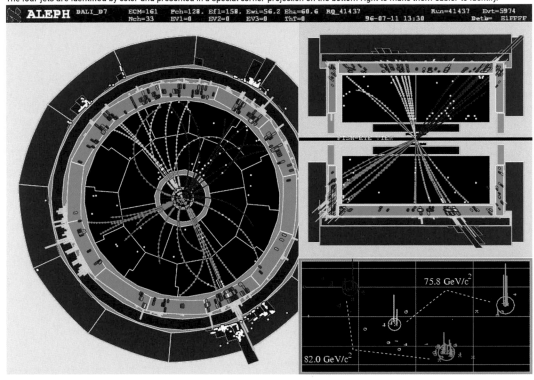

Special projections allow the well-trained eye of the physicist to quickly recognize multiple correlations
between the various particle graphs / © photo: Christoph Grab, Zurich

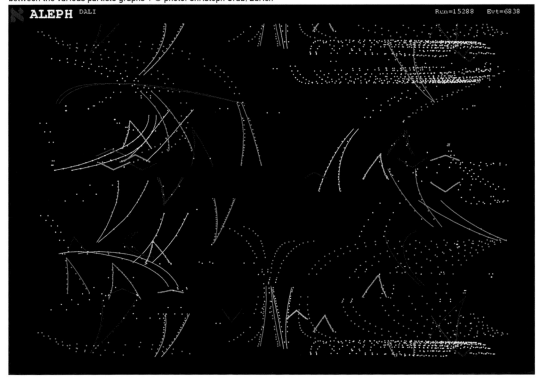

construction. In order to understand images, we must find new bearings: the image does not refer (any more) to a world "behind" or "under" the image. It is not a probe that sounds the depths to bring to light something essential, fundamental – the truth. The vertical dimension is really a horizontal one. The image relates to other images; as a representation it refers to other forms and media of representation. It is a sign within a certain field of reference of other signs, and at the same time it is the scene on which science takes place – as if parallel to reality. As a scene or stage it is an element of production and action within a liminal field of transitions, displacements, overlappings, synthetizations. As both an epistemic product and object it is interesting as a visual metaphor, as a conduit for transference, but not in its "ontological" status. Its performative quality and function are foregrounded. The image is a performance which makes visible how science takes place and throws light on the conditions of visibility. Its significance shifts from the eureka of the search for truth to the heuristic moment of processes. Scientific insight takes place in the mutuality between theory and experiment. The images are visually realized theoretical models; they do not show the world, but rather think about the world. They visualize world-conceptions. This is equally true for analogue imaging processes; it is not, as is often said in contemporary media theory, a problem of the digitization of imaging. The images are also not virtual in the sense of fantasy products and thus distant from the world, but, rather, they are virtual as images of the possible and thus they belong to reality. They refer to reality – although not directly to the reality of the factual, but to its possible representation. And it is also with reference to us that they are real, although here only in the sense that they dis-illusion. Thinking with the eye[2] cannot hope for visual evidence nor promise faith in the world; it takes place discursively. Scientific images in particular, which claim credibility in the traditional sense, show that you cannot trust, but only understand them. This is their culturally produced inherent iconoclash. |

2

_ Bettina Heintz and Jörg Huber (eds), *Mit dem Auge denken. Strategien der Sichtbarmachung in wissenschaftlichen und virtuellen Welten*, Edition Valdemeer, Zurich, 2001.

Has critique ended?

THE CRITICAL GESTURE IN PHILOSOPHY

Robert Koch

»*For offending the gods I am honored by men.*« PHAEDRUS, 242D

»*A sentimentalist is he who enjoys without incurring the immense debtorship
for a thing done.*« GEORGE MEREDITH, THE EGOIST

CRITIQUE HAS ALWAYS BEEN PHILOSOPHY'S TRUE DESTINY:
from the very beginning philosophy has seen its task as that
of distinguishing the true from the false, the friend from the
rival, the original from the copy, knowledge from opinion.
And in this role as judge, philosophy has invariably been
hostile to images of all sorts, to the phenomenal world as such.
What appears is not what it appears to be, and there is a reality
that is by definition invisible, grasped only by the mind and
its concepts.

For a long time, philosophy thought the best way to do
its job was to formulate theories about this real world, about
what in reality constitutes truth, friendship, origins, or
knowledge. Only then could it model itself on the structure of
reality and derive the proper ways of acting in the phenomenal
world.

But it has never really been enough to just make up
theories; you have to destroy false claims before you can
make true ones yourselves. If there is something unique in
philosophical critique, in the idea of philosophy as critique, it
is simply to see the philosophical task as one that entirely
exhausts itself in destroying false claims.

Critique begins in or as a gesture of epistemological
modesty: I don't know the truth, the essence, the thing in itself,
and neither do you. But this is the modesty of philosophy, not
of the natural sciences, a modesty forced upon it by their
success. For when the natural sciences came along with their
own ideas about truth or knowledge, when atoms and
empirical sensations began replacing monads and forms, when
information began pushing wisdom and reflection aside, then
philosophy had to shift its ground.

We propose to look at critique as a specific kind of
discourse, a specific kind of discursive intervention. Critique
only exists in relation to something other than itself, "it is a
means for a future or a truth that it will not know nor happen
to be," as Foucault put it, subordinated in relation to the posi-
tive sciences.[1] For this very reason, however, its epistemo-
logical modesty is more than made up for by its iconoclastic
immodesty.

The State of Nature

For the sake of argument, we begin in a *discursive state of
nature*. Here we have an infinite number of discourses in a
tangled network of relations, none of which have any privi-
leged status: each discourse has the natural right to modify
other discourses as far as its power extends, and each may be
modified in turn.

Let us also assume that the authority a discourse enjoys
is linked to its relationship to that which it is "about," that to
which the discourse is directed – another discourse, perhaps,
a content or theme, or some state of affairs in the world – in
short, to the "object" of the discourse. *A discourse always
bears upon something else:* it represents, embodies, expresses,
explains, or enriches this something else in some manner or
another.

Now the state of nature is not very good at ensuring
the permanence of this authority. Perhaps tomorrow another
discourse will come on the scene, one that is stronger or better
able to bear upon the object. And so discourses require some
means of perpetuating their authority.

1

_ Michel Foucault, *The Politics of Truth*, Sylvère Lotringer and Lysa Hochroth (eds),
Semiotext(e), New York, 1997, p. 25.

One way is to link the discourse to the order of the cosmos or to the will of God: the discourse is the natural or preordained expression of that order or will, and to question its authority is to question the very ground one stands upon. Naturally, it is not easy to make this link, for many discourses strive to make the same claim. But to the extent that all agree *that* this kind of link is legitimate, then such authority, once established, is not easy to budge. The authority of *tradition* depends on the *natural inertia* inherent in this idea.

This has long been the preferred choice of discursive authority; indeed, we shall see that critical discourse aims at nothing else even as it defines itself in opposition to this very mode of legitimating. But for a long time now it has been impossible to argue for a link, natural or preordained, between a discourse and that which it bears upon. And in the absence of tradition, a brave new world of discourses and objects has been freed.

Now even this situation would be unproblematic if each discourse only bore upon something unique to itself. But in the state of nature this balance is never achieved: there is always a poverty of discursive objects, or a surplus of discourses. There is always more than one claimant to an object. This is the task of philosophy – to distinguish between rival claims. And when philosophy at the same time relinquishes the task of positively bearing upon objects of its own, then we have the arrival of critique.

Excursus 1: The Mimetic Crisis

René Girard depicts the origin of social conflict as two sets of hands reaching for the same object at the same time. The consequences this "mimetic" conflict engenders are so fundamentally inimical to the social order that an attempt is made to remove the object through the use of two strategies: directly through the imposition of various social prohibitions, and indirectly through the enactment of rituals that re-enact the crisis. In such rituals a substitute object – a scapegoat – is sought out, one that can be safely removed without bringing about vengeance and a further escalation of the conflict.

Social order is thus restored to the community; and it is precisely this newly established social order that retrospectively confers deification on the scapegoat. For Girard, the sacred in culture is nothing other than the displaced violence of this initial act. All human communities arise from this founding murder, as he calls it, and all cultural institutions represent attempts to come to terms with its implications.

Now according to Girard, modernity is marked by the very process of undifferentiating that formerly led to mimetic violence and the sacrificial murder of the scapegoat figure. Whereas traditional societies erected "external" obstacles such as religious prohibitions to keep mimetic conflict in check, modern societies have somehow managed to release and re-deploy mimetic conflict such that undifferentiating does not automatically lead to violence. Thus the questions: How does modern society retain its stability in the absence of the external kinds of obstacles set up by traditional societies? How does it survive the disappearance of religion?

Science

There are many ways to solve the mimetic crisis. One can try, for example, to multiply the number of objects or, conversely, to divide the object into smaller and smaller units. In this way each discourse could bear upon an object so specific that no two discourses could be said to infringe upon the other.

But this administrative solution is not very effective nor does it last long. Let us see how scientific discourse typically resolves the crisis.

Take a discourse that bears upon "nature." Nature represents a content or state of affairs to which the claims of the discourse are directed. With respect to these claims, nature is nothing more than a domain of virtual evidence awaiting

actualization. The authority of a discourse "about" this nature hinges on its ability to actualize this evidence in some sense "better" than other discourses – more consistently, more effectively, more convincingly, etc.

The essential point is that one agrees *to allow oneself to be situated by the evidence of the object,* an object, which by definition can always resist or exceed the claims of the discourse. Such resistance or excess can then be read as an index of error; and only by orienting itself to the possibility of error can a discourse be in a position to acquire scientific authority.

In this context it is therefore not an objection to say that nature is "constructed" by each discourse, *for one still has to construct a better nature.* Or to say that the questions and claims directed towards the object are theory-laden and representative of social interests and biases. *How* this evidence is obtained is not the issue: what counts is the agreement to be situated and determined by the very evidence that one seeks to actualize through one's constructions and theories.

This is why science has never been disturbed by the idea that its authority derives from its constructions and not from some natural and naive contact with reality, and why re-defining science as one cultural activity among others, that is, as one that differs in degree only from other activities, is not sufficient to displace science's authority: *this is something that science does itself,* only that it can point to its actualizations as proof of its superiority. Yes, it mobilizes actors and black boxes its results, defying others to disagree; yes, it constructs the world: but what is the problem?

The essential – and paradoxical – point is that its theory-laden and constructed evidence nevertheless *speaks the truth of the object* – that is, allows the object to speak and so to resolve the mimetic crisis. Indeed, only when the object is freed from the oppressive imperialism of the natural order, only when it is streamlined and disciplined by the constructions of scientific discourse, is it possible to talk about an object at all.

Excursus 2: The Expropriation of the Object

The crisis of metaphysical knowledge coincides with the rise of the natural sciences. Kant continually contrasts the loss of metaphysics' prestige with the authoritative status enjoyed by mathematics and physics. He envisions a "Copernican" revolution that will enable metaphysics to find a place alongside the other sciences.

But how exactly has metaphysics failed as a science? Kant says that *reason's natural desire* for the unconditioned, for transcendence, is in fact the very source of the metaphysical crisis. The "bad" objects of metaphysics, precisely because they are situated in a space that provides no resistance and hence yield no possibility of error, destabilize the social order by allowing diametrically opposed assertions to be uttered about them. This natural dialectic of human reason, as Kant terms it, is but another name for mimetic conflict.

The "good" objects of mathematics and physics, by contrast, capture the object in such a way that *it always says the same thing.* If we are to speak about objects *in their name,* they must allow us to exclude the possibility of anyone asserting the opposite about them and thus to authorize stable and peaceful readings. The *natural* duality of mimetic desire and its domination by reciprocal violence is broken by the installation of a *civil* condition peopled by good objects. An entire system of relations is created at a single stroke: the object that compels agreement and the peaceful civil community founded upon this agreement.

The task of a critique of reason is to eliminate the conflicts that arise on the basis of the bad objects of metaphysics and to fashion for metaphysics the functional equivalents of the good objects of mathematics and physics. To this end, reason must subject itself to the pronouncements of a critical tribunal whose job is to establish once and for all the legitimate rights of reason, that is, to determine which objects it may bear upon, which objects it may actualize to speak in a single voice.

Yet this critical tribunal is a peculiar one. Like any tribunal, critique stands "above" the disputants as a neutral party, but its authority does not issue from any superior insight into the nature of the objects at the center of the disputes. If this were the case, then critique would simply be another discourse, one that appeals to the evidence of the object.

Instead, the critical tribunal operates *by abolishing all direct access to the object.* The dogmatic rationalists seek to apprehend their object through thought alone, whereas the empirical skeptics opt for the primacy of the senses; but both presuppose an immediate and essentially unproblematic access to their objects. Instead, Kant thinks we must turn towards the objects as we represent them to ourselves in our constructions.

This is what mathematics and physics have managed to do: their objects *are* their constructions, their representations as constructions. Since Kant thinks that reason can only know *what it itself has made,* reason too must construct itself, re-present itself to itself.

Only in this manner can it have access to itself *as an object.* And only in this way can the mimetic conflict be resolved. Reason now has a single object – itself. The agreement to be situated by the evidence of the object is unproblematic, since to do so is merely to acknowledge the authority of reason itself.

This alters everything. In the state of nature the object is merely a collection of immediately accessible natural predicates external to the discourse that bears upon it. In the civil condition, reason relinquishes all claims to knowing the internal grounds of external objects, for these claims lead it only into strife with itself. Instead, its task is now *to transform all representations of objects into re-presentations of itself.* Representations now have the job of signaling whether reason *has submitted its natural desires to a critique.*

Reason thus enacts what can be termed the *expropriation of the object.* The object loses its internal grounds, which are exiled out beyond the realm of what can be known, and ceases to become an assemblage of natural predicates. It enters the civil condition solely as the object of critique, as an index of reason's claim to authority.

Kant's philosophy is the first great iconoclastic gesture in philosophy – he is Mendelssohn's "all-destroyer" in every sense of the phrase. The notion of a civil condition is inseparable from that of a *critical modernity:* the incessant interrogation of any discourse whose objects do not exclude contrary claims and which do not authorize peaceful and stable readings in their name.

De Jure and De Facto

Although Kant sought to emulate the sciences, his critical resolution of the metaphysical crisis abandons what is unique to the scientific resolution of the mimetic crisis. For, from the standpoint of critique, science certainly resolves the mimetic crisis, but the new order *does not differ in kind* from its predecessor. Science still retains a purely natural relation to its object: scientific discourse, by virtue of hard work, a superior methodology, more precise observation, or natural genius, simply manages to bear upon the object (to actualize the object as evidence in a claim) better than other discourses.

The critical resolution is quite different. When, as in Kant, it looks to the sciences for a model, it does not and cannot see the *de facto* progress of the sciences as decisive. Rather, it thinks that the ability to acquire knowledge of objective states of affairs is an expression of reason's *de jure* internal condition. Reason cannot grasp the object unless it has entered the civil condition; the good objects of the sciences express first and foremost the accomplishment of reason in having carried out a critique of its natural desire.

The whole question of the right of a discourse to bear upon a state of affairs is thus reversed: it is not the discourse that expresses or represents an object but *the object that*

expresses the discourse. In this way critique, the discourse of the civil condition, becomes the rightful and anterior condition of objects that precede it in the state of nature. This is why it necessarily abandons any form of authority based upon the notion of a continuum between the natural and the social order, whether that is expressed in the form of a pre-established divine harmony or as the result of the application of a superior social technology.

Resistance

Critical discourse does not presume to criticize other discourses on the basis of the resistance of evidence or a privileged insight into a state of affairs. Yet since critical discourse does not seek to bear upon a common object deemed accessible to all, how can it accomplish this task?

Critical discourse always arrives late on a scene that has been factually given to. It is thus always a "coming-after." These discourses are *de facto* prior to critical discourse, prior to it in the state of nature. But the arrival of critical discourse, its intervention into discourses and their objects, signals the transition to a civil condition. Everything is changed in the twinkling of an eye. The discourses it now confronts only come into being (that is, enter the civil condition as good objects) on the basis of the critical intervention. Critical discourse is hence *de jure* always an "already there."

Invariably, critical discourse encounters resistance in its objects in the discourses over which it seeks to acquire authority. But this is not the resistance we saw in the case of scientific discourse, where it expressed the necessary possibility of error and the willingness to be situated by this possibility.

Resistance here does not direct one's attention to the object. Critical discourse interprets resistance instead to be *the inability or unwillingness of the discourse to enter the civil condition.* The task of critical discourse is *to break this resistance* and force the discourse to abandon the state of nature.

There is a considerable difference between inability and unwillingness. With respect to the former, critique views the discourse in question as incapable of entering the civil, through no fault of its own. The discourse naively believes it can refer to its objects and that its actualizations possess authority.

In this mode, critique takes pity on the discourse. It sees its task as articulating what the discourse is trying naively to express, to draw out what is implied in it or what can be only poorly understood due to various empirical impediments. In a sense, this version of critical intervention is close to the scientific resolution of the mimetic crisis: it seeks to treat its discourse as an object, which it then actualizes better than the object itself could ever do.

The unwillingness of a discourse to enter the civil order is another matter altogether. Here a totally new assessment of resistance is required.

Excursus 3: The Appropriation of the Object

Hegel's well-known remarks concerning the circularity of the critical procedure (it is like not wanting to go into the water before learning to swim) are not directed at the logical incoherence of such a project. Hegel was haunted by the so-called "equipollence" argument put forward by the ancient skeptics: two opposing claims put forward in the same way with no recourse to a court of law competent to decide the matter once and for all.

This is particularly the case for critique since critical discourse does not and cannot appeal to the actualization of evidence; it is, after all, founded upon prohibiting access to the object. Each new critique seeks to have the latest word, but in so doing no one critique can be distinguished from any other. This pure polemical field of discourses vying for scientific status is yet another version of the state of nature and the mimetic conflict.

But while Kant seeks to abandon the entire field of polemics altogether by removing the object of dispute, Hegel adopts another strategy. As he sees it, the problem is not the object as such but rather the *subject*: the polemical field of modern philosophy *repudiates or abandons completely any relationship to the other*. Since each disputant puts forth its claims without a view to its opponents, nothing more can be accomplished than to force the false position to confess its emptiness; and since from the beginning nothing more than this emptiness is granted to the opponent, only more and more nothing can ever be recovered.

The key is that there is no *mutual recognition* among the disputants who appear only as *pairs of subjectivities confronting one another.*

Hegel maintains that a *philosophical* critique must assume that *each claimant is at least implicitly rational,* capable of speaking the truth of the objects it bears upon. And so Hegel proposes a new way of seeing the relation of reason to its object. The entire ensemble – pairs of subjectivities fighting over the object together with the object itself – is revealed to be *the result of a reason estranged from itself.*

This is the resolution of the mimetic crisis. It has two parts. The object is and cannot be wholly Other to reason; it is a part of reason itself, a part of reason that has not comprehended itself, that has not carried out a critique of itself. Reason thinks it is seeing its Other, but in fact *it is seeing itself in the mode of being-other-than-itself.*

And in this mode of being-other-than-itself reason invariably generates subjectivity as such. The appearance of the object as Other to reason is necessarily accompanied by the appearance of mutually opposed subjectivities whose opposition is at once a testimony to reason's self-estrangement from itself.

In this way Hegel is trying to win back for philosophy some of the respect it had lost in Kant. For if the crisis of metaphysics is the result of the internal strife of reason with itself, and if this internal strife is somehow intrinsic to reason, then this crisis expresses something essential about philosophical truth. Instead of emulating the factual success of the natural sciences, philosophy must instead seek its own objects and its own kind of truths.

Taken to the extreme Hegel's position implies that the very inability of metaphysics to bear upon objects, to actualize their evidence, becomes a sign of its *superiority* over those discourses that seek to do this. The crisis of metaphysics is hence transformed into an ongoing crisis *of the natural sciences:* it is they who remain merely "positive," believing naively in their actualizations.

The Gift of Reason

The Hegelian resolution of the mimetic crisis may be said to extend *the gift of reason* to all discourses. Although this seems like a generous gesture on the part of critical discourse, we see that it runs the danger of allowing the civil condition to merge with the state of nature, of seeing the former as but the mimetic completion of the latter. If there is nothing outside reason, then there must be some sort of continuity between the state of nature and the civil condition.

Critical discourse really only comes into its own when it views the resistance of the object as expressing *the obstinate refusal* of the object to enter the civil condition.

Now to a certain extent, critical discourse interprets this refusal, this resistance, as an error. But the error has a different function. The refusal of an object to enter the civil condition is a sign of its subjectivity, that is to say, of a reason that has misunderstood itself, that has failed to carry out a critique of itself. But who or what is then to blame in such a scenario – the necessarily limited self-understanding of subjectivity, or the stunted form of the philosophical Idea of which it is the expression?

If opposed pairs of terms exist, it is because they are the expression *both* of a subjectivity that refuses to be integrated into a whole *and* of a reason that fails to integrate it into a whole. By extending to everything the gift of reason, Hegel also extends to everything *the responsibility and the duty to become rational*. But since there is nothing opposed to reason, then this guilt *stems from reason itself,* from a reason that has not yet come to know itself or that refuses to know itself.

It is impossible to measure the fury and the hatred unleashed by this dialectic. Perhaps the most dismal of all its products has been the notion of ideology critique. Previously there was reason and unreason; now there is only a reason that has failed to carry out a self-critique. Previously there was truth and error; now there is only a truth that has failed to comprehend itself. Previously there were enemies and friends; now there are only friends who become rivals by willfully avoiding the duty to become rational.

Excursus 4: The Acoustic Illusion

Kierkegaard's curious form of religious faith demonstrates the influence of the critical revolution even as it repays critical discourse with a compliment of its own.

The Sickness Unto Death articulates the state of nature in very precise terms. The self is defined as a relation that relates itself to itself, but which in so doing relates itself to a third. We can picture the self as the horizontal bases of an equilateral triangle – they are related to one another, but the bases are simultaneously related to a third term at the apex – the third term being, of course, God.

The *natural self* is a mere duality whose elements are opposed or reconciled in some fashion and which has no recourse to God. It is by definition guilty, and so oscillates between two poles that can never come to rest: too much possibility one day, too much actuality the next; too much freedom,

then too much necessity. Once again we have the mimetic crisis in another guise.

Kierkegaard's resolution implies that the God-relationship frees human beings from the natural tyranny of their desires. In this sense, God ideally performs the same function as irony in Kierkegaard: the function of the God-relationship is *to prevent all idol worship of the object*. Thus the *spiritual self,* by definition mediated by a God-relationship, no longer possesses natural instincts or drives; these, as well as the objects they obsessively and destructively attach themselves to, are never good or bad in themselves. They are either *fallen or redeemed*.

But the natural self *is also offended by the consciousness of its guilt,* even when it celebrates its unspirituality and the fateful primacy of its natural desires, even when, in its pride, it resists the call of God and desires its sin. Yet the offense at being judged guilty is not something that the natural self is capable of attaining by its own means. The offended consciousness does not understand itself but is *rather understood by God*; everything the offended consciousness thinks or says is an echo, an acoustic illusion. That is, *the offended consciousness is the indirect proof of the authority of God.*

Hence God *both sustains and destroys* the stability of the self. God prevents the closure of the self upon itself, prevents the heart from curving inward and becoming a slave to its natural passions: God is the continuous *dis-closure of the self*. But such a God is also the permanent reminder that the self is guilty; and not only that, the self is guilty of not knowing that it is guilty. God is more than paradoxical in this scenario: God is the Paradox itself.

All this is a very accurate description of how critical discourse deals with the problem of resistance and, more specifically, with the problem noted in the Hegelian appropriation. There we saw that the resistance of the object is in fact attributable to reason itself, to the inability of reason

to carry out a complete self-critique. And so subjective resistance carries with it an air of innocence – even in Marxist ideology critique, for example, one cannot blame the proletariat for being deluded about the real nature of their predicament.

With Kierkegaard the guilt at resisting is reflected back towards the object. This alters drastically the problem of resistance, but even more significantly it utterly transforms the question of evidential validity. The evidence of the object is now entirely in the hands of critical discourse. If the object is amenable to critical intervention, then its evidence is a "straight story" and it is brought quickly into the civil condition. If it resists, then this cannot be attributable to an error on the part of critical discourse; instead, it is yet another proof of the latter's authority.

Betrayal

Let us examine this question of evidence more closely. Scientific discourse seeks to actualize the virtual evidence of its objects as a means of saying something about them; the evidence is in some way intrinsically bound to the object, even when it is not initially visible. Scientific discourse is even able to demolish its objects and to construct completely new ones *in the search for their identity,* for its claims are ultimately grounded in the object's essential continuity with itself.

To use a metaphor often found in the discourses on nature, the object must undergo a trial and be subjected to a legislation that is not its own, but only that it may be forced to "confess" to *what it really* is. That is, there exists at bottom an ontological continuity between the levels of evidence such that they all positively express something of the "nature" of this object; *the last word belongs to the object itself,* even if the object at the end of the process is no longer recognizable in its original form and even if it has been, to use Bacon's infamous phrase, tortured on the rack.

Critical discourse is very different. It preserves its object, leaves it intact, but hollows it out from the inside so that the object *speaks with a voice that is not its own.* Critical discourse seeks to actualize evidence that is not intrinsic to its object, which counters the ostensible identity of the original discourse; here the object is forced to confess to *what it really is not. The object betrays itself.*

This is a very important achievement. Critical discourse can substantiate its claims even when the overt evidence of the object may seem to contradict these; it establishes *in the object itself* the very conditions by which the latter will confess to its guilt. There is no going back, no possibility of pleading ignorance, no empirical exit: the object is cut off from the state of nature and now exists only in and through the critical utterances that bear on it. It is guilty. It has entered the civil condition.

Performative Contradiction

In the state of nature discourses circulate and produce positive statements bearing upon their objects. Now it sometimes appears as though critical discourse offers up propositions or statements that assert something about an object. In a strict sense, however, critical discourse does nothing of the kind.

Critical discourse, as critical discourse, must never formulate positive statements; it is always "negative" in relation to its object. As soon as one thinks critical discourse is saying something positive, literally asserting something about its object, then that particular critical discourse has ceased to be critical and has fallen back into the state of nature.

Critical discourse, then, in its "purest" form, must exist in a negative mode; its existence as a discourse must be a kind of non-existence. We may phrase this as follows: *The utterances that make up critical discourse assert nothing.*

It is in this light that one of the more disputed points of critical discourse can be best understood. At some point or

another all critical discourse finds itself confronted by the charge that it exempts itself from the constraints that it applies to other discourses. The protest against this alleged illegitimate exemption is an ethico-logical one – the charge being that practitioners of critical discourse enact a "performative contradiction" when they make apparently absolute claims validity of about the relative validity of all other claims.

But one will continue to miss the point of critical discourse until it is seen that its claims are not intended to be about the objects or discourses it bears upon; this is what makes critical discourse so unique among all other discourses. The latest word claimed as its privileged domain by critical discourse is in fact *the word of the object reflected back upon itself;* the word bounces off the black wall of critical discourse (which itself says nothing) and performs a self-critique.

Excursus 5: Narcissism

Girard's theory of mimetic violence has a very precise connection to critical modernity. Girard claims that modernity has invented *desire*, the form human relationships take when there is no longer any resolution of the mimetic crisis through the victim. In traditional societies the prohibitions established to prevent the reappearance of this conflict are necessarily "passive and inert" obstacles; in modernity all this changes. The obstacle now becomes an "active, mobile and fierce" *rival* – precisely the thing that traditional societies sought to prevent.

Each subject desires the object; each is a rival to the other. But each rival is, in turn, a *model* that *mediates* the subject's desire for the object: the subject desires the object because the rival has first "designated" the object as desirable by desiring it. The rival is both model and disciple at once, but always a rival.

Girard refers to this relationship of pure reciprocity as one of *doubles*. The modern social field can be interpreted as the struggle of these doubles to avoid the mimeticism they are inexorably bound to in the absence of any sacrificial objects.

This is why dividing or multiplying the object, such that everybody has his or her own specific object and domain of authority, is at best only a provisional solution to the mimetic conflict. It never quite works because *the real object of mimetic conflict is not the object as such but the rival's desire for that object.* No matter how many objects are available to bear upon, discourses will invariably come into conflict, since the object is nothing in itself but merely a sign of the rivals' desires.

The pervasiveness of this desire in the modern world results in increasingly "pathological" forms of desire. The disciple first imitates the model's desire for the object, but then the model subsequently imitates the disciple's desire, that is, the model imitates his or her own desire as reflected in that of the disciple.

Yet it would be wrong to suggest in this scenario that objects have simply disappeared; they have instead been incorporated into mimetic desire in the form *of narcissistic self-sufficiency.* In a long and complex reading of Freud's theory of narcissism, Girard concludes that mimetic desire invents the idea of self-sufficiency in order to give itself an object *that forever refuses access.* Desire is attracted to models whose self-sufficiency demonstrates their indifference to that desire.

On the one hand, in giving itself an object like this, desire ensures its failure – which is, of course, just what it desires. On the other hand, desire also seeks to destroy the very self-sufficiency that makes it attractive (and thus again to destroy itself). Desire strives to demystify its model, to convince it that its self-sufficiency is in fact an illusion.

All this is very relevant to critical discourse, the discourse of modern desire par excellence. Girard explicitly links this form of mimetic desire to the practice of critical

discourse. Critical demystification, he says, "is mimetic desire itself, gnawing away at the last vestiges of the sacrificial system inveigling everything outside its grasp into the mad whirl of doubles. The more aggravated mimetic desire becomes, the more it allows itself to be fascinated by ontological illusions, from which it has ceased to draw any benefit. That is why everything that seems to be endowed with the least stability, everything that escapes or appears to escape the structure of doubles, stirs up resentment and gives our intellectuals the demystifactory itch on which their analyses of desire are inevitably dependent."[2]

The Double Bind

The ideal form of critical intervention is thus the following: critical discourse acquires authority over its object (that is, another discourse naively bearing upon an object) by compelling the discourse to enter the civil condition, which means compelling it to betray itself, to confess its guilt, to speak with a voice that is not its own, to break its own resistance to critical authority.

Yet to the extent that objects perform a self-critique of themselves, *they become rivals of critical discourse.* An object that betrays itself, that becomes critically reflective and hollows itself out, is clearly superior to one that resists being dragged into the civil condition.

It appears, then, that critical discourse is doomed to remain entangled within a double bind. If it calls too much attention to itself, claiming to be the means by which the self-critique of the object is carried out, then it will be accused of coercion, of finding in the object only what it has itself put into it. But if it performs its job too well, then the object will be seen to have entered the civil condition on its own, to have carried out a critique of itself.

Yet – and this is the whole point– critical discourse *desires nothing else than to find itself in such a double bind.*

It is itself responsible for this state of affairs, and would have things no other way. What critical discourse must do *is to extract itself from this double bind while remaining within the double bind structure itself* – a paradoxical situation, no doubt, but one that is precisely suited to critical discourse and is itself exemplary of the double bind as such.

Excursus 6: The Exappropriation of the Object

The general outlines of Derrida's reading of Hegel are well known. Hegel represents the culmination of philosophy, the telos of all western metaphysics as such; whatever was only imperfectly expressed in other philosophers comes to its complete fruition in Hegel. And Hegel embodies this telos because of the role of dialectics in his thought: it is precisely *because* Hegel seeks to take account of reason's Other that he becomes in Derrida's eyes the most perfect embodiment of metaphysics. Metaphysics takes account of difference only by appropriating it as the same, as a moment of reason's self-estrangement.

As such, Hegelian discourse represents a threat to critical discourse, for it employs critical discourse *as a means of ensuring its survival.* Not only is dialectics prepared for any form of critique, it *needs* critique in order to function. More strongly still, dialectics *is* critique, the culmination of philosophy as critique. The melancholy fate that awaits all discourse in the wake of Hegel is to be overtaken by the Hegelian law of appropriation.

Derrida is acutely aware of this Hegelian "cunning." But if Hegelian discourse anticipates its own critique in order to absorb it, if it allows the Other just enough validity to be able to sublimate it, how can Derrida stop the dialectical machine from functioning? How can he prevent Hegel from having the last word?

The struggle of mimetic rivals requires that they incessantly seek to differentiate themselves, to prove that they

2

_ René Girard, *Things Hidden Since the Foundation of the World,* Steven Bann and Michael Metteer (trans.), Stanford University Press, Stanford, 1987, p. 379.

are unique – which, of course, only proves that they are the same. Critical energy becomes increasingly directed at critical discourses themselves: critical discourse *must distinguish itself from false doubles*, that is, from false forms of self-critique.

This is the real source of Derrida's fascination with Hegel: *Hegel represents the model of all critical discourse as such*. And to this extent, Derrida must imitate him: he must render a critique of Hegel. But it is not a "real" critique: instead, Derrida "reads" Hegel, which is to say he enacts a *parodying or mock-heroic simulation* of Hegel's self-critique. For the self-moving Hegelian concept we have Derrida's perpetual deconstructive engine; for *the real is rational* we have *il n'y a pas de hors-de-texte*. And so on, and so forth.

Derrida's critique of Hegel, that is, of critique in its metaphysical form, is not undertaken because of a tender regard for those discourses crushed by the encompassing and imperialistic movement of the Absolute. Quite the contrary. *It is to be rejected because it has produced "Derrida,"* that is, the critical discourse that will supplant it. The very emergence of "Derrida" *as a fact* testifies to the *de jure* right of "Derrida" to enact an "exappropriation" of its model.

Hegel's weakness, and the weakness of any metaphysical critique that seeks to appropriate its object, is that, by conceiving the Other as the same it dialectically brings about its own downfall. Derrida must therefore "exappropriate" his object: but again, this is not done so as to free the object but rather to block any escape exits, to cut the object off from any autonomous existence outside the civil condition of deconstructive critique.

When this is accomplished, deconstruction will always have the last word. Deconstruction is *by definition* demystified, that is, it has the de jure right to perform a critique of any object, and it can put forward this claim because it sees that *it is itself* the source of the mystification that it finds in its object, which is to say, of the resistance to the deconstructive intervention.

Pathos

Now all of this is rather bewildering to be sure, and one is entitled to wonder whether the twisting and turning of critical discourse in its attempts to assign and avoid guilt is worth very much. It is true that they are not worth much with respect to bearing upon common objects and seeking to actualize their evidence. This is something that critique has long since abandoned. Its gestures (like wanting to assert nothing) do not have cognitive intelligibility as their medium of expression. Instead, critical discourse employs a *pathetic* form of communication. This pathos assumes two basic forms.

The pathos of failure. Critical discourse is permeated by the sense of failure, and more specifically, of the failure of expression. This sense of failure is linked to its self-acknowledged cognitive modesty: its claims, as we have seen, are not intended to be about something intelligible in the world, not even when they speak about themselves; they are instead intended to empty themselves of meaning as far as possible.

The pathos of this failure is expressed in a series of terms that carry with them a "negative" connotation – one invariably finds reference to lacks, gaps, fissures, ruptures, etc. – but of course this is given a heroic "spin," the celebration of what is non-cognitive or extra-cognitive, of what is irrational or "beyond reason."

The pathos of subversion. The pathos of subversion may be seen as merely an extension of the pathos of failure; nevertheless, it warrants separate treatment, for several new features appear that are not immediately obvious in the former category.

The pathos of subversion traverses a rhetorical field occupied by the opposing personae of *policeman* (God, father, logos, meaning, signified, interiority) and *master thief* (signifier, trace, *différance*, play, exteriority, jouissance, etc.). The object of critical discourse is taken as representative of repressive authority in general and the critical intervention is cele-

brated as a political act. This satisfies the lingering demand that critical discourse should be "oppositional" in some fashion while marking its difference from previous discourses whose gestures of refusal were based upon nostalgia for lost totalities.

Yet to be subversive does not mean to break the rules or to somehow occupy a position outside the civil condition. Critical discourse *is* the civil condition. It is the discourse of the civil condition that knows itself to be the source of all resistance to that condition. To be "subversive" in this context means to operate within the parameters of a given set of rules, thus acknowledging their binding force, but to delegitimate them at the same time.

The motto of critical discourse at this advanced level might be: *We know how to break the rules – but properly.*

The End of Critique

Critical discourse first interprets the autonomy of the object as a resistance to its authority; then it renders that resistance internal to itself, such that it becomes the source of the resistance to itself. Anything "outside" the civil condition of critique is merely an effect generated by critique itself; it is, in fact, critique in its fallen state, a critique that has not freed itself from a natural or positive relation to the objects it purportedly imitates or represents.

In this sense, critical discourse has no end. It produces its own resistance, finds ontological traps everywhere, renders objects possible and impossible at once – ensuring its own necessity and authority all the while. It is *de jure* prior to objects that *de facto* precede it. It possesses the *de jure* right both to interrogate all other discourses without regard for empirical evidence and to deploy the same evidence whenever and wherever it deems fit.

Thus Derrida's specific *pathos* is to be glimpsed in his staging of this *both* as the subversive resistance of deconstruc-

tion to philosophical mastery *and* as a kind of inverted wonder (and resentment) at the resistance of philosophy to deconstruction. To the extent that "Derrida" has comprehended philosophy as critique, such that he can even render an account of Hegelian dialectics, then we may say that "Derrida" represents the end of critique. *There can be no critique of "Derrida."* There will, to be sure, be many critiques, many attempts to supplant this form of critical discourse; but it is hardly imaginable that they will be different.

But does this not apply to the present discourse? What we have been doing all along here? Have we not been providing a critique of critique? Has this not been yet another attempt at one-upmanship? At showing how unique we are in having avoided the snares of critical discourse – and thereby demonstrating that we are, at bottom, just the same as everyone else? Isn't it better to confess to the necessity of playing the critical language game?

To be sure, the very instant one sets out to examine critical discourse one becomes entangled in the machinery. The very instant one opens one's mouth to speak the wheels start turning, and one expropriates, appropriates, and exappropriates to infinity. The critical machine is built to run like this, it offers the lure of ironic mastery, the pathos of exercising mastery in the name of its refusal.

But to be drawn into the machinery does not mean there are no exits. Critical discourse extends its self-reflective claim to authority by first setting the boundaries of the civil condition and then successively making sure that there can be no escape from this condition. There are several variations on this theme: one says that one is "always already" rational (Hegel) or that one is "always already" guilty (Kierkegaard) or "always already" textual (Derrida).

One can imagine several others: we are "always already" in language, in the social, in the economic, etc. We are "always already" other than we think we are, and it is this otherness that critical discourse latches on and uses to bind

its objects to itself. Any attempt to envision a state of affairs outside of the civil condition is viewed as a projection, an illusion, nostalgia, or whatever, and, in true critical fashion, as something regrettable but necessary since it is a function of the acoustic illusion.

But perhaps we should go more slowly. If it were really true that one cannot get out of reason, or out of language, or out of the social, *then one could not have gotten in either.* There must be a way "out," and that way is *given to us* by reason, or language, or the social.

Here it is a question of interpreting the curious experience to which the discourse of reason in its critical form stands as testimony: one is always already beyond where one is. Northrop Frye speaks of the strange workings of unrelieved irony by using an image from Dante's *Divine Comedy:* At the bottom of hell Dante follows Virgil down over the body of the upright evil giant, only to emerge on the other side to see the stars; for now the devil is standing on his head, hurled downward from heaven upon the other side of the earth.

One has two routes, each equally effective, to clamber over the evil giant: to retrace the steps of the critical demand, back through the double bind and the acoustic illusion, back through the steps of appropriation and expropriation, so as to understand the initial demand to enter the critical condition and the insistence that one is always already within it as soon as there are stable readings and good objects; or to go forward, to go into the machinery as far as possible, to experience the critical weariness of which Girard speaks, to let it saturate one's thinking until one can no longer look upon the objects of the world except as raw material for a fresh critique.

Then the world changes in the twinkling of an eye. It is possible once again to take the risk of ontology, to bear upon and learn from the objects of which one speaks, to ironize irony, to offer one's discourse as a gift to be passed around, altered and wrung dry of meaning and joy. To create sense. To break into song, to break into laughter.

Critical discourse is right about one thing: it is itself the cause of itself, and all that happens to itself. In the end, one has only to give it up.

Towards the end of the sixteenth century, when iconoclasm was raging in the Netherlands, three brothers, young students from Wittenberg, met a fourth brother, who was a preacher in Antwerp, in the city of Aachen … The four brothers, inflamed by misguided enthusiasm, youth, and the example of the Dutch Protestants, decided to provide this city, too, with the spectacle of an iconoclastic riot. They spent the night in an inn wining and dining and cursing popery and gleefully agreed on a signal at which they would begin to smash the windows. They set out towards the cathedral when the bells began to ring, determined not to leave one stone standing on another … ‖ Some ugly scenes had already taken place in the cathedral, where gradually more than a hundred miscreants had gathered, of all ages and of high and low estate, armed with axes and crowbars: the armed servants posted at the entrance had been subjected to ribald mockery, and the rioters had not scrupled to shout the most impudent and shameless insults at the sisters … ‖ The administrator came to the sacristy and implored the Abbess on his knees to cancel the celebration. But the Abbess resolutely insisted that this festival, ordained for the glory of the Most High God, must take place. Sister Antonia, who had fallen violently ill of a nervous fever a few days before, suddenly appeared at the top of the steps carrying under her arm the score of an ancient Italian Mass. The nuns immediately sat down at their music-stands with their instruments; the music was played with supreme and splendid brilliance; during the whole performance not a breath stirred from where the congregation stood and sat. Especially at the Salve Regina and even more at the Gloria, in Excelsis it was as if the entire assembly in the church had been struck dead. In short, despite the four accursed brothers and their followers, not even a particle of dust on the floor was blown out of place … ‖ Six years later, long after this incident had been forgotten, the mother of the four young men arrived from the Hague in the hope of discovering where they had gone. Someone remembered that quite a few years earlier four young men had been admitted to the city lunatic asylum. As, however, their illness consisted in a kind of religious obsession that seemed to indicate that the persons in question were Catholics; the mother could not set much store by this report. Nevertheless, she went one day to the asylum to ask if she could see the four unfortunate, deluded men. But how shall we describe the horror of the poor woman when, on entering the room, she immediately, at first glance, recognized her sons! The woman, sinking down half fainting onto a chair, asked the warders about their condition. The warders assured her that the young men were in perfectly good health; that when they were told they were mad, they would pityingly shrug their shoulders, declaring that if the good city of Aachen only knew what they knew, it too would lay aside all its activities and gather, as they had done, round the crucified Lord to sing the Gloria. ‖ The woman could not bear the terrible sight of her unfortunate sons and almost immediately asked to be taken home, hardly able to walk. The next day she went to visit a merchant who, she had been told, had been involved in the fateful events six years previous. The merchant welcomed the stranger very kindly, made her sit down in a chair, and spoke as follows: ‖ »More than three hundred ruffians from this city, misguided as it was then, were standing ready with axes and torches, waiting for the preacher to give the prearranged signal at which they would have razed the cathedral to the ground. As soon as the music began, your sons surprised us by suddenly taking off their hats; slowly, as if with inexpressibly deep and ever greater emotion, they pressed their hands to their bowed faces. Thrown into utter confusion of mind by this sight, the pack of miserable fanatics, bereft of their ringleaders, stood irresolute and inactive until the end of the Mass, the wonderful music of which went on pouring down from the organ gallery.« ‖ »On the way back to their lodgings my friends and I repeatedly asked them what

in all the world had happened to them that was so terrible and had been able to cause such a revolution in their very souls; they looked kindly at us, pressed our hands, gazed pensively at the ground and, from time to time, alas! wiped tears from their eyes with an expression which it still breaks my heart to remember.« || »Then, suddenly, it struck midnight; your four sons suddenly rose with a simultaneous movement from their seats and began, in voices that filled us with horror and dread, to intone the Gloria, in Excelsis. It was a sound something like that of leopards and wolves howling at the sky in icy winter. At this appalling spectacle we dispersed in all directions through the surrounding streets, which in no time were filled by more than a hundred people seeking the source of this ghastly and hideous ululation which rose, as if from the lips of sinners damned eternally in the uttermost depths of burning hell, to God's ears and implored his mercy.« || Three days later the woman, profoundly shaken by this narrative, made her way to the convent to take a look at the terrible place in which God had struck down her sons, blasting them as if with invisible lightening. A passing nun happened to learn whom the woman standing by the entrance was, whereupon the abbess sent a message requesting the woman from the Netherlands to come up and see her. While sitting in the abbess's office, the woman cast a glance at the music score which lay on the music desk; it occurred to her that this might be the piece of music performed in the cathedral on that strange Corpus Christi morning six years ago. She gazed at the unknown magical signs, with which some terrible spirit seemed to mark out its mysterious sphere; and the earth seemed to give way beneath her when she noticed that the score happened to be standing open at the Gloria, in Excelsis. She felt as if the whole dreadful power of the art of sound, which had destroyed her sons, were raging over her head; she thought the mere sight of the notes would make her fall senseless, and after quickly pressing the sheet to her lips in an impulse of divine humility and submission to Divine Omnipotence, she sat down again on her chair ... || At that moment the abbess came in and addressed the woman. || »God himself, on that wonderful day, protected the convent from your grievously erring sons. You would scarcely understand what I have to say to you on this subject, since you are a Protestant. Nobody really knows whom it really was who, in the stress of that terrible hour, when the forces of iconoclasm were about to burst in upon us, sat calmly at the organ and conducted the work which there lies open before you. Sister Antonia, the only one of us who was able to conduct that work, was lying in her cell, sick, unconscious, and totally paralyzed, the whole time. She died on the evening of that very same day. I have just received a Papal letter confirming that Saint Cecilia herself performed this miracle which was both so terrible and so glorious.« || The woman returned to The Hague, so deeply moved by the incident that she was received back into the bosom of the Catholic Church; her sons, for their part, lived to an advanced age and died happily and peacefully, after once more, as was their custom, performing the Gloria, in Excelsis. ||

ADAPTED FROM HEINRICH VON KLEIST, ST. CECILIA, OR THE POWER OF MUSIC

Heinrich von Kleist, The Marquise of O and Other Stories,
David Luke and Nigel Reeves (trans.), Penguin, Harmondsworth, 1978.

Francis Picabia / Spanish Lady with child / 1922 /
gouache and ink on paper glued to carton / 25 x 18,5'' /
private collection, Palma de Mallorca

Sigmar Polke / So sitzen Sie richtig (nach Goya und Max Ernst)
[This is how you sit correctly (after Goya and Max Ernst)] / 1982 / acrylic, fabric /
78.7 x 70.9" / Collection Frieder Burda

Sigmar Polke / Dürer Hase [Dürer rabbit] / 1968 / oil on canvas /
31.5 x 23.6" / Collection Frieder Burda

Moderne Kunst

Sigmar Polke / Moderne Kunst [Modern Art] / 1968 / acrylic and lacquer on canvas /
59 x 49.3" / René Block and Collection Froehlich, Stuttgart /
© photo: Collection Froehlich, archive

Gerhard Richter / Zwei Grau nebeneinander [Two greys next to each other] / 1966 / oil on canvas / 78.6 x 59" /
Collection Froehlich, Stuttgart / © photo: Uwe H. Seyl, Stuttgart

Elaine Sturtevant / Study for Johns White Numbers / 1973 / encaustic on canvas / two pieces / 26.8 x 35.4" / private collection / © photo: Christof Hierholzer, Karlsruhe

Elaine Sturtevant / Duchamp Bicycle Wheel / bicycle wheel, wooden footstool / 53.2 x 23.6 x 13.8" / FER Collection / © photo: FER Collection, archive

Jean d'Esparbes / Massacre ou le bourreau de soi-même / Musée d'art moderne et contemporain de Strasbourg / © photo: Angèle Plisson, Musées de Strasbourg

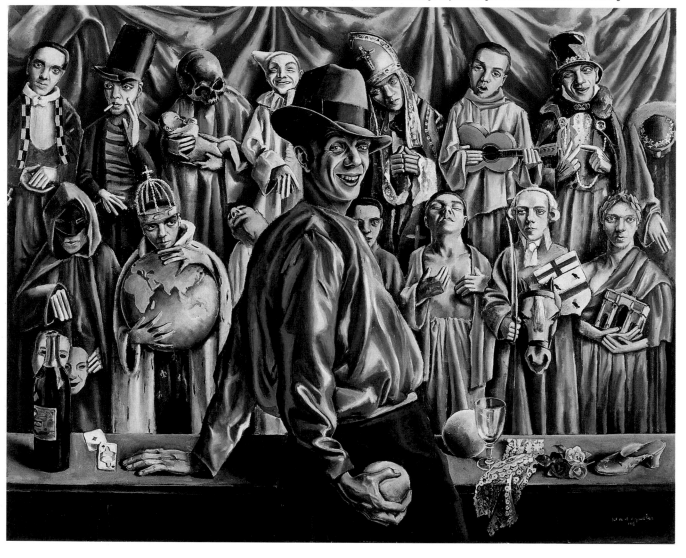

What has happened to modern art?

TO SEE THE WORLD IN A SQUARE OF BLACK

Adam Lowe

THE MAIN FOCUS OF THE TEXTS IN THIS BOOK is on overt acts of image destruction and control. Dramatic gestures of artistic damage and devastation more immediately capture public attention than the constraints of copyright, academic ego, loan applications, conservation considerations, financial control, political will, personal whim, and a host of other elements that control how and where we see images; the containment of the discourse of iconophilia is endemic and not often a theatrical phenomenon. The wordsmiths mediate visual logics while the professionals involved with the preservation and display of images are subjected to, and happily collude in, the oversimpli-

fications that reduce the complexities of visual communication to mission statements and "black boxed" trophies.

In the debates that surround Iconolash, images not only vie with words in the ongoing tussle between the iconoclast and the iconophile, but also with the emergence from and descent into blackness. Blackness is the definitive void, but also the ultimate space of creative possibility. It both veils and reveals; it is a field of noise that contains everything yet simultaneously represents the ultimate iconoclastic gesture. The cracks that cover the surface of Malevich's suprematist *Black Square* provide the starting point for this text, and reveal that, despite its reductive exterior, this simple image is profoundly complex. Its blackness is self-inflicted but time (and a lack of interest in technique) has caused the surface to crack, revealing two enigmatic forms in the foreground and various horizontal and vertical presences. The blackness partially masks the thoughts and procedures that went into its making but they are still present – influencing the character of the square. This text contains a series of interconnected visual thoughts that are based around an appreciation and interest in the processes and transformations that are involved in the making of images.

All images are made. Their makers are reputedly masters of their art, skillfully able to compress nuances of subtlety into their incredibly complex surfaces. Confronting an image is a strangely situated activity. As soon as you engage you are encouraged to play the part of an archaeologist, working back from the finished object, unravelling the entanglement of intention and process involved in its making, understanding each of the procedures which condition the experience of the whole image. But, like the archaeologist working on site, these layers are never as stratified as they appear, the mix of theory and historical understanding never quite as clear. The activity of excavation is already overdetermined. Theoretical projections tend to already know what they want to find. Discarded or neglected things contain more information,

Jean Dubuffet / Jeux d'ombre II / from the Phenomene series / 1959 / lithograph from the back of an etching plate / cream paper / 12.8 x 15.5" / © VG Bild-Kunst, Bonn 2002
The series of prints collectively referred to as Phenomene were made from the marks that appeared on the back of the plate during printing. Dubuffet's interest in images that are not over-proscribed resulted in a lifelong interest in L' Art Brut – the works produced by people outside of the professional art world – despite the fact that many of these individuals think of themselves as artists they are now commonly referred to as »outsiders« and while they are considered a fruitful territory to borrow from, their work is seldom embraced by the major institutions.

Manuel Franquelo / Untitled / 1994 / oil and water based paint on board / 51.2 x 31" / private collection / © photo: J.J. Blázquez, Madrid

albeit in less obvious forms, than the elements that are carefully recorded, archived, and stored to become the subjects of future study and discourse. Perhaps this dilemma captures the oddly intimate relationship between image breaking and image making.

One particularly resonant example of this connection between breaking, making, and layering can be seen in the temple of Medinet Habu in Thebes, which offers an oblique and fascinating parallel with Malevich's *Black Square*. Until a few years ago the small temple of Amun at Medinet Habu was covered in layers of black soot and dirt – the detail on the walls and ceiling barely visible and badly damaged after years of continuous occupation by "les Salles Copts," as the French invaders of 1798 referred to the local inhabitants. In the early 1990s funding was secured to remove the dirt to allow the temple to be photographed as part of an epigraphic study. After testing with a variety of solvents it was decided that the most effective way to clean the dirt from the walls was to use a dilute solution of nitric acid. Initial tests revealed that water dissolves the pigment (suspended in gum Arabic) covering the brittle layer of thin gesso clinging to the crumbling sandstone walls. Despite a clear understanding of what was going to be

A detail of black paint with graffiti from the tomb of Seti I / photo taken with permission from the Supreme Council of Antiquities, Egypt, during work undertaken in the tomb of Seti I by Factum Arte, Madrid / © photo: Adam Lowe, 2001
The photograph shows a section of the ceiling in the tomb of Seti I from the Hall of Beauties. Candles were used in the tomb in the nineteenth century covering the ceiling in soot. The graffiti is probably more recent.

lost during the cleaning it was decided that the veil of black must be removed. The Nitric acid was applied, stripping away the surface and leaving the more stubborn traces of paint and gesso attached to the pitted stone. Cracks were filled and the resulting restoration was covered in the conservators preferred consolidant, Paraloid B-72 suspended in acetone. Paraloid B-72 theoretically strengthens the surface without unduly sealing it. This initial restoration certainly revealed the images and removed a substantial quantity of dirt. But it also imposed a different aesthetic on the surface. Coating with acetone and Paraloid B-72 unifies the surface but it has unfortunate side effects – it changes the nature and perceived color of the pigment – especially in the pale colors where Huntite (a white clay) is mixed with the pigment to lighten the color. When coated, the clay loses its opacity and becomes transparent. It also darkens the color of the stone changing all the color relationships.

This restoration is a classic example of the "killing with kindness" that is so often the result when works of art are restored. In the removal of the blackness far more was lost than was gained, as a contemporary understanding of the images was imposed upon the temple at the expense of the surface and character of the walls and many of the levels of history that make the images so potent. The site is now in the process of being re-restored by the Oriental Institute of the University of Chicago who are meticulously removing the consolidant and alterations made by the previous restoration and scrutinizing every minute nuance of the wall. The complex layerings will provide work for many years for the restorers, archaeological draftsmen, epigraphers, photographers, and other members of the team dedicated to preserving what remains of the temple and deciphering the images, sculptures, and texts embedded within the wall.

The work they are undertaking, and the meticulous documentation they are producing is obsessively iconophilic and involves a team of specialists who each add their insights

Restoration test from the tomb of Seti I / detail / photo taken with permission from the Supreme Council of Antiquities, Egypt, during work undertaken in the tomb of Seti I by Factum Arte, Madrid / © photo: Adam Lowe, 2001

The tomb of Seti I was badly damaged after its discovery in 1817 by Belzoni. Museums in England, France, and Italy removed large sections of the tomb and molded directly from the walls in either wax, plaster, or paper. This detail shows a successful test to remove the layer of paper left on the wall. The paper is the by-product left behind in the nineteenth century during the production of a paper mould. The paper is the by-product left from lightly dampening the surface and gently rubbing away the paper fibers to reveal the paint beneath. However this sample was then covered with Paraloid B-72 which effectively varnishes the surface. The blue and green, both of which contain a clay to lighten the color, change tone and quality dramatically. The Paraloid B-72 can be partially removed with acetone but its effect on the colors and on the wall is permanent.

High resolution 3D laser scan of a detail of black from a scarab beetle in the tomb of Seti I / taken with permission from the Supreme Council of Antiquities, Egypt, during work undertaken in the tomb of Seti I by Factum Arte, Madrid / © photo: Factum Arte Madrid, 2001

It clearly shows the complexity and particular characteristics of the surface in an area that has never been cleaned or molded. The appearance of this particular black is that of a rich deep black. Color analysis reveals it to be a charcoal gray.

to the recorded data, overcoming individual perspectival limitations and producing multi-layered data that reflects the complexity of the temple – via a procedure developed in the 1930s that involves photography, drawing in pencil and ink, bleaching, producing blueprints, photocopies, and eventually lithographic plates, the walls are turned from their physically complex state into meticulous outline drawings that follow the contours of the dominant forms. The aim is to prioritize the hieroglyphs and tease them out of the surrounding and distracting noise.

A Brief History

The small temple at Medinet Habu was dedicated to Amun-min and built in Thebes on the site of an early cult worship "holy place" or Jeme. Its location is closely related to the temple of Karnac and the cliffs at Deir el Bahri, the preferred burial site for Kings, Queens, and nobles. It has been subjected to a cascade of iconoclastic assaults and iconophilic alterations to both image and text, to neglect re-dedication, change of use, tourist damage, and most recently to extensive restoration. Queen Hatsheput started the building of the small temple in 1490 B.C.E. Her original six-chambered temple preserved the core of the cult temples that stood on the site. At her death, Thoutmosis III carried on building, adding carvings and inscriptions which charted his own increased importance as he moved from the position of co-regent with Hatscheput to that of regent. Accordingly he removed all traces of Hatsheput and her presence is now only signaled by areas of damaged wall and a royal falcon, which, being divine, could not be removed. On one wall of chamber three Thoutmosis, defaced by the Coptics, stands with Amun, (defaced and dismembered in the Armanah period – it is common in iconoclastic assaults to remove all the sensory organs) in front of a large rectangular area of chisel-marked sandstone – Hatsheput's image and cartouche have been completely

Coptic and other graffiti at the Temple of Medinet Habu / © photo: Adam Lowe, 2002

removed. In photographs of this scene in the library at Chicago House this area used to be totally blackened. Due to the presence of the imperial falcon particular attention was paid to this damaged area during the cleaning process. The surface now resembles Monument Valley in microcosm with small columns of sandstone rising out of the hacked-off surface, each capped with a flat plateau of varying size, the surface of which shows traces of paint. In this case the paint is green – Hatsheput was turned by Thoutmosis into a still life, a votive pile of lettuce. In the midst of this complexity, however, Ray Johnson, the director of Chicago House, believes he has found the ear of the queen – a small red point in a sea of sand and traces of lettuce.

Thoutmosis's changes were the first of many. During the Armanah period the cult temples were ravaged on the instruction of Akhnaton. The figure of Amun was systematically hacked from the walls, the sculptures were smashed (with particularly destructive energy expended on the double portrait in black granite of Amun and Thoutmosis III that has now been partially reassembled), and cartouches were ren-

dered illegible by defacement. Akhnaton imposed his brand of religion onto the complex Pharonic culture. It is now fashionable to oversimplify things and champion him as the father of both monotheism and iconoclasm. In the Armanah period the cult services were suspended and the sacked temple fell into ruin. Under Ramses III, rebuilding started once again and the small temple was enlarged with significant alterations.

Iconophilic damage to the walls of the Temple of Medinet Habu / © photo: Adam Lowe. 2002

Reliefs and inscriptions were added. The carving of the low relief gets deeper and deeper – perhaps in an attempt to make future destruction and re-carving more difficult.

The temple was sacked again in the Twentieth Dynasty after the economic collapse under Panedjem I. Three centuries of neglect followed before the Ethiopian Kings (Twenty-fifth Dynasty) gave the temple special protection and began restoring it with further alterations and enlargement, primarily by Shabaka and then by Taharka (688 – 683 B.C.E.), who extensively chiseled out cartouches and inscriptions. In one place, the name of Taharka can clearly be seen overlaying the name of Shabaka. The cycle was then repeated as the Asyrians destroyed the temple before it was restored again. In the years that followed, Nectanebo, the main temple of Medinet Habu, fell into decline yet again and was used as a stone quarry, but the small cult temple continued to thrive. In the Ptolomeic period, Ptolemys VI, VII, VIII, IX, and XI all added their names to the temple in the way a dog cocks its leg on a wall to mark its territory. The importance of the additions they made rests on the content rather than on artistic merit. In many of the changes made during this time, there is clear evidence of an attempt to stick to the artistic styles of Hatsheput and Thoutmosis. The slightly caricatured Ptolemaic figures are still visible. Ptolemaic control in Thebes ended with a Theban revolt in 88-85 B.C.E. Over the next 200 years the importance of the temple gradually diminished. The Roman Emperor Antonius Pius began an ambitious re-building plan that altered the architecture, but this work was never completed. In the late fifth century the marauding fundamentalist Christian monks from the White Monastery near Sohag under the leadership of Shenouda, repeatedly assaulted Karnac in an attempt to remove the last traces of Pagan worship. At the same time the Coptics moved in and turned the temple of Medinet (town) Habu (the Coptic name for Ramses III) into a town. The Coptic additions in the small temple were less drastic than those in the main temple where many of the

figures were decapitated and those on the end wall removed completely as the temple was converted into a cathedral. The small temple was marked with graffiti, crucifixes and many of the figures were hacked off the walls. The assumption has always been that the rooms of the small temple were used as dwellings but there is surprisingly little evidence of a thousand years of domestic activity – except for a few traces of food and broken crockery that normally accompany a prolonged period of dwelling. It seems more likely that the holiness of the site was respected by the Coptics and the Small Temple remained a place of worship, the fires, lights and incense gradually turning the walls black with soot and accumulated dirt. Whatever the cause, they were soot black when restoration began in the 1990s, a blackness that still covers the stars on the ceilings but which is almost entirely gone from the walls. In its black state the temple looked sad and tired but all the evidence of the transformations that have taken place there remained intact.

While the small temple at Medinet Habu illustrates the historical complexity that can exist within one small site, a comparable degree of complexity can be seen in the surface of a remarkable painting completed in 1994 by the Spanish artist Manuel Franquelo. After many hours of close scrutiny (and conversations with the artist) this painting starts to reveal some of the subtleties that can exist as paint, in various states, is applied by various methods to a gesso covered panel.

Manuel Franquelo has a cult reputation in Spain. He has produced only eleven paintings over the past fifteen years. They are all still lifes worked with an obsessive attention to detail applied evenly to every point on the surface. A scratch or stain on the wall, a speck of paint on a drawing pin, are given the same importance as any of the objects that ostensibly constitute the subject of the composition. Layers of mediation cascade in company, compressed onto a flat surface. This obsessive and time-consuming activity, mixed with Franquelo's interest in structure and composition, increases the apparent resolution of the surface, adding complexity and demonstrating that the constraints imposed on representation by the lens are both temporally and geographically local. Once sufficiently complex information has been assembled, the eye ceases to question the fact that it is being offered a representation. The experience of the painting is an iconophilic delight. The normally rigid barrier between representation and reality is breached:

> "When I was working on the nude study of my wife I would paint the color of the muscles and the translucent membranes over them, and then I would do the veins and capillaries. I took samples of her blood and tried to match it – its consistency and color – with my materials. But I didn't replicate the venous system exactly as it was. I followed the laws by which blood vessels are connected. I went by the rule book, instead of copying visually. Then I would paint the translucent whitish-yellow coats of the tubules, which make the red beneath look blue. This blue would turn greenish as I built up the layers of the skin."

This is how Manuel Franquelo describes the process of painting the skin of his wife Elena. There are other ways to paint skin, much more economical ways, ways that are quicker and focus not on the skin but on the artist who moves the brush. Mix a little ochre, Indian red, and a touch of olive green with white and take a loaded brush. Work some blue into the shadows. Do it in primary colors that mix optically on the surface. Screen-print a layer of shocking pink. Forget about realism. Embed yourself in a tradition and follow the rules. But there are no other ways to paint the skin that forms the figure of Elena, or the hair on her armpits, or the texture of the nipple. These are all specific. They are what they are and not something else. They belong to no one else.

Look at the black surface behind the figure. Look at where it meets the hair of the figure – a similar tone but a

fundamentally different quality. Every inch of this black wall is painted with the same attention to detail and composition as the figure. From wall to plaster, to the layers of paint that coat it, every element is meticulously observed and analyzed. Its characteristics, the way it changes in texture and absorbency as it dries and flakes, are understood and recorded. Then comes the transformation. These qualities have to be reconstituted in paint. For the surface to contain the necessary diversity of visual information to convince the eye, the application of paint must contain the same degree of complexity. This cannot be done with a brush alone and Franquelo has produced a whole range of tools, from airbrushes to ink applicators that can place a dot of any color with the tip of a single shard of fibreglass, to miniature sandblasters and a range of stencils and stencil making tools. As with the skin on the figure, the transformation that happens in the act of applying paint mixes what we see and what we understand about it after reflection on its inner nature. There is no hierarchy of object. The figure and the dust on the wall are equally embedded in their environment. The artist's wife occupies a place alongside the non-human elements of which she is a part.

Does the illusion ever collapse and reveal its illusory nature? Is the paradox of illusion in play? The complexity and physical presence of Franquelo's paintings allow us to lose our focal register and enter their domain but the experience is deliberately curtailed at various points, particularly where objects meet. Here the illusion weakens and the flatness of the image reasserts itself. At these points, objects approach each other along different planes. The stereoscopic nature of their relationship cannot be contained within the flatness of the picture plane. The edges are in conflict. They can be separated by changes in the way they are made, in color, texture, reflectivity, but not in the way they move in relationship to each other, not in terms of stereoscopic optics. When this happens, the experience is almost painful, a genuinely discordant note is struck. The all-seeing divine eye which is

Anonymous / Tempora Mutantur Et Nos Mutamur In Illis [Time changes and we change in it] / c. 1580 / carved oak panel from the front of a preaching box / 51.5 x 3.5" / Collection Adam Lowe

The quotation comes from William Harrison's Description of Britain (1577). William Harrison was vicar of Radwinter in Essex and an important protestant theologian.

Manuel Álvarez / San Ignacio /
c. 1750 / Museum of the Cathedral
in Cuenca / originally in the Jesuit
Convent in Cuenca /
© photo: Adam Lowe, 2000

not constrained by perspectival limitations is replaced by
Franquelo's embodied and cognitively imperfect human view
of the world:

> "I am not interested in passing on a 'second-hand'
> reality, I am not concerned, as the hyper-realists were,
> to comment on mass production by presenting images
> of its objects in as cold and impersonal ways as
> possible. I am not involved in the type of mediation
> that photography represents. Quite the opposite: I am
> trying to attain an intimate, almost mystic contact with
> paint. I want to capture that aura, if you like, that the
> human condition imparts to common, everyday
> objects."

As Rachel Campbell Johnson has pointed out in her discussion of Franquelo in a recent edition of *The Tatler*, his work has as much to do with photo realism as Fabergé has to do with battery eggs. He works with a tradition of painting where the multiple facets of object, surface, and space are brought together in a seamless whole. The artist is never visible: he does not occupy a fixed position. There are no image-bites, no polemic, no distance or irony, no distinction between art and craft. These are hybrid products of the Islamic and Christian cultures that characterize what we have come to think of as Spanish painting from the fifteenth to the seventeenth centuries. The achievements of Zurbaran's bodegones and Juan Sanchez Cotan's still lifes can be seen in the attention to detail and concern with the composition, while the work of Pacheco and Velazquez informs the importance of process. Velazquez worked at a moment when it was possible to celebrate the economy of means and effort with which the artist could transform the canvas. In one passage the paint becomes flesh; in another, mastery of technique can produce flocked velvet. A flat mass of burgundy clearly showing traces of the brush is overpainted with a reference to the pattern in a dark tone with a few highlights flicked on with the wrist in a warm white. The visual conceit is stunning in its simplicity and audacity. It links process and pictorial fact in a way impossible in the photography of the dark-room.

Perhaps one of the most important contributions of Spanish art of the late sixteenth and seventeenth centuries lies in its choice of subject matter; the depiction of visionary experience; the representation of the unrepresentable, the making visible of the invisible. At the heart of these mystical concerns lies an understanding that vision lies in the apprehension of an image not in the understanding of the message. A fact that was exploited by the power brokers of the counter reformation who nurtured and controlled a highly political iconophilia on the part of the church. In marked contrast to the Lutheran attempts to remove the image and replace it with the word, the Catholic church needed to encourage the perception of images as a mediating stage in religious experience in order to reinforce their view that there is no unmediated world. Many paintings produced in Spain at this time dealing with visionary experience adopt an innovative visual conceit – the literal division (usually horizontal around the eyeline of the painting) between the fleeting world seen from the "point of view of a dog" and the eternal, all-seeing divine space. In the lower part of the paintings, shadow is important, as is an awareness and use of focus and not just in a photographic sense. Think of El Greco's hands; how does the world look when your attention is not directed and does not rest on one selected object. To comprehend the physical effect of this type of looking consider the two ways that you have to look at a random dot stereogram (invented by Bela Jelesz but popularised in the 1990s as *Magic Eye* prints) for the illusion to work. The paisley pattern that covers the surface is a field of noise that the eye moves over; in order to see the three dimensional illusion embedded in this pattern you must adopt a different gaze – a non specific, unfocused gaze – similar to that depicted so often in the images of saints in ecstasy. When the perception of the image shifts from one register to another, it produces a moment of genuine excitement and surprise. You fluctuate between the two states; you cannot perceive them simultaneously. They are mutually exclusive states.

The long conflicted stories of iconoclasm and picturing refer first and foremost to the image making which renders the everyday objects of this world. A history which focuses exclusively on the impalpable and the otherworldly obscures this truth. The scriptures taught that the deity was present in, and also a spectator of the objects of creation. The ban on icon making was always a ban on worked, graven images. So the virtuous enterprise would imitate, thus remake, the way the deity saw this world. The Old Testament forbade the making of "any graven image, or the likeness of anything that is in heaven above or in the earth below" (Exodus 20:4). Theo-

Robert Fludd, Utriusque Cosmi Maioris silicet et Minoris Mataphysica, vol. 1, first edition, 1617 / detail: Black Square Flag (pp. 26/27) / Staatsbibliothek zu Berlin – Preußischer Kulturbesitz. Department of Historical Prints / © photo: Piers Wardle

logians like St. Thomas Aquinas worried that such images would simply be worshipped for their earthly beauty, rather than as a means of coming closer to God. "Religion," argued Aquinas "does not offer worship to images considered as mere things in themselves, but as images drawing us to God incarnate. Motion to an image does not stop there at the image but goes on to the thing it represents."

The aim was to make images that were, nevertheless, not made by human hands. Such images could barely be comprehended without an entire system of profound and paradoxical relations, between vision and blindness, speech and silence. No human hand could recreate God's creative vision except through both attention and blindness; no human viewer could properly respond to such visions except through both silent meditation and also loquacious reflection. Such images as those of Franquelo, like those of the early Islamic miniaturists, need to be contemplated and discussed among like-minded connoisseurs. Hence a strangely unstable history develops for such works. They belong to a history of realism that crosses religious and artistic divides, yet they also belong unambiguously to their own place and time.

While the Catholics and Protestants occupy polemically opposite positions on the role and nature of images, the Islamic position, when not usurped by fundamentalists, may prove to be profoundly iconophilic.

Contemporary versions of this set of Islamic traditions have much to teach us about the enterprises of image making and contemplation. In his remarkable book *My Name is Red,* the Turkish novelist Orhan Pamuk restores voice to the great miniaturists of Herat and Tabriz, and to their Istanbul disciples of the 1590s. They speak about the works they make, about the division of labor within each work, and the values that were prized and those judged heretical by their culture. As is common in the finest conversations of art, complex contrasts and encounters between traditions animate these discussions. Pamuk's protagonists are forced to view and discuss the

Frankish and Venetian paintings that were beginning to impose a very different world-view. On the other side of the Adriatic from the territories of triumphant Islam, artists were rendering the view from the street, complete with its perspective and shadows, the small figures in the distance and the realism of individual faces.

August Strindberg / Celestograph / 1894 / photo without camera and lenses / 3,5 x 4,8" / Royal Library, National Library of Sweden, Stockholm
A process of fixing blackness through the use of light.

Padre Justo / Column in the Cathedral of the
Virgin of Pilar / Mejorana del Campo /
© photo: Adam Lowe, 2000

Guided by a vision of the Virgin Mary, Justo
Gallego has dedicated more than forty-five
years of his life to the construction of a
cathedral next to Madrid's Barajas airport.
The airplanes animate the sky above the
cathedral like modern day angels. Working
with found and donated materials (particularly
the reject bricks from a local factory) and
rudimentary lifting devices of his own making,
this seventy-five year old man has replaced
his lack of architectural knowledge, structural
engineering skills, and money with inspiration
and deep faith. The result is a spectacular
construction rising thirty-three meters above
the suburban sprawl that surrounds it.

On first glance, it seems impossible that the
deformed, seemingly fluid bricks can support
the towers and structure of the building.
Inside transformations proliferate. Car tires
form the moulds for the capitols; the columns
themselves are cast in oil drums. The bases
of coca cola bottles are cast as sormers on
some of the finer pillars. Justo's greatest
problems are with the professionals and
politicians who want to pull down his vision.

"'It's as if the Venetian paintings were made to frighten us,' observes one of Pamuk's Turkish characters. 'And it isn't enough that we be in awe of the authority and money of these men who commission the works, they also want us to know that simply existing in this world is a very special, very mysterious event. They're attempting to terrify us with their unique faces, eyes, bearing and with their clothing whose every fold is defined by a shadow. They're attempting to terrify us by being creatures of mystery.'"[1]

"Mystery" is of course here a deliberate etymological cognate of "mastery," the individuated artfulness of the image maker. Pamuk's tale startlingly reorients notions of the adorable image: who is the maker of the properly divine picture? Which tradition is the more seductive and therefore inevitable? The individuality of the artist is a key issue in these debates of iconophiles and iconoclasts. So is exchange. The commercial seductiveness inherent in the Venetian style seems irrepressible. The great tradition of Islamic scholars and artists seems destined to fade, not because of any error, but because, so it seems,

Lawrence Sterne, The life and opinions of Tristram Shandy, Navarre Society Ltd., London, 1873, pp. 36-37 / © photo: Piers Wardle

1

_ Orhan Pamuk, *My Name is Red*, Faber and Faber, London, 2001, p. 108.

they are less seductive at street level and in the market place. Perversely, the commercial system that produced the figure of the individual artist finds its equivalent in the blindness to which the finest miniaturists aspired. Sightlessness was indeed part of the realization of the divine view of the world. Pamuk's artists recapture the wonder that links the loss of sight with memory, manual mastery, and thus the imitation of the sacred:

Illustrating was the miniaturist's search for Allah's vision of this earthly realm, and this unique perspective could only be attained through recollection after blindness descended. Thus Allah's vision of the world only becomes manifest through the memory of blind miniaturists. For even the most miserable illustrator, a picture is possible only through memory. The masters of Herat regarded the illustrations they made as training for the hand – as an exercise. *They accepted the work as the pleasurable labor that delivered the miniaturist to blindness. Wherever the blind miniaturist's memories reach Allah there reigns an absolute silence, a blessed darkness and the infinity of a blank page.*[2]

The link between memory and observation has long been understood by artists but has never really been analyzed in depth. Ingres used to make his students draw with the model on one floor and their drawings on another. Anyone who has tried to draw the face of a close friend from memory will immediately realize how little the memory can grasp unless the mind turns the face into a drawing in the process of looking, converting the mass of sensory information into lines which can be memorized as the attention turns from the subject to the drawing. In his remarkably detailed analysis of the painter Humphry Ocean at work, John Tchalenko has been recording, with eye tracking devices, video footage, and observation, the ways in which Ocean looks, rehearses with his hand and finds the graphic equivalents which he then notates on the paper. His looking is targeted and specific, selecting only certain configurations which fit with his vision and for which he has a haptically remembered vocabulary of line. In his

drawing of *Luc*, and the subsequent drawings done from memory one and two years later, it is clear that his memory is not of a face but of a drawing; the lines are repeated with extraordinary correlation, changes creep in but he only remembers lines he has previously drawn.

The Arab painters could admire the technical virtuosity and the seductive nature of Italian and Frankish painting. It revels in the earthy and gestures towards the divine. The main reason that Islam is seen as an iconoclastic religion is not that there is a dislike of images, but rather that it keeps trying to elevate then onto a different level – to aspire to universal truths and not subjective and transient perceptions from the perspective of the street (or the marketplace). When this becomes doctrine, it becomes iconoclastic (as all things do). Yet the line really reflects a love of images and a respect for them that understands the conceits involved in their making and the artifice of the artist; a profoundly iconophilic world view.

"Before the art of illumination there was blackness and afterward there will also be blackness. Through our colors, paints, art, and love, we remember that Allah had commanded us to 'See!' To know is to remember what you've seen. To see is to know without remembering. Thus, painting is remembering the blackness. The great masters, who shared a love of painting and perceived that color and sight arose from darkness, longed to return to Allah's blackness by means of color. Artists without memory neither remember Allah nor the blackness. All great masters, in their work, seek that profound void within color and outside time."[3]

The desire to create the world in all its sensuality ultimately leads back to the infinite blackness and nothingness of divinity. In attempting to recreate the "essence" of a thing, the Islamic miniaturist ultimately embraces an iconoclastic gesture that leads to negation and blackness, and the erasure of style and artistic individuality. The impact of fifteenth century, Western,

2

_ op. cit., p. 80.

3

_ Pamuk, op. cit., p. 76.

Marc Quinn / DNA Garden / 2001 / stainless steel frame, polycarbonate agar jelly,
bacteria colonies, 77 plates of cloned DNA, 75 plants, 2 humans / 73.8 x 126 x 4.4" /
courtesy Jay Jopling, White Cube, London / © photo: Roger Sinek

perspectival realism on this tradition was fatal. For Pamuk, in Renaissance Venetian painting, "the observer has the impression not of painting but of reality; to such a degree that this image has the power to entice humans to bow down before it, as with icons in churches ... this is the Devil's work, not only because the art of perspective removes the painting from God's perspective and lowers it to the level of a street dog, but because your reliance on the methods of the Venetians as well as your mingling of our own established traditions with that of the infidels will strip us of our purity and reduce us to being their slaves."[4]

Once this Western tradition establishes its pre-eminence, its commercial and individual seductiveness creates what T.S. Eliot calls the "disassociation of sensibility": the catastrophic separation between the image and what it represents. The ultimate rejection of this disassociation lies in the great masters of Herat and Tabriz. It is this relationship between object and image that Manuel Franquelo attempts to recapture and which places him in an alternative tradition – outside the iconoclastic canon of the late-twentieth century to which his paintings do not belong. During the process of developing this exhibition, certain fundamental differences started to emerge among the curators (some of these are referred to in Bruno Latour's summary of the aims of the undertaking). There was no consensus about the definition of art, who should be considered an artist and what can be considered art. Named artists and curators working in a gallery environment may form an international family that can share their frame of reference and social activities but increasingly, even among this group, there is an awareness that the diversity of creative energy that exists outside of their sphere completely subsumes the small iconoclastic voice that has come to represent the "art world." If depicted as a Venn diagram this activity is a very small subset of a much larger iconophilic tradition. Lawrence Gowing used to lecture at the Slade School of Art (University of London) on "The Alternative Tradition" – an attempt to show that the canon is unnecessarily narrow and Eurocentric.

Guided by a vision of the Virgin Mary, Justo Gallego, has dedicated more than forty-five years of his life to the construction of a cathedral next to Madrid's Barajas airport – the airplanes animating the sky above the cathedral like modern day angels. Working with found and donated materials (particularly the reject bricks from a local factory) and rudimentary lifting devices of his own making, this 75 year old man has replaced his lack of architectural knowledge, structural engineering skills, and money with inspiration and deep faith. The result is a spectacular construction rising thirty-three meters above the suburban sprawl that surrounds it.

On first impressions it seems impossible that the deformed, seemingly fluid bricks can support the towers and structure of the building. Inside, transformations proliferate – car tires form the moulds for the capitols, the columns themselves cast in old oil drums which are peeled away, leaving a metal band at the top and bottom embedded in the cement. The bases of Coca-Cola bottles are cast in concrete and repeated to form decorative elements and aerosol cans are used as formers on some of the finer pillars. Similar transformations work on an architectural scale; doorways become sculptural forms and the double columns that line the body of the cathedral have both practical and aesthetic functions.

Justo's greatest problems are now with the professionals and politicians who, for different reasons, want to pull down his vision.

Look at the black behind the figure in Franquelo's Portrait of Elena. Think about the complexity of blackness. When the Kiev artist Kasimir Malevich made his Suprematist Black Square in 1915, he ensured it took the place traditionally occupied by the icon. In Russia, these icons belonged to stories of images made without the work of human hands. Black Square links all the occupants of Red Square – the Revolution, the Cathedral, the Mausoleum. It was said by the Orthodox

4

_ Pamuk, op. cit., p. 160.

John Jones / Black square / after Joshua Reynolds' Miss Frances Kemble / 1784 / mezzotint on Japanese paper / 15 x 10.4" / The British Museum, London / © photo: The British Museum, London

James Gillray / Titianus Redivivus or The seven-wise-men consulting the new Venetian Oracle / 1797 / etching and engraving, with publishers watercolor / courtesy Andrew Edmunds, London

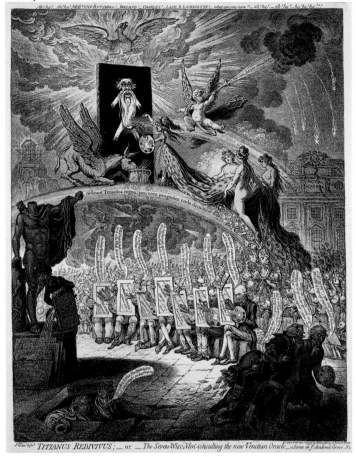

that long ago the leprous King of Edessa, Adgar the Black, had once sent his painter to make a portrait of Jesus. Having failed to capture the divine image, the artist was instead provided by Jesus with an image impressed by His face upon a wet cloth. The imprint became a cult, the "Redeemer made without Human Hands," transferred from Edessa to Constantinople, then shown in its iconic form in twelfth century Novogorod Cathedral and honored in a festival every August. Such stories ended rather than started with utmost darkness. Malevich perfectly understood that the black square could not be a point

of departure, but an ending. The inevitable question to be posed is: what lies beneath the black square? Standing in front of this image, contemplating its iconic status in the iconoclastic modern age, it is clear that it is not a simple reductive image; nor is it an existential depiction of nothingness. Its cracked and textured surface, overworked and charged with presence, is the final stage of a profoundly iconophilic endeavor.

The *Black Square* finds its direct counterpart, put to a very different end, in the censorship of *SLORC* in Burma, where images and texts that offend the censor have to be overprinted with black, at the printer's cost. Here censorship surely reveals that something has been removed. But if examined in a certain light, the dark sanction reveals the image that has been suppressed. With absolute control it is easy to remove the publication from circulation. It is not accidental that the one who is financially punished is the printer, the person who is responsible for bringing the image into being. It is not only its content that is being disapproved of, but also the skills of the printer who should never have agreed to print it in the first place – the maker of graven images.

A Material Shift

To paint the most beautiful, infinitely deep sky you start with a ground of Venetian red and then layer, using translucent glaze upon glaze, a mix of ultramarine and white until the desired density is achieved – the finer the pigment the richer the blue – there is no shortcut. In the same way, to produce a rich black you need a mix of Prussian blue and alizarin Crimson, not mixed but glazed, to produce the optical effects of an infinite black. The use of a carbon black will never reach the same degree of blackness; but then everything is relative, and the blackest black in a painting need not be truly black to create the illusion of blackness. Malevich's black square is not black. An understanding of technique is only important now, in this debate on the crisis of representation, because it

is ignored and overlooked, masked by the theoretical rhetoric that conditions modern understandings of how images are made and what it is to be an artist. The materials condition everything. An understanding of their physicality adds yet another layer. The pigments, dyes, gums, resins, varnishes, gessoes, gelatines, milk and egg products, oils, bristles, chemicals all have their own stories and histories.

As Wolfgang Schivelbusch's history of spices reminds us, the high medieval imagination was fascinated by the exoticism of these imported, oriental, commodities. Carpets and sofas, silks and taffetas, took their place at court alongside pepper and cochineal. The linkage between an entire cultural reformation of taste and the source of these goods in an imagined Eastern paradise, placed colors, like balms, condiments, cloths, and spices, in the realm of high symbolic value and sacred space. Islamic stories, taken up with enthusiasm by Christian travelers, told of the paradisiacal origin of the highly-colored and highly-prized treasures of the East. It was said by the Arabs, for example, that after the fall, Adam had been thrown by the angels onto a mountain in Ceylon. Stuck to his body were the leaves and seeds of the trees and plants of Eden. Divine gusts blew these leaves and seeds throughout

Tannery in Fez, Morocco / © photo: Adam Lowe, 2002

the Indies, sprouting "perfumes, oils and fruits which grow only there," along with spices and bright jewels. It was easy for Western Christians to assimilate these tales, and their fabled merchandise, to their own cults of sacred oils and colors magically transmuted in the Eucharist. Both palates and palettes were marked with new, and ancient, alien, and domesticated, luxury powders such as saffron. By working with these quasi-magical substances the faraway was made close at hand in the images of elsewhere.

Richly colored powders poured in from Afghanistan and China, from India and Africa. They were the specialized wares of the Arab colormen who plied their wares in Istanbul, Venice, and other European ports in the fourteenth and fifteenth centuries. The magical and alchemical nature of their production, embodied in their high material value, added to their exotic flavor. Simple materials like dirt and urine were mysteriously transformed and then laboriously ground to produce the richest colors. Others were produced from essences extracted from plants and beetles.

Learning traveled in company with these goods. Arab translators remained crucial to the survival and transmission of the thoughts of the great Greek philosophers. Long-range networks of exchange which are surprising in their extent and duration only by a narrative, parochially limited by Western European perspectives, carried condiments and colors with cloths and writings. The Eastern Nestorians, doyens of oriental Christianity and of a challenging version of the sacred icons of the Church, established in Edessa, then Persia from the fifth century, then central Asia and China, preserved and developed classical doctrines. No doubt their scholarship and iconography lay at the source of stories such as the great Edessa icon. In the thirteenth century, indeed, a Chinese Nestorian Christian, Rabban Sauma, came from the valley of the Huang-ho river to the court of the Mongol ruler of Tabriz, and was then sent as legate to the West: he debated idolatry and the creed with the Roman college of cardinals, attended the royal

court at Paris, and celebrated mass for the English king in Bordeaux in 1287. The Persian leopards he brought as gifts were soon turned into icons of the English crown. Entangled in these voyages were the transport of relics and riches, pictures and politics. These oriental experts maintained the direct link with the Greeks through their language, travel, and, perhaps above all, the fact that they understood that the principle of image making is that images are made.

Arab traders enabled the practical mastery and comprehension of colors that sustained the developments of Renaissance Europe. Pamuk's novel brilliantly captures the long-held belief that Venetian artists of the sixteenth century possessed a chromatic secret learned from the East. The costumes of the Doges and the colored surfaces of Venetian buildings and paintings were all taken as signs of its ingenious and potent orientation, its emulation of the cities and cultures to its east. In a manner common in the condescending traditions of Western orientalism, it seemed to many that the Venetians possessed an occult "secret" which could only be unlocked to turn its output into mechanically reproducible wares. In the 1790s, just as their French enemies set sail for Malta and Egypt, London artists were still in search of the Venetian enigma. The young Ann Jemima Provis claimed to have found an old Italian document setting out the recipe: a deeply absorbent black ground, refined linseed oil, and a mixture of crimson lake with Hungarian blue. She sold members of the Royal Academy the recipe for ten guineas a hit. James Gillray, the capital's leading cartoonist, depicted the scandal and the disaster with characteristic wit: Provis leads the nation's principal painters over a delusory rainbow towards a canvas marked with a black square and a grimacing patriarch, while Joshua Reynolds groans of "black spirits and white, mingle, mingle, mingle" from his grave and others wonder whether the deep black of the secret would "make a dunce a colorist at once?" Others have followed in Provis' wake, ever seeking a way of explaining away the orientalism of Renaissance palettes.

The shadowy and the dark had long held the philosophical secret of color. In these matters, the role of pure theory seemed strangely distant from that of image makers. At the same time that Titian's pseudo-recipe was unveiled in London, Johann Wolfgang von Goethe launched his own inquiry into the true ground of color. German Nazarenes and, eventually, Joseph M. William Turner, followed where he led. Turner proclaimed the end of the scientific hegemony over color making and seeing. He reflected, in significant terms, on the faulty if iconic status science had till then played in making colors fast.

> "The Catholic may enter his temple, sprinkle himself with holy water, kneel before the priest, and then with no special piety conduct a business discussion with friends or pursue affairs of the heart. Similarly, every treatise on dyeing begins with respect mention of color theory without any later evidence that something has come of this theory, that this theory has explained or clarified anything."

Goethe's iconoclastic gesture at Roman religion matched his critique of the sacred status of orthodox color science. The ancients, and their Islamic commentators, had long held that colors were of two kinds – real, such as those of mundane dyestuffs, and imaginary, such as those shown in the divinely meaningful rainbow. The savants of the Scientific Revolution iconoclastically changed all this. Galileo had urged the fundamental distinction between primary qualities, such as size and shape, and secondary ones, including color. All colors would then be imaginary, and the real occupants of the world were primary. Hence flowed trouble: in the Eucharist, the wine changed to Christ's blood while preserving all its secondary qualities of redness and vinous flavor. Galileo reckoned these qualities were already separate in nature; so the Mass would need no miracle. His Jesuit enemies made the point: "What miracle if the priest who recites the holy formula finds the

The Black Basalt Mecca (Ka'aba) / Moroccan popular print / Collection Adam Lowe

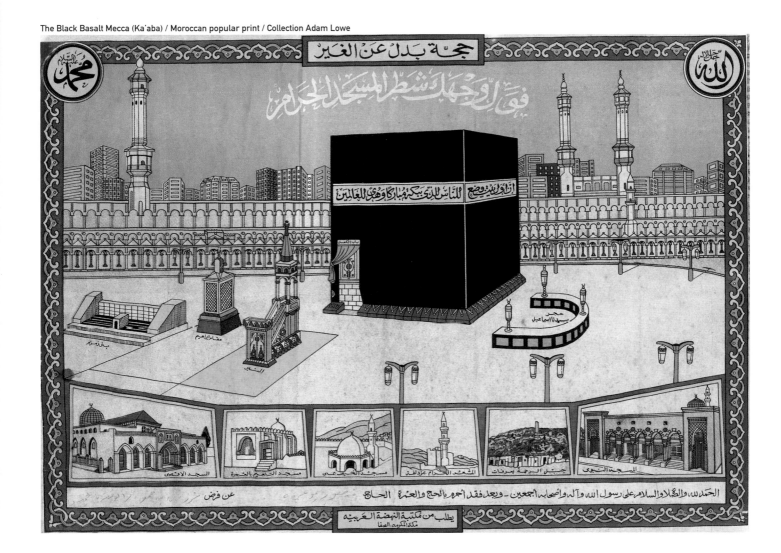

Golgotha / medieval / diameter: 204 x 12" / St. Andrews Church, Cullompton / © photo: Piers Wardle
Time has removed the paint that once covered this medieval sculpture and the actions of the reformation iconoclasts have removed the three crosses that once slotted
into the holes in the base. Now removed from its original position on top of the rood screen, it sits behind the door of St. Andrews Church, Cullompton.

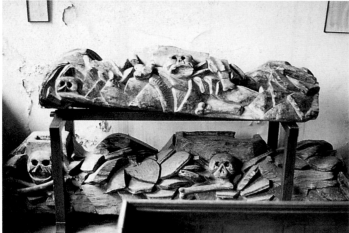

qualities of the bread already separated from the body through the work of nature?"

Galileo's philosophical friends pursued the thought. René Descartes, much concerned with the behavior of light both divine and material, used news from Italy to launch his own inquiry on the nature of color. After a series of terrifying dreams, he vowed to journey through Italy to Loreto, where it was said that the Holy House of the Virgin had landed after a miraculous flight from Palestine. He made the pilgrimage in 1624, staying at Venice on the way to witness the Doge's ceremonial marriage with the sea. Then he returned to France, and to subsequent permanent refuge in the Netherlands, home of superb optical technology and fierce iconoclasts. There he learned, at the end of 1629, that the Jesuit astronomers had seen strangely figured false suns in the sky above Rome. He wrote an essay to explain the origin of these parhelia. "Because we must turn our eyes to the sky to see them," he wrote, "we imagine them to be so high that poets and painters even make them into God's throne, and picture Him there." If Descartes could explain meteorological colors, he could show the physical origin of mere wonder. All color, he urged, was imaginary. So all were made the way the rainbow was. And

there was an earthly mimicry of the phenomenon in the deeds of the prism. Descartes held all colors were made when light bent at a boundary between light and dark, as through a figured glass prism. The world of glass and shadow was turned into the exhaustive scientific theory of color.

Dark shadows stayed fundamental for seventeenth century optics. Having read Descartes' stories in the early 1660s, the young Isaac Newton turned his own rooms into a large-scale camera obscura. We can only now understand, in view of the pervasive presence of the camera and the lens in the artful image making equipment of his contemporaries, just how banal, yet decisive, was Newton's set up. The shutters fastened, a hole drilled through them to admit sunlight, a prism set at the opening, Newton's basic experiments revealed to him that color is present in pure sunlight, and that such light is truly composed of exactly seven primary color making rays, each distinguishable by their different refrangibilities. "The science of colors must be considered mathematical," he pronounced. Newton was the fiercest enemy of icons, damning pagans and Catholics as mere image worshippers. But he changed the meaning of the word spectrum, till then only linked to ghostly specters. The spectrum became, first, the

name of the solar image in his strange prismatic camera, then, and portentously, the label for the colored band his prisms produced in darkness. This left his avatars with an ambiguous legacy. It seemed that Newton's optics had established beyond doubt that colors are best analyzed in darkness, that black was but a privation of light, that colors are all present in white light. The Apocrypha told stories of Jesus on a visit to a dye works, throwing seventy-two colors into a vat, and hauling them out pure white. Newton had in this sense strangely imitated Christ, analyzing pure white into its components, synthesizing white from the principal colors.

Yet dyers and painters knew otherwise. Thus when the American spy, Fellow of the Royal Society, and Surinam medic Edward Bancroft began importing American black oak for yellow dyes into London in the 1780s, he soon wrote a fierce attack on Newton's doctrine of color as a mere result of refraction of light in a darkened room, arguing, "the permanent colors of different bodies or substances are not produced by mere refraction." Newton's assertion gave colors the disembodied and objectively absolute view that had previously been the sole property ascribed to a godlike view point omniscient, omnipotent, incapable of error. These were the themes to which Goethe had responded by 1800, and Gillray satirized. "Black was supposed to remind the Venetian nobleman of republican equality," so Goethe thought. He explicitly saw Newtonian optics as a kind of dark Bastille, which the revolutionaries of optics would at last liberate, open, and display. Above all, the ancient notion that colors are made where dark meets light returned in force. And this notion had long given shadow play its canonical role in the iconography of color making and image production.

So Newton's ultimate iconoclastic gesture, the reduction of color to a spectral presence, and a mathematical one at that, drove the last nail into the coffin of the Arab miniaturists. Not only had the lens won in the depiction of reality from the point of view of a dog but it had also proved that the magical pigments the colormen brought from the East were in fact immaterial – an illusion.

The blackness described in Pamuk's book allowed the painter to produce images from memory, relying on the sense of touch, and the ingrained movement of the hand. In contrast, the blackness of Malevich's square is a closed loop, charged with potential images but ultimately a cul de sac. If so much can exist in a square of black what does it say about the iconoclastic theorizing of most modernist and post modern discourse? At the core of an iconophilic understanding is the potential for infinite interconnectivity. At its best this produces a completely free flow of direct communication; at its worst a field of noise. Either way it bypasses the crisis in representation.

Perhaps the black basalt in Mecca is a more potent symbol of the potential iconophilic communication than the black hole left in the Collumpton Golgotha after the cross, once embedded in this plinth of carved wood imitating rock and skulls, was ripped out during that decisive moment in the history of iconoclasm, the Reformation.

Time has removed the paint that once covered this medieval sculpture and the actions of the reformation iconoclasts have removed the three crosses that once slotted into the holes in the base. Now removed from its original position on top of the rood screen, it sits behind the door of St. Andrew's Church, Cullompton. |

»Are you afraid, my child?« said Enishte Effendi compassionately, »of the paintings we've made?« || The room was black now, I couln't not see for myself, but I sensed that he'd said this with a smile. || »Our book is no longer a secret,« I answered. »Perhaps this isn't important. But rumors are spreading. They say we've underhandedly committed blasphemy. They say that, here, we've made a book – not as Our Sultan had commisssioned and hoped for – but one meant to entertain our own whims; one that ridicules even Our Prophet and mimics infidel masters. They have those who believe it even depicts Satan as amiable. They say we've committed and unforgivable sin by daring to draw, from the perspective of a mangy street dog, a horsefly and a mosque as if they were the same size – with the excuse that the mosque was in the background – thereby mocking the faithful who attends prayer. I cannot sleep for thinking about such things.« || »We made the illustrations together,« said Enishte Effendi. »Could we have even considered such ideas, let alone committed such and offense?« || »Not at all,« I said expansively. »But they've heard about it somehow. They say there's one final painting in which, according to the gossip, there's open defiance of our religion and what we hold sacred.« || »You yourself have seen the final painting.« || »Nay, I made pictures of whatever you requested in various places on a large sheet, which was to be a double-leaf illustration.« I said with a caution and precision that I hoped would please Enishte Effendi. »But I never saw the completed illustration. If I had seen the entire painting, I'd have a clear conscience about denying all this foul slander.« || »Why is it that you feel guilty?« he asked. »What's gnawing at your soul? Who has caused you to doubt yourself?« || »… to worry that one has attacked what he knows to be sacred, after spending months merrily illustrating a book … to suffer the torments of Hell while living … if only I could see the last painting in its entirety.« || »Is this that troubles you?« he said. »Is this why you've come?« || Suddenly panic seized me. Could he be thinking something horrendous, like I was the one who'd killed the ill-fated Elegant Effendi? || »Those who want Our Sultan dethroned and replaced by the prince,« I said, »are furthering this insidious gossip, saying that He secretly supports the book.« || »How many really believe that?« he asked wearily. »Every cleric with any ambition who's met with some favor and whose head has swollen as a result will preach that religion is being ignored and disrespected. This is the most reliable way to ensure one's living.« || Did he suppose I'd come solely to inform him of a rumor? || »Poor old Elegant Effendi, God rest his soul.« I said, my voice quavering. »Supposedly, we killed him because he saw the whole of the last painting and was convinced that it reviled our faith. A division head I know at the palace workshop told me this. You know how junior and senior apprentices are, everyone gossips.« || Maintaining this line of reasoning and growing increasingly impassioned, I went on for quite some time. I didn't know how much of what I said I myself had indeed heard, how much I had fabricated out of fear after doing away with that wicked

slanderer, or how much I improvised. Having devoted much of the conversation to flattery, I was anticipating that Enishte Effendi would show me the two-page illustration and put me at ease. Why didn't he realize this was the only way I might overcome my fears about being mired in sin? || Intending to startle him, I defiantly asked »Might one be capable of making blasphemous art without being aware of it?« || In place of an answer, he gestured very delicately and elegantly with his hand – as if to warn there was a child sleeping in the room – and I fell completely silent. »I has become very dark,« he said, almost in a whisper, »let's light the candle.« ||

ORHAN PAMUK, MY NAME IS RED, FABER AND FABER, LONDON, 2001, CHAPTER 28, PP. 157-159

Kasimir Malevich / Black Square / c. 1923 / oil on canvas / 41.7 x 41.7" /
The State Russian Museum, St. Petersburg / signed on back side: K. Malevich 1913 g

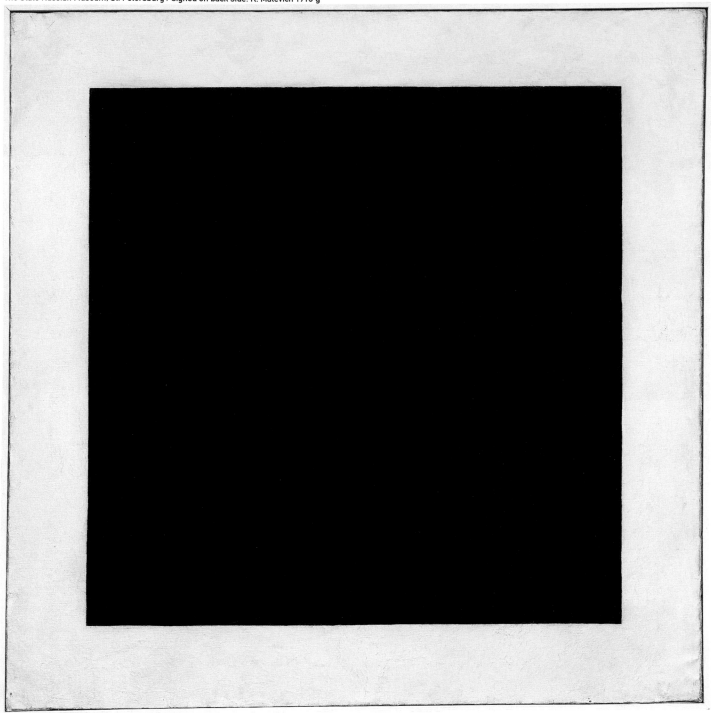

Kasimir Malevich / Black Circle / c. 1923 / oil on canvas / 41.3 x 41.3" /
The State Russian Museum, St. Petersburg / signed on back side: K. Malevich 1913

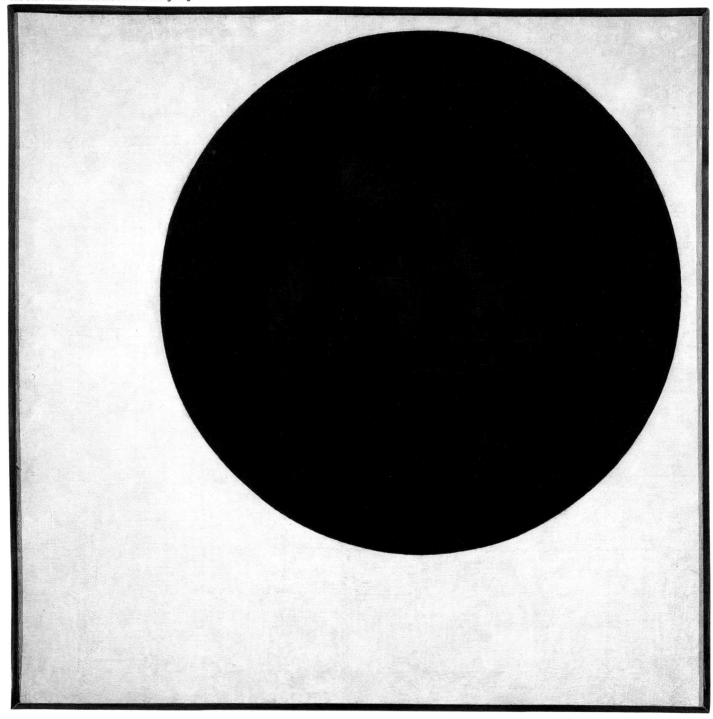

Kasimir Malevich / Black Cross / c. 1923 / 41.7 x 41.7" /
The State Russian Museum, St. Petersburg / signed on back side: K. Malevich 1913 g

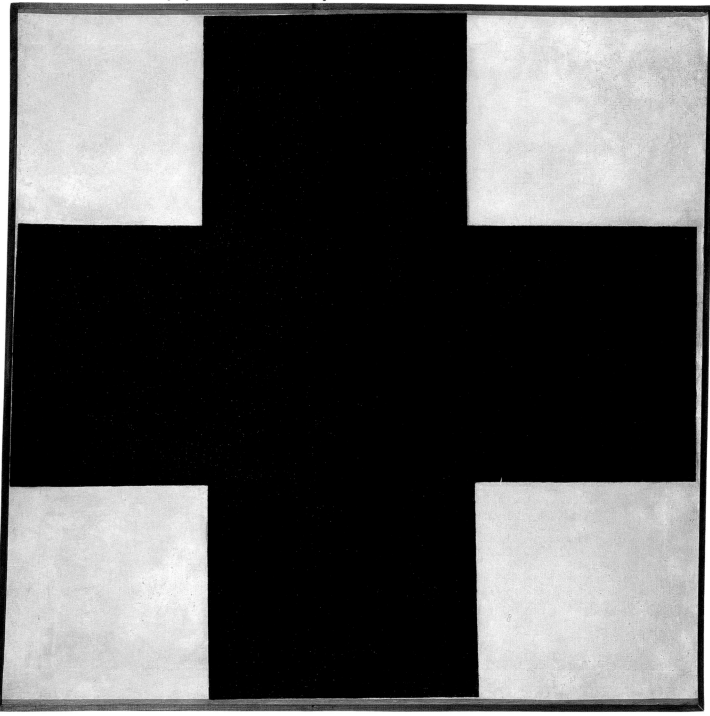

Aleksandr Rodchenko / Black on Black / 1918 / © VG Bild-Kunst, Bonn 2002

Aleksandr Rodchenko / Pure Red Color, Pure Yellow Color, Pure Blue Color / 1921 /
oil on canvas / 3 plates / each 24.4 x 20.7" / Rodchenko-Archive, Moscow

Paul Mansouroff / Untitled / 1922 /
oil on wood / 45.3 x 14.2"

Barnett Newman / Prometheus Bound / 1952 / synthetic resin on canvas /
131.9 x 54" / Museum Folkwang, Essen / © VG Bild-Kunst, Bonn 2002

Francis Picabia / Le noir des noirs [The Blackest Black] / 1949 / oil on cardboard / 25.4 x 21.26" / © VG Bild-Kunst, Bonn 2002

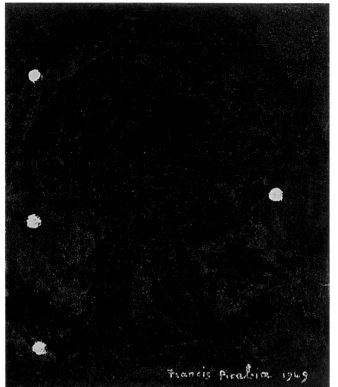

Robert Rauschenberg / Black Painting / 1951-1952 / oil on newspaper on canvas / 71.5 x 52.75" / Robert Rauschenberg / © VG Bild-Kunst, Bonn 2002

Francesco Lo Savio / Composition / oil on canvas / 43.3 x 51.2"

Antoni Tàpies / Black Room / 1960 /
oil on canvas / 102.4 x 154.3" / © VG Bild-Kunst, Bonn 2002

Ad Reinhardt / Black on Black No. 8 / 1953 / fabrics / 81.3 x 61.3" /
Neue Galerie am Landesmuseum Joanneum, Graz, Collection Ploil, Vienna

Ad Reinhardt / No 16 / 1955 / oil on canvas / 80 x 42" /
Collection Ploil, Vienna / © VG Bild-Kunst, Bonn 2002

Ad Reinhardt / Abstract Painting / 1960 / oil on canvas / 15 x 15"/
courtesy Georg Kargl, Vienna / © photo: courtesy Georg Kargl, Vienna

Ad Reinhardt / iris. time / 1963 /
newspaper / courtesy Georg Kargl, Vienna /
© photo: courtesy Georg Kargl, Vienna

Gil J. Wolman / L'anticoncept [The Anticoncept] / 1951 / filmstills / L'Institut Scandinave de Vandalisme Comparé /
from: Joseph Wolman »L'anticoncept«, Éditions Allia, Paris, 1994, p. 66

Peter Kubelka / Arnulf Rainer / 1958-60 / film / 35 mm / 6.5 min /
stills of two frames showing four elements of the film: light, dark, sound, silence / from: Peter Weibel (ed.),
Wien, Bildkompendium Wiener Aktionismus und Film, Kohlkunstverlag, Frankfurt/M., 1970, pp. 17-18

George Macunias / Diagram of Historical Development of Fluxus and other 4 Dimentional, Aural, Optic, Olfactory, Epithelial and Tactile Art Forms. (incomplete) / detail

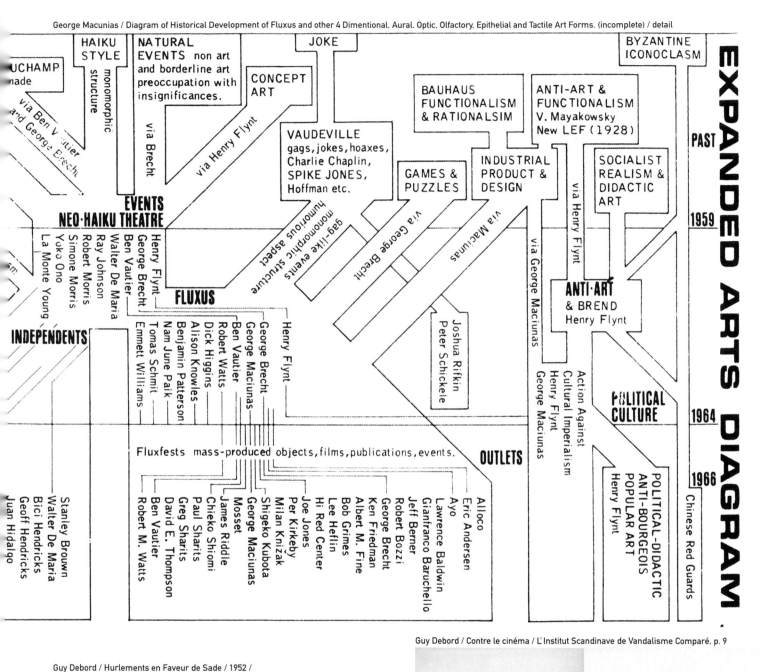

EXPANDED ARTS DIAGRAM.

PAST

1959

1964

1966

Chinese Red Guards

HAIKU STYLE — monomorphic structure

NATURAL EVENTS non art and borderline art preoccupation with insignificances.

JOKE

CONCEPT ART

DUCHAMP ...nade

via Ben V...tier and George ...echt

via Brecht

via Henry Flynt

VAUDEVILLE gags, jokes, hoaxes, Charlie Chaplin, SPIKE JONES, Hoffman etc.

BAUHAUS FUNCTIONALISM & RATIONALSIM

ANTI-ART & FUNCTIONALISM V. Mayakowsky New LEF (1928)

BYZANTINE ICONOCLASM

INDUSTRIAL PRODUCT & DESIGN

GAMES & PUZZLES

SOCIALIST REALISM & DIDACTIC ART

EVENTS NEO·HAIKU THEATRE

gag-like events

humorous aspect

monomorphic structure

via George Brecht

via Macunias

via Henry Flynt

via George Macunias

FLUXUS

Henry Flynt
George Brecht
Ben Vautier
Walter De Maria
Ray Johnson
Robert Morris
Simone Morris
Yoko Ono
La Monte Young

Henry Flynt
George Brecht
George Macunas
Ben Vautier
Robert Watts
Dick Higgins
Alison Knowles
Benjamin Patterson
Nam June Paik
Tomas Schmit
Emmett Williams

Henry Flynt

Joshua Rifkin
Peter Schickele

ANTI·ART & BREND Henry Flynt

Action Against Cultural Imperialism Henry Flynt George Macunas

INDEPENDENTS

Stanley Brouwn
Walter De Maria
Bici Hendricks
Geoff Hendricks
Juan Hidalgo

George Brecht
George Macunas
Ben Vautier
Robert Watts
Shigeko Kubota
George Macunas
Milan Knižak
Per Kirkeby
Joe Jones
Hi Red Center
Lee Heflin
Bob Grimes
Albert M. Fine
Ken Friedman
George Brecht
Robert Bozzi
Jeff Berner
Gianfranco Baruchello
Lawrence Baldwin
Ayo
Eric Andersen
Alloco

Robert M. Watts
Ben Vautier
David E. Thompson
Greg Sharits
Paul Sharits
Chieko Shiomi
James Riddle
Mosset

POLITICAL CULTURE

POLITICAL-DIDACTIC ANTI-BOURGEOIS POPULAR ART Henry Flynt

Fluxfests mass-produced objects, films, publications, events.

OUTLETS

Guy Debord / Hurlements en Faveur de Sade / 1952 /
excerpt from the manuscript for the film / from: Guy Debord, Contre le cinéma.
L' Institut Scandinave de Vandalisme Comparé, p. 20

voix 1 : Je n'ai plus rien à te dire.

voix 2 : Après toutes les réponses à contre-temps, et la jeunesse qui se fait vieille, la nuit retombe de bien haut.

SILENCE DE TROIS MINUTES
DURANT LEQUEL L'ÉCRAN RESTE NOIR.

voix 2 : Nous vivons en enfants perdus nos aventures incomplètes.

SILENCE DE VINGT-QUATRE MINUTES
DURANT LEQUEL L'ÉCRAN RESTE NOIR

Guy Debord / Contre le cinéma / L' Institut Scandinave de Vandalisme Comparé, p. 9

L'INSTITUT SCANDINAVE DE VANDALISME COMPARÉ

PRÉSENTE

GUY DEBORD

CONTRE

LE CINÉMA

Robert Rauschenberg / Mother of God / c. 1950 / oil, enamel, printed maps, newspaper, and copper and metallic paints on Masonite / 48 x 32.1" / Collection Robert Rauschenberg / © photo: David Heald

Robert Rauschenberg / Crucifixion and Reflection / c. 1950 / oil, enamel, water-based paint, and newspaper on paperboard, attached to wood support / 47.75 x 51.1" / The Menil Collection, Houston / © photo: Dorothy Zeidman, New York

Robert Rauschenberg / White Painting (one panel) / 1951 / oil on canvas / 48 x 48" / Collection Robert Rauschenberg / © photo: Glenn Steigelmann, New York

Joseph Albers / Study for Homage to the Square: White Signal / 1961 / oil on hardboard / 31.9 x 31.9 x 2" / FER Collection / © VG Bild-Kunst, Bonn 2002 / © photo: FER Collection, archive

Richard Serra / Left Corner Square / 1979 / painstick on Belgian linen / 109.5 x 109.5" / © VG Bild-Kunst, Bonn 2002

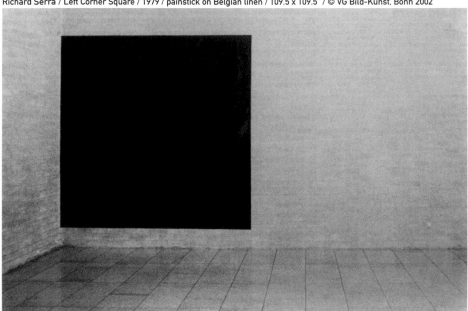

Francesco Lo Savio /
Metallo nero opaco
uniforme, piano parabolico
con articolazione / 1963 /
steel plate, lacquered /
70.9 x 31.5 x 3.5" /
Galleria La Salita, Rome

Allan McCollum / 30 Plaster Surrogates / 1982-1990 / acrylic on plaster / 189 x 67" (installation) /
frames from 16.1 x 13.2" to 20.1 x 16.1" / Sprengel Museum, Hannover / © photo: Michael Herling and Aline Gwose

Imi Knoebel / Schwarzes Quadrat auf Buffet
[Black square on buffet] / 1984 / fiberboard and
acrylic on fiberboard and cardboard / four parts /
84.6 x 65 x 20.3" / Collection Froehlich, Stuttgart /
© photo: Jochen Littkemann, Berlin

Rudolf Schwarzkogler / action / Vienna, May 1965 / from: Peter Weibel (ed.), Wien,
Bildkompendium Wiener Aktionismus und Film, Kohlkunstverlag, Frankfurt, 1970, p. 117

Young Hay / Bonjour Young Hay
(performance after Courbet), Hong Kong Trip /
1995 / gelatine silver print / 63 x 47.2" /
Prüss & Ochs Gallery, Berlin / © photo: Kith Tsang

Timm Ulrichs / The End / 1970/90/97 / video film on DVD, color and black-and-white, silent /
6.09 min / three parts / Timm Ulrichs / © VG Bild-Kunst, Bonn 2002

AN END TO THE »END OF ART«?
ON THE ICONOCLASM OF MODERN ART

Peter Weibel

»*And do you see, I said, men passing along the wall carrying all sorts of vessels, and statues and figures of animals made of wood and stone and various materials, which appear over the wall? Some of them are talking, others silent. You have shown me a strange image, and they are strange prisoners. Like ourselves, I replied; and they see only their own shadows, or the shadows of one another, which the fire throws on the opposite wall of the cave?*«[1] PLATO

»*La chair est triste, hélas! et j'ai lu tous les livres.*
Fuir! Là bas fuir! Je sens que des oiseaux sont ivres
D'être parmi l'écume inconnue et les cieux!
Rien, ni les vieux jardins reflétés par les yeux
Ne retiendra ce cœur qui dans la mer se trempe
O nuits! ni la clarté déserte de ma lampe
Sur le vide papier que la blancheur défend'
Et ni la jeune femme allaitant son enfant.
Je partirai! Steamer balançant ta mâture
Lève l'ancre pour une exotique nature.«[2] STÉPHANE MALLARMÉ

The Political Reasons for the Iconoclastic Urge

Ever since the iconoclastic controversy of the eighth and ninth centuries in Byzantium, the questions of what an image is, what it is for, and what functions a picture serves seem to have divided the audience into two camps: iconoclasts and iconophiles. In the modern period this split has been accompanied by a parallel classification: radical progressivism and naïve conservatism. Since the Byzantine iconoclastic controversy, the iconoclasts who wanted to purify the Church by eliminating idolatry are considered by their later day descendants as radical and progressive and the iconophiles, who wanted to maintain the traditional liturgical practices, are considered conservative. At least that is the official version, which this exhibition and this catalog show to be largely an illusion (see Koerner, Mondzain – in this catalog). The following essay attempts to uncover the roots of image destruction and image worship, but its actual goal is to uncover the roots of this perspective which has always given iconoclasm the reputation of being radical and progressive and idolatry the reputation of being conservative and backward (see Koch). Can this split in the view of the image be explained from the world of the image itself? Or is it more likely that the cause of this political labeling – what is progressive and what is conservative – can be traced back to a character attribution from beyond the field of the image, as already supposed by Jaraslov Pelikan.[3]

What political conflict lies behind the iconoclastic controversy? What political situations are hidden behind the iconoclasts and the iconophiles? What political purposes are served by the reverence, disrepute, and repeal of the picture's functions? Is there a politics of representation? Is the power of images derived from images of power, from their function in providing the representation of power?

In seventeenth-century England, the relationship between the function of the image and its corresponding social movement remained fairly undisguised. In the English civil war, the conflict over images lay behind the struggle between the monarchists and the reformers.[4] Also, England's eigh-

2 4 1 3

_ Plato, Politeia, VII. Book, 515b.

_ Stéphane Mallarmé, Brise marine, 1866.

_ A social movement in disguise that uses doctrinal vocabulary to rationalize an essentially political conflict, in *The Spirit of Eastern Christendom* (600-1700), University of Chicago Press, Chicago, 1974, Chapter III.

_ See the chapter Eikonoklastes and Idolatry, in Christopher Hill, *Milton and the English Revolution*, Penguin Books, London 1977. See also Trevor Cooper (ed.), *The Journal of William Dowsing. Iconclasm in East Anglia During the English Civil War*, reprint: Boydell and Brewer, Woodbridge, 2001.

teenth-century aesthetic practices were, according to Ronald Paulson – bound to the dialectics of image breaking and image remaking, to the aesthetics of revolution and restoration.

The French Revolution was of course the century's best-known form of active iconoclasm. As one Jacobin Club prescribed:

> "Destroy these signs of slavery and idolatry which only serve to perpetuate ignorance and superstition. Replace them with images of Rousseau, Franklin, and all the other great men, ancient and modern, which will fill the people with a noble enthusiasm for liberty."[5]

The idea of revolution would henceforth parallel the idea of iconoclasm and be equally as ambiguous (see Gamboni). The revolutionary often thinks of himself or herself as a true iconoclast. Since the French revolution, the breaking of images and destruction of idols has been linked to the rhetoric of progressive revolutionary politics, liberty, and enlightenment: reason rather than superstition. Those who maintained political systems not only held onto the political status quo, but also to the visual status quo. The reformers, on the contrary, wanted to destroy actual political power along with the images of political power (see Christin, Pietz, Corbey).

These well-known facts already contribute to the answer to our critical question of where the ideologizing of the pictures comes from. It appears that, consistently throughout history, political reformers and reforms wanted to destroy the pictures and statues of the previous political class. This law seems to reign until today, from the razing of the Vendôme column on 16 May 1871 (see Gamboni) to the widespread destruction of Lenin and Stalin statues in post-communism and the destruction of the Buddha statues by the Taliban (see Centlivres, Clement, Frodon). Iconoclastic conflicts, which we call iconoclashes, thus correlate with social conflicts. *The representation of politics is present in the politics of representation.* Perhaps this perspective can provide an answer to our

question: why is iconoclasm considered progressive and iconophilia restorative?

But do iconophile strategies in fact always aim at re-establishing historical political situations? Is the critique of the conditions of picture production always synonymous with the progressive critique of the conditions of political construction? Can image smashers be politically anachronistic and conservative? Might it be possible that restoration, seemingly bound to the re-establishment of historical, political, economic, and social conditions, is at the same time aiming at the dissolution of historical pictorial conditions? Is every admirer of painting a political reactionary? Or can, on the contrary, an abhorrer of painting also belong to the reactionary camp? Such comparisons between aesthetic and political reaction or progressivism appear to necessarily accompany the aesthetic, ideological, and political debates over the function of images from Byzantium, to the realism conflict of the 1920s up through the discussions about abstract painting.

> "The essence of English iconoclasm was the substitution – on the walls of churches as well as in books – of words for visual images. Words – whether seen, spoken, or imagined – were privileged, while visual images were marginalized and discredited [...] One paradigm for English iconoclasm then was the replacement of visual images with words. But words too could be raised to the dangerous status of the image."[6]

Another paradigm present in English iconoclasm was the destruction of the intervening medium. Set against the world of idols and phantoms it is important that there is nothing that mediates between you and God's work. As the Bible states: "Ye shall destroy their alters, break their images, and cut down their groves" (Exod. 34:13) (see Mondzain).

In present times, when pictures hold a power unimaginable for the ancient idolaters, the mechanisms of the picture are more indeterminable than ever. The more power pictures

5

6

_ Ronald Paulson, *Breaking and Remaking, aesthetic practice in England, 1700-1820*, Rutgers University Press, New Brunswick a.o., 1989, pp. 16-17.

_ Quoted in Albert Mathiez, *Les origines des cultes révolutionnaires*, Société nouvelle de librairie et d'édition, Paris, 1904, reprint: Slatkine – Megariotis, Genf, 1977, p. 115.

have, the less we seem to know about how they operate (see Koerner). That is what also seems to assuage a portion of their power. Thus we repeat an argument of the Enlightenment that knowledge of the production of images breaks the power of the images, that enlightenment about the ways an image functions, banishes the political and epistemological claims that arise from it. In the age of Enlightenment, the picture was a perfectly transparent medium through which reality was represented in a way that made reality understandable. Today, however, many theorists who criticize the media agree in the tradition of Plato that images are prisons that block, deceive, and misplace an understanding of the world. Images have become riddles and problems, rather than a transparent "window" to the world, as Leon Battista Alberti defined the image. Images today are considered regimes of signs that make representation impossible, mechanisms that present representations, which deceive and misplace.[7] The critique of visual representation, which means the difficulty or even impossibility of seeing the world correctly, had its apotheosis in the later work of Wittgenstein when he claimed that even words could not adequately represent the world. Representation is replaced by the convention, the agreement on the use of words.[8]

But the empiricist English philosophers from Francis Bacon to John Locke went even further. Locke's first insight was that all experience enters through the senses; the second was that words are no more transparent than images, that both words and images are only conventional signs for reality. For Locke, idols are the innate ideas of scholastic philosophy and true images are the direct impressions of the senses, whereas for the Platonists, idols were merely false images of sensory appearance. The danger appears where images or words are used to represent, interpret, or communicate the results of the senses and intervene between ourselves and nature or God, thereby taking their place, thus becoming idols (see Tresch). This ban of images and this Puritan

substitution of images with words is still dominant in contemporary British art, for example in the work of the group "Art & Language." In the eighteenth century, iconoclasm comes to speak not only for Protestantism, but also skepticism and subversion, whereas iconolatry (idolatry) becomes associated with institutional authority or religion in general. Idolatry in art became a designation that extended from an old master painting to a canonical sculpture. The iconoclastic mind carried within it the seeds of civil rebellion and vice versa. One of our initial questions can thus be answered: social movements frame the perspective from which the function of images is evaluated. But the reverse is also true, as we will see, and image theories play very strong roles in political movements (see Konchok, Stoddard).

The »End of Art« as Declared by Philosophy

The politics of representation is in no way limited to political symbols or to the field of art. It has one of its bases in philosophy, and it is there that the theme of the "end of art" has been articulated most explicitly. This is not surprising since ideas, idols, images, and representations are all related terms. The term "ideology" itself has its origins in the term "idea." And it is precisely the mutual definition of idea and image that lies at the base of the conflict between iconophiles and iconoclasts. In the history of philosophy, the science of ideas is difficult to separate from iconology. Ideas are understood as images. The question is: what is the role of images of ideas?

Emmet Kennedy named Destutt de Tracy as the founder of the concept of ideology.[9] The modern origins of pictorial critique and the connotation of political progressivism can be located in the Enlightenment and also in the iconoclastic conflicts of the French Revolution and its aftermath, with the destruction of the Vendôme column as its visual symptom. During the French Revolution, intellectuals first used the term "ideology" to invent a classical science of ideas in which

8 7 9

_ In *A Philosopher in the Age of Revolution: Destutt de Tracy and the Origins of Ideology*, American Philosophical Society, Philadelphia, 1978, p. 255.

_ In art, no one less than René Magritte pointed out the crisis of the image and the crisis of representation through his wavering meanings. It is not a surprise that one of the most important poststructuralist critics of representation, Michel Foucault, reflects in his theory not only on a picture from Velazquez, *Las Meninas*, but also on the pictorial world of Magritte. See chapter Las Meninas, in Michel Foucault, *Les mots et les choses*, Gallimard, Paris, 1966, and Michel Foucault, *Ceci n'est pas une pipe*, Gallimard, Paris, 1974.

_ See Daniel J. Boorstien, *The Image*, Harper & Row, New York, 1961; Roland Barthes, *Image-Music-Text*, Hill & Wang, New York, 1977; Bill Nichols, *Ideology and the Image*, Indiana University Press, Bloomington, 1981.

social affairs would gain the certainty of materialist empirical science. An "ideology" of all things seemed to be the right method to differentiate true ideas from false ones, by determining which ideas have a true and real relationship to external reality. Therefore, "ideology" was about those ideas that have the ability to represent reality in a realistic way; it was not about utterly denying the image this ability. Ideology was originally a science that believed in the representational ability of the image. It was a matter of separating the right images from the wrong ones. In this respect, the iconoclastic science of ideas took ideology as its own idol. The first contradiction can be noticed here. That is the swaying ambivalence that this catalog constantly points out (see Latour): iconoclasm at the service of idolatry.

The view of ideology as a method of differentiating between false and true images goes back to Francis Bacon and Descartes. Francis Bacon wrote in 1620 in *The New Organon*:

"The Idols and false notions which are now in possession of the human understanding, and have taken deep root therein, not only so beset men's minds that truth can hardly find entrance, but even after entrance is obtained, they will again in the very instauration of the sciences meet and trouble us, unless men being forewarned of the danger fortify themselves as far as may be against their assaults."[10]

Between 1790 and 1830, a reaction to the Enlightenment formed in Germany. Drawing on medieval art, Dürer, and the Renaissance, particularly Raffael, an emotionally bound subjectivity was rapturously acclaimed. The marriage of art images and religion was proclaimed and aesthetic genres such as Lessing's were rejected. In artworks, the borders between the genres dissolved. Romantic poets and painters rejected classicism and rationalism and the calculations of reason and rationality of German idealism that found their culmination in Hegel's conceptual system. They discovered the directness of the view. They discovered the power of the image against the hegemony of the concept, as is clearly expressed in the lines from Novalis:

If numbers and figures no longer
Held the keys to all creatures,
If they sang or kissed
Deeper than the learned know,
If the world lived freely,
And life was recommenced in the world,
If then light and shadow again
Became true clarity,
And we saw in tales and poems
The true world history,
Then from a secret word
All false being would flee.[11]

Access to the world and to understanding of the world is achieved in opposition to Plato's rejection of the image through the image itself. Contemplation is the window to the world. Art works teach us to see, and even more, to see for the sake of seeing.[12] This romantic reaction was the absolute opponent to German idealism, which relied heavily on the power of conceptually rational thought. In the *Phenomenology of Mind*, which Hegel completed in Jena in 1806, he wrote: "The element of truth is the Concept, and its true form the scientific system."[13] Hegel probably recognized himself to be an opponent to the Romantic conviction that "the Absolute [...] is not to be grasped in conceptual form, but felt, intuited; it is not its conception, but the feeling of it and intuition of it that are to have the say and find expression."[14] In his confrontation with the positions of Schelling, Schlegel, and the Romantics, Hegel gained the standpoint that the knowledge of truth is only possible through the medium of a systematically developed concept. Hegel accused the Romantic attempt to rehabilitate the image and direct contemplation with a lack of concept:

10 12 13 11 14

_ This poem may be found in the notes to the continuation of Novalis' novel *Heinrich von Ofterdingen*, in *Novalis. Schriften*. Band III: *Das philosophische Werk II*. Richard Samuel, Hans-Joachim Mähl, and Gerhard Schulz. (eds), W. Kohlhammer Verlag, Stuttgart, 1968, p. 675.

_ Georg Wilhelm Friedrich Hegel, *The Phenomenology of Mind*, Harper & Row, New York and London, 1967, p. 70.

_ Hegel, op. cit., p. 71.

_ August Wilhelm Schlegel asks in *Die Gemälde. Gespräch* regarding the images of the people of Dresden, "When will you see for the sake of seeing?", Athenaeum, 2 volumes, vol. 1, Berlin, 1799, p. 62.

_ Francis Bacon, *The New Organon* (1620), quoted from William J.T. Mitchell, *Iconology. Image, Text, Ideology*, University of Chicago Press, Chicago and London, 1986, p. 164.

"In the contrast and opposition between these two aspects (the initial and the developed stages of science) seems to lie the critical knot which scientific culture at present struggles to loosen, and about which so far it is not very clear. One side parades the wealth of its material and the intelligibility of its ideas; the other pours contempt at any rate on the latter, and makes a parade of the immediate intuitive rationality and divine quality of its content."[15]

Here we can recognize our matrix of the organization of ideology and image. The Enlightenment insisted on the concept and rationality and accused Romanticism of mere appearances and sacredness. Here we can see the two vanishing lines of history: the history of materialism versus the history of sacredness. Hegel set the course for the rational direction of philosophy in the nineteenth century, and thereby assured the triumph of pure reason, the victory of science over the humanities. His conflict with Romantic art, due to his primacy of concepts, finally led him to first express the dictum of "the end of art" that was so decisive for the modern era.

"In all these respects art, considered in its highest vocation, is and remains for us a thing of the past. Thereby it has lost for us genuine truth and life, and has rather been transferred into our *ideas* instead of maintaining its earlier necessity in reality and occupying its higher place."[16]

The crisis of art thus began at that moment when philosophy denied it the role of a medium of knowledge and truth, of a medium with whose help the world could be recognized and explained. Based on Hegel's experience with the Romantic concept of art, art was obviously, according to philosophy and religion, no longer a transparent window to the world, but rather, an opaque steamy window, obscured by what the Romantics claimed to be a "direct knowledge of the absolute"(Jakobi) which for Hegel was mere supposition. As I will show, art internalized these externally imposed dictates and in a series of manifestos during the twentieth century, continually proclaimed a crisis of representation and the end of art.

From the complementary histories of the conflict between ideology and image, we can derive the theorem that *the discourse of the crisis of representation and the discourse of the end of art are mutually dependent.* Both crises appear at exactly the same historical moment.

Nearly every critical thought on culture cites the Marxist concept of ideology. The key text on ideology is *The German Ideology*, written by Karl Marx between 1845 and 1847, and first published after his death. In this text, Marx employs the term "ideology" to analyze the working methods of the mind and consciousness, and to drive out the influence of idealistic philosophy. Interestingly, as W. J. T. Mitchell has so clearly pointed out,[17] Marx compares the function of ideology to the mechanisms of a camera obscura:

"If in all ideology men and their relations appear upside-down as in a *camera obscura*, this phenomenon arises just as much from their historical life-process as the inversion of objects on the retina does from their physical life-process."[18]

The camera obscura as a metaphor for ideology is to some extent enticing because the conceptual machine of ideology is based on the camera as an image machine. From that, it is possible to conclude that ideology itself is an image machine, *a machine which produces pictures*, pictures of the world, representations of the world under the dictates of ideology. Ideology thus colors the window to the world.

The camera obscura metaphor thus repeats the cave metaphor from Plato. Sensations are the windows through which the light of the world penetrates into the dark room. If Locke had a positive understanding of the camera obscura,

15 16 17 18

_ Karl Marx and Friedrich Engels, The German Ideology, in *Collected Works, vol. 5*, Progress Publishers, Moscow, 1976, p. 36.

_ Hegel, op. cit., p. 77.

_ Hegel's Introduction to *Aesthetics: as the introduction to the Berlin aesthetics lectures of the 1820s*, translated by T. M. Knox, with an interpretative essay by Charles Karelis, Clarendon Press, Oxford and Oxford University Press, New York, 1979, p. 11.

_ In Mitchell, op. cit., pp. 160-208. My argumentation owes a lot to this text.

Marx had a negative understanding of it. Like ideology, it delivers the mechanisms of illusion: phantoms, chimera, ghosts, and shadows of reality. Marx used the camera obscura to ridicule the illusions of idealistic philosophy. In his philosophy, he wants to set right again the relations that appear upside down in a camera obscura. From that he derives his claims – in an iconoclastic strategy – of anchoring the inverted images of ideology (the upside down images of the camera obscura), in the historical life process and rectifying them.

Mitchell lists three iconoclastic strategies. The first strategy is not to trust any representation; to turn back all mediations. This call for direct positive knowledge is, however, very problematic when it meets with Locke's model of empirical observation. The question becomes, how to maintain true images, versions, and representations of the world and likewise avoid the camera obscura, the instrument of mediation (see Schaffer). Is it at all possible to maintain pure unmediated direct knowledge (see Galison, Rheinberger, Macho)? Radical iconoclasm believes in the possibility of seeing without eyes, of maintaining pictures of the world without instruments. If it is not possible to cast a direct glance at reality, is the alternative to work through ideology through a process of critical interpretation?[19]

The third option, which avoids the dilemma of the idealists with their shadow world and the empiricists with their direct representation, is historical materialism, which recognizes both the shadow of illusion and direct representation as historical products. Only through the reconstruction of the material history of production from which pictures and ideas arise can ideology be rectified. The dead facts of the empiricists and the imagined activities of the idealists cease through the connection of the images with the material conditions of their production. Historical experience thereby becomes the ultimate signifying practice. Marx does not see himself as external to this historical process, but rather as a conscious agent for a certain class, namely, the class of the proletariat

that does not hold authoritarian power. Is history now the new idol of the mind?

It is thus possible to say that the iconoclastic conflict is an ideological conflict. But it is not only a conflict *about* the ideology of the image, about the representation of the world through images, but a conflict about the composition of the world itself, and thus *a social and political conflict*. And once again the question arises: why are those who worship images, based on their ability to correctly represent the world, described as naïve and reactionary, whereas those who destroy images because of their inability to correctly represent the world are valued as progressive and advanced? Those who want to glance behind the images, behind the mechanisms and conditions with which and under which images represent the world, are considered to be critical minds and fighters of ignorance (see Koch). Those who want to leave the images as images, trusting the images themselves with the power of enlightenment are considered anti-Enlightenment and obscurantists in spite of everything that is shown in this catalog and in the exhibition.

Therefore the question arises once again; where does the judgment on iconoclasm and idolatry come from? Why do the supposed iconoclasts believe that they are critical of the power of the image? And why are the supposed idolaters thought to be in a kind of unconditional surrender, in love with the images? Our argument is that it is in the special and limited case of painting and its modernist history that one can more clearly see the roots of "the end of art" argument.

The »End of Art« as Declared by Art

This exhibition makes clear that the word "image" includes all sorts of representations and mediations (see Latour). The case of painting in the Western tradition is so striking that it will be followed in some detail, even though the general outline is well known. Here, the death of art is a consequence of

19

_ To draft a hermeneutics of suspicion like Boris Groys has recently done in *Unter Verdacht: eine Phänomenologie der Medien*, Hanser, Munich, 2000.

František Kupka / Abstraction / c. 1932 / gouache on paper crème / 11 x 11" / Musée national d' art moderne, Centre Georges Pompidou, Paris

Sam Francis / Edge Painting / 1968 / oil on canvas / 42.1 x 31.9" / Louisiana Museum of Modern Art / © VG Bild-Kunst, Bonn 2002

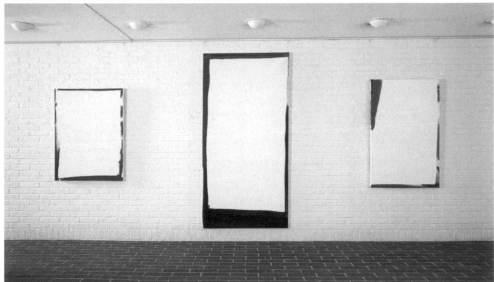

Jo Baer / Untitled / 1969 / oil on canvas / 36 x 39" / courtesy Galerie Meyer Kainer, Vienna

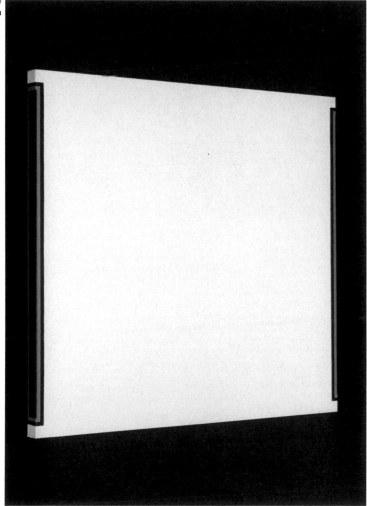

Jasper Johns / Canvas / 1956 / encaustic and collage on wood and canvas / 30 x 20" /
Jasper Johns / © VG Bild-Kunst, Bonn 2002

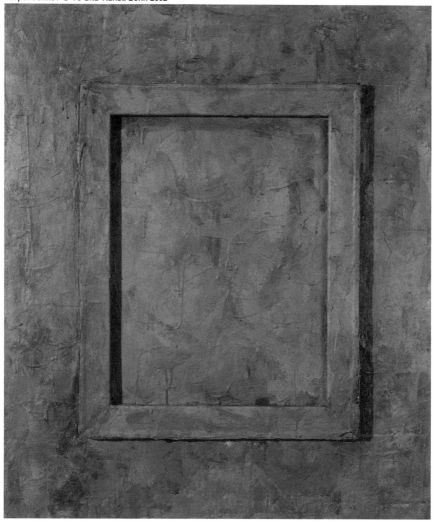

Fabio Mauri / Disegno / 1960 / cardboard on wood / 26 x 29.5" / Fabio Mauri

Cornelis Nobertus Gijsbrecht / Rear panel of a painting / 17th century / oil on canvas / 21.3 x 25.6" / Statens Museum for Kunst, Copenhagen

Timm Ulrichs / Bildrückseitenbild [Picture of the back of a picture] / 1961–1968 / photograph on canvas on stretchers (front view) / fabric tape, labels, hanger (back view) / 15.7 x 19.7" / edition of 50, numbered and signed pieces / Collection Hüper, Timm Ulrichs / © VG Bild-Kunst, Bonn 2002 / © photo: Foto-Wolff, Hannover
The front view of the object shows the precise photographic copy of its own back view.

Giulio Paolini / Chimera / 1975 / pencil, acrylic, frame on canvas / 31.5 x 63" / FER Collection / © photo: FER Collection, archive

Ger van Elk / Paysage saignant [Pressure sandwich] / 1991 /
Collection Liliane & Michael Durand-Dessert, Paris / © photo: PPS

Guilio Paolini / Mnemosine / 1979-1980 / nine canvases / drawing, collage /
each 47.2 x 31.5" / courtesy Galerie Löhrl, Mönchengladbach /
© photo: Paul Maenz, Berlin, archive

Richard Jackson / Untitled / 1971–1988 / free-standing constructed painting of three paired canvases / each pair 95 x 42 x 2" / installation view
The Menil Collection, Houston / Richard Jackson, courtesy Galerie Hauser & Wirth, Zurich / © photo: Paul Hester

Arnulf Rainer / The empty painting / 1951 / exhibition Künstlerhaus Klagenfurt / photography
with Arnulf Rainer, torn into two pieces by the artist / from: Peter Weibel (ed.), Wien,
Bildkompendium Wiener Aktionismus und Film, Kohlkunstverlag, Frankfurt/M., 1970, p. 2

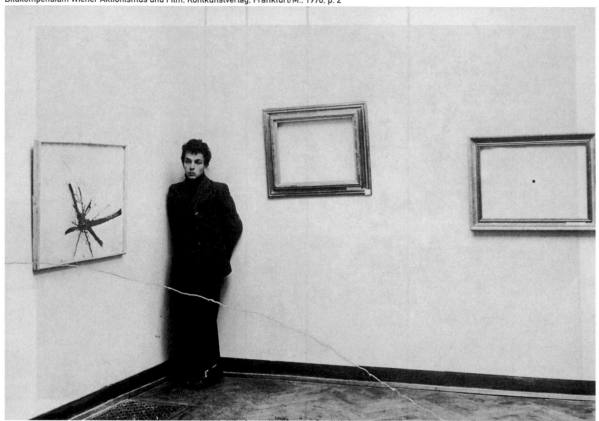

Imi Knoebel / Keilrahmen [Stretcher] /
1968 / wood, paint / 11.8 x 11.8" /
Carmen Knoebel, Düsseldorf /
© photo: Nic Tenwiggenhorn

Imi Knoebel / 30 Keilrahmen [30 stretchers] / 1968-1969 / installation / wood / 94.5 x 114.2 x 31.1" / Carmen Knoebel, Düsseldorf / © photo: Nic Tenwiggenhorn

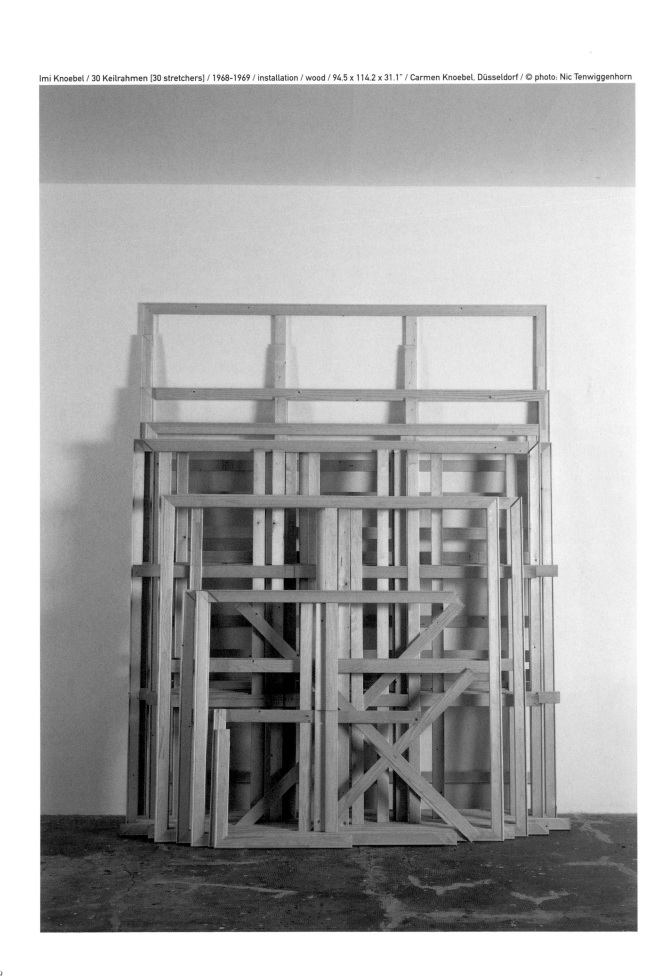

Reiner Ruthenbeck / Rotes Bandquadrat mit Metallstab [Red Square with metal tool] /
1988 / ribbon, metal tool / Collection Falckenberg, Hamburg / © VG Bild-Kunst, Bonn 2002

Richard Artschwager / Handle / 1962 / Kasper König, Cologne /
© photo: Achim Lengerer

Christian Eckart / Eidelon No. 1102 / golden frame, 23 caratage / 96 x 66.1" /
Galerie Thaddaeus Ropac, Salzburg

Bertrand Lavier / Concorde / 1987 / light runners, beams / from: Bildlicht.
Malerei zwischen Material und Immaterialität, exhib. cat. Wiener Festwochen,
1991, Europaverlag, Vienna, 1991 / © VG Bild-Kunst, Bonn 2002

Peter Weibel / exhibition: painting between anarchism and research / 1992 / empty cross shaped frames hanging on the ceiling, on the walls frames accumulate in frames / Neue Galerie am Landesmuseum Joanneum, Graz / © photo: Peter Weibel

Peter Weibel / Frame Conditions, reflecting the evolution of an electric collapse / 1991 / steel band, soldered (gelötet) / 21.1 x 67.2 x 0.2" / Neue Galerie im Landesmuseum Joanneum, Graz / © photo: Koinegg, Neue Galerie am Landesmuseum Joanneum, Graz

Peter Weibel / Frame Conditions, reflecting the number of visitors of a day, a week, a month, a year in the Neue Galerie / 1991 / wooden frame, glued spruce wood / 73.6 x 24.8 x 5.5" / Neue Galerie am Landesmuseum Joanneum, Graz / © photo: Koinegg, Neue Galerie am Landesmuseum Joanneum, Graz

Franz Erhard Walther / 40 Sockel [40 plinths] / 1978 / installation / cotton, wood, glue / 148 pieces, each 14.6 x 3.5" / approx. 393.7 x 141.7 x 39" (installation) /
Franz Erhard Walther, courtesy Galerie Vera Munro, Hamburg / © VG Bild-Kunst, Bonn 2002 / © photo: Jens Rathmann

Claude Rutault / dlm 126 bis / 1984 / 88 canvases / Musée d'art moderne et contemporain, Strasbourg / Collection Brolly, Paris / © photo: Richard Decker, 1998

Imi Knoebel / Weiße Wand [White wall] / 1975-1976 / ampheolin on wood / eight parts / 64.6 x 95.5 x 22.1" / Carmen Knoebel, Düsseldorf

Peter Weibel / Am Boden gestapelte leere Graphikmappen aus den Beständen des Museums [Empty print books piled on the floor from the museum's collection] / exhibition: Malerei zwischen Anarchie und Forschung / 1992 / Neue Galerie am Landesmuseum Joanneum, Graz / © photo: Peter Weibel

Martin Kippenberger / Orgon-Kiste / 1982 / dispersion, wood, metal, oat flakes, oil paint, canvas / 47.3 x 43.3 x 35.4" / Grässlin Collection

Richard Jackson / Untitled (stacked painting) / 1989 / canvas, wood, acrylic paint / 120 x 180 x 96" / courtesy Tschudi Gallery, Glarus

Marcel Broodthaers / Dix-neuf petits tableaux en pile / 1973 / installation with 19 canvases on stretchers, the edges painted, inscribed with date »29 September 1973« / 15.2 x 18 x 15.2" / © VG Bild-Kunst, Bonn 2002

Endre Tót / Gorbatschow in New York / 1991 / acrylic on canvas / 33.9 x 48.4" / courtesy Galerie Berndt, Cologne

Endre Tót / Dada-Messe in Berlin [Dada-fair in Berlin] / 1989 / acrylic on canvas / 49.2 x 79.1" / Collection Speck, Cologne

Installation view of Robert Ryman's exhibition in the Kunsthalle Basel, June 1975 / © photo: Christian Baur

Endre Tót / Die abwesenden Bilder [The absent pictures] / 1971-1992 / acrylic on canvas / 94.5 x 59.1"

Ewa Partum / Present, Absent / 1965

Endre Tót / A Visit to the Museum (Blackout Paintings Cabinet) / 1972 /
from: Endre Tót. Who's Afraid of Nothing, exhib. cat Museum Ludwig, Cologne, 1999, p. 82

John Isaacs / Ah! Donald Judd,
my favourite! / 1991/1999 /
gelatine silver print / silk screen
on baryt paper / 20.8 x 17''
(framed) / Fluid Editions, Basel

Ah! Donald Judd, my favourite!

Ewa Partum / Absent / 1965

Ewa Partum / Present / 1965

Ewa Partum / Breakfast on the grass (Manet) / 1971

Stephen Prina / Exquisite Corps, The Complete Paintings of Manet / 1988 / silkscreen on cardboard /
Neue Galerie am Landesmuseum Joanneum, Graz / © photo: Koinegg, Neue Galerie am Landesmuseum Joanneum, Graz

Stephen Prina / Exquisite Corps, The Complete Paintings of Manet / 1988 /
silkscreen on cardboard / detail / Neue Galerie am Landesmuseum Joanneum, Graz /
© photo: Koinegg, Neue Galerie am Landesmuseum Joanneum, Graz

Daniel Buren / Second episode; from now on, work in situ / November – December 1975 /
Städtisches Museum Abteiberg, Mönchengladbach / © VG Bild-Kunst, Bonn 2002

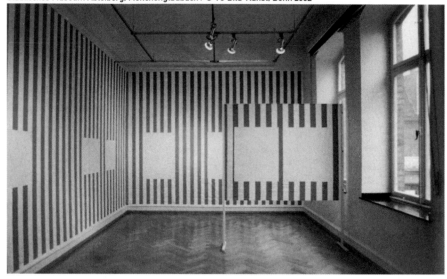

Daniel Buren / Inside and outside the frame / 1970 / dimensions variable / Collection FER /
© photo: VG Bild-Kunst, Bonn 2002

Timm Ulrichs / »Bild«-Bilder [»Picture«-pictures] / 1966 / black adhesive plastic letters, adhesive tape /
size variable / installation view / detail / Städtisches Museum Leverkusen, Schloß Morsbroich /
© VG Bild-Kunst, Bonn 2002 / © Holger Schmitt, Leverkusen

Daniel Buren / Demultiple (instruction) / 1973 / 11.8 x 19.7" / Collection Speck, Cologne / © VG Bild-Kunst, Bonn 2002 / © photo: Lothar Schnepf, Cologne

Maria Eichhorn / Wand ohne Bild [Wall without picture] / 1991 / © VG Bild-Kunst, Bonn 2002 / © photo: Jens Ziehe

André Cadere / Peinture sans fin [Painting without end] / 1974 / wooden bead-molding, polychromed from 52 individual parts / 0.8 x 47.6" / Neue Galerie am Landesmuseum Joanneum, Graz / © VG Bild-Kunst, Bonn 2002 / © photo: Koinegg, Neue Galerie am Landesmuseum Joanneum, Graz

Daniel Buren / Demultiple / 1973 / acrylic on marquee fabric / 83 x 3.9" / Collection Speck, Cologne / © VG Bild-Kunst, Bonn 2002 / © photo: Lothar Schnepf, Cologne

Maria Eichhorn / Vier Ecken eines entfernten
Blattes Papier [Four corners of a removed
piece of paper] / 1991 / adhesive tape, paper /
courtesy Galerie Barbara Weiß, Berlin /
© VG Bild-Kunst, Bonn 2002

Robert Barry / Painting in Four Parts / 1967 / oil on canvas over wood /
four parts / each 4.1 x 4.1" / FER Collection / © photo: FER Collection, archive

Michael Asher / installation view in Claire Copley Gallery, Inc., Los Angeles / 1974 /
© photo: Gary Kruger

the death of painting. It is not about a death which was announced from the outside, but, rather, *from within*: from the painters themselves. We are dealing more precisely with what could be called *the suicide of art*. The death of painting that the painters themselves called for, took place in three steps which can be described through the triangle of Van Gogh-Malevich-Duchamp: from making colors absolute to the self-dissolution of painting.

Van Gogh and his famous proclamation "the painter of the future will be a painter of colors" can stand for making colors absolute (dispensing with local colors that represented the colors of objects). When colors were no longer obliged to represent objects, then, in a next step, the painting was not obliged to represent objects at all. The painting became a flat screen for colors, even for only one color. Kasimir Malevich's declaration of the end of painting, of painting as a "prejudice of the past," in his famous picture *White Square on White Ground* (1918), set a date for the end of color painting and the beginning of non-representational (object-less) painting. Duchamp actually scoffed at painting as mere retinal stimulation and gave it up completely by introducing artworks that were objects not produced by the artists: the ready-mades.

This *internal* death of painting as the beginning of the end of art is not the same as the death of painting proclaimed at the advent of photography. Flaubert in his *Dictionnaire des idées reçues* had already denounced as commonplace the view that photography "détrônera la peinture."[20] Naturally, it is evident that the paradigm of photography, which has reigned for more than 150 years, produced a crisis of representation for painting in more radical terms than ever before. It is also evident that this crisis led to the end of art in its historical form. We can refer to this epoch, this period, this ensemble of strategies that tried to cope with the crisis of representation under the paradigm of photography as *modern art*. The method of modern art's dealing with the crisis followed in the tradition of iconoclasm.

This process of self-dissolution follows that dialectic of the modern era, which can be explained in three steps: first, how paint as a medium of painting can be analyzed and given new emphatic accents, i.e., in impressionism; second, how paint becomes independent, leaves behind the laws of local colors and receives its own absolute status, i.e., from Symbolism to Suprematism; and third, how paint as a material (Faktura) is replaced by other materials such as aluminum for white.

The Emancipation of Color

The dethroning of the object was brought about by pure colors becoming independent. The colors' becoming absolute formed the first non-classical, anti-objective transformation of the Cartesian coordinate system of panel painting. In place of the object, the historical point of reference, color was put in as the new reference point.

Because color was considered the source of painting until Malevich, and Kandinsky could still not imagine painting without color in 1938, it was possible to say that painting without color is not painting. "We will never have the possibility of creating a picture without 'the color' and without 'the drawing'," Kandinsky wrote about concrete art in 1938. Kandinsky was not right. We could not only make pictures, but even paintings without color and without paint. Historical painting, as painting identical to color, bade adieu with the elimination of color in the picture.

The dissolution of the representative responsibility of painting and the crisis of representation in art already began as early as the nineteenth century with the shedding of certain artistic pictorial strategies such as perspective and the attempts at primacy or liberation of individual constitutive elements of painting such as light, color, and surface in what was still representative painting. The liberation of color and light were certainly the most spectacular and dramatic moments in the nineteenth century's freeing of the picture from the dictates of

20

_ After he investigated photography commissioned by the French Academy for Daguerrian photography, Paul Delaroche announced painting's death in 1839: "From this day on, painting is dead." This proclamation was only an echo of the thesis which had already been expressed in 1622 by Constantijn Huygens on the occasion of the camera obscura and its mimetic perfection: "Toute peinture est morte."

representation. Making colors absolute worked as a motor to decisively push forth the abstraction of painting and most powerfully repeal the dictate of the object from painting.

In 1874, in the studio of the photographer Nadar, Claude Monet exhibited his picture *Impression d'un soleil levant* which gave a name to the new art movement. Through the dismantling of light, the natural phenomenon is presented as a play of colors according to subjective feeling. Impressionism discovered the independent status of colors and through that, local color lost importance. To the same degree, also *the object lost importance.* Monet repeatedly painted well-known variations of the same motif. Painting was positioned more prominently than the motif, color more prominently than the object. Color's breaking free from local color – obliged to the representation of an object – to an autonomous color based on its own laws, representing only itself, also meant the independence of the image as compared to the reproduction of visible nature. It is color that transforms a reproduction into an image. Since the Impressionists, the image as pure color image has tended to no longer need a concrete cause. For the first time, the autonomous colors make the image independent of the object. Using a haystack picture from Claude Monet, Kandinsky quite beautifully described how the splendor of colors displaced the objects:

"At the same time (1895) I experienced two events which were to mark my entire life and at the time shook me to the core. That was the French exhibition in Moscow – primarily the *Haystack* from Claude Monet. Previously I only knew realistic art ... and suddenly for the first time I saw a picture. It was the catalog that told me that that was a haystack. I numbly felt that the object was missing in this picture. Painting received a fabulous power and magnificence. Unconsciously, the object was also discredited as the inevitable element of the picture."[21]

The painterly strategy of Impressionism suppresses the characteristics of the objects and the reference to the objects. "Color interaction consumes object distinction," wrote Max Imdahl in *Farbe* (Color), his 1987 epochal study.[22]

The more that colors turned away from the object and the more they became self-referential and became color as color (and did not remain object color or local color), the more they discredited the object. This autonomy of color ("la couleur pour la couleur") also celebrated the pure brush stroke. Thus the independent spot, the stroke, became visible. The term *tache* (spot, stroke) first appeared in the critique of the impressionist paintings. Later, making it absolute, the term would nourish an entire movement, Tachism. The impressionist pictures were accused of not having any objects or persons, only "taches."[23] Maurice Denis painted a picture in 1890 with the title, *Taches de soleil sur la terrasse.* This surfacing of new painterly features and criteria were typically felt as a loss since the old features did, in fact, actually disappear.[24]

Painters tirelessly preached the abstraction of color from the object. For instance, Vincent van Gogh:

"I am thoroughly occupied by the laws of color – if only they had been taught to us in our youth! That the laws of color, which Delacroix first determined are of light is utterly clear. The true painters are those who do not make local colors, that was what Ch. Blanc and Delacroix talked over one day. ...
The painter of the future will be a colorist, the likes of which has never been seen."

Painting, as it now is, promises to become more subtle, more music and less sculpture, finally, it promises color; if only it fulfils this promise, of bringing forth a color which is tied with feelings like music with arousal.[25]

"La couleur pure! Et il faut tout lui sacrifier," Gauguin answers the poet Gauthier. Above all, the object was sacrificed

21 24 23 25 22

_ Max Imdahl, *Farbe. Kunsttheoretische Reflexionen in Frankreich*, Fink, Munich, 1987.

_ Refers to the picture *Boulevard des Capucines* (1873) by Claude Monet, which was not only painted from specific formal elements of photography of the time, but was even painted from the studio of the photographer Nadar, where, incidentally, the first impressionist exhibition took place, the critic Louis Leroy wrote that the people on the boulevard were mere "taches."

_ Even Théophile Gautier criticized: "L'art vit de sacrifice [...] mais supprimer tout est trop. Se borner à poser des taches, comme on dit aujourd'hui [...] c'est vraiment trop simplifier la mission de l'artiste." (In Max Imdahl, op. cit., p. 23.) The investigation of color by Michel Eugène Chevreul *De la loi du contraste simultanée des couleurs*, published in 1839, greatly influenced the French painters of the nineteenth century and brought in new terms: retina, light, and simultaneous contrast.

_ Maurice Denis, *Nouvelles Théories sur l'Art Moderne sur l'art Sacré 1914-1921*, quoted after *Vom Licht zur Farbe: nachimpressionistische Malerei zwischen 1886 und 1912*, exhib. cat. Städtische Kunsthalle Düsseldorf, 1977, p. 57.

_ Wassily Kandinsky, Reminiscences, 1913, in *Kandinsky – Complete Writings on Art*, Kenneth C. Lindsay and Peter Vergo (eds), Faber & Faber, London, 1982, vol. 1, p. 363

for color. Gauguin thus stated in another context: "Do not work after nature. Art is abstraction."[26]

Seurat defines painting as a synthesis of "phénomènes de la durée de l'impression lumineuse sur la rétine."[27] This definition of painting as a retinal experience later inspired Duchamp to attack painting as pure retinal stimulus.

According to Maurice Denis, "[i]t is not the rendered object which should be the artist's expression, but, rather, the means of expression (lines, forms, volumes, colors). The picture is again – according to my definition from 1890 – a surface with a color arrangement according to a certain principle."[28]

Subsequently, the material means of expression such as frames and canvas were also thematized. In the end, not only the frames of pictures but even the institutional framework conditions of art came to be absorbed by the field of expression. In the twentieth century the analysis of the means of art progressively replaced the rendered, represented object as a medium of expression. *The analysis of the means of representation became the object of representation* thus proving modern art as an iconoclast activity from a historical point of view and thus defying any definition of modern art as being either iconoclast or iconophile (see Gamboni) from the point of view of this exhibition.

Similar to the literature of the modern era, the analysis of the world was accompanied and replaced by an analysis of the means implemented for an analysis of the world. In the modern era, painters and writers increasingly analyzed and represented the conditions of representation itself. In a type of laboratory situation, the critique and crisis of representation became the medium of representation in modern art. With that, art merely followed the logic of the path of color abstraction that it had already taken in the nineteenth century. This path was not taken entirely voluntarily, but, rather, accelerated under the historical conditions of the paradigm of photo-

graphy. Thus, another interpretation of the same history is possible (see Lowe): far from showing a distance to objects and a search for purity, the painters, on the contrary, show an ever more attentive interest in the mediations of the painting medium itself. Although iconoclasts in one sense, the same painters can be read as iconophiles in another, since they remain passionately attached to the transformative power of the mere medium.

Emancipation of Surfaces

The first transformation of the panel painting occurred when color, rather than object, became the reference point for painterly consideration. In a second transformation, color itself was seen in reference to the surface. The object was sacrificed to color and thus color needed a new point of reference. The surface became the new field of reference for color.

In 1929, Henri Matisse described in retrospect the development of color and surface:

"Then one also comes across Gauguin and van Gogh. Here are original ideas: construction with color surfaces. Looking for the most effective color affects – the material is irrelevant. Revolt against the spread of a local color in light. The light is not suppressed, but finds itself in harmony with luminous color surfaces."[29]

The construction of an autonomous surface through the pure means of color replaced reproduction of the world. The ability to construct the image, the construction of the image as surface, had already begun with the discovery of perspective in the Renaissance. With the identification of the image as a pure color surface, which repealed the obligation of objective presentation, the picture's task of representing the world was relinquished.

The actual radical subversive function of the colors, which had become independent and absolute, was not so

28

_ Quoted after, Walter Hess, *Dokumente zum Verständnis der modernen Malerei*, Rowohlt, Hamburg, 1956, p. 31.

26 27

_ Georges Seurat, Letter of 28 August 1890 to Maurice de Beaubourg, in *Klassiker der Kunst*, Luzern, Stuttgart, and Vienna, 1972, p. 90.

_ Initial publication under the pseudonym Pierre Louis in *Art et Critique*, 23 August 1890. Reprinted in Linda Nochlin, *Impressionism and Post-Impressionism 1874-1904: Sources and Documents*, Prentice-Hall, Englewood Cliffs, 1966, p. 187.

29

_ Quoted in: *Vom Licht zur Farbe*, op. cit., p. 59.

much the expulsion of the object from the image, but the simultaneous banning of the form and the retreat to the surface. That formed the actual explosive material for the painting of the twentieth century and the exit from the canvas. The end of painting was achieved to a certain extent through this non-objective painting, where color is simultaneously form, surface, and content. *With the loss of the object, painting was also lost from historical sight.* The image as pure color surface became an object itself, *an image object.*[30]

The abstraction of color from the object, which led to the dispensing of the object from the image and to non-objective, abstract painting forms the first step of abstraction. Banning the object from the image resulted in two things: first of all, the surface became a new field of reference for color, and second, with the object and with the limitation of the color design to the surface, the form derived from the object was relinquished. In this second step of the self-dissolution of painting, the abstract formal language of geometry came into contact with the abstracted (locally foreign) color, to create non-objective abstract images with geometric forms. Soon, however, surface and form became more important than color. Mainly, the materiality of color ("Faktura") and surface became more important than color. In a recent accent shift, not only the historical elements of painting such as the object were completely omitted, but also the central elements such as color and form. Through recourse of pure color to pure surface, the image would soon become pure surface design without color. Following the total absoluteness of color was the total absoluteness of surface. The monochrome image announced its arrival. Dispensing the color from the image, for example in the monochromes of Rodchenko or the achromatic paintings of Manzoni, forms the third step of abstraction, which brought painting *even closer to the border of its elimination.* Monochrome paintings could only be colored at the edges. Surface design without painted color allowed making paintings without paint and color, allowed

mere surfaces of wood, metal, marble, or cardboard to hang or lean on the wall as paintings. The paint-less or monochrome easel-painting could be cut or drilled or torn, attacked by fire or acid. Finally only the empty frames of paintings, or just the backs of paintings would be shown. Even the surface of the canvas could be replaced by the surface of the skin. Monochrome painting on the body followed the exit of the canvas. Naked bodies covered with paint covered the canvas. Painting as the arena of action (Action Painting) became a bodily action on the canvas and finally a painting on the body, an action without canvas. Centered on the artist's body, even the products of this body (like feces) could find the social consensus to be accepted as artworks. Naturally there was a period when a social consensus was not found. The iconoclastic impulse of modern art (the progressive version of iconoclasm) provoked an iconoclastic impulse against modern art (the conservative version of iconoclasm). In the totalitarian systems of Stalin and Hitler, the war against the image and against representation of modern art was answered by terror against modern art in favor of the image and representation. The rhetoric of liberation, one of the basic axioms of modern art, could be founded on this attempt at its annihilation by totalitarian systems. Again we see ideological reasons for the war between iconoclasts and iconophiles.

Will the Last Painter Please Turn off the Light When Leaving Art?

There are still several steps from the non-objective world to the colorless world. Malevich's Suprematism redeemed true non-objectivity (*Black Square on White Ground*, c. 1915), which was followed quite shortly by the state of non-color (*White Square on White Ground*, 1918) (see Lowe). Suprematism, like all other painting theories of the time, naturally saw the origins of painting in color, but Malevich, in his struggle against the object, also attacked as enemy the new deputy of

30

_ Delaunay already perceived that the pure color surface forms the transition from "the deformation of the retinal reproduction" (Cézanne) to the first laws, which would transform the entire structure of the image – where the image appeared as itself, as "image object." (Delaunay, 1923-24).

Kasimir Malevich / Analytical chart / c. 1925 / cut-and-pasted photomechanical reproductions, printed papers, pencil drawings on paper and transparent paper, gelatine-silver prints, wood, and ink on paper / 25 x 32.5" / The Museum of Modern Art, New York

KUBISMUS FUTURISMUS SUPREMATISMUS

the object: color. His first suprematist image thus consists of the non-colors black and white and his second important image consists of only white. Malevich equates non-objectivity with non-color (white): the "white world of suprematist non-objectivity." Thus, for Malevich, non-objectivity also secretly meant non-color. "Suprematism as a non-objective, white equivalent" landed in the "desert … in nothing, in non-objectivity."[31] On 17 December 1915, these works were presented for the first time in St. Petersberg in the "last futuristic exhibition 0.10." The exhibition's title was *Zero Ten*, because ten artists showed zero forms of pictures, hence the word "last" in the description: these were last pictures. *One could apparently go no further than to reduce painting to these basic forms and colors.*

31

The (geometric) forms and colors, reduced practically to non-entities, created nonentity pictures, zero pictures. That is also where the name "zero movement" came from about fifty years later. This object of the zero zone was still capable of intensification. In 1918, Malevich created his picture *White Square on White Background*. That same year Rodchenko painted *Black on Black*. Both were shown at the 1919 exhibition *10. Staatliche Kunstausstellung*. The difference between the color form and color surface had been wiped out or was hardly noticeable. One single color dominated the field. The color zone and the image zone, color field and image field became identical. A monochrome color field came into existence. White on white or black on black meant the final non-object and non-color as a common fate. Non-objectivity

_ The monochrome white or black pictures in the 1950s and 1960s from Fontana, Manzoni, and the zero movement (Reinhardt, Ryman, Rauschenberg, etc.), follow Malevich into his colorless, objectless world.
Malevich uses only three basic forms (square, circle, cross) and three basic colors (black, white, red) in his work.

Arnulf Rainer / Übermalung [Overpainting] / 1984-1988 / oil on wood / 30.1 x 21.3" / Collection Frieder Burda / © photo: Ralf Cohen, Karlsruhe

Wolf Vostell / Mozart Partitur [Mozart score] / 1982 / piano minuet, ink, paint / 29.5 x 7.5" / Collection Feelisch, Remscheid /
© VG Bild-Kunst, Bonn 2002 / © photo: Studio Müller & Schmitz, Remscheid, Collection Feelisch, archive

Arnulf Rainer / Übermaltes Schwiegermuttermonument [Overpainted monument to a mother-in-law] / 1960, 1970, 1971 / Neue Galerie am Landesmuseum Joanneum, Graz

Joseph Beuys / Cosmas und Damian [Cosmas and Damian] / 13.7 x 17.5" / photos on cardboard, silver-bronze, brown oil paint / Collection Speck, Cologne / © VG Bild-Kunst, Bonn 2002 / © photo: Lothar Schnepf, Cologne

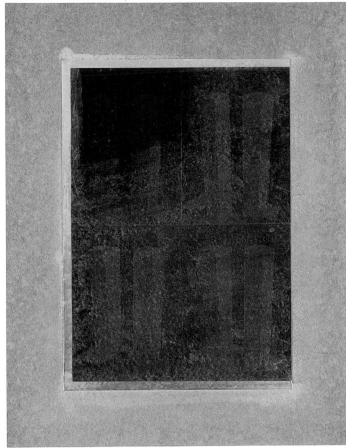

Timm Ulrichs / Selbstauslöschung durch Malerei [Self dissolution through painting] / 1973-1976 / heavy paint-overpainting of a
sheet of glass as a sequence in 10 photos laminated onto cardboard / each 11.8 x 9.4" / wooden frame painted grey / 28.8 x 52.8 x 1.9" /
with engraved aluminum title-sign / Staatsgalerie Stuttgart / © VG Bild-Kunst, Bonn 2002 / © photo: Foto-Hoerner, Hannover

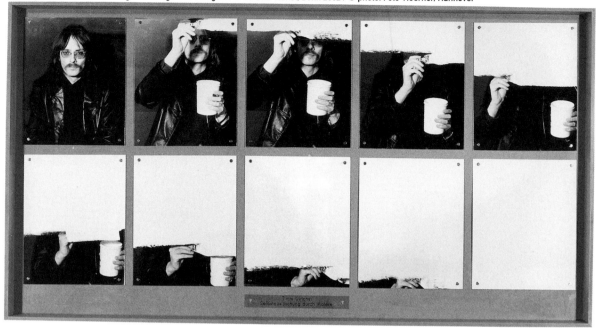

Reiner Ruthenbeck / Objekt zur teilweisen Verdeckung
einer Video-Szene [Object to partially cover a video scene] /
1972-1974 / installation / © VG Bild-Kunst, Bonn 2002

Reiner Ruthenbeck / Objekt zur teilweisen Verdeckung einer Video-Szene [Object to partially
cover a video scene] / 1972-1974 / stills from the video / © VG Bild-Kunst, Bonn 2002

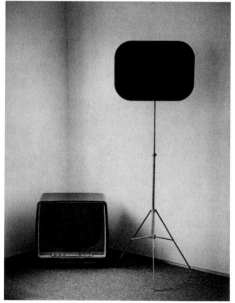

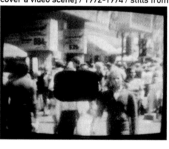
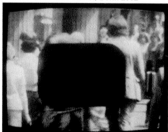

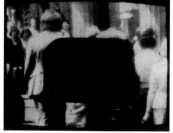

Lucio Fontana / Concetto spaziale, ATTESTE »Questa« mattina mi sono ... ed mal di denti« [spatial concept, sentence »this« morning I ... and had a toothache«] / c. 1967 / acrylic on canvas / 21.4 x 25.6" / Collection Frieder Burda / © photo: Ralf Cohen, Karlsruhe

Alberto Burri / Combustione [Combustion] / 1963 / plastic and combustion / 78.3 x 97.6" / collection Alberto Burri

Gustav Metzger / South Bank Demonstration, London 1961 / reconstruction Los Angeles 1998 / © photo: Francesco Conz

Alberto Burri in atelier / 1960 /

Jean Tinguely / Homage to New York /
invitation card / 1960 / Museum Jean Tinguely, Basel

Raymond Hains / Palissade de
trois planches [Fence with three
planks] / 1959 / Poster fragments
on original boards of a fence /
39.4 x 25.2 x 0.8" / Museum
moderner Kunst Wien, Vienna,
former Hahn Collection /
© VG Bild-Kunst, Bonn 2002

Giulio Paolini / Proteo I / 1971 /
fragments of a plaster bust /
3.9 x 7.9 x 3.9" /
Kunstsammlungen zu Weimar,
Neues Museum, Weimar

Gordon Matta-Clark / Conical Intersect / 1975 / cibachrome / 30 x 40" / David Zwirner, New York / © VG Bild-Kunst, Bonn 2002

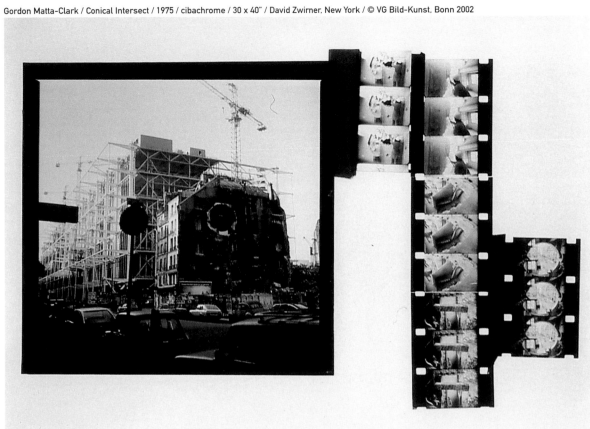

Gordon Matta-Clark / Conical Intersect / 1978 / three color prints / each 16 x 20" / detail (one print) / David Zwirner, New York / © VG Bild-Kunst, Bonn 2002

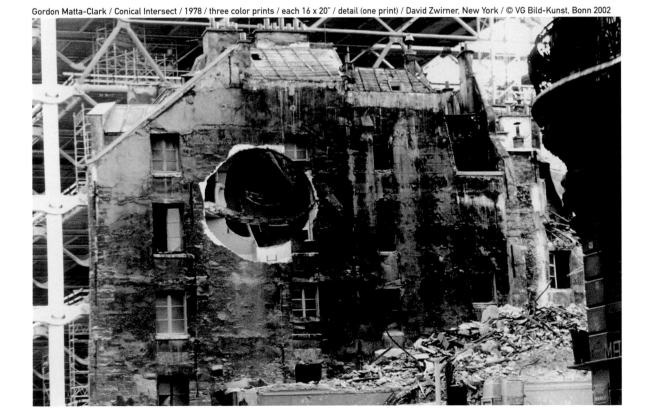

Cerith Wyn Evans / Allen Jones Pirelli Calender / 1973 (penetrated 1999) / 12 works in frames / 15.7 x 22. 8" / Galerie Daniel Buchholz, Cologne

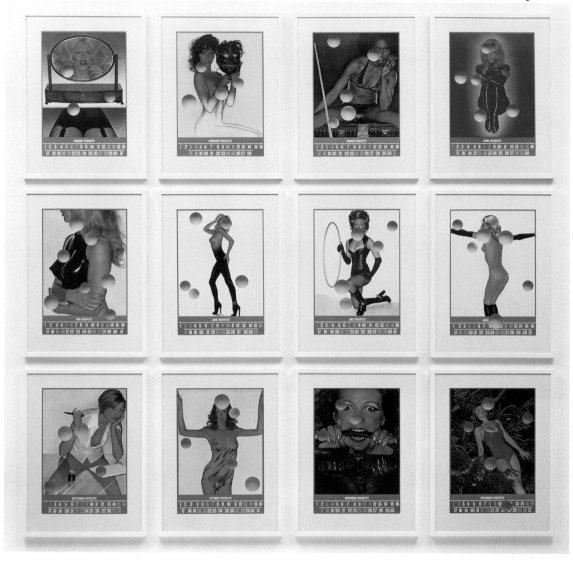

Ger van Elk / Pressure Sandwich Sculpture II / 1990 / Art & Project, Slootdorp

Martin Kippenberger / Untitled (Container) / 1991 / installation view San Francisco Museum of Art, S.F. /
from: Ulrike Lehmann and Peter Weibel (ed.), Ästhetik der Absenz, Klinkhardt & Biermann, Munich and Berlin, 1994

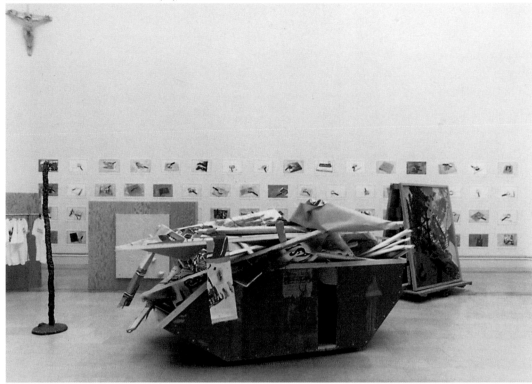

Martin Kippenberger / Zerschnittenes Acryl-Bild [Sliced acrylic picture] / 1991 / oil on canvas / part of a 188.1 x 118.1" picture, photography
that was slit apart at the Kölnischer Kunstverein / 20 x 15.4" / Collection Speck, Cologne / © photo: Lothar Schnepf, Cologne

Rudolf Herz / Dachau. Museumsbilder 1976-1996, Nr. 1-4 / © VG Bild-Kunst, Bonn 2002

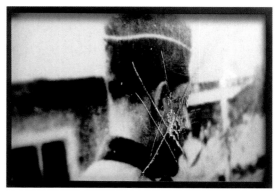

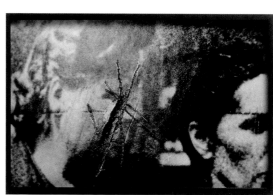

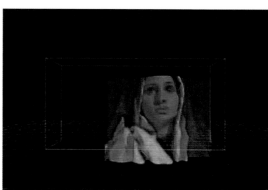

Richard Aczel, Robert Koch, Márton Fernezelyi, and Zoltán Szegedy-Maszák / ExAltarcation / 2002 / multi media installation / 394 x 394" / detail: stills

This interactive installation explores the moment of iconoclasm within the image itself. Instead of positing an observer who defaces the world of the observed, it figures the icon as an interface, a breach, a fold, between two interdependent worlds of seeing and being seen. The icon-as-interface is not an object, found or made, but an event that actively generates the worlds it connects. It is the breaking, the folding, that brings these worlds together and holds them apart. It is the axis of a conversation, turning to and through the other in a dialogue of interproductive gazes.

The installation space is conceived as an altar where the movements of the visitor alter (break and remake) the images encountered and even the installation space itself. Entering the installation, the visitor picks up a wireless tracking device that can function both as a creative tool and as a destructive weapon. (http://www.c3.hu/~szmz/exaltercation/docs/exaltarcation.html)

Axel Roch / »../voyure en survol« – Pour Petit a.
[»../voyeur and surveil« – for little a.] / 2002 /
interactive installation / linux based PC with
AMD - 2 GHz and GeForce3, eye/gaze-tracking system,
Infrared 50 Hz, polystyrol and reflective object,
mirror, data-projector XGA / 197x 138 x 236" /
sound: Olaf Geuer / 3d-rendering: Jordi Moragues /
© Axel Roch

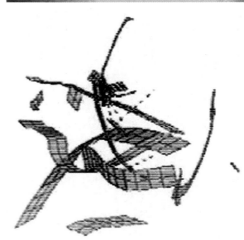

Joachim Sauter and Dirk Lüsebrink /
Zerseher [The De-Viewer] / installation,
DVD / Joachim Sauter, Dirk Lüsebrink

Lucio Fontana / Concetto spaziale | Attesa / 1960 / mixed media on canvas / 51.4 x 38.2" / Stedelijk Van Abbemuseum, Eindhoven

Günter Brus / Der helle Wahnsinn (Selbstverletzung) [Sheer madness (self-inflicted injury)] / Aachen, 1968 / from: Peter Weibel (ed.), Wien, Bildkompendium Wiener Aktionismus und Film, Kohlkunstverlag, Frankfurt/M., 1970, p. 62

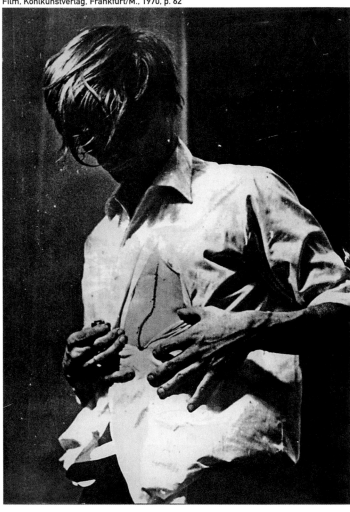

Günter Brus / Selbstbemalung [Self-painting] / 1964 / from: Peter Weibel (ed.), Wien, Bildkompendium Wiener Aktionismus und Film, Kohlkunstverlag, Frankfurt/M., 1970, p. 56

Günter Brus / Wiener Spaziergang [Vienna promenade] / police sentence: »in that they were painted over with white paint« / 1965 / from: Peter Weibel (ed.), Wien, Bildkompendium Wiener Aktionismus und Film, Kohlkunstverlag, Frankfurt/M., 1970, p. 58

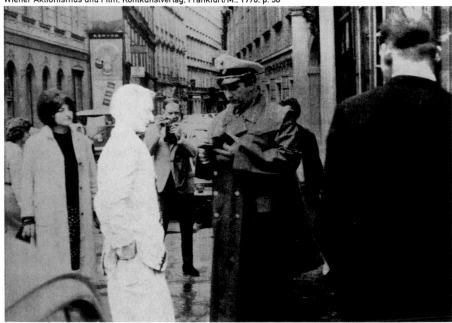

Günter Brus / Der helle Wahnsinn (Exkretion) [Sheer madness (Exkretion)] / Aachen, 1968 / from: Peter Weibel (ed.), Wien, Bildkompendium Wiener Aktionismus und Film, Kohlkunstverlag, Frankfurt/M., 1970, p. 62

Piero Manzoni / Merda d'artista 078 / 1961 / metal can / hight 1.89", diameter 2.55" / Archivio Opera Piero Manzoni, Milan / © VG Bild-Kunst, Bonn 2002 / © photo: Orazio Bacci, Milan

Günter Brus / Der helle Wahnsinn (urinieren) [Sheer madness (to urinate)] / Aachen, 1968 / from: Peter Weibel (ed.), Wien, Bildkompendium Wiener Aktionismus und Film, Kohlkunstverlag, Frankfurt/M., 1970, p. 63

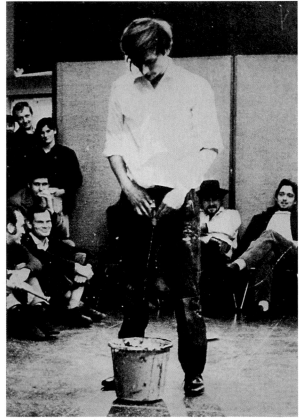

demonstrated the fate of the absolute color, which had originally expelled the object: the expulsion of color itself. This also induced the end of painting that had stood under the primacy of color.

With his book *Suprematism: 34 Drawings*, originally published in 1920, Malevich, gave painting the ultimate deathblow. To him, painting had reached its nadir and had set out on a "lonely path." The "suprematist machine," a new satellite, was to replace painting. Yet, the critical point was that Malevich not only expelled the object from painting, but in a radical consistency expelled the color as well: *White on White* (1918).

In response to the question of what a suprematist canvas was and what there was to see on it, Malevich answered:

> "A suprematist canvas is a representation of white – but not blue – space. The reason for this is clear: blue does not provide an actual representation of the infinite. Infinite suprematist white enables the shaft of vision to advance without meeting a boundary."

White, as the representation of infinity, dissolves the objective world, but also all of the local and absolute colors. The path is revealed from the white painting all the way to and over the white wall to the white cube of the gallery. The world of white extinguishes all colors and apparently also painting altogether. The non-objective world of white is the desert in which painting is dying. "There can be no question of a place for painting in Suprematism. Painting has long since been overcome, and the painter himself is no more than a prejudice of the past." (Malevich, 1920). Painting dies as a "prejudice of the past," under the dictates of color, first expelling the object and then the form and *finally itself*.

In 1920, Constantin Umanski published *New Art in Russia* 1914-19, in which he wrote that Suprematism is a "consistent spatial painting … [and is] searching for the zero degree in art." This dates the beginning, eighty years ago, of the rhetoric about the last painting, the zero degree in art, defined by a rejection of any traditional means of artistic expression.[32] Not only painting was annulled, but with it representation, and finally, art itself. At the end of the color painting, which Van Gogh had so enthusiastically desired could be heard the battle cry for "No more representation."

In 1921, in the exhibition *5 x 5 = 25*, Rodchenko showed for the first time images which Nicolaj Tarabukin called the "last pictures" of art history or "the painter's suicide" and the "end of painting." These Faktura images radically broke with the habits of traditional and modern color images. The term faktura (form, fabric or texture), describing a Russian concept of a culture of materials, was first introduced in 1914 by Vladimir Markov (nom de plume for V. Matyeff) in his book of the same title. With "Faktura" the author examines the substance of the surface as an essential part of its texture and material properties.[33] After his paintings of 1918, *(Black on Black)*, Rodchenko put an end to his period of Faktura images, which only consisted of color and surface, lacking any sort of geometry or form; the first monochrome paintings of art history in the primary colors red, yellow, and blue emerged. The end of color painting became reality. In 1939, Rodchenko wrote about these three paintings from 1921:

> "I have brought painting to its logical end and have shown three paintings: one red, one blue and one yellow. I have done this in the knowledge that: everything is over. These are the primary colors. Each surface is a mere surface and there shall be no more representation. Each surface is filled to the border with one singular color."[34]

The slogan "No more representation" (Rodchenko) or the rejection of the representative function killed the object and created pure color for the sake of pure color. In taking color

32 34 33

_ The best explanation of the term "Faktura" in English is from Margit Rowell in her excellent article Vladimir Tatlin: Form/Faktura, in *October*, no 7, winter 1978, pp. 83-108.

_ Alexandr Rodchenko, 1939, quoted in A. Moszynska, Purity and Belief. The Lure of Abstraction, in C. Joachimides and N. Rosenthal (ed.), *The Age of Modernism: Art in the 20th Century*, Gerd Hatje, Stuttgart, 1997, p. 204.

_ Umanski then quite rightly lists the relevant successors to Malevich as: Olga Rozanova (who died tragically much too early in 1918), Ivan Kliun, Nikolai Punin, Rodchenko, and others.

as the sole theme of the surface, not only the boundaries of the surface, but also of painting had been reached.[35]

This spell on representation, radically dictated by Rodchenko, is answered by Rodchenko in a materialist way, offering us the pure materiality of color, the "Faktura." Thereafter, he left painting completely and started to work exclusively with photography. But then he left art altogether and aimed to produce something that has a use value for the masses and the workers in the sense of Marx. In 1925, Rodchenko moved beyond two-dimensional work to design a three-dimensional structure, a model workers' club. As his partner Stepanova wrote:

> "The fundamental requirements to be met in each object for the workers' club:
> 1) Economy in the use of the floor-area of the club-room and of the space occupied by an object with maximum utility.
> 2) Simplicity of use and standardization of the object; it must be possible to increase the size or the number of its component parts."[36]

Rodchenko's interest in the material aspects of art had already led him as early as 1918 to produce special constructions. This material-based approach, focussing on the object and on technical experiments, led in 1921 to the formation of the First Working Group of Constructivists. With the constructivists began a new approach to end the crisis of representation and to find a useful solution for this crisis. Instead of representing things in a painting, the artists started to construct and produce the things. The production of useful things, whether furniture or photographs, replaced representation. The movement of the Productivists (Tatlin) followed the Constructivists. At a 1920 Dada exhibition in Berlin, John Heartfield and George Grosz unveiled a placard claiming: "Art is dead. Long live Tatlin's new machine art." Modern art is therefore not only iconoclastic, abolishing painting, image making, and representation, but going so far in its iconoclasm to construct and produce objects (furniture, clothing, kitchenware, and houses). So modern art finds in itself a solution to the crisis of representation. This solution is not iconophilic, but anti-iconoclastic, because it does not stay within the limits of iconoclasm. So modern art is iconoclastic and at the same time, as a consequence of this iconoclasm, it propagates a non-iconoclastic solution to the iconoclastic fallacy and trap. This construction of useful things follows the practice of Brancusi (who already in 1914/15 produced benches) and anticipated the sculptural furniture of Artschwager and his followers in the 1980s: sculpture as object, object as furniture.

The Theme of "the End" in the Nineteenth Century

Rodchenko's refutation of representation – without the aspect of its material solution – can be seen as the end of a non-representational strategy which began in the nineteenth century.

In the nineteenth century, the void, the zero, the blank, the white were part of the aesthetic program as the following famous verses of Mallarmé celebrate: "La chair est triste, hélas! et j'ai lu tous les livres. Fuir! la-bas fuir!" Art is similar to a ship at sea that needs to be dismantled constantly (risking submersion), to ensure progress along its prescribed route. A cult of the void extends around the blank page of the nineteenth century, through to the sparseness of twentieth century art galleries, a cult of ultimate purity and perfection. Since the nineteenth century, an aesthetic of absence and a poetry of the void has emerged, flourishing to this day, with the topicalization of the blank page.[37] "The empty page defending its whiteness" (Mallarmé) stood at the beginning of the white painted canvas and the white cubic space of today's art gallery, "the white cube" as coined by Brian O'Doherty. Spleen, repulsion, silence, emptiness, the desert, holes,[38] empty souls accompany as "cri sincère et bizarre de la fin"[39] the poems of the French Symbolists (Baudelaire, Mallarmé,

35 36 37 38 39

36 _ Quoted in Peter Noever (ed.), Aleksandr M. Rodchenko and Varvara F. Stepanova, *RI4 Zukunft ist unser einziges Ziel...*, Prestel, Munich, 1991, p. 181.

35 _ "Oh sterile desert of pain. My empty soul. Whither to flee? [...] The deep blue holes [...] here, the skies are dead." Stéphane Mallarmé, L'Azur, 1866, in Henry Mondor, *Vie de Mallarmé*, Gallimard, Paris, 1941, p. 105.

37 _ Tarabukin wrote: "The last picture executed by a painter demonstrates eloquently that painting as an art of representation – which it has been always until now – has arrived at the end of the road." (Nicolaj Tarabukin, *From the Easel to the Machine*, Moscow, 1923, p. 64).

38 _ For example, Peter Brook lectured on theater as "The Empty Space." Robert Hughes reviews James Turrell's light projections as "Poetry out of Emptiness", in *Time Magazine*, Los Angeles, 5 January 1981, vol. 117, no 1, p. 81, also referring to Mark Rothko and Barnett Newman whose paintings had been censured as being "empty." / cf. Meir Ronnen reviewing James Turrell in *Jerusalem Post Magazine*, New York, 8 October 1982, p. 14: "Something out of Nothing." / Markus Brüderlin calls Gerwald Rockenschaub's art "The Nucleus of the Void." In *Gerwald Rockenschaub*, Verlag Munro-Unverzagt, Hamburg, September 1990. / Ernst Hermann's sculptures are reviewed in *Kunstforum*, vol. 105, January/February 1990, p. 222, as "The wide expanse of emptiness." / Brian O'Doherty's comprehensive elucidation "Inside the White Cube: Notes to the Gallery Space, Part Three: Context as Context" in *Art Forum*, New York, November 1976, has become paradigmatically significant. / In the magazine *Der Spiegel*, Hamburg, June 1991, p. 220, Jean Baudrillard sees himself as "the janitor of theoretical emptiness."

39 _ Mallarmé in a letter on "L'Azur," in Mondor, op. cit., p. 105.

Rimbaud, Verlaine). The idea of the ultimate end has always born close relation to concepts of emptiness and purity.

Balzac's novel *The Unknown Masterpiece* describes the fate of purity and perfection as early as the mid-nineteenth century as ending in emptiness and void.[40] The painter Frenhofer confronts two of his pupils with a portrait *Catherine Lescault* on which he has been working for years.

"Aha," he exclaimed, "you didn't expect such perfection! You are facing a woman in the flesh, yet seeking a picture. Such is the depth on this canvas, so real its air that you cannot tell its difference from the air we breathe. Where is artifice, Art? 'Tis lost, gone!'" "Can you see something?" Poussin turns questioningly to Porbus. "No. And you?" "Nothing, either."

Already in the nineteenth century, the vanishing of art was well articulated.

Painting and the Semiotic Rupture

In what initially came as a shock, the crisis of representation and the declared end of painting as a consequence of the prior emancipation of its specific elements (such as color, plane, and form), culminated in a tremendous liberation for the arts in the twentieth century. It had obviously been necessary for twentieth century art to rid itself of all the ballast of previous artistic conventions through a break with easel painting. Thus object art, media art, installation art, concept art, Happening, body art, action art, and performance art in all their infinite variety came into being. The "end of art" as already pronounced by Hegel, was instigated when a particular world order disintegrated, the order of things being replaced by the order of the sign through the Industrial Revolution. That semiological rupture[41] could be said to consist of an existential denial we might describe as the crisis of representation.

Under the pressures of the technological revolution we have been compelled to review our conceptions of the human mental and physical facilities and their corresponding dimensions in the imaginary, the symbolic, and the real. Particularly the transformation of the body and its exteriorization into technological media, and the transformation of matter into waves of energy and immaterial signals have transformed art. The options at our disposal are, on the one hand, the resistance to dematerialization and an insistence on the corporeal, or, on the other, the unraveling of linguistic construction and symbolic order in a concern with phenomena of immaterialization. All these options have been resoundingly celebrated in and orchestrated by painting.

But painting is only one type of image, one type of mediation, one type of representation. There are many others that have been subjected to the iconoclast's powerful hammer. Encountering the cult of emptiness as early as the nineteenth century, it becomes obvious that the Industrial Revolution through its "telemachines" (telegraph, telephone, television, and radar) had indeed beamed actual holes through space. Not only is the film strip perforated, but the whole of society. The assembly line of time produced a new synchronicity and a new simultaneity.

It is precisely the foundations of modern art and literature in their reasoned autonomy that made a point of their conditions of method, material, origin, and tradition: making art an object of art, which in itself threatens the very existence and autonomy of modern art. Michel Foucault writes: "Flaubert is to the library, what Manet is to the museum. They both produced works in a self-conscious relation to earlier paintings or texts – or rather to the aspect in painting that remains indefinitely open. They erect their art within the archive."[42] Already at the very onset of modernism, triggered by the Industrial Revolution, the seed of its demise is sown. The examples of Mallarmé, Flaubert, Manet, and

41 40 42

_ Michel Foucault, *Language, Counter-Memory, Practice*, Cornell University Press, Ithaca, 1977, p. 92.

_ Michael Wetzel, Verweisungen. Der semiologische Bruch im 19. Jahrhundert, in Friedrich A. Kittler (ed.), *Arsenale der Seele, Literatur- und Medienanalyse seit 1870*, Fink Verlag, Munich, 1989, pp. 71-95.

_ Inspired by E.T.A. Hoffmann's *Der Baron von B.* (1819), in E.T.A. Hoffmann, *Die Serapions-Brüder. Gesammelte Erzählungen und Märchen*, vol. 3, Insel Verlag, Frankfurt/M., 1983.

Arman / Poubelle / 1964 / plexiglas on
wood panel / Collection Feelisch, Remscheid /
© VG Bild-Kunst, Bonn 2002

Robert Rauschenberg / Dairy Cage Open / 1971 / Collection
Falckenberg, Hamburg / © VG Bild-Kunst, Bonn 2002

Daniel Spoerri / Palette pour Grégoire Müller [Pallet for Grégoire Müller] / 1992 /
assemblage with color tube, empty turpentine bottles, cleaning rags, etc. on wood / 36.2 x 84.3 x 7.9" /
ZKM | Center for Art and Media, Karlsruhe / © VG Bild-Kunst, Bonn 2002

Huang Yong Ping / Devons-nous encore construire une grande cathédrale? [Do we have to built another cathedral?] / 1991 / table, stools, photograph, black-and-white, torn up paper / dimensions variable / Fondation Cartier pour l'art contemporain, Paris

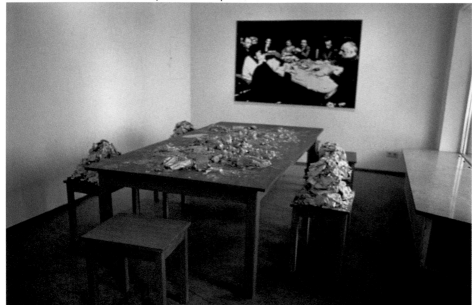

Dieter Roth / Untitled (doll in chocolate) / doll, milk chocolate / 4.7 x 11.8" / Collection Ploil, Vienna / © photo: Christof Hierholzer, Karlsruhe

Dieter Roth / Gewürzkiste [Spice box] / 1971 / wood, glass, five spices in separate compartments / 61.8 x 30.7 x 2.8" / Neue Galerie am Landesmuseum Joanneum, Graz, Collection Ploil, Vienna / © photo: Koinegg, Neue Galerie am Landesmuseum Joanneum, Graz

Dieter Roth / Literaturwurst / 1967 / torn novel »Die Rote« of Alfred Andersch, spices, gelatine, artificial intestine / 24.8 x 2.4" / weight 410 g / Collection Cremer in the Hamburger Kunsthalle

Günther Uecker / Die schöne Helena [The beautiful Helena] /
1982-1983 / broom, cleaning rag, nails from the Roman Age /
21.7 x 57.5 x 5.1" / Collection Feelisch, Remscheid /
© photo: Studio Müller & Schmitz, Remscheid, Collection
Feelisch, archive

Joseph Beuys / Silberbesen und Besen ohne Haare [Silver broom and a
broom without bristles] / 1972 / wooden broom with silver sheath and
copper broom, felt lining / 20.1 x 54.7" / 20.1 x 51.2" / Collection Froehlich,
Stuttgart / © VG Bild-Kunst, Bonn 2002 / © photo: Uwe H. Seyl, Stuttgart

Georg Herold / Handke and Fusske / 1982 /
books, two brooms, flowerpot / 46 x 31.5 x 16" / part of the
installation »Deutschland komplett«, 1998 / Collection
Falckenberg, Hamburg / © VG Bild-Kunst, Bonn 2002

Martin Kippenberger / Was ist der Unterschied zwischen Casanova und
Jesus: Der Gesichtsausdruck beim Nageln [What is the difference between
Casanova and Jesus: The facial expression while being nailed] / 1990 /
wood / 49 x 39 x 9.5" / Collection Falckenberg, Hamburg

Robert Filiou / Tool cross / 1969 / tools / 19.7 x 43.3 x 4.7" / Collection Feelisch, Remscheid /
© photo: Studio Müller & Schmitz, Remscheid, Collection Feelisch, archive

Malevich perform within this self-inflected curve of art, in this self-reflective discourse of art.

The crisis of representation, which produced abstract painting in the first half of the twentieth century, has produced the crisis of abstract painting in the second half of the twentieth century. In *The Crisis of the Easel Picture* (1948) Clement Greenberg wrote:

> "... here in America it is practised by artists so various in their provenance and capacities as Mark Tobey, Jackson Pollock, the late Arnold Friedman, Rudolf Ray, Ralph Rosenberg, Janet Sobel. [...] What, at least, it does mean for the discipline of painting is that the future of the easel picture as the vehicle of ambitious art has become very problematical; for in using the easel picture as they do – and cannot help doing – these artists are destroying it."[43]

The crisis of representation that produced the most significant signature of modern art, the abstract painting, in the end produced the crisis of the easel picture itself, which could be interpreted as an iconoclastic gesture. But inside the evolution of modern art, there have always been suspensions of these gestures, for example, Surrealism, which not only believed in the power of images to represent, its members even believed in the possibility to represent the unconscious by images. And yet another answer to the iconoclasm of modern art were the constructivists who wanted to produce useful things for the masses, or the Bauhaus for its tendency towards industrial design.

Mikhail R. Bakhtin's theory of an endless contextuality, freeing literary works from their formal limitations, opens the possibility of a new practice opposed to this closed self-reflective discourse of art.[44] According to Bakhtin, the origin of a text is only one link in a chain of possible transmissions of antecedent texts. Beheading the classic autonomy of text and author delivers the text into an endless space for interpretation. The guillotine of modernity in its introspection as a self demeaning process is lifted, and can actually be transformed into a flying-machine to escape from the labyrinth of self-reference. Bakhtin emphasizes interpretation as the origin of the text, which is equal to the creation of a text. Therefore, the reader is equal to the author, as later will be the case with the observer creating the artwork by interaction. The closed object and the closed text start to become an open practice. Applying Bakhtin's theory to painting would actually ensure the continuity of the last painting. The monochrome painter Marcia Hafif has expressed this quite vividly in her text *Beginning Again:*

> "The notion that this was the last painting was not difficult to hold. And this greater consciousness could allow parody and the easy summation of painting, including the idea that it was actually possible for its relevance to have expired. Art could merge with other disciplines – science or religion – and cease existing as an independent activity. The idea of the end of painting had been around for a long time, long before Ad Reinhardt talked about the one size, the one color ... What is there when we have taken everything away? What happens when there is very little to see? Painting has long flirted with emptiness. Think of Malevich, Humphrey, Reinhardt, Marden, Ryman. It is not a difficult task to distinguish between these 'empty' paintings. The removal of known subject matter opened the way for other content to enter in."[45]

Painting was thinned out, leaving mere traces of pictorial activity in painterly synonyms of gleaming, empty, pure, and abstract canvases as ideals of the twentieth century. Naturally the reverse was now also possible – dirty canvases, crammed with paint and real material elements, traps for a vast variety of objects of everyday life, from Pop to New Realism. Once more the almost empty monochrome canvas actually provided

44 43

45

_ See Michael M. Bakhtin, *Art and Answerability. Essays by M.R. Bakhtin,* University of Texas Press, Austin, 1990.

_ The Crisis of the Easel Picture, in *Partisan Review,* April 1948 and also Clement Greenberg, *Art & Culture: Critical essays,* Beacon Press, Boston, 1961, pp. 223-225.

_ Marcia Hafif, Beginning Again, in *Artforum,* New York, September 1978, reprint in Richard Hertz (ed.), *Theories of Contemporary Art,* Prentice Hall, New Jersey, 1985, pp. 10-15.

room to be occupied by things concrete. Material pictures and material painting were to dominate the second half of the century as much as color and form had dominated the first. The other dominant artistic tendency, arising from transcendentalism, would be their immaterialization and dematerialization. Besides these transformations of the painterly image, modern art developed other forms of art beyond painting as an answer to the crisis of representation that photography caused for painting. These new forms of art, from object art to media art, from body art to installation art, still carry forth iconoclastic impulses, but at the same time impulses to transcend iconoclasm. Painting lost its pivotal role in the field of art in the course of its transformations. At the same time, these transformations have initiated art's most radical evolutions into new domains and practices.

Under historical criteria we have so far witnessed a progressive rejection of the representative function of art, creating a rhetoric and aesthetic of absence, from the blank page via the bare plane to the empty canvas, hence from an empty frame to an empty room, seemingly edging painting closer to dematerialization. Self-doubt to the point of dematerialization is the logical force inherent in art, and advancing its development. Painting constitutes a turning of the page, every last picture representing one turn, amounting to the sort of catastrophe that is necessary to keep alive a dynamic system. Every painting could be a last picture, but every painting builds on its last predecessor-picture. I can add another last picture to every last painting, just as I could add the number "1" to any number. As any picture could be defined in terms of the sum of its predecessors, we arrive at an infinite succession of pictures that cannot be closed. Just as there is no last number, there is no last painting. The vanishing of art (in its historical appearance) belongs to the internal logic of art itself. Self-dematerialization then, is nothing more than a rejection of a historical self, of what had traditionally been seen as relevant and constitutive for art. This self-criticality as axiom

of modern art logically creates anti-art as a wiedergänger movement questioning art itself. Thus, only historical means and methods are being dispensed with in exchange for new, stronger ones. This exhibition shows some escape routes and cornerstones not only for painting after the last picture, featuring possible paintings *after* the last painting, but above all art after the end of art; art produced by iconoclastic gestures aimed to end art. This art after the end of art opened the way to new practices of art. Modern art is constantly questioning its own raison d'être. This self-criticality can be interpreted as iconoclastic, but, actually, it is the motor of its evolution and transformation. Therefore, the iconoclastic hammer does not destroy art, instead, paradoxically, it creates new art.

Open Practices as Art

Twentieth century art appears under the control of the authoritative paradigm of photography. Artistic practices derived from the primacy of photographic methods have not only led to fundamental changes in painting and sculpture but also to very new art forms such as film (see Groys) and have, above all, fundamentally changed our conceptions and practices of art (see Belting, Himmelsbach). The performative conditions of art "in the age of its mechanical reproduction" (Walter Benjamin) do not apply to photography alone, but have also forced the already existing historical art forms, sculpture and painting, to make new decisions that have decisively transformed them. Thus the impact of the radical change following Duchamp's ready-mades in 1913 cannot be explained merely in a nominal sense as a discursive operation on the meaning and institution of art. Nor can this impact be explained as a simple proposition declaring, "This is art," the standpoint expressed in the books of Thierry de Duve.[46] Rather, the truth of the Duchampian gesture is legitimated through references to new modes of production that had already existed for 100 years during industrialization and new

46

_ Thierry de Duve, *Nominalisme pictural*, Paris, 1984; Thierry de Duve, *Kant after Duchamp*, MIT Press Cambridge, MA, 1996.

Jasper Johns / Field Painting / 1963-1964 / oil on canvas with two objects /
72 x 36.6" / Jasper Johns / © VG Bild-Kunst, Bonn 2002

René Magritte / L' usage de la parole / 1927 / ink / 17.7 x 11.8" /
private collection, courtesy Galerie Christine et Isy Brachot, Brussels

René Magritte / La Trahison des Images / 1948 / oil on canvas /
5.3 x 6.5" / private collection, Geneva

Marcel Broodthaers / La Salle Blanche [The white room] / bois, photographies, ampoule, inscriptions peintes, corde /
157 x 132 x 259" / Musée nationale d'art moderne, Centre Georges Pompidou, Paris

Joseph Kosuth / Sigmund Freud Wohnung [Sigmund Freud apartment] , Vienna / 1989 / Galerie Pakesch, Vienna / Tapete: Edition Artelier, Graz / from: Das Bild nach dem Bild, exhib. cat. Galerie Metropol, Vienna, 1991, p. 188

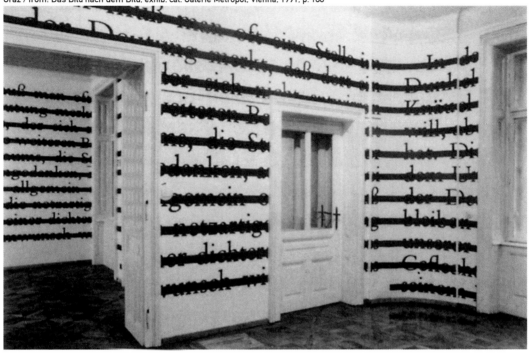

Arabian politicans / from the artist book: 1/2 Dozen Incomplete Visual Informations / 1974 / from: Endre Tót, Who's Afraid of Nothing, exhib. cat Museum Ludwig, Cologne, 1999, p. 82

Mel Ramsden / Secret Painting / 1967-1968 / liquitex on canvas, text board / 48 x 48", 35.8 x 35.8" / courtesy Galerie Bruno Bischofsberger, Zurich / © photo: Galerie Bruno Bischofsberger, archive

Art & Language / 100% Abstract / 1967-1968 / acrylic on canvas / 24.2 x 27" / Collection Art & Language / © Art & Language / © photo: courtesy Lisson Gallery, London

Art & Language / Guaranteed Painting / 1967-1968 / liquitex on canvas and photostat / two parts, each 12 x 17.7", framed 16.7 x 22.4" / Collection Art & Language / © Art & Language / © photo: John Riddy, courtesy Lisson Gallery, London

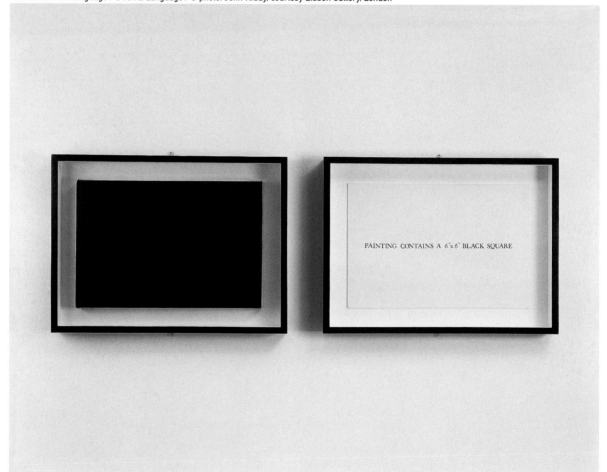

Art & Language / Painting - Sculpture / 1967 / acrylic on hardboard / two parts /
each 24 x 15.5" / Collection Art & Language / © Art & Language / © photo: John Riddy, courtesy Lisson Gallery, London

Art & Language / Abstract Art No 7 / 1967-1968 / silkscreen on canvas / 24 x 15" /
Gallery Mulier Mulier Knokke-Heist, Belgium / © Gallery Mulier Mulier, Knokke-Heist, Belgium / © photo: Felix Tirry

LETWIN, S. R. *The Pursuit of Certainty*. Cambridge: The University Press, 1965. viii, 391 pp. $9.50—An enjoyable and well-written discussion of the change in the conception of politics from David Hume through Jeremy Bentham, and John Stuart Mill to Beatrice Webb. The longest, most interesting, and most useful section is on Hume, who expresses the dominant view of the eighteenth century that "man is a balanced whole whose object is to live decently and enjoyably." The discussion of Hume is the background for a less favorable consideration of Bentham, Mill, and Webb and although the latter half of the book fails to match the first half in depth and interest, it remains a work which can be recommended and read with joy. — K. A. M.

Walter de Maria / Word / 1963 / pencil on cardboard / 39.6 x 39.6" / Collection Speck, Cologne / © photo: Lothar Schnepf, Cologne

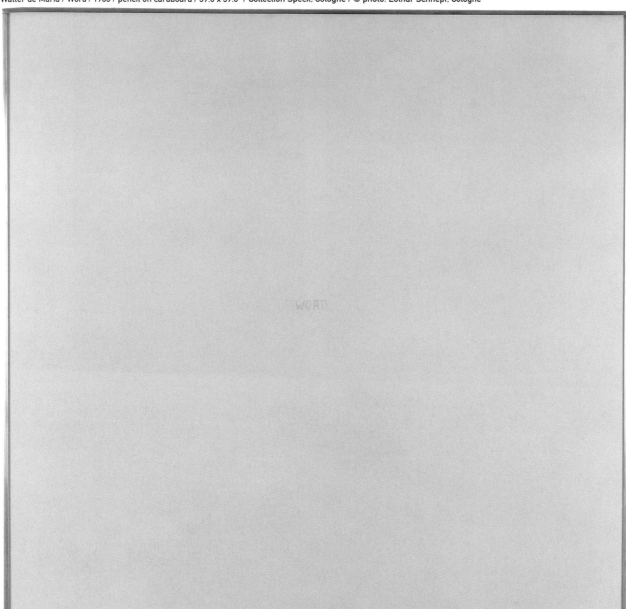

John Baldessari / Everything is purged /
1966-1968 / from: Bildlicht. Malerei
zwischen Material und Immaterialität,
exhib. cat. Wiener Festwochen 1991,
Europaverlag, Vienna, 1991

Walter de Maria / New York Eats Shit / 1970 / pencil on drawing board / 59 x 39.4" /
Collection Speck, Cologne / © photo: Lothar Schnepf, Cologne

Walter de Maria / Rome Eats Shit / 1970 / pencil on drawing board / 59 x 39.4" /
Collection Speck, Cologne / © photo: Lothar Schnepf, Cologne

Roman Opalka / 1 - ∞ (detail) / 1965 / oil on canvas / 77.2 x 52.8" / FER Collection / © VG Bild-Kunst, Bonn 2002 / © photo: FER Collection, archive

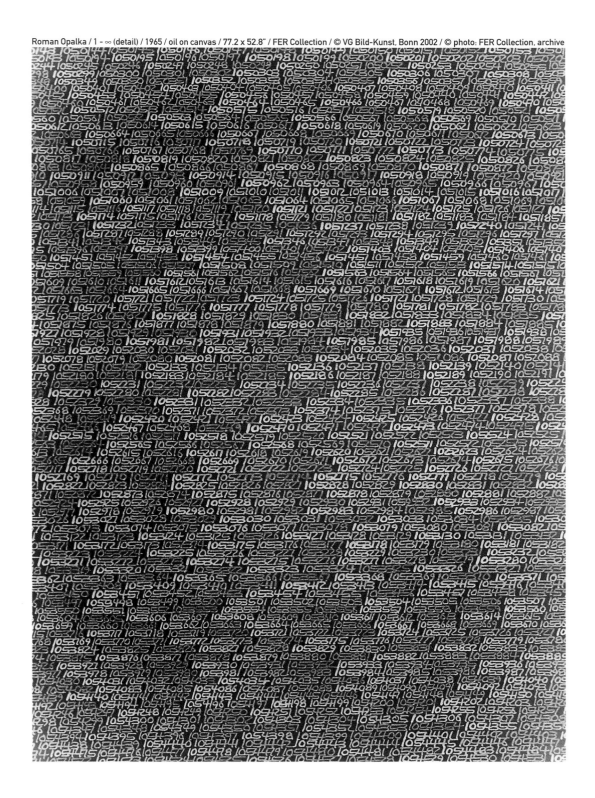

Marcel Broodthaers /
M.B. (La signature série 1)
[The signature series 1] / 1969 /
black and red silkscreen on white
tracing paper / 29.5 x 21.7" /
Collection Feelisch, Remscheid /
© VG Bild-Kunst, Bonn 2002 /
© photo: Studio Müller & Schmitz,
Remscheid, Collection Feelisch, archive

Fiona Banner / Arsewoman in Wonderland /
2001 / silkscreen on aluminum / 112.2 x 112.2" /
Jack Helgesen, Oslo / © photo: David Brandt,
courtesy Galerie Barbara Thumm, Berlin

Robert Watts / Events / 1964–1965 / transparent box / 7.2 x 5.1 x 1.2" / Collection Feelisch, Remscheid / © photo: Studio Müller & Schmitz, Remscheid, Collection Feelisch, archive

Georg Brecht / Water Yam / 1963–1965 / plexiglas tin with sticker / approx. 19.7 x 7.9 x 11.8" / Collection Feelisch, Remscheid / © photo: Studio Müller & Schmitz, Remscheid, Collection Feelisch, archive

Jenny Holzer / More Survival / 1985 / electronic led sign with red diodes / 5.5 x 60.6 x 4" / Ute and Rudolf Scharpff, Stuttgart / © Collection Rudolf and Ute Scharpff, Stuttgart / © VG Bild-Kunst, Bonn 2002 / © photo: Bernhard Schaub, Cologne

Peter Zimmermann / Isaak Babel. So wurde es in Odessa gemacht [Isaak Babel. That is how it is done in Odessa] / acrylic on canvas / 23.6 x 15.8" / Neue Galerie am Landesmuseum Joanneum, Graz, Collection Weibel / © VG Bild-Kunst, Bonn 2002 / © photo: Koinegg, Neue Galerie am Landesmuseum Joanneum, Graz

Simon Linke / Gene Davis | Jenny Holzer (Artforum) / 1986-1987 / oil on canvas / 72.1 x 72.1" / Neue Galerie am Landesmuseum Joanneum, Graz / © photo: Lackner, Bild- und Tonarchiv, Graz

Joseph Beuys / Der Fehler beginnt schon dann, wenn jemand Leinwand und Farbe kauft [The mistake already begins when you buy canvas and paint] / 1985 / poster / offset / 33 x 23.4" / Edition Staeck, Heidelberg / © VG Bild-Kunst, Bonn 2002

Jörg Immendorff / Hört auf zu malen [Stop painting] / 1966 / synthetic resin on canvas / 53.1 x 53.1" / Stedelijk Van Abbemuseum, Eindhoven

Klaus Staeck / ... es darf ruhig etwas mehr kosten [... it can easily cost a bit more] / 1988 / postcard / 5.8 x 4.1" / © VG Bild-Kunst, Bonn 2002 / © Edition Staeck, Heidelberg

Sigmar Polke / Die drei Lügen der Malerei [The Three lies of Painting] / 1994 / synthetic resin on polyester fabric, partly printed / 118.1 x 90.6" / Gallery Michael Werner, Cologne and New York / © photo: Lothar Schnepf, Cologne

Joseph Beuys / Hiermit trete ich aus der Kunst aus [I hereby resign from art] / 1985 / postcard /
5.8 x 4.1" / © VG Bild-Kunst, Bonn 2002 / © Edition Staeck, Heidelberg

Timm Ulrichs / »Ich kann keine Kunst mehr sehen!«, 11.3.1975 [I can't stand
seeing art any more, 11 March 1975] / 1975 / poster and postcard edition /
Timm Ulrichs / © VG Bild-Kunst, Bonn 2002 / © photo: Ellen Poerschke, Berlin
Demonstration as »sandwich man« with a blind man's cane and arm band /
Internationaler Kunstmarkt Köln 1975, fair grounds, Cologne-Deutz

Klaus Staeck / Vorsicht Kunst [Beware of Art] / 1982 / chop /
© photo: Christof Hierholzer, Karlsruhe / © VG Bild-Kunst, Bonn 2002

Ben Vautier / No more art / 1985 / postcard / 5.8 x 4.1" /
© VG Bild-Kunst, Bonn 2002 / © Edition Staeck, Heidelberg

Marcel Duchamp / To be Looked at (from the Other Side of the Glass) With One Eye, Close to, for Almost an Hour / 1918 / "391", Paris, no. 13, July 1920, p. 2

Joseph Beuys / »Das Schweigen von Duchamp wird überbewertet« / 1964 / paper, brown oil paint, ink, chocolate, felt, photograph / pasted / 61.2 x 70.1 x 0.8" / Stiftung Schloß Moyland, Collection van der Grinten

Joseph Beuys / Das Schweigen [The Silence] / 1973 / five film spools of Ingmar Bergman's movie »Das Schweigen«, galvanized / 9.8 x 15" / Collection Froehlich, Stuttgart / © VG Bild-Kunst, Bonn 2002 / © photo: Uwe H. Seyl, Stuttgart

Joseph Beuys / Sich selbst [Itself] / 1977 / postcard / 5.8 x 4.1" / © VG Bild-Kunst, Bonn 2002 / © Edition Staeck, Heidelberg

Georg Brecht / No smoking / 1961 / steel plate with letters /
31.5 x 13.8" / Collection Feelisch, Remscheid /
© photo: Studio Müller & Schmitz, Remscheid,
Collection Feelisch, archive

Georg Brecht / No Smoking Event / event card
from Water Yam / Collection Feelisch, Remscheid

NO SMOKING EVENT

Arrange to observe a NO SMOKING sign.

● smoking

● no smoking

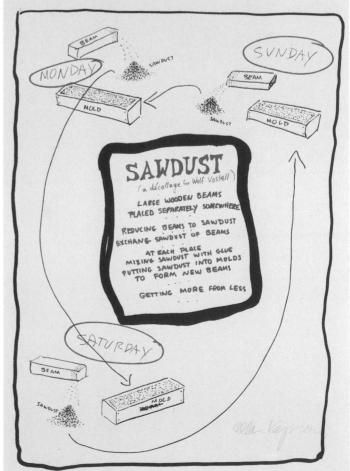

Allan Kaprow / Sawdust / 1970 / offset on paper /
16.9 x 24" / Collection Feelisch, Remscheid /
© photo: Studio Müller & Schmitz, Remscheid,
Collection Feelisch, archive

Franz Erhard Walther / Objekt für Wechsel (1. Werksatz) [Object for change (1. set of tools)] / 1967 /
typewriter paper, photograph, black-and-white / 23.6 x 15.8" / Collection Feelisch, Remscheid /
© VG Bild-Kunst, Bonn 2002 / © photo: Studio Müller & Schmitz, Remscheid, Collection Feelisch, archive

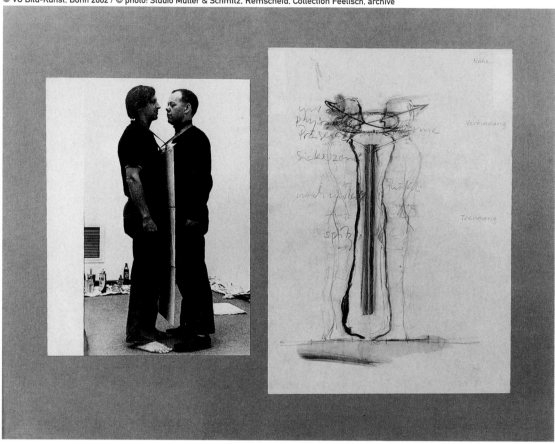

Giovanni Anselmo / Invisible /
1971 / installation / slide-projection,
showing the word "invisible" /
FER Collection / © VG Bild-Kunst,
Bonn 2002 / © photo: FER Collection,
archive

Valie Export and Peter Weibel / tapp and tastfilm / Munich, 14. November 1968 / images from the premiere /
from: Peter Weibel (ed.), Wien, Bildkompendium Wiener Aktionismus und Film, Kohlkunstverlag, Frankfurt/M., 1970, p. 196

Valie Export and Peter Weibel /
Aus der Mappe der
Hundigkeit [From the Portfolio
of Doggedness] / 1969 /
photograph, black-and-white /
19.7 x 15.9" / Generali
Foundation, Vienna /
© VG Bild-Kunst, Bonn 2002
(Valie Export)

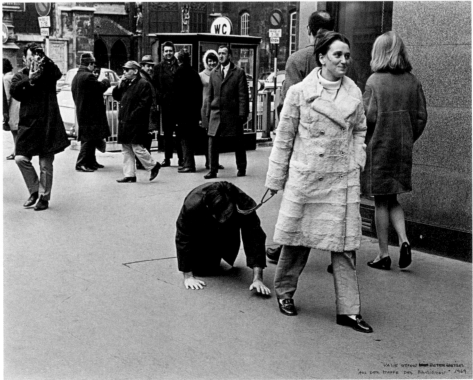

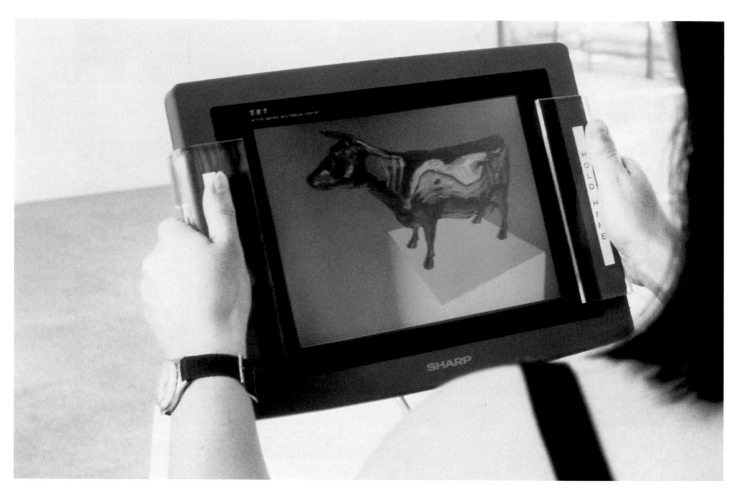

Jeffrey Shaw / The Golden Calf / 1995 /
installation / pedestal and portable LCD monitor /
19.7 x 39.4 x 19.7" / Jeffrey Shaw /
© photo: Jeffrey Shaw

image-manufacturing processes and reproduction techniques such as photography. Photographs, through the invention of the negative, could now be industrially produced as serial products that no longer required the signature of the artist nor even the handiwork or hand of the artist since the device was capable of producing the image on its own, as the title of the famous lecture by William Henry Fox Talbot in London on 31 January 1839 underscored: "An account of the art of photogenic drawing or the process by which natural objects may be made to delineate themselves without the aid of the artist's pencil."

From this point on, it was clear that, through the logic of art, artists were forced to carry this process over into *other forms of image production and of art production in general*. Not only pictures, but also sculptures could be produced without the artist's hand or tool, as Duchamp's ready-mades proved. In 1977, Jean Clair[47] and Rosalind Krauss[48] noted from different perspectives that parallels could be drawn between the production process of the ready-made and photography. The print, the proof, and other image production procedures, which had been devalued, gained a new, primary position with photography. This was first pointed out by Rosalind Krauss and later by George Didi-Huberman in a comprehensive publication and exhibition in Paris in 1997. [49] The print as process has obviously made an essential contribution to modernity in sculpture and, in this light, it is obvious that Duchamp's entire sculptural work shows evidence of indexical processes, prints and traces from the famous *Dust Breeding* (1920), which Man Ray photographed on *The Large Glass*, to the work *Female Fig Leaf* (1950) and the foam rubber breast on black velvet (1947) with the title *Please Touch*. Thus Duchamp radically enlarged the register of sculpture by introducing *the object in place of the sculpture*. The painters themselves reacted to the end of painting. Painters, not sculptors, introduced the object into art history in an attempt to solve the crisis of representation that has produced the end of painting. Also in the realm of sculpture they produced the end of representation through a paradigmatic shift from the classical anthropological sculpture representing the human body, to the object that does not represent anything, but, merely exists. The ready-made and the object as sculpture are in the same horizon as Rodchenko's battle cry "no more representation." Common objects and industrially produced use objects were seen as sculptures, ready-mades that allowed the industrial fabrication of serial objects without the hand of the artist. Duchamp has drawn the artistic consequence of the photographic paradigm without becoming a photographer.

Surrealism was of special importance for the dialectical development of the object (see Sloterdijk); similar to the collage, the surrealists combined real and painted objects. They used manufactured commercial objects but also mathematical and other scientific models and even objects of nature, so-called "found objects," "objets trouvés." These objects were either transformed by the artist or combined with other objects; finally, there were also objects with symbolic functions that were fabricated by the artist. The development of the object thus occurred along two axes: usefulness and uselessness. The sphere of objects can thus be divided into functional and non-functional realms. As the term "use object" already suggests, objects are normally useful. Likewise, art objects are not useable in an everyday sense. Thus Duchamp provocatively suggests using a Rembrandt as an ironing board (see Gamboni). A sculptural strategy for the future consisted in making art objects useable, in direct opposition to their historical function. The Surrealists exerted their strategy by making common objects useless and unusable, for example fixing nails into an iron, such as Man Ray's renowned *Cadeau* (1921) or Meret Oppenheim's *Fur Cup* (1936).

The development of the object as sculpture thus followed that paradoxical dialectic of making hitherto unusable art works useful and useful objects unusable. Brancusi,

47 48 49

_ Georges Didi-Huberman, *L'empreinte*, Centre Georges Pompidou, Paris, 1997.

_ Rosalind Krauss, Notes on the Index: Seventies Art in America. (Part 1), *October*, 3, Spring 1977, pp. 68-81 and Krauss, *The Originality of the Avant-Garde and Other Modernist Myths*, MIT Press, Cambridge, MA, 1985, pp. 196-209.

_ Jean Clair, *Duchamp et la Photographie*, Chene, Paris, 1977.

whose friendship with Duchamp was so close that Duchamp acted for decades as his agent and dealer, played a significant role in this counter movement in the transformation of sculpture. It is well known that Brancusi used the pedestal, which, depending on the organization of the studio, could be employed as furniture or sculpture. The pedestal could stand on its own as a sculpture, or serve as a base for another sculpture or even a seat. However, less commonly known is that, as of 1914, Brancusi produced wooden furniture for his atelier in a free interpretation of a rustic Romanian style and exhibited it – not as furniture, but as sculpture equally important to his bronze or marble pieces. The benches thus overstepped their function as subordinates to sculpture to the extent that the artist photographed them and presented them as autonomous sculptures.[50] In contrast to Duchamp, Brancusi produced his artworks by hand, thereby asserting the proposition that all objects made by Brancusi, whether abstract geometric sculptures or furniture pieces, are art works. By using the furniture functionally within the framework of his studio, but then transforming its function to a pedestal for his sculpture for his exhibitions, Brancusi produced an important contribution in the transition of the sculpture to a useful object.

Following the material investigations of the objects was the counter movement of the "dematerialists." The material-bound object-like paradigm was abandoned through the term "conceptual art" or "post-objectiveness." Fundamental to the idea of conceptual art is the insight into the linguistic nature of all artistic statements, regardless of the elements used in production.[51] They replaced the conventional methods of painting and sculpture with linguistic operations in the field of visual representation.

The results of the expanded view of conceptual art, namely, land art, process art, behavior art, etc., were, in principle, documented through photography. Thus the photographic paradigm once again shifted into the position of painting and sculpture, even in those movements which were keen on expanding or even abandoning the referential framework and the practice of painting and sculpture under the heading: "departure from the image." Parallel to this expansion of the idea of art in the 1960s, it was primarily Fluxus, Happening, and Actionism that transformed the concept of sculpture. Interestingly, the otherwise antagonistic forms of concept art and action art have a common artistic practice in one field, namely, the "propositions," "instructions," and "statements."[52] In *Art after Philosophy* (1969) Kosuth wrote as an answer to Hegel's dictum *Philosophy after Art*: "A work of art is a kind of proposition presented within the context of art as a comment on art."[53]

These techniques of instruction were addressed to the viewer of art, from which the model of audience participation in the construction of the artwork developed in the 1960s in various forms. One of the earliest artists of the neo-avant-garde to use instructions to an anonymous audience as artform was Yoko Ono.

"Painting to Hammer a Nail
Hammer a nail into a mirror, a piece of
glass, a canvas, wood or metal every
morning. Also, pick up a hair that came
off when you combed in the morning and
tie it around the
hammered nail. The
painting ends when the surface is covered
with nails."[54]

"Painting to Hammer a Nail
Hammer a nail in the center of a piece
of glass. Send each fragment to an
arbitrary address."[55]

Robert Morris, in his 1971 retrospective at London's Tate Gallery, developed sculptures specifically for audience participation: plywood constructions on which visitors could walk,

51 50 52 54 55 53

_ As appears in the title of the book from Lawrence Weiner, *Statements*, Seth Siegelaub Gallery, New York, 1968.

_ Yoko Ono, Spring 1962.

_ In addition to Lawrence Weiner, Douglas Huebler, and Sol LeWitt, also worthy of mention are the works from Joseph Kosuth and Art & Language who described themselves as the purely analytical branch of conceptual art because they did not produce any materials, drawings, or paintings, but rather, carried out investigations of art and its conditions purely through language analysis. (Kosuth 1965: "Works of art are analytical propositions.")

_ Yoko Ono, Winter 1961.

_ Brancusi also began the genre of the furniture sculpture, which Richard Artschwager completed in the 1960s. With sculptures such as *Socrates and Cup* (1922) and *Arc* (1914-1916) Brancusi made use objects unusable and sculptural art works, such as his benches (1914-1916) useable.

_ There are numerous written instructions from the Fluxus and event artists: "Draw an imaginary map" wrote Yoko Ono in 1962. The famous telegram that Robert Rauschenberg sent to Iris Clert in 1961 as a contribution to a portrait exhibition stated: "This is a portrait of Iris Clert if I say so."

Marcel Duchamp / Fountain / 1917 / inscribed porcelain urinal on its back /
signed as R. Mutt / © photo: Alfred Stieglitz, reproduced in The Blind Man, 2, May 1917

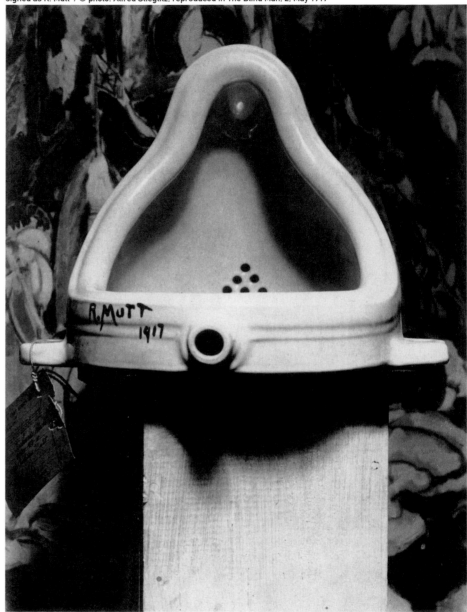

Constantin Brancusi / Stool / c. 1920 /
from: Peter Weibel (ed.), Erwin Wurm, exhib. cat.
Neue Galerie am Landesmuseum Joanneum, Graz, 2002

Constantin Brancusi / Bank / c. 1915 / wood / 27.5 x 124.5 x 9" / © VG Bild-Kunst, Bonn 2002

Aleksandr Rodchenko / Worker's Club / 1925 / shown at the international exhibition of applied arts in Paris / © VG Bild-Kunst, Bonn 2002

Aleksandr Rodchenko / Design for the
furnishing of a Worker's Club / 1925 /
colored ink, paper / 14.4 x 9.8" / shown at the
international exhibition of applied arts in Paris /
© VG Bild-Kunst, Bonn 2002

Richard Artschwager / Table and Chair / 1963–1964 / Tate Gallery, London, purchased 1983 / © photo: Tate Gallery, London

Richard Artschwager / Archipelago / 1993 / installation view / wood / created for an exhibition at Portikus, Frankfurt / © photo: Horst Ziegenfusz

René Magritte / Perspective II: Le Balcon de Manet / oil on canvas / 31.9 x 23.6" / Museum van Hedendaagse Kunst, Gent

Thomas Locher / Wer sagt was und warum / 1992 / installation view,
Kölnischer Kunstverein, Cologne / © Alistair Overbruck, Cologne

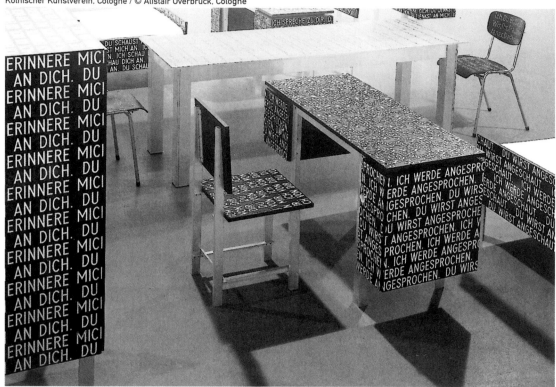

Erwin Wurm / The Three Philosophers / 2001 / detail: one chair /
3 chairs, drawing / installation, The Box, Torino

Erwin Wurm / The Three Philosophers / 2001 / detail: one drawing /
3 chairs, drawing / installation, The Box, Torino

Erwin Wurm / 5 Objects / 1998

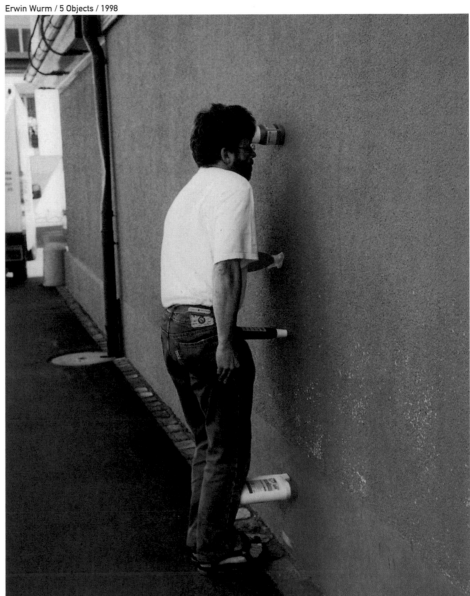

Erwin Wurm / Instruction Drawing (5 Objects) / 1998 /
ball point on paper / 11.7 x 8.3" / private collection

John M. Armleder / RAL 3000 / 1987 / wooden chair with red plastic cover,
acrylic on canvas / 21.7 x 35.4 x 23.6" (chair), 17.7 x 63" (canvas) /
Collection Feelisch, Remscheid

ropes, on which they could balance, and wooden walls they could lean against. After the innovative decades of the 1960s, sculpture was completely transformed and changed into almost its opposite: dematerialized and made semiotic. It was staged under very new conditions on the one hand as a medium of reproduction under the photographic paradigm (land art, etc.), on the other hand as a model of participation. The human body was no longer represented in an anthropomorphic sculpture (or even abstracted like in a Moore sculpture), but utilized for sitting, walking, sleeping, eating, pissing, using objects in various ways.

In his 1968 *Objects, to use*, Franz Erhard Walther presented a whole volume in which the activities of persons using prescribed objects results in a new definition of sculpture.[56] In the series *One Minute Sculptures* featuring the artist, Erwin Wurm, and others, human bodies, in association with objects and in positions they could only assume for minutes, became the ideal extension of sculpture into the media of photography and video. The elements that he uses are objects, bodies, and media, but the way in which he combines these elements and actualizes them has a linguistic nature. He continually uses the methods of contiguity (tangibility, jointure) and metonymy. Sculpture *as a behavioral form replaces abstract sculpture and the sculpture as object*. Visitors' and spectators' use of objects – like furniture – as sculpture opens a new range of artistic practices beyond the crisis of representation. The sculptural forms of enactment, and the new media works with interactive and participatory behavioral patterns are the innovations of the twentieth century. Thus we are able to speak of three great metamorphoses of the plastic form in the twentieth century: *sculpture, object, and enactment*.

One of modernity's consequences is the aesthetic reflection upon its own nature: the critique of modernity is an integral part of modernity itself. In its striving for transparency under rationality and the terms of the European Enlightenment, modernity continuously feels the need to justify itself.

Hence, novelty for its own sake is less a characteristic of modernity than is radical reflexivity, which ceaselessly revises the conventions and agreements regarding the nature of art and modernity. Indeed, with the advent of modernity, reflexivity takes on a new character. It does not help to stabilize the concept of art, as is often hoped for or expected, but, rather, contributes to its instability and uncertainty, as this catalog should make clear (see Belting, Sloterdijk, Gamboni). In the 1960s, the first world political opposition against the exploitation of the third world created a context which brought about a radical revision of the conditions and conventions of European society and history and the art of modernity. During these years, critiques of the aesthetic practices of modernity and of the object status of the work of art began to run parallel to political critiques and emancipation. A renegotiation of the concept of art began.[57] Reflecting the history of modernity and the immediate historical political past, the traumas of Stalinism and Fascism, the Holocaust and the atomic bomb, a radical iconoclasm returned in the theater of the absurd and in critical theory. Theodor W. Adorno made his famous 1949 statement against representation after the holocaust:

> "Cultural criticism finds itself faced with the final stage of the dialectic of culture and barbarism. To write poetry after Auschwitz is barbaric. And this corrodes even the knowledge of why it has become impossible to write poetry today."[58]

The holocaust researcher, Raul Hilberg, follows the same reasoning. A real object instead of a visual representation re-enacts the Germany of Hitler:

> "(...) a can of Zyklon gas (...), with which the Jews were killed in Auschwitz and Maydanek. I would have liked to see a single can mounted on a pedestal in a small room, with no other objects between the walls, as the epitome of Adolf Hitler's Germany, just as a vase of Euphronios was shown at one time by itself in the

56

57 58

_ Walther writes: "The pieces are a kind of pedestal and the persons standing on them can be seen as sculptures. Correlates of activity, referring to position, space, and time, change. Meaning is first produced in the handling of these." (Franz Erhard Walther, *Objekte, benutzen*, König, Cologne, 1968).

_ Theodor W. Adorno, Cultural Criticism and Society (1967), *Prisms*, trans. Samuel and Shierry Weber, MIT Press, Cambridge, MA, 1981, p. 34.

_ This brought consequences such as the de-framing of images, the departure from the image, the "dematerialization of the art object" (Lucy R. Lippard, *Six Years. The Dematerialization of the Art Object from 1966 to 1972*, Praeger, New York, 1973) and the deconstruction of the "white cube."

Metropolitan Museum of Art as one of the supreme artifacts of Greek antiquity."[59]

Again we see political reasons for the iconoclastic urge, which I have described as paradigmatic in the beginning of this essay. A horizon beyond the status quo in society and in art emerged. Within this horizon new strategies and practices beyond the limits of art and beyond the limits of society were developed. To move beyond the crisis of representation and beyond the image wars became the program for a new way of life.

The tendency towards the conceptualization and im-materialization of the art object was also formulated by Umberto Eco with his theory of the *Open Work of Art* (1962).[60] Eco describes the transformation of the work of art during the shift from the machine-oriented industrial age to the post-industrial age of cybernetics and information and communications technologies. The artwork of modernity is an autonomous aesthetic object, a closed system. The dissolution of the object status of the work of art brought to an end the age of modernity. After modernity, art became an open system. Its playing field has shifted from purely aesthetic rules of object construction to the framework of social practices, for example, action-determined events and situations, from Fluxus to Happening, from Actionism to Performance. The sphere of art thus expanded in numerous ways. In the context of the aforementioned reflexivity, *the author, the work of art and the viewer, in other words, the three constants of classical art, were radically subverted and transformed*. Groups, collectives, algorithms etc. replaced the single subject of the author. The artwork as object was supplanted by open events, actions, processes, games, action instructions, and concepts. The passive observer became co-creator, player, and participant. The boundaries between the diverse social actors in the art fields as well as between aesthetic and non-aesthetic objects and events became porous and invisible. The aesthetic was no longer disassociated from the cognitive or the social and political; as a result, economic and ecological, political and social, cognitive and scientific agendas returned to the sphere of art.

When a signifying chain operates over a closed object field – for example a number of apples as the well-defined selection from the world of objects – this chain produces a semantic closure which corresponds to the material closure of a work of art, i.e., framed, on a pedestal, cast in iron, sculpted from marble. Artistic practices which were subjected to the influence of chance during production and reception – for example to the freedom of the interpreter – brought about an opening of the closed, signifying chain which until now had defined both the meaning of a work of art and its identity as such. The signifying chain became unchained. The elements of the chain loosened and fell apart. The strict differentiation that had prevailed between the sphere of high art and that of low everyday life, between artist and consumer, between aesthetic communication and social agency, became fluid and diffuse. Modernity's system of representation allowed only objects to be real, not people and actions. The media-supported second modernity focused on the introduction of real actions and people into art's representational frame.

The art community has long given real objects the status of art; it has refused, however, to lend actions the status of art. It is interesting to observe that the institutions of the art community can agree that a stove can be an art object, not, however, the act of cooking. A real bed can be an art object, however not the act of caring for a sick person in that bed. The art of open practice radically calls such distinctions into question. Fluxus, Happening, and Action Art are the first artistic strategies that replaced representation with reality on several levels. The image of a dog was replaced with a real dog, the image of a breast was replaced with a real breast. Real people could touch this breast. The painting became a painter painted white and walking through the streets of Vienna. The

60 59

_ Raul Hilberg, *The Politics of Memory: the journey of a Holocaust Historian*, Chicago, 1996, pp. 130-131.

_ Umberto Eco, *Opera aperta*, Bompiani, Milano, 1962.

Klaus Staeck / Auf der Barrikade (1789-1989) [On the warpath (1789-1989)] / 1988 / postcard / 5.8 x 4.1" / © VG Bild-Kunst, Bonn 2002 / © Edition Staeck, Heidelberg

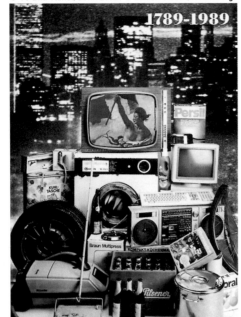

Klaus Staeck / Coca-Cola / 1994 / postcard / 5.8 x 4.1" / © VG Bild-Kunst, Bonn 2002 / © Edition Staeck, Heidelberg

Klaus Staeck / Zurück zur Natur [Back to nature] / 1985 / postcard / 5.8 x 4.1" / © VG Bild-Kunst, Bonn 2002 / © Edition Staeck, Heidelberg

Jochen Gerz / Harburger Mahnmal gegen Faschismus [The Harburg monument against fascism] /
1986 / 15 out of a series of 80 slides / Atelier Gerz / © VG Bild-Kunst, Bonn 2002 /
© photos: Petra Bopp, Ellermeyer, André Lützen, Esther Shalev-Gerz

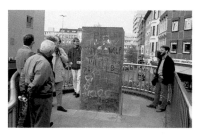

Jochen Gerz / 2146 Steine – Mahnmal gegen Rassismus [2146 Stones – Memorial Against Racism] / 1993 / four photographs / each 15.6 x 11.8" / Atelier Gerz / © VG Bild-Kunst, Bonn 2002 / © photo: M. Blauke, Esther Shalev-Gerz

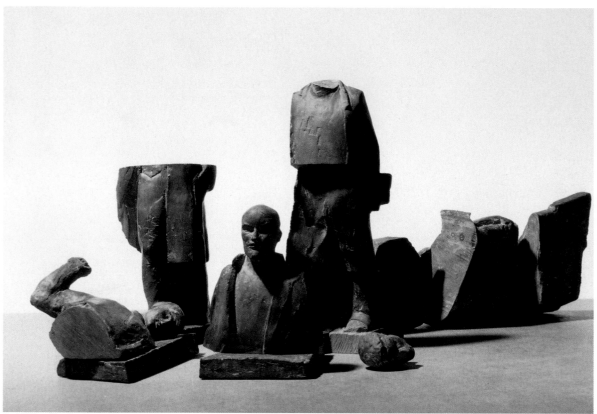

Rudolf Herz / Lenins Lager. Entwurf für eine
Skulptur in Dresden
[Lenin's camp. Model for an Sculpture in
Dresden] / 1991 / granite / Collection Kurtze /
© photo: Hans Döring

The Dresden city councilors have decided to remove from their city-scape the monument to Lenin, which has become unpleasant, and to offer it as a gift. The results of the cleansing action are evident. The reviled monument will be removed from sight and memory, thereby eliminating an important starting point for the controversial discourse about the most recent past.
This situation has given cause for the development of the sculpture »Lenins Lager. Entwurf für eine Skulptur in Dresden.«
The concept aims at maintaining a constant public presence of the bildersturm, and simultaneously preserving the monument from its final elimination. »Lenins Lager« consists of the single stone blocks that were originally placed together with the monument. The red granite blocks will be dismounted and assembled together in a narrow space as a sculptural object. This arrangement recalls a museum depot or an archeological expanse of rubble: the state between deconstruction and museum-like reconstruction.
»Lenins Lager« is a heretical critique of state politics' reappraisal rituals after the fall of the GDR, an objectionable keepsake with political and aesthetic sources of friction. It should find a home at the monument's former site in front of the train station.
Rudolf Herz, 20 November 1991

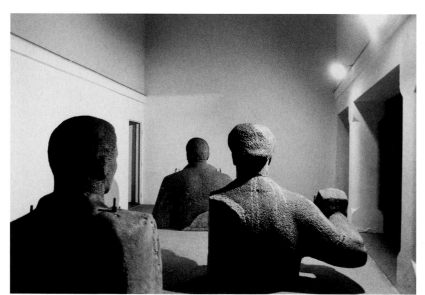

Rudolf Herz / Melancholic Sculpture / 1996 / installation view Badischer Kunstverein, Karlsruhe, 1996 /
© photo: Hans Döring

image of pain became real pain. Out of this refusal to represent, actual sexual and political actions developed. Not only in painting as image art, but even in the art of cinema as image medium, the image was replaced by real activities in the expanded cinema movement, performances with cinematographic means on open stages. The introduction of the body into the art system was the guarantee that art took place in real time and in real space. As iconoclasts, these artists believed in the romantic tradition in the possibility of an unmediated approach to reality, similar to the Situationiste Internationale. At the same time, the departure from the picture was documented and depicted by photographs. In the end, the departure from the picture through action ended in a further picture, even if the picture was not a painting but just a photograph. So even action art could not dispel the authoritarian paradigm of photography. The ambivalent character of iconoclastic art is again evident. What can be said in favor of all forms of action art is that it created an algorithmic art, that is the art of instructions for participatory spectators, be it in theatrical plays or in media based interactive installations. Through these practices, it became possible for social enactments to gain the status of art.

These practices replaced the closed aesthetic object with open signifying fields and practices, allowing plural and multiple relations to be created by the viewer. Hence they exceed not only the object status of art, but also radically transcend the horizon of symbolic representation. Real actions replace symbolic ones. The de-representation of the work of art follows the deframing of the image. The critical transformation of modernity has reached a decisive turning point – the freeing of social actors and agents. The crossing of the boundary of the symbolic, the replacement of the object with practices and acts of communication, enables art to act aesthetically in the social realm; whereas until now it could only act socially in the aesthetic realm. Open practices replace the open work of art.

With these new practices, the crisis of representation is dissolved. We saw the evolution of modern art as a continuous reflection of the end of art as a consequence of the crisis of representation, beginning in nineteenth century and dominating twentieth century art. Now with these new practices we observe the advent of the end of the crisis of representation and therefore the end of modern art, which was the product of this crisis. Iconoclasm as axiom of modern art comes to an end. "Farewell to an idea" is therefore the correct prognosis to the fate of modern art as T. J. Clark has formulated it.[61]

The end to the rhetoric of the end of art,[62] to the deconstruction of art as a rhetoric of liberation, freeing art from all its constraints, is supported and derived by an epistemological shift in image making. For hundreds of years painters were the sole experts able to make images, art had the monopoly on image making. After the invention of photography the monopoly collapsed and there arose a great number of other experts with the ability to make images. In the universe of the technical image, image production from that class of experts formerly called "artists" became marginal compared with the image production of mass media such as magazines, television, and cinema. A new class of experts, in particular the natural scientists, from astronomy to medicine, can create with the help of computers and other new tools new images from the hitherto invisible. The images of science have the tendency to believe in the power of images, to believe in the faculty of representation of the image. Science once had an iconoclastic tendency, a line of thought that intensified around 1800 with Lagrange who rejected every image and every graphical symbol in order to achieve the ideal mathematical form.

"One will not find figures in this work. The methods that I expound require neither constructions, nor geometrical or mechanical arguments, but only algebraic operations, subject to a regular and uniform course."[63]

63 62 61

_ Timothy J. Clark, *Farewell to an Idea: Episodes from a History of Modernism*, Yale University Press, New Haven, 1999.

_ See Arthur C. Danto, After the End of Art, Princton University Press, Princton, 1997, and Hans Belting, *Das Ende der Kunstgeschichte?* [The End of Art History?], Deutscher Kunstverlag, Munich, 1983, and its revised version: *Das Ende der Kunstgeschichte: eine Revision nach zehn Jahren*, Beck, Munich, 1995.

_ Joseph-Louis Lagrange, *Mécanique analytique (Analytical Mechanics)*, Berlin, 1788, Preface.

With the advent of the fractal, we experienced a triumphant return of the image to mathematical sciences.[64] From mathematics to medicine, from computer supported proof methods to computer tomography, we see an iconophilic science trusting the representative power of the image. We therefore live in a period where art, as the former monopolist of the representative image, has abandoned this representative obligation. Even all media theory is critical of the role of technical images in art and entertainment, yet science, in contrast, fully embraces the options which technical machine based images offer for the representation of reality. Through science, the image is developed one step further, in a useful way. Therefore, it could be the case that mankind will find the images of science more necessary than the images of art. Art is threatened with becoming obsolete because of its obsolete image ideology, and it is threatened with being marginalized if it does not try to compete with the new pivotal role of the image in the sciences by also developing new strategies of image making and visual representation. Art must look for a position beyond the crisis of representation and beyond the image wars, to counterpoint science.

64

_ Benoit B. Mandelbrot, *The fractal geometry of nature*, Freeman, San Francisco, 1982.

»In that Empire, the craft of Cartography attained such Perfection that the map of a Single Province covered the space of an entire City, and the Map of the Empire itself an entire Province. In the course of Time, these Extensive maps were found somehow wanting, and so the College of Cartographers evolved a Map of the Empire that was of the same Scale as the Empire and that coincided with it point for point. Less attentive to the Study of Cartography, succeeding Generations came to judge a map of such Magnitude cumbersome, and, not without Irreverence, they abandoned it to the Rigours of sun and Rain. In the western Deserts, tattered Fragments of the Map are still to be found, Sheltering an occasional Beast or beggar; in the whole Nation, no other relic is left of the Discipline of Geography.« ‖

JORGE LOUIS BORGES, FROM A UNIVERSAL HISTORY OF INFAMY, 1954

EDIA]

1

the typosophic society
(typosophes sans frontières)
/ the typosophic pavilion /
ecke bonk / richard hamilton /
21 juni – 28 september 1997 /
documenta X, Kassel

The typosophic pavilion is
a poetic rendering of
neighbouring disciplines:
science, technology,
rhetoric, geometry,
viticulture and the arts.

1 Ecke Bonk / aide moi o
media / 1991 /
Neue Galerie am
Landesmuseum
Joanneum, Graz

(mirror image)
Richard Hamilton /
Kitchen / 1994/1995 /
from: Seven Rooms / 1995

2 Vitrine:
Richard Hamilton /
Ashtray, 1979 / Carafe,
1978 / House of Keyes,
1988

Ecke Bonk / tts.wine, 1995
/ tts.beakers, 1997 / coin-
icon, 1987

3 Richard Hamilton / DIAB
DS-101/ computer
1985-89 / Tate Gallery,
London
The computer presents an
infoloop of shorter notes
(1912-14) from the Green
Box and the White Box by
Marcel Duchamp

4 Sebastian Le Clerc /
L'academie des sciences
et des beaux arts / 1695 /
Herzog Anton Ulrich
Museum, Braunschweig

5 Ecke Bonk / Towards
Tautology / 1997

6 Wilson Cloud Chamber
(Nebelkammer) / 1997 / in
collaboration with Phywe
GmbH, Göttingen

© photos: Monika Nikolic,
Kassel / typosophes sans
frontières supports The
Campaign to Free Vanunu

a

b

c

d

e

forschungsgruppe_f

The research group was founded by students, artists and lecturers of the University of Art and Design Zurich in spring 2000 and it has now become a project in cooperation with the the Stuttgart State Academy of Art and Design. It consists of a project-based interdisciplinary study group, working on questions of pictural organization on the basis of interaction between motor and sensory functions.
The study group examines the forms of reception and perception in terms of action research (happy science) by situative intervention and action.
We are working on the problem of the constitution of visualized realities and how conditions of production and reception are organized. Existing operating systems are enhanced by interactive forms of action. States of self-organization are tested.

www.hgkz.ch/fotografie/forschungsgruppe_f

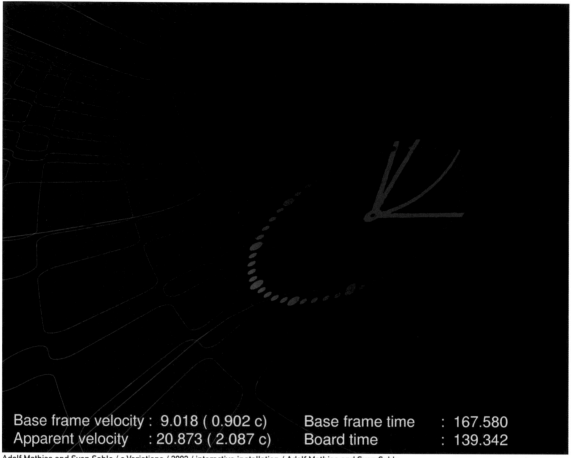

Base frame velocity : 9.018 (0.902 c) Base frame time : 167.580
Apparent velocity : 20.873 (2.087 c) Board time : 139.342

Adolf Mathias and Sven Sahle / c Variations / 2002 / interactive installation / Adolf Mathias and Sven Sahle

Natural Science generally has a lack of sensory impressions. If one throws a glance into a typical scientific book one once in a while will find a photograph or an illustration, as well as relatively abstract diagrams. Primarily one encounters with a great deal of formulas.
Art, on the contrary, for a long time emphasized sensory perception in order to follow the intention to mediate aspects of a conception of the world. The so-called concept art tries to correct this and avoids to be purely perceptible by the senses as an enhancement of even earlier attempts in painting to reduce narrative components of artworks because the latter are usually rich in ideology. Often the trick in concept art is to let disappear the difference between the works of art and everyday life. Stepping down of the art onto sensory perception is thereby as far as possible avoided.
Recently, science increasingly breaks new ground and pleads for the opposite. To a large extend this is due to the fact that new fields of research crucially depend on computer simulations like nonlinear dynamics and complexity, in order to gain knowledge. The reason lies in a lack of mathematical analyticity of the regarded systems as well as in the increasing degree of abstraction of research contents. The fact that scientists are increasingly commited with sensory perception is not (at least not mainly) for didactical reasons, but is rather epistemologically justified. Additionally, the scientist creates new reality by the ontogenetic process of a simulation.
The computer-aided, interactive installations »Chaotic Itinerancy, Micro Relativity, Liquid Perceptron«, and »c Variations« are examples of sensory perceptible realisations of abstract research contents. All these installations have been produced at the basic research department of the ZKM as an accompanying measure to the »usual« research. The installation »c variations« by Adolf Mathias and Sven Sahle is presented in the Iconoclash exhibition and briefly explained in the sequel.
Hans H. Diebner

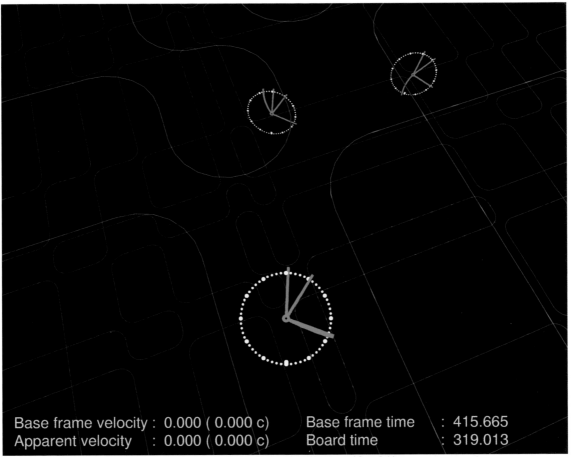

Base frame velocity : 0.000 (0.000 c) Base frame time : 415.665
Apparent velocity : 0.000 (0.000 c) Board time : 319.013

Adolf Mathias and Sven Sahle / c Variations / 2002 / interactive installation / Adolf Mathias and Sven Sahle

Even insiders often have serious problems to make themselves relativistic phenomena clear. Some of the effects are extremely contra-intuitive. The postulate »the velocity of light, c, is a finite constant« sounds so simple, but it is not as simple as that. The installation »c Variations« allows the spectator to navigate through an instructive landscape, thereby encountering with all the phenomena of special relativity as an effect of his or her relative velocity to a given inertial frame.

The simulation illustrates the warping of space, Doppler wavelength shift, aberration and other phenomena mainly as a result of light runtime differences between a given object and the observer as well as the Lorentz transformation. For example, the figure shows an instructive grid and a clock which are warped as an effect of the observer's motion. Specifically, one hand of the clock which makes one turn per second shows the most pronounced distortion whereas the slower moving hands show less distortions. All of the geometry of the displayed objects further shows clearly the impact of the Lorentz transformation. Furthermore, the spectator experiences light runtime phenomena of animations along the grid lines as well as the Doppler shift and the search light effect.

The Doppler effect manifests itself in a blue shift of the incident light from objects in travelling direction of the observer. The search light effect causes a strong intensification of light in travelling direction and attenuation in all other directions.

The »cockpit display« shows the travelling velocity with respect to the inertial frame of the grid. Further, the apparent velocity measured by the observer by taking the fraction of the known undistorted covered distance and the observer's frame time. The comparison of the corresponding frame times also displayed in the simulation allows to experience the well known twin effect.

The authors gratefully acknowledge stimulating discussions with Laurent Nottale and Peter Weibel.
Hans H. Diebner and Adolf Mathias

Heinrich Hertz / Labornotizen [laboratory notes] / december 1887 / paper /
from: VVS Saarbrücken (ed.), Mehr Licht, Merve Verlag, Berlin, 1999

Heinrich Hertz / Labornotizen – Scheinbild von elektromagnetischen Wellen
[laboratory notes – simulacrum of electromagnetic waves] / december 1887 / paper /
from: VVS Saarbrücken (ed.), Mehr Licht, Merve Verlag, Berlin, 1999

Drawings of electronic waves / Christmas 1887, Karlsruhe
We make, for ourselves, inner illusory images or symbols for outer objects, and we make them of such a type that the inevitable conceivable (or imaginable) consequences of the images are always once again images of the inevitable natural consequences of the depicted objects. So that this challenge can be met, certain correspondences must be available between nature and our minds. Experience teaches us that this challenge cannot be met and that these agreements in fact exist.
Heinich Hertz, Die Prinzipien der Mechanik, Johann Ambrosius Barth, Leipzig, 1894, p. 67

C.T.R. Wilson / Sketch of his cloud chamber / from the notebook /© photo: Royal Society, London

C.T.R. Wilson's sketch of his cloud chamber in a
notebook from 1895.
In his notebooks, Wilson took notes of what he
saw in his cloud chamber. On 29 March 1911, he
drew a sketch and wrote: »On one occasion in
addition to ordinary thread-like rays, one large
finger-like ray was seen, evidently a different
form of secondary ray - giving rise to enormously
more ionization than even ordinary ray.«

C.T.R. Wilson / Sketch of his cloud chamber /
detail / © photo: Royal Society, London

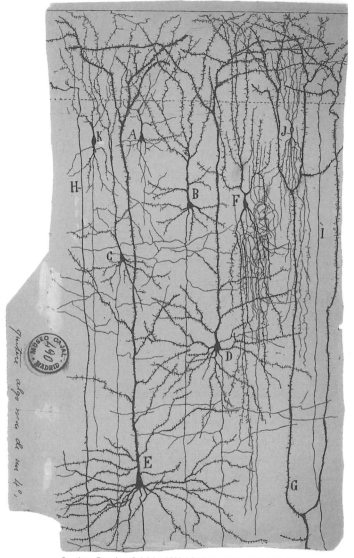

Santiago Ramón y Cajal / c. 1892 / © photo: Museo Cajal, Madrid
The drawing depicts the first, second, and third layers of the precentral gyrus of the cerebrum of a child of one month.
Cajal made discoveries that turned contemporary views on the structure and function of the nervous system upside down. Most reaserchers of the day held that the nervous system was made up of a continuous network of cells. Cajal proposed that each cell was a separate, independent entity, ending in so-called synapses, where nerve impulses were transferred from one cell to another.

X-ray of heart catheterization / © photo: Wolf-Georg Forssmann
The first heart catheterization was performed in 1929 by Werner Forssmann on himself

Peter Robinson / Inflation theory 1 / 2001 / fiberglass, acrylic paint / courtesy Govett-Brewster
Art Gallery Collection and Kapinos Galerie, Berlin / © photo: Bryan James

CERN / UA1 experiment
The UA1 experiment, which verified the existence of the W and Z particles, demanded the use of huge equipment.

Tracks of paritcles created by the collision of a proton and antiproton.
Through these charts the existence of the W and Z particles could be confirmed.

Achim Mohné / Firefiles / 2000-2001 / light installation / views

Appendix

Ulay / Da ist eine kriminelle Berührung in der Kunst / 1976/1997 / video / 25 min / 6 out of 20 filmstills / camera: Körg Schmid-Reitwein / © Ulay / ZKM | Mediathek, video-collection, Karlsruhe

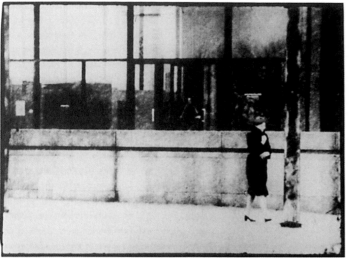

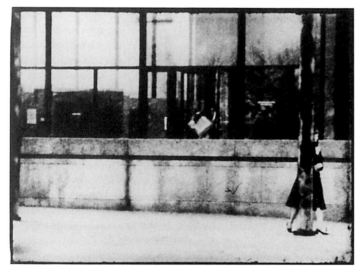
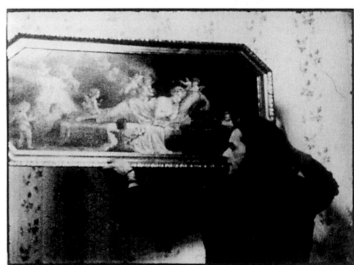
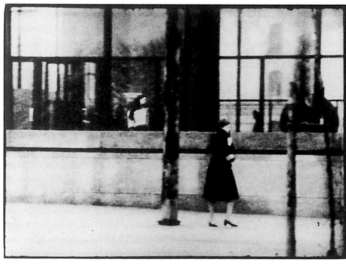
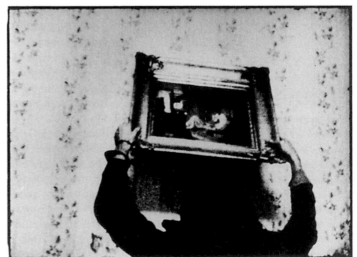

LENDERS TO THE EXHIBITION

INSTITUTIONS

Physikalisches Institut der Rheinisch Westfälischen Technischen Hochschule Aachen
Rijksmuseum, Amsterdam
Stedelijk Museum, Amsterdam
Etnografisch Museum, Antwerp
Tinguely Museum, Basle
Staatliche Museen zu Berlin – Preußischer Kulturbesitz, Kupferstichkabinett
Staatsbibliothek zu Berlin – Preußischer Kulturbesitz, Berlin
Mauermuseum Haus am Checkpoint Charlie, Berlin
Bernisches Historisches Museum, Bern
Schweizerische Landesbibliothek, Bern
Haus der Geschichte der Bundesrepublik Deutschland, Bonn
Herzog Anton Ulrich-Museum Braunschweig, Kunstmuseum des Landes Niedersachsen, Braunschweig
Margaret J. Geller and Michael T. Kurtz, Smithsonian Astrophysical Observatory, Cambridge
Kunstsammlungen der Veste Coburg, Coburg
Nationalmuseet, Copenhagen
Det Kongelige Bibliotek, Copenhagen
Evang.-Luth. Kirchengemeinde Dinkelsbühl
Historisches Museum, Frankfurt/M.
CERN European laboratory for particle physics, Genève
Musées d'art et d'histoire, Genève
Justus-Liebig-Universität Gießen, Universitätsbibliothek, Gießen
Mathematisches Institut der Georg-August-Universität Göttingen
Schloßmuseum Gotha, Gotha
Neue Galerie am Landesmuseum Joanneum, Graz
Hamburger Kunsthalle, Hamburg
Sprengel Museum Hannover, Hannover
Ruprecht-Karls-Universität Heidelberg, Universitätsbibliothek, Heidelberg
ZKM | Museum für Neue Kunst, Karlsruhe
Forschungszentrum Karlsruhe, Karlsruhe
Musée Cantonal des Beaux Arts, Lausanne
The British Museum, Department of Prints and Drawings, London
Tate Modern, London
Universitätsbibliothek Marburg
Musée Anne de Beaujeu de Moulins, Moulins
Bayerische Staatsbibliothek München, Munich
Staatliche Graphische Sammlung München, Munich
Jane Voorhees Zimmerli Art Museum, Rutgers University, State University of New Jersey, New Brunswick
Germanisches Nationalmuseum, Nuremberg
Bibliothèque nationale de France, Paris
Musée Carnavalet – Histoire de Paris, Paris
Fondation Cartier pour l'art contemporain, Paris
The Andy Warhol Museum, Pittsburgh
Musée des Beaux-Arts de Rennes, Rennes
Museum Boijmans van Beuningen, Rotterdam
ARS AEVI Collection, Center of Contemporary Art Sarajevo, Sarajevo
Museo de Bellas Artes de Sevilla, Sevilla
The State Russian Museum, St. Petersburg

Grand Séminaire, Strasbourg
Musée d'art moderne et contemporain, Strasbourg
Archiv Sohm, Staatsgalerie Stuttgart, Stuttgart
Tel Aviv Museum of Art, Tel Aviv
Evangelische Kirchengemeinde, Ulm-Jungingen
Musée de Ville de Valence, Valence
Albertina, Vienna
Generali Foundation, Vienna
Heeresgeschichtliches Museum Wien, Vienna
Museum moderner Kunst Stiftung Ludwig Wien, Vienna
Kunstsammlungen zu Weimar, Neues Museum, Weimar
Herzog-August Bibliothek, Wolfenbüttel
Fachbereich Physik, Universität Wuppertal
Deutsches Elektronen-Synchrotron DESY, Hamburg and Zeuthen
Museum Rietberg, Zurich

PRIVATE COLLECTIONS

Collection Falckenberg, Hamburg
Collection Frieder Burda
Collection Jack Helgesen, Oslo
Collection Jean Brolly, Paris/Strasbourg
Collection Feelisch, Remscheid
Josef Kurz, Natursteine GmbH, Gundelfingen/Donau
Edition Staeck, Heidelberg
Gaby and Wilhelm Schürmann, Herzogenrath
Family Ronge, Ittenbach
Collection Speck, Cologne
Laura Mulvey & Mark Lewis, London
FER Collection
Archiv Baumeister, Stuttgart
Collection Ute und Rudolf Scharpff, Stuttgart
Collection Froehlich, Stuttgart
Ploil, Vienna

GALLERIES

Galerie Kapinos, Berlin
Prüss & Ochs Gallery, Berlin
Galerie Barbara Weiss, Berlin
Galerie Vera Munro, Hamburg
Galerie Daniel Buchholz, Cologne
Galerie Johnen & Schöttle, Cologne
Mulier-Mulier Gallery, Knokke-Heist
Sadie Coles HQ, London
Lisson Gallery, London
Gallery Michele Maccarone, New York
The Estate of Gordon Matta-Clark and David Zwirner, New York
Susan Hobbs Gallery, Toronto
Georg Kargl, Vienna
Galerie Hubert Winter, Vienna
Galerie Hauser & Wirth, Zurich

WORKS IN THE EXHIBITION

Aczel, Richard and Robert Koch, Zoltán Szegedy-Maszák, Márton Fernezelyi / ExAltarcation / 2002 / multi media installation / 394 x 394" / Richard Aczel, Robert Koch, Zoltán Szegedy-Maszák, Márton Fernezelyi / C3 Center for Culture and Communication, Budapest

Albers, Josef / Study for Homage to the Square: White Signal / 1961 / oil on hardboard / 31.9 x 31.9 x 2" / FER Collection

AMANDA / model of the South Pole-Neutrino-Telescope / 2001 / 86.6 x 17 x 17" / plexiglas, LED, electronics / Physics Department, University Wuppertal

Anonymous (German) / Wounds of Christ / c. 1450 / woodcut, hand colored / 22.6 x 17" / Staatliche Museen zu Berlin – Preußischer Kulturbesitz, Kupferstichkabinett

Anonymous (Netherlandish) / Calvinist Iconoclasm / 1566 / engraving / 6.7 x 8.7" / Rijksmuseum Amsterdam

Anonymous / Alexamene Worships His God! / poster of the anti-Christian graffiti from the early third century / Palatine, Rome / Archive Alinari

Anonymous / Als wie der größte Mann Berns auf Befehl der kleinen Götter des Materialismus geopfert und enthauptet wird [How the Biggest Man of Berne is Being Sacrificed and Beheaded on Order of the Little Gods of Materialism] / woodcut / 4 x 6" / published in Die Schweiz, 3 March 1865 / Schweizerische Landesbibliothek, Berne

Anonymous / altar front from the Torslunde church / 1561 / wood, colored / 42.9 x 69.3 x 1.5" / National Museum of Denmark, Danish Collection, Copenhagen

Anonymous / Calvinist iconoclasm in Veitlin / 1621 / engraving / 13.8 x 11.5" / Kunstsammlung der Veste Coburg, Coburg

Anonymous / Christ as Man of Sorrows / 1480 / wood, polychrome / 59 x 15.7 x 11.8" / Musée d'art et d'histoire, Geneva

Anonymous / Christ in the Wine Press / woodcut, handcolored / 4.8 x 3" / The British Museum, London

Anonymous / Christoffel am Christoffelturm in Bern [Christoffel Tower in Berne] / c. 1860-1865 / photograph, black-and-white / 10.2 x 7.9" / Bernisches Historisches Museum, Berne

Anonymous / Christoffels Kampf und Sieg [Christopher's Fight and Victory] / woodcut / in Postheiri 28, December 1861 / Schweizerische Landesbibliothek, Berne

Anonymous / Coronation of Mary / 15th century / 27.2 x 18.5 x 3.7" / relief of wood / Grand Séminaire, Strasbourg

Anonymous / Crucifix / c. 1460 / wooden cross / approx. 182.3" x 34.6" (cross), 34.3" (figure head to toes) / Evangelisch-Lutherisches Pfarramt, Dinkelsbühl

Anonymous / Feet of the Christoffel figure / fragment of the figure once placed at the Christoffel Tower in Berne / 1498 / 13 x 22 x 27" (right foot), 14 x 20 x 30" (left foot) / Bernisches Historisches Museum, Berne

Anonymous / Head of Adenauer carved from the portrait of Hitler / height 41.3", diameter 19.7" / stone on pedestal

Anonymous / Mess of St. Gregory / woodcut / illustration in Johann Bäumler, Chronik von 1476 (Augsburg), 1476 / Justus-Liebig-Universität, Gießen

Anonymous / Opening of the Erste Internationale Dada-Messe [First International Dada Fair] / Burchard Gallery / Berlin, 30 July 1920 / Bildarchiv Preußischer Kulturbesitz, Berlin

Anonymous / Photograph of the demolition of the Christoffel Tower / 1865 / photograph / 9.3 x 7" / Bernisches Historisches Museum, Berne

Anonymous / Pietà / 15th century / collection TUDOT / marble / Museum Anne de Beaujeu, Moulins

Anonymous / Portrait of the murderer Hans von Berstatt / 1540 / woodcut / 15.7 x 11.3" / Schloßmuseum Gotha

Anonymous / Prayer at Christ's Side Being Pierced (The Holy Heart Carried by Angels) / woodcut, hand colored / 9 x 6.8" / Albertina, Vienna

Anonymous / Retabel / 1537 / wooden plaque with stand / 37.4 x 66.1" / Evangelisch-Lutherische Kirchengemeinde, Dinkelsbühl

Anonymous / Seven-Headed Papal Beast / c. 1530 / woodcut / 22.6 x 17.1" / Staatliche Museen zu Berlin – Preußischer Kulturbesitz, Kupferstichkabinett

Anonymous / Sheet of Four Veronicas / before 1462 / Cistercian psalter, illuminated / 4.3 x 3.2" / Det Kongelige Bibliotek, Copenhagen, MS Thott 117, 8, fol. iv

Anonymous / St. Bridget Triptych / c. 1490 / woodcut, handcolored / 10.5 x 15" / British Museum, London

Anonymous / The Augsburg Confession / 1711 / oil on canvas on wood / 35.4 x 34.4" / Evangelische Kirchengemeinde Ulm-Jungingen

Anonymous / The Holy Heart / c. 1460 / woodcut, colored / 3 x 2.4" / Albertina, Vienna

Anonymous / True Image of the Apostolic Church / c. 1600 / 7.9 x 27.6" / engraving / Bibliothèque nationale de France, Paris

Anonymous / Christ Ecce Homo / late 15th century / ink on paper / 7.6 x 5.3" / British Museum, London

Anonymous / Flagellation / late 15th century / woodcut / 6 x 5.1" / British Museum, London

Anonymous / Vision of a Sick Woman / late 15th century / woodcut / 7 x 5" / British Museum, London

Anselmo, Giovanni / Invisible / 1971 / installation / slide-projection, slide showing the word "invisible" / FER Collection

Arman / Poubelle / 1964 / plexiglas on wood panel / 28 x 20.1 x 4.7 / Collection Feelisch, Remscheid

Armleder, John M. / RAL 3000 / 1987 / wooden chair with red plastic cover, acrylic on canvas / 35.4 x 21.7 x 23.6" (chair), 63 x 17.7" (canvas) / Collection Feelisch, Remscheid

Art & Language / 100% Abstract / 1967-1968 / acrylic on canvas / 27 x 24.2" / courtesy Collection Art & Language and Lisson Gallery, London

Art & Language / Abstract Painting / 1967 / silkscreen on canvas / 24 x 15 x 1.6" / courtesy Mulier Mulier Gallery, Knokke-Heist

Art & Language / Guaranteed Painting / 1967-1968 / liquitex on canvas and photostat / two parts, each 17.7 x 12" / courtesy Collection Art & Language and Lisson Gallery, London

Art & Language / Map not to indicate / 1967 / letterpress print / edition of 50 / 19.7x 24.4" / courtesy Lisson Gallery, London

Art & Language / Painting – Sculpture / 1967 / acrylic on hardboard / two parts / each 24 x 15.5" / Collection Art & Language

Artschwager, Richard / Untitled (Piano) / 1994 / wood / 56.3 x 51.6 x 24" / Collection Froehlich, Stuttgart

Baldung Grien, Hans / The Ascension of Christ (Christ's Body Being Carried to Heaven) / 1517 / woodcut, hand colored / Albertina, Vienna

Banner, Fiona / Arsewoman in Wonderland / 2001 / silkscreen on aluminum / 112.2 x 112.2" / Jack Helgesen, Oslo

Baron, H. / The Breaker of Images / etched on steel by L. Massard / 6 x 4" / in Augustin Challamel and Wilhelm Ténint, Les Français sous la Révolution, Paris, 1843 / private collection

Barry, Robert / Painting in Four Parts / 1967 / oil on canvas over wood / four parts, each 4.1 x 4.1" / FER Collection

Barry, Robert / Radiation Piece / 1969 / cesium 137 (liquid in plastic pipe, 0.51 MEV beta energy) H.L. 30 years / two parts / each 5.9 x 7.9" / FER Collection

La Bastille / c. 1793 / modell of the bastille / 18.9 x 23.2 x 40.6" / modeling: Pierre Francois Pallois, Paris / Bernisches Historisches Museum, Berne

La Bastille / stone of the Bastille with engraving / 31.5 x 19.7 x 19.7" / Musée de Valence, Valence

Bateman, Henry Mayo / The Boy who Breathed on the Glass in the British Museum / 1916 / drawing in Punch / 8.3 x 16.5" / reprinted in Bateman, *A Book of Drawings*, New York, 1921 / ZKM | Center for art and media, Mediathek, Karlsruhe

Baudinet, Judith / The Holy Shroud / installation, sound / 157.5 x 137.8 x 275.6" / Judith Baudinet

Baumeister, Willi / Mann mit Spitzbart [Man With Pointed Beard] / c. 1941 / pencil and colored pencil, writing / on postcard of Adolf Ziegler's painting Göttin der Künste / 6 x 4" / Archive Baumeister, Stuttgart

Baumeister, Willi / Herr mit Spitzbart II – Simultanbild [Man With Pointed Beard – Simultaneous Image] / c. 1941 / pencil, gouache and watercolor / on postcard of Adolf Ziegler's painting Göttin der Künste / 6 x 4" / Archive Baumeister, Stuttgart

Baumeister, Willi / Portrait mit Hut [Portrait with hat] / 1955 / gouache, ballpoint pen / 6 x 4" / Archive Baumeister, Stuttgart

Berliner Mauer / Segment of the Berlin Wall / 1975 – November 1989 / original piece no. 296 / concrete / 141.7 x 47.2 x 82.3" / weight 2.6 t / Haus der Geschichte der Bundesrepublik Deutschland, Bonn

Berliner Mauer / Segment of the Berlin Wall / 1975 – November 1989 / original piece of the Wall in acrylic / 3.9 x 11.8" / Mauermuseum Haus am Checkpoint Charlie, Berlin

Bernhard Neubauer / Joseph Beuys' former assistant Johannes Stüttgen holding the remains of Beuys' 1982 Fettecke in the Kunstakademie Düsseldorf with another showing its original location in the background / 9 October 1986 / photograph, black-and-white / 19.7 x 15.7" / Bernhard Neubauer, Düsseldorf

Beuys, Joseph / Cosmos und Damian [Cosmos and Damian] / 17.5 x 13.7" / photos on cardboard, silver-bronze, brown oil paint / Collection Speck, Cologne

Beuys, Joseph / Cosmos und Damian [Cosmos and Damian] / 1973 / postcard / 5.8 x 4.1" / Edition Staeck, Heidelberg

Beuys, Joseph / Das Schweigen [The Silence] / 1973 / five film spools of Ingmar Bergman's movie Das Schweigen / galvanized / 9.8 x 15" / Collection Froehlich, Stuttgart

Beuys, Joseph / Das Schweigen von Duchamp wird überbewertet [The silence of Marcel Duchamp is overrated] / 1964 / foil / 18.1 x 18.3" / Edition Steack, Heidelberg

Beuys, Joseph / Der Fehler beginnt schon dann, wenn jemand Leinwand und Farbe kauft [The mistake already begins when you buy canvas and paint] / 1985 / poster, offset / 23.4 x 33" / Edition Staeck, Heidelberg

Beuys, Joseph / Der Fehler beginnt schon dann, wenn jemand Leinwand und Farbe kauft [The mistake already begins when you buy canvas and paint] / 1985 / postcard / 5.8 x 4.1" / Edition Staeck, Heidelberg

Beuys, Joseph / Hiermit trete ich aus der Kunst aus [I hereby resign from art] / 1985 / postcard / 5.8 x 4.1" / Edition Staeck, Heidelberg

Beuys, Joseph / Manifest / 1985 / postcard / 5.8 x 4.1" / Edition Stacck, Heidelberg

Beuys, Joseph / Manifest / 1985 / poster / 33 x 23.2" / Edition Steack, Heidelberg

Beuys, Joseph / Silberbesen und Besen ohne Haare [Silver broom and broom without bristles] / 1972 / wooden broom with silver sheath and copper broom, felt lining / 54.7 x 20.1" and 51.2 x 20.1"

Bianchini, Samuel / Sniper / The Disp[n] series / interactive image on the Web and installation / 1999 / Samuel Bianchini / programming: Emmanuel Méhois / http://www.dispotheque.org/sniper

Blotcamp, Carel / Naar Duchamp / 1976 / paper and plywood / 3.9 x 4.7 x 2" / private collection, The Hague

Boltanski, Christian / Forbidden Images – Scratch Room / digital print, judder material / 177.2 x 196.9"

Boltanski, Luc / Le Foetus et la guerre des images / 2002 / 25 photographs / each 20 x 27.9" / Luc Boltanski and Valérie Pihet, Paris

Bonk, Ecke / Camera Typosophica / 2002 / contains the works: aide moi o media, 1986-1996 / no it is opposition, 1986-1996 / o grammar go, 1986-1996 / mirror, cloud chamber / Neue Galerie am Landesmuseum Joanneum, Graz, private collection

Borland, Christine / Webs of Genetic Connectedness I + II / 2000 / shot glass, MDF and wood / 23.6 x 7.9 x 7.9" / Lisson Gallery, London

Brakhage, Stan / Sirius Remembered 1, 2 & 3 / 1959 / 16mm film, color, silent / 11 min / ZKM | Mediathek, video-collection, Karlsruhe

Braquehais, Bruno / La destruction de la Colonne Vendôme [The destruction of the Vendôme Column] / 1871 / photographs / 6 folios / Bibliothèque nationale de France, Cabinet des estampes, Paris

Brecht, Georg / No smoking / 1961 / steel plate with letters / 13.8 x 31.5" / Collection Feelisch, Remscheid

Brecht, Georg / Water Yam / 1963-1965 / plexiglas tin with sticker / approx. 7.9 x 19.7 x 11.8" / Collection Feelisch, Remscheid

Breer, Robert / Hommage to Jean Tinguely's Hommage to New York / 1960 / film, DVD (originally 16mm), monitor / ZKM | Mediathek, video-collection, Karlsruhe

Breitz, Candice / Babel Series / 1999 / video installation, seven monitors, seven DVD players, color, sound / Johnen + Schöttle, Cologne

Broodthaers, Marcel / M.B. (La signature série 1) [The signature series 1] / 1969 / black and red silkscreen on white tracing paper / 21.7 x 29.5" / Collection Feelisch, Remscheid

Brosamer, Hans / Martinus Luther Siebenkopf [Seven-Headed Martin Luther] / woodcut / title illustration / in Johannes Cochlaeus, *Sieben Köpffe Martini Luthers*, Valentin Schumann, Leipzig, 1529 / Germanisches Nationalmuseum, Nuremberg

Brus, Günter / Selbstbemalung I [Self-painting I] / 1964-1984 / 15 photographs / Neue Galerie am Landesmuseum Joanneum, Graz

Brus, Günter / Selbstbemalung II [Self-painting II] / 1964-1984 / 20 photographs / Neue Galerie am Landesmuseum Joanneum, Graz

Brus, Günter / Wiener Spaziergang (Körperanalysen) [Viennese Walk (body analyses)] / 1965 / video, monitor, pedestal / 23.6 x 39.4 x 19.7" / ZKM | Mediathek, video-collection, Karlsruhe

Brus, Günter / Wiener Spaziergang [Viennese Walk] / 1965 / 16 photographs, black-and-white / 15.4 x 15.4" / Neue Galerie am Landesmuseum Joanneum, Graz

Buren, Daniel / Demultiple / 1973 / acrylic on marquee fabric / 83 x 3.9" / Collection Speck, Cologne

Burgkmair, Hans / Schweißtuch der Heiligen Veronika [The Veil of St. Veronica] / 1510 / woodcut / 8.6 x 6.5" / Albertina, Vienna

Cadere, André / Peinture sans fin [Painting without end] / 1974 / wooden bead-molding, polychromed from 52 individual parts / 47.6 x 0.8" / Neue Galerie am Landesmuseum Joanneum, Graz

Calle, Sophie / Le Major Davel / 1994 / installation / cibachrome, photograph, black-and-white, text / 59 x 53" / Musée cantonal des beaux-arts, Lausanne

Chludov-Psalter / Marfa Vjaceslavovna Scepkina: Miniatjury chludovskoj Psaltyri, Greceskij. Illjustr. Kodeks 9 veka, Moskau / 1977 / book / 8.3 x 10.6" / Staatsbibliothek zu Berlin – Preußischer Kulturbesitz, Handchriftenabteilung

Chludov-Psalter / Faksimile: Marfa Vjaceslavovna Scepkina: Miniatjury chludovskoj Psaltyri, Moskau / 1977 / book / 8.3 x 10.6" / Ruprecht-Karls-Universität, Heidelberg, Universitätsbibliothek

Cloud Chamber, PHYWE PJ80/3 / c. 50 x 50 x 50" / Forschungszentrum Karlsruhe GmbH

Couloir du Charivari [Cacophony corridor] / 2002 / sound installation / concept: Denis Laborde, production: ZKM | Center for Art and Media, Karlsruhe, Denis Laborde and Pascal Cordereix, Bibliothèque nationale de France, Paris

Cranach the Elder, Lucas / Christus Dornenkrönung [Christ's coronation of thorns] / woodcut / 4,7 x 3.7" / in Passional Christi und Antichristi, texts by Melanchton and Johan Schwerdtfeger, Wittenberg, 1521 / British Museum, London

Cranach the Elder, Lucas / Kreuzigung [Crucifixion] / 1509 / woodcut on parchment, hand colored / 9.84 x 6.7" / Albertina, Vienna

Cranach the Elder, Lucas / Kreuzigung mit Longinus [Crucifixion with Longinus] / 1538 / oil on panel / 33.5 x 22" / Museo de Bellas Artes, Sevilla

Cranach the Younger, Lucas / Das Alte und Neue Testament [The Old and the New Testament] / book / 10.5 x 13" / British Museum, London

D' Esparbes, Jean / Massacre ou le Bourreau de soi / 1927 / Musée d'art moderne et contemporain, Strasbourg

Dâkinî Vâsya- Vajravârâhî / 15th century / bronze / height 13.7" / Tibet / Museum Rietberg, Zurich

Dean, Max / As Yet Untitled / 1992-1995 / mixed media / robots, photographs / diameter approx. 196" / Max Dean, courtesy Susan Hobbs Gallery, Toronto

Debord, Guy / In Girum Imus Nocte et Consumimur Igni / 1978 / 35mm, transferred to DVD / black-and-white, sound / 80 min

Descartes, René / Principia philosophiae, Amsterdam 1644 / 8 x 6.5 x 1" / Bayerische Staatsbibliothek, Munich

Duchamp, Marcel / Invitation Card "Hommage to New York" / 1960 / facsimile / 29.5 x 9.1" / Museum Jean Tinguely, Basel

Duchamp, Marcel / La boîte blanche [The White Box] / 1967 / 125 notes / private collection

Duchamp, Marcel / La boîte verte [The Green Box] / 1934 / box coated with green velvet, contents 93 parts / 13 x 11 x 1" / Neue Galerie am Landesmuseum Joanneum, Graz

Duchamp, Marcel / La boîte-en-valise (1936-1941) [Box in a suitcase] / 1966 / box, coated with red linen, contents 80 parts / 16.3 x 15 x 4" / Neue Galerie am Landesmuseum Joanneum, Graz

Dürer, Albrecht / Engelsmesse [Angels' Mass] / c. 1500 / pen, ink, and watercolor over metalpoint / 24 x 19" / Musée des beaux arts de Rennes

Dürer, Albrecht / Schweißtuch Christi von einem Engel ausgebreitet [The Veil of Christ Being Spread by Angels] / 1516 / etching / 7.4 x 5.3" / Albertina, Vienna

Durham, Jimmi and Maria Theresa Alves / Stone Videos / eight parts: Incident at Middelberg, 1996, 1 min / A Stone from Metternich's House in Bohemia, 1996, 0.30 min / 13, Rue Fenelon, 1996, 1 min / Enough!, 1996, 2.45 min / A Heavy Stone, 1996, 1 min / HTV, 1996, 3 min / Pink Granite at Work, 1997, 1 min / Nature Morte, 2000, 0.45 min / ZKM | Mediathek, video-collection, Karlsruhe

Electron Beam Diffraction Tube / 12 x 12 x 6" / electron beam diffraction tube, stand, high-voltage power supply / ZKM | Center for Art and Media, Karlsruhe

Evans, Cerith Wyn / Allen Jones Pirelli Calender / 1973 (Penetrated 1999) / 12 works in frames / 15.7 x 22.8" / courtesy Galerie Daniel Buchholz, Cologne

Export, Valie and Peter Weibel / Tapp und Tastkino [Tap and Touch Cinema] / 1968 / video on DVD, black-and-white / Generali Foundation, Vienna

Fairhust, Angus / Man abandoned by color / 1992 / photographs (3 parts), black-and-white / Angus Fairhust and Sadie Coles HQ, London

Fichot / Vue de la ville de Berne depuis la Tour Goliath [Berne seen from the Goliath Tower] / c. 1860 / lithography / 20 x 26" / Bernisches Historisches Museum, Berne

Filiou, Robert / Werkzeugkreuz [Tool cross] / 1969 / tools / 43.3 x 19.7 x 4.7" / Collection Feelisch, Vienna

Flötner, Peter / Die Neue Passion Christus [The New Passion of Christ] / c. 1530-1535 / woodcut / 5 x 18.7" / Germanisches Nationalmuseum, Nuremberg

Fludd, Robert / Utriusque Cosmi Maioris silicet et Minoris Mataphysica, vol. 1, first edition, 1617 / pp. 26/27: Black Square Flag / Staatsbibliothek zu Berlin – Preußischer Kulturbesitz, Department of Historical Prints

Fontana, Lucio / Concetto spaziale, ATTESTE "Questa mattina mi sono ... ed mal di denti" [spatial concept, sentence "this morning I ... and had a toothache"] / c. 1967 / acrylic on canvas / 25.6 x 21.4" / Collection Frieder Burda

Fontana, Lucio / Concetto spaziale / plastic / 11.8 x 11.8" / Galerie am Landesmuseum Johanneum, Graz

Franquelo, Manuel / Unfinished Still Life Materials / 1994 / oil and acrylic on board / 35.4 x 23.6" / private collection

Franquelo, Manuel / Untitled / 1994 / oil and water based paint on board / 31 x 51.2" / private collection

Gerz, Jochen / 2146 Steine – Mahnmal gegen Rassismus [2146 Stones – memorial against racism] / 1993 / four photographs / each 11.8 x 15.6" / Atelier Gerz

Gerz, Jochen / Harburger Mahnmal gegen Faschismus [The Harburg monument against fascism] / 1986 / slide show, 80 slides / Atelier Gerz

Gheerhaerts the Elder, Marcus / Allegory of Iconoclasm / c. 1566-1568 / etching / 15 x 10.4" / British Museum, London

Gill, André / Cover of Gill-Revue. Le Salon pour rire (Paris) / 1868 / handcolored woodcut / Jane Voorhees Zimmerli Art Museum, Rutgers University, State University of New Jersy

Gleyre, Charles / Le Major Davel / 1850 / fragment / oil on canvas / 57.7 x 40.2" / Musée cantonal des beaux-arts, Lausanne

Gmelin, Felix / A new Painting after Rauschenberg's Erased de Kooning Drawing / 1994-1995 / from The Art Vandal Series / after Willem de Kooning and Robert Rauschenberg (1953) / tempera on paper and panel in a gold leaf frame / 24.8 x 21.7 x 1.4" / Felix Gmelin, Stockholm

Gmelin, Felix / A Small Contribution to Purity / 1996 / from The Art Vandal Series / after Barnett Newman (1969-1970) and F. Keller (1982) / oil on canvas / 76.8 x 116.1 x 1.2" / Felix Gmelin, Stockholm / Gallery Michele Maccarone, New York

Gmelin, Felix / Erased Green Dollar Sign / 2001 / from The Art Vandal Series / after Kasimir Malevich (1927) and Alexander Brener (1997) / oil on panel / 37.5 x 29" / private collection

Gmelin, Felix / Kill Lies All / 1996 / from The Art Vandal Series / after Pablo Picasso (1937) and Tony Shafrazi (1974) / oil on canvas / 77 x 116 x 1.2" / Felix Gmelin, Stockholm

Gmelin, Felix / Puking in Yellow on a Composition in Black, Red and White / 2001 / from The Art Vandal Series / after Piet Mondrian (1935) and Jubal Brown (1996) / 102 x 105 x 0.9" / Felix Gmelin, Stockholm

Gmelin, Felix / The Avant-Garde Will Never Change Its Spots / 1996 / from The Art Vandal Series / after an unknown artist and Asger Jorn (1962) / oil on polyester / 24 x 29" / private collection

Gmelin, Felix / The Overpainting / 1996 / from The Art Vandal Series / after Arnulf Rainer (1973) / oil on canvas / 43.3 x 35.8 x 1.9" / private collection

Gordon, Douglas / Feature Film / 1999 / color, sound / 90 min / 35 mm, transferred to DVD / Douglas Gordon

Goya, Francisco de / No sabe lo que hace [He doesn't know what he's doing] / Album E, p. 19 / c. 1814-1817 / portfolio with drawings, brush and gray and black wash / 17.1 x 22.6" / Staatliche Museen zu Berlin – Preußischer Kulturbesitz, Kupferstichkabinett

Grien, Hans Baldung / Portrait from Luther / 1521 / woodcut / in: Acta et res gestae D. Martini Lutheri in comitijs principum Vuormaciae, Anno M D XXI / 11.4 x 8.3" / Universitätsbibliothek Marburg

Groys, Boris / Iconoclastic Delights / 2001 / film collage / color, sound / 22 min / DVD

Haacke, Hans / Brocken R.M. / 1986 / enamel plaque, gilded snow shovel with broken handle / courtesy Galerie Hubert Winter, Vienna

Halpern, Orit and Tal / Visions of Excess: Life, Information and Communication / 196.9 x 196.9" / interactive computer-installation / Orit Halpern

Hamilton, Richard / Duchamp Map (Big Glas) / 2002 / inkjet print / 53.9 x 66.9", 51.2 x 66.9" / Museum Boijmans van Beuningen, Rotterdam

Hay, Young / Bonjour Young Hay (performance after Courbet), Hong Kong Trip / 1995 / gelatine silver print on aludibond / 63 x 47.2" / courtesy Prüss & Ochs Gallery, Berlin

Heller, Eric J. / Images inspired by Science: Correspondence, 1997, 44 x 28" / Transport IV, 2000, 48 x 34" / Caustic I, 2001, 48 x 96" / Double Diamond, 2000, 48 x 42" / Monolith, 2000, 49 x 44" / Rosetta Stone, 1984, 48 x 35" / Random Synthesis, 2000, 50 x 50" / Creation of "Transport XIII": Random Sphere and Random Sphere II, 2000, 48 x 96" / Eric J. Heller, Lincoln

Henning, Bardo / Hymnenstreit / 1998 / installation, video, sound / dimensions variable / Bardo Henning

Herold, Georg / Das Bild als Verleumder [The picture as libelist] / 1983 / emulsion paint, jacket / 39.4 x 27.6" / Collection Falckenberg, Hamburg

Herold, Georg / Deutschland komplett [Germany complete] / 1998 / show-case with works / 86.6 x 31.5 x 43.3" / Collection Falckenberg, Hamburg

Herold, Georg / Handke und Fusske / 1982 / books, 2 brooms, flower pot / 46 x 31.5 x 15.7" / Collection Falckenberg, Hamburg

Herold, Georg / Holz ohne Raum [Wood Without Room] / wooden plank / 118.1 x 5.9 x 5.9" / private collection

Herold, Georg / Ruhm und Ehre der Sowjet-soldaten [Spendor and honor of the Sowjet soldiers] / 1984 / roofplanks, treemold, socks / 19.7 x 23.6" / Collection Falckenberg, Hamburg

Herold, Georg / Umweltschützer Herbert Zimmermann [Ecologist Herbert Zimmermann] / 1983 / emulsion paint, Schiefer / 11.8 x 8.67" / Collection Falckenberg, Hamburg

Herz, Rudolf / Melancholische Skulptur [Melancolic sculpture] / 1996 / three parts / approx. 39.4 x 27.56" / Collection Josef Kurz, Natursteine GmbH, Gundelfingen/Donau

Hicks, Wolfgang / Bilderstürmer [Iconoclasts] / 1970s / paper / 15.4 x 9.4" / Haus der Geschichte der Bundesrepublik Deutschland, Bonn

Hicks, Wolfgang / Genossen Komilitonen, jetzt demonstrieren wir für den Wiederaufbau [Comrades, students, let's demonstrate now for the reconstruction] / 1976 / paper / 18.9 x 14.2" / Haus der Geschichte der Bundesrepublik Deutschland, Bonn

Hogenberg, Franz / Calvinistischer Bildersturm [Calvanist iconoclasm] / 1566 / etching / 16.5 x 22" / Hamburger Kunsthalle, Kupfer-stichkabinett

Holzer, Jenny / More Survival / 1985 / electronic led sign with red diodes / 5.5 x 60.6 x 4" / Collection Ute and Rudolf Scharpff, Stuttgart

Huang Yong Ping / Devons – nous encore construire une grande cathédrale? / 1991 / installation / 98.4 x 78.7 x 236.2" / Foundation Cartier, Paris

Immendorff, Jörg / Hört auf zu malen! [Stop painting!] / 1966 / catalog Jörg Immendorff. Bild mit Geduld, Kunstmuseum Wolfsburg, 1996

Interview on "Auto-destructive Art" / 1997 / video / c. 40 min / Gustav Metzger interviewed by Hans Ulrich Obrist at Café Cosmo, London

Interview on Milano Triennal 1968 / April 2002 / video / c. 20 min / Giancarlo de Carlo interviewed in Milan by Hans Ulrich Obrist / Thanks to Stefano Boeri

Isaacs, John / Ah! Donald Judd, my favourite! / 1991/1999 / gelatine silver print / 20.9 x 16.9" / Fluid Editions, Basel

Isozaki, Arata / The Electric Labyrinth / reconstruction of the space of Arata Isozaki at '68 Triennale di Milano / installation / 472.4 x 204.7 x 590.6" / Arata Isozaki, Tokyo

Jackson, Richard / Untitled / 1971/1988/2002 (reconstruction for iconoclash of an 1971 installation at the Cocoran Gallery of Art, Washinton) / acrylic on canvas, wood / three parts / each 95 x 42 x 2" / Richard Jackson, courtesy Gallery Hauser & Wirth, Zurich

Jarman, Derek / Blue / 1993 / color, sound / 76 min / 35mm, transferred to DVD

Jones, John / Black square / after Joshua Reynolds' Miss Frances Kemble / 1784 / mezzotint on Japanese paper / 15 x 10.4" / The British Museum, London

Joreige, Khalil and Joanna Hadjithomas / The circle of confusion – The wonder of Beirut / 1995 / installation, photos on a mirror / 118.1 x 78.7"' / Khalil Joreige and Joanna Hadjithomas, Paris

Joreige, Khalil and Joanna Hadjithomas / The circle of confusion – The wonder of Beirut / 1995 / postcards / 59 x 1.6" / Khalil Joreige and Joanna Hadjithomas, Paris

Jorn, Asger / Selfportrait as Lille havefru / 1963 / gelatine silver print / 11.8 x 7.9" / archive Axel Heil / thanks to Jaqueline De Jong

Kaprow, Allan / Sawdust / 1970 / offset on paper / 16.9 x 24" / Collection Feelisch, Remscheid

Kippenberger, Martin / Modell Interconti / 1976 / table with Gerhard Richter painting / 14 x 27.6 x 15.8" / Gaby and Wilhelm Schürmann, Herzogenrath

Kippenberger, Martin / Zerschnittenes Acryl-Bild [Sliced acrylic picture] / 1991 / oil on canvas / part of a 188.1 x 118.1" picture / 15.4 x 20" / Collection Speck, Cologne

Kippenberger, Martin / Was ist der Unterschied zwischen Casanova und Jesus: Der Gesichts-ausdruck beim Nageln [What is the difference between Casanova and Jesus: The facial expression while being nailed] / 1990 / wood / 49 x 39 x 9.5" / Collection Falckenberg, Hamburg

Knoebel, Imi / 30 Keilrahmen [30 stretchers] / 1968-1969 / installation / wood / 114.2 x 94.5 x 31.1" / Carmen Knoebel

Knoebel, Imi / Keilrahmen [Stretcher] / 1968 / wood, paint / 11.8 x 11.8" / Carmen Knoebel

Knoebel, Imi / Schwarzes Quadrat auf Buffet [Black square on buffet] / 1984 / acrylic on fiberboard / four parts / 84.6 x 65 x 20.3" / Collection Froehlich, Stuttgart

Knoebel, Imi / Weiße Wand [White wall] / 1969/1975/1997 / acrylic on wood / eight parts / 95.5 x 64.6 x 22.1" / Carmen Knoebel

Koinzidenzzähler [array counter] / 136 x 46.8 x 46.8" / szentillation detectors, NIM-electronics, counter, flash light, oszilloscope / Institute for Nuclear Physics, Forschungszentrum Karlsruhe GmbH

Komar, Vitaly and Alexander Melamid / Project for the modification of a monument from the Communist era / 1999 / computer-assisted drawing / 11 x 8.7" / private collection

Korda, Alberto / Guerillo Heroico / 1960 / photo-graph / 11 x 8.3" / private collection, Cologne

Lafontaine, Pierre-Joseph / Alexandre Lenoir s'opposant à la destuction des monuments de Saint-Denis [Alexandre Lenoir Opposing the Destruction of the Royal Tombs in the Church of St. Denis] / 1793 / drawing / 9 x 8" / Musée Carnavalet – Histoire de Paris

Linke, Simon / Gene Davis | Jenny Holzer (Artforum) / 1986-1987 / oil on canvas / 72.1 x 72.1" / Neue Galerie am Landesmuseum Joanneum, Graz

Locher, Thomas / Kleine Hermeneutik des Schweigens [Little hermeneutics of silence] / 1991 / table with two chairs, aluminal construction, wood, engraved / 1.2 x 78.7 x 27.6", 3.1 x 16.5 x 20.9" / courtesy Thomas Locher

Macunias, George / Diagram of Historical Development of Fluxus and Other 4 Dimensional, Aural, Optic, Olfactory, Epithelial and Tactile Art Forms / 1973

Macunias, George / FLUXFLAX / 1995 / dedicated to the memory of George Macunias / plastic brief case / printed on silkscreen / Neue Galerie am Landesmuseum Joanneum, Graz

Mahâmantrânusârinî / c. 1400 / height 11" / Tibet / Museum Rietberg, Zurich

Malevich, Kasimir / Black Square / c. 1923 / oil on canvas / 41.7 x 41.7" / The State Russian Museum, St. Petersburg

Malevich, Kasimir / Black Circle / c. 1923 / oil on canvas / 41.3 x 41.3" / The State Russian Museum, St. Petersburg

Malevich, Kasimir / Black Cross / c. 1923 / oil on canvas / 41.7 x 41.7" / The State Russian Museum, St. Petersburg

Malevich, Kasimir / Photograph of Suprematism / 1920-1927 / with the green dollar sign sprayed by the Russian artist Alexander Brener on 4 January 1997 / Stedelijk Museum, Amsterdam

Manzoni, Piero / Merda d'artista 078 / 1961 / metal can / hight 1.89", diameter 2.55" / Staatsgalerie Stuttgart, Archive Sohm

Maria, Walter de / New York Eats Shit / 1970 / pencil on drawing board / 59 x 39.4" / Collection Speck, Cologne

Maria, Walter de / Rome Eats Shit / 1970 / pencil on drawing board / 59 x 39.4" / Collection Speck, Cologne

Maria, Walter de / Word / 1963 / pencil on cardboard / 39.6 x 39.6" / Collection Speck, Cologne

Mathematical models / various materials and seizes / from the collection of the Institute of Mathematics, Georg-August-University, Göttingen

Mathias, Adolf and Sven Sahle / C-Variationen [C-variations] / 2002 / interactive installation / Adolf Mathias and Sven Sahle

Matta-Clark, Gordon / Office Baroque / 1977 / photograph, color / 39.8 x 19.7" / courtesy Georg Kargl, Vienna

Matta-Clark, Gordon / Conical Intersect / 1974 / DVD / ZKM | Mediathek, video-collection, Karlsruhe

Matta-Clark, Gordon / Conical Intersect / 1975 / cibachrome / 30 x 40" / courtesy The Estate of Gordon Matta-Clark and David Zwirner, New York

Matta-Clark, Gordon / Conical Intersect / 1978 / cibachrome / 40 x 30" / courtesy The Estate of Gordon Matta-Clark and David Zwirner, New York

Matta-Clark, Gordon / Conical Intersect / 1978 / triptych / three color prints / courtesy The Estate of Gordon Matta-Clark and David Zwirner, New York

Matta-Clark, Gordon / Humphrey Street Splitting / two photographs, black-and-white / 9.8 x 7.9", 7.9 x 9.8" / Neue Galerie am Landesmuseum Joanneum, Graz

Die Mauer / 1961-1989 / sequences from film and documentary of the GDR on the wall and the fall of the wall / 10 min / Progress Film-Verleih GmbH, Berlin

McCollum, Allan / 30 Plaster Surrogates / 1982-1990 / acrylic on plaster / 67 x 189" (installation) / Sprengel Museum, Hannover

Meckenem, Israel van / Gregormesse [St. Gregory's Mass] / engraving / 17.9 x 11.6" / Albertina, Vienna

Meckenem, Israel van / Schmerzensmann [Man of Sorrow] / engraving / 6.8 x 4.5" / Albertina, Vienna

Meister E.S. / Versuchung des Glaubens aus der Ars Moriendi [Temptation from Faith from Ars Moriendi series] / c. 1460 / engraving / 22.6 x 17.1" / Staatliche Museen zu Berlin – Preußischer Kulturbesitz, Kupferstichkabinett

Mellan, Claude / The Veil of St. Veronica / etching / 1649 / Hamburger Kunsthalle, Kupferstichkabinett

Minkoff, Gérald L. / Video Blind Piece / 2002 / installation, 14 monitors connected with 14 cameras / Gérald L. Minkoff, Geneva

Misiano, Viktor and Evgeny Asse, Dmitri Gutoff, Vadim Fishkin / Reason is something / video / 12 min / shown at the Venice Biennale, 1995 / Vadim Fishkin, Dimitri Gutoff, Evgeny Asse, Viktor Misiano, Moscow and ARS AEVI Collection, Center of Contemporary Art, Sarajevo

Moffatt, Tracy and Gary Hillberg / Artist / 1999 / DVD, color, sound / 10 min / ZKM | Media Art Collection, Karlsruhe

Mohné, Achim / Fireflies / 2002 / light installation

Monogrammer H / Christ as Cornerstone / 1524 / woodcut / 22 x 14" / Germanisches Nationalmuseum, Nuremberg

Morishige, Kinugasa / Untitled (The nine contemplations of the impurity of the human body) / 17th century / 19 parts: 9 paintings (gouache), 10 written pages, framed / 11 x 15" (paintings), 13.6 x 25.6" (frames) / Ethnografisch Museum, Antwerp

Mulvey, Laura and Marc Lewis / Disgraced Monuments / 1994 / video / 50 min / ZKM | Mediathek, video-collection, Karlsruhe

Ono, Yoko / Painting to Hammer a Nail In / Cross Version / installation / 55 x 55 x 98" / Yoko Ono

Ono, Yoko / This Is not Here / catalog / 1971 / Staatsgalerie Stuttgart, Archive Sohm

Opalka, Roman / 1 – ∞ / 1965 / oil on canvas / 52.8 x 77.2" / FER Collection

Ostendorfer, Michael / Die Wallfahrt zur schönen Maria in Regensburg [Pilgrimage to the Beautiful Virgin Mary of Regensburg] / 1520 / woodcut / Kunstsammlung der Veste Coburg, Coburg

Palomar observatory sky survey glass plate copies / 7.8 x 13.8" / glass photographic plates / Margaret J. Geller and Michael Kurtz, Smithsonian Astrophysical Observatory, Cambridge

Paolini, Giulio / Chimera / 1975 / acrylic on canvas / 31.5 x 63" / FER Collection

Paolini, Giulio / Proteo I / 1971 / fragments of a plaster bust / 3.9 x 7.9 x 3.9" / Kunstsammlungen zu Weimar, Neues Museum

Pepperstein, Pavel / Ikone gegen Spiegel [Icon against mirror] / 2002 / reconstruction of the installation / Vadim Zacharov, Köln (Icon)

Picabia, Francis / Spanish Lady with Child / 1922 / gouache and ink on paper glued to cardboard / 25 x 18.5" / private collection, Palma de Mallorca

Polke, Sigmar / Dürer Hase [Dürer rabbit] / 1968 / oil on canvas / 31.5 x 23.6" / Collection Frieder Burda

Polke, Sigmar / Moderne Kunst [Modern Art] / 1968 / acrylic and lacquer on canvas / 59 x 49.3" / René Block and Collection Froehlich, Stuttgart

Polke, Sigmar / So sitzen Sie richtig (nach Goya und Max Ernst) [This is how you sit correctly (after Goya and Max Ernst)] / 1982 / acrylic, fabric / 78.7 x 70.9" / Collection Frieder Burda

Powers, Richard / De-Signing by Design / installation / computer, interactive / thanks to Adrian Hollay and Marco Sonntag

Prajnaparamita Manuscript / 13th century / damaged pages / handwriting, illustrations / 6.9 x 24.4" / Family Ronge, Ittenbach

Prina, Stephen / Exquisite Corps: The Complete Paintings of Manet / 1988 / silkscreen on cardboard / Neue Galerie am Landesmuseum Joanneum, Graz

Quinn, Marc / DNA Garden / 2001 / stainless steel frame, polycarbonate agar jelly, bacteria colonies, 77 plates of cloned DNA, 75 plants, 2 humans / 73.8 x 126 x 4.4" / courtesy Jay Jopling, White Cube, London

Rainer, Arnulf / Overpainting / c. 1954 / photograph, pencil and felt pen / 16.1 x 19.1" / private collection

Rainer, Arnulf / Übermaltes Schwiegermutter-monument [Overpainted mother-in-law monument] / 1960 / oil on canvas / 78.7 x 51.4" / Neue Galerie am Landesmuseum Joanneum, Graz

Rainer, Arnulf / Übermalung [Overpainting] / 1984-1988 / oil on wood / 21.3 x 30.1" / Collection Frieder Burda

Reinhardt, Ad / Abstract Painting / 1960 / oil on canvas / 15 x 15" / courtesy Georg Kargl, Vienna

Reinhardt, Ad / iris.time / 1963 / newspaperprint on paper / courtesy Georg Kargl, Vienna

Rembrandt / A Scholar in His Studio (Faust) / 1652 / etching / 8.4 x 6.6" / The British Museum, London

Rembrandt / Three Crosses / 1653 / etching / 12 x 20" / The British Museum, London

Richter, Gerhard / Zwei Grau nebeneinander [Two greys next to each other] / 1966 / oil on canvas / 78.6 x 59" / Collection Froehlich, Stuttgart

Ristelhueber, Sophie / Iraq / 2001 / 3 color photographs on aluminum / each 70.9 x 47.2" / Sophie Ristelhueber

Robinson, Peter / Inflation Theory I / 2001 / fiberglass, acrylic paint / 64.5 x 81.1 x 59.1" / Galerie Kapinos, Berlin

Robinson, Peter / Into the Void / 68.9 x 47.2" / Galerie Kapinos, Berlin

Roch, Axel / "../voyure en survol" – Pour Petit a. / ["../voyeur and surveil" – for little a.] / 2002 / interactive installation / 197 x 138 x 236" / Axel Roch

Roth, Dieter / Gewürzkiste [Spice box] / 1971 / wood, glass, five spices in separate compartments / 30.7 x 61.8 x 2.8" / Neue Galerie am Landesmuseum Joanneum, Graz, Collection Ploil, Vienna

Roth, Dieter / Untitled (Milk chocolate covered doll) / doll, milk chocolate / 11.8 x 4.7" / Collection Ploil, Vienna

Rutault, Claude / d/m 126 bis / 1984 / 88 canvases / Musée d'art moderne et contemporain Strasbourg, Collection Jean Brolly, Paris

Ruthenbeck, Reiner / Rotes Bandquadrat mit Metallstab [Red Square with metal tool] / 1988 / ribbon, metal tool / Collection Falckenberg, Hamburg

Sadeler, Raphael / Die vier letzten Dinge [The Four Last Things] / series of four engravings: death, hell, purgatory, heaven / 66.5 x 43.3", 66 x 45", 66 x 45", 65 x 43.3" / Staatliche Graphische Sammlung München, Munich

Saendredam, Pieter Jansz. / interior view of the southward aisle of the St. Bavo church in Haarlem / brown ink, watercolor over black chalk / 15.7 x 12.6" / Albertina, Vienna

Sauter, Joachim and Dirk Lüsebrink / Zerseher [The De-Viewer] / installation, DVD / Joachim Sauter, Dirk Lüsebrink

Scanning table / scanning table inclusive bubble chamber images / 78.7 x 98.4 x 78.7" / Rheinisch-Westfälische Technische Hochschule, Aachen, Physikalisches Institut

Schön, Erhard / Klagrede der verfolgten Götzen und Tempelbilder [Complaint of the Persecuted Idols and Temple Images] / c. 1530 / woodcut / 5 x 14" / Germanisches Nationalmuseum, Nuremberg

Searle, Ronald / l'oeuf cube et le cercle vicieux / 1968 / book / 9.6 x 8" / Librairie Arthème Fayard, Paris / private collection

Shaw, Jeffrey / The Golden Calf / 1995 / installation / portable LCD monitor / 39.4 x 19.7 x 19.7" / Jeffrey Shaw

Sound installation for the exhib. Iconoclash / 24 samples (Bach) in a 9 m long corridor / 2002 / concept: Denis Laborde, production: ZKM | Center for Art and Media, Karlsruhe, Denis Laborde and Pascal Cordereix, Bibliothèque nationale de France, Paris

Spark chamber / 1999 / 43.3 x 78.74 x 31.5" / metal, plexiglass, electronics / DESY (Deutsches Elektronen-Synchrotron), Hamburg and Zeuthen

Spoerri, Daniel / Palette pour Grégoire Müller [Pallet for Grégoire Müller] / 1992 / assemblage with color tube, empty turpentine bottles, cleaning rags, on wood / 36.2 x 84.3 x 7.9" / ZKM | Center for Art and Media, Karlsruhe

Spoerri, Daniel / Utiliser un Rembrandt comme planche à repassser (Marcel Duchamp) [Use a Rembrandt as an Ironing Board (Marcel Duchamp)] / 1963 / painted wooden chair, wood, panel, printed textile, iron / 34 x 29 x 16" / Tel Aviv Museum of Art, Tel Aviv

Staeck, Klaus / ... es darf ruhig etwas mehr kosten [... it can easily cost a bit more] / 1988 / postcard / 5.8 x 4.1" / Edition Staeck, Heidelberg

Staeck, Klaus / Auf der Barrikade (1789-1989) [On the warpath (1789-1989)] / 1988 / postcard / 5.8 x 4.1" / Edition Staeck, Heidelberg

Staeck, Klaus / Coca-Cola / 1994 / postcard / 5.8 x 4.1" / Edition Staeck, Heidelberg

Staeck, Klaus / Vorsicht Kunst [Beware of Art] / 1982 / chop / 3.1 x 2" / Edition Staeck, Heidelberg

Staeck, Klaus / Vorsicht Kunst [Beware of Art] / 1982 / emaille plate / 7.9 x 7.9" / Edition Staeck, Heidelberg

Staeck, Klaus / Vorsicht Kunst! [Beware of Art!] / 1982 / postcard / 5.8 x 4.1" / Edition Staeck, Heidelberg

Staeck, Klaus / Vorsicht Kunst! [Beware of Art!] / 1982 / poster / 98.4 x 139.4" / Edition Staeck, Heidelberg

Staeck, Klaus / Vorsicht Kunst! [Beware of Art!] / 1982 / sticker / 2 x 4" / Edition Staeck, Heidelberg

Staeck, Klaus / Zurück zur Natur [Back to nature] / 1985 / postcard / 5.8 x 4.1" / Edition Staeck, Heidelberg

Stimmer, Tobias / Das Gorgonenhaupt [The gorgon head] / 1568 / 9.6 x 8.4" / woodcut / Herzog Anton Ulrich-Museum, Braunschweig

Stolpovskaya, Olga and Dimitriy Troitskiy / Bruner'$ (dollar sign) Trial / 1998 / video, color / 11 min / private collection

Strauch, Lorenz / Hall of the Reformation Church in Stein near Nuremberg / 1630 / engraving / 10.2 x 13.5" / Germanisches Nationalmuseum, Nuremberg

Strindberg, August / Celestograph / 1894 / three photographs / 3.5 x 4.8 / Strindberg Museum, Stockholm

Sturtevant, Elaine / Duchamp Bicycle Wheel / 1969-1973 / bicycle wheel, wooden footstool / 53.2 x 23.6 x 13.8" / FER Collection

Sturtevant, Elaine / Study for Johns White Numbers / 1973 / encaustic on canvas / two pieces / 35.4 x 26.8" / private collection

Tibetan Stupa / reconstruction of the Densathil temple, Tibet / installation: 200 drawings, video, sculptures / 315 x 551" / from different collections

Tibetan Tathâgata Akṣobhya / 14th century / bronze / height 11" / Museum Rietberg, Zurich

Tibetan Tathâgata Amoghasiddhi / 14th century / bronze / height 12.4" / Museum Rietberg, Zurich

Tót, Endre / Dada-Messe in Berlin [Dada-fair in Berlin] / 1989 / acrylic on canvas / 49.2 x 79.1" / Collection Speck, Cologne

Tót, Endre / Golgotha / 1993 / acrylic on canvas / 78.7 x 118.1" / Endre Tót, Cologne

Uecker, Günther / Die schöne Helena [The beautiful Helena] / 1982-1983 / broom, cleaning rag, nails from the Roman Age / 57.5 x 21.7 x 5.1" / Collection Feelisch, Remscheid

Ulay / Da ist eine kriminelle Berührung in der Kunst / 1976/1997 / video / 25 min / ZKM | Mediathek, video-collection, Karlsruhe

Ulrichs, Timm / "Bild"-Bilder ["Picture"-pictures] / 1966 / black adhesive plastic letters, adhesive tape / dimensions variable / Timm Ulrichs, Münster

Ulrichs, Timm / "Ich kann keine Kunst mehr sehen!", 11.3.1975 [I can't stand seeing art any more, 11 March 1975] / 1975 / postcards and emaille pins / Timm Ulrichs, Münster

Ulrichs, Timm / Bildrückseitenbild [Picture of the back of a picture] / 1961-1968 / photograph on canvas on stretchers (front view) / fabric tape, labels, hanger (back view) / 15.7 x 19.7" / edition of 50, numbered and signed / Collection Hüper, Timm Ulrichs

Ulrichs, Timm / The End / 1970/90/97 / video on DVD, color, silent / 6.09 min / three parts / Timm Ulrichs, Münster

Vautier, Ben / No more art / 1985 / laquer on canvas / 19.7 x 27.6" / Edition Staeck, Heidelberg

Vautier, Ben / No more art / 1985 / postcard / 5.8 x 4.1" / Edition Staeck, Heidelberg

Vierge, D. / The Fall of the Vendôme Column, Paris 16 May 1871 / wood engraving by F. Méaulle / 8.3 x 5.1" / published in Victor Hugo, L' année terrible, Paris, 1874 / private collection

Vostell, Wolf / Mozart Partitur [Mozart score] / 1982 / piano minuet, ink, paint / 7.5 x 29.5" / Collection Feelisch, Remscheid

Walther, Franz Erhard / 40 Sockel [40 plinths] / 1978 / installation / cotton, wood, glue / 148 pieces / each 14.6 x 3.5" / Franz Erhard Walther, courtesy Gallery Vera Munro, Hamburg

Walther, Franz Erhard / Objekt für Wechsel (1. Werksatz) [Object for change (1. set of tools)] / 1967 / typewriter paper, photograph, black-and-white / 15.8 x 23.6" / Collection Feelisch, Remscheid

Warhol, Andy / Empire (excerpt) / 1964 / 16 mm, film transferred to Beta SP Pal videotape / black-and-white, silent / 250 min at 16 frames per second (complete film: 480 min) / The Andy Warhol Museum, Pittsburgh / Founding Collection, Contribution The Andy Warhol Foundation for the Visual Arts, Inc.

Warmerdam, Marijke van / Another Planet / 1998 / installation / DVD / Marijke van Warmerdam

Watts, Robert / Events / 1964-1965 / transparent box / 5.1 x 7.2 x 1.2" / Collection Feelisch, Remscheid

Weibel, Peter / Rahmen-Formalismus [Frames-formalism] / 1992 / steel band, soldered / 21.1 x 67.2 x 0.2" / Neue Galerie im Landesmuseum Joanneum, Graz

Weibel, Peter / Rahmenproportionen [Frame proportions] / 1992 / wooden frame, glued spruce wood / 24.8 x 73.6 x 5.5" / Neue Galerie am Landesmuseum Joanneum, Graz

Weibel, Peter and Valie Export / Aus der Mappe der Hundigkeit [From the Portfolio of Doggedness] / 1969 / photographs, black-and-white / each 19.7 x 15.9" / Generali Foundation, Vienna

Weiditz, Hans / Pietà / woodcut / 11.6 x 8.6" / Albertina, Vienna

Will, Johann Martin / The Demolition of the Bastille, 14 July 1789, Paris / 1789 / engraving / 14 x 18,6" / Heeresgeschichtliches Museum, Vienna

Wire Chamber / 1967 / 0.8 x 49.2 x 49.2" / CERN (European Organization for Nuclear Research), Switzerland

Witz, Konrad / Maria und Christus in der Stube [The Virgin Mary and Christ in the parlor] / c. 1440 / drawing / 17.1 x 22.6" / Staatliche Museen zu Berlin – Preußischer Kulturbesitz, Kupferstichkabinett

Wolgemut, Michael, shop / Skizzenbuch [Sketch-book] / c. 1490 / pen, ink, and watercolor / 7.8 x 5.5" / Staatliche Museen zu Berlin – Preußischer Kulturbesitz, Kupferstichkabinett

Zimmermann, Peter / Isaak Babel. So wurde es in Odessa gemacht [That is how it is done in Odessa] / acrylic on canvas / 23.6 x 15.8" / Neue Galerie am Landesmuseum Joanneum, Graz, Collection Weibel

BIOGRAPHIES OF THE AUTHORS

Patricia de Aquino, B.A., philosophy (PUC University – Rio de Janeiro/Brazil); Graduate Degree in anthropology (National Museum – Rio de Janeiro/Brazil); Master of Science, ethno-psychiatry (Université Paris 8); currently finishing a Ph.D. in anthropology at L' École des Hautes Études en Sciences Sociales (EHESS), Paris; worked as a researcher associated with the Centre Sociologie de l'Innovation /Ecole Nationale Supéreure des Mines de Paris (CSI/ENSMP); and with the Etablissements Régionaux d'Enseignement Adapté/Centre National de la Recherche Scientifique, Paris (EREA/CNRS).

Hans Belting, born 1935, has been professor of art history and media theory at the Hochschule für Gestaltung in Karlsruhe since 1992, and honorary professor at the University of Heidelberg since 1993. Visiting fellow of Harvard University, from 1969 until 1980; professor of art history in Heidelberg until 1980, and until 1993 at Munich University. In 2000, inauguration of the interdisciplinary research project *Anthropology and the image. Image-Media-Body*. Appointed to the European Chair of the Collège de France in Paris.

Samuel Bianchini, Centre de Recherches d' Esthétique du Cinéma et des Arts Audiovisuels, Université Paris 1 Panthéon-Sorbonne (CRECA laboratories) and Centre de Recherche en Informatique du Conservatoire National des Arts et Métiers (CEDRIC). biank@dispotheque.org – http://www.dispotheque.org

Luc Boltanski, born in 1940, Director of the École des Hautes Études en Sciences Sociales (EHESS), Paris, and professor of sociology. Recent books: *De la justification* (with L. Thévenot, 1991); *La souffrance à distance* (1993, Engl. transl., *Distant Suffering*, 1999); *Le nouvel esprit du capitalisme* (with E. Chiapello, 1999).

Jerry Brotton, lectures in Renaissance studies at Royal Holloway, University of London. Author of *The Renaissance Bazaar: From the Silk Road to Michelangelo* (2002) and *Global Interests: Renaissance Art between East and West* (with Lisa Jardine, 2000), which focus on artistic and material exchanges between the East and West in the early modern period. Currently researching the art collection of King Charles I.

Pierre Centlivres, professor emeritus, University of Neuchâtel (Switzerland), former Director of the Institute of Ethnology, adviser at the Kabul Museum from 1964 to 1966. Research in and around Afghanistan for thirty-five years. Publications, among others: *Et si on parlait de l'Afghanistan* (with Micheline Centlivres-Demont, 1988), *Chroniques afghanes 1965-1993* (1998), *Les Bouddhas d'Afghanistan* (2001).

Elisabeth Claverie, anthropologist at Centre National de la Recherche Scientifique (CNRS) in Paris. For several years working in Medjugorje, Bosnia-Herzegovina, a site known for its apparitions of the Virgin Mary, also explored Holy Virgin apparitions in San Damiano, Italy.

Jean-François Clément, teaches cultural studies at the Institut Commercial de Nancy. He was responsible, together with Gilbert Beaugé, for the publication *L'Image dans le monde arabe* (1995), Centre National de la Recherche Scientifique, Paris.

Raymond Corbey, associate of the Department of Philosophy of Tilburg University and the Department of Archaeology of Leiden University, both in the Netherlands. Current research focus: the history and epistemology of anthropology. Most recent book: *Tribal Art Traffic: A Chronicle of Taste, Trade and Desire in Colonial and Post-Colonial Times* (2000).

Olivier Christin, professor of early modern history at the University of Lyon, published several essays on art and iconoclasm, among them: *Une révolution symbolique. L'iconoclasme huguenot et la reconstruction catholique* (1991), *Johannes Molanus' Traité des Saintes images* (with François Boespflug, 1996).

Lorraine Daston, Director at the Max Planck Institute for the History of Science, Berlin; recent publications include: *Wonders and the Order of Nature, 1150-1750* (1998, with Katharine Park), *Eine kurze Geschichte der wissenschaftlichen Aufmerksamkeit* (2001), and *Wunder, Beweise und Tatsachen: Zur Geschichte der Rationalität* (2001).

Brigitte Derlon, an anthropologist, did a lot of fieldwork in New Ireland, Papua New Guinea. Studied local malanggan, funerary woodcarvings that are highly prized in Europe as pieces of primitive art.

Jean-Michel Frodon, born 1953, journalist and critic, and senior editor for cinema at *Le Monde*; also teaches. Published several essays, including: *L' Age moderne du cinema francais* (1995), *La Projection nationale* (1998), *Hou Hsiao-hsien* (1999), *Conversation avec Woody Allen* (2000).

Peter Galison, professor of history of science and physics at Harvard University. Publications: *How Experiments End* (1987), *Image and Logic: A Material Culture of Microphysics* (1997); co-editor *Picturing Science/Producing Art* (1998) and *The Architecture of Science* (1999). Recently he co-produced a documentary film titled *Ultimate Weapon: The H-Bomb Dilemma*.

Dario Gamboni, professor of art history at the University of Amsterdam. Since the 1980s he has been studying controversies surrounding the display of modern and contemporary art in public space and museums. Author of *The Destruction of Art: Iconoclasm and Vandalism since the French Revolution* (1997).

Peter Geimer, Ph.D. in art history, researcher at the Max Planck Institute for the History of Science in Berlin.

Boris Groys, born 1947, studied philosophy and mathematics at the University of Leningrad. He received his Ph.D. in 1992. He was professor at the University of Pennsylvania in 1988, at the University of Southern California, Los Angeles in 1991, and since 1994 at the Hochschule für Gestaltung in Karlsruhe. He is a member of the Association International des Critiques d'Art (AICA). Among other works, he has published: *Logik der Sammlung. Am Ende des musealen Zeitalters* (1997); *Unter Verdacht. Eine Phänomenologie der Medien* (2000).

Joanna Hadjithomas and **Khalil Joreige**, filmmakers, video artists and photographers. Their works deal with the modalities of representation, primarily with the recent history of Lebanon.

Sabine Himmelsbach, born 1966, worked for galleries in Munich and Vienna. From 1996 to 1998, project manager for exhibitions and symposia for the Styrian Autumn Festival in Graz, Austria. Since 1999, exhibition director at the ZKM | Center for Art and Media, Karlsruhe.

Gregor Jansen, art historian, born 1965. Numerous exhibitions and publications primarily on contemporary art; co-curator of *Continental Shift* (Ludwig Forum, Aachen, 2000); project leader for *Iconoclash* (ZKM | Center for Art and Media, Karlsruhe, 2002). Lectures on media theory at the Fachhochschule Aachen. Writes for: *taz, Blitzreview, springerin,* and *Kunst-Bulletin*.

Caroline Jones, fellow at the Wissenschaftskolleg in Berlin; completing a critical history of the art writer Clement Greenberg, and continuing her research on nationalism, internationalism, and globalism in modern art and new media. Author of *Machine in the Studio* (1996), co-editor of *Picturing Science, Producing Art* (1998, with *Iconoclash* contributor Peter Galison). In autumn 2002, she will join the History, Theory, and Criticism Program at the Massachusetts Institute of Technology as associate professor in art history.

Moshe Halbertal, professor of Jewish thought and philosophy at the Hebrew University in Jerusalem and a fellow at the Hartman Institute in Knoxville, Tennessee. Author of several books, among them *Idolatry* (co-authored with Avishai Margalit, 1994) and *People of the Book* (1997).

Nathalie Heinich, French sociologist and researcher at the Centre National de la Recherche Scientifique (CNRS) in Paris. Work field: the sociology of singularity, mostly through issues in art, identity, and collective values; studies contemporary art as an interactive game between art works, public reception, and institutional management.

Jörg Huber, Ph.D., Director of the Institute for Theory of Art and Design at the University of Art and Design, Zurich; he created a series of lectures and a yearbook, *Interventionen*; his main concentration is on research and publication in the theory of visual culture.

Michel Jaffrennou, multi-media artist; author of *My life, My œuvre, My nose Interactive Web Man Show* by www.diguiden.net, 100 % algorithmic actor, the Dragon's single messenger to the ten thousand icons, a pure on-line phantasm.

Christian Kassung, born 1968, studied German, physics, philosophy, and pedagogy in Aachen and Cologne; 1999 Ph.D.; since 2000 assistant to Prof. Dr. Thomas Macho at the Cultural Studies Seminar of the Humboldt-Universität, Berlin. Publishes mainly on epistemology and culturality of the natural sciences.

Norman Klein, critic and historian of media; author of *The History of Forgetting* (1997) and *Seven Minutes* (1996), is completing his next book, *The Vatican to Vegas: The History of Special Effects*; and the DVD *Bleeding Through*.

Robert Koch, Chair of Applied Linguistics at the University of Technology in Aachen; interested in developing a critical ontology of objects and presences.

Joseph Leo Koerner, professor of history of art at University College London. His works include: *Die Suche nach dem Labyrinth* (1983), *Caspar David Friedrich and the subject of Landscape* (1991), and *The Moment of Self-Portraiture In German Renaissance Art* (1993). His new book, *The Reformation of the Image*, will appear in autumn 2002.

Pema Konchok, independent researcher living in New York working on modern and contemporary Tibet, has made several research missions to the Tibet Autonomous Region over the last decade.

Denis Laborde studied at the Conservatoire National Supérieur de Musique, Paris, and anthropology at the École des Hautes Études en Sciences Sociales (EHESS), Paris, working on the perspective of an ethnology of music in the Western cultures. Researcher at the Centre National de la Recherche Scientifique (CNRS) in Paris, and member of the Mission Historique Française en Allemagne in Göttingen. Research interests include both improvisation (in relation to the cognitive perspective) and "iconoclashes" (Bach and Saint Matthew Passion, Bardo Henning and the Day of German Unity, 1998 etc.). He is writing a book on Steve Reich's opera *Three Tales*.

Bruno Latour, philosopher and anthropologist working at the Centre de sociologie de l'innovation École des Mines in Paris; he has written many books on the linkages between science and culture; *Iconoclash* is his first confrontation with the hard work of curatorship.

Jean-Marc Lévy-Leblond, professor at the University of Nice, is a physicist (theoretician) and epistemologist (experimentalist), critic of science, and publisher of the review *Alliage* (culture, science, technology).

Pierre-Olivier Léchot studied theology, hermeneutics and history from 1997 to 2001 at the Universities of Neuchâtel, Berne and Tübingen. Received his "licence en herméneutique religieuse" from Neuchâtel, 2002, and since then has been working on his doctoral thesis on "the history of Christianity" about the Neuenburger reformer (and "iconoclast") Guillaume Farel, and the history of his effects from the sixteenth to the eighteenth centuries.

Dominique Linhardt, working on his Ph.D. in Paris, studies the major "political iconoclash" that occurred in the 1960s and 1970s in the German Federal Republic – how the extra parliamentary opposition and the subsequent urban guerrilla managed to break apart the nice image of the West German postwar "democratic" miracle.

Adam Lowe, artist of the craft tradition, lives in London, was never interested in the destruction of images, but rather, the indefinite metamorphosis of prints and traces through the many mediums offered by science and technology. Curated, together with Simon Schaffer, the N01SE exhibition in Cambridge; visited Burma in 1995; presently duplicates Egyptian tombs.

Catherine Lucas, studied history in Paris and has traveled extensively in the Middle East, especially Syria and Iran. She is particularly interested in Islam and its popular expressions of faith.

Thomas Macho, Managing Director of the Cultural Studies Seminar at the Humboldt-Universität, Berlin, and also a professor of cultural history. Recent publications: *Todesmetaphern. Zur Logik der Grenzerfahrung* (1987) and *Weihnachten. Der gescheiterte Kindsmord* (2001).

Lydia Marinelli, historian and curator, Research Director of the Sigmund Freud Society, Vienna, has produced several exhibitions on the history of psychoanalysis and has published on this topic and on the history of dreaming. Her recent book, co-written by Andreas Mayer, is *Dreaming after Freud* (2002).

Noortje Marres, is working on a dissertation in philosophy at the University of Amsterdam. She aims to provide an update of the controversy between the American pragmatist John Dewey and the American journalist Walter Lippmann on the fate of democracy after the rise of new media. As part of an ongoing research project with Richard Rogers, she has been mapping and theorizing issue-networks on the Web since 1998.

Andreas Mayer, sociologist and historian of science currently based at the Max-Planck-Institute for the History of Science, Berlin. His recent publications deal with the question of how the materiality of psycho-techniques can be understood through the history of hypnotism and psychoanalysis. Current project: history of locomotion studies in the nineteenth century.

Andrei Mogoutov, born in the former Soviet Union in 1963, studied physics and applied mathematics at Moscow State University. Moved to France in 1990, obtained his Ph.D. in theoretical physics at the University of Paris VI. Since 1994, specialized in the methodology of the social sciences. Collaboration with the European University in St. Petersburg and the Centre de Sociologie de l'Innovation of Ecole Nationale Supérieure des Mines de Paris in developing and teaching new approaches and methods for empirical research in the social sciences. Co-founded AGUIDEL, a consulting company.

Marie José Mondzain, a former student of the École Normale Supérieure, Sèvres; Research Director of the Groupe de Sociologie Politique et Morale at the Centre National de la Recherche Scientifique (CNRS) in Paris. She has a Ph.D. in philosophy and on byzantine history and civilization.

Tobie Nathan, born 1948 in Cairo, Egypt, holds Ph.D.'s in psychology (1976), arts and sciences (1983). He is a professor of clinical psychology and psychopathology at the University of Paris VIII with special areas of interest in psychoanalysis, psychotherapy, and ethno-psychiatry.

Arkadi Nedel, born in the former Soviet Union in 1969, studied philosophy at Moscow State University. Received his M.A. in philosophy and medieval history from the Universities of Tel-Aviv and Beer-Sheva, Israel. Since 1998 in France, he continued his research at the University of Sorbonne. Publishes in different languages on the history of Western philosophy, theory of literature, history, and art criticism.

Hans Ulrich Obrist, born 1968 in Zurich, is curator at Musée d'art moderne de la ville de Paris, and co-curator of international traveling shows such as *Cities on the Move, Laboratorium, Mutations*. He is preparing a seminar, book, and exhibition on the theme of Utopia, co-edited and co-curated with Molly Nesbit and Stefano Boeri for 2002/2003.

William Pietz, author of several influential articles on the idea of the fetish. More recently, he has written on the history of forensics, the genealogy of debt, and the concept of the person.

Bruno Pinchard, born 1955, thinks of Italy as a very beautiful woman: he visits her, he pilfers her, he cries for her. *Iconoclash* has awakened in him obscure forces of this obsessive cult. He has recently published *Méditations mythologiques. Les Empêcheurs de penser en rond* (2002) and teaches philosophy in Tours, France.

Richard Powers, author of seven novels that frequently deal with the themes of representation, narration, and technologies. His work includes: *The Gold Bug Variations* (1992), *Galatea 2.2* (1996), and *Plowing the Dark* (2002).

Hans-Jörg Rheinberger studied philosophy and biology in Tübingen and Berlin; Executive Director of the Max Planck Institute for the History of Science in Berlin. Published numerous articles on molecular biology and the history of science. He has written, among other books: *Experiment, Differenz, Schrift* (1992), *Toward a History of Epistemic Things. Synthesizing Proteins in the Test Tube* (1997), *Experimental systeme und epistemische Dinge* (Göttingen 2001).

Margit Rosen, born 1974, studied art history, philosophy, and media arts in Munich, Paris, and Karlsruhe. She began working at the ZKM | Center for Art and Media, Karlsruhe, in 1999.

Ramon Sarró, social anthropologist, based at the University of Oxford. Since 1993 he has conducted ethnographic and historical research among the Baga people of coastal Guinea in West Africa. Research focus on religious change, and especially on the legacy of an iconoclastic movement that took place in 1956.

Simon Schaffer, historian of science at the University of Cambridge. Curated with Adam Lowe exhibitions about information and transformation, N01SE (www.kettlesyard. co.uk/noise). Curated with staff of the Whipple Museum of the History of Science exhibitions about physics and public science in 1900 (http://www.hps.cam.ac.uk/whipple/PubFPAG.html). Produced with Steven Shapin a book about experiment and the social order, Leviathan and the air pump (http://www.stanford.edu/class/history34q/readings/ShapinSchaffer/ShapinSchaffer_Seeing.html).

Peter Sloterdijk's recent publications include: *Titel Globen* (1999), the second volume of his *Sphären*-Trilogy, and also *Luftbeben. An den Quellen des Terrors* (2002).

Heather Stoddard heads the Tibetan Department of the National Institute for Oriental Languages and Civilizations in Paris. She has been on twenty research missions to China and Tibet since 1982. Founder of Shalu Association for Tibetan Cultural Heritage, she is working on the conservation of early sites in the Autonomous Region of Tibet.

Z. S. Strother, associate professor of African art history at the University of California, Los Angeles, and author of *Inventing Masks: Agency and History in the Art of the Central Pende* (1998).

Miguel Tamen heads the Program for Literary Theory at the University of Lisbon, and is a regular visiting professor at the University of Chicago. In his most recent book, *Friends of Interpretable Objects* (2001), he discusses the connections between iconoclasm and museums and anti-iconoclasm and vandalism.

Michael Taussig graduated in medicine in Sydney, Australia, studied sociology at the London School of Economics, and has visited Colombia, South America, every year since 1969. He taught in the Performance Studies Department of New York University and is professor of anthropology at Columbia University, New York. His latest book, *Defacement* (1999), concerns the unexpected consequences of unmasking, especially how it thickens the public secret.

Anne-Christine Taylor, senior researcher at the Centre National de la Recherche Scientifique (CNRS) in Paris, where she heads a research unit on Amerindian ethnology. She has been working among the Jivaroan Achuar Indians of Ecuador since 1978 and has published extensively on various aspects of Jivaroan culture and history. Her present work deals with indigenous conceptualizations of selfhood, emotion, and memory.

John Tresch teaches philosophy and anthropology at Columbia University, New York. He is working on a book about science, literature, and society in nineteenth century Paris *(Mechanical Romanticism)*.

Peter Weibel, born in Odessa in 1944, was appointed professor for visual media art at the Hochschule für Angewandte Kunst in Vienna in 1984 and head of the digital arts laboratory of the Media Department of New York University, Buffalo from 1984 to 1989. He founded the Institute of New Media at the Städelschule in Frankfurt in 1989. From 1986 to 1995 he was artistic consultant and later artistic director of the Ars Electronica in Linz, from 1993 to 1998 curator at the Neue Galerie Graz. He commissioned the Austrian pavilions at the Venice Biennale from 1993 to 1999. Since 1999 he is Chair and CEO of the ZKM | Center for Art and Media, Karlsruhe.

Albena Yaneva, post-doctoral research fellow at the Max-Plank Institute for the History of Science in the group *The Common Languages of Art and Science*.

Dörte Zbikowski received her doctorate with a thesis on primitivism. She was curator at the Hamburger Kunsthalle, Hamburg, ZKM | Museum für Neue Kunst, Karlsruhe, and Flick Collection, Zurich. Her publications concentrate on international contemporary art.

INDEX